W9-CZM-193

CLAES OLDENBURG COOSJE VAN BRUGGEN
SCULPTURE BY THE WAY

Exhibition realized with the support of
FONDAZIONE CRT

Claes Oldenburg Coosje van Bruggen:
Sculpture by the Way

Castello di Rivoli Museum of Contemporary Art, Rivoli-Turin
October 25, 2006 – February 25, 2007

Exhibition Curators and Catalogue Editors
Ida Gianelli, Marcella Beccaria

Curatorial Coordination
Federica Martini

Translations
Meg Shore (from Italian to English, text by G. Celant)
English translation © 1997 by translator Joachim Neugroschel
(from German to English, text by D. Koepplin)

General Editing
Michele Abate

Editing
Stephanie Salomon

Graphic Design
Leftloft, Milan

Cover
Dropped Flower, 2006
Polyurethane foam, fiber-reinforced plastic, felt, burlap, rope,
aluminum, copper, expanded polystyrene; painted with acrylic
9 ft. 8 in. × 16 ft. 4 in. × 24 ft. 2 in.
Castello di Rivoli Museum of Contemporary Art, Rivoli-Turin
Permanent loan
Fondazione CRT Project for Modern and Contemporary Art

Fabrication for Dropped Flower
Modelleria Angelino, Roletto-Turin

Project Manager for Dropped Flower
Marco Della Torre

First published in Italy in 2006 by
Skira Editore S.p.A.
Palazzo Casati Stampa
via Torino 61
20123 Milano
Italy
www.skira.net

Printed and bound in Italy. First edition

ISBN-13: 978-88-7624-870-2
ISBN-10: 88-7624-870-6

Distributed in North America by Rizzoli International
Publications, Inc., 300 Park Avenue South, New York, NY 10010.
Distributed elsewhere in the world by Thames and Hudson
Ltd., 181a High Holborn, London
WC1V 7QX, United Kingdom.

ACKNOWLEDGMENTS

The exhibition and the catalogue *Claes Oldenburg Coosje van Bruggen: Sculpture by the Way* have been realized through the combined efforts of many individuals and institutions. We are extremely grateful to them all.

Foremost, both the exhibition and the catalogue would not have been possible without the generous collaboration of the artists, Claes Oldenburg and Coosje van Bruggen, who were involved in every aspect of the project. We also thank them for making a large number of artworks available on loan. Selected from their private collection, these works include examples that have been rarely exhibited. For their continuous assistance throughout the project, we thank Sarah Crowner and Sara Greenberger Rafferty, of the Oldenburg van Bruggen Studio.

We owe a particular debt of gratitude to PaceWildenstein, New York, for its generous and extensive participation in the project and for its loan of many works. We especially thank Arne and Milly Glimcher, Douglas Baxter, and Marc and Andrea Glimcher.

Special thanks go to the Museé d'Art Moderne, Saint-Etienne, France, and Lorand Hegyi for permission to exhibit *From the Entropic Library* (1989).

We wish to express our gratitude to the following private collectors, who graciously loaned works to the exhibition: Frank and Berta Gehry, Santa Monica, California; Mr. and Mrs. Christopher Harland, New York; Robert and Jane Meyerhoff, Phoenix, Maryland; and Julie and Edward Minskoff, New York; in addition to those lenders who wish to remain anonymous.

We also acknowledge the valuable assistance and loans provided by the following galleries and

institutions: Paula Cooper Gallery, New York; Konrad Fischer Galerie, Düsseldorf; and The UBS Art Collection.

For the catalogue, we are very grateful to Stephanie Salomon for editing the English-language edition.

We also extend our deepest thanks to the photographers who permitted their remarkable images documenting the artists' work to be included. We particularly wish to recognize those who have worked closely with Claes Oldenburg and Coosje van Bruggen for many years: Todd Eberle, Marina Faust, Hans Hammarskiöld, Gerd Kittel, Attilio Maranzano, Douglas Parker and Fran Salomon, Paolo Pellion, Karl Petzke, and Ellen Page Wilson.

Our gratitude goes to the following authors for kindly allowing selected essays to be reprinted: Germano Celant, Dieter Koepplin, and Richard Morphet.

Finally, we gratefully acknowledge the cooperation of the numerous individuals, museums, and other institutions worldwide who have granted permission to reproduce certain images and texts. We especially thank Lisa Dennison, Solomon R. Guggenheim Museum, New York; João Fernandez, Museu de Arte Contemporânea de Serralves, Porto; Martin Hentschel, Kunstmuseen Krefeld, Krefeld, Germany; Juan Ignacio Vidarte, Guggenheim Museum Bilbao, Bilbao, Spain; Tuula Karjalainen, Contemporary Art Museum Kiasma, Helsinki; Lars Nittve, Moderna Museet, Stockholm; Luminita Sabau, Deutsche Genossenschaftsbank, Frankfurt-am-Main; James S. Snyder, The Israel Museum, Jerusalem; Marianne Stockebrand, The Chinati Foundation, Marfa, Texas; and Gijs van Tuyl, Stedelijk Museum, Amsterdam.

We would like to express our profound thanks and heartful gratitude to:

the Piedmont Region, which since 1984 has believed in contemporary art and supports it through the activities of Castello di Rivoli,

the CRT Foundation, which, in addition to having always supported the Museum, in 2000 initiated the Project for Modern and Contemporary Art, which has allowed the Museum to expand its permanent collection and to acquire the work *Dropped Flower*, reproduced on the cover of this publication.

FOLLOWING PAGE:
*Il Corso del Coltello
(The Course of the
Knife)*
INSTALLATION VIEW
CASTELLO DI RIVOLI
MUSEUM OF
CONTEMPORARY ART,
RIVOLI-TURIN

Claes Oldenburg and Coosje van Bruggen call their artistic collaboration "a unity of opposites." Marked by a constant exchange between two strong and distinct identities, this collaboration has redefined the concept of sculpture, dynamically addressing the complexity of the contemporary world. *Claes Oldenburg Coosje van Bruggen: Sculpture by the Way* documents the unique nature of the artists' creative path.

In conceiving the exhibition, we have chosen the last twenty years of the artists' work, identifying *Il Corso del Coltello (The Course of the Knife)* and related drawings as our starting point. This performance revealed Oldenburg and van Bruggen's capacity to open their art up to a dialogue with architecture, performance, literature, and theater, using complete expressive freedom; held in Venice in 1985, it was, in fact, a turning point in their exploration. It also defines their particular way of approaching the urban context and declares their courageous determination to confront the viewer beyond the security offered by the museum context.

Oldenburg and van Bruggen work for the most part on the production of large-scale projects, creating public works for urban sites in Europe, America, and Asia. Their specific approach, in which careful consideration of the context is based on inexhaustible creative potential, has given new meaning to monumental sculpture, placing it on the same level as architecture. The rediscovery of the complexities of sculpture is also seen in the artists' renewed interest in the museum as context. Since the early 1990s, Oldenburg and van Bruggen have created some of their most inventive installations, in which the dynamic tension unleashed by the performance gesture has led them to address themes tied to human fragility in the face of the inexorable forces of nature, especially time.

Throughout their artistic process, Oldenburg and van Bruggen accompany their work with drawings. Within the framework of their unique dialogue, which is focused on words and images, the artists set down every intuition on paper. Like the largest of their projects, even the smallest sketch manifests a depth of content and ability to communicate universal values that trascend linguistic or cultural barriers.

The exhibition has been developed with Claes Oldenburg and Coosje van Bruggen, who have loaned many works from their private collection, including those seldom seen by the public. The artists' total involvement has extended to collaborating on the exhibition's catalogue, in which in their own words they have described the genesis of each of their principal large-scale projects. The selection brought together in *Sculpture by the Way* represents a journey through the artists' creative universe and offers an invaluable occasion to observe their dynamic magic at close range.

Their generosity has also led Oldenburg and van Bruggen to create *Dropped Flower*, conceived specifically for the exhibition. Acquired with the support of the Fondazione CRT Project for Modern and Contemporary Art, the work joins *Architectural Fragments* (1985) and *Project for the Walls of a Dining Room: Broken Plate of Scrambled Eggs, with Fabrication Model of the Dropped Bowl Fountain* (1987), which are already part of Castello di Rivoli's collection. This latest addition further attests to the close bond between the museum and the artists.

Ida Gianelli
Director

Marcella Beccaria
Curator

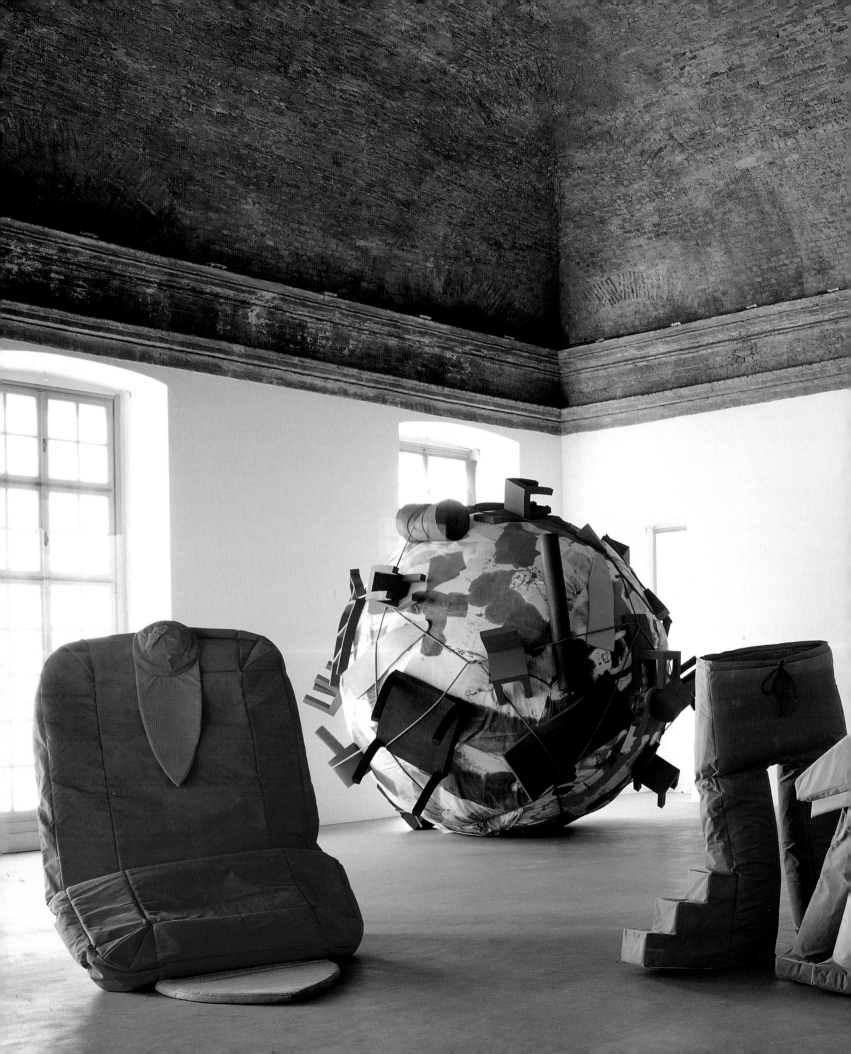

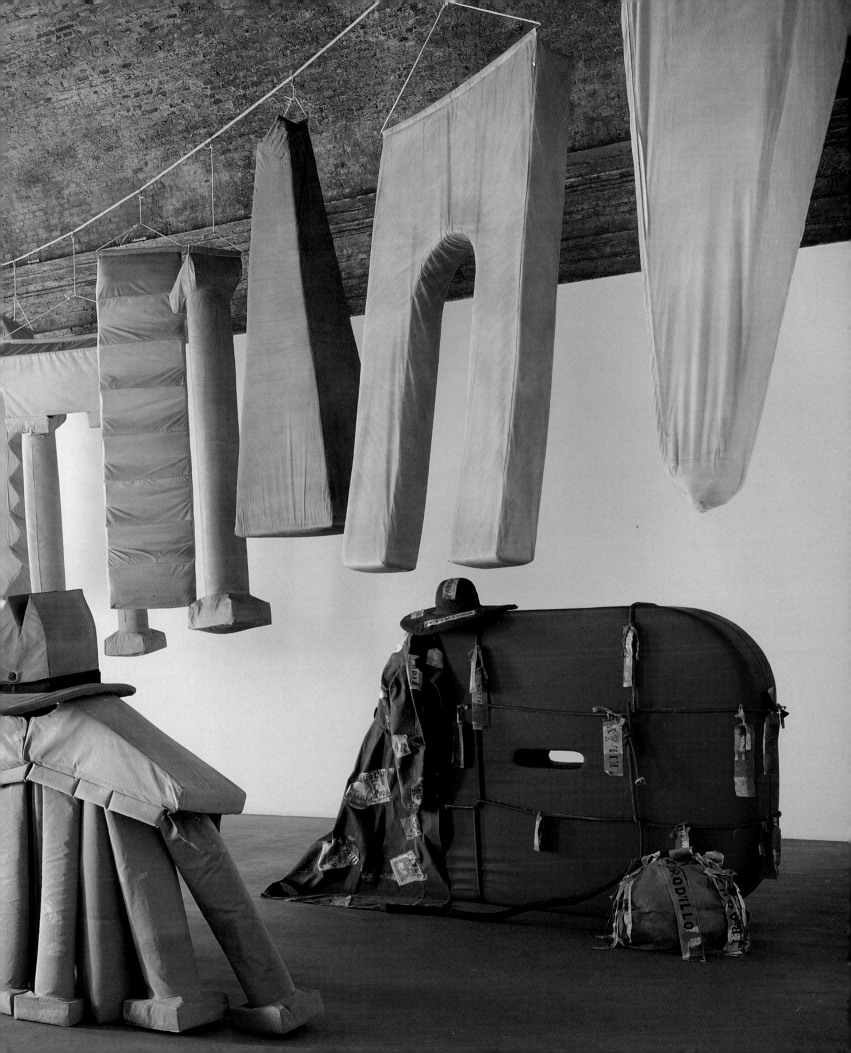

CONTENTS

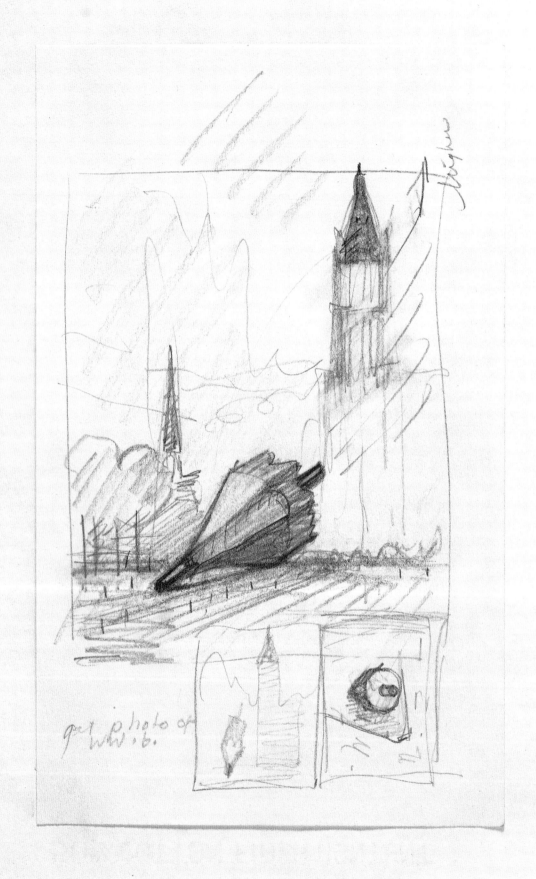

get photo of
w.w.b.

SOLITUDE FOR TWO, SHARED
A WALK WITH IDA GIANELLI

IDA GIANELLI: The setting for much of your work is public – whether indoors in a museum or outdoors in a park – yet the originals seem to be very personal and the result of what could be called a synthesis of a dialogue that transpires between the two of you.

CLAES OLDENBURG: In public sites, our sculptures reflect both the surroundings and their context, but through our imagination and selective perception – which is what makes them also personal. We feel free to use all the approaches that come naturally to our non-monumental works: variations in scale, similes, transformations, a wide range of materials, and, of course, our use of familiar objects. We want to communicate with the public but on our own terms, even if the images are stereotypical.

Our dialogue, which leads to the definition of a project, may take place anywhere, but we usually make decisions in our studio where we are surrounded by objects, models, notes, and drawings from the recent past and present, stimulated, whenever possible, by recollected observations of a site. We work our way through one image after another in words and sketches, testing them in models that can serve as the starting point of fabrication in large scale.

COOSJE VAN BRUGGEN: A few years ago, when we were in our studio in Beaumont, I asked Claes how he became such a scavenger. The accumulation of all kinds of leftovers – canvas, nails, wire, clothesline, and model-construction remnants, such as bits of wood, dowels, and a rubber ball cut in half for plaster-casting, even branches and leaves – had me wondering if it was because he wanted to rely only on himself, to have at hand all the materials needed to transform one thing into another. Or, maybe it was to maintain a simplicity of form, a certain gestalt? I know that it works out: a chunk of Styrofoam left in a Fed-Ex box was picked away at until a sliced apple core appeared. One of several marbles brought back from the Faites-le Vous-Même (Do it yourself) store in Tours was covered with white paint and transformed into a pearl that was mounted on a little piece of cardboard folded into a miniature envelope – small changes rather than great jolts. In *Resonances, after J.V.*, the pearl and envelope landed on top of a softened viola da gamba. This tableau is about a woman's vision (mine) through a man's hand (Claes'), and in that sense similar to *Study for Cross Section of a Toothbrush with Paste, in a Cup, on a Sink: Portrait of Coosje's Thinking*, made from scraps of cardboard coated with resin, with a length of clothesline functioning as the toothpaste.

The predilection for deliberate, improvisatory primitiveness, the recovery of the inherent nature of materials or of the magic

NOTEBOOK PAGE: SCULPTURE IN THE FORM OF A COLOSSAL PENCIL POINT, WOOLWORTH BUILDING AND TRINITY CHURCH IN BACKGROUND, 1994 PENCIL AND CRAYON 8 1/2 × 5 5/8 IN. ON SHEET 11 × 8 1/2 IN.

of a previous life present in a bundle of ancient burlap, for example, turn the studio into a state of flux, a place that is a source of images changing into other, equivalent ones. Italo Calvino talks about "a field of analogies, symmetries, confrontations." That's our particular landscape, the one in which we function. Working together supposes an almost complete understanding of the other, an impossibility in any case, so instead we choose a unity of opposites, a convergence of our different dynamics, of symmetry and asymmetry, of acceleration or implied speed and stillness, of a polychrome and monochrome palette, gravity and lightness – all interrelating and interchangeable elements to be used by either one of us. Juxtaposed or superimposed, the components are put together into an image through a dialogue between us that proceeds like a game of Ping-Pong, to and fro, toward its ultimate crystallization, first into a sketch and then into a three-dimensional study or a model, a process of using the senses rather than analysis, in sharp contrast to the rational fabrication phase that follows.

CO: A good example is the *Mistos*, for Barcelona. It was early 1987 and, as usual, we were working on several projects at once, especially on pieces that would become *The Haunted House*. After *Il Corso del Coltello*, Coosje had formulated a new approach, using discarded, fragmented objects freely floating in space or brought together by the forces of nature, which she called "flotsam." One of the first sculptures in this direction was a wooden match about half burnt that had been made at Coosje's suggestion for an AIDS benefit at the Leo Castelli Gallery. This had led to a larger, room-scale version, which I was in the process of carving out of Styrofoam in Brooklyn. As a result, there were fragments of matches in various stages of use all over the studio and studies of matches for projects under development in Vail, Colorado, and Middlesbrough, England. Coosje's response to the commission in Barcelona was a field of paper matches torn from a matchbook, some burnt, some not. The concept had an affinity for a sketch made in Madrid the year before of shoes dancing on a stage among dropped fans, which lent support to the image.

The composition needed a focus and Coosje proposed placing the remaining match cover – the source of the scattered matches – in the center. The profile of a half-opened fan on the Madrid stage suggested the position of the match cover seen from the side.

A little model was made out of clay and painted paper in which the small object of a match cover showed itself surprisingly capable of monumental scale. Coosje then set down the mostly unconscious intuitive reasons for our attraction to this image for the

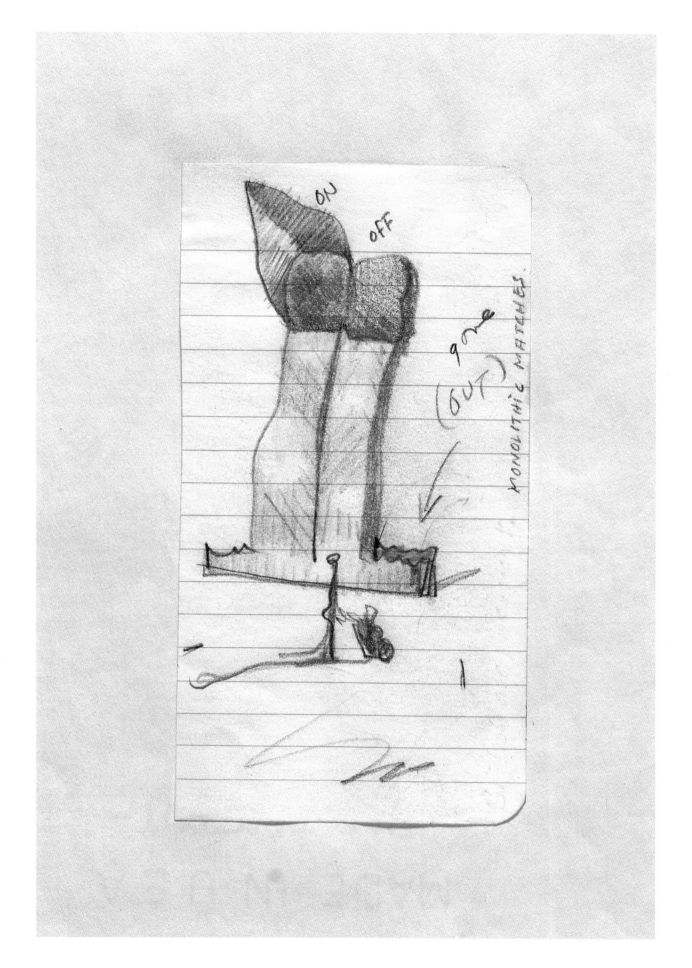

NOTEBOOK PAGE:
"MONOLITHIC
MATCHES," WITH
WOMAN AND BABY
CARRIAGE, 1987
PENCIL AND COLORED
PENCIL
5 × 2 ¾ IN. ON SHEET
11 × 8 ½ IN.

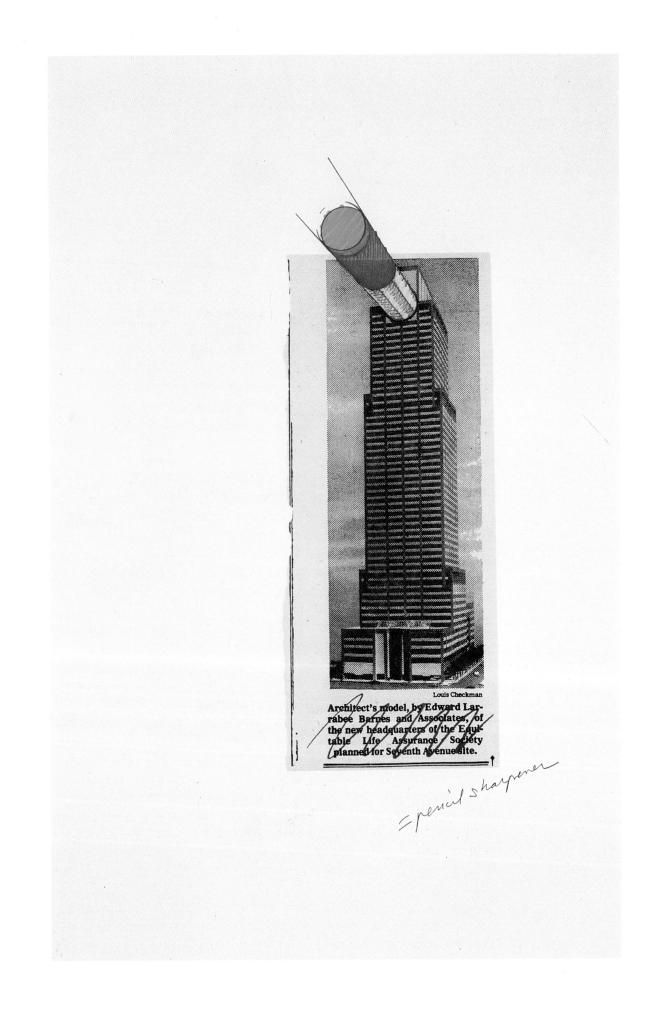

Louis Checkman

Architect's model, by Edward Larrabee Barnes and Associates, of the new headquarters of the Equitable Life Assurance Society planned for Seventh Avenue site.

= pencil sharpener

NOTEBOOK PAGE:
*EQUITABLE BUILDING AS
A PENCIL SHARPENER*,
1983
PENCIL, COLORED PENCIL,
WATERCOLOR, CLIPPING
11 × 8 ¹/₂ IN.

site in Barcelona, some of which she included in the lines of a prose poem she wrote on a drawing of the proposal we first presented shortly afterward while participating in a symposium on projects for the city.

CvB: The symbolic subject of fire is concealed within a simple, everyday object in the form of a matchbook, passing from hand to hand and carried around in a pocket, a communal object. Within the small paper packet, rows on rows of matches stuck together, each a slender piece of wood or paper with a red phosphor tip, exude the rigidity of perfection yet contain the potential for momentous chaos leading to both illumination and negation. The individual touch creates infinite variations of form: the user's mood and skill in striking any given match against the rough surface of its cover, through the force of combustion, determines the appearance of what is left of the original. The idea of the individual gesture and explicit style leaving traces of how the disposal of each match took place defines the end result of the *Mistos*: torn-up, unlit, single matches, bent and crumpled, lie on the ground along with partly burnt ones, scattered over the site in order to humanize the otherwise foreboding scale of the matchbook.

Only one match is aflame, like a beacon, its contour transforming into a lance or a fiery pen, recalling the words of Cervantes' *Don Quixote of La Mancha*: "The lance has never blunted the pen nor the pen the lance." The matchbook, like the typewriter eraser, over the years has become an archetypal object on the verge of disappearance, subject to a telescopic perspective that shifts between the emotive intimate hand-held object and the detached nearly abstracted large project with an architectonic structure and scale.

IG: Creating in such a large scale has necessarily brought you into an interaction with architecture. How does this interaction work?

CO: Vision for me consists of shapes of all kinds, near and far, seen without function or identification, in fluctuating scales as a child might see them – and as an artist ought to.

In the real world of fact, large urban scale is defined in terms of architecture. A large-scale sculpture in an urban setting is not only architectural in itself, but must necessarily be related to the architectural forms around it.

We have all heard the complaint, "Why should buildings always be boxes?" That was some time ago. Architecture has certainly begun to move away from that – except that now I notice that boxes – stacked – are becoming part of the variations.

I enjoy taking vision literally, for example, making a pencil as large as a skyscraper by

holding it close to my eye, and inserting it into the postmodern aperture on top of the Equitable Building in midtown Manhattan – reminiscent of the zeppelins that were expected to moor at the tower of the Empire State Building when it was first erected. Another use of the subject was a large-scale project in the form of a broken pencil, its point stuck in the ground, in New York's Financial District, with the fallen tip of the Woolworth Building lying nearby for comparison. In the realm of the feasible, there is the *Blasted Pencil (Which Still Writes)*, a sculpture in the scale of a building, proposed by Coosje as a memorial to students and faculty members who disappeared over the years during a pattern of violent government incursions into the National University of El Salvador in the course of which the Library of Social Sciences was set on fire. A detailed model with exact engineering plans was donated to the university, although the work was never realized.

When Coosje and I worked with the architect Frank O. Gehry on projects for downtown Cleveland, Frank told us to follow our whims – all the stops were out. Some of the inventions had a certain authority because of the resemblance between building and objects, such as the roof for a skyscraper in the form of a vast folded newspaper, or a huge C-clamp as an architectural component holding a fitness center to a plaza overhanging a freeway.

CvB: By that time we had long ago left behind the safety of the pristine white walls of the museum and were working in large scale as part of the urban landscape. We had formulated a more and more complex vocabulary combining geometric architectural structure with a softer organic approach, executed in an industrial style derived from early shipyard and aeronautical-engineering techniques, such as welding, box construction, casting in aluminum and stainless steel, carving in foam, and molding in fiber-reinforced plastics.

Increasingly, the dynamics of the context influenced our work. We began to move away from the specific object or monolithic sculpture that draws all energy into itself, in favor of a looser, freer configuration that emits the reflected energies of the urban surroundings. The large-scale projects, in their hybridization, fragmentation, and scattering of objects, and in their relation to prominent features in the skyline, became both anchored to the site and expanded beyond it. Examples include the *Batcolumn*, in which the diamond pattern of criss-crossing steel bars relates to the Hancock Building in Chicago, and the *Cupid's Span* for Rincon Park in San Francisco, one of our later works, which not only frames the splendid vista of the bay and its bridge but also, through the angles at which bow and arrow are set in the landscape, evokes sailboats tacking in a

direction diagonal to the traffic that flows alongside the sculpture.

Situated on the ground, on the street, along the banks of a river or in the median of a road, our large-scale projects are objects in transition. Through precision of contour, shape, hue, and the freezing of a specific moment in time, they can be read as still life. Yet, perceived over time, these sculptures become emotive signs, the identification of a park, a building, a neighborhood, or even an entire city.

IG: Your art obviously has a theatrical intention and your aim of creating a lasting symbol can also be achieved through theatrical means. Do you see these two coming together in *Il Corso del Coltello*?

CvB: As performed in the Canaletto-like panorama of the Campo dell'Arsenale, *Il Corso del Coltello* was the paradigm for the ebullient process of discovering cultural and physical properties of a site that could be transformed into the equivalent of a large-scale project. The ultimate summation of the complex Venetian environment was one image – the Knife Ship – which was launched from the ancient naval yard, raising and lowering its blades and corkscrew while rotating its oars. Within the panorama, contending forces swirled in many disguises, reflected in the characters and props.

Spectators had the chance to see objects and performers in action, eclipsing one another or embedded within props. Many of the characters were hampered in their movements, which were often repeated over and over: Basta Carambola in wooden leggings, recalling the pool table on which he played; Châteaubriand, the front end of a lion, carved from soft foam, concealing a performer; or the two performers sitting in a large fish head that was rolled about, with only their eyes visible through a hole. Objects and human beings seemed engaged in an ongoing tug-of-war.

In the aftermath – the performance was presented only three times to a total of 1,500 people – certain props were sidelined, receding from view after the performance itself. Other strong, mnemonic images, like the costumes of the leading characters, Dr. Coltello, Georgia Sandbag, and Frankie P. Toronto, or the *Architectural Fragments* and the *Houseball*, in their strong reverberations of implied movement, plasticity, and painterly qualities, especially through the skin-like appearance of their canvas surfaces, became soft sculptures larger than life. This was not unlike some of the soft props found in the *Ray Gun Theater*, from the early 1960s, such as *Freighter and Sailboat* and *The Upside Down City*. The whole idea of soft sculpture evolved out of these early props.

CO: *Il Corso del Coltello* offered us a tremendous motivation to produce smaller-scale works, providing relief after our exclusive concentration on large-scale projects. Inspired by the performance, and having been given the opportunity to interact with museum sites since *Documenta 7* in 1982, we started a form of indoor installation that was a residue of action, like the conditions of a site after a performance, staged, yet as if chanced upon. We continued with the techniques and materials used in the performance: cardboard, carved Styrofoam, and stiffened canvas, painted in strong colors. *The Haunted House* was the first piece based on the aftermath of an event envisioned by Coosje, in which used-up objects and fragments were imagined to have been thrown through the windows of the Haus Esters Museum in Krefeld, Germany – the apotheosis of her "flotsam" subject and, ironically, a way of returning to exhibiting "inside" a museum.

Although the concept was Coosje's and we developed the parts of the installation together, she chose to write a description of the exhibition for the catalogue from the outside viewpoint of an art historian – which she was well prepared to do. In a somewhat tongue-in-cheek and deliberately histrionic way, she examined the work of an artist called Oldenburg, a stance that allowed her to analyze the exhibition and its connection to earlier works in objective minute detail, only leaving herself out of the picture.

IG: Soon after the Haus Esters installation, the two of you created the *Project for the Walls of a Dining Room: Broken Plate of Scrambled Eggs, with Fabrication Model of the Dropped Bowl Fountain*, in 1987. How did this come about? Did *The Haunted House* engender the room?

CO: No, but the focus on the aftermath of throwing things and broken crockery might have carried over. Miami's Art in Public Places, which had commissioned the *Dropped Bowl with Scattered Slices and Peels*, was asked to participate in the Triennale of Milan in 1988, with a contribution that would involve Frank O. Gehry, Ed Ruscha, and us, among other American artists and architects. We decided to feature a rather elaborate presentation model we had made of our Miami project, which would be realized the following year. Since the model seemed lost in the space of the exhibition hall, next to a portion of a ship by Gehry, we felt it needed a container of its own, a room within a room. Our thoughts went back in time to the earliest piece that had dealt with broken flying fragments, a model of which Coosje had once unearthed among discarded works at Broome Street. This image, of a plate of scrambled eggs breaking against a wall,

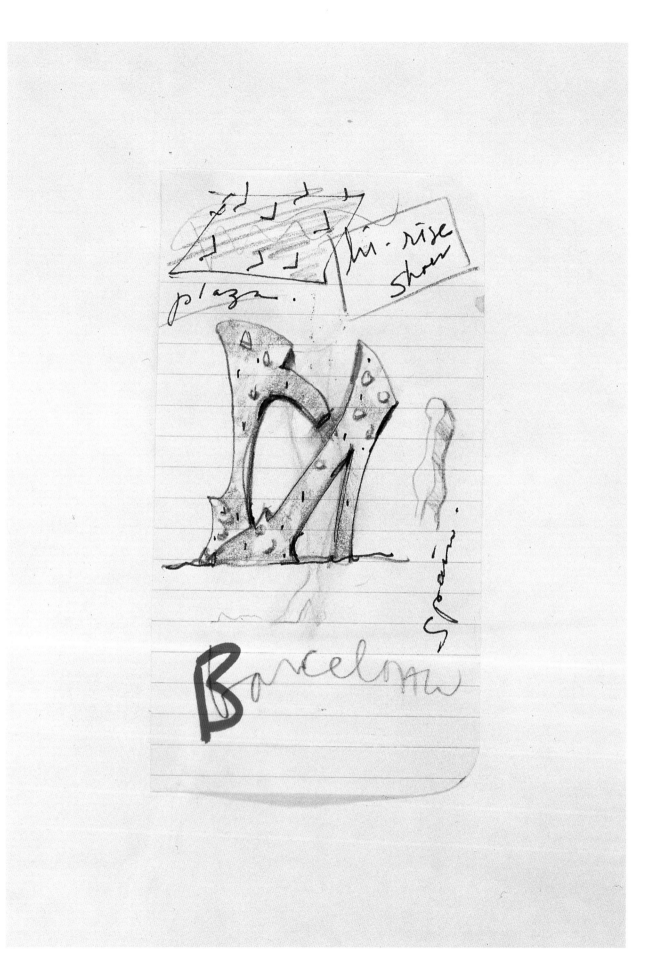

NOTEBOOK PAGE:
FLAMENCO DANCER'S
SHOES IN ACTION, 1987
PENCIL, COLORED PENCIL,
BALLPOINT PEN, FELT PEN
5 × 2 3/4 IN. ON SHEET
11 × 8 1/2 IN.

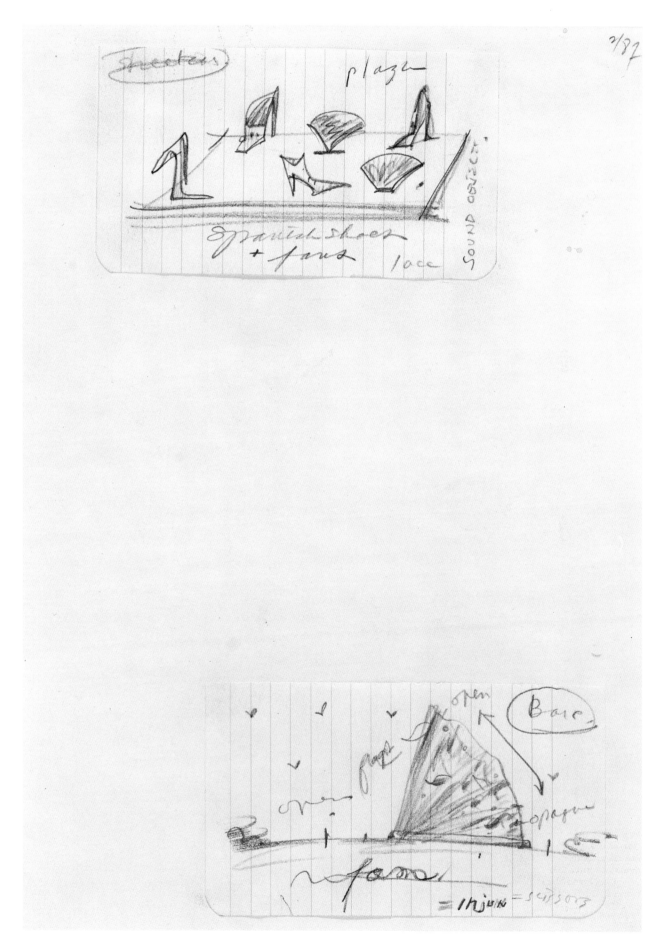

**NOTEBOOK PAGE:
STUDIES TOWARD A
SCULPTURE FOR
BARCELONA**, 1987
PENCIL, COLORED PENCIL,
FELT PEN
TWO SHEETS, EACH
2 3/4 × 5 IN., ON SHEET
11 × 8 1/2 IN.

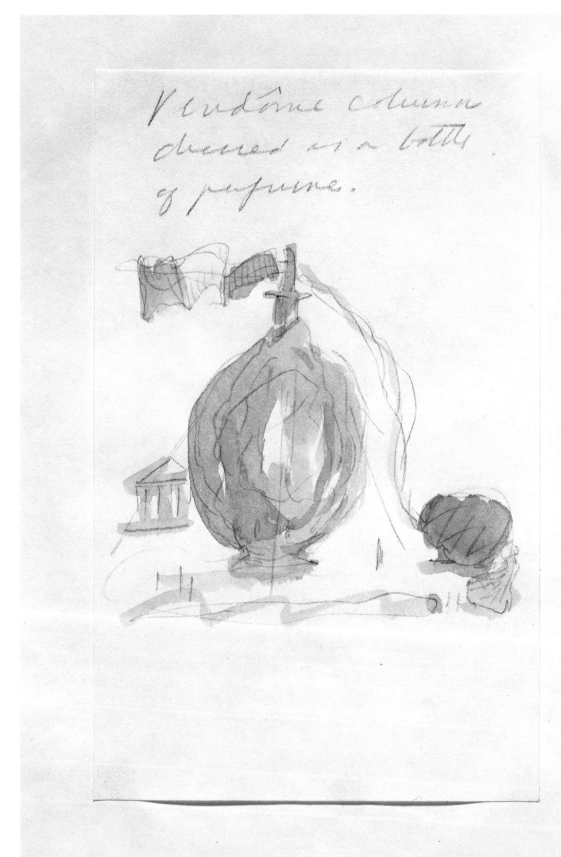

Notebook Page:
Column Dressed as a
Bottle of Perfume,
Place Vendôme, Paris,
1992
Pencil and watercolor
8 7/16 × 5 3/8 in. on sheet
11 × 8 1/2 in.

in fact had served as a starting point for the design of the *Dropped Bowl*.

A version of the scrambled eggs model in large scale, its shards executed in flat aluminum silhouettes and its eggs in painted Styrofoam, was mounted onto a wood frame – the interior of the room stripped down to its wooden studs – through which both the scrambled eggs and the model of the *Dropped Bowl* could be seen from all directions. We tilted the room, leaning it up against the wall, making it appear as if the room itself had been thrown. The installation was donated to the Castello di Rivoli after the Triennale, where the open structure proved serendipitously functional in the setting of the castle rooms, admitting views of the historical murals as a background to the flying plates and scrambled eggs.

IG: This installation was followed a year later by *From the Entropic Library*, your largest indoor work and perhaps your most symbolic statement.

CvB: It was conceived for a survey of global art, with an emphasis on non-Western forms, called *Magiciens de la Terre*. The brainchild of Jean-Hubert Martin, the exhibition was held in a huge hangar-like space, La Grande Halle, in the Parc de la Villette, on the outskirts of Paris. The work expresses the inevitable frailty of technology and human culture in the face of the processes of nature. Arranged between bookends that take the shape of a hybrid between an outboard motor and an elephant's head are decaying books – symbolizing the accumulation and loss of knowledge – which one can imagine to have been left behind by an explorer who, while discovering untrodden corners of the earth brings in pollution, and leaves his alien effects behind, which as the years go by, finally erode.

The earth is full of ruins of civilizations, such as the successive destructions by fire of Alexandria's library, or, more recently, the 1966 flood in Florence when two million books were irreparably damaged by the waters of the Arno River. Equal in impact to natural disasters, however, are the inexorable facts of nature, chiefly time. In time, knowledge becomes obsolete, and like a flower dried between the pages of a book, gradually disintegrates into dust. Single words are scattered around the library, dropped out of disconnected phrases, such as Proust's "Houses, avenues, roads, are, alas, as fugitive as the years"; H.D., quoting her psychoanalyst Sigmund Freud, "In Rome, even I could afford to wear a gardenia"; William Carlos Williams' "No ideas but in things"; and fragments of conversations overheard in the street – all leading in multiple directions and sparking the hope of approaching truth, a hope that, in its turn, will be doused by time.

Executed in architectural scale, the books

of *From the Entropic Library* stand like dilapidated tenements, with here and there an alleyway, a crack of light between them.

IG: *The European Desktop* has not been discussed as much as *From the Entropic Library*, perhaps because the former seems more enigmatic. Can you talk about its origins and content?

CvB: *The European Desktop* is the third and the last in the series of theatrical installations that grew out of the Coltello performance, after *The Haunted House* and *From the Entropic Library*. All three are about history, the past, and are centered in Europe. *The European Desktop* was shown in Milan, and has several affinities with that city, but exists in a less defined context than the other two installations. While the composition is based on objects that could be found on desktops from the past – a pad, a quill, an ink bottle, a blotter, and a postal scale – which we studied, especially in Paris and London, it resembles a jagged landscape, perhaps a battlefield.

I wrote a prose poem, starting with the line, "Crashing surfaces of shredded treaties," which expressed the reaction I had to a headline in the *International Herald Tribune*: "Undoing Yalta, 45 Years Later, a New Europe." The general theme of *The European Desktop* became a war over national boundaries, a battle that ultimately vanishes into willful amnesia. That it takes place on a desktop as well as in a blasted landscape summons up the succession of broken treaties of the past. Inkblots recall the bottle of ink thrown by Martin Luther at a fly, which, according to legend, he identified with the Devil (hence, the exploding ink bottle). Today, such desktop objects are artifacts; they have been deprived of their basic use, and are about to be lost in time, which lends them overtones of pathos, while their shapes and appearances have become more abstracted.

CO: The time span of *The European Desktop* is a continuum in which certain events from different dates coexist. Handwriting, today also old-fashioned, plays an important part – ink solidified, tangible, as the evidence of history. From the distant past there is the handwriting of Leonardo da Vinci, cryptic lines about "the great bird" taking its first flight "on the back of the great swan"; from the present that of Coosje's prose poem composed while thinking of the nineteenth century and the disastrous stay of Georges Sand and Chopin in Majorca, interrupted by the cacophony of sirens in contemporary New York. The scripts are intermingled by their transfer to a blotter, which reverses everything, making the handwriting of da Vinci, who wrote backward, legible and Coosje's illegible – in fact, Coosje can write backward too, and both are left-handed. The roughly

carved shapes and gray hues and dark greens of the sculpture reflect the ponderous landscape of Milan and evoke the nineteenth-century tomb statuary of its cemetery and that of Genoa. The grouping of disparate objects was influenced by seeing the *Bagni Misteriosi* fountain by Giorgio de Chirico, located behind the Triennale building in Sempione Park, in 1989, when the fountain was in a neglected, inoperative state. *The European Desktop* may be seen as an opera for several object-characters, for which the spectator has to provide the libretto.

IG: After the historical vision of *The European Desktop*, it seems you began an increasing involvement with present-day Europe, particularly France.

CO: We began traveling to factories in La Rochelle and Arcachon, working on the *Buried Bicycle (Bicyclette Ensevelie)*. Seeing the French countryside brought back to Coosje memories of time spent in France during her youth and a desire to establish a second residence there. In 1992, she discovered the Château de la Borde (castle on the riverbank), an estate in Beaumont-sur-Dême, forty kilometers north of Tours, which we then acquired. Having concentrated on nineteenth-and early-twentieth-century French literature as a graduate student, Coosje was naturally attracted to the Loire region, an area saturated in literary history. While a demanding schedule of fabrication of large-scale projects continued, with travels between New York, California and other parts of Europe, Château de la Borde provided us with a retreat for inspiration where ideas could be pursued without interruption – truly a place of solitude. Our capacities for production at the château were kept to a minimum. Sketches and models for larger works to be completed elsewhere were improvised in the former stables, which came to be our studio.

In 2000, the château's eighteenth-century salon became a site for a group of our sculptures in the form of musical instruments that had begun as studies for larger works but had taken on a life of their own. The techniques used to produce them were kept simple, with the emphasis on the concept. Each subject was deconstructed and its parts remade and reassembled to perform a new function according to our vision. The viola, turned into a soft form, hung against the wall of the salon like a hunting pouch full of game. Two ghostly white soft clarinets, facing each other, curved expressively onto the mantelpiece in place of the traditional coat of arms. On one side of the room hung a French horn, its length unwound to resemble the hoses in our garden, its flaring bell cut in half, as if the horn were embedded in the wall. On the opposite side of the room hung a purple vio-

lin, its strings slack and dangling, sliced into sections that in a way recalled the instrument's construction and were spread like a fan, which suggested the movement of a pendulum or a distant echo of salon gatherings. A trumpet shape of cardboard profiles and canvas strips, splashed with yellow enamel, stood on a table, its valves and tubes compressed by the knot of a length of red-painted rope. The ensemble was presided over by a *Silent Metronome*, whose authoritarian posture was undercut by its frayed canvas construction.

CvB: Balancing between rigidity and a state of repose – in anticipation of an orchestra about to perform or during its aftermath – each instrument in what we called *The Music Room* is isolated in time and space and, in the decomposition of its essential parts, is reconfigured into correspondences between vivid colors, explicit forms, and actions imposed on them, such as tying, slicing, unwinding, and entwining. With hints remaining of their original individual identities and objectness, the recomposed instrumental pieces, cut off from their habitual function, turn into stand-ins, projecting absurdist overtones. Each piece, now with an intensified tactility, bears the imprint of human presence, in absence.

The sensation of gravity possesses all the pieces, particularly *Falling Notes*, in which pages tumble and send musical notes into a free fall, spilling off their staves as if captured by a sudden gust of wind – the kind that causes chestnuts to drop, linden seeds to spin, and leaves to sail in the air. We also imagined a giant *Leaning Clarinet*, like a wheelbarrow propped up against a tree trunk, which we developed into a freestanding version, twisting, curving in resistance to the wind, its keys loosened into restless shapes resembling stirred-up branches and leaves. Recalling the brilliant blue of the summer sky through the canopy of the tree, I mixed a cerulean blue with a slight touch of green to enhance the clarinet's crisp, lucid sound – the outdoors brought indoors.

We have always been involved in the relationship between nature and man-made nature. But until we began to spend time in Beaumont-sur-Dême, we worked mainly within cityscapes, with architectonic structures, such as skyscrapers, bridges, ferryboats, water towers, chimneys, and the like. In harmony with the beauty of the overgrown and neglected park at the Château de la Borde, our inner resources were released into a more organic approach to sculpture. This approach is expressed in our recent *Dropped Flower* which can be seen as, in Baudelaire's words, one of "ces fleurs mystérieuses dont la couleur profonde entre dans l'oeil despotiquement" – "those mysterious flowers whose profound color imperiously seizes the eye."

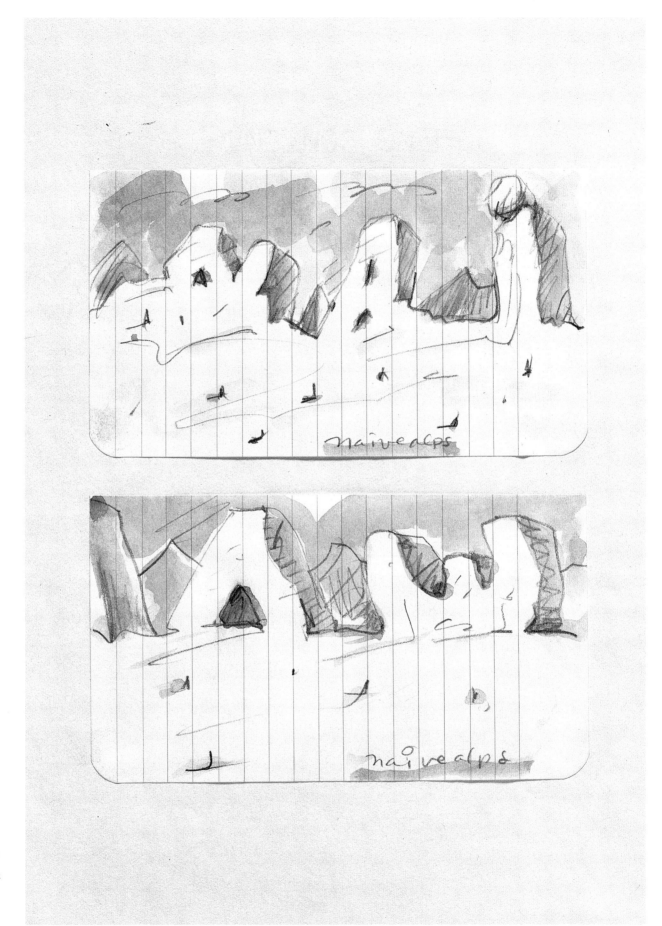

NOTEBOOK PAGE:
COLOSSAL SIGN FOR THE
ALPS: EVIAN, REVERSED,
1988
PENCIL AND WATERCOLOR
TWO SHEETS, EACH
2 $^3/_4$ × 5 IN., ON SHEET
11 × 8 $^1/_2$ IN.

SCULPTURE BY THE WAY

IL CORSO DEL COLTELLO
(THE COURSE OF THE KNIFE), 1985

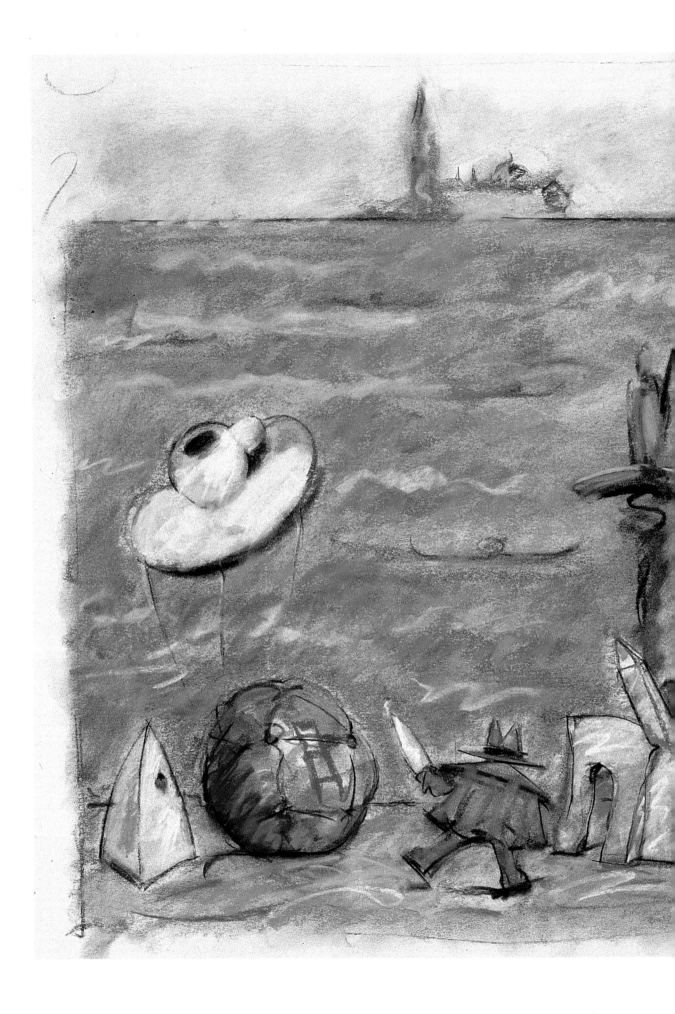

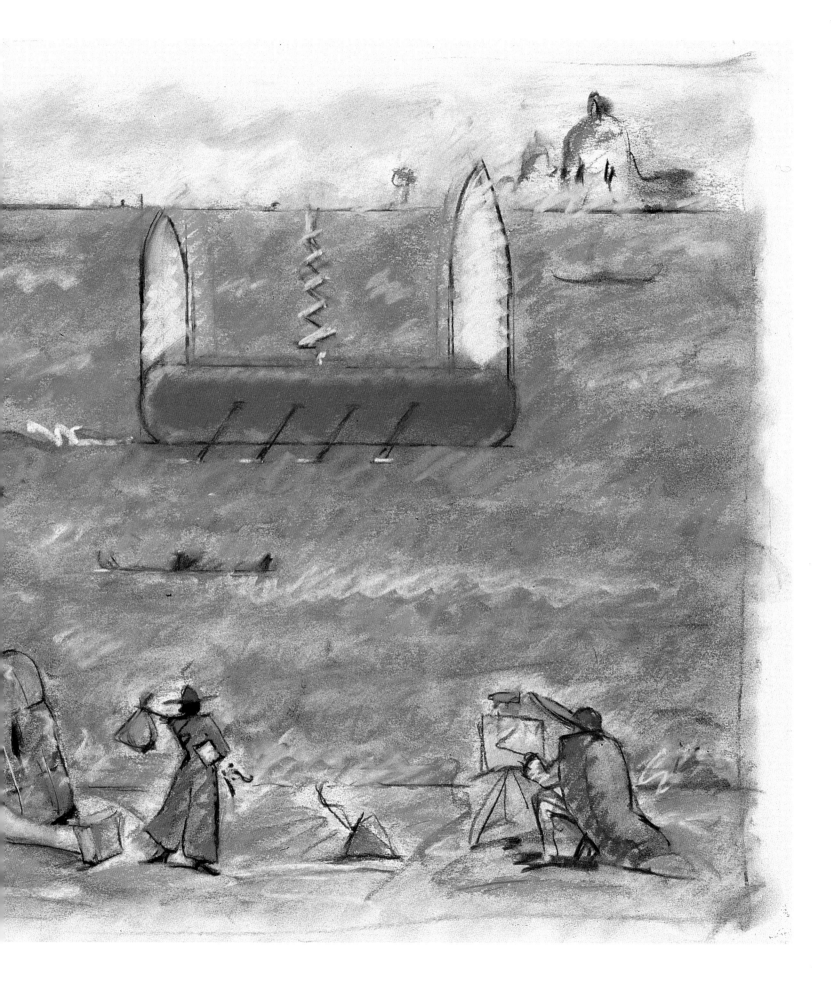

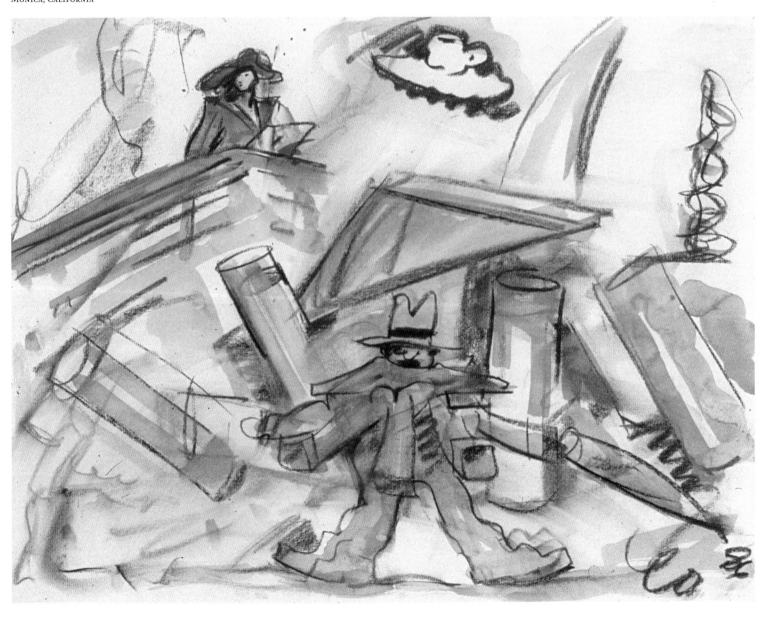

Proposed Events for
Il Corso del Coltello,
a Performance in
Venice, Italy, 1984
Crayon, pencil,
watercolor
24 × 18 3/4 in.
The UBS Art Collection

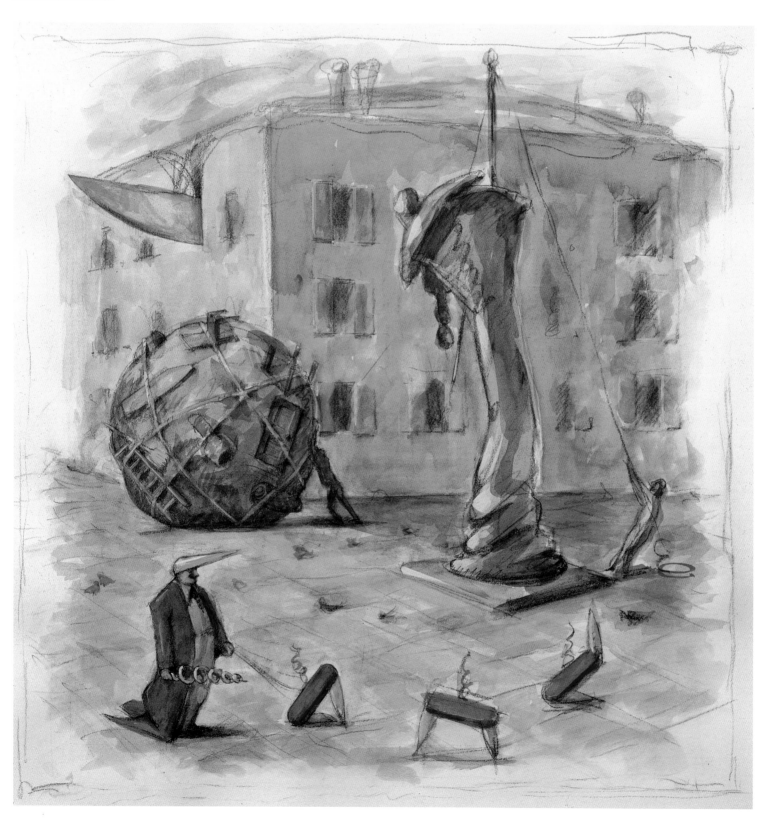

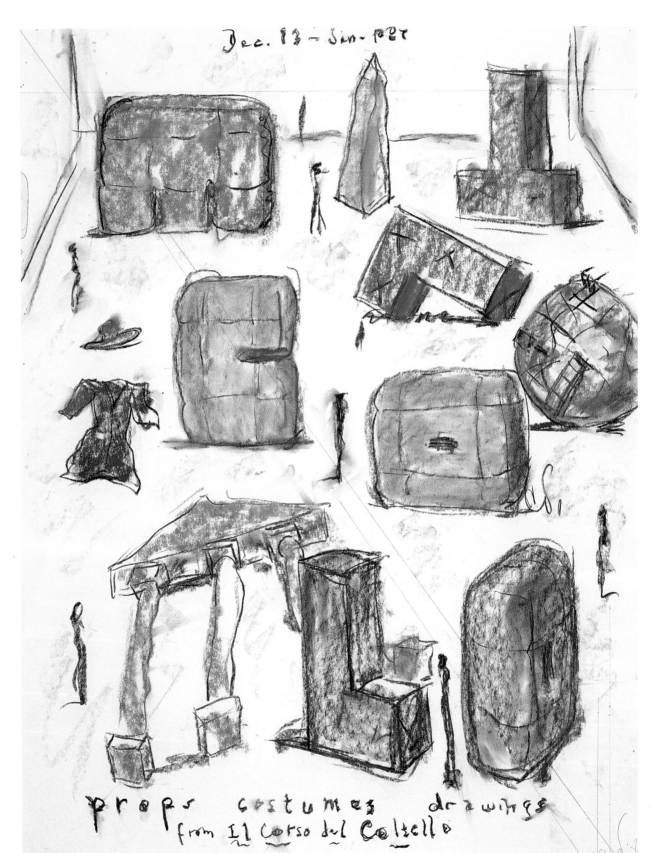

Props and Costumes for Il Corso del Coltello, handwritten text in image: "Dec. 13 – Jan. 1987" and "props costumes drawings from Il Corso del Coltello"

PROPS AND COSTUMES FOR IL CORSO DEL COLTELLO, EXHIBITION STUDY, 1986
CHARCOAL AND PASTEL
40 × 30 $\frac{1}{16}$ IN.
COLLECTION
CLAES OLDENBURG AND
COOSJE VAN BRUGGEN,
NEW YORK
COURTESY PAULA COOPER
GALLERY, NEW YORK

FOLLOWING PAGE:
PROPS AND COSTUMES FOR IL CORSO DEL COLTELLO, 1986
CHARCOAL AND PASTEL
40 × 30 IN.
COLLECTION ROBERT AND
JANE MEYERHOFF,
PHOENIX, MARYLAND
COURTESY
PACEWILDENSTEIN,
NEW YORK

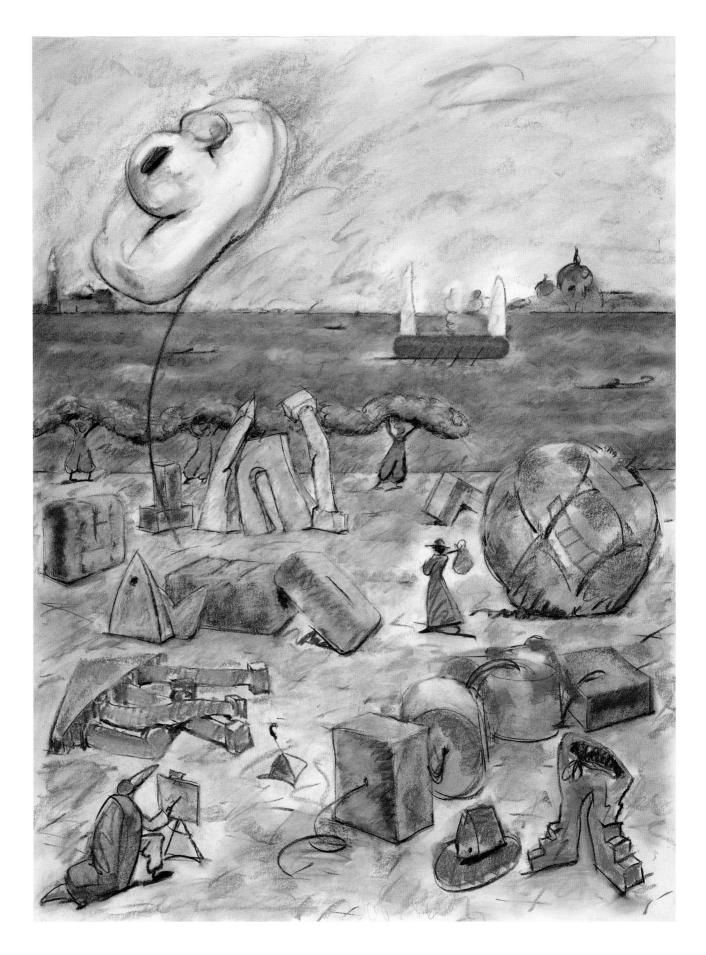

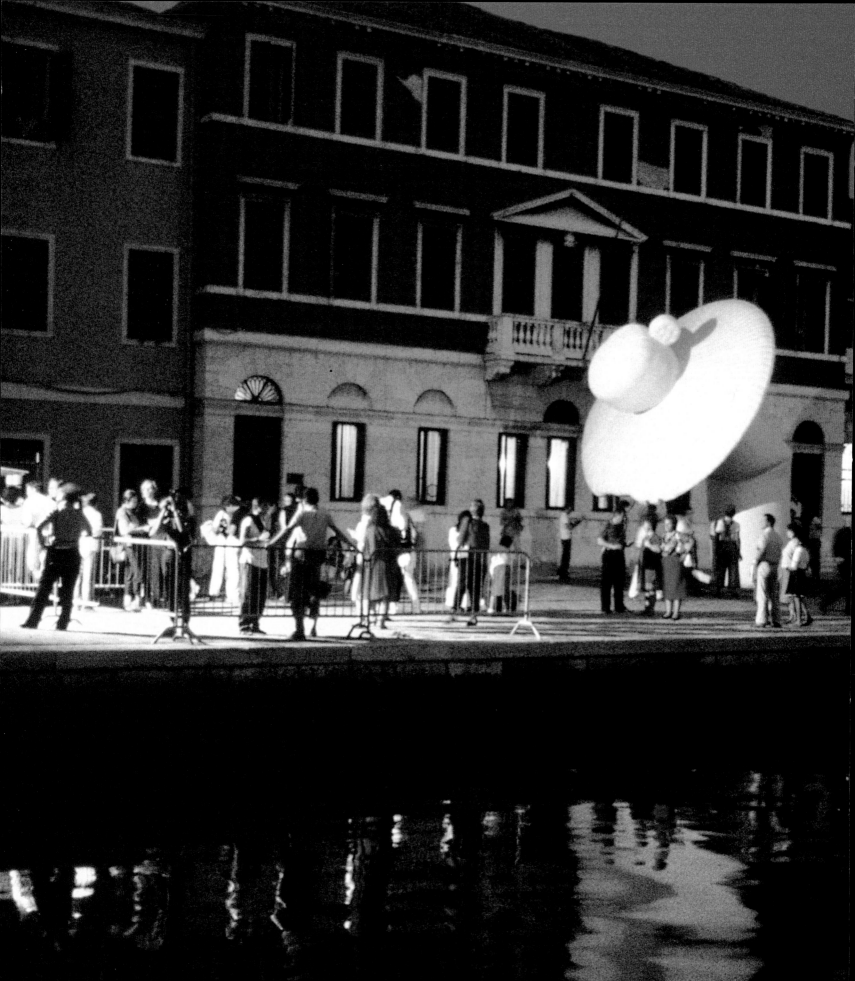

PAGES 42-51:
IL CORSO DEL COLTELLO,
PERFORMANCE, VENICE,
ITALY, SEPTEMBER 6-7-8,
1985.

PREVIOUS PAGE:
THE AUDIENCE
APPROACHING THE CAMPO
DELL'ARSENALE WITH THE
ESPRESSO CUP COLUMN
NEAR THE ENTRANCE

SLEAZY DORA,
D'ARTAGNAN, BUSGIRLS,
LORD STYROFOAM,
LEOPARD WOMAN, AND
GEORGIA SANDBAG'S
PORTERS WITH THE
HOUSEBALL DURING THE
PROLOGUE

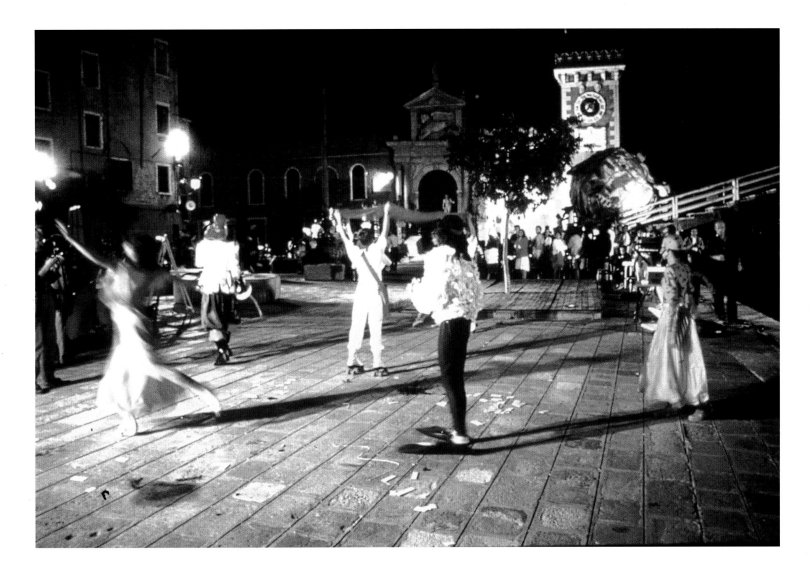

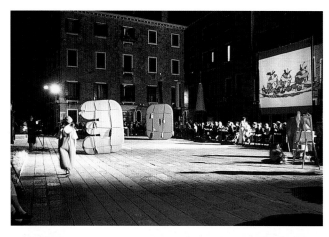

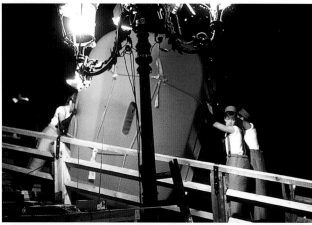

Dr. Coltello

Coosje van Bruggen

Dr. Coltello, also called the Kitsch-Dragon or Murky Apollo, is an importer of souvenirs from Switzerland who tries to sell his wares without a license while posing as a tourist. He is a master of disguises.

Obsessed with expansion, exploration, and invention, he turns imagination into reality under his motto, "I made it all up when I was a little kid."

As a boy Dr. Coltello used to wander along the shores of Lake Michigan pretending that he was flying over the Sahara desert. Inspired by the travels of Marco Polo, he studied maps of exotic places and discovered a country of his own, which he called Neubern. A palmist advised him once to buy an airplane company in order to visit the many little pieces of him she saw scattered all over the world; moreover, the form of his thumb indicated that he would always survive a building collapse. Estimating the scale of things by using the same unique thumb, Dr. Coltello is on his way to becoming a notorious Sunday painter, in the style of Francesco Guardi.

A connoisseur of hedonistic flotsam, aware of his weakness for accumulating collectibles, Coltello confines himself to no more luggage than the number of letters of his own name, but the bags and crates have become enormous due to his lack of restraint. Among his treasures, the most popular items are three souvenirs of Venice: the Leopard Woman, D'Artagnan, and the Knife Dancer. To keep him company, to watch over his goods, and to provide himself with an uncritical audience, Dr. Coltello has created the Knife Dogs, a special breed, in his likeness.

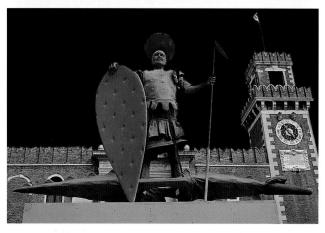

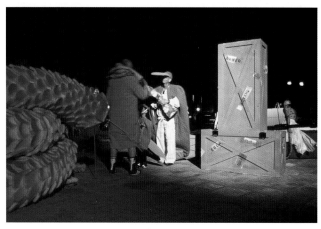

THE MIXED-UP SLIDE SHOW AND DR. COLTELLO'S SOFT LUGGAGE BEING HANDLED DURING THE PROLOGUE IN THE CAMPO DELL'ARSENALE

PORTERS TRANSPORTING THE SOFT "O" ACROSS THE PONTE DEL PARADISO DURING THE PROLOGUE

ST. THEODORE (PONTUS HULTEN) WITH CROCODILE, ON TOP OF A GREEN CAPITAL IN THE FINALE

PRIMO SPORTYCUSS (PONTUS HULTEN), A KNIFE DOG, AND DR. COLTELLO (CLAES OLDENBURG) DURING THE LECTURE

FOLLOWING PAGE: DR. COLTELLO (CLAES OLDENBURG) PAINTING IN THE CAMPO DELL'ARSENALE WITH KNIFE DOGS (ALEJO AND SAMI GEHRY)

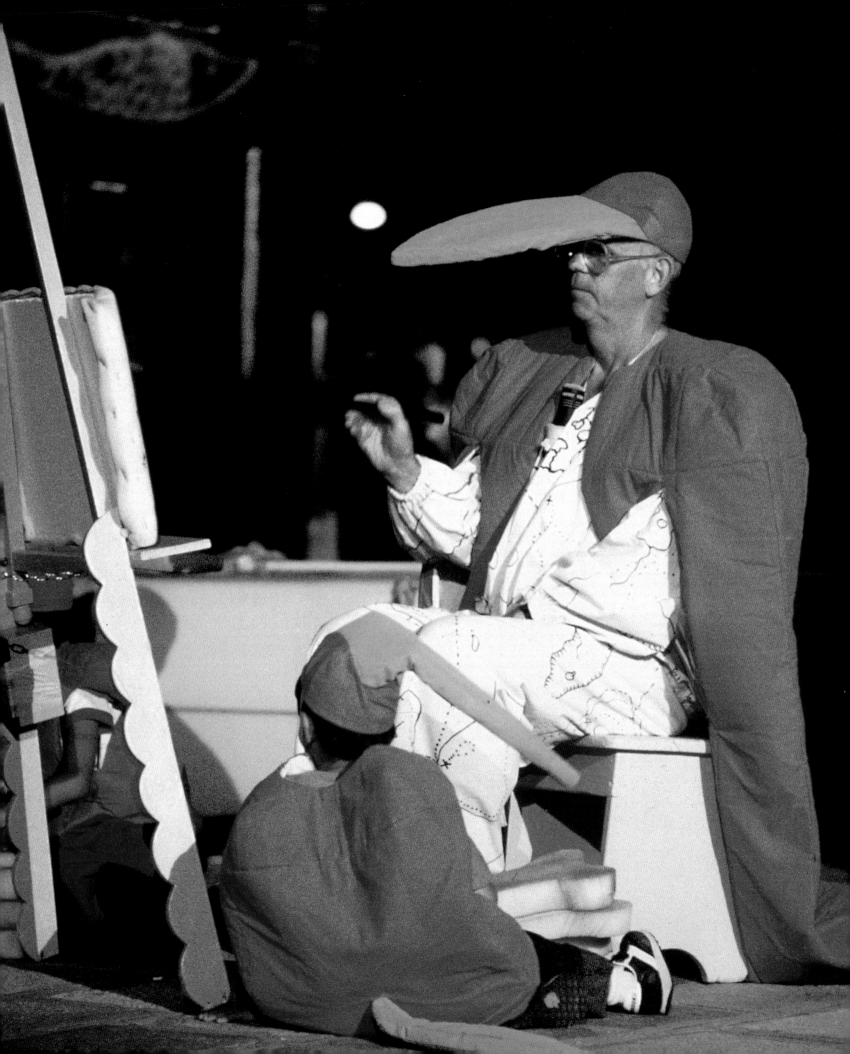

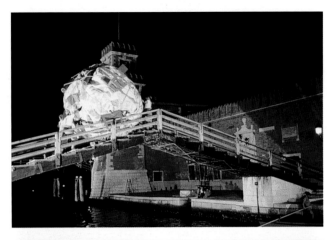

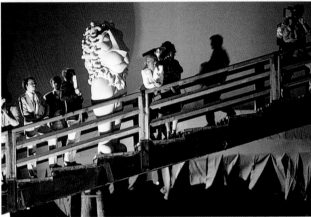

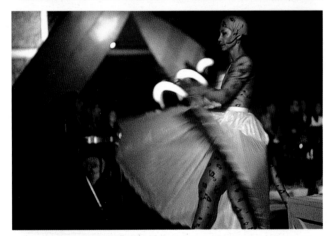

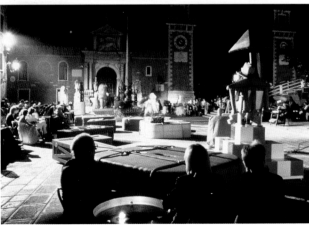

Georgia Sandbag

Coosje van Bruggen

Georgia Sandbag was formerly a travel agent who developed a taste for adventure while sitting behind a desk all day helping others journey to exotic places. Her job reminded her of an incident that took place in her youth: her cousin had just become a Boy Scout and had gotten his first pocketknife, with two folding blades, a corkscrew, and tweezers. She still treasures the moment she first held the knife, feeling the cold steel blades, their razor sharpness. But just before putting the knife back in the safe darkness of his pocket, the cousin had screamed with joy: "Let's play horse. I have the knife, so I am the driver. You are the horse!"

The maverick Sandbag is now exploring the "sweet life" on her own. She is a self-made writer in the tradition of Calamity Jane, and keeps her own "intimate journals." To her, at all times, experiencing life and nature surpasses the pleasures of man-made wonders of art and architecture.

Dressed in a cornflower-blue Western overcoat patched with travel stickers, Georgia crosses the Alps by mule, along untrodden paths. Dreaming of Constantinople and the Orient, she makes her appearance in Venice, where she initiates a movable "Salon des Refusés" that includes the Isadora Duncan scholar Sleazy Dora; Lord Styrofoam, a troubadour following in Byronic footsteps; and Chateaubriand, a lion aspiring to be Othello.

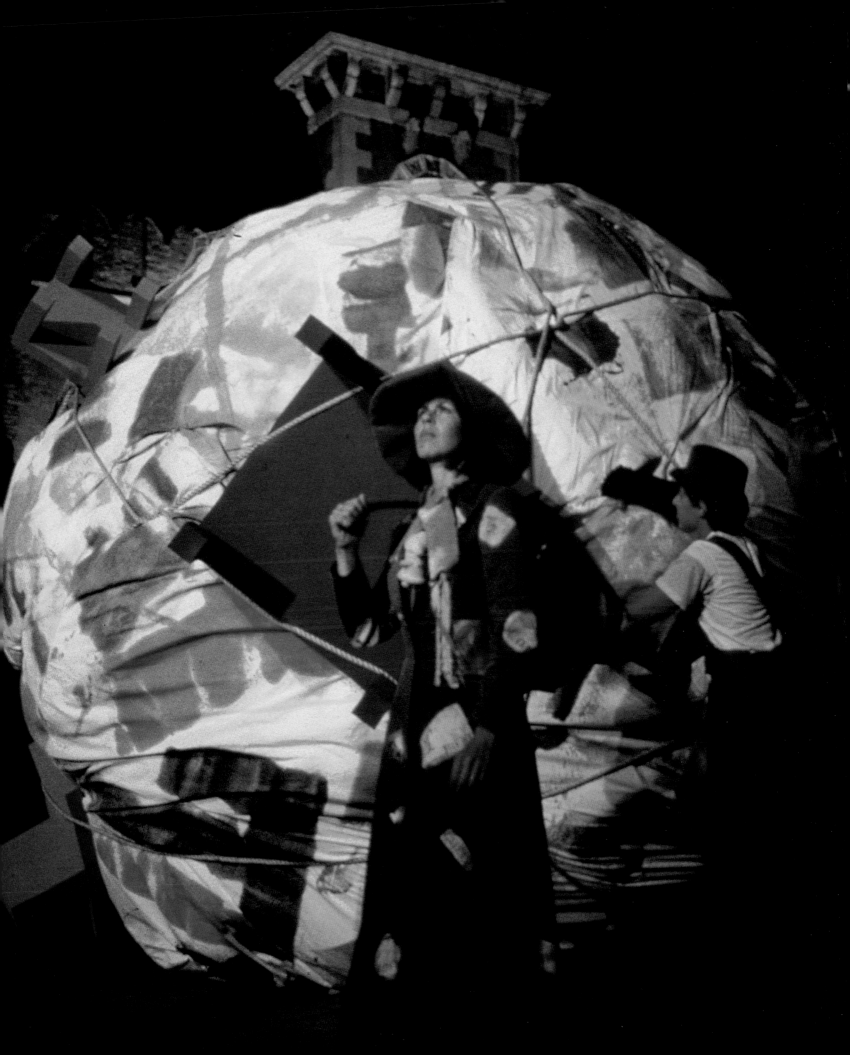

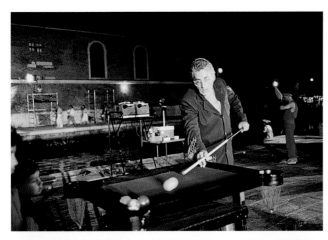

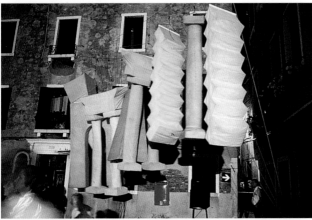

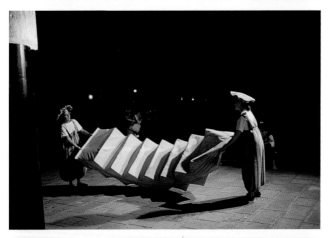

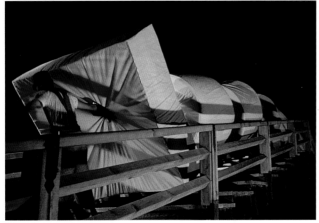

FRANKIE P. TORONTO

Coosje van Bruggen

Frankie P. Toronto is a barber from Venice, California, on a perpetual lecture tour presenting his theory of "disorganized order" in architecture derived from the cutting and slicing effects of a Swiss Army knife. In pursuit of his childhood fantasies, he especially likes to elaborate on the metamorphoses of the knife into the biomorphic structures of fish and snake.

When he was a boy living in Toronto, his grandmother would take him on Thursdays to the market where they would buy live carp. He recalls the fish swimming in the bathtub until it would be cut up and turned into gefilte fish. After dinner his grandmother would sit next to him on the floor and together they would build large cities out of blocks which, while playing earthquake, he loved to kick over.

Though he is a successful barber, Toronto dreams of using the connections of his mobster clientele to further his ambition of becoming a contemporary Palladio. He has taken up residence in Venice, Italy, where in anticipation of his breakthrough he has built his own *Temple Shack*, classical in form but covered with modern tar paper on which graffiti is scrawled. During the evenings, Toronto, dressed up in a camel-colored suit of protruding architectural fragments, lectures to tourists in the local café next door. There he becomes acquainted with Dr. Coltello and Georgia Sandbag, who, as a token of her friendship and at the request of the oldest Knife Dog, shaves off Toronto's moustache to help him reveal his true self.

BASTA CARAMBOLA (GERMANO CELANT) PLAYING POOL, ACCOMPANIED BY THE AMPLIFIED SOUNDS OF POOL BALLS CLICKING TOGETHER

THE SOFT *ARCHITECTURAL FRAGMENTS* HUNG UP BY THE WASHERS IN THE CAMPO DELL'ARSENALE

WASHERS TRANSPORTING ONE OF THE *ARCHITECTURAL FRAGMENTS*

TUG-OF-WAR WITH THE *SLICED SOFT COLUMN* BETWEEN LONGSHOREMEN, WAITERS, AND PORTERS ON THE PONTE DEL PARADISO

FOLLOWING PAGE: FRANKIE P. TORONTO (FRANK O. GEHRY) LECTURING IN THE CAMPO DELL'ARSENALE

PAGES 50-51: *KNIFE SHIP* DURING THE FINALE OF THE PERFORMANCE

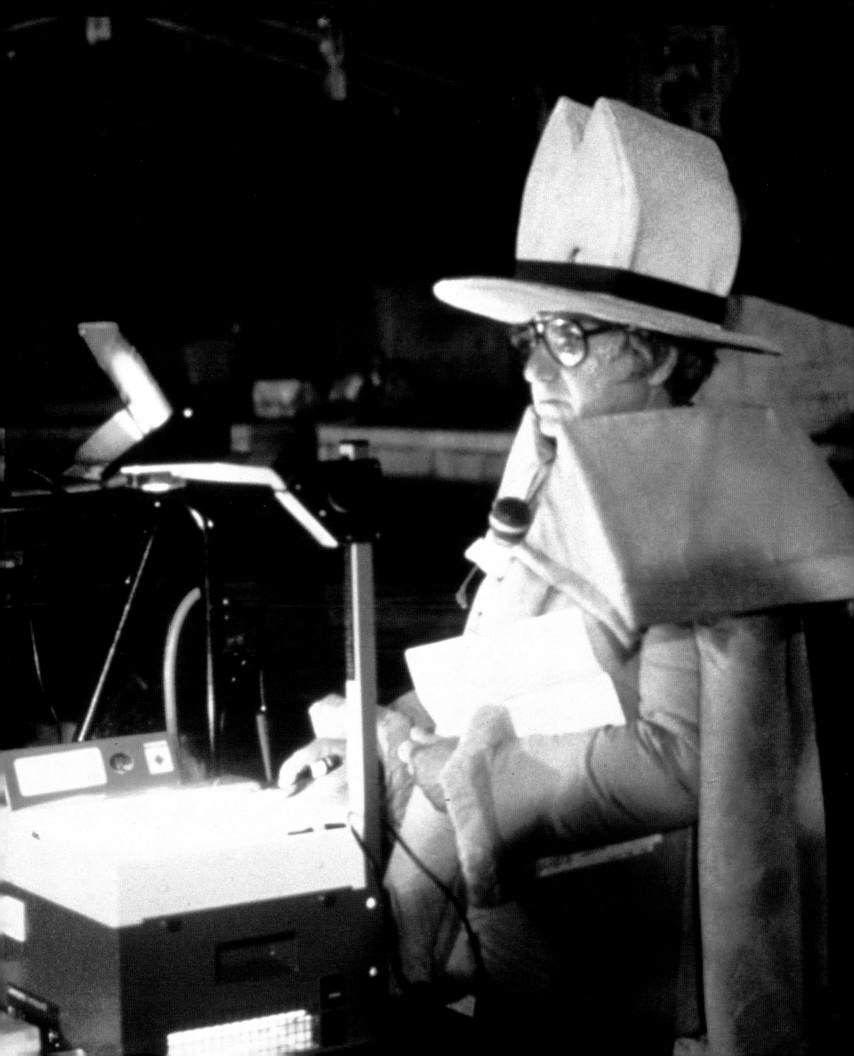

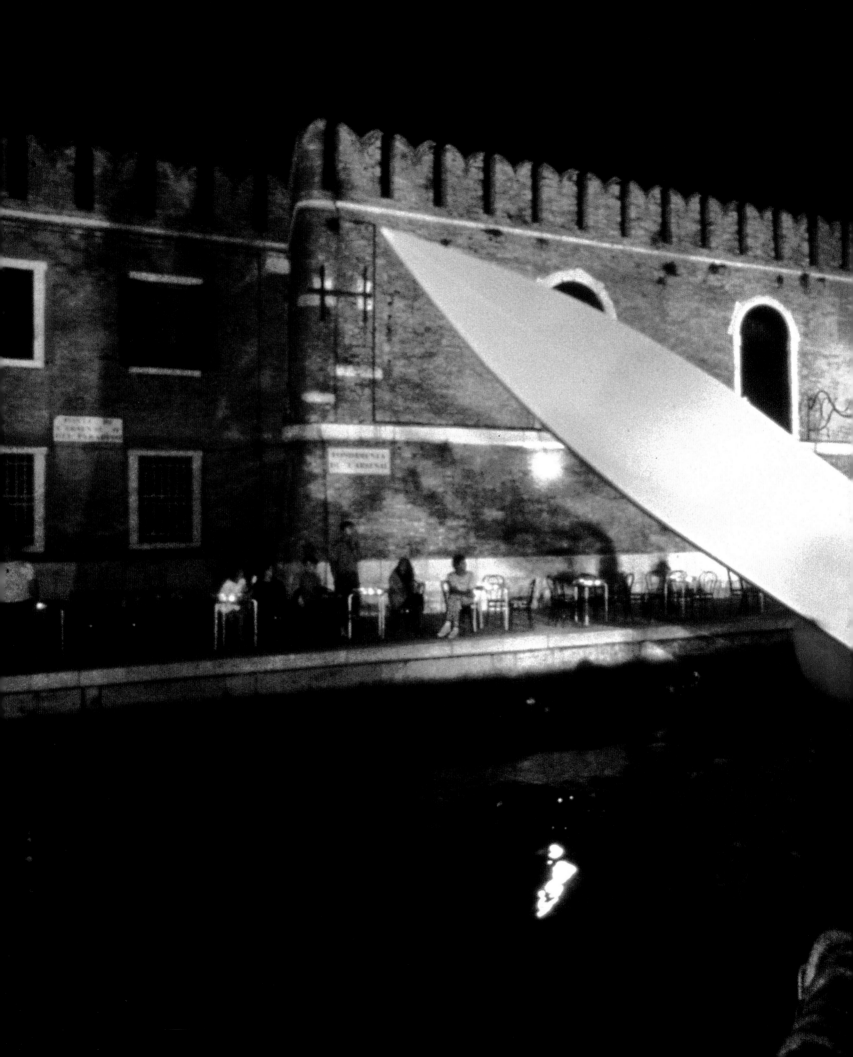

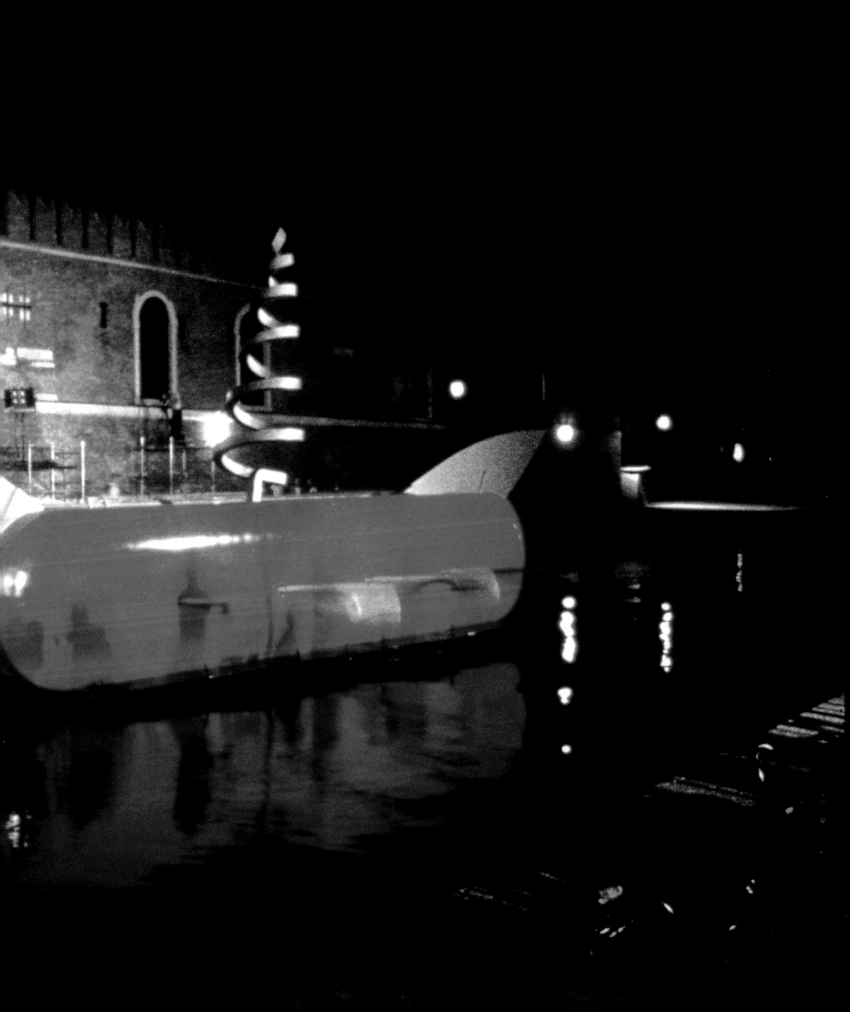

**DR. COLTELLO COSTUME –
ENLARGED VERSION**, 1986
CANVAS FILLED WITH
POLYURETHANE FOAM;
PAINTED WITH LATEX
8 FT. 8 IN. × 5 FT. ×
1 FT. 8 IN.
COLLECTION
CLAES OLDENBURG AND
COOSJE VAN BRUGGEN,
NEW YORK
COURTESY
PACEWILDENSTEIN,
NEW YORK

FOLLOWING PAGE:
**GEORGIA SANDBAG
COSTUME – ENLARGED
VERSION**, 1986
CANVAS FILLED WITH
POLYURETHANE FOAM;
PAINTED WITH LATEX
6 FT. 9 IN. OVERALL HEIGHT;
BAG: 13 × 39 × 12 IN.,
LETTER "O": 6 FT. 4 $\frac{1}{2}$ IN.
× 8 FT. × 1 FT. 11 IN.;
COLLECTION
CLAES OLDENBURG AND
COOSJE VAN BRUGGEN,
NEW YORK
COURTESY
PACEWILDENSTEIN,
NEW YORK

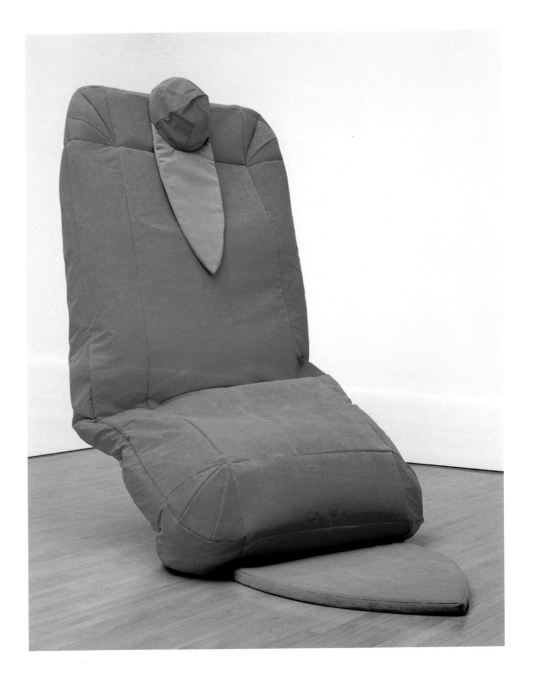

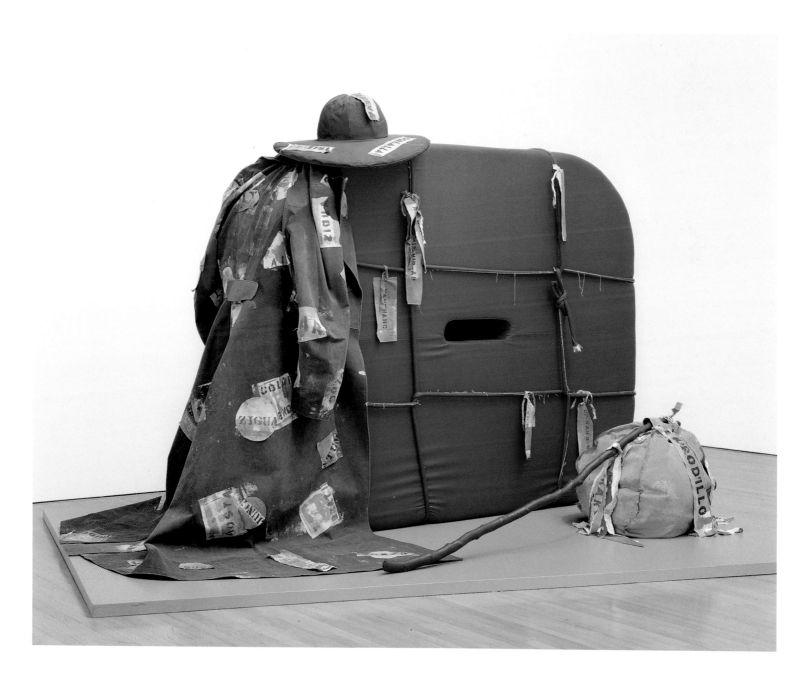

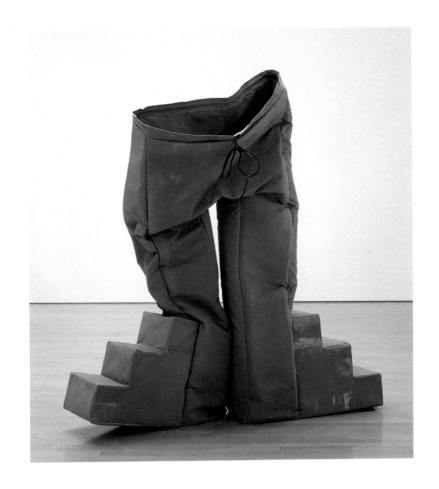

FRANKIE P. TORONTO COSTUME – ENLARGED VERSION, 1986
CANVAS FILLED WITH POLYURETHANE FOAM; PAINTED WITH LATEX
PANTS: 6 FT. 3 IN. × 5 FT. 5 IN. × 1 FT. 1 IN.; JACKET WITH HAT: 6 FT. 7 IN. × 7 FT. × 2 FT. 8 IN.
COLLECTION CLAES OLDENBURG AND COOSJE VAN BRUGGEN, NEW YORK
COURTESY PACEWILDENSTEIN, NEW YORK

FOLLOWING PAGE:
HOUSEBALL, 1985
CANVAS, POLYURETHANE FOAM, ROPE; PAINTED WITH LATEX, ALUMINUM
APPROXIMATELY 12 FT. DIAMETER
COLLECTION CLAES OLDENBURG AND COOSJE VAN BRUGGEN, NEW YORK
COURTESY PACEWILDENSTEIN, NEW YORK

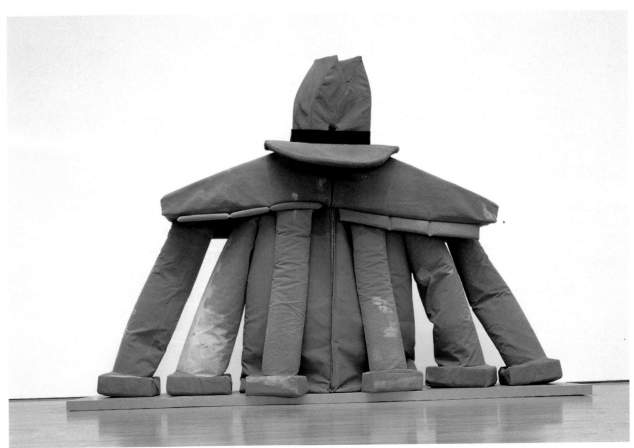

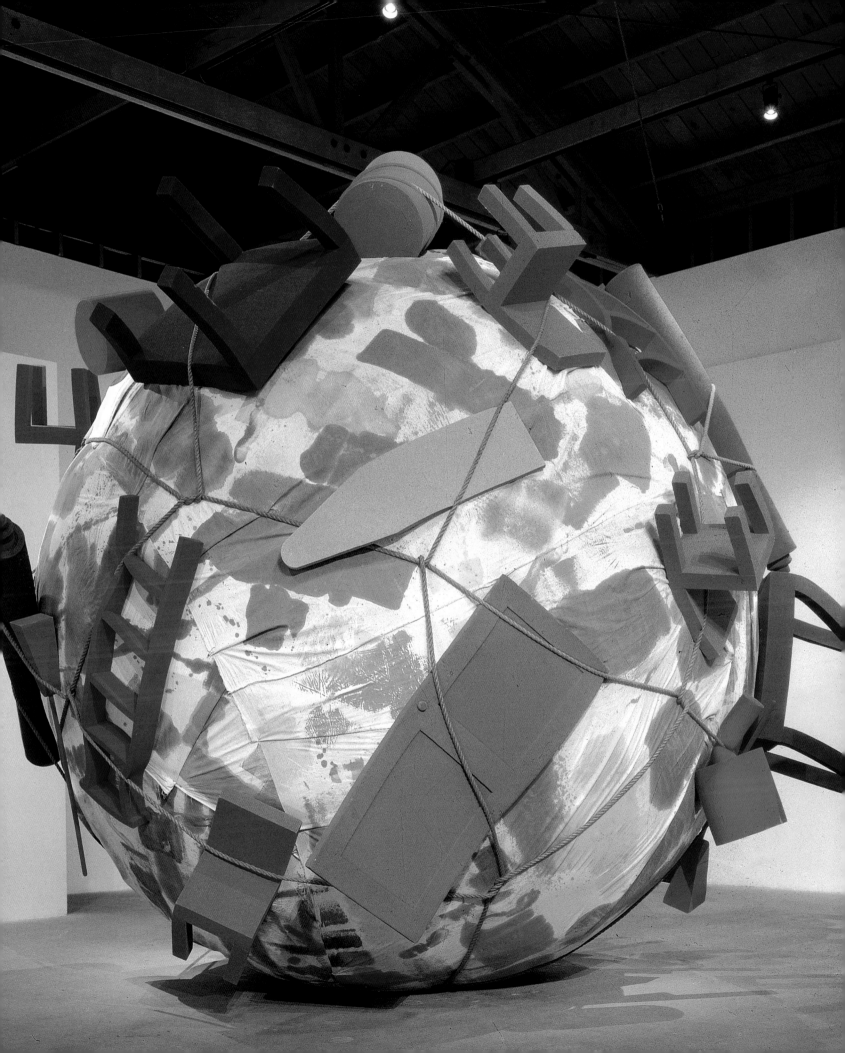

***Architectural
Fragments***, 1985
Canvas filled with
polyurethane
foam; painted with
latex
Seven elements,
yellow stairs: 112 × 34
× 34 $^1/_2$ in.; yellow
columns with
architrave: 112 × 78 $^3/_4$
× 10 $^1/_2$ in.; gray stairs:
112 × 34 × 34 $^1/_2$ in.; red
column: 119 $^1/_4$ × 19 ×
19 $^3/_4$ in.; green obelisk:
123 × 31 × 19 in.; red
arch: 126 × 52 $^3/_4$ × 21 $^1/_4$
in.; yellow obelisk:
123 × 31 × 19 in.
Castello di Rivoli
Museum of
Contemporary Art,
Rivoli-Turin
Installation view

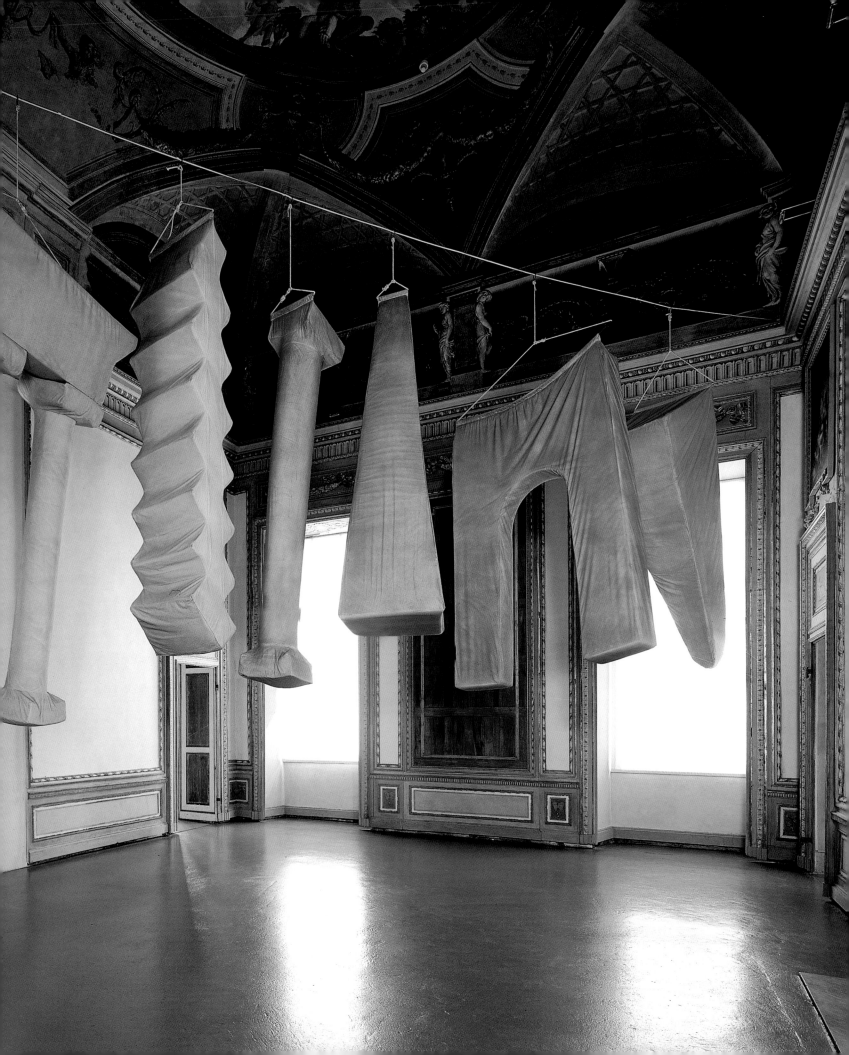

PROJECT FOR THE WALLS OF A DINING ROOM: BROKEN PLATE OF SCRAMBLED EGGS, WITH FABRICATION MODEL OF THE DROPPED BOWL FOUNTAIN, 1987

PAGES 58-61:
PROJECT FOR THE WALLS OF A DINING ROOM: BROKEN PLATE OF SCRAMBLED EGGS, WITH FABRICATION MODEL OF THE DROPPED BOWL FOUNTAIN, 1987
WOOD, ALUMINUM, STEEL, GALVANIZED METAL, CAST RESIN, EXPANDED POLYSTYRENE; PAINTED WITH LATEX AND SPRAY ENAMEL
9 FT. 10 $^1/_8$ IN. × 15 FT. 3 $^1/_{16}$ IN. × 18 FT. 2 IN.
CASTELLO DI RIVOLI MUSEUM OF CONTEMPORARY ART, RIVOLI-TURIN
INSTALLATION VIEWS

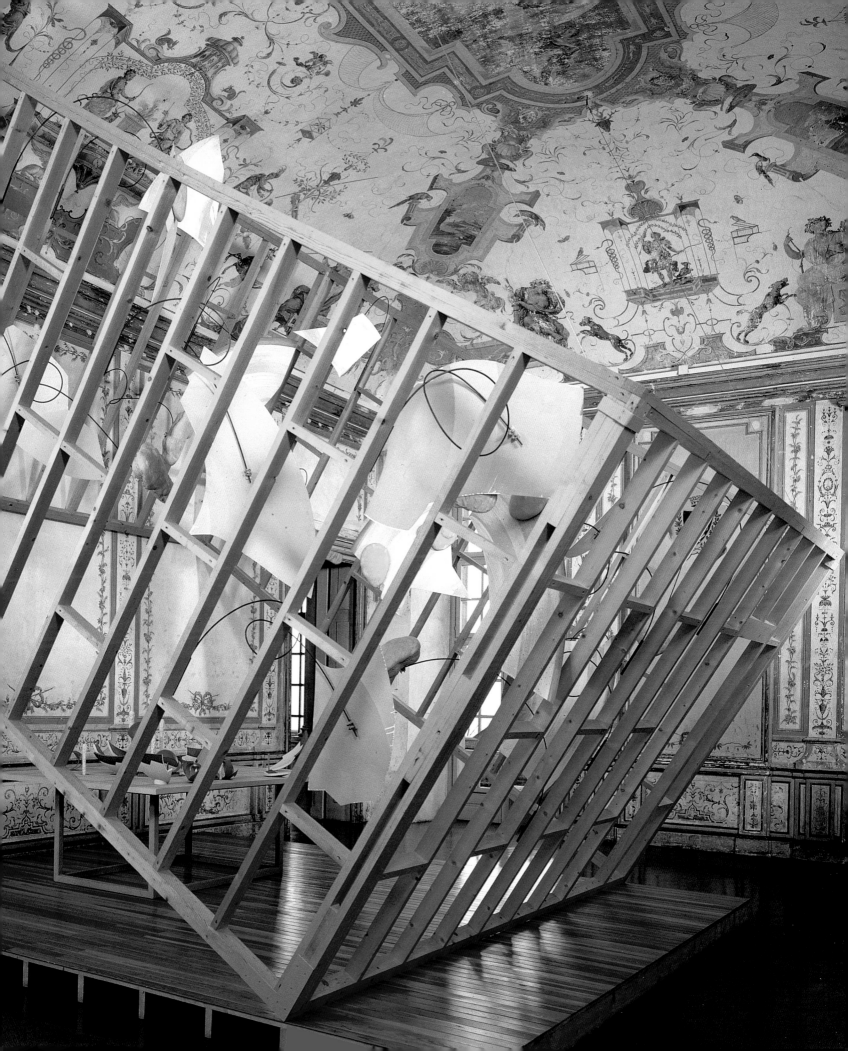

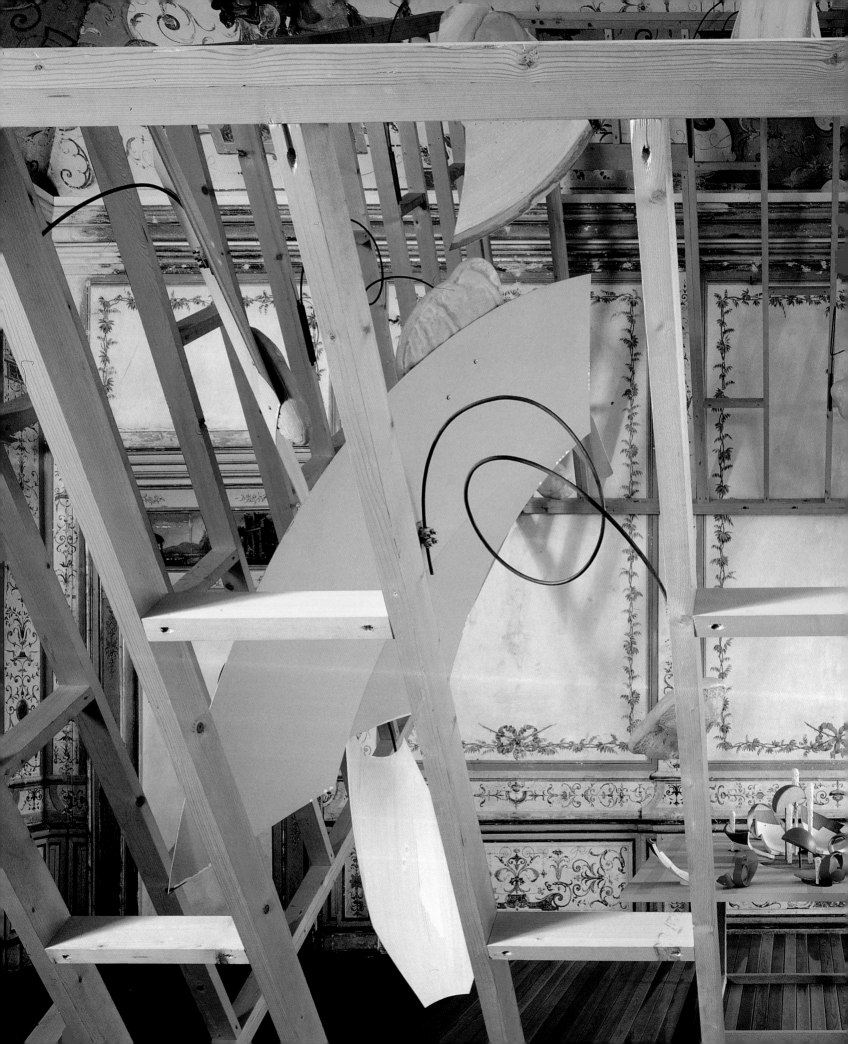

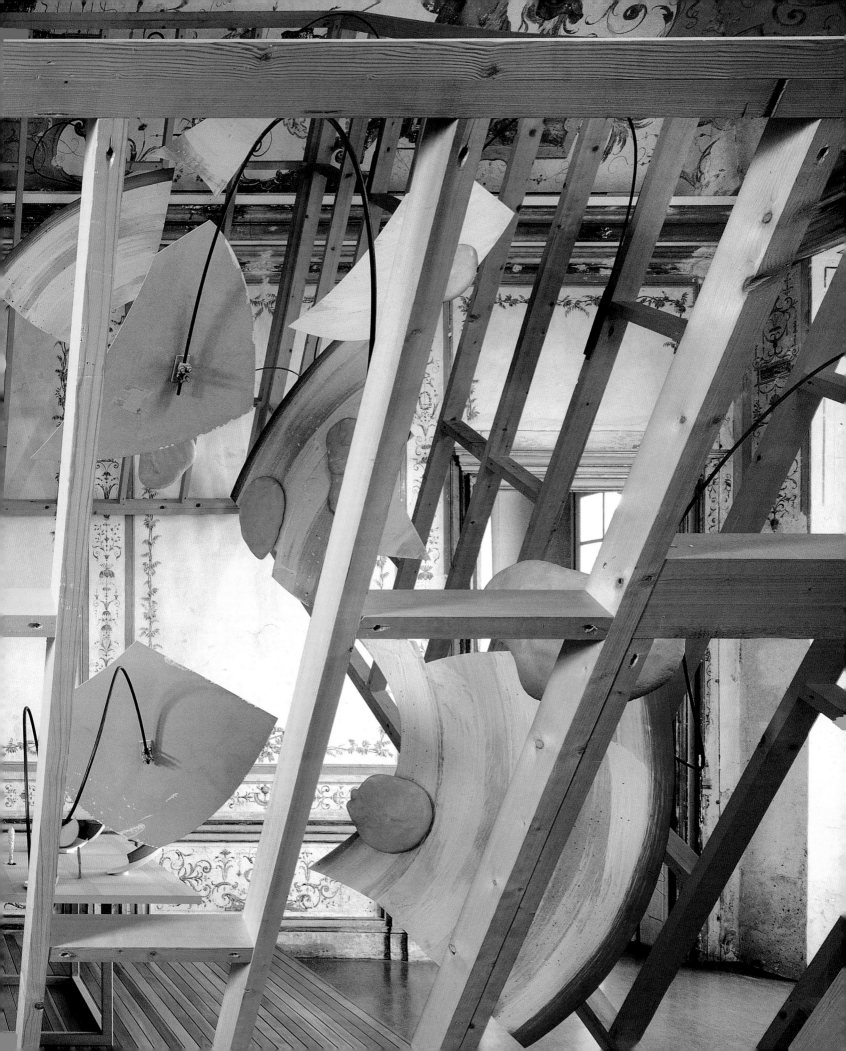

FROM THE ENTROPIC LIBRARY

Coosje van Bruggen

"it is a great art to saunter"
"no ideas but in things"
"barges and tugboats and freighters going
in all directions"
"the futility of yearning for perfection"
"Crazy Horse Road"
"not mere repetition, but re-creation"
"in Rome, even I could afford to wear a
gardenia"
"you may have to get it done on your own
terms"
"crossing things out so smashingly
beautiful"
"the danger is in the neatness of
identification"
"OK, I found a fish-joint, and if that
doesn't do it…"
"the faint trace of a smile or of a word"
"houses, avenues, roads are, alas, as
fugitive as the years"

FROM THE ENTROPIC
LIBRARY – THIRD STUDY,
1989
CHARCOAL AND CHALK
30 × 40 IN.
COLLECTION
CLAES OLDENBURG AND
COOSJE VAN BRUGGEN,
NEW YORK

PAGES 63-65:
FROM THE ENTROPIC
LIBRARY, 1989
CLOTH, WOOD,
ALUMINUM, EXPANDED
POLYSTYRENE; COATED
WITH RESIN AND PAINTED
WITH LATEX
11 FT. 9 $\frac{3}{4}$ IN. × 22 FT.
6 $\frac{1}{16}$ IN. × 8 FT. 4 IN.,
VARIABLE DIMENSIONS
MUSÉE D'ART MODERNE,
SAINT-ETIENNE, FRANCE
INSTALLATION VIEWS,
CASTELLO DI RIVOLI
MUSEUM OF
CONTEMPORARY ART,
RIVOLI-TURIN

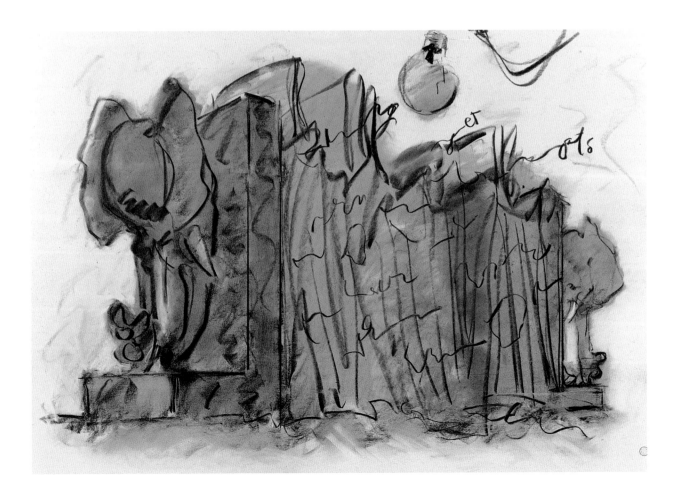

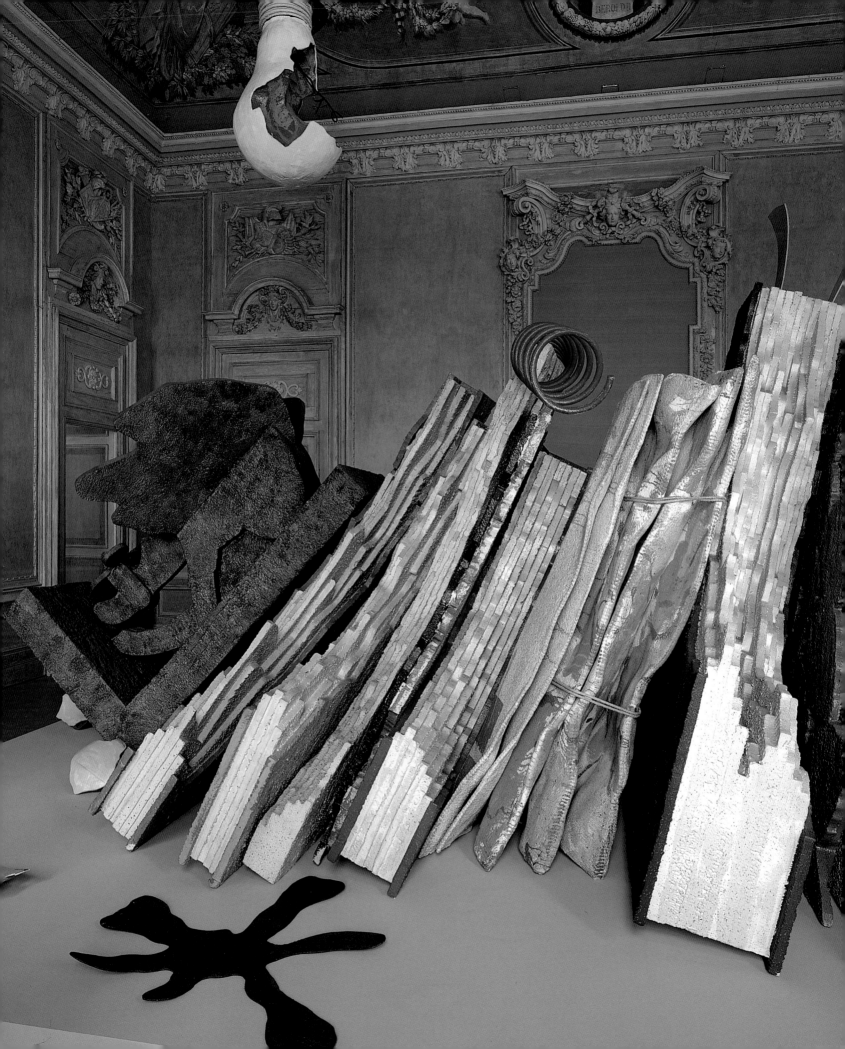

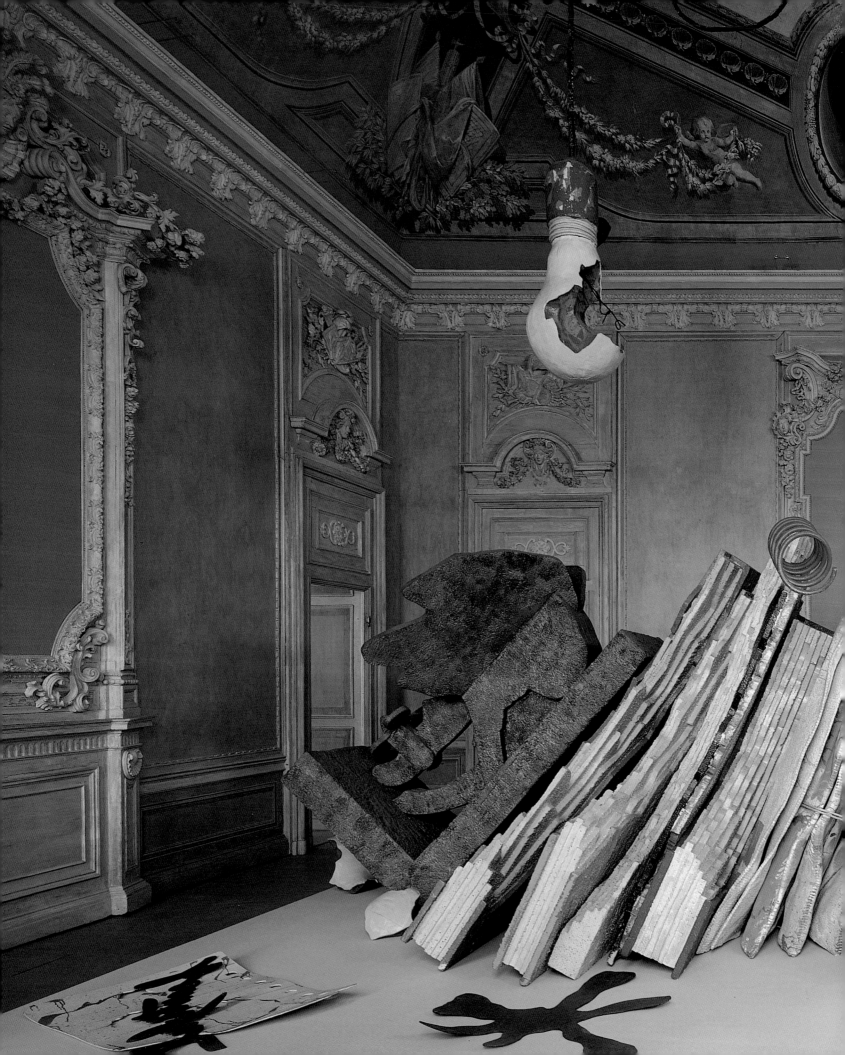

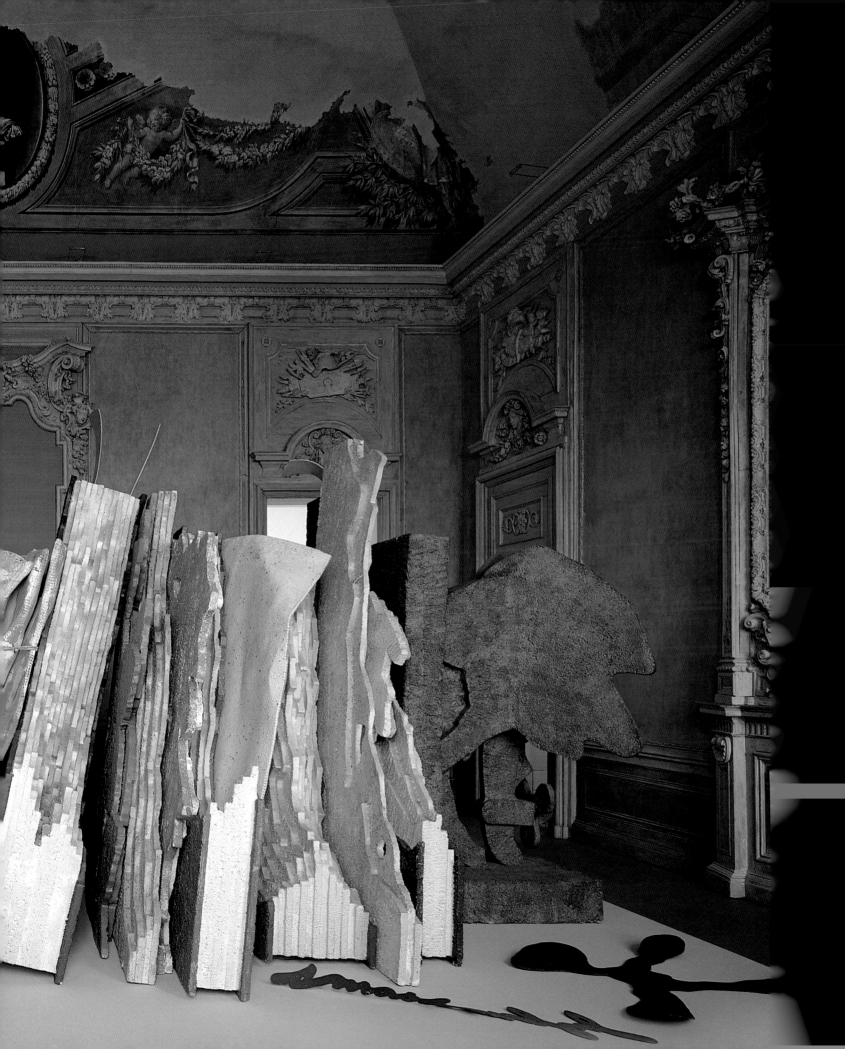

THE EUROPEAN DESKTOP, 1990

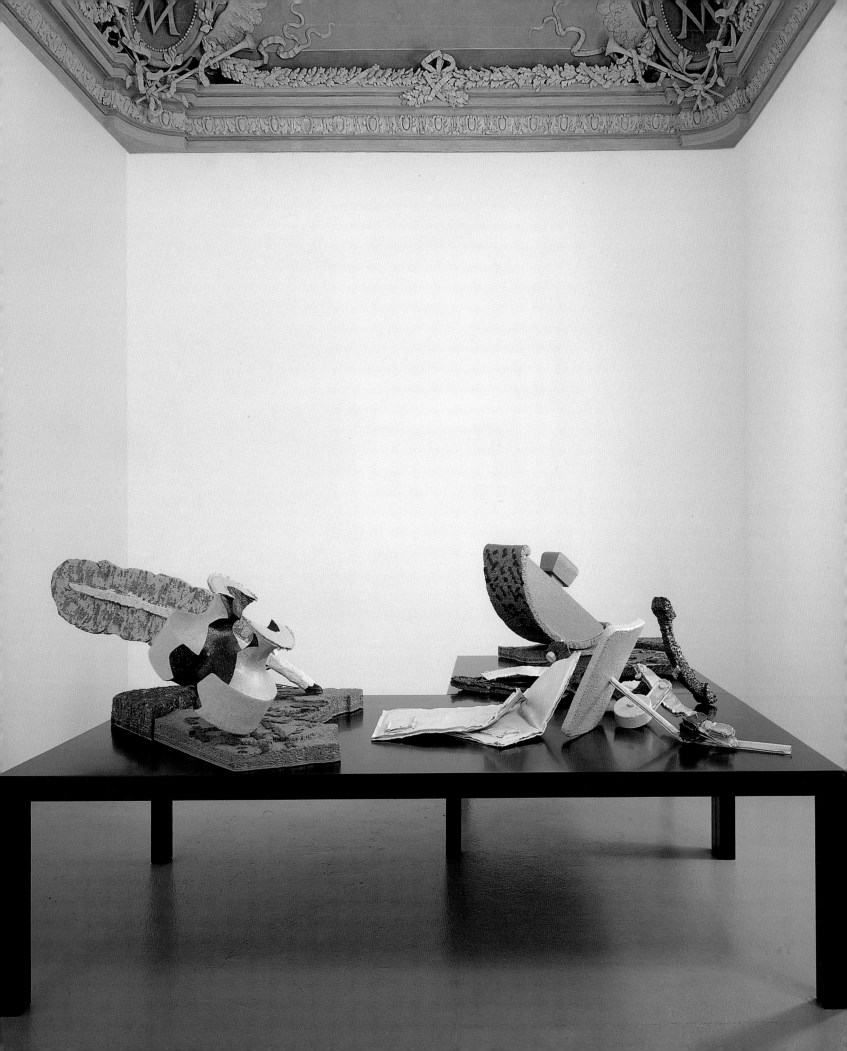

**QUILL ON A FRAGMENT
OF DESK PAD**, 1990
CHARCOAL AND
WATERCOLOR
38 3/16 × 50 IN.
COLLECTION
CLAES OLDENBURG AND
COOSJE VAN BRUGGEN,
NEW YORK

**STAMP BLOTTERS ON
SHATTERED DESK PAD**,
1990
CHARCOAL, PENCIL,
PASTEL
38 3/16 × 50 1/8 IN.
COLLECTION
CLAES OLDENBURG AND
COOSJE VAN BRUGGEN,
NEW YORK

Stamp Blotter on a Fragment of Desk Pad (Study for Rolling Blotter), 1990
Charcoal and watercolor
38 ¹/₈ × 50 in.
Collection
Claes Oldenburg and
Coosje van Bruggen,
New York

Study for Collapsed European Postal Scale,
1990
Pencil and watercolor
30 × 40 in.
Collection
Claes Oldenburg and
Coosje van Bruggen,
New York

RESONANCES, AFTER J. V., 2000

RESONANCES, AFTER J. V.,
2000
CANVAS, POLYURETHANE
FOAM, CARDBOARD;
COATED WITH RESIN AND
PAINTED WITH LATEX,
WOOD, PAPER,
CLOTHESLINE, STRING;
PAINTED WITH LATEX,
HARDWARE, "ENVELOPE"
AND "TILES": CRAYON,
PENCIL, WATERCOLOR
OVERALL DIMENSIONS:
58 $\frac{7}{16}$ × 55 $\frac{3}{16}$ × 16 $\frac{1}{8}$ IN.;
COLLECTION
CLAES OLDENBURG AND
COOSJE VAN BRUGGEN,
NEW YORK
COURTESY
PACEWILDENSTEIN,
NEW YORK

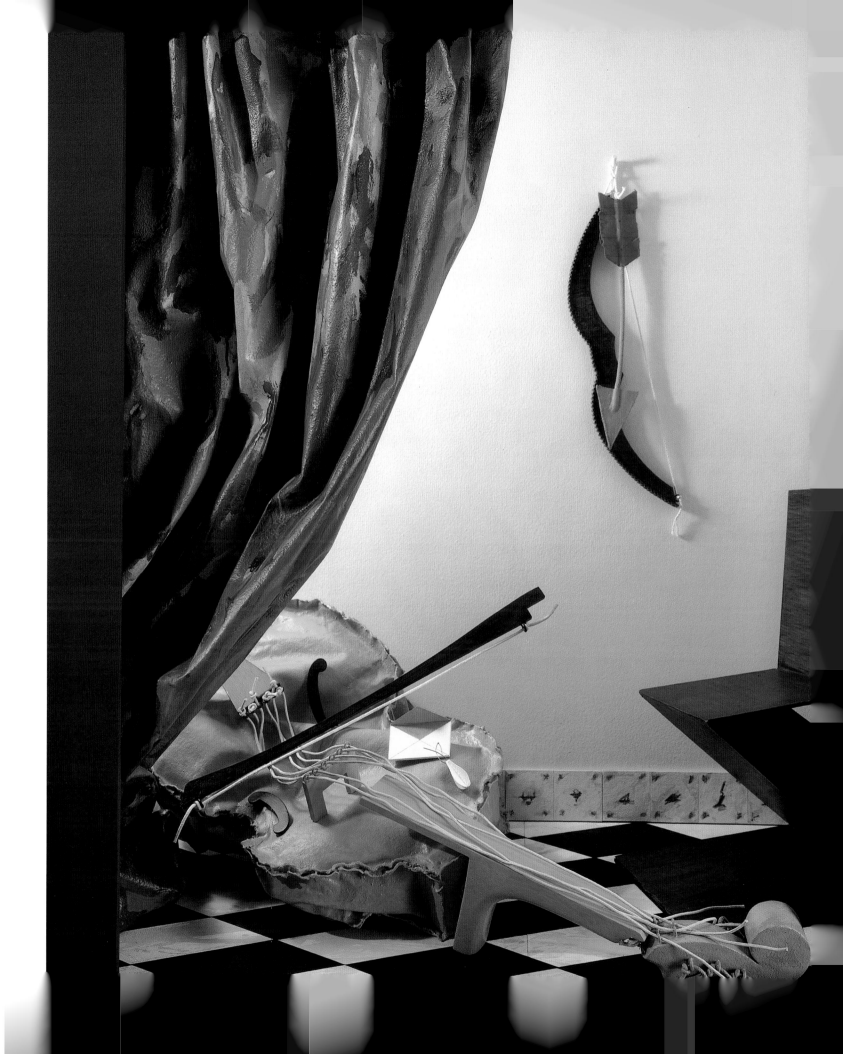

FALLING NOTES, 2003
CANVAS COATED WITH
RESIN, CORD, STRING;
PAINTED WITH LATEX AND
SPRAY ENAMEL
37 $^{7}/_{16}$ × 21 $^{1}/_{4}$ × 11 $^{13}/_{16}$
IN., VARIABLE DIMENSIONS
COLLECTION
CLAES OLDENBURG AND
COOSJE VAN BRUGGEN,
NEW YORK
COURTESY
PACEWILDENSTEIN,
NEW YORK

FOLLOWING PAGE:
LEANING CLARINET 1/3,
2006
ALUMINUM PAINTED WITH
ACRYLIC POLYURETHANE
11 FT. 9 IN. × 5 FT. 2 IN.
× 2 FT. 8 IN.
PRIVATE COLLECTION,
PARIS
COURTESY
PACEWILDENSTEIN,
NEW YORK
INSTALLATION VIEW,
CASTELLO DI RIVOLI
MUSEUM OF
CONTEMPORARY ART,
RIVOLI-TURIN

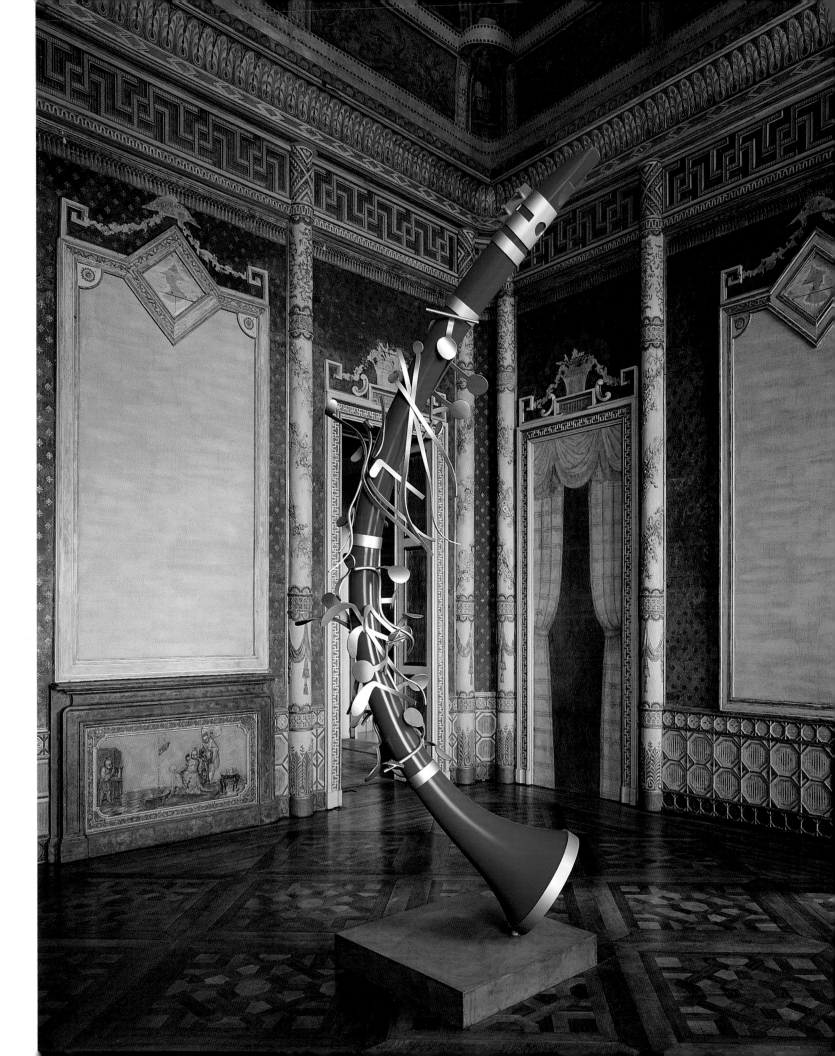

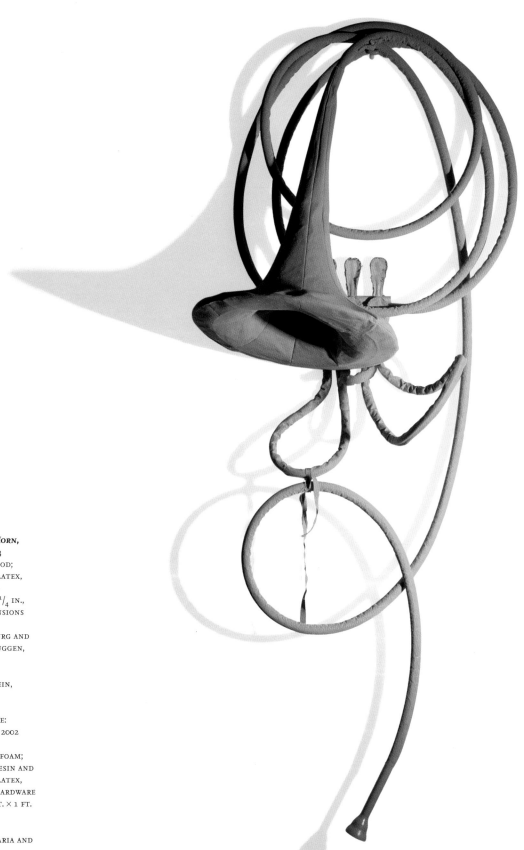

Soft French Horn, Unwound, 2003
Canvas and wood;
painted with latex,
plastic tubing
80 $\frac{1}{2}$ × 30 × 25 $\frac{1}{4}$ in.,
variable dimensions
Collection
Claes Oldenburg and
Coosje van Bruggen,
New York
Courtesy
PaceWildenstein,
New York

Following page:
Soft Viola 2/2, 2002
Canvas, wood,
polyurethane foam;
coated with resin and
painted with latex,
clothesline, hardware
8 ft. 8 in. × 5 ft. × 1 ft.
10 in., variable
dimensions
Collection Maria and
Conrad Janis,
Los Angeles

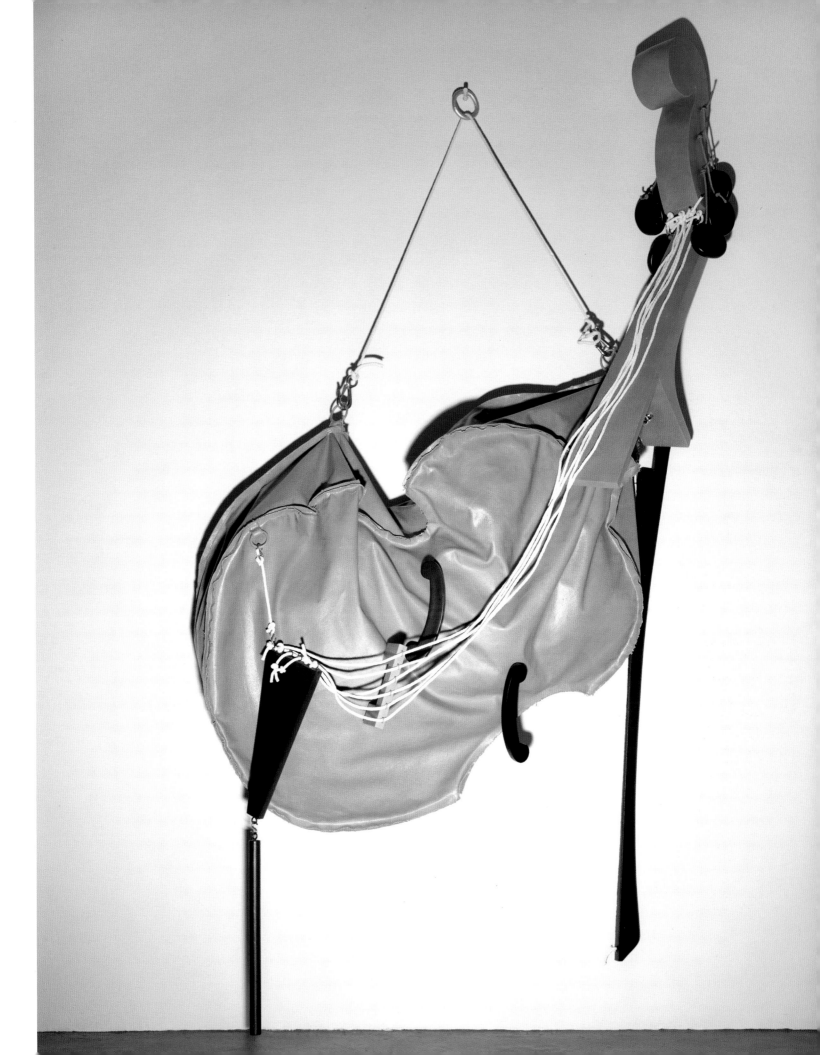

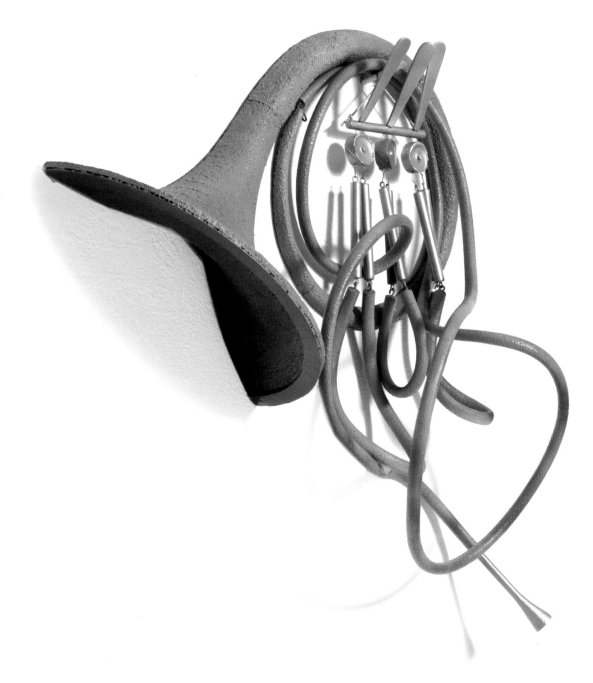

**FRENCH HORN, SLICED
AND UNWOUND**, 2003
EXPANDED POLYSTYRENE,
CARDBOARD, PLASTER,
WOOD, HARDWARE;
PAINTED WITH LATEX AND
SPRAY ENAMEL
33 $\frac{1}{2}$ × 31 $\frac{9}{16}$ × 9 $\frac{7}{8}$ IN.
COLLECTION
CLAES OLDENBURG AND
COOSJE VAN BRUGGEN,
NEW YORK

FOLLOWING PAGE:
TIED TRUMPET 2/3, 2004
ALUMINUM, CANVAS, FELT,
POLYURETHANE FOAM,
ROPE, CORD; COATED WITH
RESIN AND PAINTED WITH
LATEX, PLASTIC TUBING
50 $\frac{1}{2}$ × 23 $\frac{1}{2}$ × 15 IN.
COLLECTION
CLAES OLDENBURG AND
COOSJE VAN BRUGGEN,
NEW YORK
COURTESY
PACEWILDENSTEIN,
NEW YORK

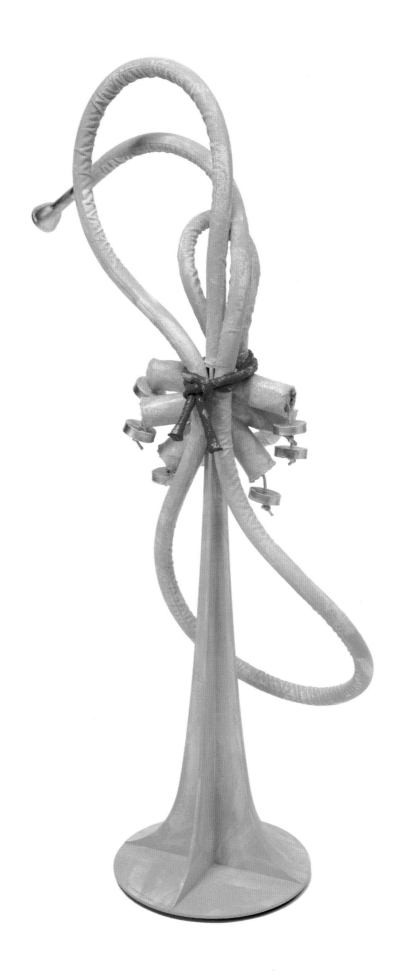

Silent Metronome,
16 inch, Version Three,
2005
Canvas, wood,
hardware; painted
with acrylic and latex
$16 \times 8 \frac{1}{2} \times 10$ in.,
variable dimensions
Collection
Claes Oldenburg and
Coosje van Bruggen,
New York
Courtesy
PaceWildenstein,
New York

Following page:
Sliced Stradivarius –
Crimson, 2004
Canvas, felt, wood,
cord, hardware;
painted with latex
$45 \times 18 \times 7$ in., variable
dimensions
Collection Mr. and
Mrs. Christopher M.
Harland, New York

Sliced Stradivarius –
Rose, 2003
Canvas, felt, wood,
cord, hardware;
painted with latex
$45 \times 18 \times 7$ in., variable
dimensions
Collection
Claes Oldenburg and
Coosje van Bruggen,
New York

Pages 80-83:
The Music Room
Installation views,
Castello di Rivoli
Museum of
Contemporary Art,
Rivoli-Turin

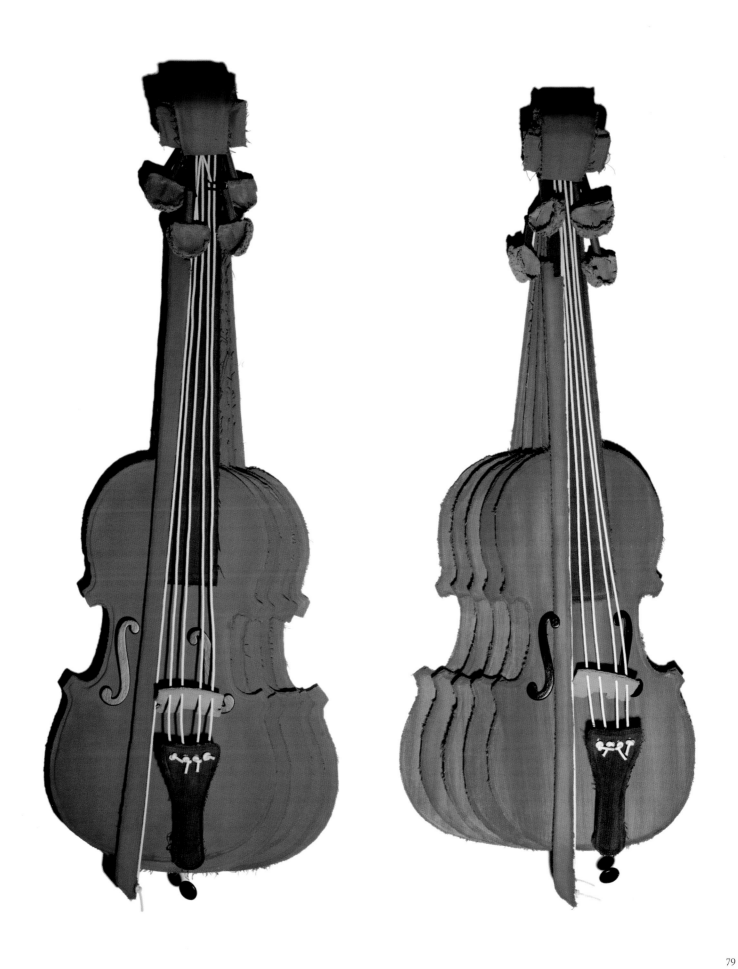

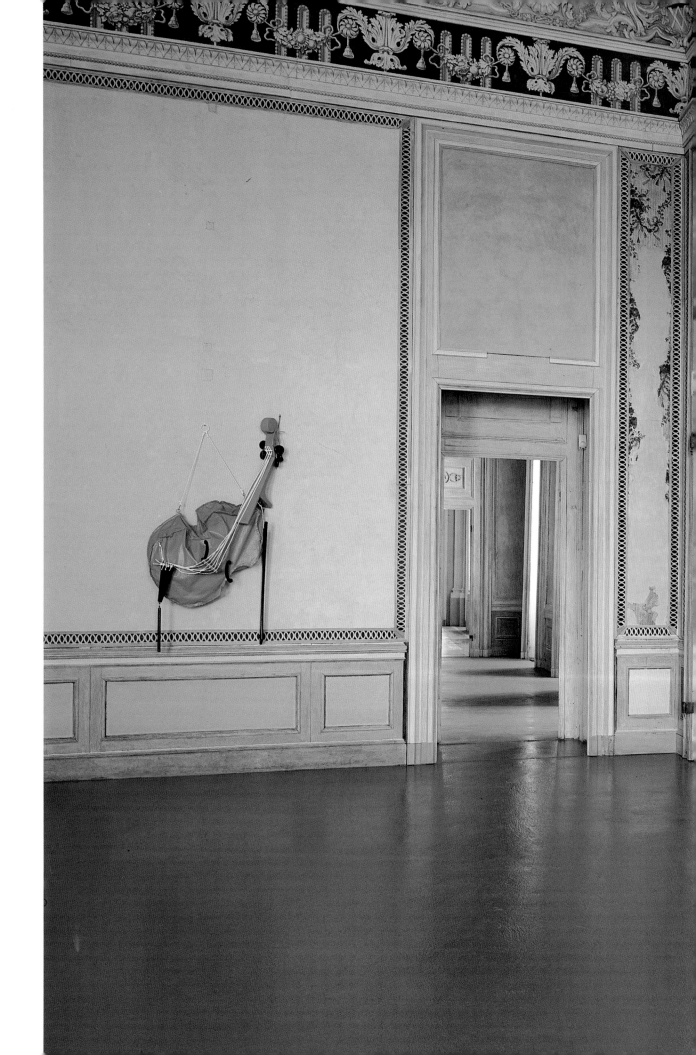

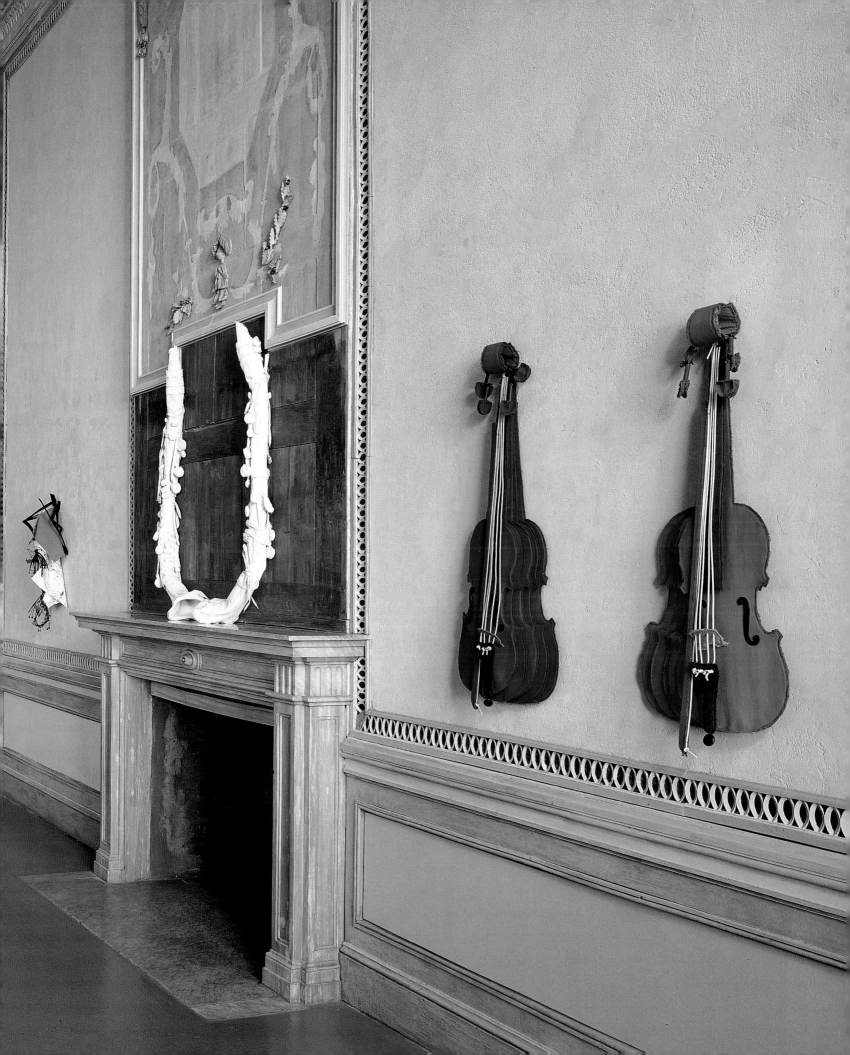

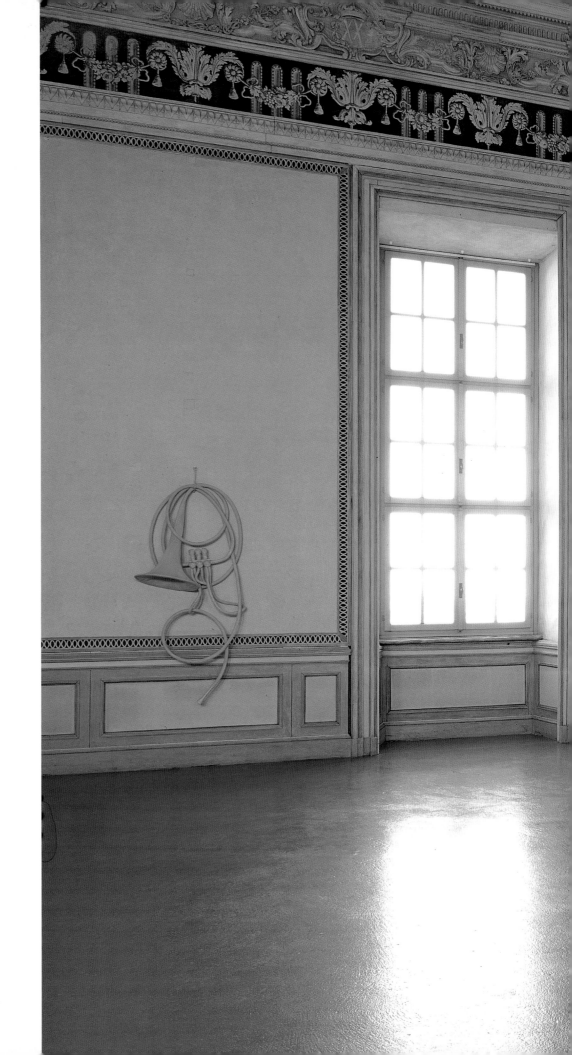

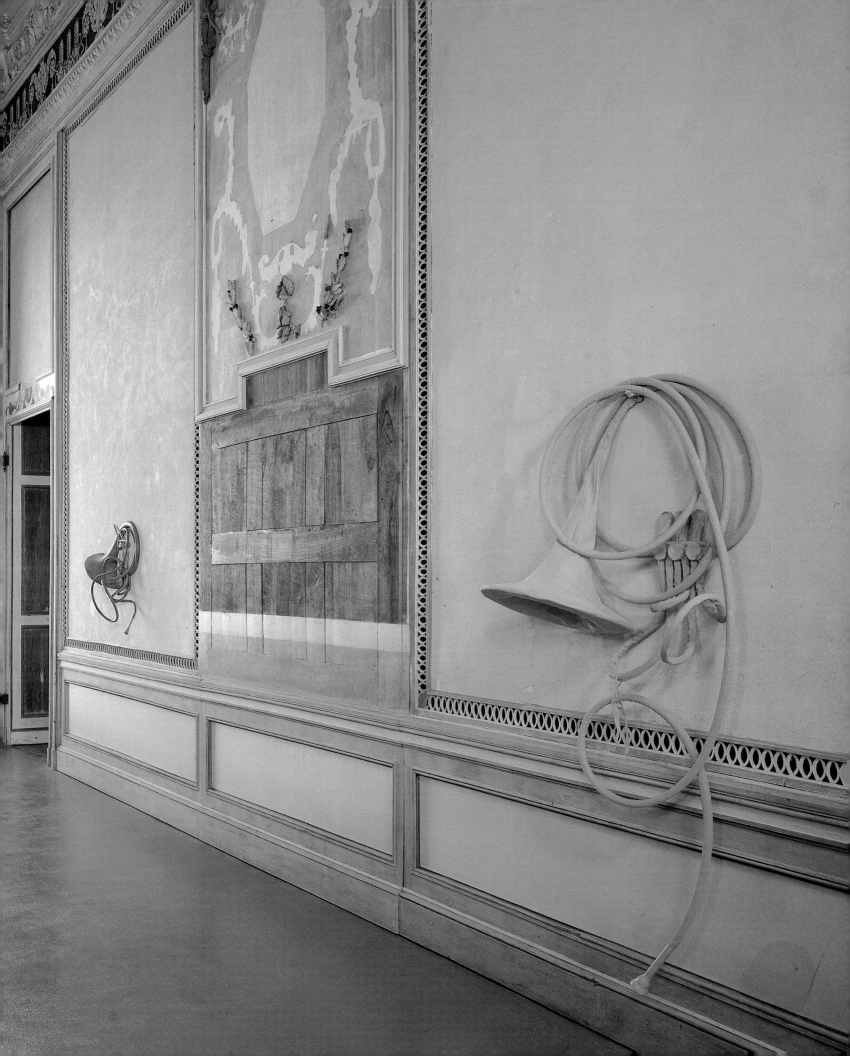

STUDY FOR A SOFT SCREW,
1969
CANVAS, WOOD, WIRE,
NAILS; PAINTED WITH
LATEX
10 $\frac{1}{4}$ × 7 $\frac{1}{8}$ × 3 $\frac{1}{2}$ IN.
COLLECTION
CLAES OLDENBURG AND
COOSJE VAN BRUGGEN,
NEW YORK

***STUDY FOR A SCULPTURE
IN THE FORM OF A SAW,
CUTTING***, 1973
CARDBOARD PAINTED
WITH SPRAY ENAMEL
14 $\frac{1}{8}$ × 10 × 10 IN.
COLLECTION
CLAES OLDENBURG AND
COOSJE VAN BRUGGEN,
NEW YORK

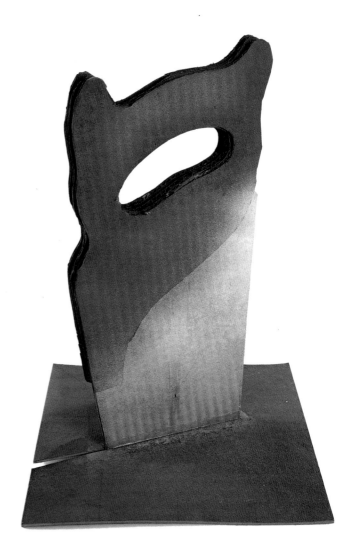

Balancing Tools,
Study, 1983
Cardboard, wood (floor
segment), paper,
screwdriver, nails;
painted with spray
enamel
9 $\frac{1}{4}$ × 14 $\frac{3}{4}$ × 9 $\frac{1}{4}$ in.
Collection
Claes Oldenburg and
Coosje van Bruggen,
New York

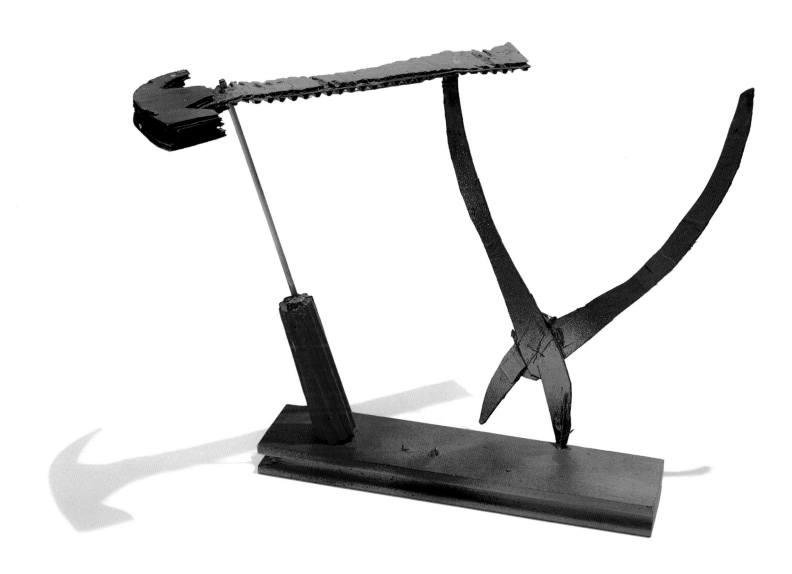

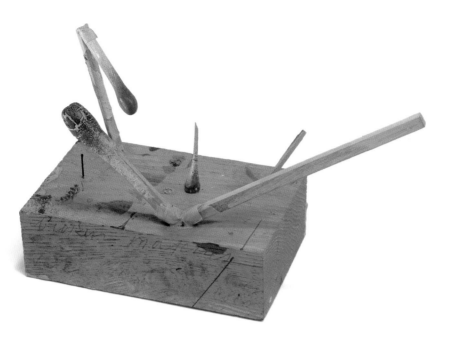

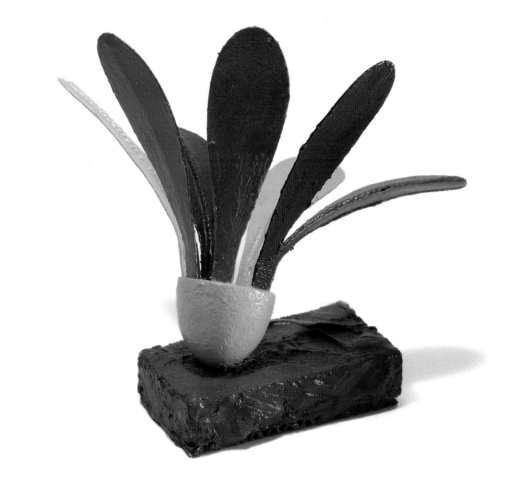

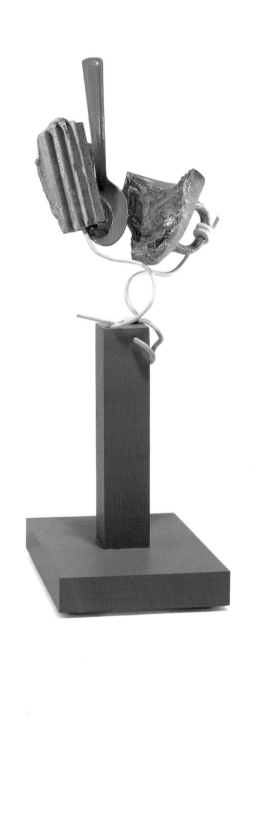

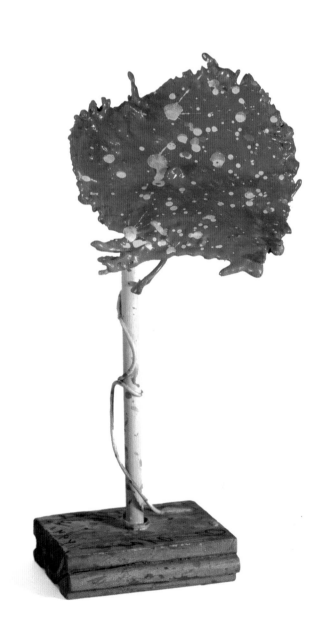

PREVIOUS PAGE:
STUDY FOR SCULPTURE OF
MADELEINE DIPPED IN
TEA, 2001
PLASTER, METAL, COATED
WIRE, FRAGMENT OF
PORCELAIN CUP, METAL
SPOON, WOOD; PAINTED
WITH LATEX AND SPRAY
ENAMEL
13 $\frac{3}{8}$ × 6 × 4 $\frac{5}{16}$ IN.
COLLECTION
CLAES OLDENBURG AND
COOSJE VAN BRUGGEN,
NEW YORK

STUDIO VALENTINE, 1994
BURLAP COATED WITH
RESIN, WIRE, WOOD;
PAINTED WITH LATEX
AND SPRAY ENAMEL
9 × 4 $\frac{1}{2}$ × 4 IN.
COLLECTION
CLAES OLDENBURG AND
COOSJE VAN BRUGGEN,
NEW YORK

LEAF BOAT WITH
FLOATING CARGO, STUDY,
1992
CANVAS, WOOD, WIRE,
CARDBOARD, APPLE CORE,
ICE CREAM STICK, PEANUT
SHELL, POTATO CHIP,
CORK; COATED WITH RESIN
AND PAINTED WITH LATEX
11 $\frac{3}{4}$ × 11 × 11 $\frac{3}{4}$ IN.
COLLECTION
CLAES OLDENBURG AND
COOSJE VAN BRUGGEN,
NEW YORK

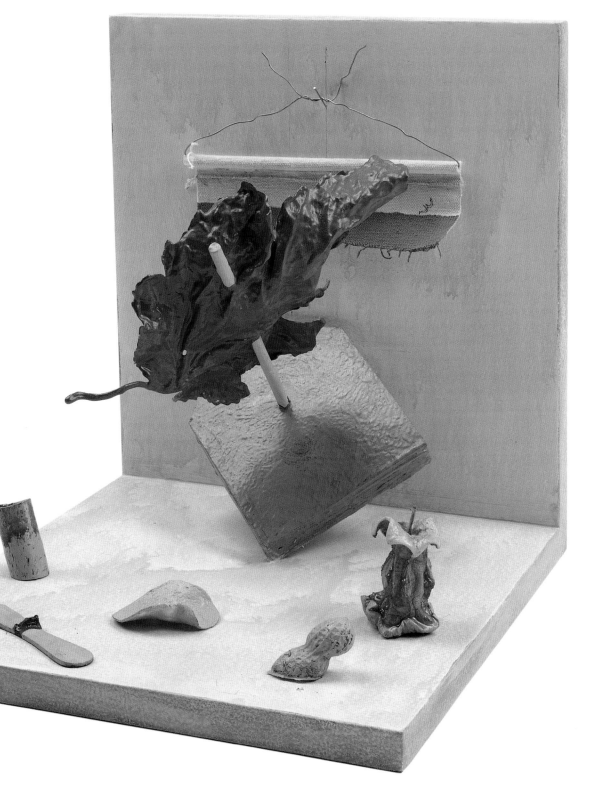

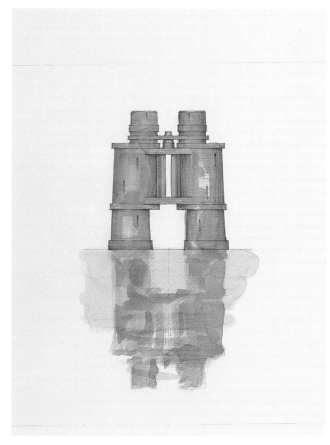

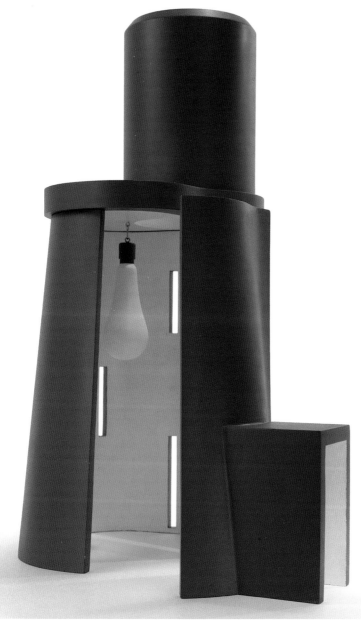

DESIGN FOR A THEATER LIBRARY FOR VENICE IN THE FORM OF BINOCULARS AND COLTELLO SHIP IN THREE STAGES, 1984 (DETAIL)
PENCIL, COLORED PENCIL, CHALK, WATERCOLOR
30 × 40 IN.
COLLECTION
CLAES OLDENBURG AND
COOSJE VAN BRUGGEN,
NEW YORK

MODEL FOR THE CHIAT/DAY BUILDING, LOS ANGELES, BINOCULAR WITH LIGHTBULB, 1984
WOOD PAINTED WITH LATEX, HARDWARE
$31\,^{3}/_{4} \times 15\,^{1}/_{2} \times 16\,^{3}/_{4}$ IN.
COLLECTION
CLAES OLDENBURG AND
COOSJE VAN BRUGGEN,
NEW YORK

FREE STAMP, 1984
PENCIL, WATERCOLOR,
TAPE; ON PHOTOPRINT
31 $\frac{1}{2}$ × 23 $\frac{1}{2}$ IN.
COLLECTION
CLAES OLDENBURG AND
COOSJE VAN BRUGGEN,
NEW YORK

*FREE STAMP, SECOND
VERSION, MODEL*,
1985-1991
WOOD PAINTED WITH
LATEX AND SPRAY ENAMEL
14 $\frac{1}{2}$ × 22 $\frac{3}{8}$ × 20 $\frac{1}{4}$ IN.
COLLECTION
CLAES OLDENBURG AND
COOSJE VAN BRUGGEN,
NEW YORK

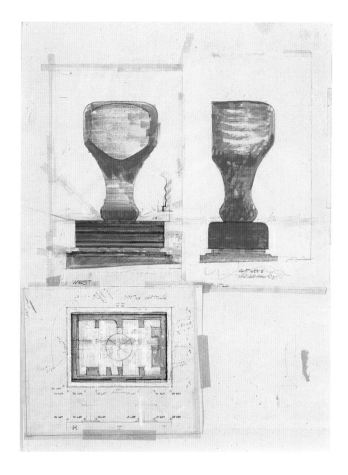

Sculpture in the Form
of a Match Cover –
Model, 1987
Cardboard, expanded
polystyrene, felt pen
38 ¹/₂ × 19 × 38 in.
Collection
Claes Oldenburg and
Coosje van Bruggen,
New York

Valentine Perfume 1/2,
1999
Cast aluminum painted
with acrylic
polyurethane
46 $\frac{1}{2}$ × 25 × 20 in.
Collection
Claes Oldenburg and
Coosje van Bruggen,
New York

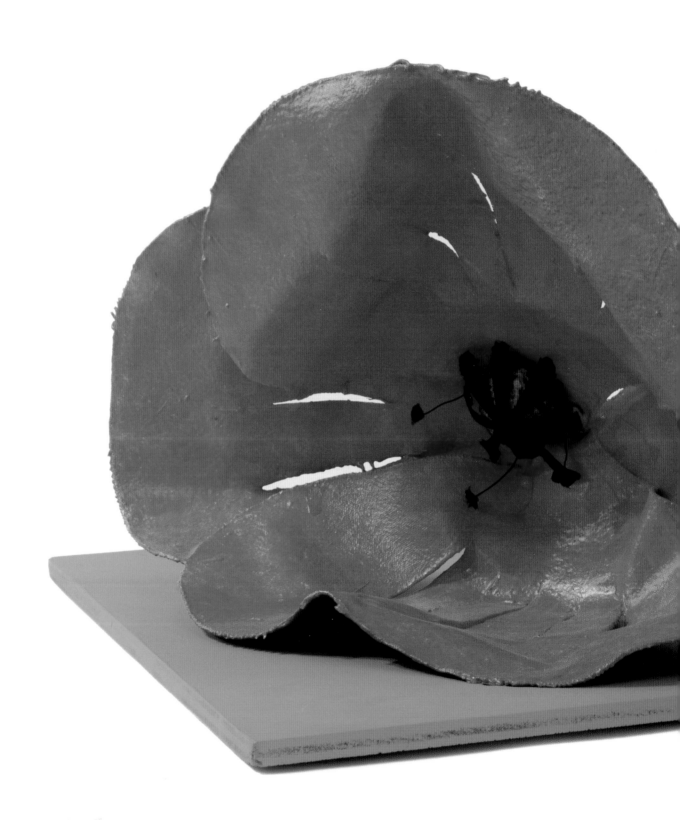

GAZEBO IN THE FORM OF
A DROPPED FLOWER
WITH FIGURE FOR SCALE,
MODEL, 1998
CANVAS, TAPE, STRING,
WIRE, WOOD, METAL,
POLYSTYRENE FOAM;
COATED WITH RESIN AND
PAINTED WITH LATEX
12 $\frac{1}{4}$ × 29 $\frac{1}{4}$ × 21 IN.
COLLECTION
CLAES OLDENBURG AND
COOSJE VAN BRUGGEN,
NEW YORK

**MODEL FOR DROPPED
CONE**, 2000
CLAY, WOOD, PAPER;
PAINTED WITH LATEX
28 × 21 $\frac{1}{2}$ × 24 IN.
COLLECTION
CLAES OLDENBURG AND
COOSJE VAN BRUGGEN,
NEW YORK

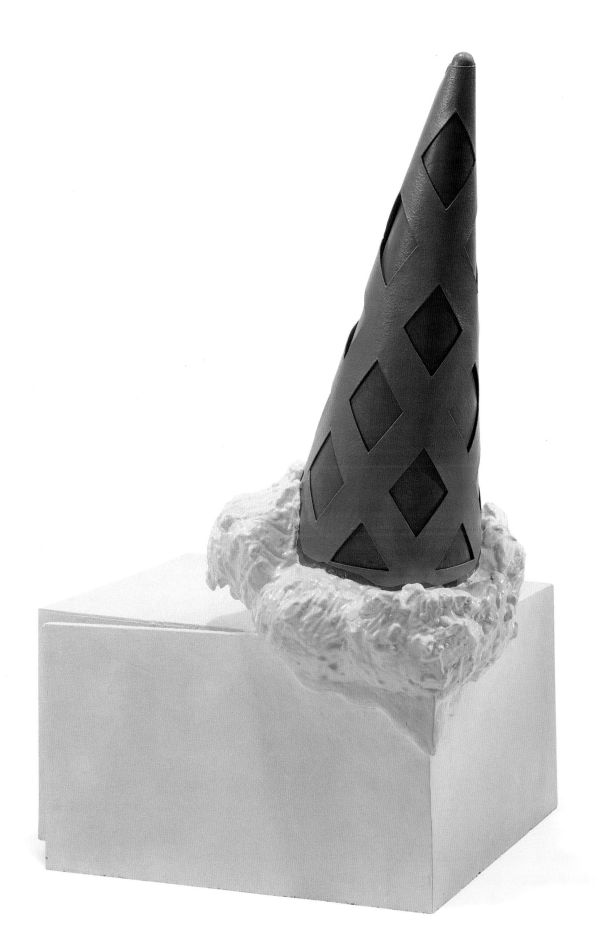

Big Sweep, Model, 1999
Aluminum painted
with acrylic
polyurethane
59 $\frac{1}{2}$ × 45 $\frac{5}{8}$ × 27 $\frac{3}{4}$ in.
Collection
J. Landis and Sharon
Martin, Denver,
Colorado

Following page:
Collar and Bow 1:16,
2005
Aluminum painted
with polyurethane
enamel
51 $\frac{1}{2}$ × 45 $\frac{1}{4}$ × 39 $\frac{1}{2}$ in.
Collection
Claes Oldenburg and
Coosje van Bruggen,
New York
Courtesy
PaceWildenstein,
New York

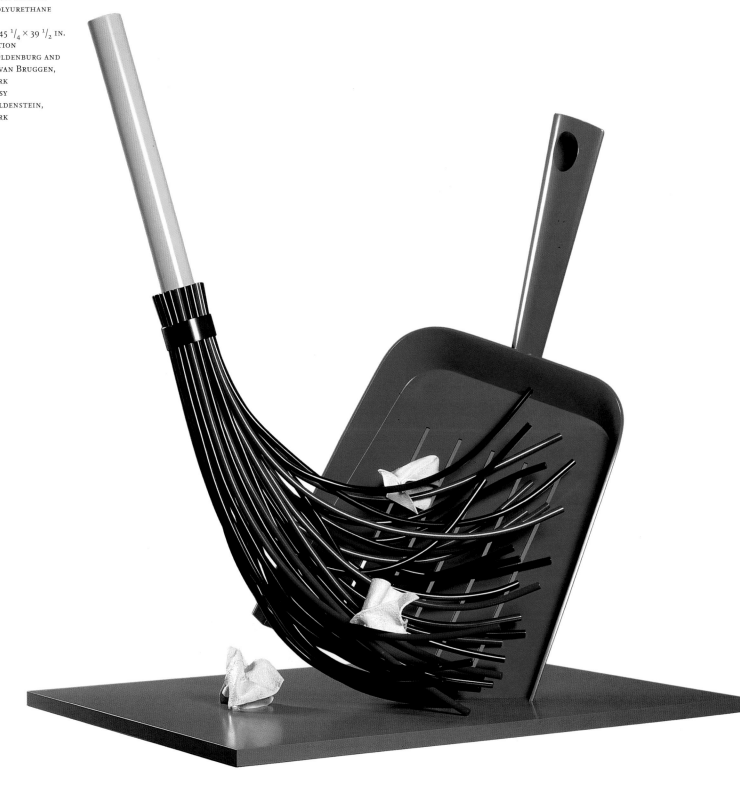

100

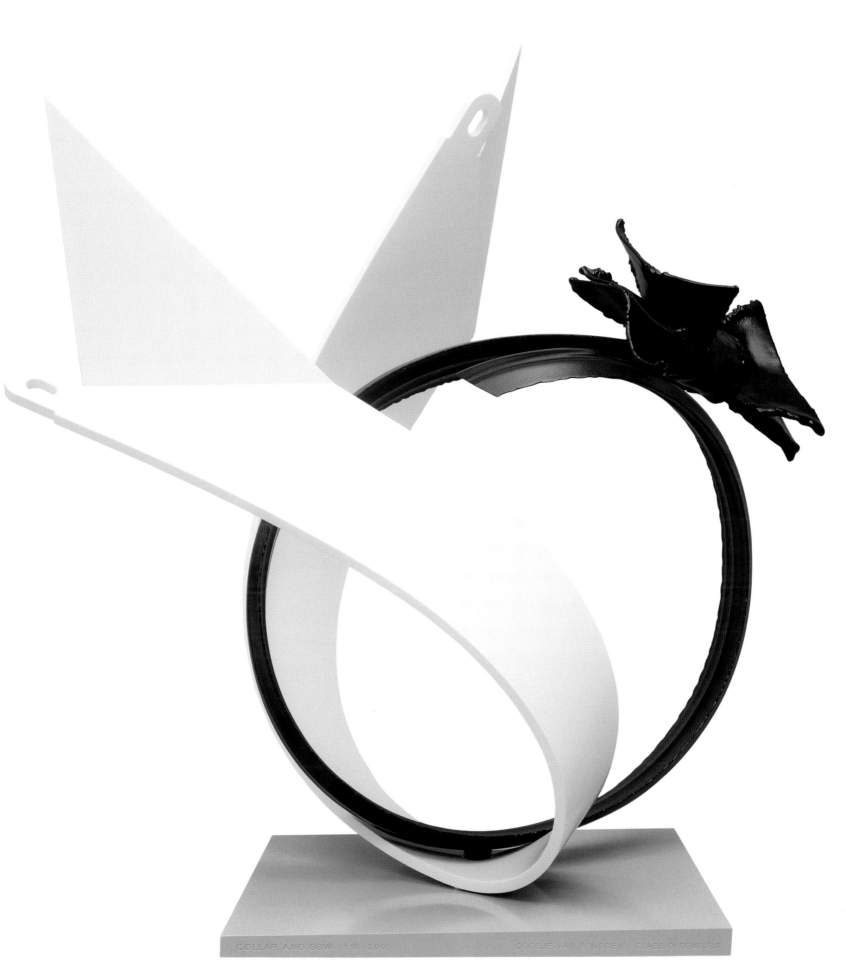

COLLAR AND BOW 1:16 2005 COOSJE VAN BRUGGEN · CLAES OLDENBURG

LARGE-SCALE PROJECTS

Knife Ship I, 1985

Knife Ship II, 1986

Toppling Ladder with Spilling Paint, 1986

Spoonbridge and Cherry, 1988

Dropped Bowl with Scattered Slices and Peels, 1990

Bicyclette Ensevelie (Buried Bicycle), 1990

Monument to the Last Horse, 1991

Binoculars, Chiat/Day Building, 1991

Free Stamp, 1991

Mistos (Match Cover), 1992

Bottle of Notes, 1993

Inverted Collar and Tie, 1994

Shuttlecocks, 1994

Houseball, 1996

Saw, Sawing, 1996

Torn Notebook, 1996

Lion's Tail, 1999

Ago, Filo e Nodo (Needle, Thread, and Knot), 2000

Flying Pins, 2000

Dropped Cone, 2001

Cupid's Span, 2002

Big Sweep, 2006

The *Knife Ship* had its genesis in two related events. For a seminar we, along with the architect Frank O. Gehry, conducted with students at the Faculty of Architecture of Milan in 1984, Coosje selected a classic red Swiss Army knife as the key image and on the first day, we hung up a large cut-out drawing of the object in the classroom. This was to be a "course" about the knife. We gave the students two projects, one for architecture in Venice, the other for a performance about the city. In the first, the knife stood for a method of cutting and slicing applied to architecture that would yield novel results in a traditional setting. In the second, the image was transformed into a giant prop, the *Knife Ship*, for a performance that was later staged at the entrance to the Naval Yard in Venice and titled *Il Corso del Coltello*, or "The Course of the Knife."

Like all the characters in the performance, the *Knife Ship* had two identities, past and present, one, the legendary ceremonial ship of Venice, the *Bucintoro*, the other, a mass-produced tourist souvenir. In vertical positions, the blades of the *Knife Ship* echoed the spires of the city, while the corkscrew recalled the "screwiness" of *Carnevale*.

Although the spectacle was filled with references to the knife, the prop itself was dormant during most of the action, tied up to the opposite quay in the canal that ran along the courtyard in which the performance took place. It awakened dramatically only at the climax of the performance, its blades, corkscrew, and oars in full motion, a paradigm of the process of condensing our observations of place into a symbol in architectural scale. Following the performance, the *Knife Ship* traveled to several museum destinations. Out of water and isolated from context, it retained its many associations while establishing its identity as sculpture.

KNIFE SHIP I, 1985
Steel, wood, plastic-coated fabric, motor
Closed, without oars: 7 ft. 8 in. × 10 ft. 6
in. × 40 ft. 5 in.; extended, with oars: 26
ft. 4 in. × 31 ft. 6 in. × 82 ft. 11 in.; height
with large blade raised: 31 ft. 8 in.; width
with blades extended: 82 ft. 10 in.
Solomon R. Guggenheim Museum
Gift GFT USA Corporation, New York

DESIGN FOR A THEATER
LIBRARY FOR VENICE IN
THE FORM OF
BINOCULARS AND
COLTELLO SHIP IN
THREE STAGES, 1984
(DETAIL)
PENCIL, COLORED PENCIL,
CHALK, WATERCOLOR
30 × 40 IN.
COLLECTION
CLAES OLDENBURG AND
COOSJE VAN BRUGGEN,
NEW YORK

FOLLOWING PAGE:
KNIFE SHIP DURING THE
PERFORMANCE IL CORSO
DEL COLTELLO, VENICE,
ITALY, SEPTEMBER 6-7-8,
1985

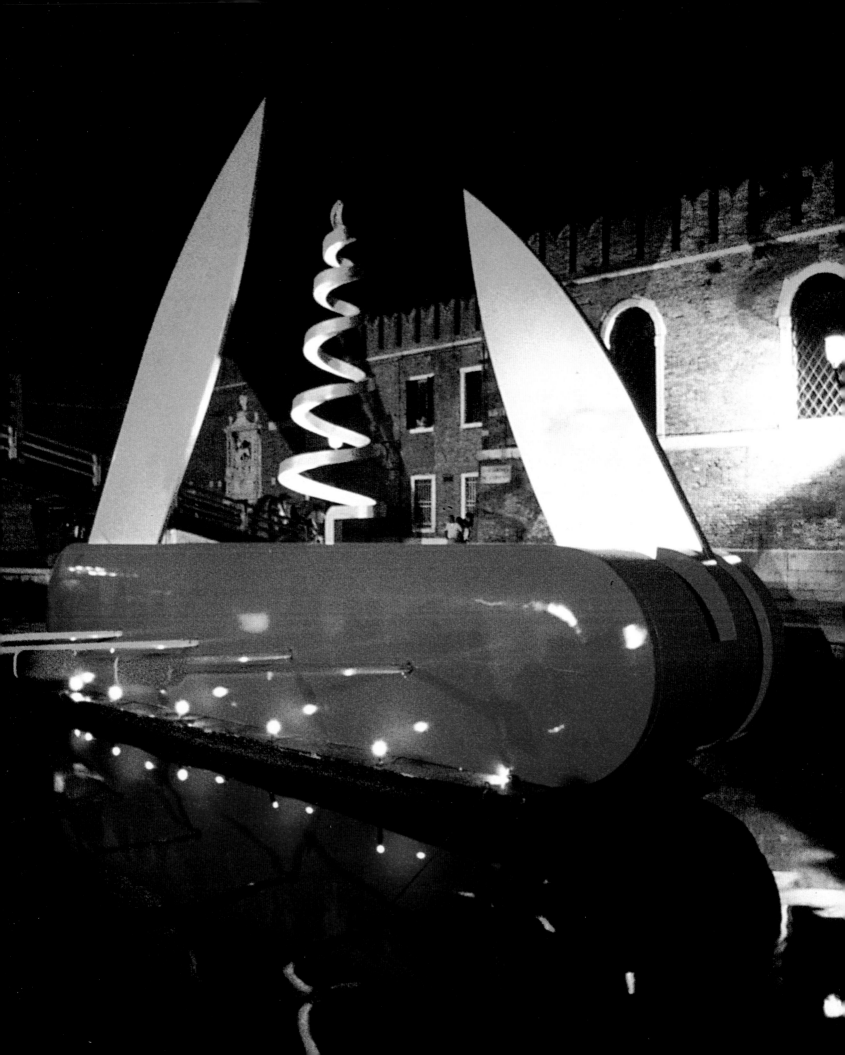

When the opportunity came to show the *Knife Ship* in the rotunda of the Frank Lloyd Wright-designed Guggenheim Museum, we decided to build a second version in New York, which was accomplished in a studio in Brooklyn, with the trial assembly occurring in an adjoining street at night. The original *Knife Ship* had been covered with red vinyl. *Knife Ship II* was painted; its structure was reinforced and more sophisticated controls were added. After the sculpture had been positioned on the floor of the museum, we programmed the blades carefully so that they would come tantalizingly close to, but not strike the surrounding ramps. There were intervals of rest, with the blades and corkscrew folded inside the knife and the oars still, followed by surprising activation of the moving parts. The oars rose and fell in unison over the stone floors, keeping museum visitors at a distance.

After its showing in New York, *Knife Ship II* was donated to The Museum of Contemporary Art in Los Angeles, where it was first installed in the Frank Gehry-designed "Temporary Contemporary" wing, to accompany our performance of excerpts from *Il Corso del Coltello* at the Japan America Cultural Center in 1988.

In 1995 *Knife Ship II* was moved outdoors for the summer to a plaza adjacent to the main museum building designed by Arata Isozaki. There the sculpture's blades and corkscrew vied with the skyscrapers clustered around them, bringing the project's architectural character into focus.

KNIFE SHIP II, 1986
Steel, aluminum, wood; painted
with polyurethane enamel, motor
Closed, without oars: 7 ft. 8 in. × 10
ft. 6 in. × 40 ft. 5 in.; extended, with
oars: 26 ft. 4 in. × 31 ft. 6 in. × 82 ft.
11 in.; height with large blade raised:
31 ft. 8 in.; width with blades
extended: 82 ft. 10 in.
The Museum of Contemporary Art,
Los Angeles,
Gift GFT USA Corporation, a
company of Gruppo GFT, facilitated
by the Rivetti Art Foundation

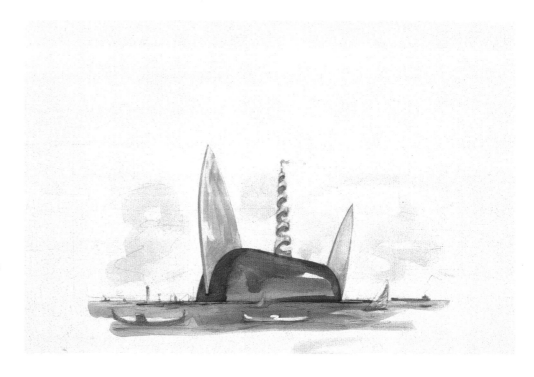

THE COLTELLO BUILDING
WITH SAILBOATS AND
GONDOLAS, 1984
CRAYON, PENCIL,
WATERCOLOR
13 × 20 1/8 IN.
PRIVATE COLLECTION

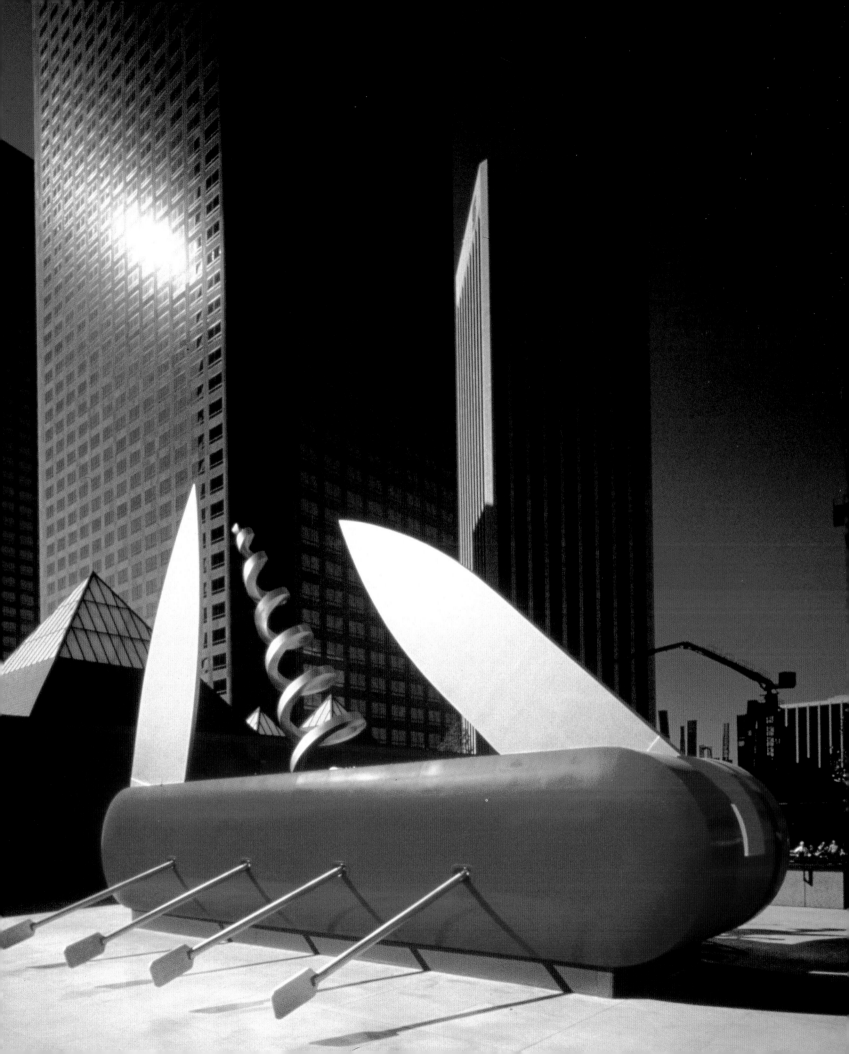

The *Toppling Ladder with Spilling Paint*, our second collaboration with the architect Frank O. Gehry, grew out of our initial 1983 visit to his office, then located in Venice, California. Over a period of a month we spontaneously discussed one another's approach to architecture, sculpture, and drawing. With Gehry we toured several of his projects in different stages of progress. One of his nearly completed projects was the campus of Loyola Law School near downtown Los Angeles, which the architect described as a "pile-up of buildings like an Acropolis."

In the center of the campus, Gehry had located Merrifield Hall, a red brick building that contained a moot court, emphasizing the facade by placing a row of four freestanding concrete columns in front of it. He explained that he had wanted to add a fifth column lying on its side, to break the regimentation. Inspired by this vision, we began to think of a proposal in place of the missing column. A sculpture implying dynamic motion in the form of a ladder about to fall was our response, and a sketch was improvised out of materials found in Gehry's office – wire cloth, foamcore, and a rubber band.

One of Gehry's trademarks at the time was his innovative use of chain-link fencing, most prominently at the shopping center known as Santa Monica Place. A more permanent model of the *Toppling Ladder* was made, its scale determined by using an actual chain-link fence in place of the rungs. An open can was attached to the top, spilling paint in a lateral direction. Three years after our visit, the full-scale work was realized by enlarging the model nine times to the approximate height of the Merrifield columns, painted in a chain-link gray so that the sculpture, like the concrete columns, appears unpainted, except for the blue splat of spilled paint, which recalls the glazed tiles Gehry designed for the Norton House in Venice.

The *Toppling Ladder with Spilling Paint* is caught in a moment of attempted equilibrium that suggested to us not only the scales of justice but also the precarious balance between architecture and sculpture.

*TOPPLING LADDER
WITH SPILLING PAINT*, 1986
Steel and aluminum; painted
with polyurethane enamel
14 ft. 2 in. × 10 ft. 8 in. × 7 ft. 7 in.
Loyola Law School, Los Angeles
Commissioned July 1985 by
Loyola Law School, with a grant
from the Times Mirror
Foundation, Los Angeles
Installed September 1986

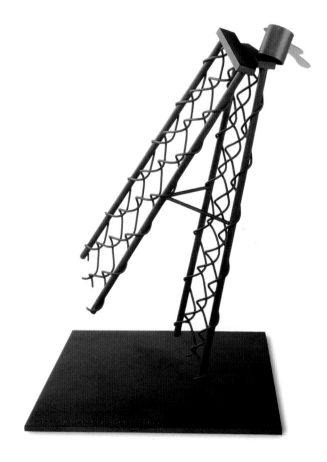

*TOPPLING LADDER WITH
SPILLING PAINT,
FABRICATION MODEL,*
1985
STEEL PAINTED WITH
POLYURETHANE ENAMEL
18 $\frac{1}{2}$ × 12 × 12 IN.
COLLECTION
CLAES OLDENBURG AND
COOSJE VAN BRUGGEN,
NEW YORK

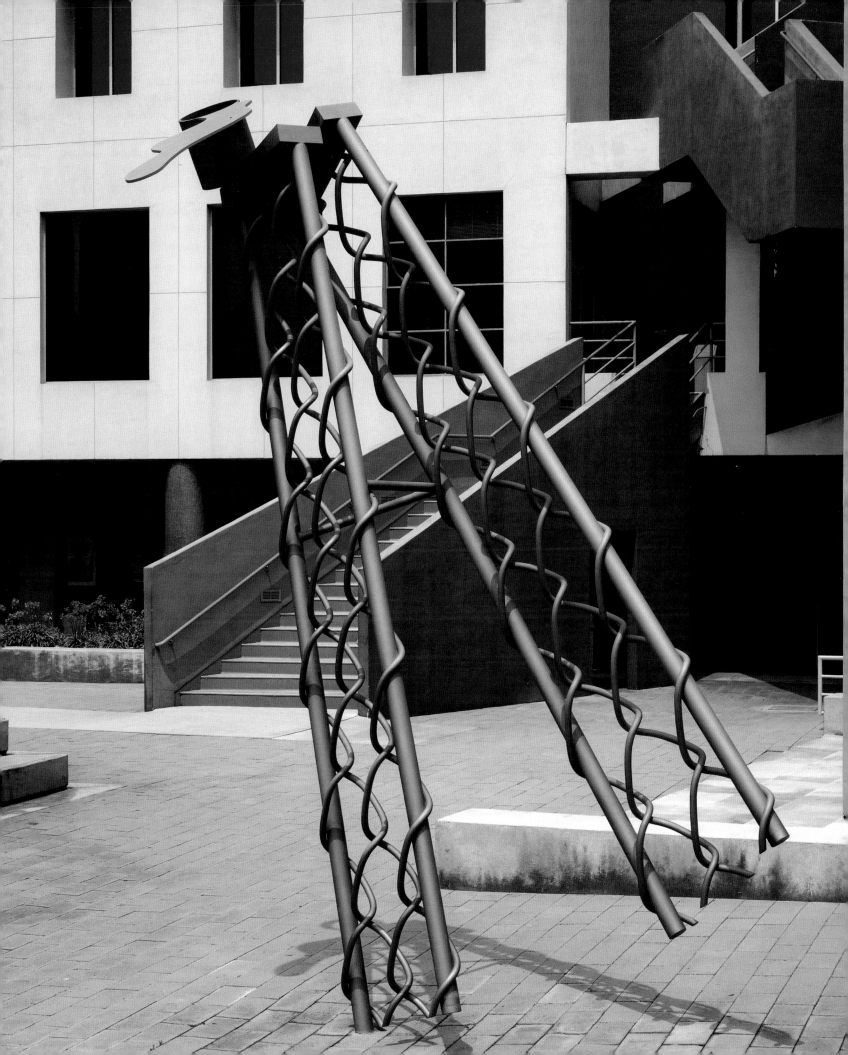

The Minneapolis Sculpture Garden is located in front of the Walker Art Center. Designed by the architect Edward Larrabee Barnes, it encompasses four large plazas, each 100 feet square and containing sculptures situated symmetrically along a broad allée that runs north to south and culminates in a wider area, which in the original plans was divided by a circular pool. The large field was intended for temporary installations.

In searching for a subject that was horizontal and included fountain elements, so as not to dominate the other sculptures in the garden, we tried a spoon over water, terminating in an island, similar in form to an earlier fantastic proposal to replace Navy Pier on Lake Michigan. Its silver color and edges suggested ice-skating, a popular activity during Minneapolis' several months of winter. The raised bowl of the spoon, in its large scale, suggested the bow of a ship. Coosje, however, had always considered the spoon form in itself too passive a sculptural subject, which she had once playfully demonstrated by placing a wooden cherry with a stem made from a nail into a spoon found in the studio, an act that instantly energized the subject. The combination was now repeated in the presentation model for the garden sculpture. The cherry stem was situated in a contrapposto relation to the curve of the spoon and eventually turned into a fountain: while spray from the end of the stem disperses in the air, water issues silently from its base, coating the voluptuous cherry so that it glistens. The cherry is aligned with the long axis of the garden allée, dramatically attracting visitors with its deep red hue. The former circular pool was transformed into the shape of a linden-tree seed pod and cattails were planted along its edge.

Spoonbridge and Cherry takes on a new aspect in the winter season. The water is shut off, but, topped with snow, the cherry turns into a mouthful of ice cream sundae.

SPOONBRIDGE AND CHERRY, 1988
Stainless steel and aluminum
painted with polyurethane enamel
29 ft. 6 in. × 51 ft. 6 in. × 13 ft. 6 in.
Minneapolis Sculpture Garden,
Walker Art Center, Minneapolis
Commissioned February 1985 by the
Walker Art Center, Gift Frederick
R. Weisman in honor of his parents,
William and Mary Weisman
Installed May 1988

VIEW OF SPOONBRIDGE AND CHERRY, WITH SAILBOAT AND SKATER, 1988
PENCIL, PASTEL, CHALK, COLLAGE
33 1/2 × 20 IN.
WALKER ART CENTER, MINNEAPOLIS, ACQUIRED IN CONJUNCTION WITH THE COMMISSIONING OF *SPOONBRIDGE AND CHERRY* FOR THE MINNEAPOLIS SCULPTURE GARDEN, 1991

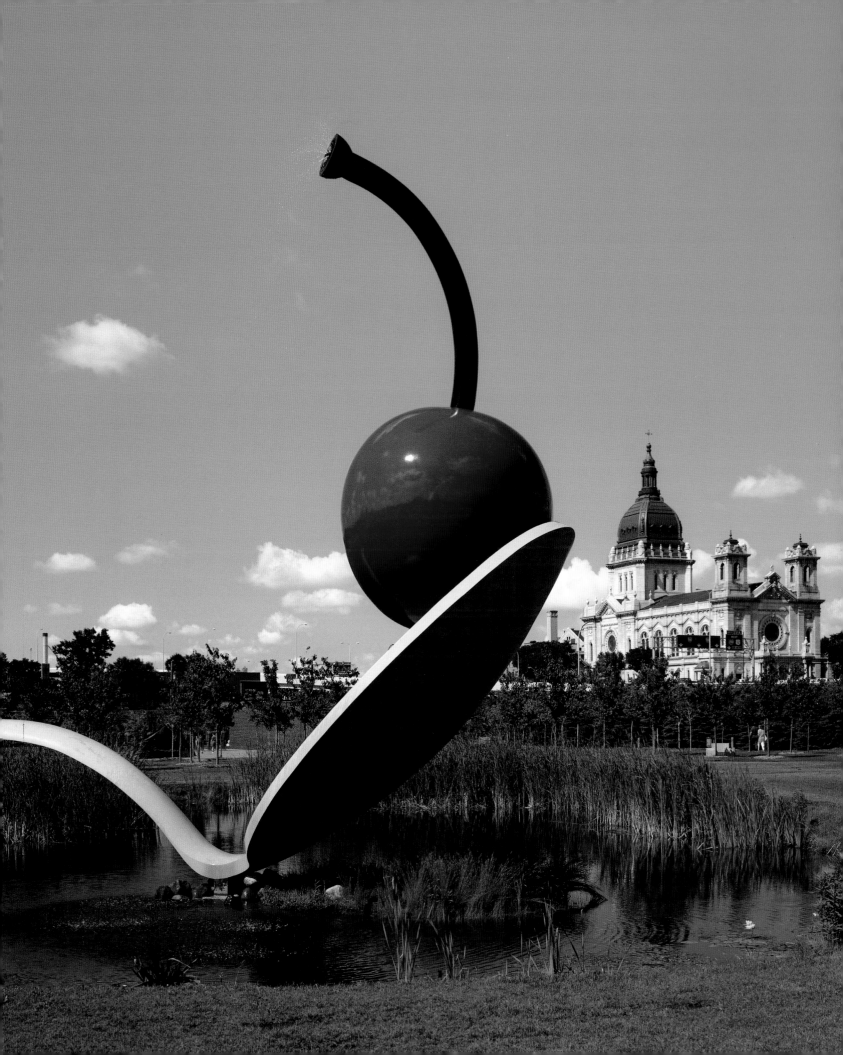

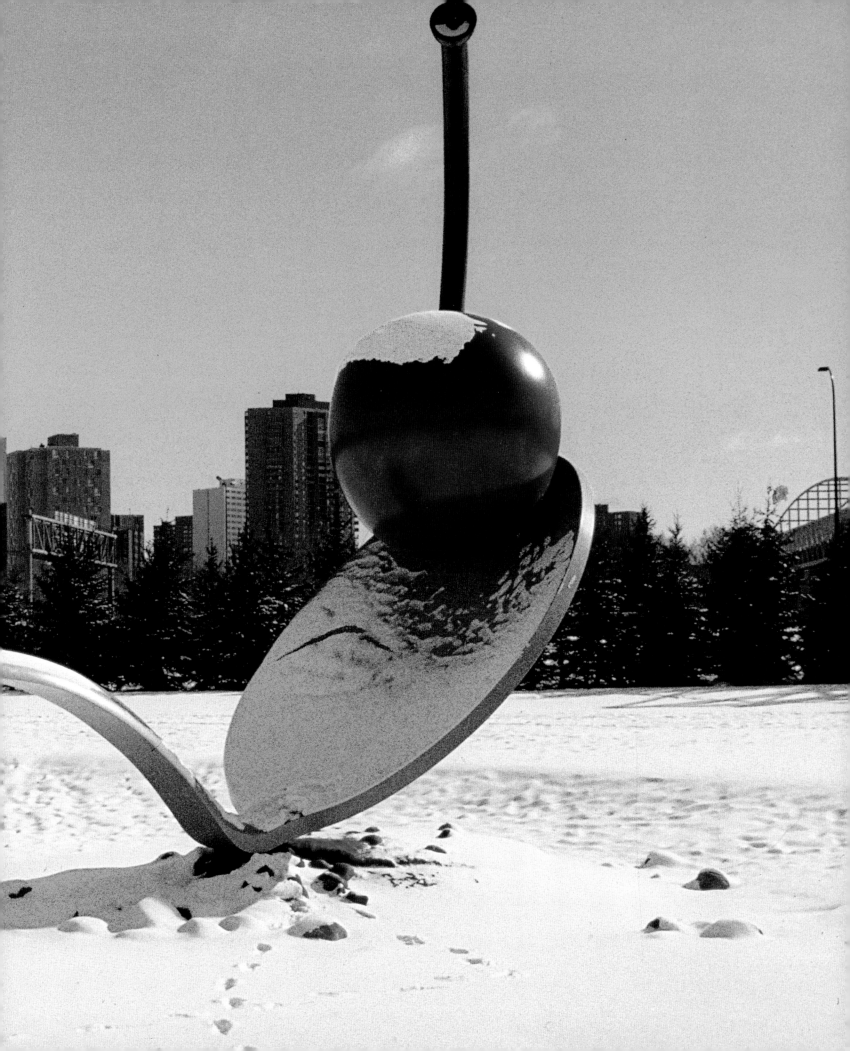

Although we had included water as an element in our *Gartenschlauch (Garden Hose)*, a sculpture for Freiburg-im-Breisgau, Germany, in 1982, we had not yet attempted a full fountain. The opportunity came with a commission from the Metro-Dade County Art in Public Places program in September 1984. Water seemed an especially appropriate subject for the city of Miami, to which we would add one of our favorite fruit subjects, the orange, also associated with the state of Florida.

The site was a wide area surrounded by an eclectic mix of architecture and highways. A centralized fountain in a circular shape surrounded by flagpoles, as projected in the landscape designer's plans, did not seem to respond to the location. Coosje proposed instead an anti-hierarchical approach, consisting of forms scattered over the plaza. In reference to the conventional shape of a fountain, ours would be round, but resembling a broken plate, with the oranges deconstructed into slices and expressively cut peels. We thought that the jagged fragments would be more interesting if they came from a bowl, coincidentally a nod to a local institution, the football stadium known as the Orange Bowl. Trying out the idea on a model, Coosje dispersed the parts with abandon to introduce chance and irregularity into the orderly grid of the plaza. Cesar Trasobares, director of the Art in Public Places program, likened the effect to a piñata, which spills treasures in all directions when it is smashed. The flying slices, peels, and fragments of the bowl are caught as if in stop-motion, bouncing off the surfaces of the plaza. Pools in the shape of spilled liquid, large and small, were cut into the pavement beneath the sculptural pieces. Jets of water emerge from the pools, programmed at irregular heights and surprising intervals in repeated reenactments of the breaking bowl's impact.

At the time of its inauguration the *Dropped Bowl with Scattered Slices and Peels* could be seen to represent a city in the making, deriving its particular order out of the apparent disorder accompanying Miami's expansion.

Dropped Bowl with Scattered Slices and Peels, 1990
Steel, reinforced concrete, fiber-reinforced plastic; painted with polyurethane enamel, stainless steel
Seventeen elements (eight bowl fragments, four peels, five orange sections), in an area approximately
16 ft. 9 in. × 91 ft. × 105 ft.
Metro-Dade Open Space Park, Miami
Commissioned September 1984 by Metro-Dade Art in Public Places Trust, under Dade County's 1.5 Percent for Fine Art ordinance
Installed September 1989

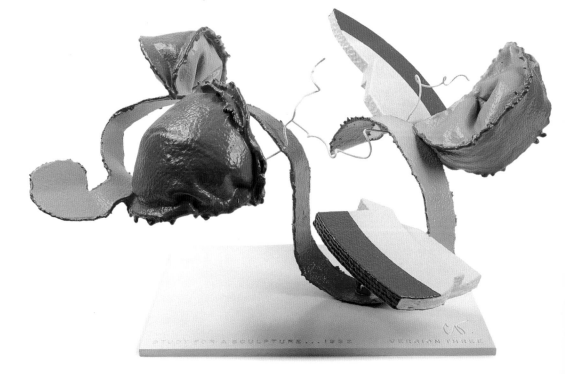

Study for a Sculpture, Version Three, 1992
Cardboard, canvas, steel; coated with resin and painted with latex, aluminum painted with latex
13 1/2 × 25 1/4 × 19 in.
Private collection

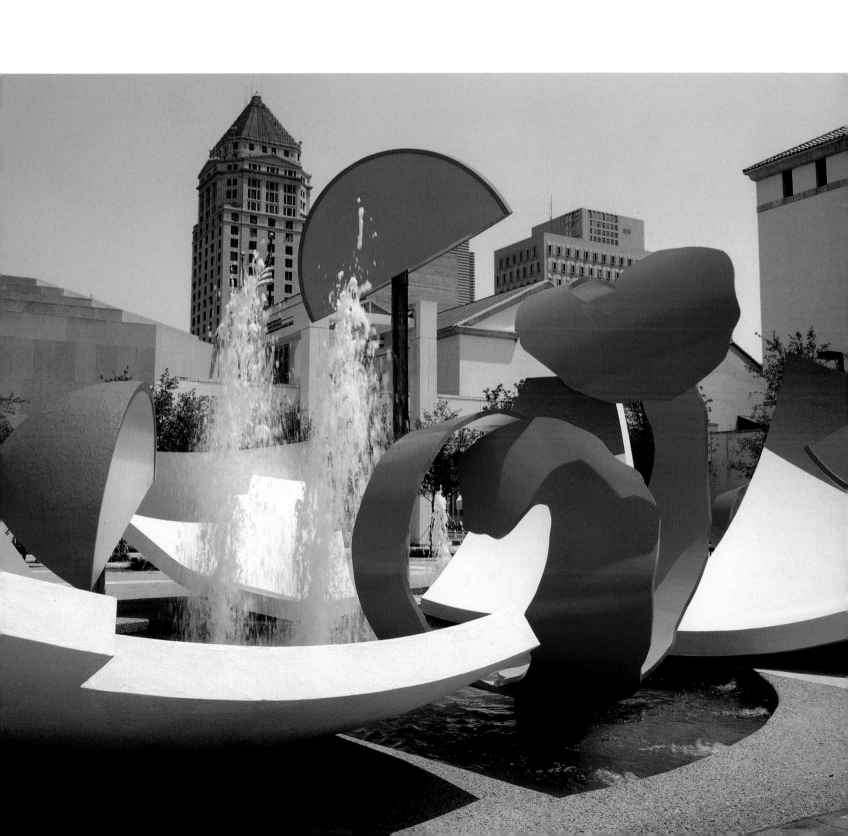

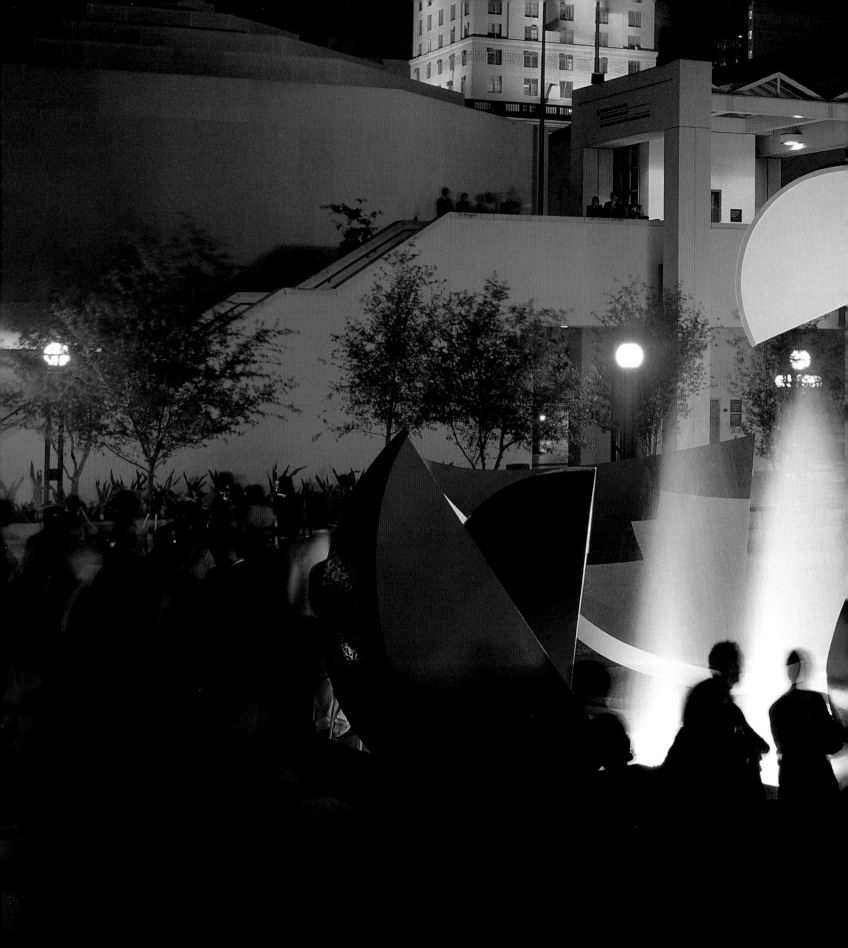

Coosje's thoughts on Samuel Beckett's anti-hero Molloy – who falls off his bicycle and finds himself lying in a ditch unable to recognize the object – prompted her selection of a bicycle as the subject for an "intervention" we had been asked to propose by the French Ministry of Culture. The work was to be incorporated into the new Parc de la Villette, designed by the architect Bernard Tschumi, on the outskirts of Paris. The bicycle has close ties to France, having been invented there and celebrated in the Tour de France. Its parts have also been featured in art, from Picasso's bull's head made out of a bicycle seat and handlebars to Marcel Duchamp's bicycle wheel mounted on a stool. In fact, we decided that the parts and details were better subjects for a configuration of sculptural elements than the unwieldy whole; our solution was to bury most of the vehicle. Doing this allowed us to select a large scale appropriate to the park's wide spaces. We settled on an invisible bicycle, 150 feet 11 inches long, with the front wheel turned slightly so that a portion would protrude above the ground, and plotted the locations of a pedal, one half of the seat, and one handlebar with a bell, using a sawed-up standard bicycle that our daughter had outgrown as a model. Where Molloy's bicycle bell had been red, the *Buried Bicycle*'s would be blue, in contrast to a number of red "follies" the architect had placed in the park.

The inevitability of the placement of the parts in relation to one another as defined by the bicycle mimicked the grid of the park. At the same time, however, our self-contained configuration was dropped as if by chance over that of the park, causing the pedal to intrude on the courtyard of the Folie Belvédère and the space occupied by a group of Philippe Starck chairs. We responded to this by simply turning the pedal, our bicycle pedaling on.

BICYCLETTE ENSEVELIE
(*BURIED BICYCLE*), 1990
Steel, aluminum, fiber-reinforced plastic; painted with polyurethane enamel
Four elements, in an area approximately 150 ft. 11 in. × 71 ft. 2 in.; wheel: 9 ft. 2 in. × 53 ft. 4 in. × 10 ft. 4 in.; handlebar and bell: 23 ft. 8 in. × 20 ft. 5 in. × 15 ft. 7 in.; seat: 11 ft. 4 in. × 23 ft. 9 in. × 13 ft. 7 in.; pedal: 16 ft. 4 in. × 20 ft. 1 in. × 6 ft. 11 in.
Parc de la Villette, Paris
Commissioned November 1985 by Etablissement Public du Parc de la Villette
Installed November 1990

STUDY FOR BICYCLETTE ENSEVELIE, HANDLEBAR WITH BELL, 1987
CRAYON AND WATERCOLOR ON PHOTOCOPY
5 7/8 × 7 1/2 IN.
PRIVATE COLLECTION, CLEVELAND, OHIO

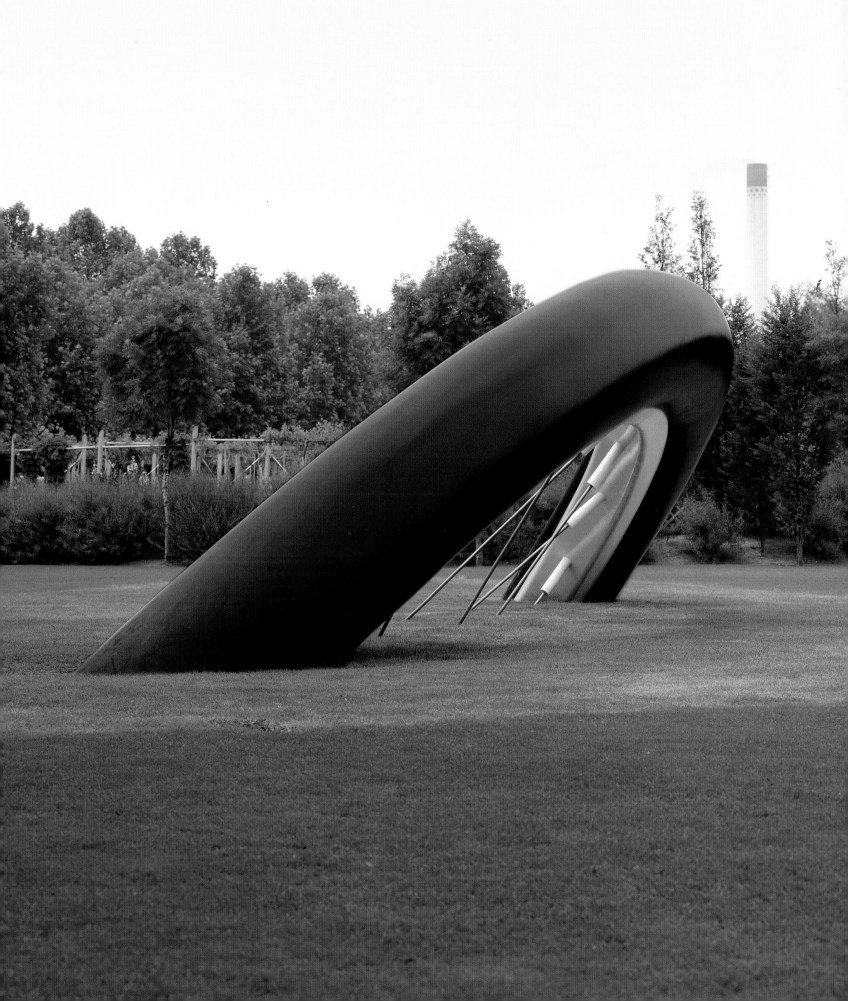

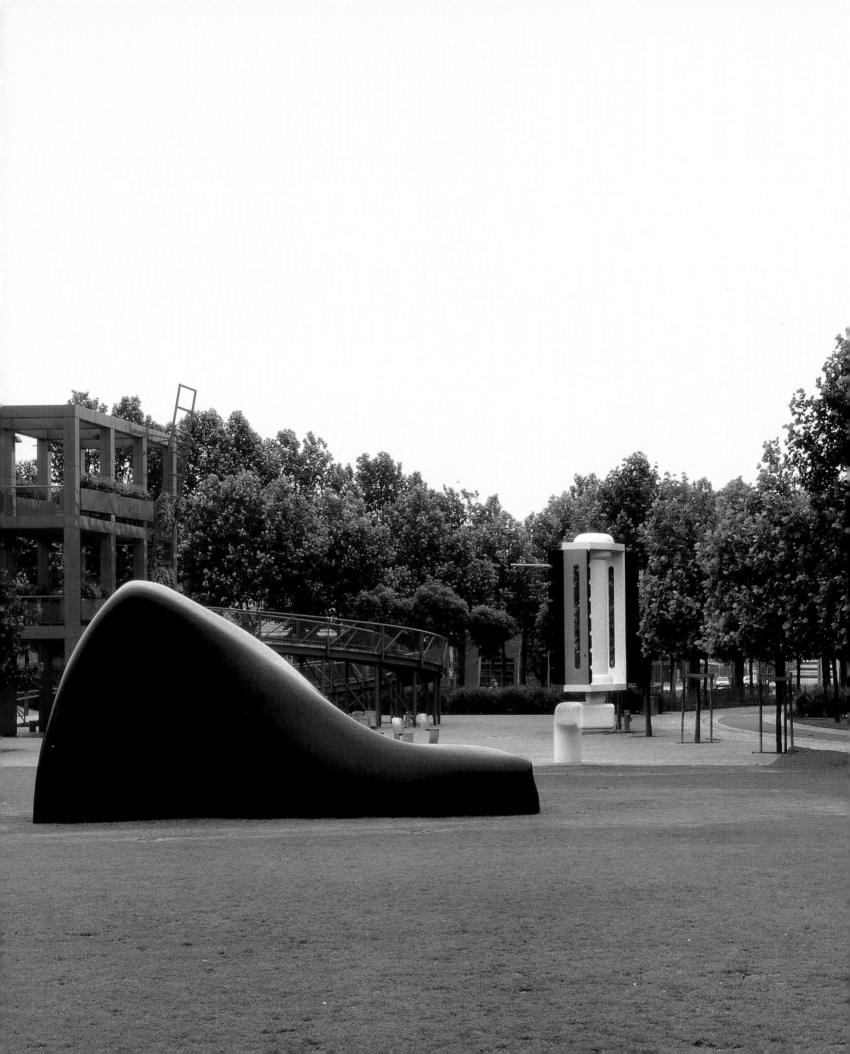

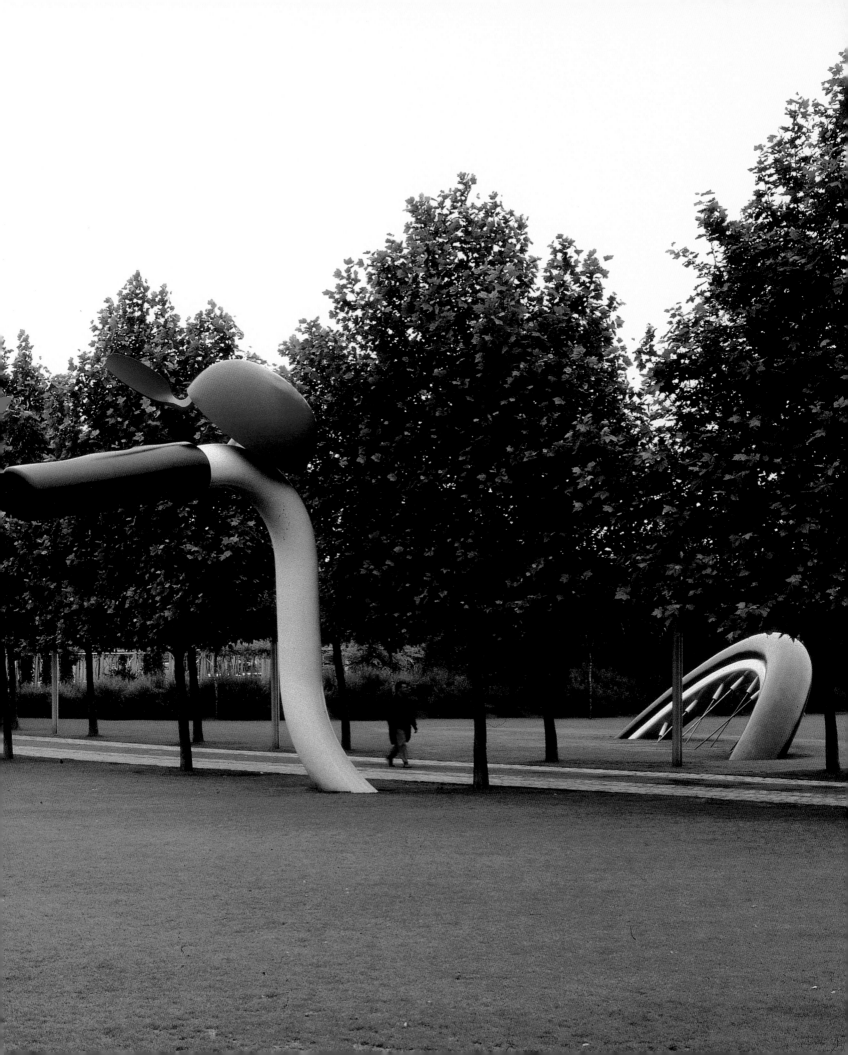

In Marfa, located in the vast highlands of west Texas, the artist Donald Judd had established The Chinati Foundation, named after a nearby mountain, to exhibit his work as well as that of several other artists. The foundation is housed in what had once been Fort D. A. Russell, the home base of the First U. S. Cavalry, and the complex of barracks and buildings includes the Arena, a former gymnasium, which Judd had restored and redesigned. In October 1987, on one of our visits to Chinati, Don, who was a close friend, showed us a crumbling marker along a dirt road commemorating "Louie," the last horse of the regiment, which was disbanded in 1932. Noting that although common in statuary, horses seldom are the subject of their own monument, Coosje proposed creating one for Louie, a project in line with Judd's desire to preserve the history of the area. Judd approved the project enthusiastically. Not long thereafter we found on his ranch near the Rio Grande an old rusted horseshoe, which became our prototype. It was twisted and a long curved nail found nearby was inserted through one of its holes, to make the shape more three-dimensional.

In talks with Don, we first planned to lay adobe on a large profile of the horseshoe to simulate earth stuck to it, but in the fabrication that eventually followed – on the East Coast, far from Marfa – sprayed rigid foam was substituted, and painted an earthy brown. The shoe was fixed on top of a larger version of Louie's original marker and, like it, inscribed "Animo et Fide" – "Spirited and Faithful."

On its way from the factory to the site, the sculpture was installed temporarily in the plaza in front of Mies van der Rohe's Seagram Building on Park Avenue, in New York City. There it passed a summer in marked contrast to its setting, before traveling to its true destination on a slope overlooking a field that contains a row of Judd's large-scale concrete pieces and affords a spectacular view of the sunrise. The *Monument to the Last Horse* was presented to The Chinati Foundation in October 1991, with a live horse, "Old Blaze," in attendance.

MONUMENT TO THE LAST HORSE, 1991
Aluminum and polyurethane foam;
painted with polyurethane enamel
19 ft. 8 in. × 17 ft. × 12 ft. 4 in.
The Chinati Foundation, Marfa, Texas
Gift Claes Oldenburg and
Coosje van Bruggen
Installed September 1991

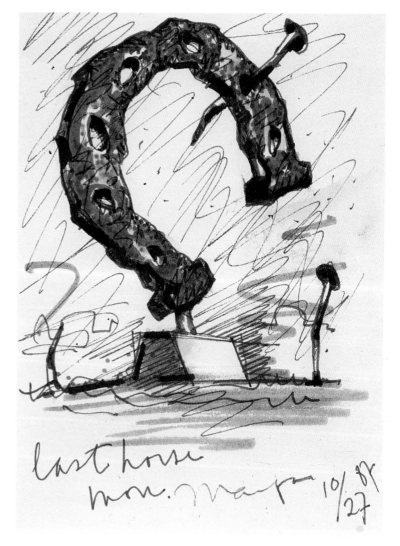

*STUDY FOR "LAST HORSE
MON. MARFA,"* 1987
BALLPOINT PEN, FELT
PEN, WATERCOLOR
4 7/8 × 3 3/8 IN.
JUDD FOUNDATION,
NEW YORK, MARFA

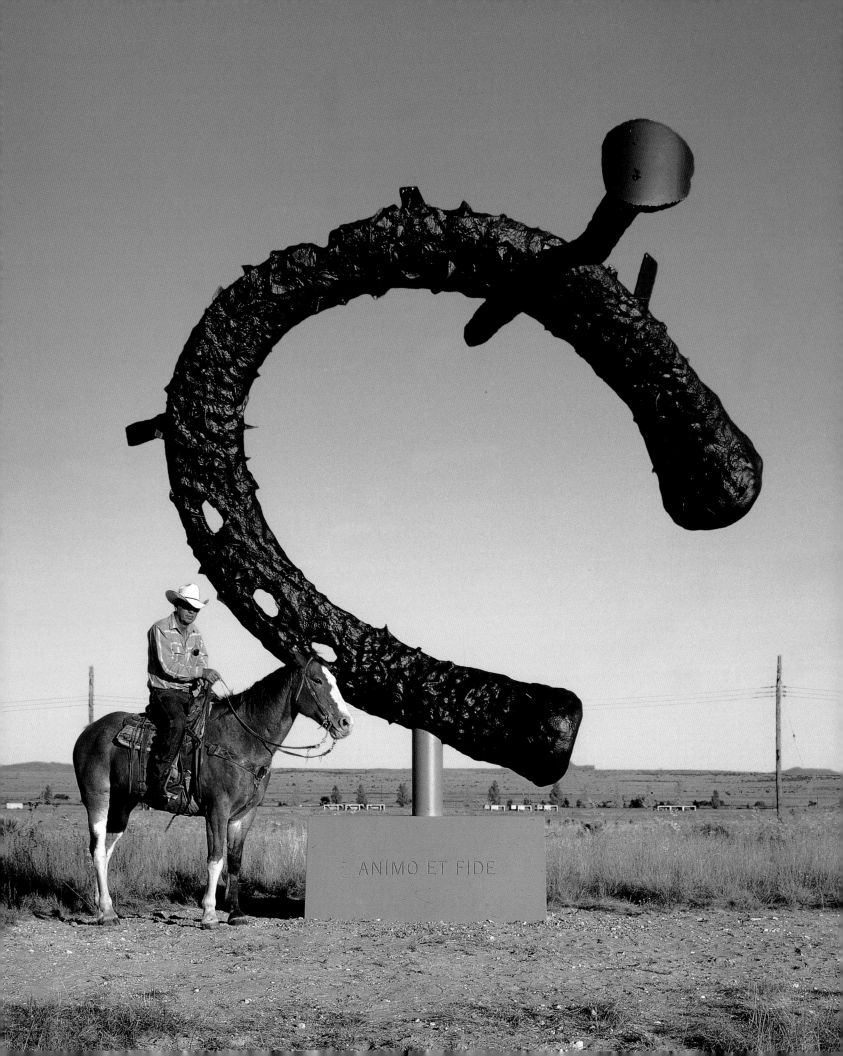

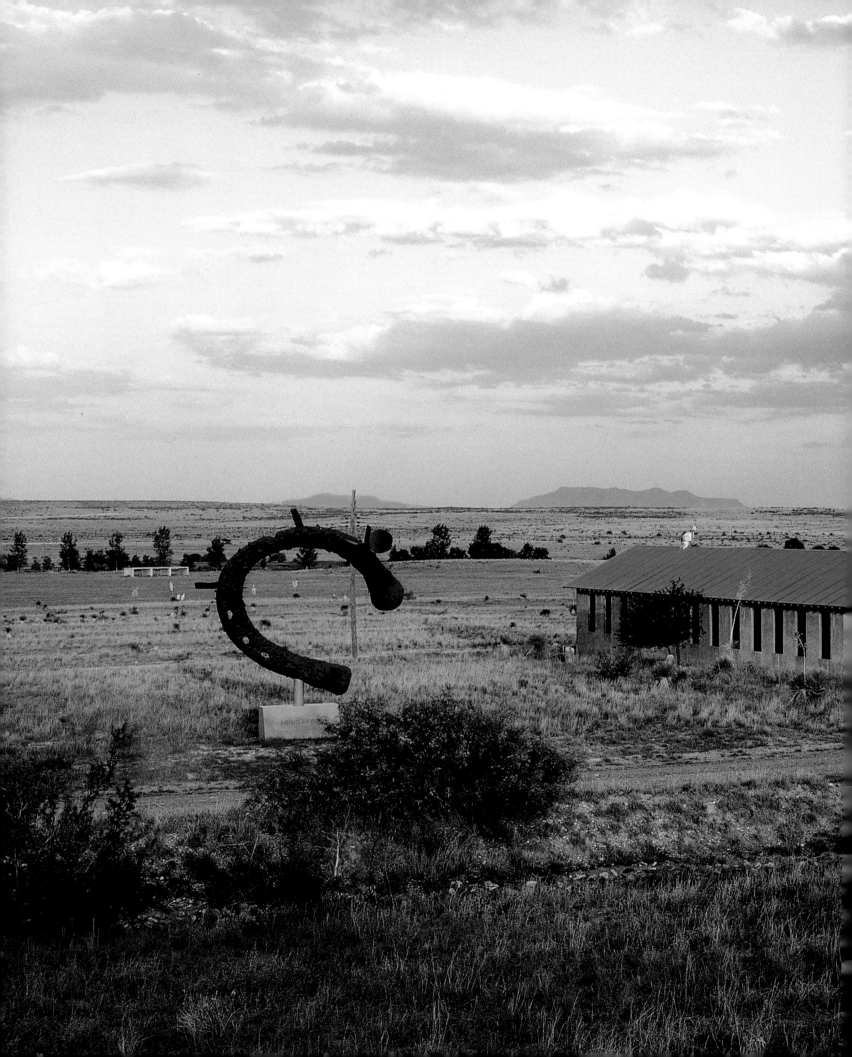

A design for an island community on Laguna Morta in Venice, Italy, had been part of the project undertaken with students at the Faculty of Architecture of Milan, along with the performance *Il Corso del Coltello*. Called "Coltello Island," the project did not materialize, although a number of models and drawings were produced. One of the models was a small study for a theater and library in the form of standing pair of binoculars, which by early 1986 had become a fixture on the architect Frank Gehry's desk.

One day we received a telephone call from Gehry and Jay Chiat, a client, who had been pondering a maquette in progress for the new Chiat/Day advertising agency to be located on Main Street in Venice, California, not far from the Pacific Ocean. The design so far consisted of two highly disparate structures, one boat-like, the other tree-like. Now Gehry wanted to join them in the center with a third structure of a sculptural character that would mediate between the two and anchor the building, but he was not yet sure how to define it. Looking for something to demonstrate what he had in mind, he placed the little binoculars – which serendipitously almost fit the scale of the model – in the center of the Chiat/Day facade.

The mimetic architecture this suggested has something of a tradition in southern California, and the precedent of imagining functional objects as buildings was well established in Claes' Colossal Monument drawings of the mid-1960s but never turned into a feasible commission. Gehry generously proposed sharing the facade of his building with us and the next few years were spent in the complex task of developing the binoculars form into a part of the architecture. Attention focused as much on the interior as the exterior of the *Binoculars* and on the addition of windows – without which, Gehry insisted, the structure would not really be a building.

Two tall unusually shaped rooms, created by following the curves of the binoculars, opened onto a conference room, the ceiling of which was covered with a version of Gehry's signature snake form. The two curved rooms were intended to serve as places of retreat. Each was furnished with a huge elongated lightbulb of resined cloth, suspended from the ceiling, softly glowing, as in comic-strip representations, the sign of a luminous idea.

Binoculars, Chiat/Day Building,
1991
Steel frame; exterior: concrete and
cement plaster painted with
elastomeric paint; interior: gypsum
plaster
45 × 44 × 18 ft.

Central component of Chiat/Day
Inc. building designed by Frank
O. Gehry & Associates, Inc., 340
Main Street, Venice, California
Commissioned May 1986
by Jay Chiat
Completed August 1991

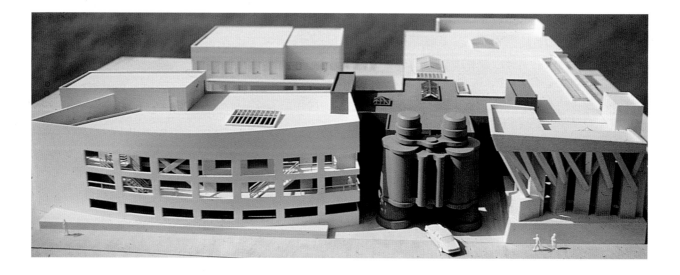

Previous page:
Design for a Theater Library in the Form of Binoculars – Model,
1984
Wood painted with latex and spray enamel
6 1/8 × 5 × 1 7/8 in.
Collection
Claes Oldenburg and Coosje van Bruggen,
New York
Shown together with model of Chiat/Day
Inc. building by Frank O. Gehry

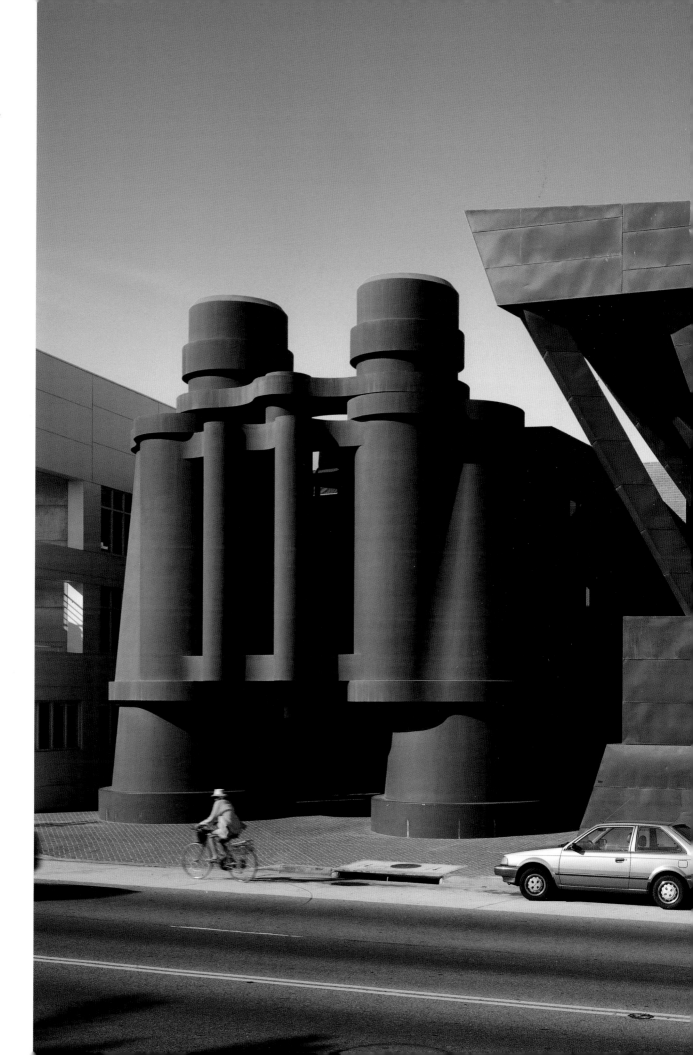

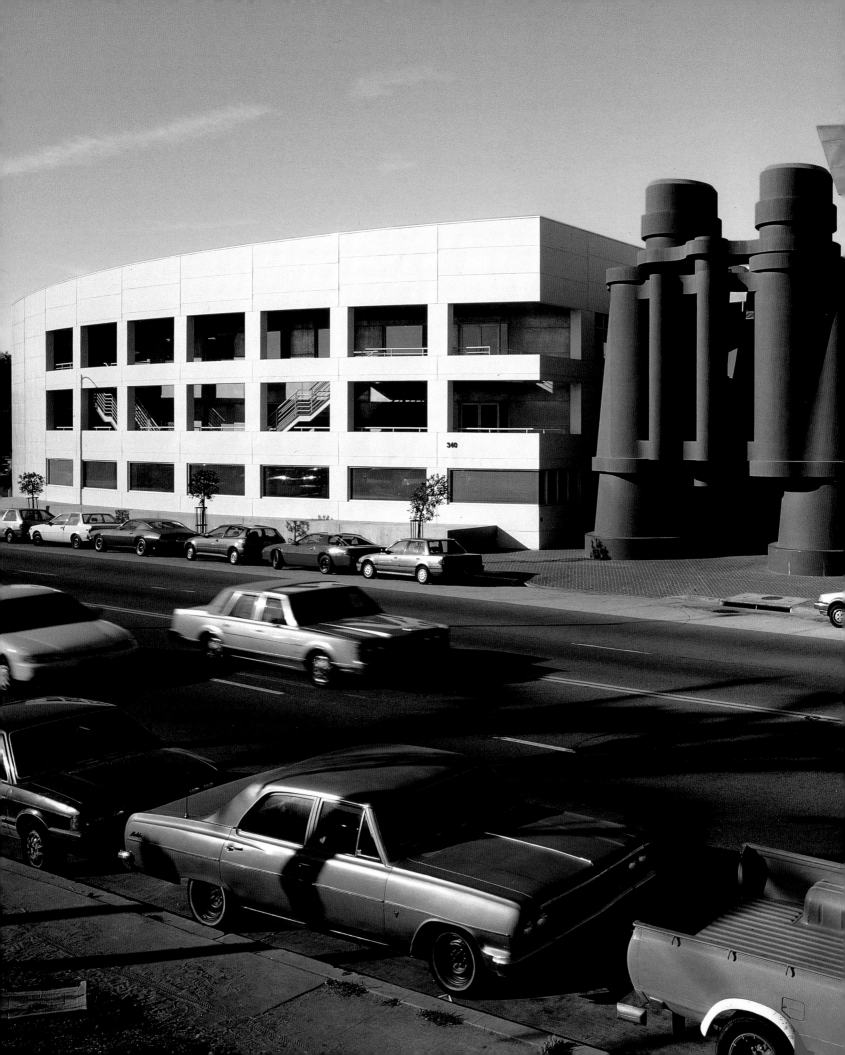

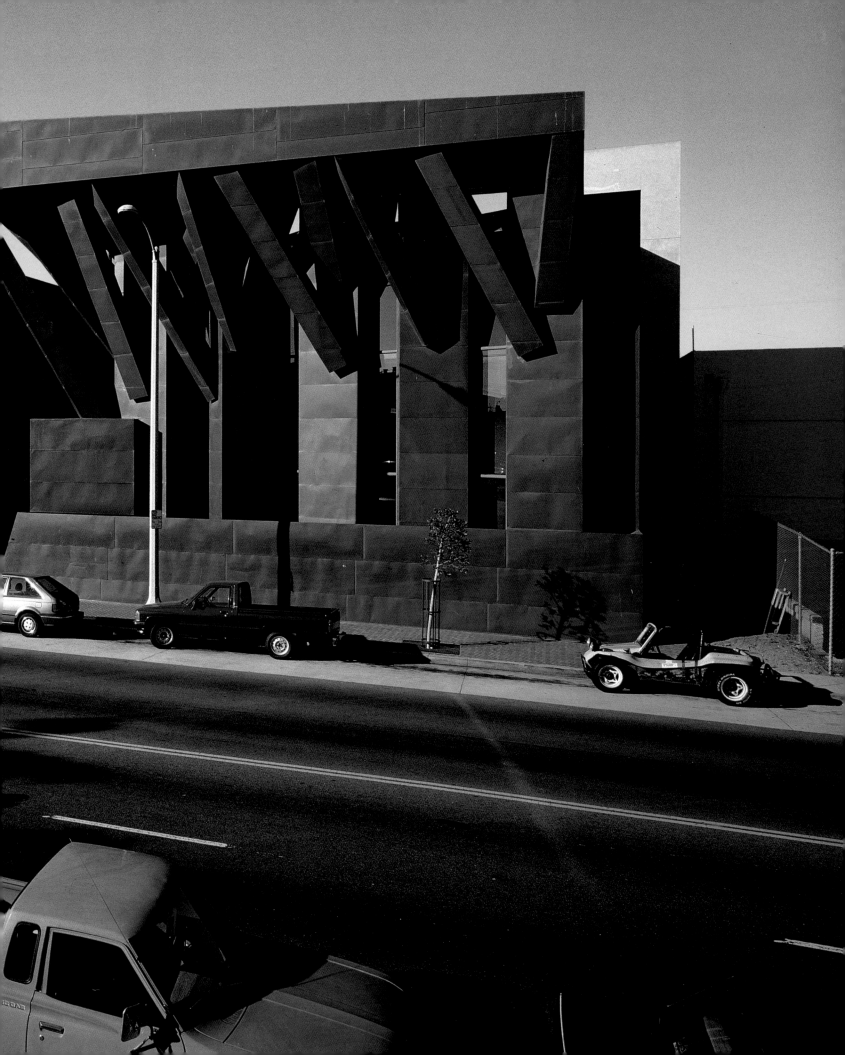

The process of creating the *Free Stamp*, from its conception to its arrival at its present location in Willard Park adjacent to Cleveland's City Hall, covers nearly ten years. In 1982 Standard Oil Company of Ohio (SOHIO) commissioned us to create a work in front of its new headquarters, a skyscraper built out of pink stone on Public Square in the city center. The base on which the sculpture was to be situated was an area made of concrete that reminded us of a stamp pad. Associations followed and soon we had our subject: a colossal rubber stamp, an object then still common in the office culture of the surroundings (though, like many of our subjects, verging on obsolescence), with a decidedly architectural character, scaled to mediate between the street and the atrium behind the sculpture. In overall shape, it also echoed the nineteenth-century Soldiers' and Sailors' Monument in the center of the square.

Our design made it necessary for us to select a short word to be "reproduced" by our stamp – four letters at most. Coosje chose "free," a word with multiple implications, comparable to "liberty," the word held aloft by the female figure atop the monument across the street. The word was related paradoxically to its compressed position, and could not be read, only imagined by studying the edges of the letters.

The *Free Stamp* was proposed and approved, and work began on its fabrication. Halfway through, however, the company changed ownership, becoming British Petroleum; as a result the sculpture was abruptly canceled. There were protests in the city and eventually we were offered alternative sites by a committee to preserve the sculpture. At first, the *Free Stamp*'s close connection to its original site seemed too strong, but we then realized that a stamp has no fixed position and is just as often seen lying down as it is standing up. One could imagine that the *Free Stamp* had been picked up and thrown, landing on its side in Willard Park, one of the sites offered by the city, in view of the British Petroleum skyscraper. The new position also had the important advantage of fully revealing the word "free," radiant in its pink hue, though in reverse.

FREE STAMP, 1991
Steel and aluminum; painted with
polyurethane enamel
28 ft. 10 in. × 26 ft. × 49 ft.
Willard Park, Cleveland, Ohio
Commissioned December 1982 by
SOHIO (later BP America, Inc.),
Gift BP America, Inc. to the City
of Cleveland
Installed August-October 1991

ARCHITECTURAL
RENDERING OF *FREE
STAMP* IN FRONT OF
SOHIO HEADQUARTERS
IN CLEVELAND'S PUBLIC
SQUARE

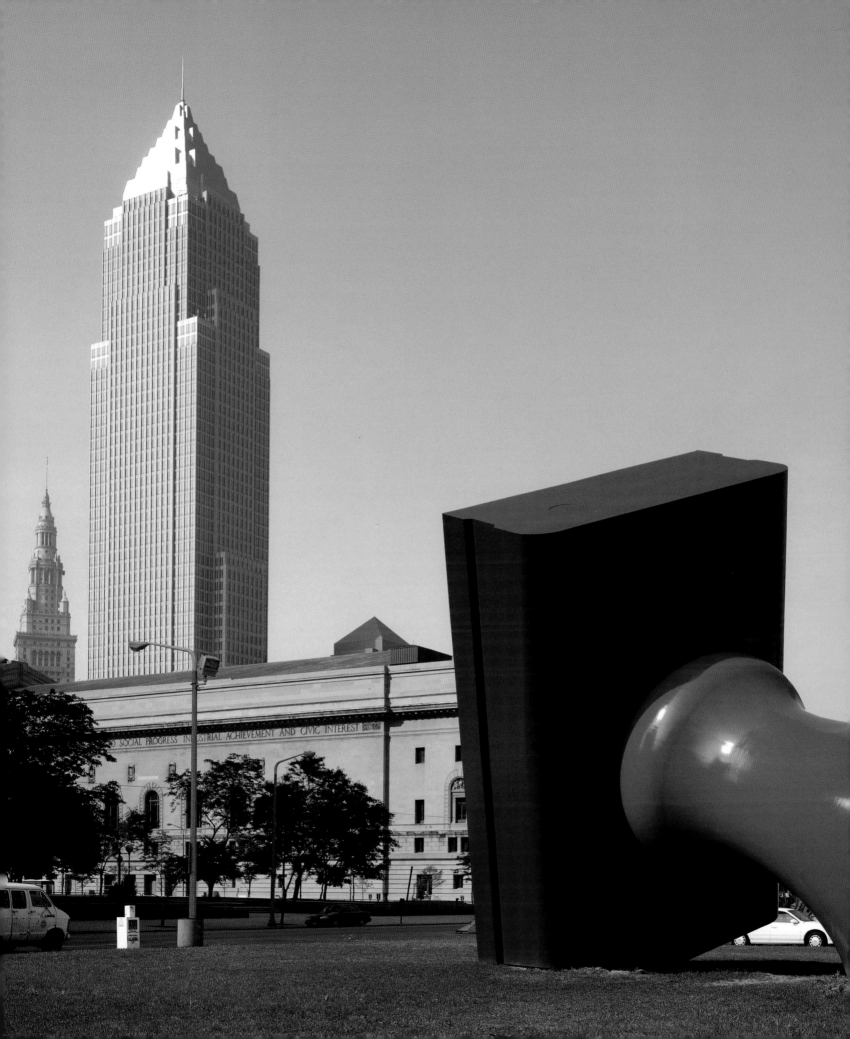

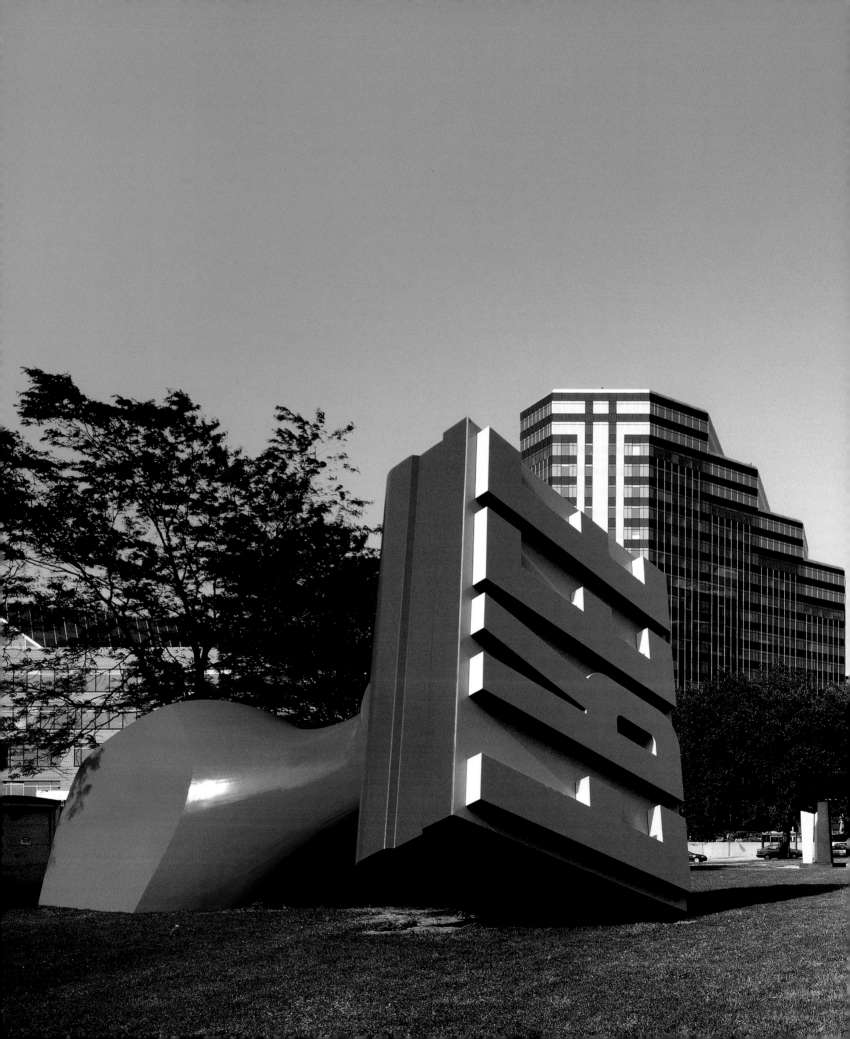

For many years Barcelona has had one of the world's most ambitious urban planning programs, interrelating architecture, parks, plazas, and outdoor works of sculpture. When we visited the city in 1986 in response to an invitation to become part of the program, we toured installations by Eduardo Chillida, Richard Serra, and Ellsworth Kelly. By the time we joined the program, it had been expanded for the 1992 Olympics to include work by an international array of architects, among them Arata Isozaki, Gae Aulenti, Richard Meier, and Frank O. Gehry.

Most of the new projects were located near the waterfront and the city center, but we were more interested in the residential areas being developed for the Olympic Games that would afterward become new neighborhoods. As our site we chose an open space in the Vall d'Hebron section in the hills overlooking the city. The only other cultural landmark in the vicinity was to be a reconstruction of the pavilion for the Spanish Republic designed by José Luís Sert for the Paris World's Fair of 1937, the building in which Picasso's *Guernica* first was shown.

Our proposal was a 68-foot-high sculpture based on a matchbook cover. Folded back so that the cover formed a base, the matches were bent, as if by use, with the exception of one erect, flaming match. Loose matches, some "burnt," were scattered over the site.

The front view of the *Mistos* is reminiscent of the facade of Antoni Gaudí's cathedral of the Sagrada Familia, while the base recalls the underpinning of the untitled "Chicago Picasso."

MISTOS (MATCH COVER), 1992
Steel, aluminum, fiber-reinforced
plastic; painted with polyurethane
enamel
Overall dimensions: 68 ft. × 33 ft.
× 43 ft. 4 in.; five detached matches:
9 ft. 2 in. × 37 ft. 1 in. × 9 ft. 7 in.;
14 ft. 10 in. × 30 ft. 3 in. × 10 ft.;
7 ft. 6 in. × 28 ft. 4 in. × 18 ft. 9 in.;
7 ft. 11 in. × 25 ft. 10 in. × 19 ft. 2
in.; 17 ft. 4 in. × 35 ft. × 14 ft. 5 in.
La Vall d'Hebron, Barcelona
Commissioned November 1989 by
Institut Municipal de Promoció
Urbanística, S.A., Barcelona
Installed October 1991

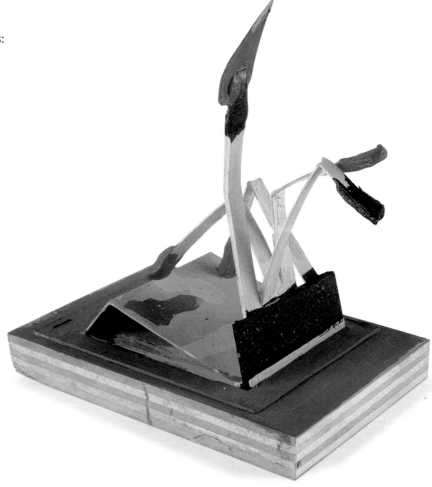

STUDY FOR A SCULPTURE
IN THE FORM OF A
MATCH COVER, 1987
WOOD, PAPER, CLAY; PAINTED
WITH LATEX
10 1/2 × 8 1/4 × 9 IN.
INSTITUT MUNICIPAL
DE PROMOCIÓ URBANÍSTICA,
S.A., BARCELONA

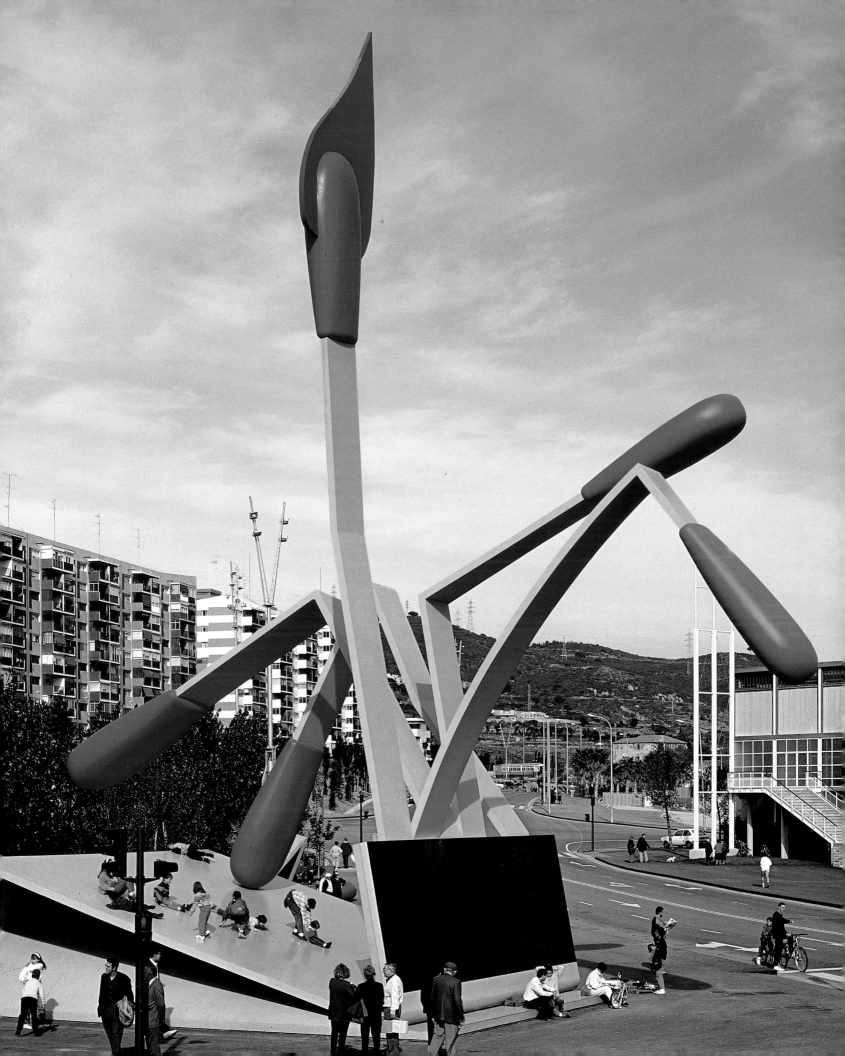

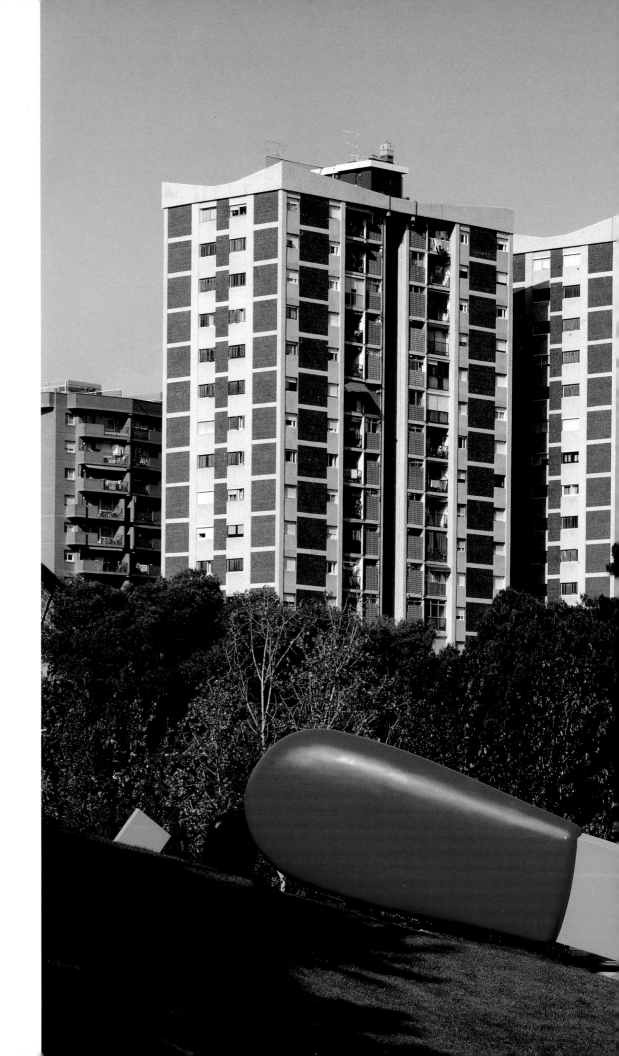

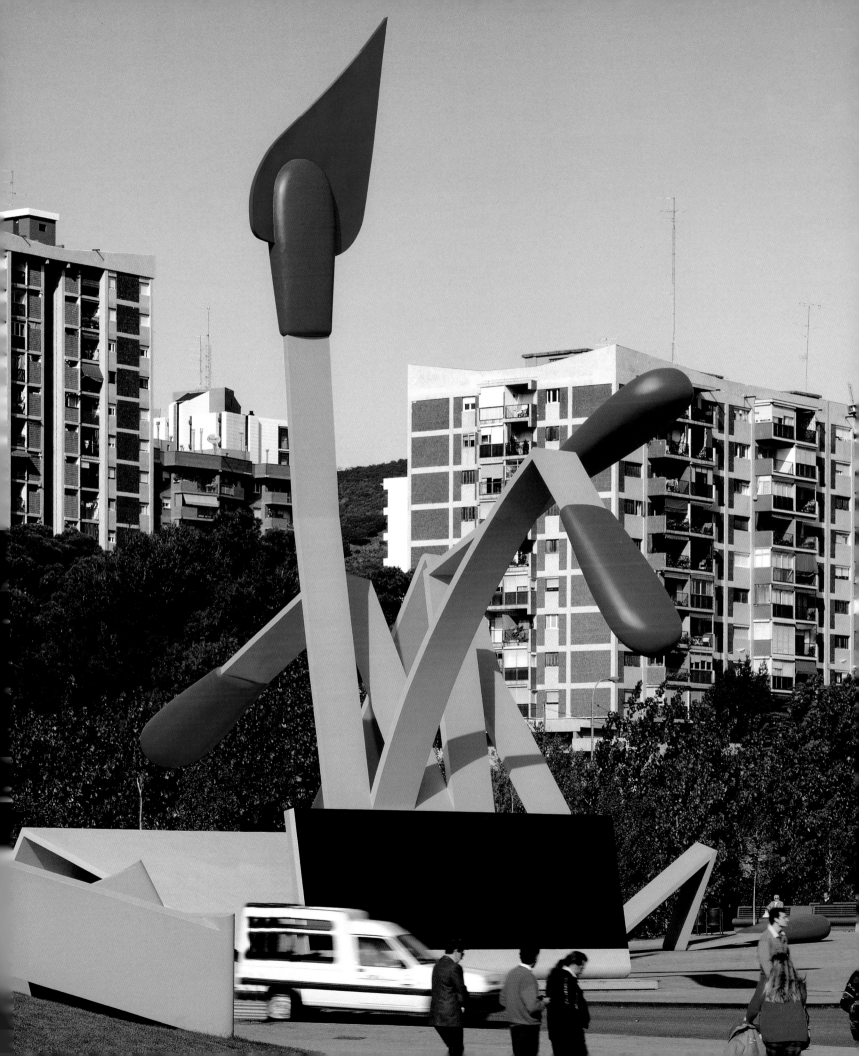

In 1986 we made our first visit to northeastern England, where a program had been started to help revitalize the economically depressed region through commissions of art. We were asked to participate by creating a sculpture for Middlesbrough, once a legendary center of steel fabrication whose kilns were now shut down. The sculpture would be built in Hebburn, helping to provide employment for workers in the abandoned shipyards along the Tyne River.

We felt that a nautical subject might not be inappropriate, especially since the famous explorer Captain Cook was born in the area. After a Lilliputian investigation of the contents of the storied Gulliver's pocket – including a snuff box and comb, neither of which seemed adaptable to sculptural forms – and trying some kind of sailing ship, we settled on a bottle, an object that could function both on land and in water, and is frequently seen washed up on the beaches of the North Sea. A recollection of Edgar Allan Poe's short story *MS. Found in a Bottle* – an account of a sailor trapped in a maelstrom – suggested the element of writing. We realized that the bottle could be made of the writing itself, which would entail the type of fabrication in steel done in the yards and therefore reflect the history of Middlesbrough.

Coosje selected as the text for the outside of the *Bottle of Notes* an excerpt from Captain Cook's *Journals* describing an astronomer's observation aboard the ship: "We had every advantage we could desire in Observing the whole of the passage of the Planet Venus over the Sun's disk." Written out in Claes' broad, angular hand, in off-white, this text formed the exterior of the bottle. In the interior, cutouts of Coosje's delicate script, in blue, spiral vibrantly upward, stopped only by the cylindrical cork, which the perforated exterior has rendered functionless. Character by character, nearly illegible, the swirling script spills out a line of one of the prose poems written by Coosje: "I like to remember seagulls in full flight gliding over the ring of canals." Recalling Amsterdam, the poem links the English shore to that of the European Continent.

BOTTLE OF NOTES, 1993
Steel painted with polyurethane
enamel
30 × 16 × 10 ft.
Central Gardens, Middlesbrough,
England
Commissioned June 1988 by
Middlesbrough Borough Council,
with funding from Northern Arts
and grants from the Arts Council
of Great Britain and other sources
Installed September 1993

*STUDY FOR THE SCRIPTS
OF THE BOTTLE OF
NOTES*, 1987 (DETAIL)
PENCIL
28 $1/2$ × 40 IN.
COLLECTION
CLAES OLDENBURG AND
COOSJE VAN BRUGGEN,
NEW YORK

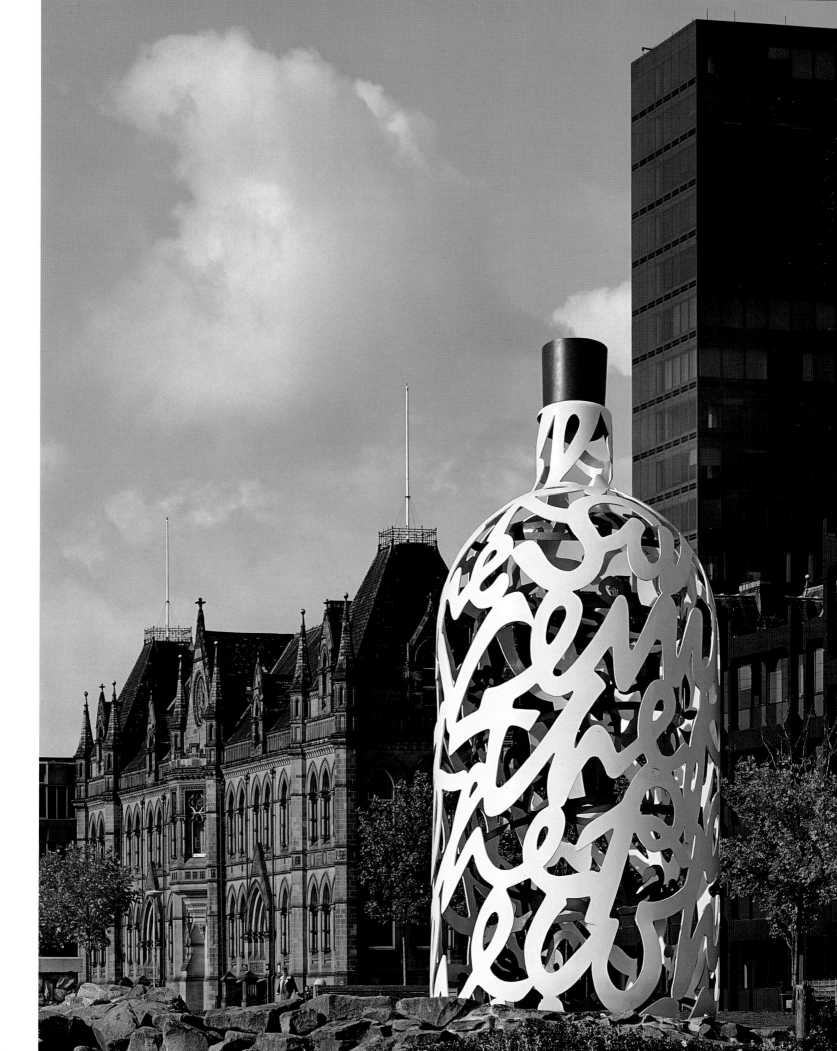

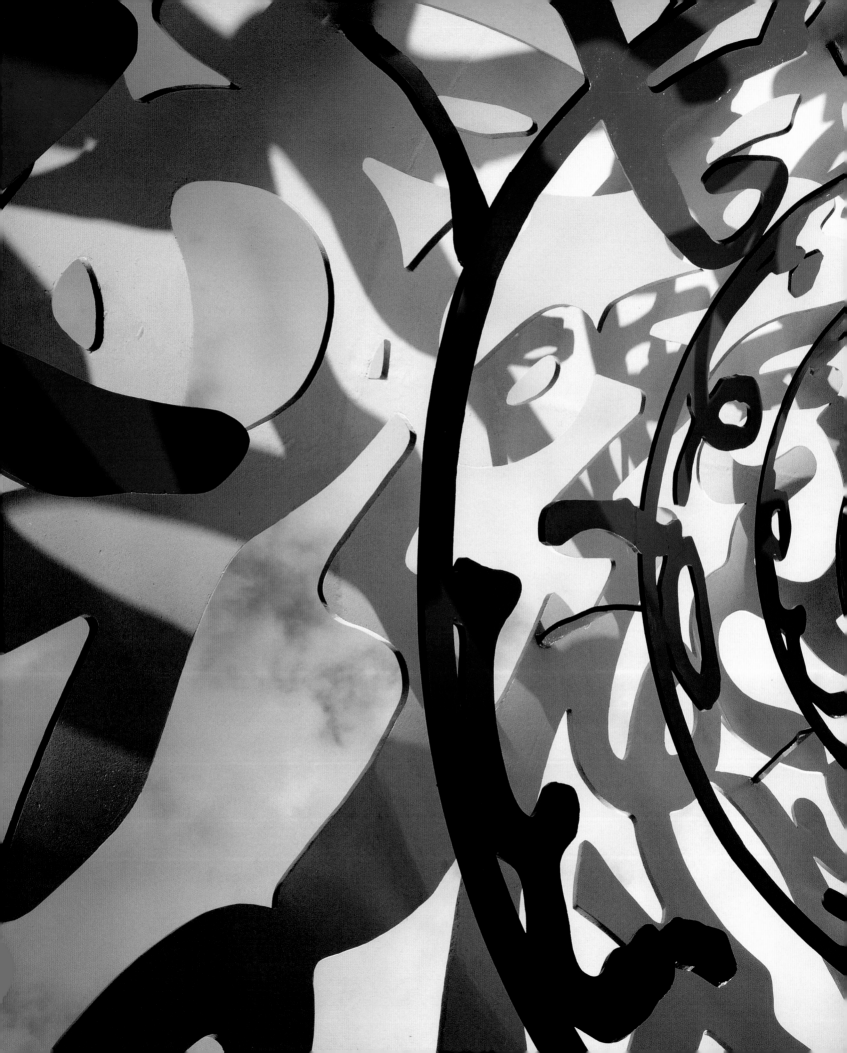

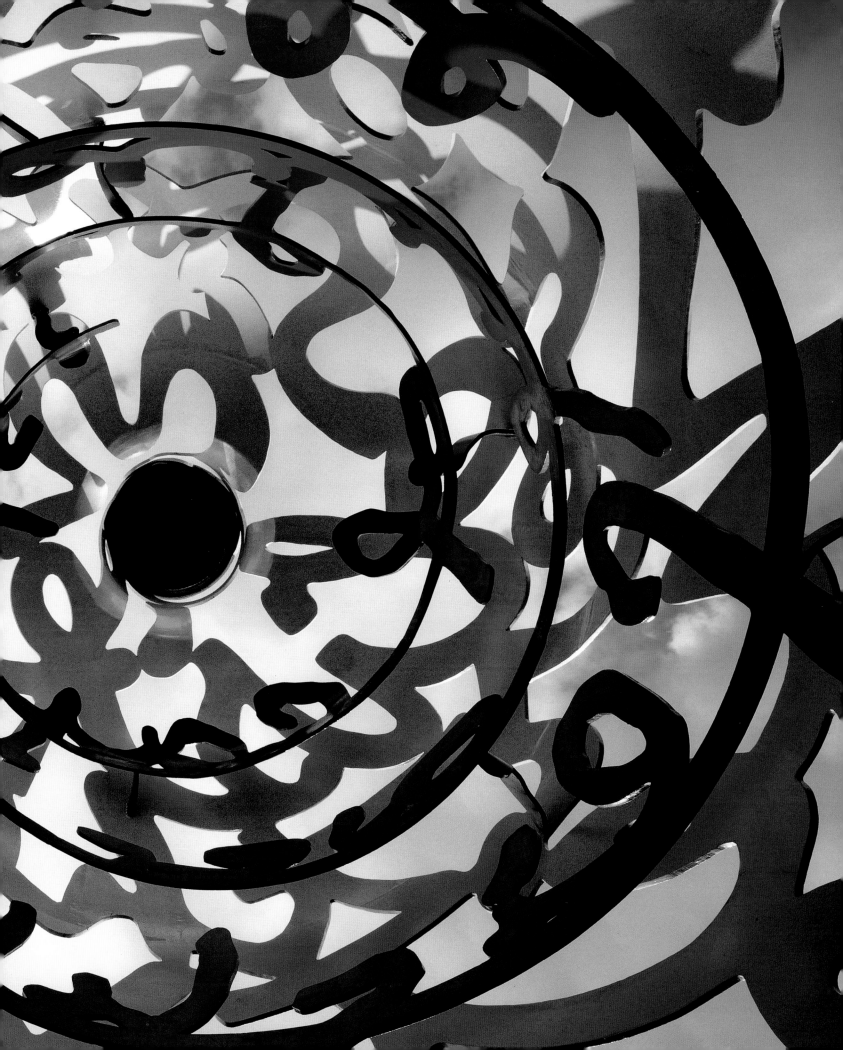

The *Inverted Collar and Tie* was our first large-scale project to be fabricated as a complex "soft" object, a departure from the processes of cutting, forming, or welding metal that we had been using so far. Since we wanted to translate our concept directly, avoiding traditional foundry-casting, we sought out a technique in which laser-cut profiles of foam were enlarged from our model, fastened on top of one another, faired to the exact form, and coated with resin.

The site of the sculpture, in Frankfurt-am-Main, Germany, a cosmopolitan center for business, was in front of a skyscraper. The subject of a tie seemed to fit, for its vertical ends could flow upward, counter to gravity, in soft mimicry of the rigid giant behind it. At the same time, we could assert a nonconformist attitude by having the sculpture appear to be sliding off its pedestal into the street. Moreover, as a traditional part of office attire, its loosening could signify the relief felt by employees at the end of the workday.

The model of the *Inverted Collar and Tie* was created in our New York studio, which has a vista of the Woolworth Building, once the tallest skyscraper in the world. The green "lining" of the tie, triangular in form, was inspired by the distinctive green pyramidal roof of the Woolworth. In its way, the sculpture is an homage to the skyscraper, exported to a rival metropolis.

INVERTED COLLAR AND TIE, 1994
Steel, polymer concrete, fiber-reinforced plastic; painted with polyester gelcoat
39 ft. × 27 ft. 9 in. × 12 ft. 8 in.
Deutsche Zentral-Genossenschaftsbank, Platz der Republik, Frankfurt-am-Main, Germany
Commissioned March 1993 by Deutsche Genossenschaftsbank, Frankfurt-am-Main, Germany
Installed June 1994

NOTEBOOK PAGE:
INVERTED COLLAR AND TIE WITH THE TOP OF THE WOOLWORTH BUILDING, 1991
PENCIL AND WATERCOLOR
5 × 2 3/4 IN. ON SHEET
11 × 8 1/2 IN.
COLLECTION
CLAES OLDENBURG AND COOSJE VAN BRUGGEN,
NEW YORK

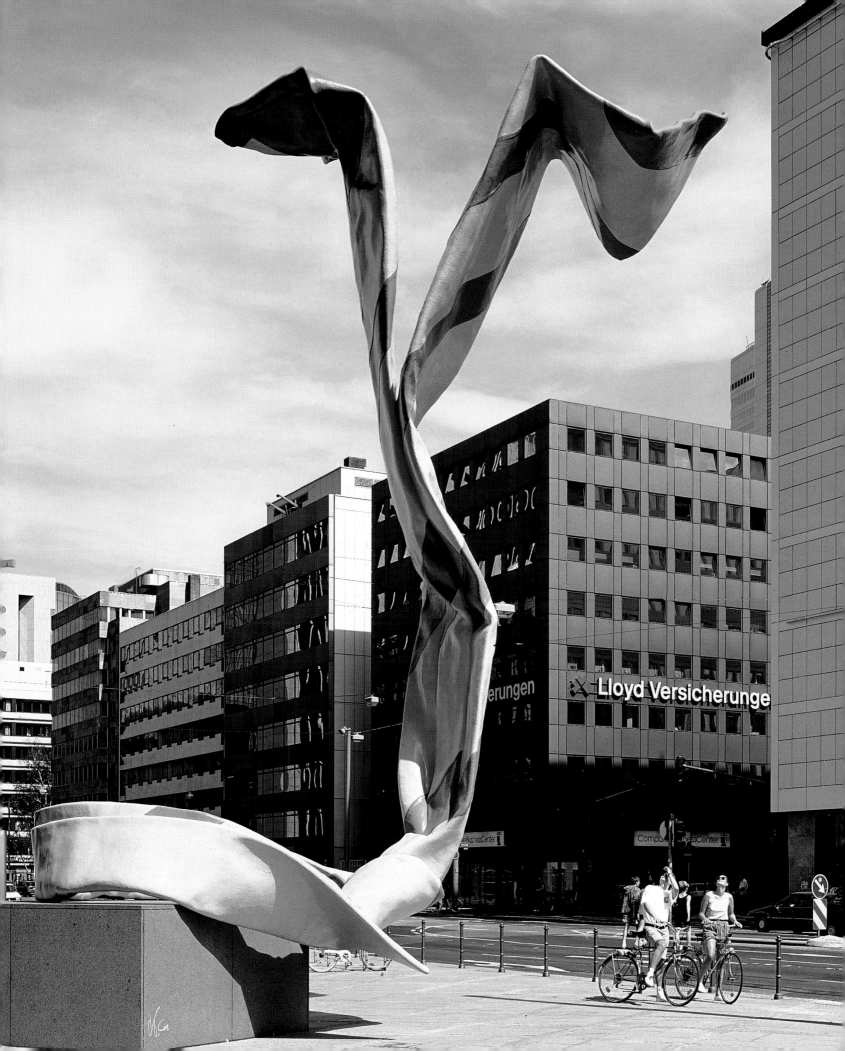

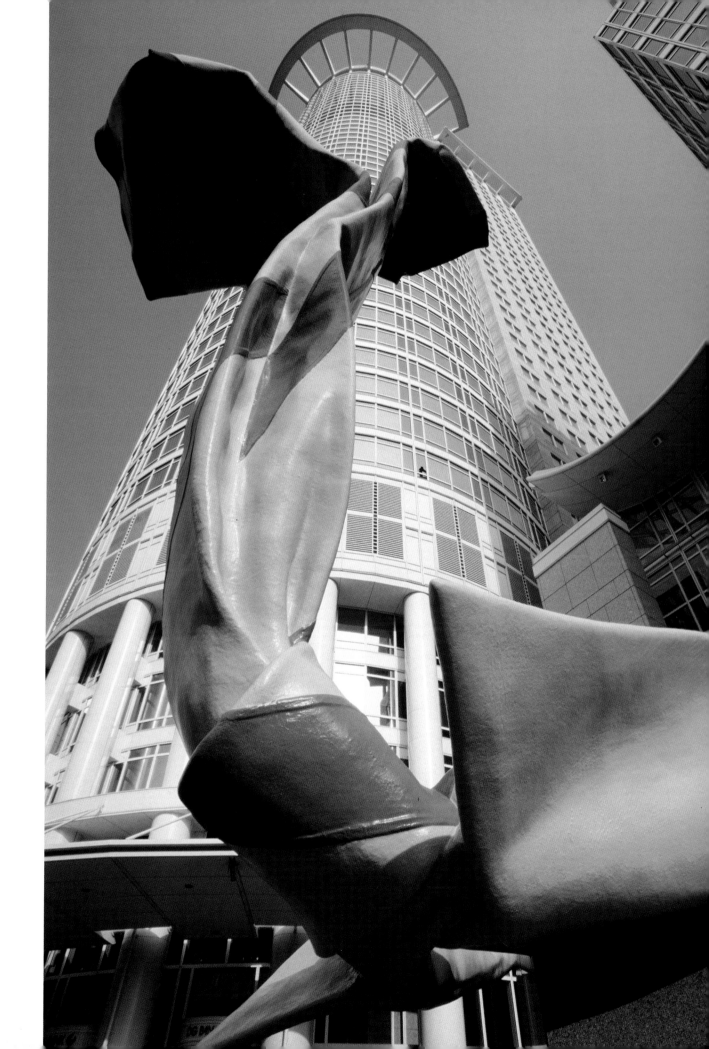

Asked to create a large-scale project integrated into the setting of The Nelson-Atkins Museum of Art, we traveled to Kansas City, Missouri, in 1991, prepared to transform the vast, imposing lawn that stretches before the massive neoclassical facade of the museum. While visiting the galleries soon after our arrival, Coosje was attracted to the headdresses worn by Native Americans in a painting by Frederic Remington, which led to our initial concept of large feathers scattered over the lawn as if dropped from the wing of a huge passing bird. As we proceeded to research the site, we came across an aerial photograph of the museum grounds that reminded us of the layout of a tennis court. We imagined the museum building as a net, with balls distributed over the grounds, but soon determined that the ball shape would be too repetitive. What if, as Coosje suggested, feathers were combined with the ball form to become a shuttlecock, a lyrical object, with the ability to float, spin, fly, and land in many different ways? We proposed three 17-foot-high shuttlecock sculptures for the lawn, each in a different position. Although their placement appeared to be random, the shuttlecocks were actually located at strategic points that would bring the far reaches of the site together. A fourth shuttlecock, in an inverted position reminiscent of a tepee, "landed" on the other side of the museum.

Instantly, a heated controversy arose over the suitability of sculptures based on such a mundane object as a shuttlecock for one of the city's most prestigious sites. Defending the project, the museum's staff offered to give a course in art history, showing that common subjects have a long tradition, to members of the Parks and Recreation Department who had objected to the sculpture, but was rebuffed by the department's president. The controversy was fanned by the city's newspaper, the *Kansas City Star*, with hostile editorials and cartoons. Donors to the project and the museum staff stood firm, however, and the *Shuttlecocks* were installed without incident.

SHUTTLECOCKS, 1994
Aluminum and fiber-reinforced plastic; painted with polyurethane enamel
Four shuttlecocks, each 17 ft. 11 in. high × 15 ft. 1 in. crown diameter and 4 ft. nose cone diameter, sited in different positions on the grounds of the museum
The Nelson-Atkins Museum of Art, Kansas City, Missouri
Commissioned May 1992 by The Nelson-Atkins Museum of Art, Gift Sosland Family
Installed June-July 1994

THE NELSON-ATKINS
MUSEUM OF ART AS
A NET, WITH
SHUTTLECOCKS, 1992
PENCIL AND PASTEL
30 1/8 × 40 IN.
THE NELSON-ATKINS
MUSEUM OF ART, KANSAS
CITY, MISSOURI, GIFT
CLAES OLDENBURG AND
COOSJE VAN BRUGGEN

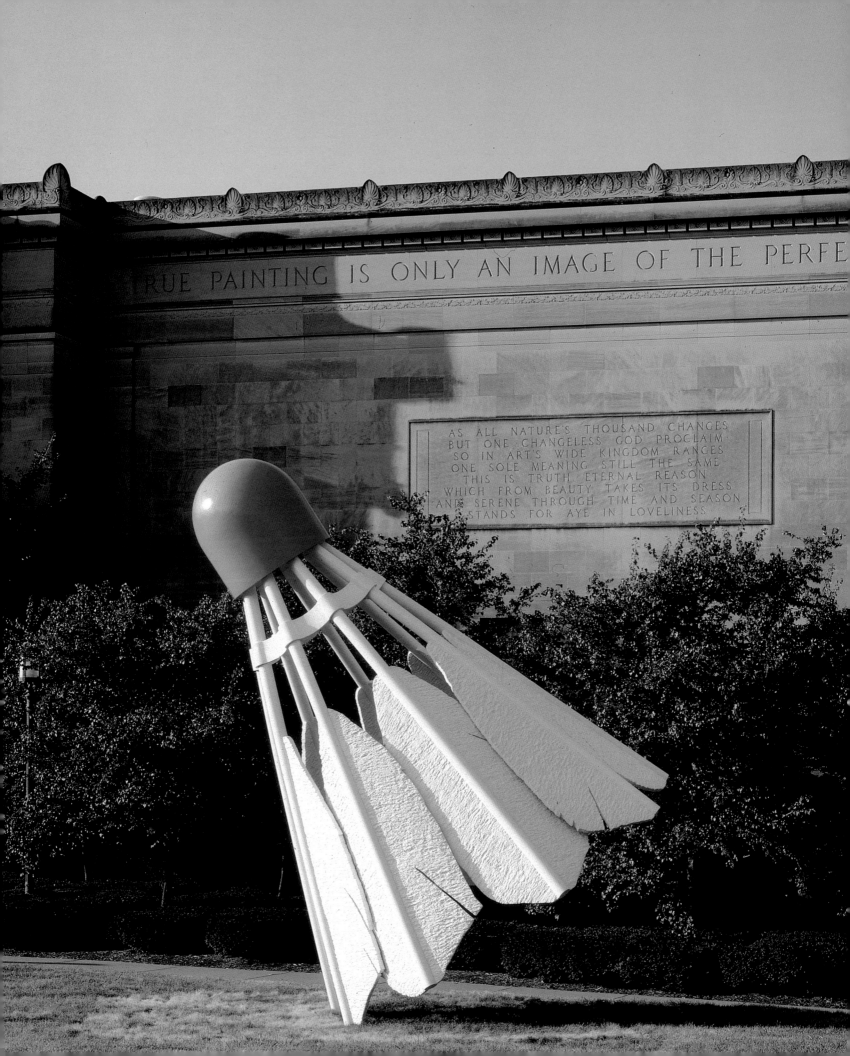

TRUE PAINTING IS ONLY AN IMAGE OF THE PERFE

AS ALL NATURE'S THOUSAND CHANGES
BUT ONE CHANGELESS GOD PROCLAIM
SO IN ART'S WIDE KINGDOM RANGES
ONE SOLE MEANING STILL THE SAME
THIS IS TRUTH ETERNAL REASON
WHICH FROM BEAUTY TAKES ITS DRESS
AND SERENE THROUGH TIME AND SEASON
STANDS FOR AYE IN LOVELINESS

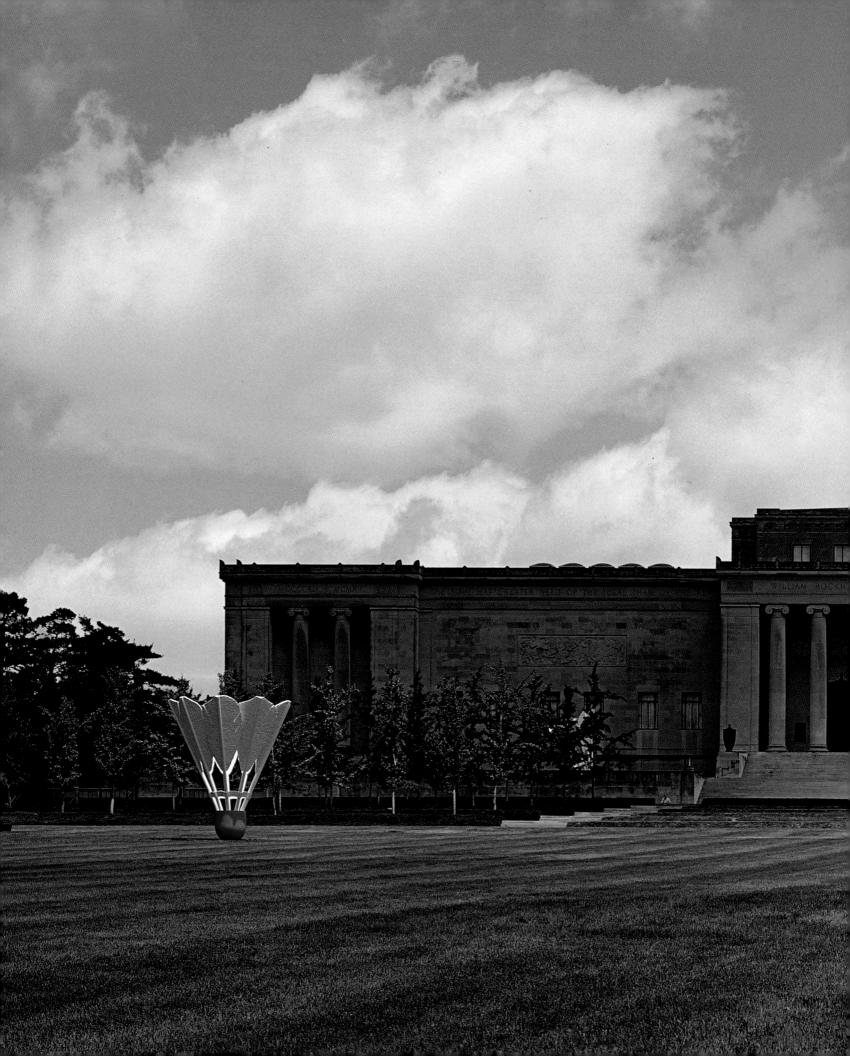

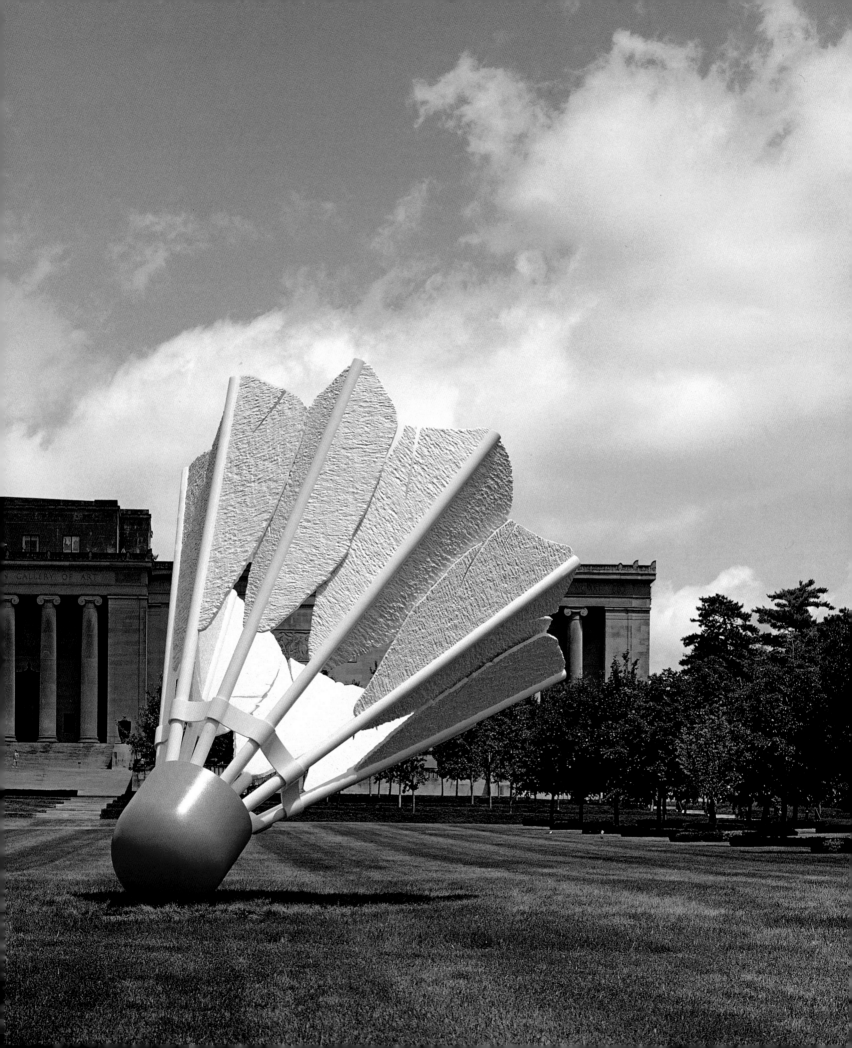

The original *Houseball*, made for the performance *Il Corso del Coltello*, was based on the idea that one could gather all one's possessions in a large cloth and tie them up in the form of a ball that would roll – thereby making any other transportation unnecessary – to its next destination. The house was left behind; its contents became a house in itself. In *Il Corso del Coltello*, the *Houseball*, second only to the *Knife Ship* as a thematic object, was made up of the possessions of Georgia Sandbag, a character played by Coosje, and it accompanied her on a journey across the Alps. Later, Coosje came to see the *Houseball* as a symbol of displaced populations, the ordeal of refugees, and in 1993 she proposed a larger, permanent version of the sculpture for a site in Berlin, near what had been Checkpoint Charlie, the gate of entry in the Berlin Wall. The site was a traffic island, visible from all sides, in the midst of a new business complex. The *Houseball* was approved, but shortly after fabrication of the piece began, the site was returned to members of a family dispossessed during World War II who planned to put a building on it. Quite characteristically, the *Houseball* was again on the move.

The first appearance of the sculpture was in Bonn, in front of the Kunst- und Ausstellungshalle der Bundesrepublik, Deutschland, to which it journeyed by boat from a factory near San Francisco through the Panama Canal and up the Rhine River. The following year the sculpture was shipped – suspended by a 300-foot-long cable attached to a Russian helicopter – from Rostock on the Baltic Sea, and lowered onto a permanent site in Berlin not far from the original location, on the Bethlehemkirch-Platz, in front of a building by Philip Johnson.

HOUSEBALL, 1996
Stainless steel, fiber-reinforced
plastic, jute netting, polyurethane
and polyvinyl chloride foams;
painted with polyester gelcoat
27 ft. 6 in. high × 24 ft. 4 in.
diameter
Bethlehemkirch-Platz,
Mauerstrasse, Berlin
Commissioned 1993 by
Ronald S. Lauder
Installed September 1997
Donated by The Honorable and
Mrs. Ronald S. Lauder to the
Foundation for Art and
Preservation in US Embassies,
Gift to the Nation, 2001

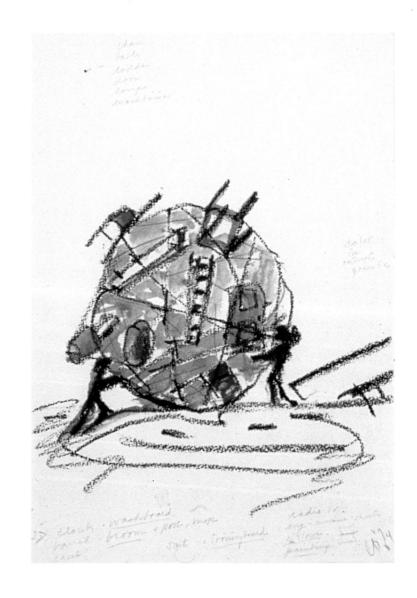

*HOUSEBALL WITH
TWO FIGURES*, 1984
CRAYON, PENCIL,
WATERCOLOR
9 3/8 × 6 5/8 IN.
PRIVATE COLLECTION

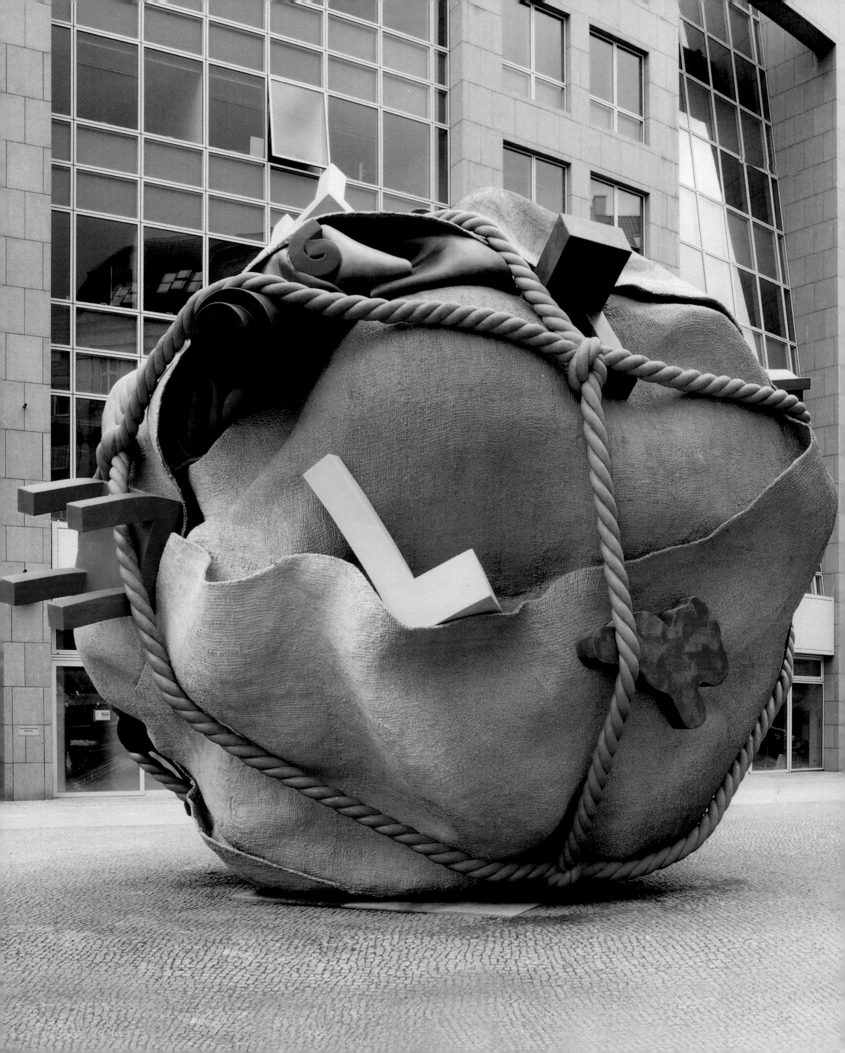

Our first commission in Japan was for the grounds of the Tokyo International Exhibition Center, "Big Sight," a massive complex of triangulated structures with four inverted pyramidal buildings. Located in Ariake, across the Rainbow Bridge from downtown Tokyo, the buildings rise from a plaza and walkways elevated above the proposed site, which was located on a level used by buses and cars accessing the garage under the plaza. The effect was of a sunken garden and, in fact, the original plans for the site, later cancelled, called for the sculpture to be surrounded by trees and plants.

We felt, however, that the sculpture should have a larger presence in relation to the architecture. The subject chosen to accomplish this was a Western-style handsaw. Coosje found the saw appropriate to the cross-cut effect of the layered construction surrounding the site. Also, the teeth of the saw would continue the triangular motif of the buildings.

We imagined the *Saw, Sawing* rising from its point of insertion into the ground high enough over the plaza to display the handle's curved organic form. Painted a vivid red with blue screw-heads, the handle would provide a sharp contrast to the pervasive geometry and gray tones of the Exhibition Center. Since the Western saw is not a tool used in Japan, we hoped that this common object, detached from its function, would become mysterious in its foreign context, subject to surprising new interpretations of its identity.

Saw, Sawing, 1996
Epoxy resin, fiber-reinforced plastic,
polyurethane and polyvinyl chloride
foams; painted with polyester
gelcoat, steel
50 ft. 8 in. × 4 ft. 9 in. × 40 ft.
Tokyo International Exhibition
Center, Big Sight, Tokyo, Japan
Commissioned January 1995 by the
Tokyo Metropolitan Government
Installed March 1996

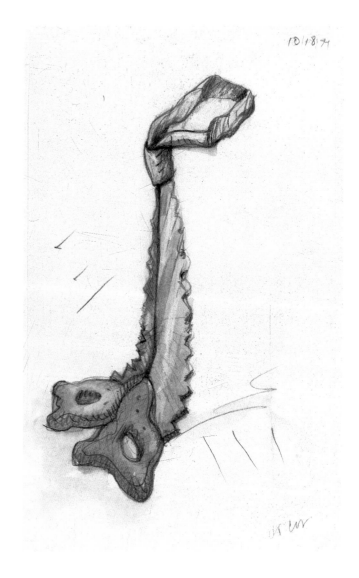

NOTEBOOK PAGE:
SAW-TIE, 1994
PENCIL AND WATERCOLOR
8 9/16 × 5 7/16 IN. ON SHEET
11 1/16 × 8 1/2 IN.
WHITNEY MUSEUM OF
AMERICAN ART, NEW YORK,
GIFT CLAES OLDENBURG
AND COOSJE VAN BRUGGEN

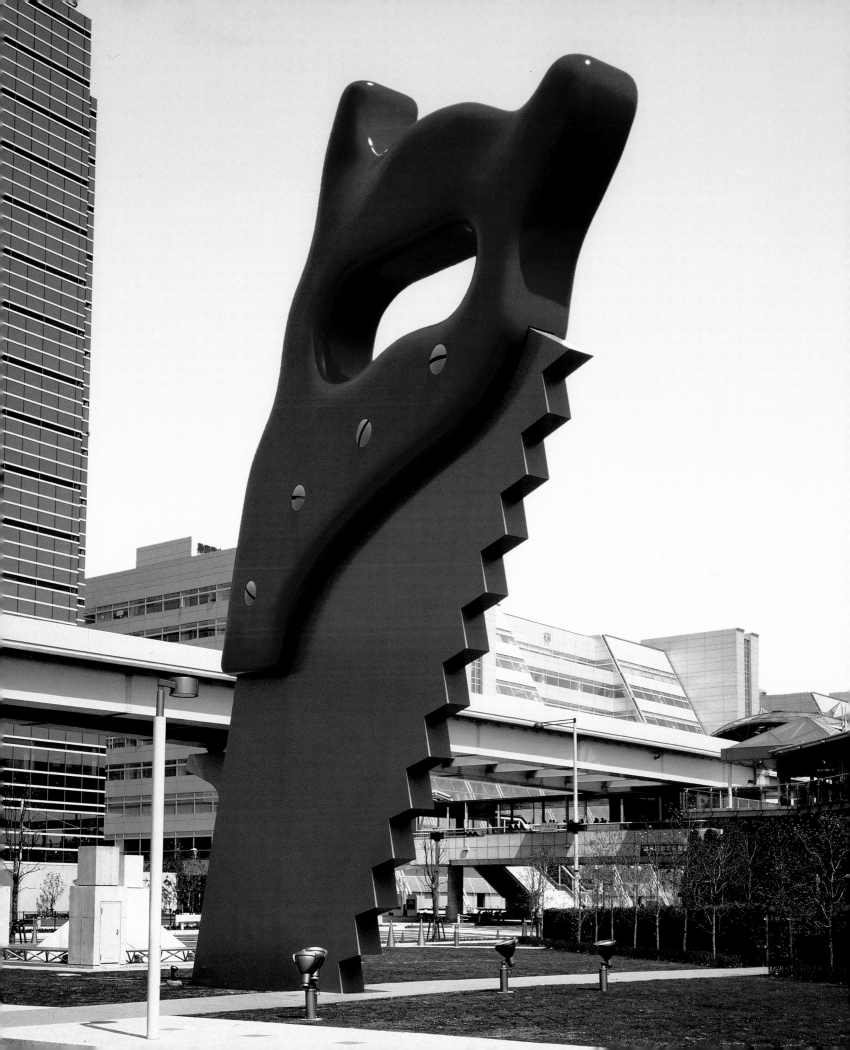

In preparation for a commission by the Sheldon Memorial Art Gallery at the University of Nebraska, we drove from Kansas City, Missouri, through the Missouri River Valley to Lincoln, the capital and location of the university, while setting down our observations along the way. Coosje's notations took the form of lyrical phrases, such as "falcons atop flagpoles," "fields of corn – one ear per stalk – in wayward winds swing," "crows on the butte," and "buffalo peas." Claes mostly wrote down names of things, for example, "barbed wire," "goose," "hoop," and "roller skate." Only when we were back in the studio in New York did we realize that a sculpture about the process of collecting observations could be the perfect subject for a university site.

For some time, as part of the process of making sculptures out of fragmented objects, or "flotsam," as Coosje called them, we had been collecting Claes' discarded spiral-bound pocket notebooks. His habit of tearing them in half after removing the pages he wanted to save resulted in a sculptural form that had already been the subject of a number of table-scale works. It was apparent to us that the torn notebook, with its twisted spiral binding and curled fragments of pages, also had the potential for a dynamic curvilinear outdoor work in large scale.

The *Torn Notebook*, as executed, appears as if it had been tossed onto the lawn that runs along the border between the campus and the city. Barely touching the ground, the sculpture seems to rise like a huge bird spreading its wings. The "pages," formed out of rolled aluminum, look "torn" roughly in half. Selections from our earlier notations are water-cut through the metal, creating a continuously changing interplay of light and shadow. Coosje's script is on the top half of the "pages" and Claes' on the bottom, in reverse relation to each other, so that one set of script will always be read backward. Loose "page" fragments are strewn over the lawn, as if blown by the wind.

Torn Notebook, 1996
Stainless steel and aluminum;
painted with polyurethane enamel,
steel
Three elements; notebook: 21 ft. 10
in. × 23 ft. × 26 ft. 1 in.; page (1): 10 ft.
× 14 ft. 1 in. × 7 ft. 1 in.; page (2): 11
ft. 8 in. × 8 ft. 7 in. × 8 ft. 2 in.
Madden Garden, University of
Nebraska, Lincoln
Commissioned March 1995 by
Sheldon Memorial Art Gallery,
University of Nebraska
Installed August 1996

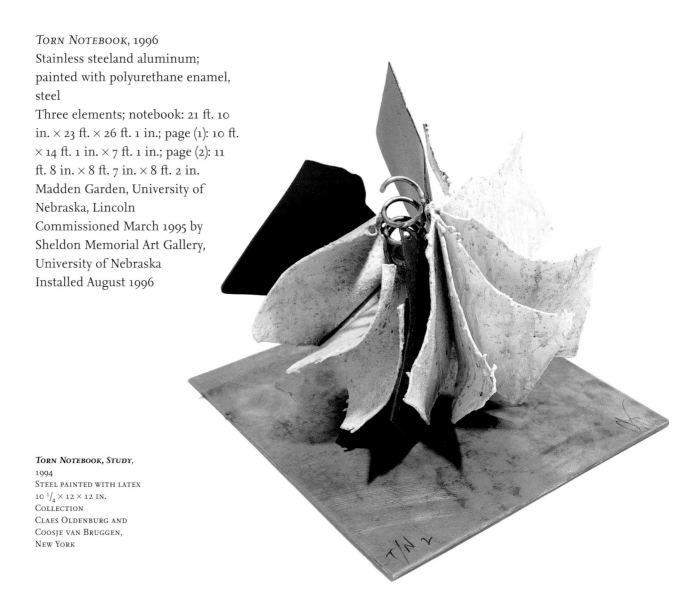

Torn Notebook, Study,
1994
Steel painted with latex
10 1/4 × 12 × 12 in.
Collection
Claes Oldenburg and
Coosje van Bruggen,
New York

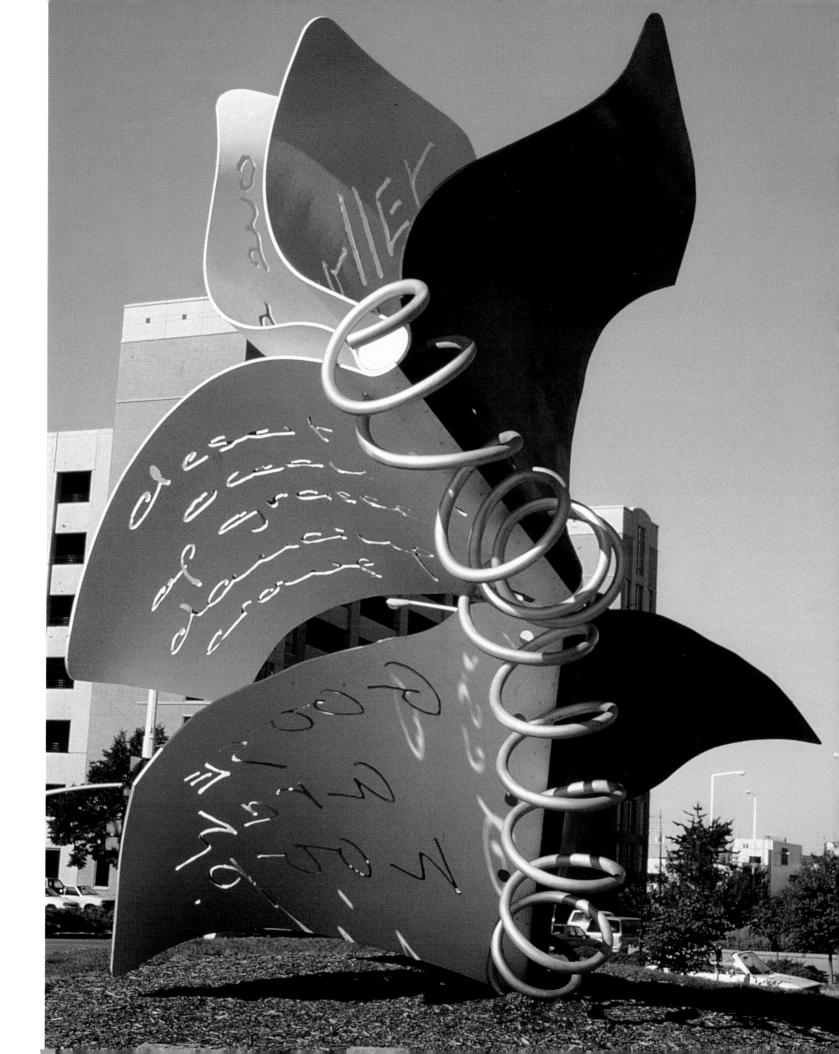

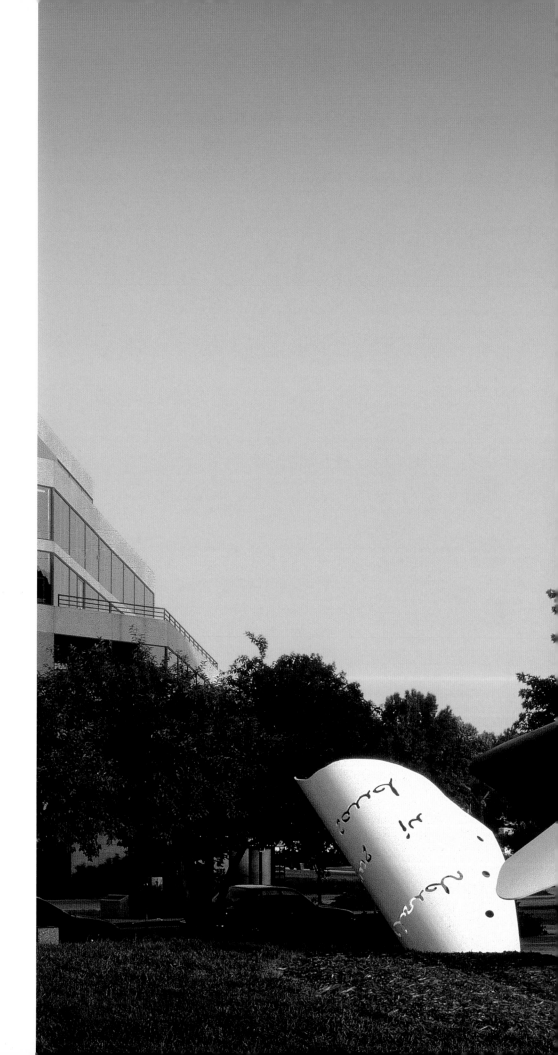

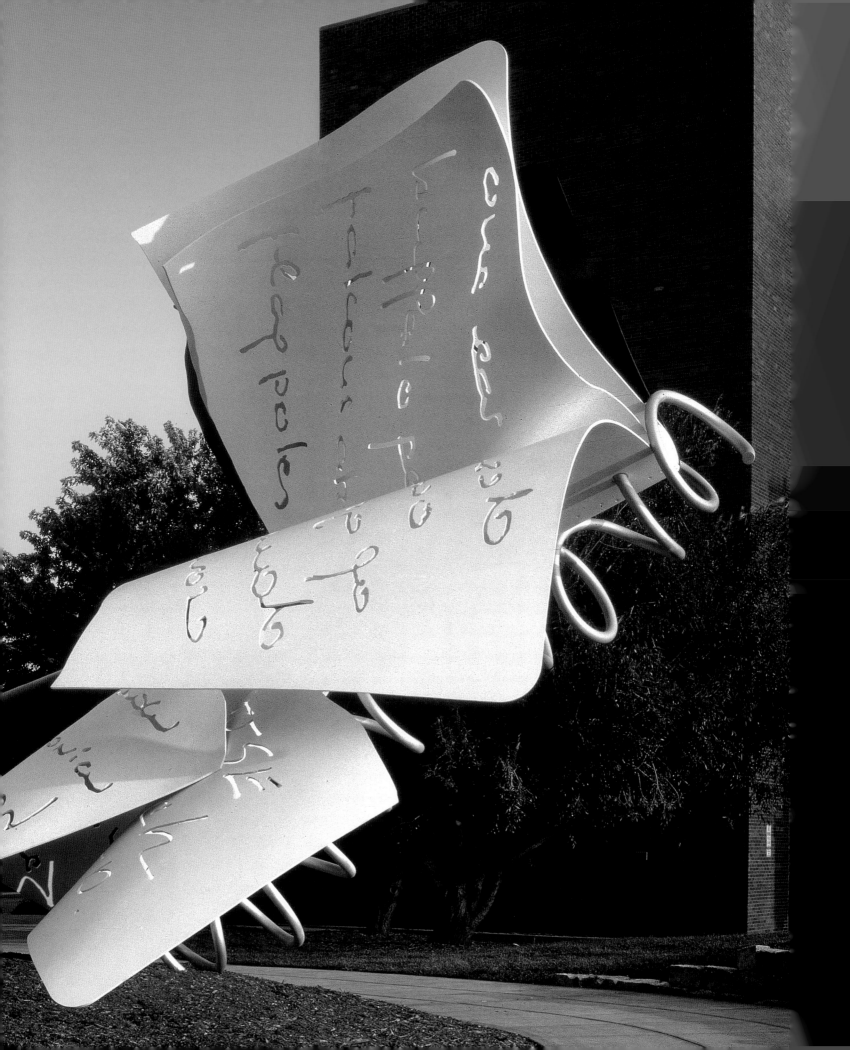

After *Il Corso del Coltello*, we did not engage the Venetian landscape again until the summer of 1999, when we returned for an exhibition at the Museo Correr. The museum, situated in a palace that was originally built to welcome Napoleon, faces the expansive Piazza San Marco, the center of city activity. Asked to create a "monument" to set off the exhibition against the repetitive columnar architecture of the square, we thought about some form of banner, which, by association, became a "tail," probably because of a recent series of drawings of *Shuttlecock/Sphinxes*, in which the tail is a prominent graphic element.

Since the site was Venice, the tail became that of its symbol, the lion – such as the one on top of a column at the opposite end of the Piazza. The "lion" at our end would appear to be inside the museum, with only its tail hanging out of a second-floor window.

The *Lion's Tail*, a little over 18 feet long, was constructed out of hollow, curved segments of painted aluminum, culminating in a cluster of hundreds of canvas strips in different shades of brown and ocher. To shape the strips we engaged a professional coiffeur, who trimmed them into a brushy tuft, designed to dangle and occasionally sway in the breeze over the heads of tourists and other passersby.

LION'S TAIL, 1999
Stainless steel, aluminum, wood,
fiber-reinforced plastic, expanded
polystyrene; painted with
polyurethane enamel, nylon
18 ft. 6 in. × 15 ft. × 4 ft.
Musei Civici Veneziani, Venice, Italy,
Gift Claes Oldenburg and
Coosje van Bruggen

STUDY FOR THE LION'S TAIL, MUSEO CORRER, 1998
COLORED PENCIL AND PENCIL
13 × 12 $\frac{1}{2}$ IN.
COLLECTION
CLAES OLDENBURG AND
COOSJE VAN BRUGGEN,
NEW YORK

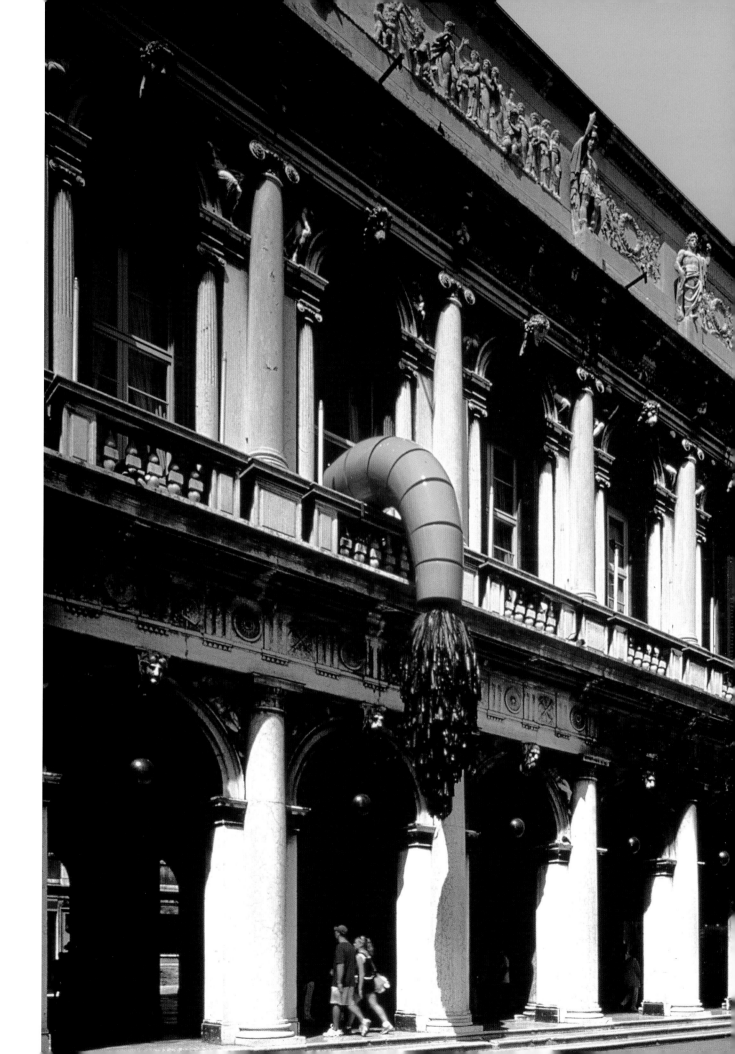

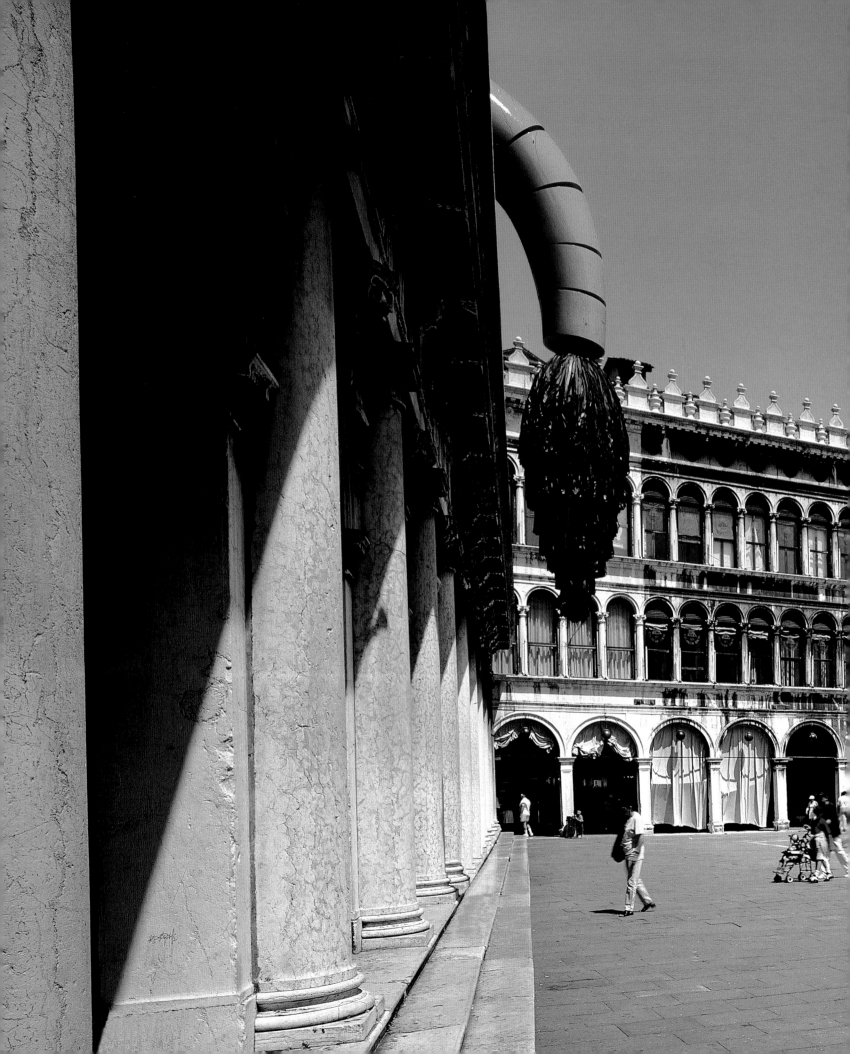

AGO, FILO E NODO (NEEDLE, THREAD, AND KNOT), 2000

During a visit to the studio of the architect Gae Aulenti in Milan, we walked with her to the Piazzale Cadorna, a busy square in front of the Stazione Nord railroad station, which she was in the process of redesigning. It was a rainy afternoon. Suddenly Aulenti took up a position on the square, holding her umbrella over her head to indicate where she thought a sculpture by us might best be placed. Its footprint clearly had to be small, as the site was not far from the station's entrance.

Our concept began with the metaphor of a train as a needle and thread, its insertion into fabric compared to the train entering an underground tunnel. Trying this image on the site, we saw that the needle could serve as the monolithic shape necessitated by the suggested location, while thread coiled around the needle would provide expansive, active contours in space, flowing down from the top of the sculpture. Contributing to the rightness of the concept was not only the subject's reference to the fashion industry, for which Milan is known. The needle and thread might be seen as a paraphrase, in contemporary terms, of the city's civic emblem – a serpent coiled around a sword.

Fabricated of gleaming stainless steel, the needle's eye engages the open dome of the nearby Sforza Castle. The needle is placed as if having just emerged from a surface and about to plunge into it again. In order to suggest the passage of the thread underground, we added a second part to the sculpture in the form of a knot at some distance from the needle to mark the imagined original point of entry. *Ago, Filo e Nodo* follows its own trajectory, independent of the Piazzale's overall design. The knot, about to be pulled taut, is situated, as if by chance, in one of the pools of water, oblivious to the grid of tiny spraying jets.

Ago, Filo e Nodo (Needle, Thread, and Knot), 2000
Brushed stainless steel and fiber-reinforced plastic; painted with polyester gelcoat and polyurethane enamel
Two elements; needle and thread: 59 ft. high × 50 $^3/_8$ in. diameter; knot: 19 ft. long × 19 $^{11}/_{16}$ in. diameter
Piazzale Cadorna, Milan, Italy
Commissioned by
Comune di Milano (City of Milan)
Installed January 2000

SKETCHBOOK PAGE:
SCULPTURE IN THE
FORM OF A NEEDLE AND
THREAD FOR PIAZZALE
CADORNA, MILAN, ITALY,
1998
PENCIL AND WATERCOLOR
7 $^5/_8$ × 5 $^5/_{16}$ IN.
COLLECTION
CLAES OLDENBURG AND
COOSJE VAN BRUGGEN,
NEW YORK

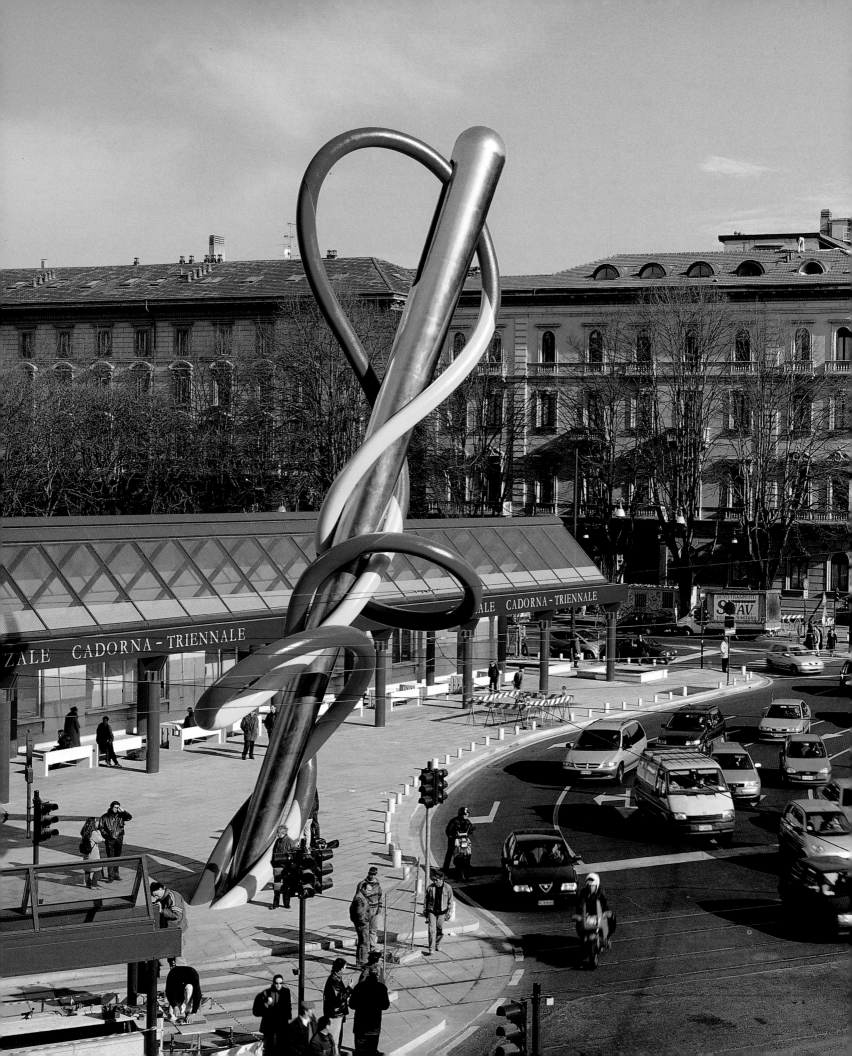

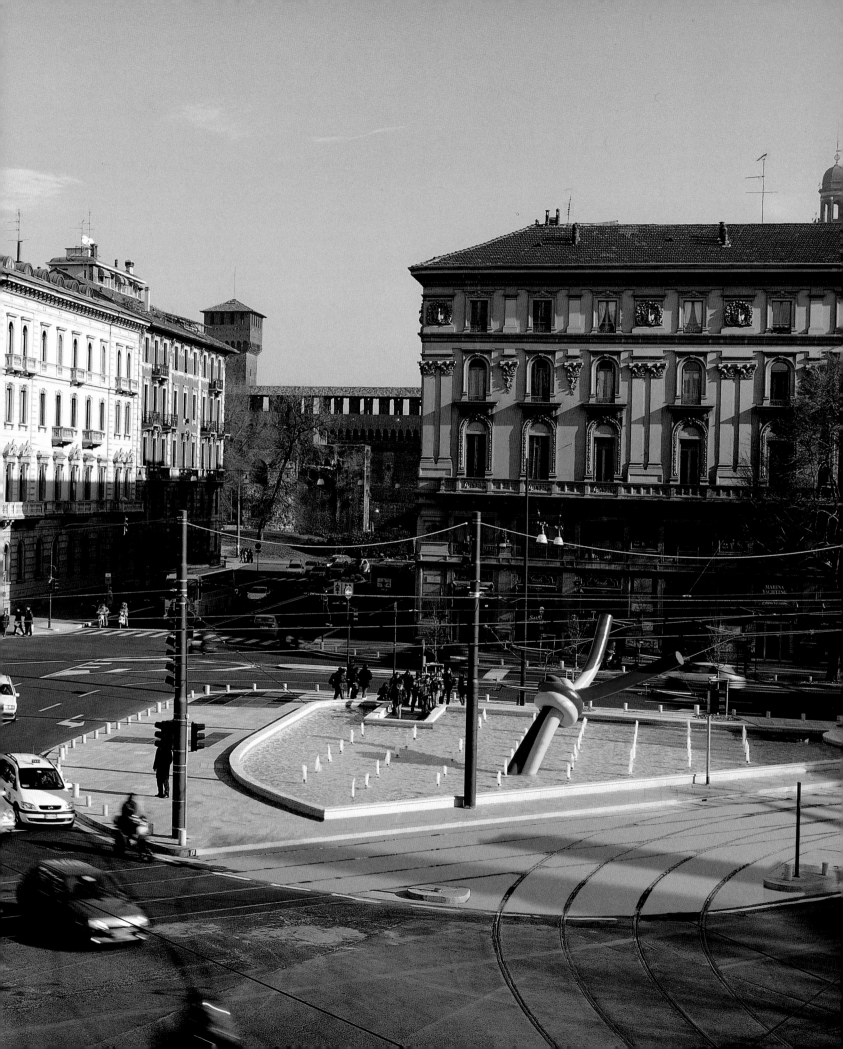

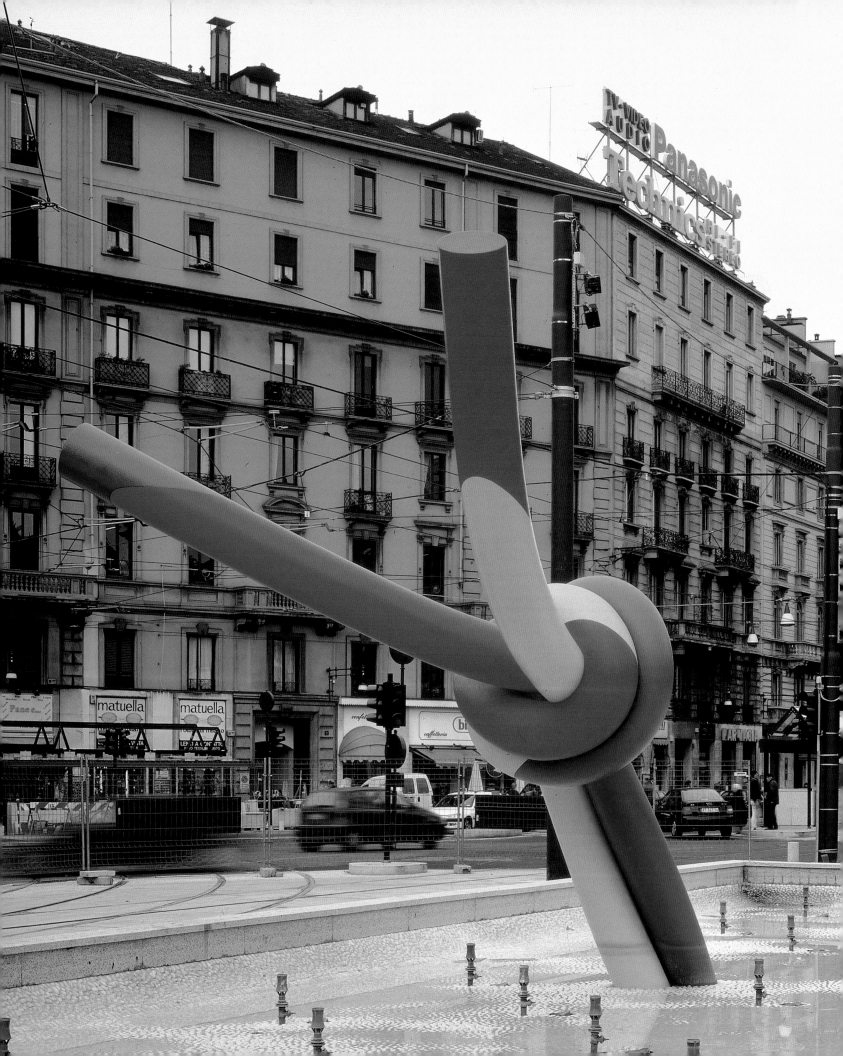

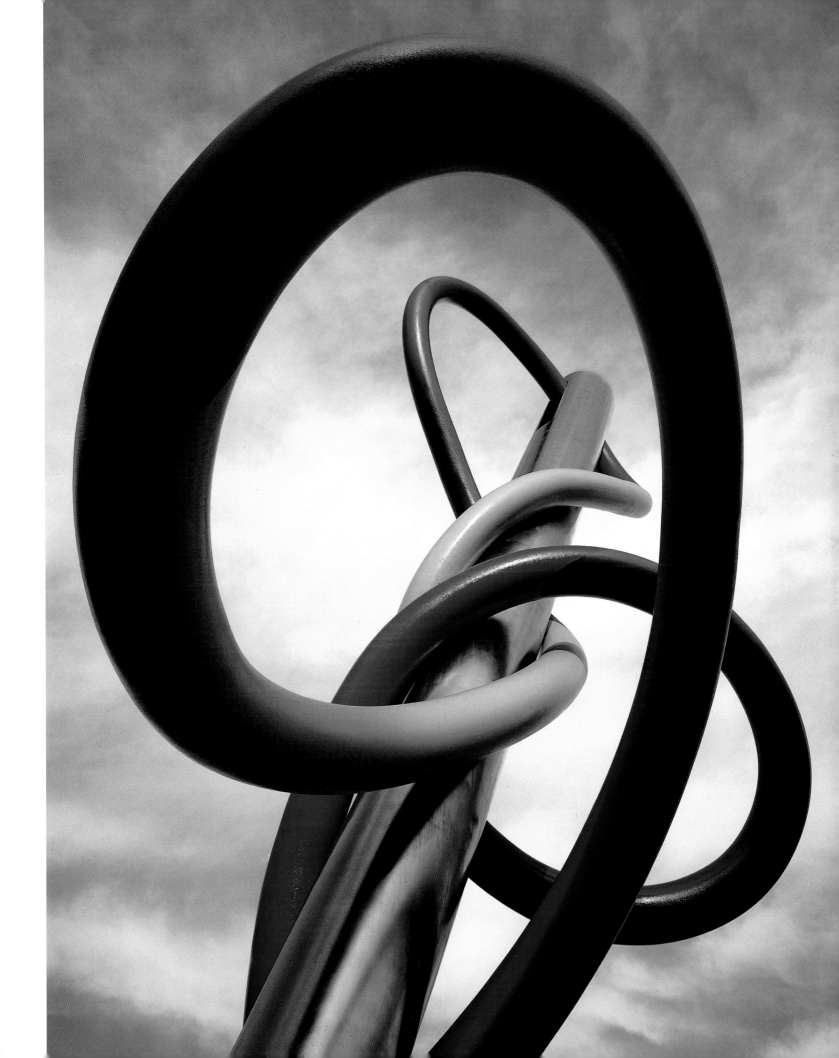

As part of a celebration of its achievements at the brink of the new millennium, the city of Eindhoven, in the south of the Netherlands, had commissioned us to create what its officials referred to as an "eye-catcher." Rebuilt after heavy bombing attacks during World War II, the city had grown into an important commercial center of the European Union by the end of the twentieth century. Its renowned contemporary art collection, the Van Abbemuseum, was adding a new wing and the city was planning to host the 2000 European Championship soccer tournament.

We chose as our site the median of the Kennedylaan, the main boulevard leading into the city center, facing a busy intersection in front of a high-rise business complex. The grass-covered space was planted with trees and was wide enough to serve as a park, although it was surrounded by the continuous flow of traffic. The site is flanked on one side by a prominent bank and on the other by a lively university campus, a location that projected maximum civic energy.

In search of a subject to embody the ubiquitous movement characteristic of the surroundings, we focused on some form of sport or game. Soccer was too obvious a choice and not suited to the limitations of the space. Instead we selected bowling, which had the advantage that the "players" in the strike, the game's climactic event, were all objects, and therefore suitable to our type of sculpture. The game also fit the location because the movements of inbound vehicles on the Kennedylaan could be equated with the imagined roll of a ball in a bowling lane. ("Laan," in fact, is the Dutch word for "lane.")

For *Flying Pins* Coosje chose as our image the immediate aftermath of the strike, when the ball drops out of sight while the pins are still flying. The simultaneous upward and downward movement was emphasized by having the ball and two of the pins partially buried in the ground. The uppermost pins were positioned horizontally to convey the greatest sensation of speed. Because the weather in the Netherlands is often gloomy, especially during long winters, Coosje selected an intense yellow color for the pins, inspired by the daffodils that emerge in the spring to light up the site.

Flying Pins, 2000
Fiber-reinforced plastic and
polyvinyl chloride foam; painted
with polyester gelcoat and
polyurethane enamel, steel
Eleven elements in an area
approximately 123 ft. long × 65 ft.
7 in. wide; ten pins, each: 24 ft. 7 in.
high × 7 ft. 7 in. widest diameter;
ball: 9 ft. 2 in. high × 22 ft. diameter
Intersection of John F. Kennedylaan
and Fellenoord, Eindhoven, the
Netherlands
Commissioned by Gemeente
Eindhoven Dienst Maatschappelijke
en Culturele Zaken and
Van Abbemuseum, Eindhoven
Installed April-May 2000

Sketchbook Page:
Study for the Flying
Pins, 1998
Pencil and
watercolor
5 ¹/₂ × 8 ¹/₄ in.
Collection
Claes Oldenburg and
Coosje van Bruggen,
New York

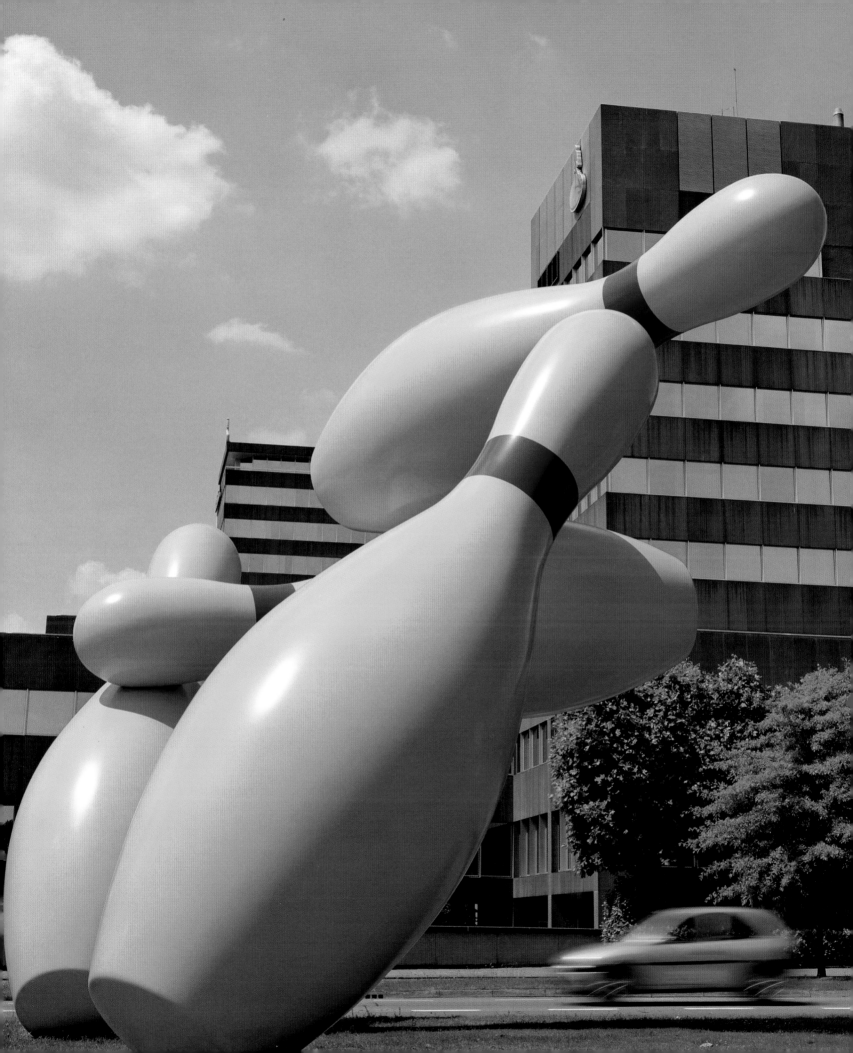

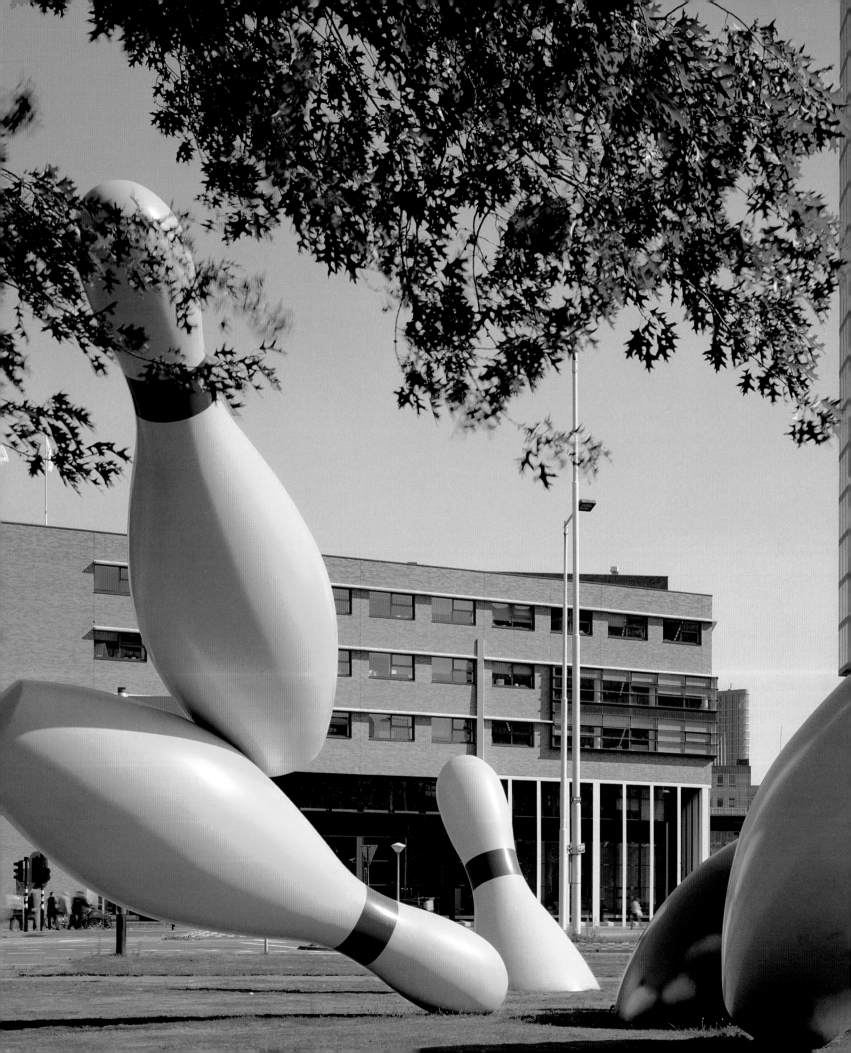

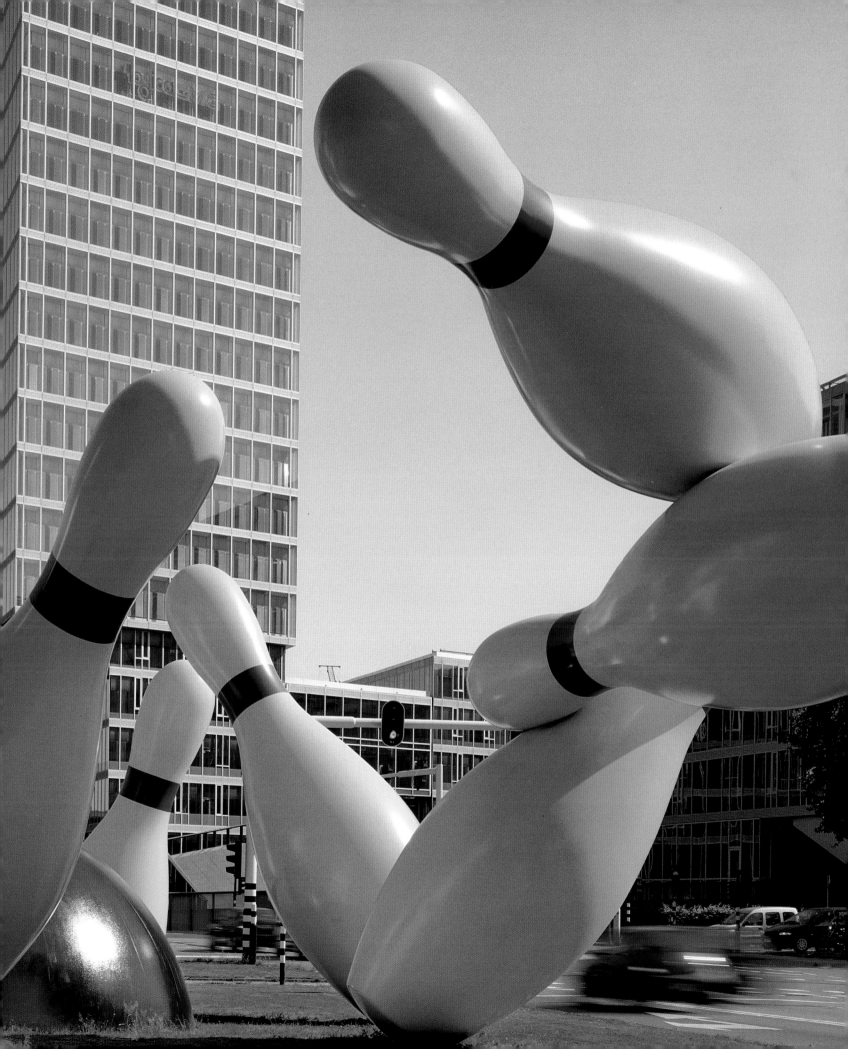

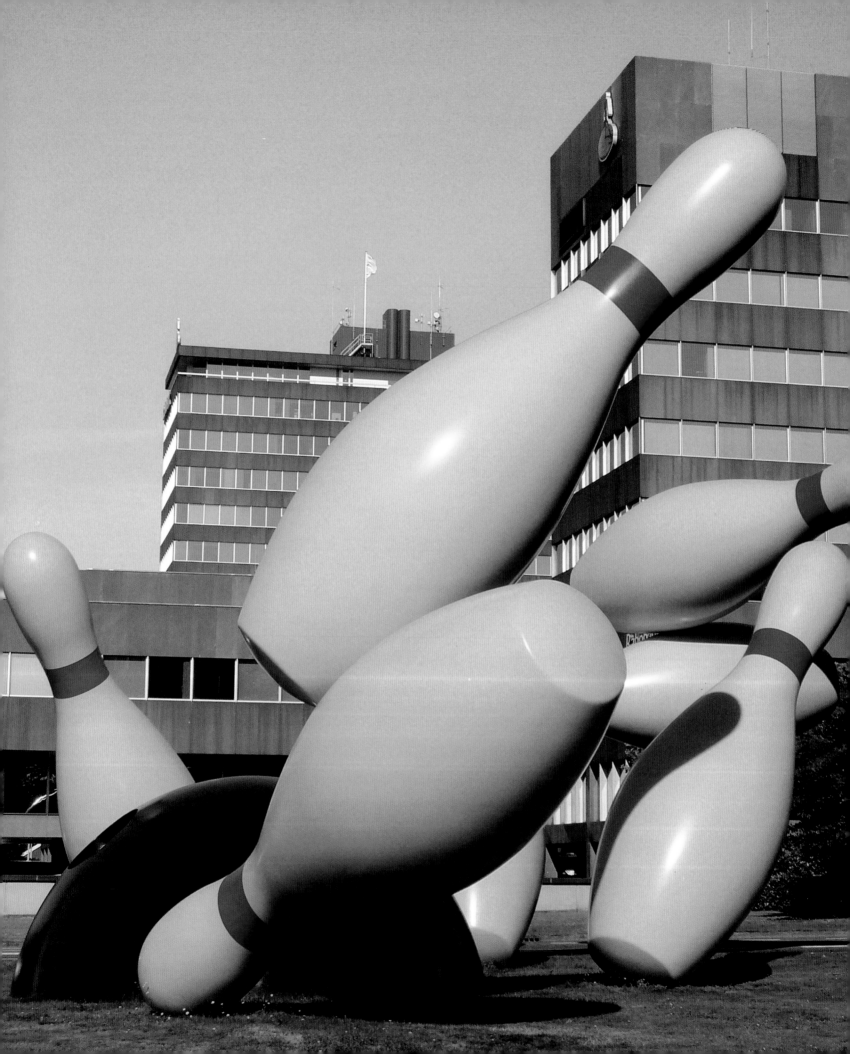

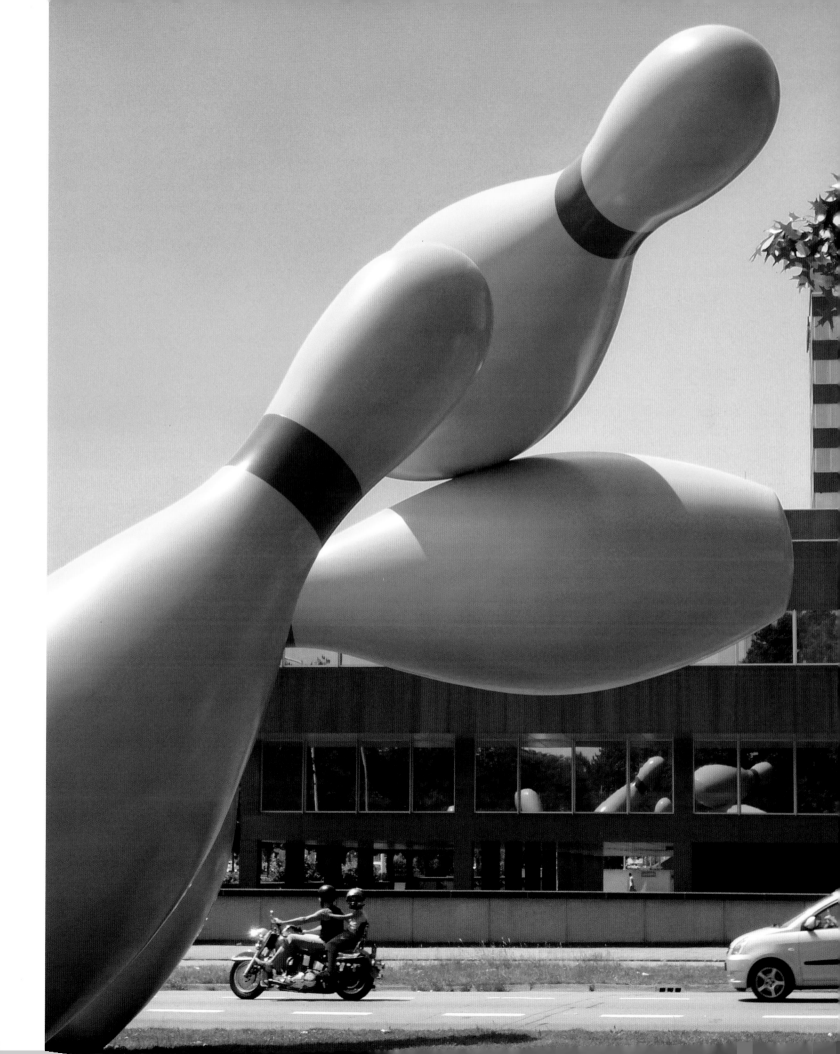

Our commission for Cologne did not come from the city itself but from the owners of a new shopping mall on the corner of the busy Neumarkt Square – the kind of commercial site that is unusual for us but which we found appropriate here, given the city's ancient history as a crossroads of trade. At liberty to choose the exact location for the work, we looked for an outdoor site and, because the streets of Cologne are so congested, decided to place our sculpture on the roof of the mall. So placed, it could also become part of the architecture around it.

The city's skyline is filled with conical church spires, dominated by the enormous, brooding Dom Cathedral. At street level this motif is turned upside down in the form of large multicolored plastic cones that appear in front of ice cream parlors, which are very popular in Cologne. The ice cream cone as a subject was irresistible to us, especially as we detected the word "cone" concealed in the letters of the city's name.

Our proposal called for a giant ice cream cone dropped upside down on one of the top corners of the building, tilted forward, so that melting ice cream would appear to drip over the windows. In her presentation of the work, Coosje referred to the *Dropped Cone* as both a "cornucopia of consumerism" and a "sign of transience."

The sculpture's tilt differentiated it from the surrounding church steeples, while the emphasis on the cone form separated it from the advertising variations found in the street. We applied a diamond pattern in relief, giving the cone an architectural character. The "ice cream" mass, its shape a convincing reflection of the impact of the "dropping" of the cone, resulted from lengthy experimentation with a clay model. While our presentation drawing for the sculpture had shown several colorful flavors, Coosje reduced the final choice to a single luminous vanilla.

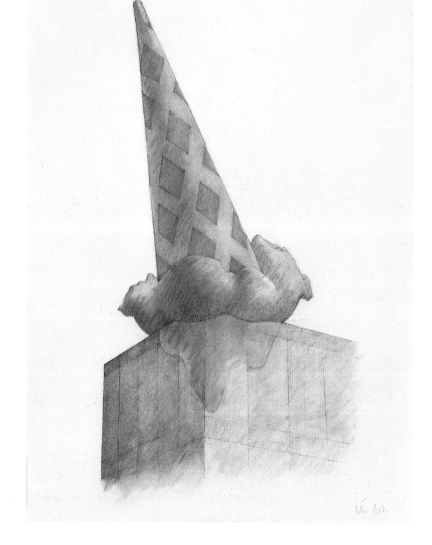

DROPPED CONE, 2001
Stainless steel, fiber-reinforced
plastic, balsa wood; painted with
polyester gelcoat, galvanized steel
39 ft. 10 in. high × 19 ft. diameter;
height above building: 32 ft. 10 in.
Neumarkt Galerie, Cologne,
Germany
Commissioned by
Neumarkt Galerie
Installed March 2001

PROPOSAL FOR A
SCULPTURE IN THE FORM
OF A DROPPED CONE,
FOR NEUMARKT
GALERIE, COLOGNE, 1998
PENCIL, COLORED PENCIL,
PASTEL
25 3/4 × 18 7/16 IN.
COLLECTION
CLAES OLDENBURG AND
COOSJE VAN BRUGGEN,
NEW YORK

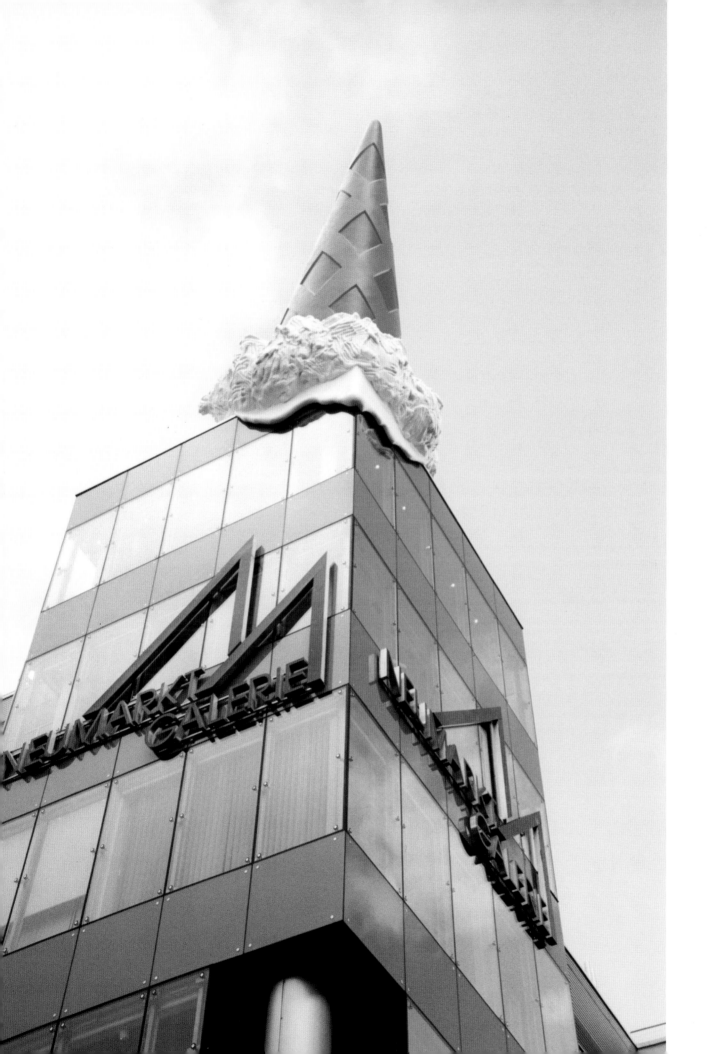

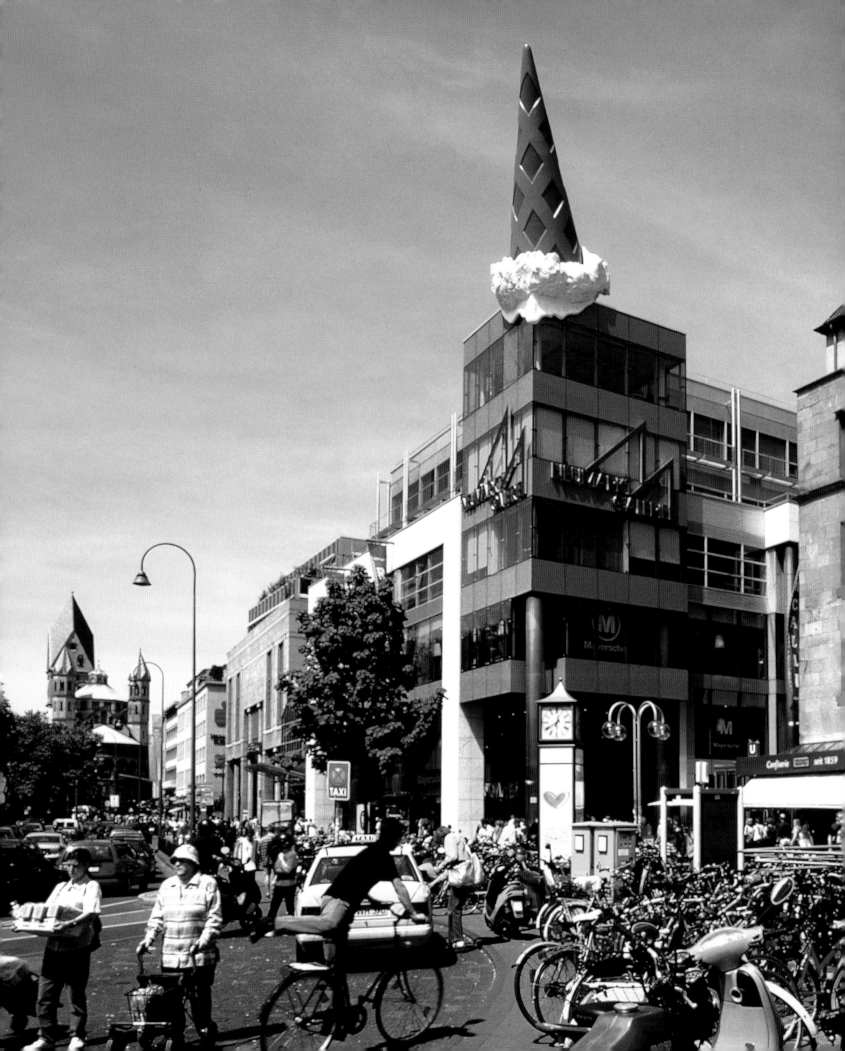

Inspired by San Francisco's reputation as the home port of Eros, we began our project for a small park on the Embarcadero along San Francisco Bay by trying out the subject of Cupid's stereotypical bow and arrow. The first sketches were made of the subject with the bowstring drawn back, poised on the feathers of the arrow, which pointed up to the sky. When Coosje found this position too stiff and literal, she suggested turning the image upside down: the arrow and the central part of the bow could be buried in the ground, and the tail feathers, usually downplayed, would be the focus of attention. That way the image became metamorphic, looking like both a ship and a tightened version of a suspension bridge, which seemed to us the perfect accompaniment to the site. In addition, the object functioned as a frame for the highly scenic situation, enclosing – depending on where one stood – either the massed buildings of the city's downtown or the wide vista over the water and the Bay Bridge toward the distant mountains.

As a counterpoint to romantic nostalgia, we evoked the mythological account of Eros shooting his arrow into the earth to make it fertile. The sculpture was placed on a hill, where one could imagine the arrow being sunk under the surface of plants and prairie grasses. By slanting the bow's position, Coosje added a sense of acceleration to the *Cupid's Span*. Seen from its "stern," the bow-as-boat seems to be tacking on its course toward the white tower of the city's Ferry Building.

Cupid's Span, 2002
Stainless steel, structural carbon
steel, fiber-reinforced plastic, cast
epoxy, polyvinyl chloride foam;
painted with polyester gelcoat
64 ft. × 143 ft. 9 in. × 17 ft. $^3/_8$ in.
Rincon Park, San Francisco
Commissioned by D&DF
Foundation, San Francisco
Installed November 2002

*Cupid's Span, Sited
in Rincon Park,
San Francisco*, 2000
Pencil, colored pencil,
pastel
30 $^1/_2$ × 21 $^3/_4$ in.
Collection Julie and
Edward J. Minskoff,
New York

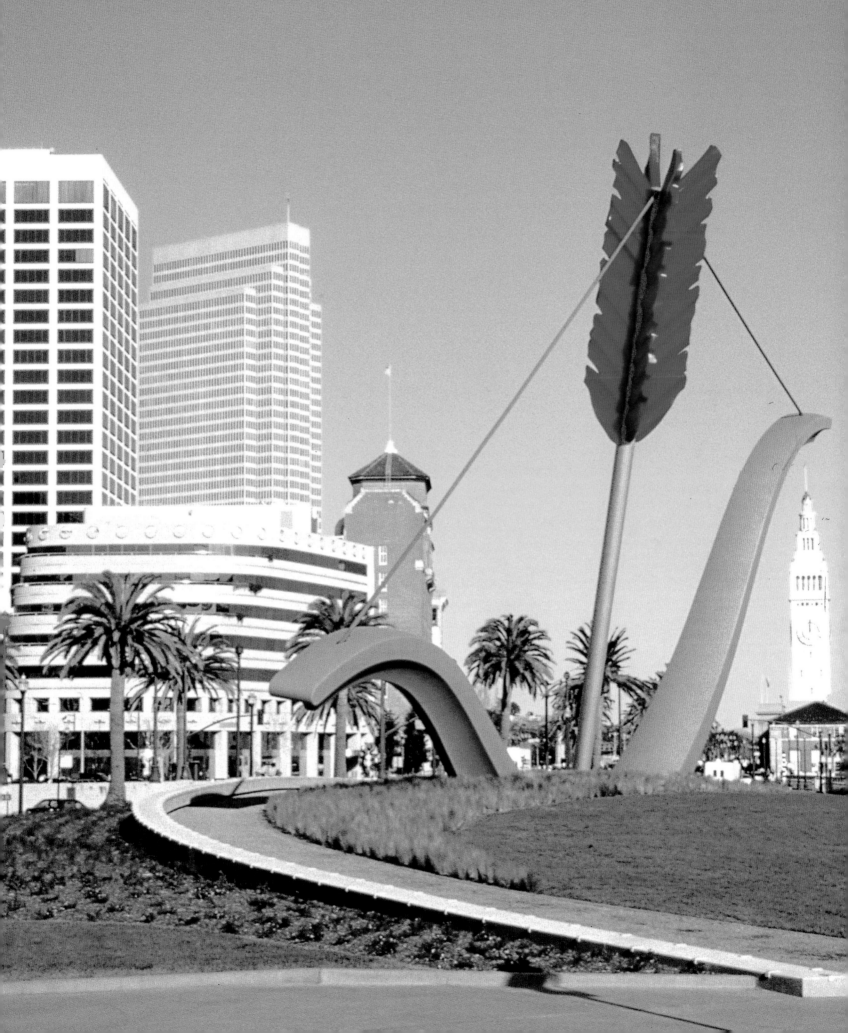

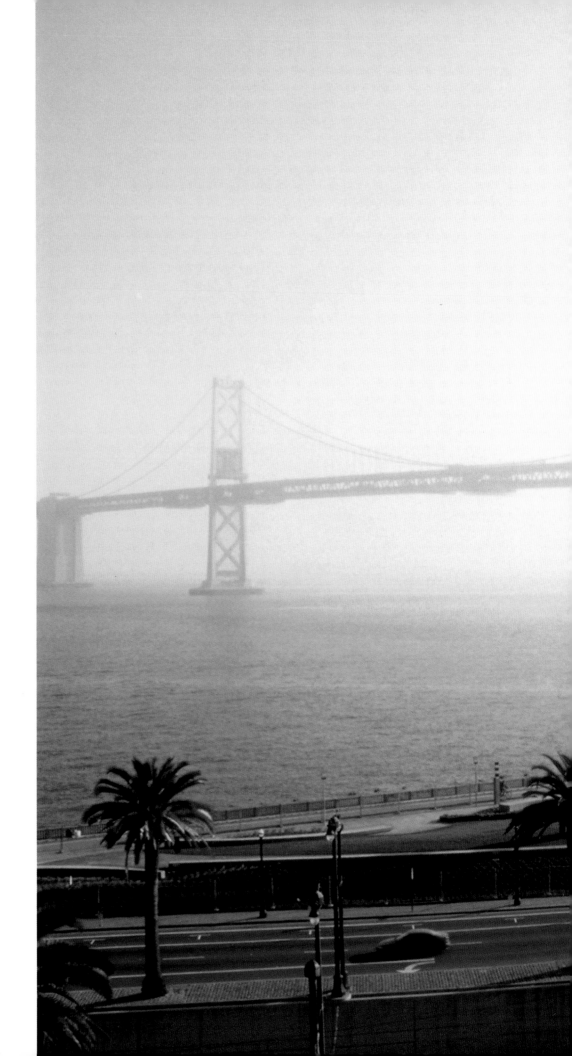

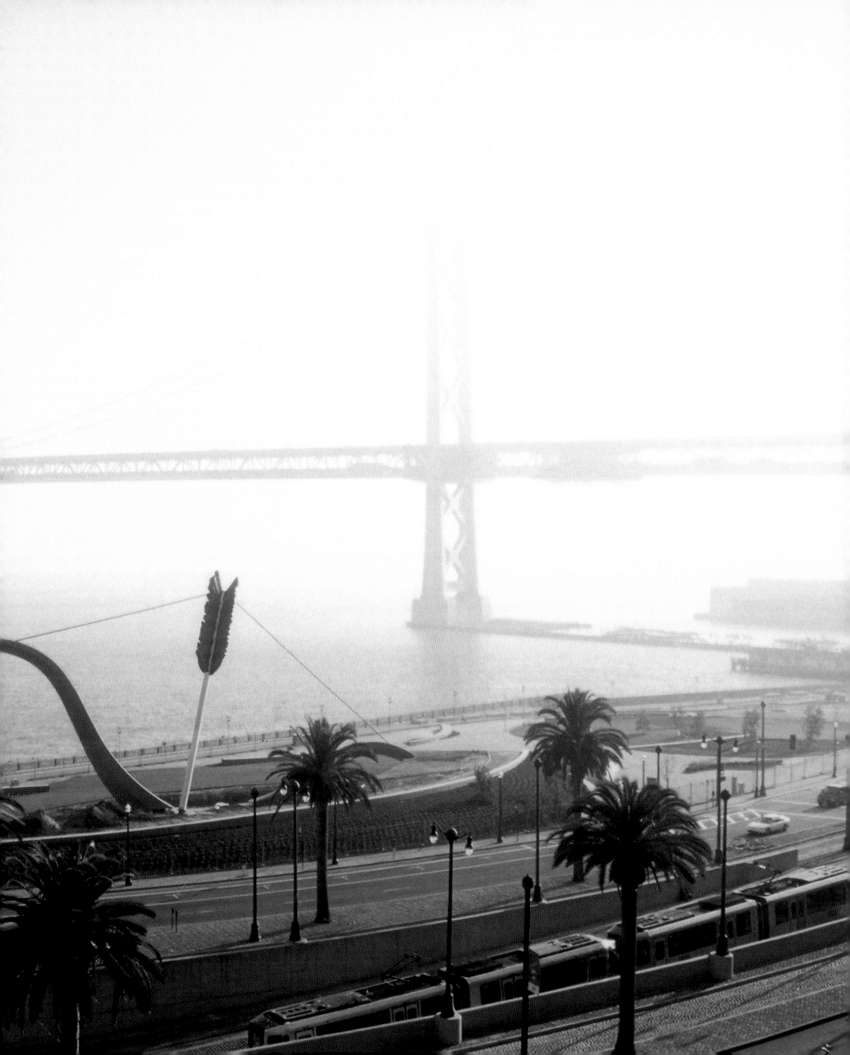

Long before the expansion of the Denver Art Museum had taken shape, we had identified a location for an outdoor sculpture in relation to the iconic existing museum building designed by the Italian architect Gio Ponti. Knowing that the environment would change radically, we nevertheless made notes – for example, determining an axis perpendicular to Mark di Suvero's sculpture *Lao Tzu*, and observing the curved roof on a Philip Johnson skyscraper in the downtown area and the view west of the Rocky Mountains' Front Range. Riding a free city bus, we glimpsed sanitation workers demonstratively sweeping trash into dustpans as part of a campaign to keep Denver clean. The sight connected with a theme we had been working on, "The Dustbin of History," which featured brooms and pans in action. As we talked over lunch, the clear blue sky combined with the characteristic browns of the Denver cityscape to elicit the image of a colossal broom and dustpan, which had appeared in a drawing in that color scheme. We visualized slits placed in the pan to restate the tall, narrow apertures of the Ponti building. The tilt of the pan might represent the slope of the mountain range and the broom the wind at its foothills. We chose to represent the moment of contact, when the bristles strike the pan, adding some debris as well.

The architect Daniel Libeskind had been commissioned to design the museum's expansion, which included a huge jutting structure of pointed planes that overshadowed our original site. Coosje opted to stay close to the Libeskind building in order to reassert the site-specific nature and preserve the scale of the sculpture. In its shifting forms the *Big Sweep* mediates between the Ponti building and the new addition. Its tilting planes offer a counterpoint to the structure hovering over it, while its rounded bristles provide contrast to the angular backdrop.

Big Sweep, 2006
Stainless steel, aluminum, fiber-reinforced plastic; painted with polyurethane enamel
31 ft. 4 in. × 25 ft. 4 in. × 15 ft. 1 in.
Denver Art Museum, Denver, Colorado
Commissioned 1999 by Denver Art Museum, Denver, Colorado
Installed June 2006

NOTEBOOK PAGE:
REFLECTIONS ON A SCOOP
SHAPE, 1992
FELT PEN AND WASH
5 × 2 3/4 IN. ON SHEET
11 × 8 1/2 IN.
COLLECTION
CLAES OLDENBURG AND
COOSJE VAN BRUGGEN,
NEW YORK

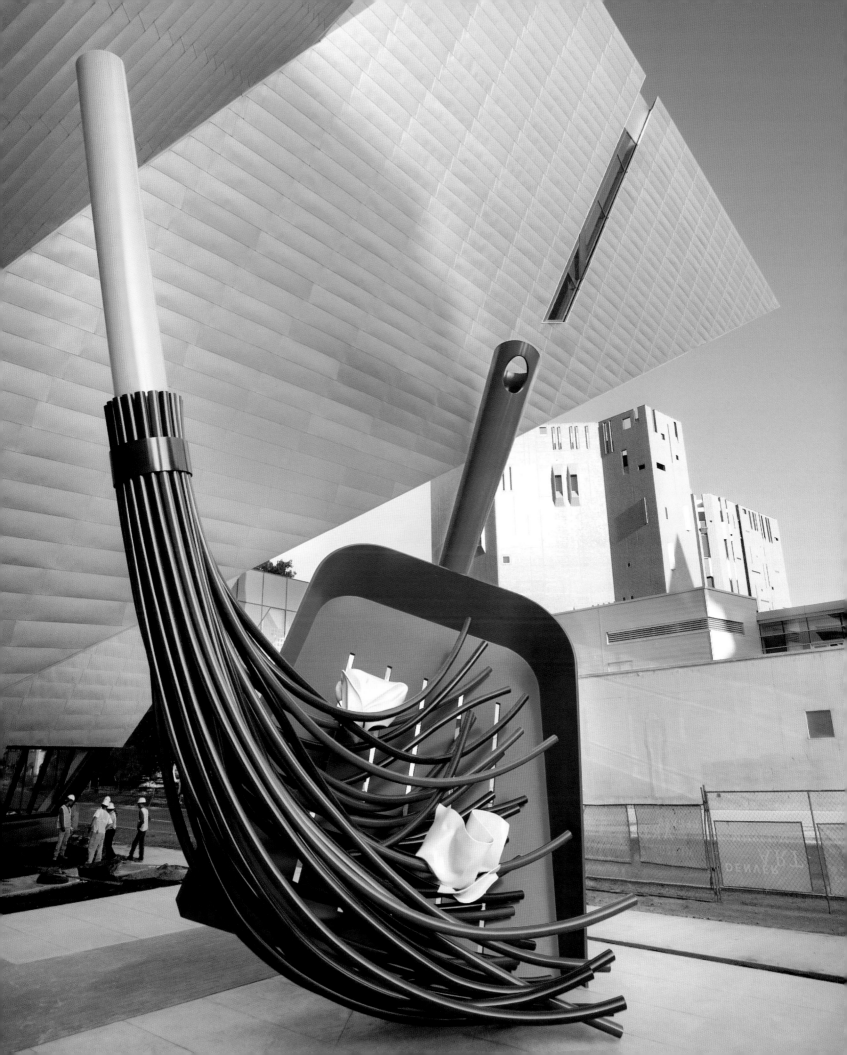

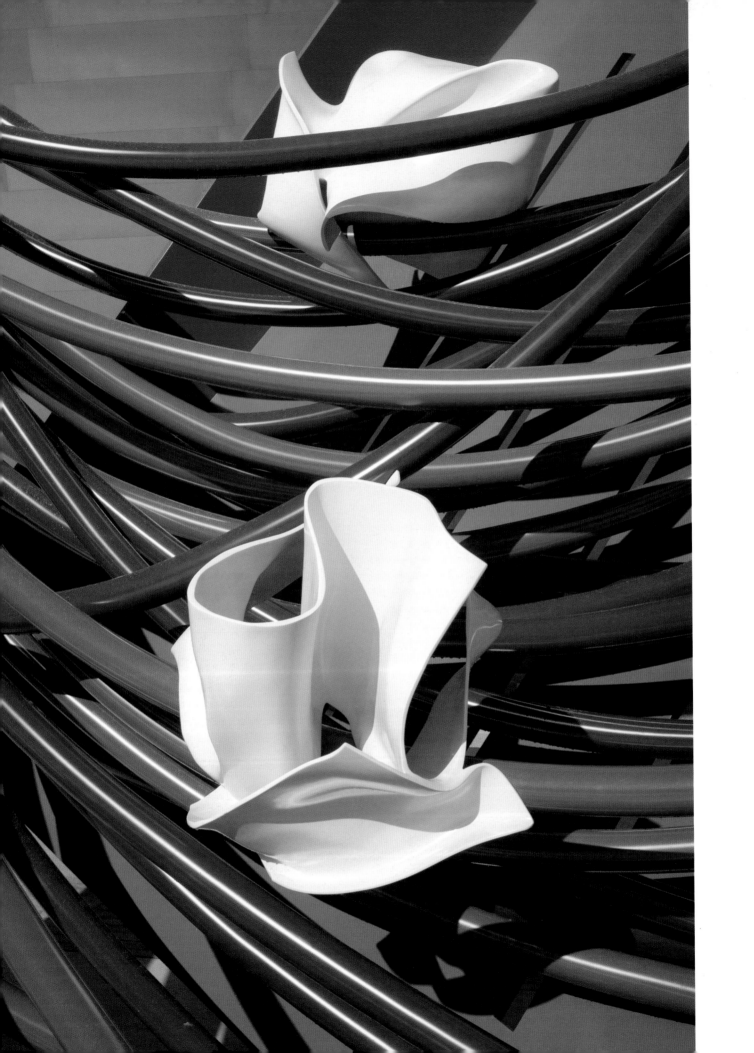

SCULPTURE IN THE PARK

MUSEUM SITES

Blueberry Pie à la Mode, Flying, Scale A, 1996

Valentine Perfume, 1997

Typewriter Eraser, Scale X, 1999

Architect's Handkerchief, 1999

Shuttlecock/Blueberry Pies, I and II, 1999

Corridor Pin, 1999

Plantoir, 2001

Apple Core, 1992

Golf Typhoon, 1996

Floating Peel, 2002

Balzac/Pétanque, 2002

BLUEBERRY PIE À LA MODE, FLYING, SCALE A, 1996
Cast aluminum painted with
polyurethane enamel
29 × 20 × 50 in.
Edition of 2
1/2, Private collection, West
Sussex, England
2/2, Collection Claes Oldenburg
and Coosje van Bruggen,
New York
Courtesy PaceWildenstein,
New York

*BLUEBERRY PIE À LA
MODE, FLYING, SCALE A* 2/2
INSTALLATION VIEW,
MUSEU DE ARTE
CONTEMPORÂNEA DE
SERRALVES, PORTO

FOLLOWING PAGE:
*BLUEBERRY PIE À LA
MODE, FLYING, SCALE A* 2/2
INSTALLATION VIEW,
ARTISTS' RESIDENCE
CHÂTEAU DE LA BORDE,
BEAUMONT-SUR-DÊME,
FRANCE

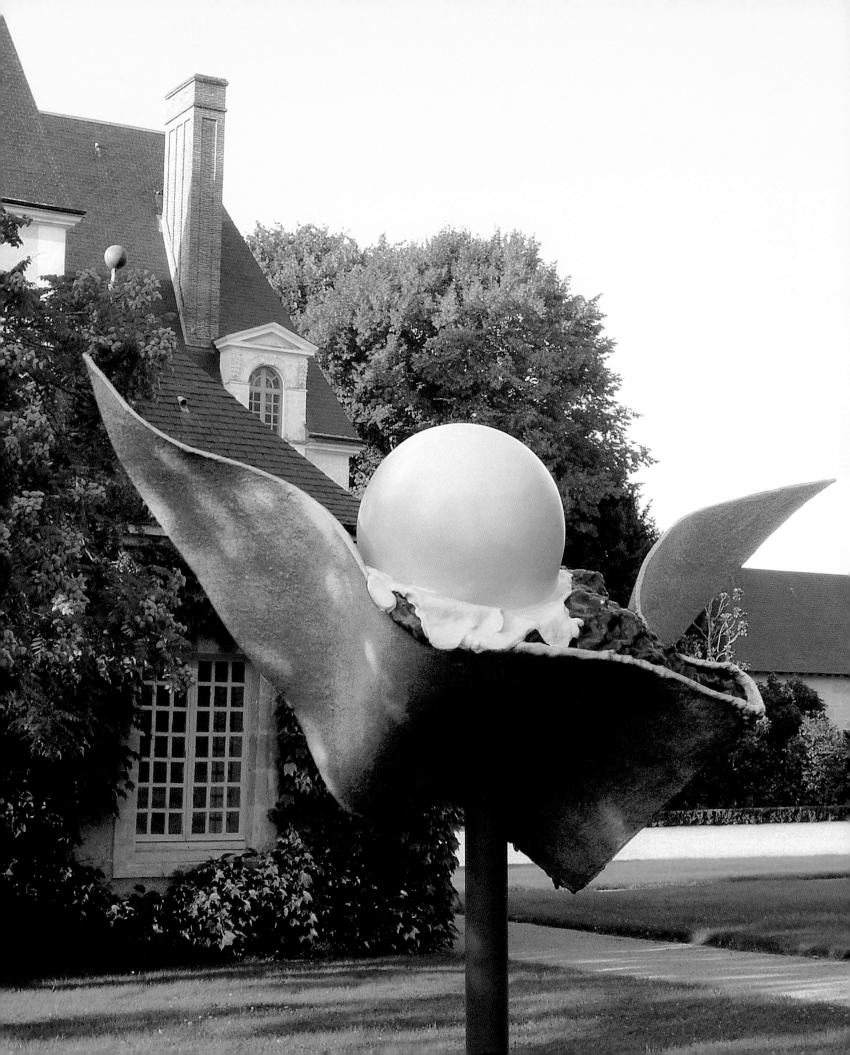

VALENTINE PERFUME, 1997

Valentine Perfume, 1997
Stainless steel, cast aluminum,
aluminum pipe; painted with
acrylic polyurethane
21 ft. × 4 ft. 9 in. × 9 ft. 4 in.
Private collection, Texas

Valentine Perfume
Installation view,
Museu de Arte
Contemporânea de
Serralves, Porto

Following page:
Valentine Perfume
Installation view,
artists' residence
Château de la Borde,
Beaumont-sur-Dême,
France

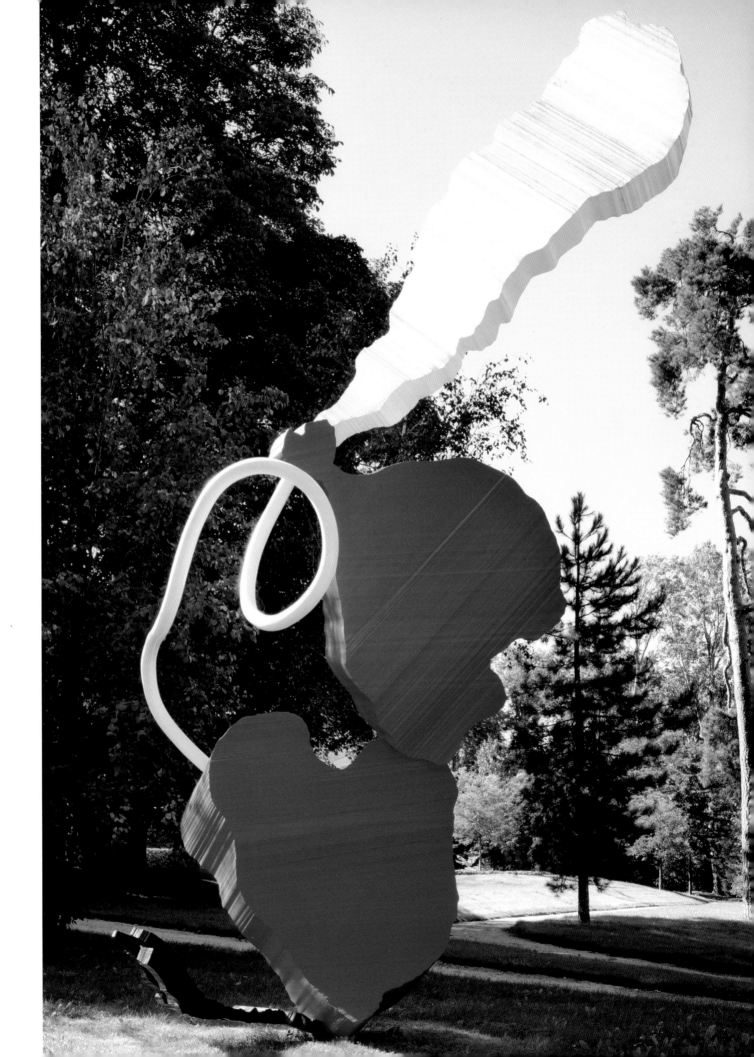

Typewriter Eraser, Scale X, 1999
Stainless steel and molded fiber-
reinforced plastic; painted with acrylic
polyurethane
19 ft. 3 in. × 11 ft. 9 ¹/₂ in. × 11 ft. 6 ¹/₄ in.
Edition of 4
1/4, Collection Samuel and Ronnie
Heyman, Greens Farms, Connecticut
2/4, National Gallery of Art Sculpture
Garden, Washington, D.C., Gift of The
Morris and Gwendolyn Cafritz
Foundation
3/4, The Paul Allen Family Collection, on
loan to the Seattle Art Museum Olympic
Sculpture Park, Seattle, Washington
4/4, Courtesy PaceWildenstein, New York

Typewriter Eraser,
Model for Scale X, 1998
Aluminum and medium-
density fiberboard;
painted with acrylic
polyurethane
38 ³/₄ × 24 × 31 in.
Collection
Claes Oldenburg and
Coosje van Bruggen,
New York

Following page:
Typewriter Eraser,
Scale X 2/4
Installation view,
National Gallery
of Art Sculpture Garden,
Washington, D.C.

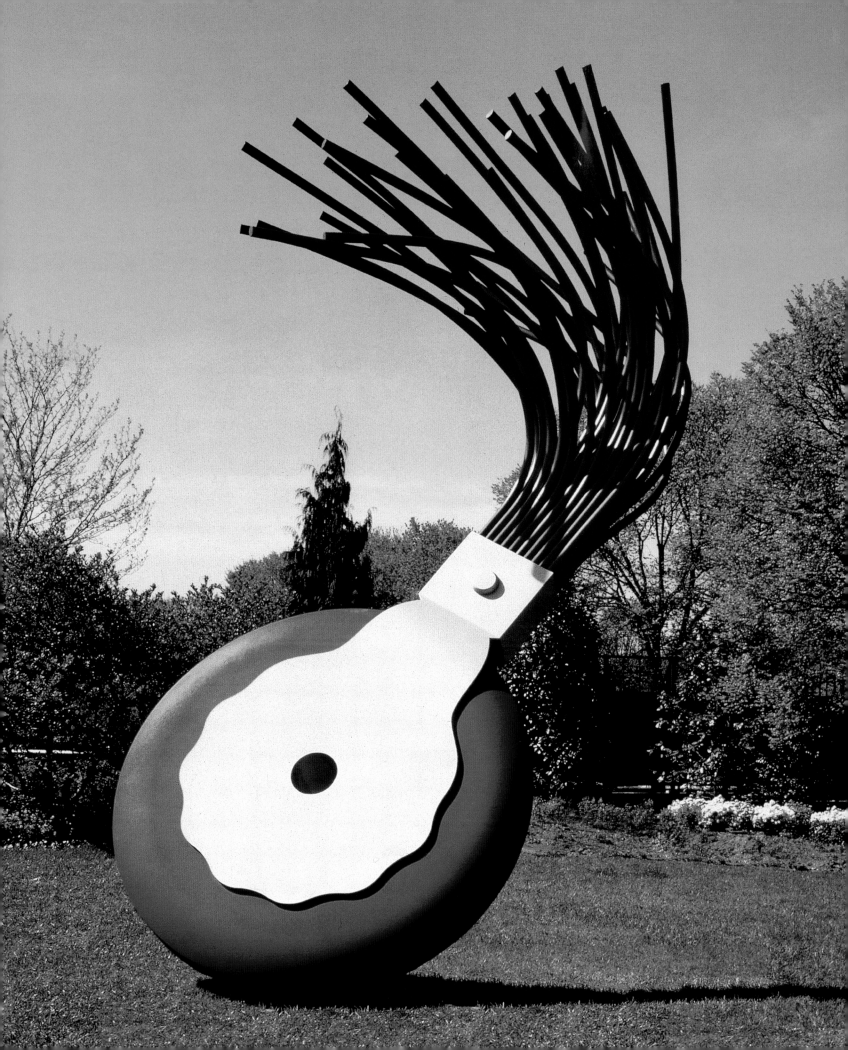

ARCHITECT'S HANDKERCHIEF, 1999
Steel and fiber-reinforced plastic
painted with polyester gelcoat and
polyurethane clear coat
12 ft. 5 in. × 12 ft. 3 in. × 7 ft. 5 in.
Edition of 3 and 1 artist's proof
1/3, Collection Shinsegae Co. Ltd.,
Shinsegae Sculpture Garden, Seoul,
South Korea
2/3 and A.P., Collection Claes Oldenburg
and Coosje van Bruggen, New York
Courtesy Anthony Grant, New York
3/3, Kemper Museum of Contemporary
Art, Kansas City, Missouri, Museum
Purchase, Enid and Crosby Kemper and
William T. Kemper Acquisition Fund
and R. C. Kemper Charitable Trust and
Foundation

ARCHITECT'S HANDKERCHIEF
1/3
INSTALLATION VIEWS,
MUSEU DE ARTE
CONTEMPORÂNEA DE
SERRALVES, PORTO

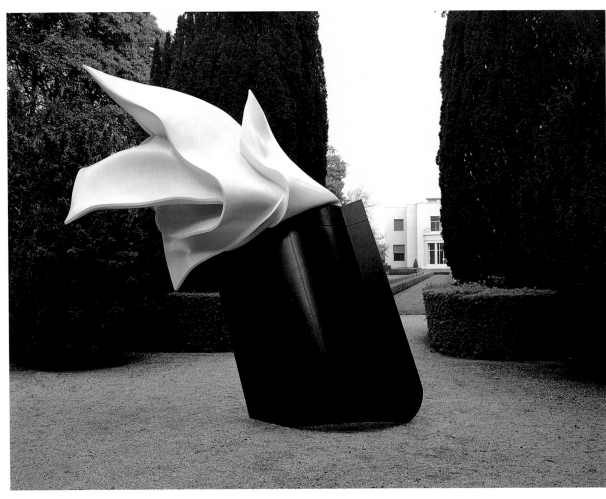

ARCHITECT'S HANDKERCHIEF
1/3

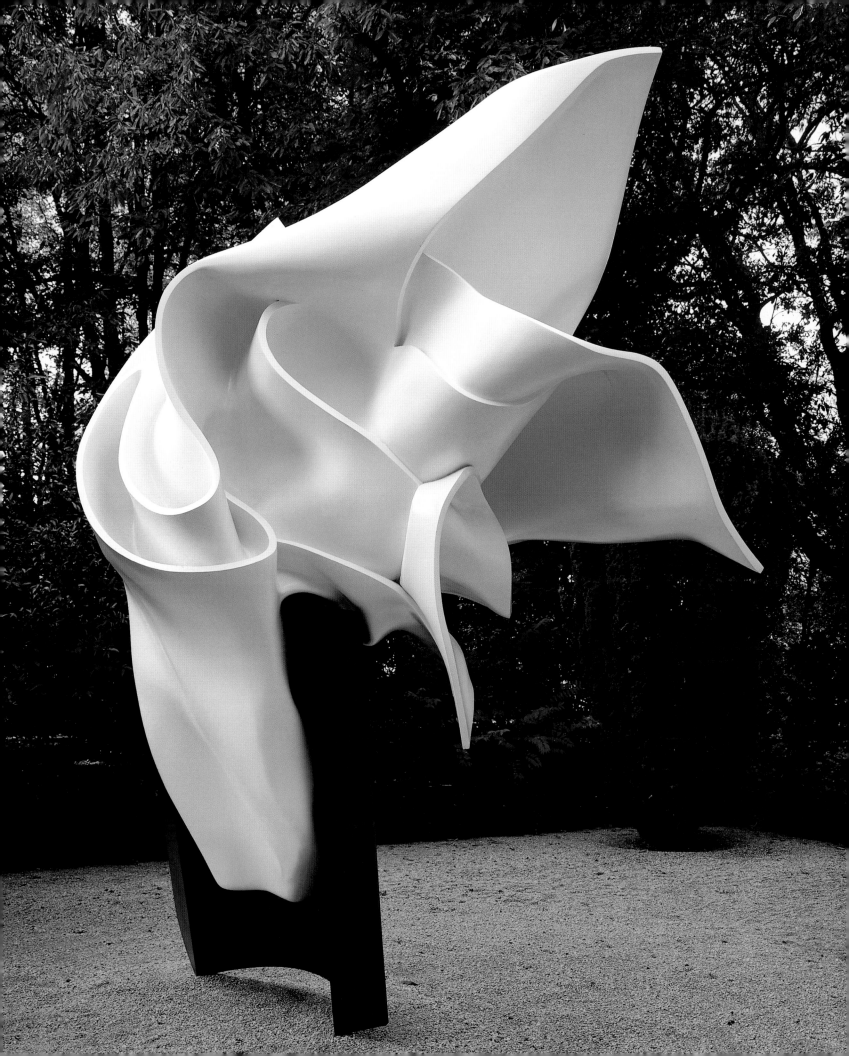

Shuttlecock/Blueberry Pies,
I and II, 1999
Cast aluminum painted with acrylic
polyurethane
48 × 24 × 24 in. each
Collection Claes Oldenburg and
Coosje van Bruggen, New York
Courtesy Paula Cooper Gallery,
New York

*Shuttlecock/Blueberry
Pies, I and II*
Installation views,
The Iris and B. Gerald
Cantor Roof Garden,
The Metropolitan
Museum of Art, New York

Pages 198-199:
*Shuttlecock/Blueberry
Pies, I and II*
Installation view,
Museu de Arte
Contemporânea
de Serralves, Porto

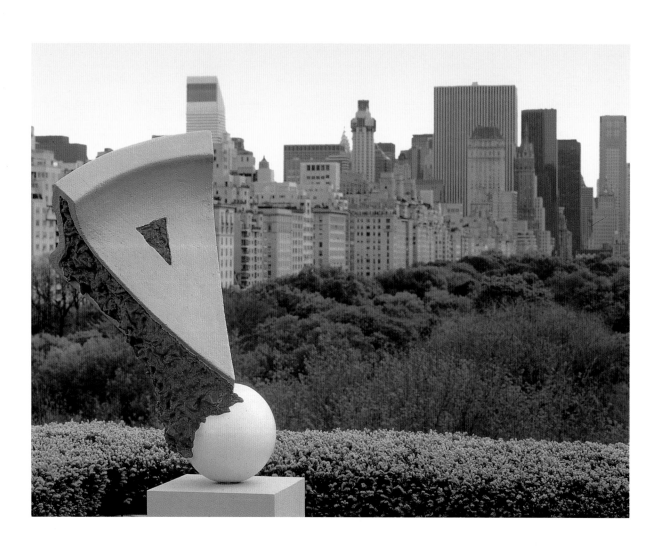

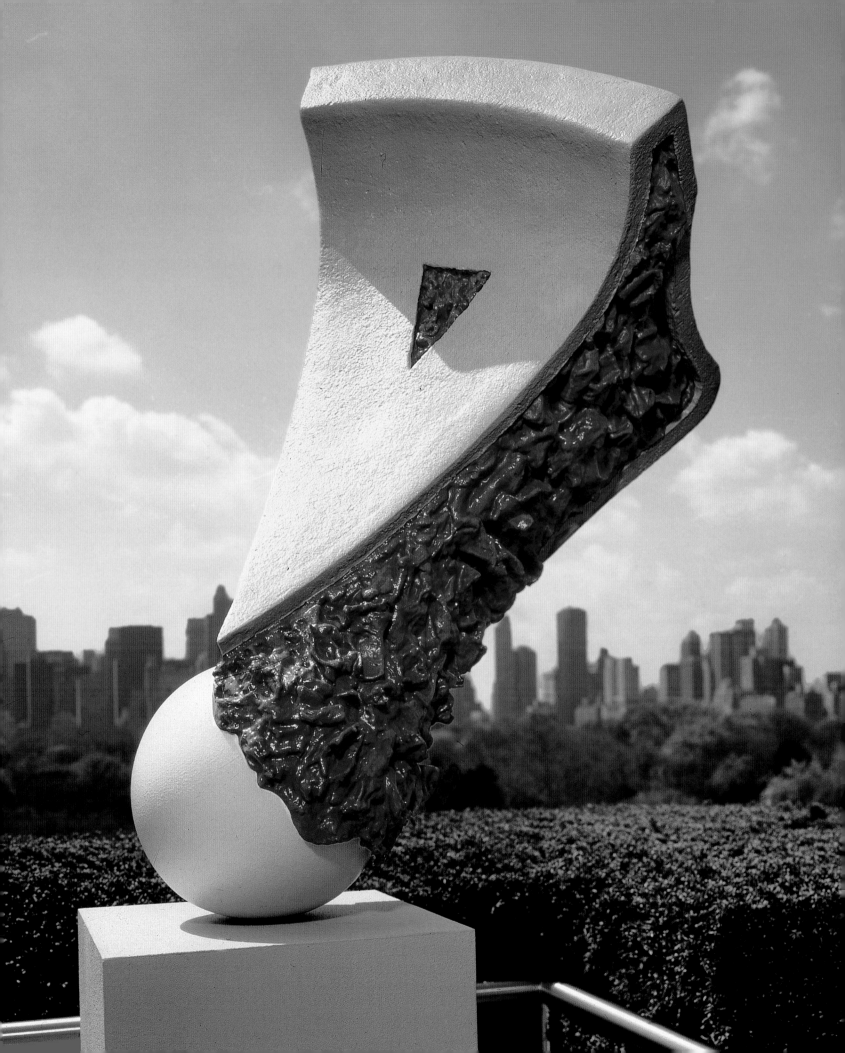

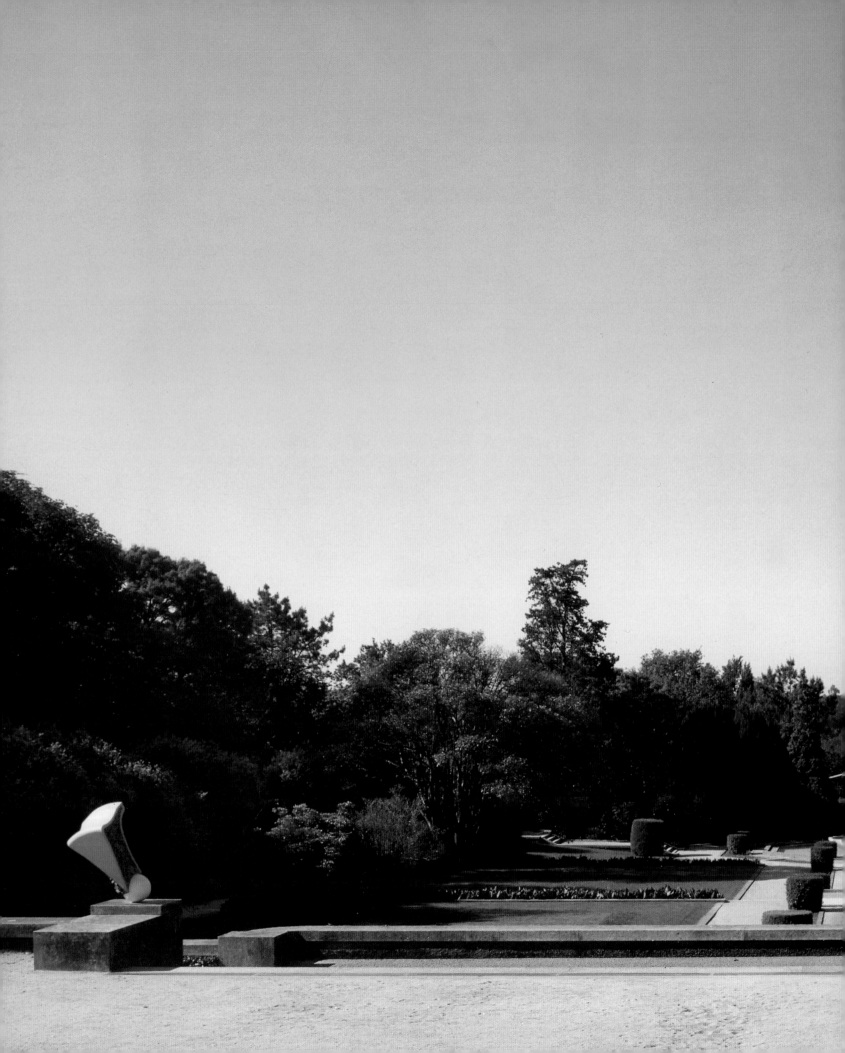

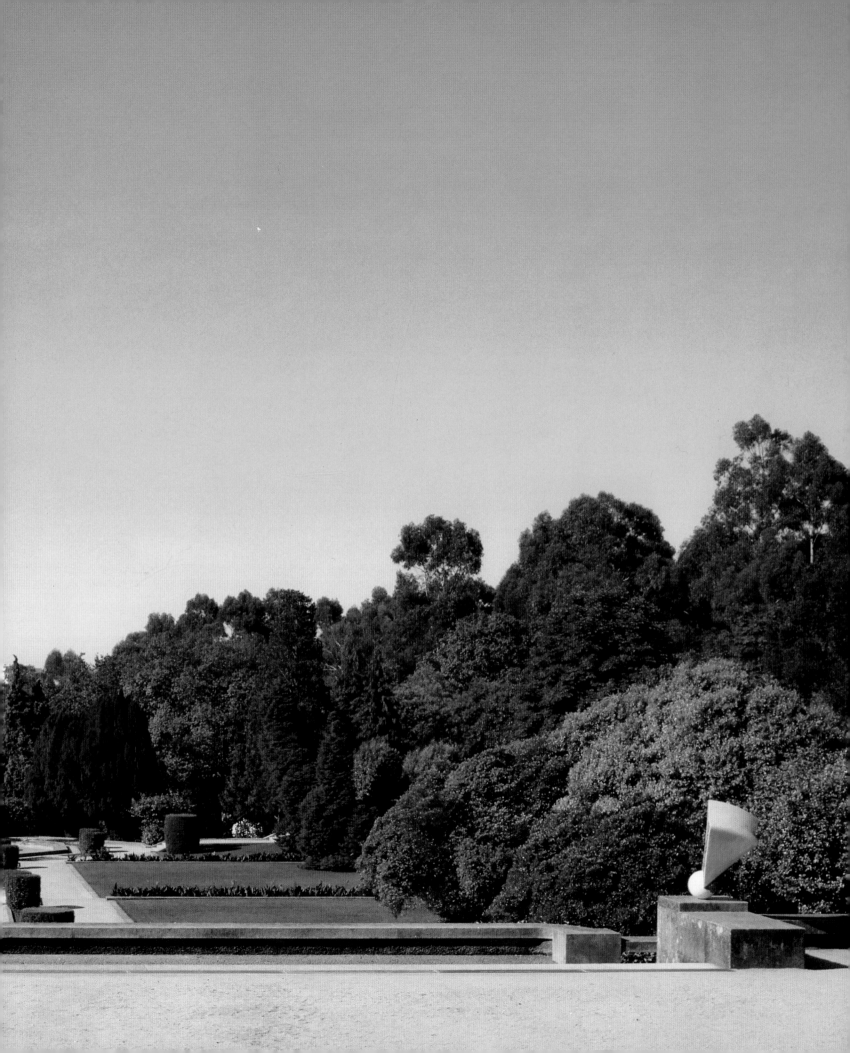

CORRIDOR PIN, 1999
Stainless steel and aluminum; painted
with polyurethane enamel
21 ft. 3 in. × 21 ft. 2 in. × 1 ft. 4 in.
Edition of 3 and 1 artist's proof
BLUE 1/3, Fine Arts Museums of San
Francisco, de Young Museum, Golden
Gate Park, Foundation Purchase, Gift of
the Barbro Osher Pro Suecia
Foundation
RED 2/3, Private collection, Los Angeles
BLUE 3/3, The Sydney and Walda
Besthoff Sculpture Garden, New
Orleans Museum of Art, New Orleans,
Museum Purchase, Sydney and Walda
Besthoff Foundation
BLUE A.P., Collection Nancy Nasher and
David Haemisegger, Dallas, Texas

CORRIDOR PIN, RED 2/3
INSTALLATION VIEWS,
MUSEU DE ARTE
CONTEMPORÂNEA DE
SERRALVES, PORTO

PAGES 202-203:
CORRIDOR PIN, BLUE A.P.
INSTALLATION VIEW,
ARTISTS' RESIDENCE
CHÂTEAU DE LA BORDE,
BEAUMONT-SUR-DÊME,
FRANCE

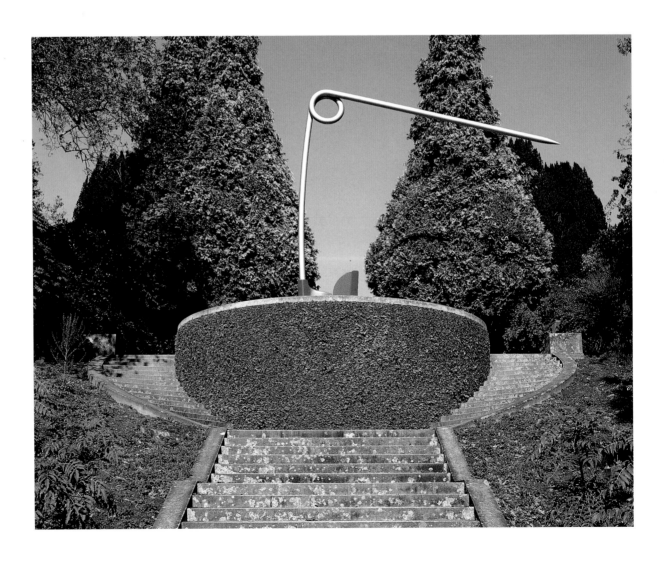

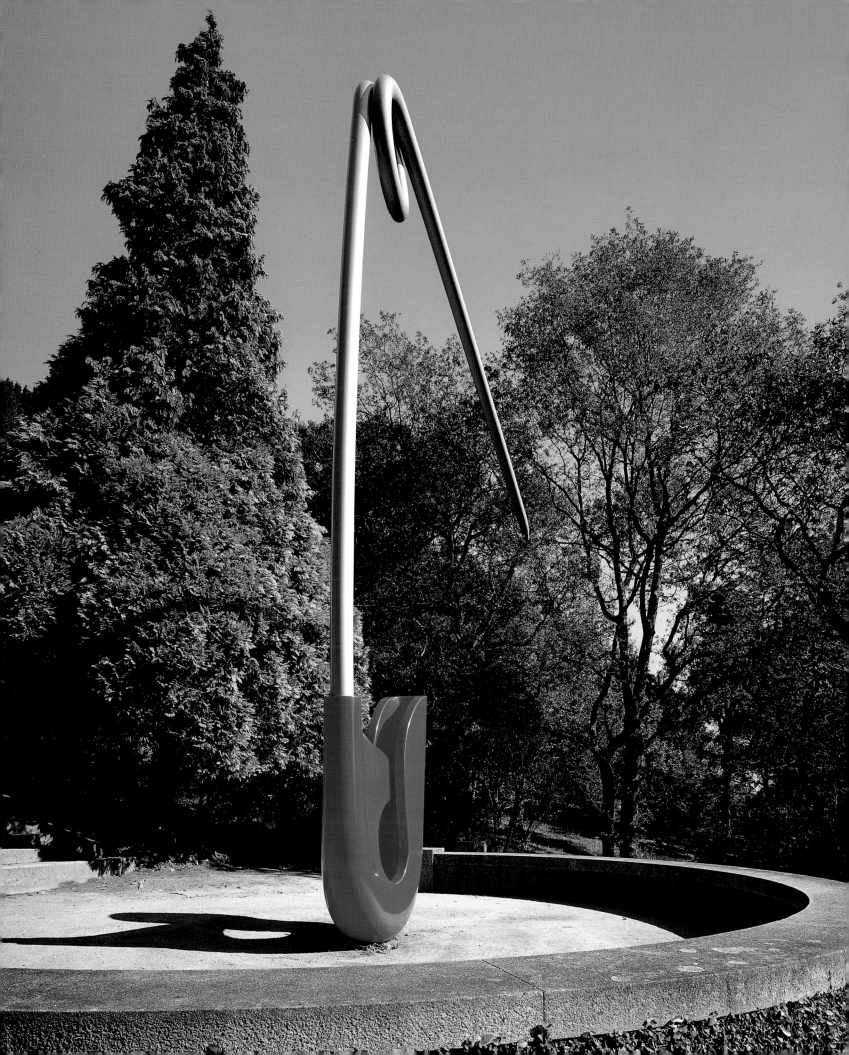

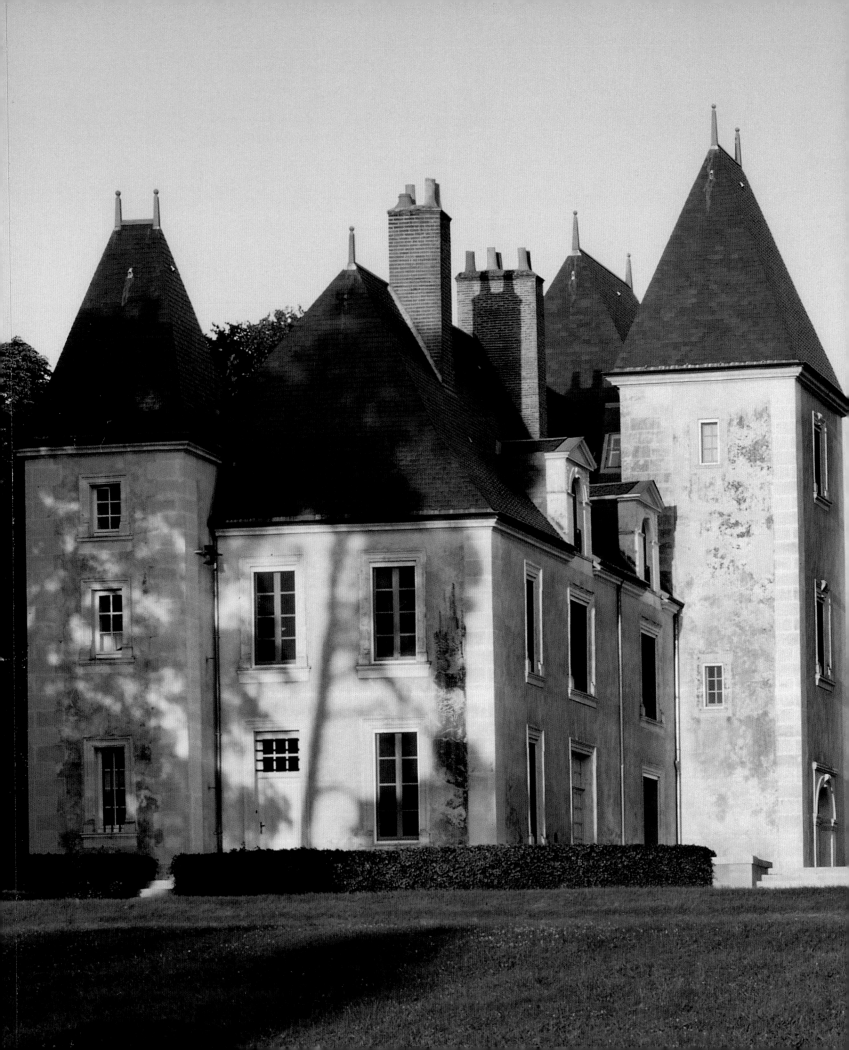

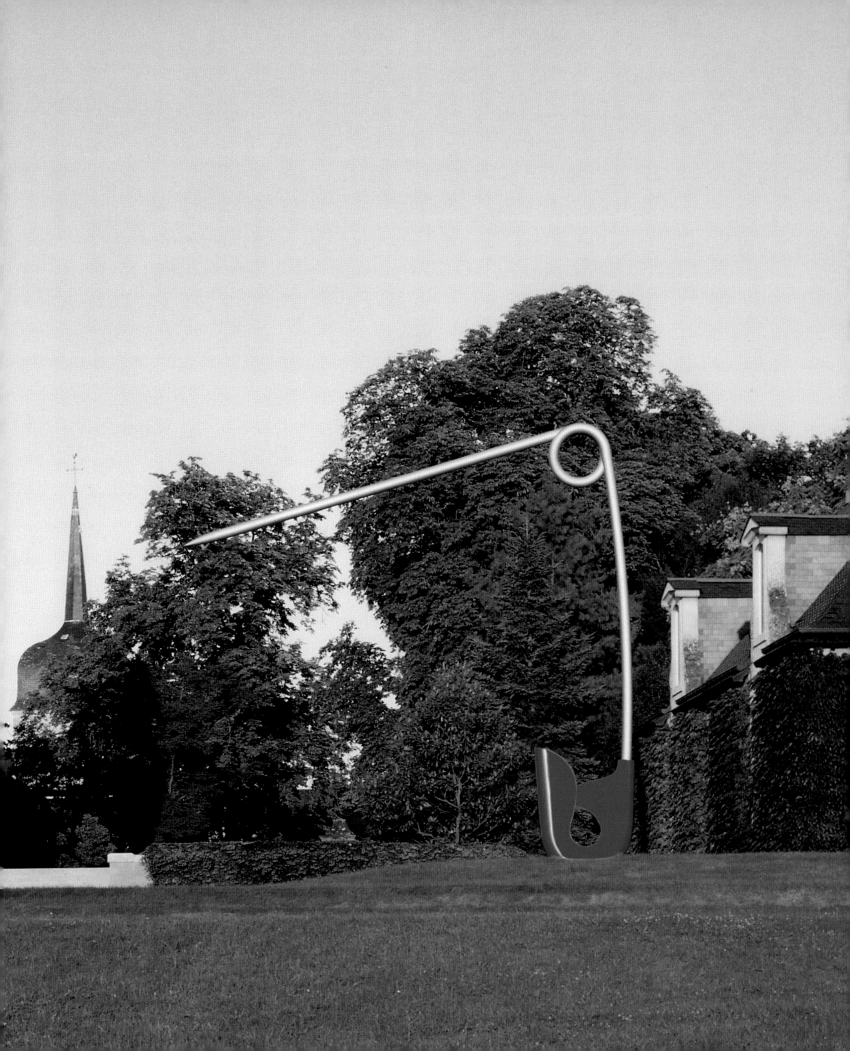

PLANTOIR, 2001
Stainless steel, aluminum, fiber-reinforced plastic; painted with polyurethane enamel
23 ft. 11 in. × 4 ft. 5 in. × 4 ft. 9 in.
Edition of 3 and 1 artist's proof
1/3, Collection Genevieve and Ivan Reitman, Montecito, California
2/3, Fundação Serralves, Porto, Purchase financed by funds donated by João Rendeiro, European Funds and Fundação Serralves
3/3, Collection Meredith Corporation, Des Moines, Iowa
A.P., Frederik Meijer Gardens & Sculpture Park, Grand Rapids, Michigan

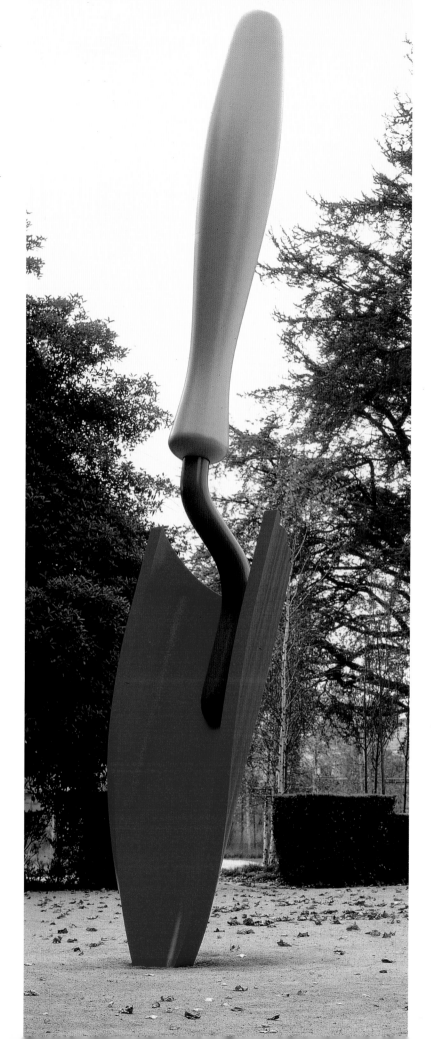

PLANTOIR 2/3
INSTALLATION VIEWS,
MUSEU DE ARTE
CONTEMPORÂNEA
DE SERRALVES, PORTO

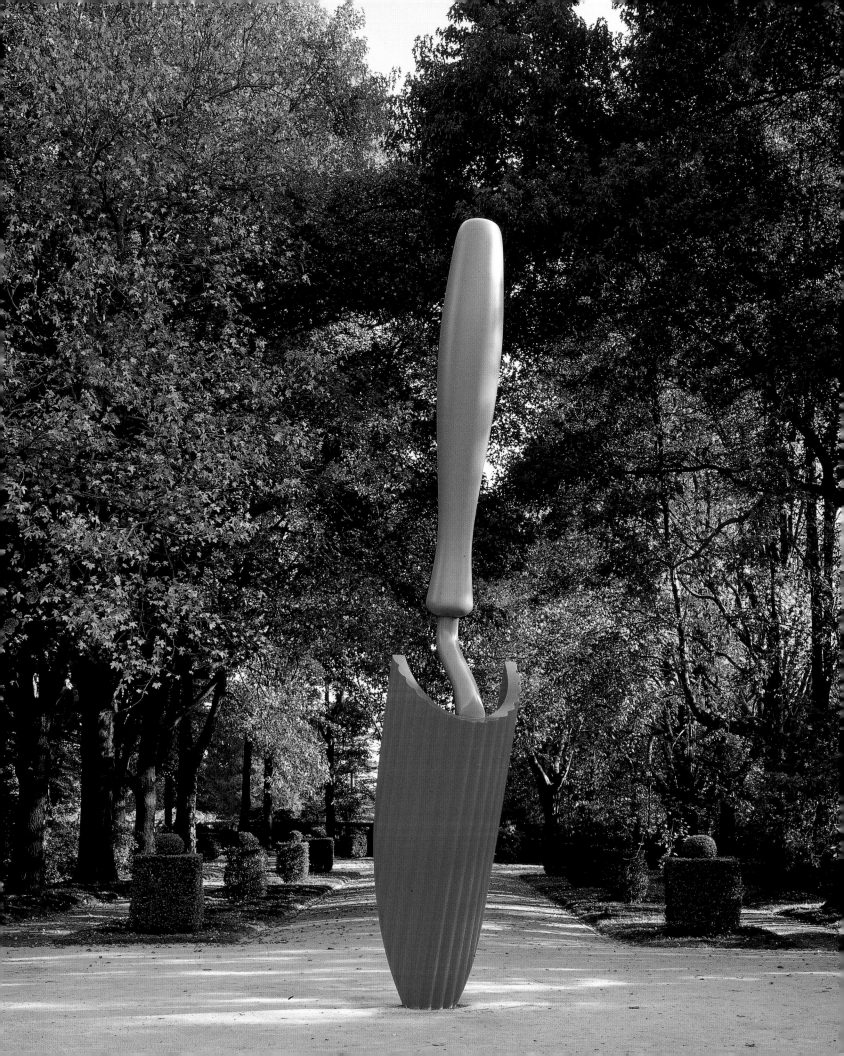

APPLE CORE, 1992
Cast aluminum coated with resin and
painted with polyurethane enamel
17 ft. 7 in. × 7 ft. 6 in. × 7 ft. 9 in.
The Israel Museum, Jerusalem, Gift of
the Morton and Barbara Mandel Fund,
Mandel Associated Foundations,
Cleveland, to American Friends of
The Israel Museum

STUDY FOR A MULTIPLE:
METAMORPHIC APPLE CORE,
1995
EXPANDED POLYSTYRENE,
CARDBOARD, WOOD; PAINTED
WITH LATEX
13 1/2 × 10 3/4 × 2 3/4 IN.
COLLECTION
CLAES OLDENBURG AND
COOSJE VAN BRUGGEN,
NEW YORK

STUDY FOR A MULTIPLE:
APPLE CORE, 1995
EXPANDED POLYSTYRENE,
WOOD, CANVAS; PAINTED
WITH LATEX
10 3/4 × 6 1/2 × 9 IN.
COLLECTION
CLAES OLDENBURG AND
COOSJE VAN BRUGGEN,
NEW YORK

GEOMETRIC APPLE CORE,
STUDY, 1991
CANVAS AND WOOD; PAINTED
WITH LATEX
9 1/2 × 12 × 8 IN.
COLLECTION
CLAES OLDENBURG AND
COOSJE VAN BRUGGEN,
NEW YORK

FOLLOWING PAGE:
APPLE CORE
INSTALLATION VIEW,
BILLY ROSE ART GARDEN,
THE ISRAEL MUSEUM,
JERUSALEM

GOLF TYPHOON, 1996
Steel and fiber-reinforced
plastic; painted with
polyurethane enamel
20 ft. × 5 ft. 7 in. × 5 ft. 6 in.
Wadsworth Atheneum Museum
of Art, Hartford, Connecticut,
Anonymous Gift

GOLF TYPHOON, FIRST STUDY,
1995
CARDBOARD, FELT, SAND,
POLYURETHANE FOAM, WOOD;
COATED WITH RESIN AND
PAINTED WITH LATEX
19 $\frac{3}{4}$ × 6 × 6 IN.
COLLECTION
CLAES OLDENBURG AND
COOSJE VAN BRUGGEN,
NEW YORK

FOLLOWING PAGE:
GOLF TYPHOON
INSTALLATION VIEW,
WADSWORTH ATHENEUM
MUSEUM OF ART, HARTFORD,
CONNECTICUT

FLOATING PEEL, 2002
Fiber-reinforced plastic painted
with polyester gelcoat
13 ft. 9 in. × 8 ft. 6 in. × 19 in.
Edition of 3 and 1 artist's proof
1/3, Collection Julie and
Edward J. Minskoff, New York
2/3, Collection Kenneth and Judy
Dayton, Minneapolis
3/3, Alturas Foundation, on loan to
The Iris & B. Gerald Cantor Center
for Visual Arts, Stanford, California
A.P., Private collection, Illinois

FLOATING PEEL 3/3
INSTALLATION VIEWS,
THE IRIS & B. GERALD
CANTOR CENTER FOR VISUAL
ARTS, STANFORD, CALIFORNIA

Balzac/Pétanque, 2002
Fiber-reinforced plastic and cast epoxy; painted with polyester gelcoat, stainless steel
8 ft. 6 in. × 25 ft. × 37 ft.
High Museum of Art, Atlanta, Georgia, Purchased with funds from Mr. and Mrs. J. Mack Robinson and High Museum of Art Enhancement Fund

Following pages:
Balzac/Pétanque
Installation views,
The Orkin Sculpture
Terrace, Wieland Pavilion,
High Museum of Art,
Atlanta, Georgia

CLAES OLDENBURG

COOSJE VAN BRUGGEN

SELECTED EXHIBITIONS 1985-2005

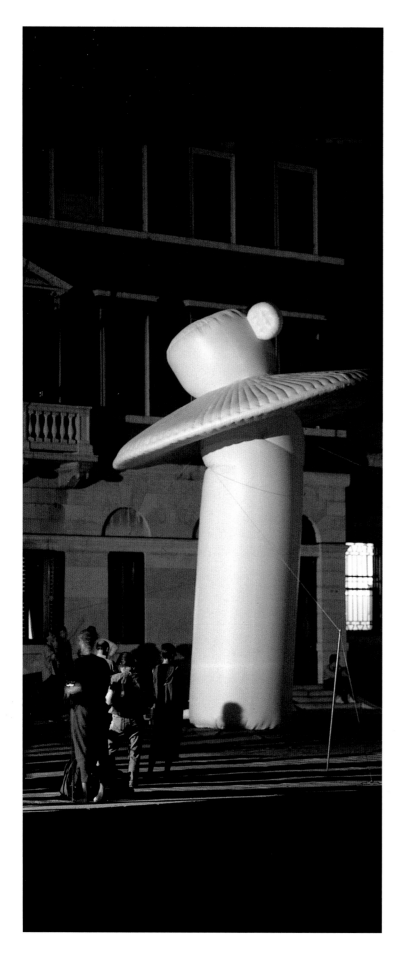

IL CORSO DEL COLTELLO,
VENICE, ITALY,
SEPTEMBER 6-7-8, 1985.
ESPRESSO CUP COLUMN,
1985 AT THE ENTRANCE
OF THE PERFORMANCE

FOLLOWING PAGE:
ST. THEODORE (PONTUS
HULTEN), FRANKIE
P. TORONTO (FRANK
O. GEHRY), DR. COLTELLO
(CLAES OLDENBURG), AND
GEORGIA SANDBAG
(COOSJE VAN BRUGGEN)
DURING REHEARSAL FOR
IL CORSO DEL COLTELLO
IN THE ABANDONED
ARSENALE CINEMA,
VENICE,
ITALY, 1985

1985

—— *IL CORSO DEL COLTELLO*, a project and performance by Claes Oldenburg, Coosje van Bruggen, and Frank O. Gehry, Campo dell'Arsenale, Venice, Italy, September 6-7-8. Curated by Germano Celant. Booklet.

Main characters – performers: Dr. Coltello (Claes Oldenburg); Georgia Sandbag (Coosje van Bruggen); Frankie P. Toronto (Frank O. Gehry); Basta Carambola (Germano Celant); Primo Sportycuss (Pontus Hulten); Sleazy Dora (Brina Gehry); Lord Styrofoam (John Miller); Chateaubriand (John Franklin); Leopard Woman (Berta Gehry); D'Artagnan (Gigi Manitto); Knife Dancer (Sandra Varisco); Knife Dogs (Alejo and Sami Gehry); Violinist (Luisa Messinis); Rower (Oscar D'Antiga); and Waiters, Busboys-Busgirls (with Maartje Oldenburg), Porters (with Paulus Kapteyn), Washers, Longshoremen (students of the Faculty of Architecture of Milan).

Works – objects: *Knife Ship, Temple Shack, Houseball, Sliced Soft Column, Dr. Coltello's Baggage, Espresso Cup Column, Fish-Architecture, Snake Pole, Architectural Fragments.*

1986

—— *EL CUCHILLO BARCO DE IL CORSO DEL COLTELLO: CLAES OLD-ENBURG, COOSJE VAN BRUGGEN, FRANK O. GEHRY,* Palacio de Cristal, Madrid, June 18 – September 9. Curated by Germano Celant. Catalogue.

Works exhibited: *Knife Ship I*, 1985, steel, wood, plastic-coated fabric, motor, closed, without oars: 7 ft. 8 in. × 10 ft. 6 in. × 40 ft. 5 in.; extended, with oars: 26 ft. 4 in. × 31 ft. 6 in. × 82 ft. 11 in.; height with large blade raised: 31 ft. 8 in.; width with blades extended: 82 ft. 10 in.

WAITING FOR DR. COLTELLO: A PROJECT BY COOSJE VAN BRUGGEN, FRANK O. GEHRY, AND CLAES OLDENBURG

Coosje van Bruggen

During the weekend of February 25-26, 1984, Claes Oldenburg and I met with Frank Gehry in New York to talk about a combined architectural and theatrical project for Venice originally proposed by the critic Germano Celant in connection with his exhibition *Art & Theater 1900-1984,* planned but not realized for the 1984 Venice Biennale. The events are now planned for the spring of 1985.

The Venice project provided a focus for a dialogue on art and architecture that the three of us had begun the previous year. Oldenburg and I spent two weeks in Gehry's office in Venice, California, where we sharpened our understanding of his architecture by following his daily routine. We made a tour of his current projects in the area, which were in various stages of completion – from a newly excavated site at Exposition Park, where the skeleton of the California Aerospace Museum was under construction, to the nearly finished campus of the Loyola Law School in downtown Los Angeles.

Because Oldenburg wanted to discover the different aspects of Gehry's work method, he made the architect's individuality his subject. As a sculptor he is inclined to observe houses for their own sake, "not for living or use," as he says, but as indicators of a particular scale, as objects. His previous experience with architects had been limited to consultations about the building specifications needed to translate his scaled-up objects into structural frameworks (for example, he had worked in this way with Stuart Cohen of Chicago, who drew up the plans for the Mouse Museum and Ray Gun Wing). Now, surrounded every day in Gehry's office by architectural scale models, he began to perceive things in terms of an architectural vocabulary. Since Oldenburg's own concern is with the tension between "thing-ness" and abstraction, the subject of buildings opened up a new, abstract manipulation of forms – if a

building functions at all, it will always be identifiable as a building, as a thing, no matter what is done to it. In the back of Gehry's office Oldenburg studiously built some architectural structures from materials at hand; one of these he paradoxically called a "bag shack," and another, a "hay high-rise." However, his efforts in this direction did not prevent him from coming up, true to form, with a sculptural proposal for the Loyola Law School, the *Toppling Ladder with Spilling Paint* – which celebrates Gehry's architectural practice of "disorganized order."

Gehry, for his part, had always had productive contact with artists; he even responded to such doctrinaire "situationalists" as Daniel Buren, Dan Graham, Michael Asher, and John Knight, who might turn commenting on architecture

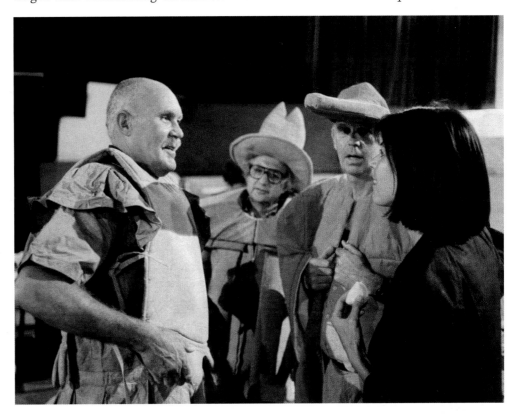

into art but who maintain a strict separation between the two disciplines. When in 1980 Gehry worked with his friend Richard Serra on a visionary project for a bridge in Manhattan that was to have spanned the distance between the Chrysler Building and the World Trade Center, each from his side tried to expand his territory – Serra by proposing the use

of two smooth steel slabs the size of buildings, which were to support the bridge on one end, and Gehry by designing biomorphic architecture, in the form of a huge scaly fish, which would have supported the other end.

Gehry's working method converged with Oldenburg's in its recognition of the sculptural objectness of architecture and in its identification of the shell of a building, as in Oldenburg's design for a museum based on a cigarette package and tobacco tin, done in 1968. At the time, the proposal was offered as an alternative for the Pasadena Museum then being planned. "Using a tobacco ad in the *Los Angeles Times,* I made my proposal and followed it to its conclusion," Oldenburg wrote in his notes of 1968. "The telescoped construction suits the different scales required for a muse-

um's function – food/books, exhibitions, and auditorium. Beautification is achieved by literal rendering of the original – its color, the revealed tobacco in relief and the ripped-open silver paper of the cigarette package (a flourish). In the scale I imagine, the source of the structure would not be obviously identifiable, except from an airplane."

The concept of making a museum out of a found object, to which this new function would be arbitrarily assigned, intrigued Gehry. He himself would never start out with an object or image that, taken out of its context, creates an illusion, but instead he begins with a conception of what is needed for a museum in terms of materials, building codes, and structure. In Gehry's opinion the selection of a found object, as Oldenburg has proposed, need not preclude so-called "serious" architecture. Since serious architecture is also determined by such incongruous factors as economic and social conditions, building codes, traditions, and available construction methods, the end result of any building project is to a large degree accidental.

Oldenburg's concept of the enlargement of stereotypical objects to an architectural scale so that people can relate immediately to the exterior regardless of the building's function coincided with Gehry's declared desire to make "a stronger sculptural statement of the shell so that a person who comes in can make a response to it." Gehry's attitude rejects canned environments in which everything has a fixed place, a concept summed up in a Holiday Inn slogan: "The best surprise is no surprise." To Gehry, "the notion that a building program is a rigid thing has been proven not important. People moved into warehouses in Soho, New York. I come from a background in commercial architecture where generalized spaces are designed in order to function for different purposes."

The new Loyola campus is relatively small and compact; it has been designed as a cluster of architectural structures in different scales. Some, like the main office and the administration building, which bounds the campus along one side, are radical alterations of existing structures. Others, like the moot court, classroom buildings, and chapel, are built in a smaller scale and are separate objects, each with a strong sculptural identity. Gehry's concept transforms a nondescript site in the midst of urban confusion in downtown Los Angeles into a homogeneous complex. At the same time, the architecture of the campus connects with that of the city around it. Because of the scattered layout of the buildings, the hierarchical significance of the exterior of the main office building is reduced by inserting stairways with a dense overlay of detail into it, thus breaking it up into separate parts.

The architectural surfaces of the buildings interact with the textures of the environment. Some natural materials, such as the stucco in its unpainted cement color, blend into the surroundings. Others stand out from it, such as the galvanized steel used for the columns and the birch plywood sheets (of a material called Finply) with which the chapel is covered.

The classroom buildings have the quality of Roman courthouses, conveying a sense of order to the campus. Immediately the Roman Forum comes to mind. Paradoxically, the irregularity of the landscaping, whose patches of green and octagonal brick flowerpots recall the Katsura gardens of Japan, offsets the symmetry of the building units. The fragmented effect in the plan of the campus is continued in the exteriors of the buildings themselves, in the form of disconnected parts. For the south classroom, Gehry set a row of four cement columns free from the facade. Originally he wanted to lay one of the columns on the ground, but the idea was rejected by the client.

Oldenburg's twelve-foot-high *Toppling Ladder with Spilling Paint*, made of steel and aluminum, would be situated slightly off the axis of the four columns and, in its implied fall, would break the rigidity of the row according to the architect's unfulfilled wish. The sculpture is a sort of ironic "monument" to Gehry's aesthetic of precarious forms and basic materials, of revealed construction and the creative use of chance elements.

The model of the *Toppling Ladder* is made of four steel rods and two bars with a sec-

tion of standard chain-link fence laid over the rods in place of steps. A segment of steel tubing is welded to the top of the ladder as a representation of the paint can; to it is attached a piece of organically shaped steel that signifies the paint flying out. The pastel blue color of the paint was suggested by the tilework used in one of Gehry's houses (on a sailboat trip with his family one Sunday, we had noticed how prominently the blue tile wall of the Norton House on the Venice beachfront stood out from all the other colors along the shore). The paint flies sideways out of the can in one big spill in imitation of the lateral movement of an earthquake, a dominating factor in Los Angeles' building regulations. Gehry had first elevated chain-link fence, the most prosaic and inexpensive of building materials, into the most prominent element in Santa Monica Place, completed in 1980. By making this common element the essence of the sculpture, Oldenburg mimicked the architect's approach, with the intent of monumentalizing it; the standard chain-link fence on the model will be enlarged six times in the final work. Finally, the sculpture "frozen in space" is in balance, like Justice with her scales. In reality the work is caught at just the moment before collapse, which symbolizes not only the vulnerability of law but also the delicate balance between art and architecture – both subject to, and beyond laws.

In view of our concurrent ideas, we were eager to follow up on the proposal for the other Venice when we met again in February 1984. (We would continue with a one-week work session in March with students at the Faculty of Architecture of Milan.) The architecture and theater project seemed appropriate to that older Venice, a city laid out like a stage. Though the performance is conceived as a fantasy, it is intended actually to be executed. (Unfortunately our architectural structures, which would have dealt with real factors, will have to remain unexecuted due to their scale and complexity.) We decided to begin with a site about which all three of us had strong recollections, the Arsenale, an ancient citadel and abandoned Navy yard whose oldest sheds, along the Darsena Vecchia (Old Dock), date back to the twelfth and thirteenth centuries.

We knew that discussions had been held at the Faculty of Architecture of Venice University about what to do with the Arsenale, whether to let it remain what it is, a slowly disintegrating ruin, which might be preserved with great difficulty as a relic, or to revitalize it in some way. One plan was to convert the sheds into a Museum of Contemporary Art. Another was to make the Arsenale, which lies within the working neighborhood of Castello, part of the city again, and to bring back craftsmen and boat storage and maintenance yards, which are still needed in today's Venice. We preferred to keep an area in which artisans could live and work.

Gehry associated the Darsena Grande with a project he had done during a "charette" in Kalamazoo, Michigan, in October 1981. His problem there was to bring housing back to a downtown area that contained mostly office buildings. The usual tendency in urban development is to erect high-rise apartments, but the small downtown area of Kalamazoo did not require that much housing. Instead Gehry proposed a stagelike setup of "bleachers" over a parking garage, next to a lake that would be developed by tapping an underground river. Separate houses would be placed on top of the bleachers at different intervals. For the scale of the houses Gehry selected that of the town's standard clapboard houses, built with simple porches and adorned with fretwork exteriors in American Colonial or Gothic Carpenter style. The houses would serve to link the new development with the existing city so that the downtown area would receive new housing while retaining an iconic identity. This procedure was similar to ours in developing the Biennale project, in that we too were looking for a symbol associated with a particular urban site to serve as the subject for a large-scale sculpture. We would all now apply this method to Venice, with the Arsenale as the focus.

We needed a composite image, flexible enough to tie together the performance and the architecture, and to reconcile the past with the present. I envisioned, as the main performer, a red "Swiss Army knife" that Oldenburg had been doing studies of for a sculpture, but which had not yet been placed in a definite site. The knife could be used both in its normal function of cutting, as the recurrent theme in the architecture, and in a dislocated way, apart from its function, in the performance. We felt it should be a simple pocketknife, because a fancy one, with can opener, and tweezers, and so forth, would complicate the meaning and detract from its archetypal form. In its reducibility to a horizontal body, with two perpendicular blades capable of 360-degree rotation and a spiral corkscrew, the subject would be as suitable to sculpture as to architecture.

The knife as icon could correspond structurally to ships in all scales: the ubiquitous gondolas, modern red tugboats, ancient galleys, and even the Venetian ceremonial ship, the *Bucintoro*.

With its corkscrew and blades folded upward it would echo all kinds of vertical structures in Venice, including the campanile of San Marco and the parapets of the Arsenale. The color red could be associated with ceremonial events such as those shown in the paintings of Canaletto. Finally, its identity as souvenir and its foreign origin would point to Venice's main source of income, tourism.

Metamorphically, the knife could be a fish as well as a gondola: "*C'est un bâtiment long et étroit comme un poisson, à peu près comme un requin... Le bec d'avant de la gondole est armé d'un grand fer en col de grue, garni de six larges dents de fer.*" (It is a long narrow vessel like a fish, or perhaps like a shark... The prow of the gondola has a large iron piece shaped like a crane's neck, with six big iron teeth. Charles de Brosses, *Lettres d'Italie,* Dijon, 1739.) By happy coincidence, the knife and corkscrew could be equated not only with a fish but also with a snake, the two biomorphic shapes that Gehry was currently using in his architecture. This made Oldenburg think of the statue of St. Theodore and the Dragon on one of the columns in the Piazza San Marco. He also introduced into the discussion the play *Othello,* which sounded like *coltello,* the Italian word for pocketknife. The corkscrew, the eccentric element, could suggest the cone-shaped cap of Harlequin in the commedia dell'arte, thus giving the object a range of reference from the tragic to the comical. However, we decided to avoid the connotations of violence and present the knife

constructively in ordinary activity, such as peeling, whittling, scraping, and so on, and to emphasize its capacity to alter form by carving and cutting, in all scales.

We also wanted to make a "cut" through the rhetoric of art and architecture and to cut ourselves off from the commercialized tradition of Venice as well. Any architect who tries to intervene in Venice is forced to take tradition into account to such a degree that the new architecture almost inevitably ends up conformist. For this reason, Gehry wanted to make something that was "a clean cut" with the existing structures of the Arsenale, though adjacent to it. The bleacher structure developed for Kalamazoo, projected onto the north bank of the Arsenale basin, would provide the break that Gehry wanted and also counterbalance the structures on the opposite side.

Our February meeting ended with a mutual agreement to title the project *Il Corso del Coltello*. "*Corso*" (course) referred both to the impending session with the students who would work with us on the architecture and the performance and to the path that the performance would take through the canal that traverses the Arsenale. Gehry returned to California, and Oldenburg and I continued to elaborate the subject in New York. Just before our departure for Venice and Milan, Dr. Coltello surfaced in Oldenburg's notes: "Dr. Coltello is a tour guide, harassed, with no expectations, not at all honest or attractive, a man just getting on and waiting for his transformation, his 'awakening.' He is our hero whom we now see wake and leave his miserable chamber in a forgotten part of town. He cuts his way out, just as the night before, wanting a bit of air, he cut himself a window. You can be direct with architecture, being a knife as he is."

On March 25, as the first step in *Il Corso del Coltello* Gehry, Oldenburg, and I finally visited the Arsenale, having been given special permission to do so by the admiral in charge. Instantly it became clear that we would never want to change this amalgam of enormous brick sheds, workshops, and ramps, built over many centuries and mixed with rusting cranes and corroding machinery.

Gehry saw this conglomeration as an example of urban design in harmony with the natural development of the city. "The way I perceive urban experience is in a fragmentary form, which I try to express in the combination of more or less unrelated objects that leave a fundamental but not obvious relationship," he said later. This approach was comparable to the plotlessness of our (planned) performance, and seemed to apply to both projects. But since the north bank of the Darsena Grande was lined with sixteenth-century sheds and the impressive ruin of the Porta Nuova (New Gate Tower) from 1811, we had to abandon the idea of placing new housing next to the basin.

In the afternoon we met the students, who had taken the train from Milan, and their teachers, Germano Celant and the architect Maurizio Vogliazzo. Then we all set out to explore the site and to gather materials related to the Arsenale and Venice, such as snapshots, stock photographs, maps, souvenirs, and so on. We took Vaporetto No. 5, the boat line that operates through the Old Dock and canals of the Arsenale, then emerges out of a hole in the back wall into the Laguna Morta, giving a view of the cemetery and, in the distance, the islands of Murano and Burano. This waterway seemed an ideal layout for the performance, all the more so because the high, abrupt wall facing the uneventful expanse of the lagoon gave the feeling of being "backstage." Later, as we walked along the passageway attached to the outside of the wall, Gehry found the solution to the architectural project: an entirely new section of the city, in the form of an island to begin about 150 feet from the shore behind the Arsenale.

After we had returned to Milan the following day, the students developed a model of the area around the Arsenale including the proposed new island – which we called "Coltello Island" – and another large model of the island itself, so that we could simultaneously work in two different scales. A building program was worked out that specified housing for about two hundred artisans, a post office, a medical clinic, a bank, a theater, a fire station, an office building, a swimming pool, and a fruit market.

The critical question of our collaboration would be how to relate sculptural architecture with objects that identify an exterior architectural shell; especially, how the two might meet – whether in a collision, in a clear cut, or in a gradual transition of the object into architecture, or vice versa. The following structures were projected: Gehry felt that the knife shape, which Oldenburg drew with the blades and screw up, was best suited to the bank. The fire station would be in the form of a snake and the covered swimming pool in the form of a fish, both based on earlier designs by Gehry for a folly. An office building shaped like the opened lid of a grand piano, designed by Oldenburg, would be placed next to the fire station, while a vast canopy over the fruit market would be suspended from a colossal corkscrew fountain. The facade of the theater would be a pair of binoculars, with a library located in the upper part. Instead of the houses being placed on bleachers, the bleachers would become containers for the housing, cut through and placed at different angles. The presence of the knife would be felt in other buildings as well; the aesthetic of "cutting" would bind together all these scattered elements.

At this stage of the project we left Milan and the students. At the end of April Oldenburg and I traveled again to Los Angeles, where we continued to work on Coltello Island with Gehry. But the completion of a final model was set aside in favor of an actual project that would allow us to realize our joint working method – a commission to design a camp for children who have cancer, to be situated in the Santa Monica Mountains above Malibu.

Originally published in *Artforum* (New York) 23, no. 1 (September 1984)

El Cuchillo Barco

de

Il Corso
del Coltello

Claes Oldenburg
Coosje van Bruggen
Frank O. Gehry

Palacio de Cristal
Parque del Retiro,
Madrid

del 18 de Junio
al 9 de Septiembre
de 1986

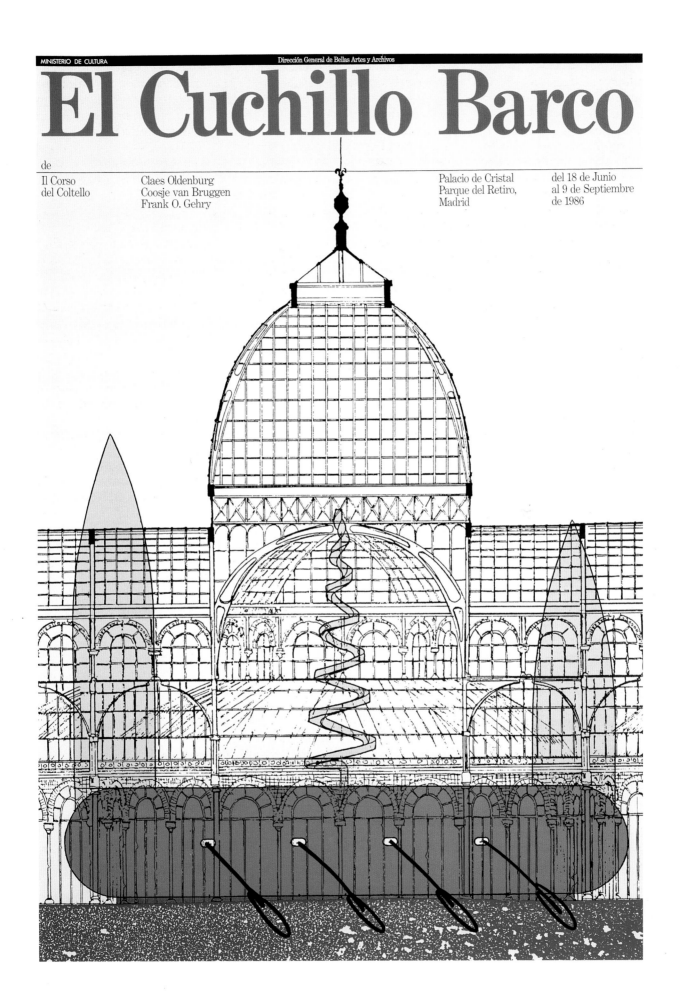

COOSJE'S JOURNALS

Coosje van Bruggen

AUGUST 10, VENICE

Last night John Franklin, Claes' assistant (who also plays Chateaubriand, the lion fragment), was still struggling to complete the shipment of seven huge crates loaded with soft props, costumes, and tools. These include 700 paper plates and Frank Gehry's models of the red and white checkered podium; the golden umbrella in the shape of an obelisk tip (reminiscent of a doge's umbrella); and the section of a snake, eighteen inches in diameter, that is to be wrapped around the flagpole in the Campo dell'Arsenale. John called to say that cargo this large can be flown from New York to Venice only twice a week, and therefore Keating, the transport firm, is sending the stuff to Milan instead. From there it will be sent on by truck. We all still hope the crates will arrive in Venice by Monday or Tuesday.

These problems reminded Claes of the difficulties in delivering the American art to the Venice Biennale, in 1964, when the works finally had to be flown in by the American Air Force to the Udine air base near Venice. That incident added to the general feeling among Europeans that they were being assaulted by American Pop art. Castelli's advertisement in the summer issue of *Art International* fortified this attitude by showing a map of Europe on which the name of his artists – Bontecou, Chamberlain, Ed Higgins, Johns, Lichtenstein, Rauschenberg, and Stella – were imprinted over the cities of London, Kassel, and Venice. That was the year in which Rauschenberg won the Biennale prize. Dr. Coltello's luggage should enter in a train from the northwest end of the Campo dell'Arsenale. The *Houseball* should move as slowly as Hannibal's elephants crossing the Alps. On the Campo the activity of loading the merchandise and carrying it back and forth should be going on as much as the selling of it: there should be harbor activity as well as café and market activity.

AUGUST 11

After a siesta at the Lido, Ida, Germano, John Franklin, Paulus, Maartje, Claes, and I met with the designers of GFT at the abandoned cinema just down from the Campo dell'Arsenale, which is to be our studio. The space is immense. The total supply of materials to be used for the props – among other things 3,500 square feet of polyurethane, a whole truckload – looked lost inside it.

We got our first look at the costumes made by GFT. At first glance, it appeared that fashion and kitsch had taken over. The costumes seemed to belong in a Broadway musical, or maybe even Disneyland. The colors looked too bright in comparison with the props and costumes, in muted color schemes done by Claes in New York. The GFT designer had gotten especially carried away with D'Artagnan's costume, the pièce de resistance of which is a droopy red cape embroidered with gold lamé and sequin patterns.

After looking at them more closely, we realized that with a few changes many of the costumes would be usable. For instance, by removing the banding on Basta Carambola's pool-tablecloth jacket we could make it seem less like a Chanel blazer and more like a pool table. To make the reference even stronger we could add nets instead of pockets to show the pool balls. As the finishing touch, we could take off the decorative pool rack of silk on the back of the coat and Claes could remake it in canvas, like some Hell's Angels insignia. It's precisely in these embellishing details that art and fashion split. We will have to remake Basta's leggings, because their glittery golden material makes them more like part of a Maharajah's outfit than the wooden pool-table legs we expected. In general, adding soft polyurethane to some of the costumes may give them more plasticity and force the players to move more slowly and rigidly, thus tending to become static figures.

Kitsch and art contend with one another within the performance: the Souvenirs' costumes represent kitsch being transformed into art; the costumes of Frankie P. Toronto and Georgia Sandbag are art with a dash of kitsch.

The Souvenirs are programmed for a single characteristic activity. They have to move in a repetitious manner, suggesting that they are not quite human beings, but we don't want a cutesy toyshop-at-night effect, with the dolls coming to life.

AUGUST 12, NOON

Venice invites its visitors to record their thoughts. Everywhere, on street corners and in the *piazzette*, foreigners – from tanned young girls to graying old men – sit on benches with little notebooks in their hands staring dreamily into space, from time to time jotting something down.

The Frankfurt airport security confiscated a big pair of scissors that Claes was very fond of. However, he still had some scissors left in his baggage. With these he contributes to the diary cult in a more physical way by carefully cutting – from a piece of black vinyl – oversize commas, periods, quotation marks, colons, and semicolons. These punctuation marks are to be hung inside the soft "intimate journals," covered with travel stickers and containing statements about the Alps and Venice, which Georgia Sandbag will read during the performance.

AUGUST 13

Today we had a meeting with Roberto, the sound engineer for the *progetto spettacolo*, at the ASAC in the Archivio Storico della Biennale. We listened to and approved these sounds – all recorded on tape: knives being sharpened, an ax chopping, pigeons cooing and flapping their wings, the echo of a human voice in the mountains, yawning and snoring, thunder, explosions, dishes breaking, the roaring of a lion, the hissing of a snake, a Venetian boat whistle, and finally the overpowering roar of Niagara Falls. We eliminated the sounds of cats, canaries, cattle bells, and objects being dropped into water. In one of the cafés near the site, Germano will produce the sound of pool balls clicking together. We still need to find the sounds of underwater bubbles and popping corks.

Roberto and I discussed the sound schemes for the performance. For the prologue, The Café (20 minutes long), these are:
* A 20-minute tape on which the "daily specials" will be read (in both Italian and English), individually, two at a time, and in chorus, with the sound of popping corks, underwater bubbles, and footsteps mixed in alternating, overlapping, and simultaneous patterns.
* Another 20-minute tape of "garbled"

sounds, using my voice recorded backward, slowed down, speeded up, etc.

* A 20-minute soundtrack played in the *Temple Shack*, which will alternate sounds of an ax chopping with those of knives being sharpened; these will be followed by the sounds of paper or canvas being ripped close to the microphone, to accompany Frankie P. Toronto cutting himself out of the *Shack*.

* A separate soundtrack, to start seven minutes into the performance, in which two three-minute periods of yawning and snoring will bracket Primo Sportycuss' recital of a Swedish poem. At the end of the same soundtrack there will be one minute of a lion roaring combined with the soliloquy from Verdi's opera *Macbeth*: "Is this a dagger which I see before me?" This soliloquy, suggested by Roberto, is in the form of a recitativo, and thus is easier to combine with a lion's roaring. It also seems more to the point than the aria from *Otello*, which we had wanted at first, although we'll still use selections from *Otello* later in the performance.

During the first 10 minutes of the first part of the performance, The Lecture, the sounds of a hissing snake and of clicking pool balls will alternate while Frankie P. Toronto lectures and Basta Carambola comments. Eight minutes into the section a recording of Mike Kelley's percussive music will begin, and will continue for five minutes while Sleazy Dora does her stick dance in homage to Oskar Schlemmer. On another soundtrack, Chateaubriand will roar an aria from *Otello* for one minute; two minutes before the end of the scene this will be repeated.

Six minutes into part two, The Bridge, Dr. Coltello's sales talk will be accompanied by seven minutes of pigeons cooing and flapping their wings; this will be followed by five minutes of a voice echoing in the mountains, loudly at first and then gradually diminishing during the tug-of-war of the *Sliced Soft Column* and Sandbag's statements on the Alps. During the final two minutes of this section the sound of breaking dishes is to announce the upcoming lecture on natural disasters by Basta Carambola. Ten minutes into The Bridge, the lion will give an anxious roar, lasting one minute, while he walks backward off the Ponte del Paradiso.

The finale, The Ship, will start out with the sound of breaking dishes. After five minutes the sounds of thunder and explosions are added, building to a crescendo after which the roar of Niagara Falls begins quietly, increasing in volume for ten minutes or longer. After ten minutes the sound of ripping canvas coincides with a huge Knife emerging from a covered opening in the wall.

Each section of the performance – The Café, The Lecture, and The Bridge – will end with the sound of a Venetian boat whistle, recorded on a track by itself.

The equipment to be used for *Il Corso del Coltello* will consist of a four-track recorder, two two-track recorders, three stationary microphones, four radio microphones, and six loudspeakers. Roberto will have a mixer and a monitor, and the staff of the sound studio will make a recording of the first two performances using digital equipment.

AUGUST 14, 15

Claes' reputation in Italy seems to have been fixed by the 1964 Biennale, at least as far as the Venetian press is concerned. Today, analyzing our work in progress in an interview, we explained that while our performance has a lot in common with the Happenings of the 1960s, it differs significantly from them. The dissimilarities are a direct result of the collaboration between three different personalities, Claes, Frank, and myself, without our feeling compelled to conform to art-historical determinism; instead we are free to choose elements from our respective disciplines of art, architecture, and literature.

In the Happenings of the 1960s spoken texts were typically used only for their sound, but in *Il Corso del Coltello* much of the text is used to present meaningful statements. Different kinds of speech are included in the performance: lectures, translations, a sales spiel, the reading of diary entries, the seductive commercial listing of the "daily specials," and the recital of a poem by the Swedish poet Thorild. Texts-as-sound provide counterpoint to the texts-as-sense. For instance, from time to time the roaring of the lion fragment Chateaubriand accompanies Georgia Sandbag's reading of her statements; Dr. Coltello's war whoop cuts through Frankie

P. Toronto's lecture; the Knife Dogs bark while Dr. Coltello spiels; an argument in Swedish between Dr. Coltello and Primo Sportycuss interferes with Sandbag's commentary on the Alps and Basta Carambola's concurrent translation of it.

The Happenings used undeveloped stereotypes, which never aspired to be more than objects for appearance's sake. In *Il Corso del Coltello* I attempted to develop the characters into individuals with specific motivations, though they remain sufficiently generalized to permit improvisation and a wide range of interpretation.

It was said of the Happenings that they recalled the way movies developed during the silent period. *Il Corso del Coltello*, on the other hand, returns to the earliest practices of theater, and specifically to the traditions of commedia dell'arte. As in the commedia dell'arte there are no fixed written dialogues in *Coltello*; the players improvise, and don't have to learn their parts by heart. Frankie P. Toronto reads openly from a text glued to the blade of the knife he uses as a pointer; Basta chooses Venetian proverbs from his bluebird-shaped books, and Georgia recites the thoughts she has written in her soft "intimate journals." If Dr. Coltello, who improvises at all times, finds himself at a loss for words, he can fall back on reading the labels hanging from his luggage. The characteristic commedia dell'arte technique of extemporized repartee is used, and the movements of the characters are orchestrated in relation to one another. In addition, Dr. Coltello, one of the main characters, is not only his unique modern self, but also a kitsch Dragon, reminiscent of a cross between the commedia dell'arte characters of old Venetian merchant Pantalone and the Doctor who utters pompous wisecracks.

On the other hand, *Coltello* is based on the principle of simultaneity, rather than the consecutive sequences used in the commedia dell'arte; in this respect it is closer to the Happenings. A cacophony of sound effects, and the chaotic noise of the various players constantly interrupting one another's monologues and dialogues, produce disjunction everywhere, so that in the end the visual aspects prevail. As in the Happenings, natural sounds taken from the surroundings, such as the recorded sound of a

flock of pigeons flying up, are used, along with the sound of real objects in action and, here and there, a touch of music, pre-recorded or live, as Lord Styrofoam's aubade to Sleazy Dora played on the concertina.

Another strategy applied in *Il Corso del Coltello* and often used in the Happenings as well is that of harmony and discord between activity and sound. To take an example from *Fotodeath* (1961): a player representing a drunken, squandering type came out dressed in rags, carrying a burlap bag full of tin cans painted silver. He staggered around for a while and then fell down, causing the cans to roll noisily across the floor. Next a sober, rescuing type, also dressed in rags, and carrying an empty burlap bag, came out. Very carefully he picked up all the cans, while sound effects of distant explosions were heard. The explosions seemed irrelevant to the rest of the action, until one associated the tin cans with empty artillery shells.

In *Il Corso del Coltello* Frankie P. Toronto cuts himself out of the *Temple Shack* with a ripping sound; Chateaubriand, the lion fragment, roars at the same time. This seems a coincidence until we realize that the roar is in fact the recitativo from Verdi's *Macbeth*: "Is this a dagger which I see before me?," which reinforces Toronto's action.

In *Il Corso del Coltello* sound mediates among objects, players, and spectators, interfering with fixed expectations, increasing sometimes the sense of reality and at other times the feeling of alienation. In addition it provides continuity to the action, bridging the intervals between events.

Claes' 1960s Happenings dealt with specific cities – for example, Dallas in *Injun* (1962); Chicago, in *Gayety* (1963); Los Angeles in *Autobodys* (1963); Washington, D.C. in *Stars* (1963); and Stockholm, in his last performance, *Massage* (1966). The earlier Ray Gun Theater performances were concerned with New York and its history. Whenever possible he used typical sites, including a store on the Lower East Side in New York, an old farmhouse in Dallas, and a parking lot in Los Angeles. The site of *Il Corso del Coltello*, the *campo* in front of the Arsenale (once known as the "propeller" of Venice), perfectly evokes Venetian history in a concentrated area. Little has changed there since Canaletto painted it in 1730.

The props used in the Happenings of the 1960s were not intended to survive. After every performance the debris was sorted out and recycled into props for the next one. Only a few props – such as the Freighter and Sailboat from *Store Days* and the Tube from *Massage* – found their way into museum collections. On the other hand, the props for *Il Corso del Coltello* will be shown in a traveling exhibition, continuing the theme of the Coltello in the less dramatic form of an installation. The question is whether the props will take on a life of their own. *Il Corso del Coltello* results in an emblem for Venice in the form of a permanent large-scale sculpture, the *Knife Ship*. In this respect Coltello synthesizes our large-scale projects, carried on over the past 10 years, with the performance form, which Claes last worked in 19 years ago. The scattered actions, scraps of speech, and events, involving such soft and hard props as the *Sliced Soft Column*, the soft *Architectural Fragments*, the *Houseball*, Frank's *Temple Shack*, and his huge red snake coiling around the flagpole, at first seem to have no relation to one another or, if one does exist, it seems coincidental. But with the arrival of the *Knife Ship* the leitmotif of the knife and its actions becomes apparent. The diverse phenomena that have occurred to that point are tied together into one summarizing image.

AUGUST 18

Claes has delicately stenciled place names associated with George Sand and the Alps onto the colorful labels painted on Sandbag's cornflower-blue coat. A few of the names are of cities made up by Maartje, who all through the trip, when she was not reading Charlie Chaplin's autobiography, has been working on maps of an imaginary country called Cuela. Today she helped Claes by drawing imaginary explorer's maps, which look like Swiftian islands, on Dr. Coltello's suit.

A list of the cities stenciled on Sandbag's coat: Worms, Col di Tenda, Mont Blanc, Great St. Bernard Pass, Aix-les-Bains, Chiusa, Matterhorn, Gotthard Pass, Jungfrau, Aosta, Bratislava, Cairo, Col du Géant, "Devil's Bridge," Finsteraarhorn, Gross Glockner, Road to Canossa, Saguntum, Salassi, Susa, Trento, Venice, Vosges, Zeeratt, and others. Maartje's cities: Rotter

York, Ziquana, Sisco, Krodillo, and Quique. The longer names are incomplete because they did not fit on the labels.

Despite our knowledge that *The Travels of Marco Polo* is based upon the explorer's real experiences in Tibet, Burma, and the outskirts of China, we still read it as an exotic fairy-tale. Dr. Coltello, a.k.a. Murky Apollo, or Marco Polo, follows in the footsteps of this venturesome traveler, as the many labels attached to his luggage show – they bear the names of the cities Marco Polo visited, written backward.

Today, after a great deal of agitation and delay because the seamstresses could not translate his plans into patterns, Claes finally worked out Dr. Coltello's costume. It has a red cape, which suggests a cross between a pigeon, a beetle, the case for a bass violin, and Kafka's cockroach, with a blue knife dragging behind like a beaver's tail. When Dr. Coltello sits down on the stool before his easel, he will flip out the knife the way a pianist flips out the tails of his coat when he sits down to play.

AUGUST 19

For three days now John, Vittorio, and Ida have been cutting out sections of foam with a power saw and a knife, and gluing them together to form the inside supports of the soft *Architectural Fragments* and the six parts of the huge *Sliced Soft Column*. The foam is not as dense as the kind we used in New York, and as a result the forms have even less rigidity, and fall into much more comical poses than we had expected.

The *Architectural Fragments* suggest washing hanging on line, a common sight in Venice. For example, the arch and the pediment with two columns dangling from it resemble pants, the obelisk a tie, and the columns stockings. The Washers should squeeze and massage the soft *Fragments* whenever they handle them. The Washers have to carry the *Fragments* over to the line, attach them, hoist them up, and secure them from below. But to raise them with the pulleys turns out to be difficult. From now on nearly everything will probably require a solution that we haven't anticipated. In this case we will need something like counterweights so that the *Architectural Fragments* can drop quickly in the disaster part of the Finale.

AUGUST 20

All of Venice is designated a monument. Therefore sticking poles in the ground or attaching hooks or nails to the walls is prohibited. As the Arsenale is still in operation and belongs to the Italian Navy, we have a military problem on our hands as well. Monday morning Ida visited the admiral in charge, who officially gave us permission to hold the performance on the *campo* in front of the Arsenale and to use the Arsenale itself. During the time of the performance the *Knife Ship* will be moored within the Arsenale, to appear every night from between its towers, and return inside after the performance. The sailors will have to keep the gate open later than usual and close the canal entrance after the ship returns by drawing a steel net across it, one of their regular procedures at night after the last vaporetto passes through the Arsenale into the Laguna Morta.

The towers at the entrance to the Arsenale are considered very fragile and in need of restoration. Fortunately for us, there happen to be two hooks already well embedded in the sides of the towers. The admiral has allowed us to hang a screen from them on which we will project a film of Niagara Falls at the end of the performance. It doesn't matter if the screen flaps a bit in the wind; it will only add to the dizzying effect of the masses of water flowing down.

AUGUST 21

At the moment we are inundated by objects. Frank's *Temple Shack*, made from Michael Moran's plans under the direction of the city architect, Daniela Ferretti, was brought in yesterday, and today we set it up. The *Temple Shack* is built out of Styrofoam covered with a wonderfully soft, rubbery black material, and is quite overwhelming in size. The *Shack* is made of eight separate elements that look heavy but in fact are light enough to fall down easily without hurting anybody. The only thing missing from them is the Italian graffiti. We keep in contact as much as we can with Frank, who will arrive with his family at the end of the month.

The cinema has gradually filled up with props, including a podium with separate steps, painted a pale green, on top of which the contest between Chateaubriand and Primo Sportycuss – the boxer from Nova Zemlya who aspires to be St. Theodore – will take place. Soft *Architectural Fragments* are piled up throughout the space: two sets of stairs, one gray and one yellow; a pink arch; one green and one yellow obelisk; a large pink column; a light gray pedestal; and one yellow and one gray pediment, with two columns dangling from each. Add to that the six parts of the *Sliced Soft Column*, painted in a soft pink, which are to be used in the tug-of-war on the Ponte del Paradiso. On ropes along the wall hang costumes and a long row of smaller soft architectural fragments, made of fabric with (among others) Hawaiian flower or Scottish tartan motifs, purchased on First Avenue on New York's Lower East Side. Shoved against the enormous soft red *C*, green *E,* and gray and red *O*'s are three wooden crates in the form of *L*'s painted gray, blue, and red, in which the Souvenirs will be transported. All of this is Dr. Coltello's luggage. Only the *T*, which will be painted ocher and will contain St. Theodore's costume, is still missing.

AUGUST 23

Some of the actions of the characters will have to be eliminated. For instance, the baroque dance that Brina Gehry prepared for her character does not fit in with the rest of the performance. Her trampoline jumping on the terrace in front of the Arsenale has to be canceled as well, because on the trampoline we have received the movements are too staccato, and she cannot jump high enough to be seen among the statues on top of the gate.

Just as Chateaubriand, the lion fragment, is torn between his twin ambitions of auditioning for the opera and replacing the lion of St. Mark's, so Sleazy Dora's motives are also ambivalent. She vacillates between structure and formlessness (hard and soft, in Claes' sculptural vocabulary), style and nature, present and past, masculine and

feminine. She is inspired by both Oskar Schlemmer and Isadora Duncan. As Isadora she joins the goddesses, among others Bellona and Justitia, who are eternalized in the entrance to the Arsenale. She glorifies and pacifies her "sisters" with flower petals and veils, and has her own soft pedestal, on which she would take her place serenely if she did not also want to change the world. Sleazy Dora goes back and forth between these personas. Sometimes she incarnates Duncan, dancing in her pink tunic to the "Roses of the South," by Strauss. At other times she lapses into Oskar Schlemmer, working with sticks to the percussive music of Mike Kelley. The sticks are alike except for fixtures at the ends, which suggest their different functions – one is a measuring stick, another a broom, a third ends in a flag, while fourth is a double paddle.

Finally, her repertoire includes Isadora Duncan-like runs combined with masculine, stationary kung-fu movements, both done while she is encircled by a black inner tube, which from time to time she removes by rolling it in a tub of water carried by one of the Porters.

By the Finale, Chateaubriand and Sleazy Dora have acted out their identity crises. Chateaubriand, after losing the competition to become the patron saint of Venice to Primo Sportycuss, a.k.a. St. Theodore, gives up and resumes his place among the other lion trophies next to the Arsenale. As for Sleazy Dora, she refuses to be a goddess and kicks away her pedestal.

The characters in *Il Corso del Coltello* oscillate between stereotypes and human beings. They are not only parodies of historical figures who once frequented Venice, but also signs, in a Proustian way, to be interpreted, used, and misused.

At the same time the characters lose their objectness and rise above being merely distorted historical quotations through their schizoid, occasionally kitschy sensibilities, which in flashes allow them to be human.

AUGUST 26

Every morning as soon as we get up Claes and I start listing priorities among the props that we still must construct. Despite a cinema overflowing with things, we keep concentrating on what's not yet there. Props to be made are:

DR. COLTELLO
cap and corkscrew tie; easel; labels on luggage

GEORGIA SANDBAG
letters, to be sewn into soft "intimate journals"; travel stickers; hat, sandbag, and stick; knife, to shave Frankie P. Toronto; moustaches, to be tied on Knife Dogs; pigeon shadows, to accompany lecture on the Alps; campfire

BASTA CARAMBOLA
pool-ball net pockets; podium on wheels; a miniature pool table; 6 bird-books; 4 other bird-books, which can't be opened, in the tree; cue; golden ring, to be thrown into the canal

SLEAZY DORA
platform; flag; oar; butterfly net; sticks made of aluminum tubes with foam rolled around them; blue rug

LORD STYROFOAM
notebook with loose pages made of foam

PRIMO SPORTYCUSS
oversize towel; shield and spear; halo; oversize boxing gloves; medals

D'ARTAGNAN
shirt; foil

LEOPARD WOMAN
jewelry

BUSBOYS AND BUSGIRLS
pitchers; cutouts from map of Venice

WAITERS
checks with espresso cup image

KNIFE DANCER
red leotard; silver material for arms and legs

AUGUST 27

Ida went to Mestre to look at the tables. Taking Polaroids becomes a substitute for all of us visiting the factory. It takes less of our time, which by now is precious. Germano had a tough day. After waiting for two hours he finally had his first visit with the new mayor of Venice. Goodwill is there, but understanding is another matter.

Tomorrow the students will arrive, and the circus starts. There will be no more time for reflection. Action takes over!

Originally published in Germano Celant, *The Course of the Knife: Claes Oldenburg, Coosje van Bruggen, Frank O. Gehry* (Milan: Electa, 1986)

THE INDISCREET KNIFE

Germano Celant

"Despite the great developments in means of communication," writes Maurice Blanchot, "the commonplace remains elusive," for it is so familiar that it passes unobserved. In fact, the commonplace, and the objects and actions that comprise it, are based on a leveling of meanings in which no one thing has greater value than any other – they all wander about anonymously, under the flag of the insignificant, the silent. The homogeneity among these objects renders them indifferent participants in a magma of indistinct moments, without shadings or tones, without extremes or limits. In a way, the ordinary does not happen except in contrast with the extraordinary. "The commonplace" (Blanchot again) "has the characteristic of designating a zone, a level, or words to which the determination "true" or "false," or the opposition "yes" or "no," cannot be applied, in that it always remains on this side of what it affirms, and at the same time is easily reconstituted despite everything that negates it."[1] No cultural or visual system, then, can absorb it, for it is never totally present. In consequence, the commonplace lives only as an abstraction. Yet it is possible, through a process of cutting or separation, to remove a commonplace object or action from the "nothingness" that surrounds it and that it constitutes. That separation makes the commonplace happen, makes it specific. It interrupts the object's circulation within the magmatic vortex of the commonplace, gives determination to its indeterminacy, brings it into history. The specific object and action are born, each with its own identity, characteristics, colors, and forms.

Claes Oldenburg has always had a unique relationship with the commonplace. He has done more than extrapolate it from its habitual context; he has created it. He has exploited its dramatic and spectacular potential, finally giving it hypersignificance. Just as Theodor Adorno, in *Minima Moralia,* sees the obviousness of the commonplace transformed into something unsettling, a "profane enlightenment," so Oldenburg exorcises the "object folly" that surrounds human beings. In emphasizing the presence of banal objects of consumption in the world, he opens up a space for them beyond their use value. He makes them appear unexpectedly in art, where they seem enigmatic, absurd, absolute, almost hallucinatory. Yet Oldenburg is aware that the commonplace is paradoxical. In fact, he chooses it for his work because it needs neither confirmation of nor justification for its existence. Irreducible in its being, it requires no compensatory illusion of an ideal form of itself somewhere "elsewhere." It lives in the here and now.

Oldenburg removes his everyday objects – a shirt, a hamburger, a tube of toothpaste, a clothespin, a typewriter, a fan, an ice-cream cone, a saw, a baseball bat, a flashlight, a button, a knife – from the irreversible, anonymous flow of the commonplace. He renders the normal "exceptional," transforms it into the extraordinary, the singular, the anomalous. When Heraclitus, sitting by his hearth, surrounded by the everyday things of his house, received visitors who hoped to find him in some exceptional moment of his life, he remarked, "Here too the gods are present." Similarly, Oldenburg redeems the banal. His process resembles the Dadaists' extrapolation of objects from the homogeneous expanse of daily life and their insertion of them into the context of art, but his stance is more wide-ranging. He considers the thing excerpted not as a kind of generic fragment of the world, to be made to vanish in a collage of other pictorial and sculptural elements, but as something to be exalted for its own identity, for the fascination and distinction that differentiate it from everything else. Thus he refuses to humble the commonplace object, as Marcel Duchamp does when he twists its function or its name. Oldenburg exalts these things in their most absolute singularity. He erects monuments to their identities, which, as in the best psychological literature, are always fragile, lacking, defenseless, secret.

The processes by which Oldenburg has obtained his effects – which are both emotional and tactile, private or personal and public or urban – are by now well-known: the varying use of large scale, of soft, sensuous materials, and, in the sited works, of careful placement of the object with regard to the nature of the location. Expelling the human figure, but borrowing its soft, mobile corporealness at will, Oldenburg has elevated the object to the role of actor, an actor capable of passing from the comic to the obscene, from the tragic to the sentimental. The object in Oldenburg's soft sculpture is of the fabric of life, it "thinks," it is subject to tremors and convulsions that contrast with its rigid paralyzed origins. Caught in the ambiguity of its suspended, fluid state between body and thing, it reveals an erotic richness. When touched or questioned, its epidermis both inflates and retreats, implying a sensual inner life, a hidden interior paradise.

This sensuous oeuvre, which has been amply discussed by other art historians, from Barbara Rose and Ellen Johnson to Coosje van Bruggen, brings to light the virtue of desire, which always tends toward the uncontrollable and unpredictable. It provokes an invigoration of things, and the dream of a flowering of their materials. For the explosion of desire breaks the object's immobility, and sets formerly clear, definite entities in crisis. It creates vertigo and chaos. Mobility, elasticity, plasticity, a sensory sinuousness – all these qualities are projected in the impulse, both carnal and material, that pushes Oldenburg to bring his works into being. As he has said: "At the bottom of everything I have done, the motive of most radical effects, is the desire to touch and be touched. Each thing made is an instrument of sensuous communication. Subject is more a device of engagement than something important in itself. The coming out into space (into real space) of the painting, the touchability of the painting, the isolation in space of the painting – "floating color" – all this having to do more with the period of *The Store.* The performances are a way for me to touch the world around me (and be touched). A studio or academy of touch, in which the players and audience are made aware of their bodies."[2]

Oldenburg is interested in the idea of growth, or, better, of expansion. He pushes the viewer's imagination to see a vitality, a dynamic force in the commonplace object, a force that makes its body rise and swell up. And since his first realization of this epidermal liberation, around 1960, the development of his work has itself pursued a continuous growth. Just as the physical development of an organism is a term of maturation and living duration, so the artist has followed the object in all its

stages, from birth – his discovery of the found object – to the full maturity of the monuments and of the later large-scale projects conceptualized with Coosje van Bruggen. The greatest excitement comes in the extension of the work from the sphere of art into architecture, as in the collaboration with Frank O. Gehry in 1984 to 1986 on the theatrical work *Il Corso del Coltello* (*The Course of the Knife*).

Because "the commonplace is the city," where everything exists but nothing is seen, being indifferent and beyond individual responsibility, Oldenburg's first environmental piece has to do with the urban surround. *The Street* (1960) is a room-sized installation made up of burlap bags and cardboard, in dull colors; the artist intended it as a symbolic "mural" of anonymity, in particular, of daily life on New York's Bowery. The pain and squalor of the place is reflected in the chipped, decaying materials that swath the walls, ceiling, and floor. *The Street* is an antiheroic work. It reflects the existential drama of the lower depths. But it doesn't recall Albert Camus' rats; it is simply, and therefore cruelly, a statement of existing conditions. It is an image on wastepaper of the cold, undramatic condition of the marginal, meaninglessly violent life of down-and-outs. In 1961, Oldenburg opened *The Store,* a shop on New York's Lower East Side. Here, one's glance could pass over scores of objects of desire re-created in painted plaster, their lusciousness underlined by their colors and the sensuousness of the medium. Every cavity held plaster foodstuffs, clothing, and other objects, their surfaces seeming not so much cool and smooth as stiffened and congealed. An ice-cream cone, a fried egg, a sandwich, a funeral wreath – through their painted skins, they brought out the richness of everyday colors, imbuing banal objects with splendor, reawakening them. *The Store*, Oldenburg writes, "may be better understood if it is considered not itself a psychological statement but a collection of psychological statements which exist concretely in the form of signs and advertisements. Placements and relation unfixed, free. An imitation not of nature or nature in the city but nature altered toward psychology, which is to say: the true 'landscape,' of the city."[3]

The work was an influx of interior energies that emerged from the stasis of the magmatic everyday through their presentation as provocative and exciting flesh.

If *The Street* is a work of retrieval, of record, then *The Store* was a labyrinth of American banalities, case studies ranging from the bride in white to high-top sneakers. Its images and objects were monuments to common obsessions. The result was a "baroque bordello" of the pleasures of consumption and class, reinvented and crystallized in plaster and violent colors. It was a cadaverous reincarnation of the grotesqueness of everyday life. *The Street* and *The Store* were silent theaters for the transmutation of the commonplace into art, and thus they opened up the approach that Oldenburg would adopt in his narratives and characters to come.

From 1962 on, Oldenburg was no longer satisfied with transforming only the substance and skin of an object, but reached toward modifications of both form and scale. In the soft sculpture, he simultaneously blurred and enlarged the shapes of things, as if moved toward an expansive gesture by the impatient plentitude of the commonplace. He would puff up a pay telephone, a hamburger, an ice cream cone, and their metamorphoses would introduce an element of tension, of surprise, a weakening of the stability of the viewer's perception. This vertiginous situation would dissolve the identities of "being" and "object," establishing around these two states a sort of seductive trance in which the individual understands his or her quality as an everyday thing, and the everyday thing undergoes an initiation into life. As Oldenburg remarked of the "Happenings" he created between 1960 and 1965, "The 'Happening' is one or another method of using *objects in motion*, and this I take to include people, both in themselves and as agents of object motion...I present in a 'Happening' anywhere from thirty to seventy-five events or happenings (and many more objects), over a period of time from one-half to one and a half hours, in simple spatial relationships – juxtaposed, superimposed...The event is made simple and clear, and is set up either to repeat itself or to proceed very slowly, so that the tendency is always to a static object."[4]

Oldenburg's Happenings, which are the remote matrix of *Il Corso del Coltello*, in particular appeared as linguistic abysses. Their participants' relationships to each other, to the space, and to the objects in the space were all changed. The Happenings implied an alteration of vision, a mixing of forms and materials, tempos and rhythms, theater and painting; they had an iconoclastic dimension. They also presupposed the disappearance of the subject, dislocated somewhere within a collective ritual; the play of mirrors that they set up threw into doubt the ideas of autonomy, of the objective, of the existentially true. The essence of the Happening was simultaneity and equivalence, the exchange of everything with everything else. In these destructurings of the representation of movements and words, things and figures, all solid content tended toward dissolution. Just as *The Store* was a kind of grasping of the commonplace object, so the Happenings were a kind of grasping of everyday language. And just as the Happenings were a disorienting fusion of order and disorder, in which the story tended to vanish in the wake of the action, so what struck the "client" of *The Store* was a sense of dissociated space, of the extraordinary multiplication, variation, and transitory identity of the objects and products on view. In Happenings such as *Injun* (Dallas, 1962), *Autobodys* (Los Angeles, 1963), and *Washes* (New York, 1965), the center of attention was removed from what was spoken to what was done, from the object itself to its passage. Since that passage was never linguistically explained it became enigmatic. Both in *Injun* and in *Autobodys* the deconstruction of story or representation caused central characters and theatrical archetypes to disappear, denying conventional theater's assumption of privileged dramatic moments and sequences in time. In fact, these works implied the eclipse of the tragic dimension of life in favor of a syntony with the everyday experience of everyone and everything. The commonplace was brought into focus: in *Injun* this could signify violence and disaster, war, aggressive instincts, arbitrariness, terror, pathos, and memory; in *Autobodys* it could evoke the lack of rules in Los Angeles' Kafkaesque metaphysical universe of freeways, parking lots, and cars. The happenings had an enormous dissolvent, nihilistic energy, for they transformed reality into a mere game of tensions, in which life and death were functions of accident and chance. They accurately reflected today's urban adventure, where countless things can

happen at the same moment. Perceiving the present in its social, collective, and worldly actuality, they tied the artistic event to the circumstances of the city.

Since 1976, Oldenburg, working with van Bruggen, always poses a relationship between his large-scale works and the historical and cultural environment. His permanent installations involve a flow of metaphors and allegories around the essence of the site, be it a street or a square, a museum or a skyscraper, a university or a factory, a city or a village. The commonplace object selected for the sculpture – a button, an umbrella, a flashlight, a ladder, an electrical plug – reveals the mark of the surrounding world. It is linked to the desires or needs of the various people who make up the urban constellation that surrounds it. Oldenburg's "Colossal Monuments," a series of sculptural projects from 1966 on, encouraged him in an effort of interpretation of the urban landscape, with obvious results in works that relate to architecture. Some of these ideas are for objects that would replace preexisting iconic architectural configurations: the proposal for a large-scale frankfurter, tomato, and toothpick for Ellis Island, in New York Harbor (1965), for instance, or for a pair of scissors to fill the space of the Washington Monument, in Washington, D.C. (1967). Here, Oldenburg hypothesizes urban meanings that are neither economic nor social, but rather have to do with passions, emotions, memories. His images trace a disturbing physiology in which the buildings along New York's Park Avenue are equivalent to a *Good Humor Bar* (1965), while the Chicago Tribune office becomes a huge clothespin (1967).

Through these works Oldenburg crosses the barrier of the commonplace, extolling the usually invisible object to the point where it becomes more than visible, "ultravisible." He discloses a view of the world as populated by signs, by seemingly ordinary things woven into dreams. Oldenburg and van Bruggen have been able to make some of their architectural projects reality. In part, the Chicago *Batcolumn* (1977), the Des Moines *Crusoe Umbrella* (1979), the Las Vegas *Flashlight* (1981), the Salinas *Hat in Three Stages of Landing* (1982), and the Weil-am-Rhein *Balancing Tools* (1984) are symbolic containers for the social, environ-

mental, and economic ideas that determine the environments in which they are placed. In addition, these everyday things enlarged to monumental scale serve to reveal and to perpetuate intimate, unknown aspects of the city. They are transformed into instruments that "agitate" the significance of the site, inviting a rediscovery of its original allegorical substrata. Once set in imaginative circulation, the play of cross-references and identifications to which they give rise upsets the order of everyday vision. The thing enlarged makes the private public, the invisible visible, the internal external. And this does not happen by chance; the works unleash the power of their images intentionally. Sometimes on the site, or in the local markets and shops, sometimes through studying the history of the city or the region in question, Oldenburg and van Bruggen choose their subjects so as to touch the heart of the place.

Having discovered that to cut the umbilical cord uniting everyday things in anonymity is to energize one's interpretation of the world, Oldenburg could make what is void and absent vibrate with life. In his vision, death is transformed into birth, and the spent bodies of an ashtray or a pair of scissors, a toaster or a light switch, radiate emotions – not only joy and happiness but anguish and grief. Through the soft sculpture, it is as if the everyday object had reentered the womb in search of another life, as if its larval, unformed state in the womb allowed it an existential multiplicity of being, a role as both thing and enigma. Such proposals as these cancel the distance between public reality and private intimacy. They signal a turning point in our way of thinking about buildings or areas of a city, monuments or bridges. Oldenburg's building proposals are constructions that both adhere to an essence of the imagination and incorporate entirely real, nonabstract forms, forms neither made up of geometrical figures, such as cubes or other parallelepipeds, nor based on Greek temples or other antique models, but re-creating objects of daily life, objects of consumption. Thus he illuminates the primitive origins of architecture.

Since 1984, Oldenburg, Frank O. Gehry, and van Bruggen have built an architecture that oscillates between a cosmology of usually zoomorphic images and the archetypal

permanence of the city, juxtaposing, in other words, the primitive and the technologically evolved.

One factor here is the precarious tempo and the transitoriness that regulate life in these artists' cities – Oldenburg and van Bruggen live in New York, Gehry in Los Angeles. The commonplace rules in places such as these, to the point where the present is the only dimension of time, and a forest of everyday objects is one's only home. In these labyrinths, these places without exits, Oldenburg, Gehry, and van Bruggen see traces of a primordial condition of human beings. It is as though they lived in a ruined world, marked by massive cataclysms and disasters. As in paleolithic necropolises, the artists travel about, perceiving objects and forms whose function is no longer evident. Mountains of images accumulate beside them, and they try to wrench them from oblivion. A fragment of the past – a button, a fish, a penknife, a serpent – becomes the image of a world to be rebuilt.

Gehry pushes into areas quite distant from the primitive, yet, while Oldenburg revives contemporary objects (some of them unspeakably, disturbingly beautiful, others repellently ugly), this California architect dedicates himself to a realm of natural and zoomorphic forms. He reminds us that the original figures of architecture were not circles or squares, but animals and human beings.[5] His use of the images of a fish or a serpent, an eagle or a crocodile, doesn't so much threaten the architectural tradition as it deepens it iconographically and, in consequence, technically. His *Fish House*, at the Castello di Rivoli, Italy, 1986, is not a negation of the abstract principles of most architectural construction, but an enlargement of them, so that they may include their "primitive" ancestors. Gehry's interest in zoomorphic figures can be compared to our prehistoric forebears' search for totemic images, a search that left its mark on their landscape as well as on their built dwellings. In fact, ancient hunters linked their practical knowledge and skills to their mythic beliefs, and their construction of their homes and villages was informed by a desire to establish a relationship between these structures and the human body. In particular, they often incorporated the figure of the giant in their villages, each part of which symbolized a part of the giant's body.

The metamorphosis of gigantic fragments into urban structures is a common principle for Oldenburg and Gehry. Yet Gehry does not use the human figures as a model; rather, he sets up a spatiotemporal continuity of the extremely old connection between dwelling and animal. Establishing zoomorphic references, rich in mythical and ritualistic implications in his buildings, he seeks roots in an ancient period when there was no distinction between animal, human being, and nature. Through this "excavation" he has defined a "Copernican revolution" of contemporary architecture. Reviving the mythical figures of the fish and the serpent as symbols of the founders of space and time, he has re-proposed a "natural" vision of architectural events. Thus he has reopened the city's ancient and continuous exchange between anthropomorphism and zoomorphism.

If one considers that similar concepts in prehistoric hunting societies were tied to the sacrifice and dismemberment of animals, in a ritual that eventually gave rise to the creation of the village, one gains a new perspective on the themes of the cut and the gigantic fragment in Gehry's and Oldenburg and van Bruggen's work. In their desire to free the commonplace and the primitive from their ties with the homogeneous and the anonymous, these artists have produced the iconic and structural ruptures that could lead to "sanctuaries of tomorrow." To obtain these breaks, through which a new urban methodology bursts out, they have produced cuts in reality. By slicing around an image and removing it from its everyday connotations, they have made it speak of a beauty or a dream not yet lost. The cut dissociates, rendering the object, the event, or the figure unique, changing its destiny. And Oldenburg and van Bruggen have often considered cutting instruments, like the pickax, scissors, and blades, for their projects, almost as if to emphasize that their intervention provokes a break in familiar chains of relationships. Thus it was natural that sooner or later there would appear among their urban metaphors the figure of the knife.

In 1983, the knife emerged from the silent crowd of everyday objects and entered the scene of Oldenburg and van Bruggen's work, to assume, first in a series of notes, the condition of a monument conceived for Basel (but unbuilt), and later, after a trip to Italy, the role of protagonist in *Il Corso del Coltello*. In the Basel idea, as a Swiss Army knife, it is an ironic metaphysical interpretation of the environmental and historical context of Switzerland; a sort of flag recalling the country's three linguistic geographies (German, French, and Italian), identifiable in the pair of shiny blades planted on the ground and in the irregular corkscrew poking up into the air. As a multiuse implement, it is an allegory for national multiplicity, the outcome of which is neutrality. At the same time in its indiscreet entrance in the quiet subalpine landscape, it suggests a world where the pocket-sized and the functional take control, confusing the outlines of things, breaking the silence, and establishing the grotesque situation of a federation "dismembered" into cantons. The knife here is a totem of separation.

Yet this object, like all mass-produced industrial products, can be born anew anywhere. Above and beyond the meanings it gains from its context, the knife acts as a witness to the "other." It signifies the cut, the active principle that modifies passive material; it is, therefore, a sign of physical and intellectual initiation, indicating the creative will that serves to distinguish and to clarify works of imagination and thought. And this was the way it was used in the collaboration between Gehry, van Bruggen, and Oldenburg on *Il Corso del Coltello*. The knife was offered here as a metaphor of a process of investigation, and as a correlative of the analyses and thought processes of the three artists, assisted by students at the Faculty of Architecture of Milan. These analyses focused on Venice's Arsenale, an immense urban knot in the city, which still waits to be loosened or cut. Given the vastness and uselessness of the Arsenale, Venice's ancient shipyard, the image of the large knife in *Il Corso del Coltello* implied an energy that could open up the space, activating it and transforming it into a channel or fulcrum that could vitalize the contact between the Laguna Morta (the "dead lagoon") and the Canale di San Marco. The idea crossed the boundaries between art and architecture.

For Gehry, architecture is a well-honed, two-edged scalpel that crosses, cuts, separates, distinguishes, and illuminates, cutting to the core of spatial, architectural and urban problems.[6] It is an active instrument of modification and cognition, an intellectual and environmental knife that penetrates buildings and building technology to reveal their infinite meanings. From the O'Neill Hay Barn (San Juan Capistrano, California, 1968) to the California Aero Space Museum (Los Angeles, California, 1982-1984), from the Cabrillo Marina Museum (San Pedro, California, 1979) to the Spiller House (Venice, California, 1980), from the Loyola Law School (Los Angeles, California, 1981-1984) to the Wosk Residence (Beverly Hills, California, 1982-1984), his projects, admitted into the California environment, upset perception and conventional conceptions of habitation, setting the imaginary and the real on the same plane, granting them a common life. This synthesis associates the visible with the invisible, the reproduced with the reflection, the natural with the artificial, the old with the new, the opaque with the transparent. For Gehry, the scalpel of architecture not only allows for the possibility of dialogue, as in the architect's houses, where one structure enters another, but places in doubt the difference between true and false, inside and outside, today and tomorrow. Through the cut, the city no longer appears as the background for an architectural dynamic, but enters into it. Gehry's urban houses are sum totals of interdependent structures. Kitchen, bedroom, study, and the other rooms form a kind of villagelike dwelling; to pass from one room to another, it is necessary to change buildings. (The Whitney House, Los Angeles, California, 1981, and the Wosk Residence exemplify this configuration.) Thus Gehry upsets the linear mode of perceiving space and function. Demarcating the territory, the autonomy, of the different zones of the house, he emphasizes their different qualities. He makes architecture out of everyday activities, like sleeping, working, washing, and parking.

In Milan, in 1984, working with this sort of methodological and conceptual syntony, Oldenburg, van Bruggen, and Gehry began to develop the piece that would become *Il Corso del Coltello*. They accepted van Bruggen's proposal of the knife as the icon in which the hypotheses and desires in question could be invested. A performance,

BASTA CARAMBOLA
(GERMANO CELANT) AND
GEORGIA SANDBAG
(COOSJE VAN BRUGGEN)
DURING REHEARSAL FOR
IL CORSO DEL COLTELLO,
CAMPO DELL'ARSENALE,
VENICE, ITALY, 1985

PAGE 236:
CHATEAUBRIAND (JOHN
FRANKLIN) ON THE PONTE
DEL PARADISO, DURING
THE PERFORMANCE OF
IL CORSO DEL COLTELLO,
VENICE, ITALY, 1985

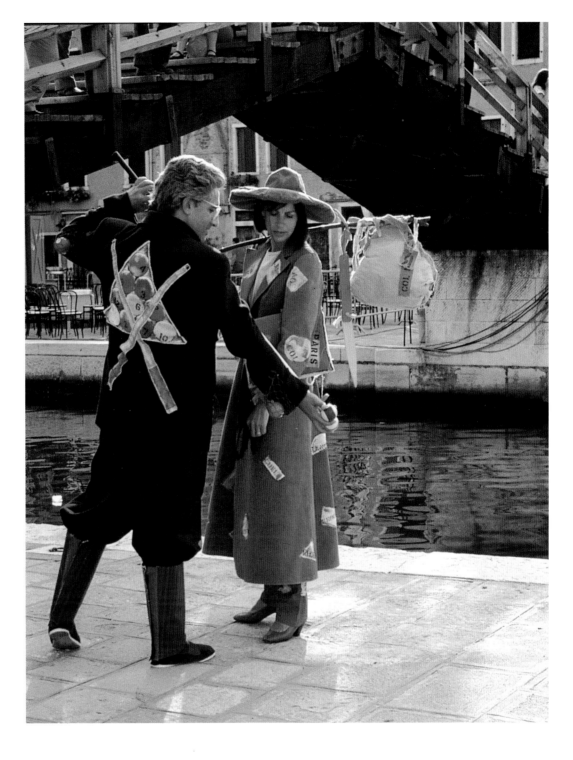

they thought, could be used to establish a connection between the Arsenale and the lagoons, while architecture would involve the building of an archipelago of islandlike buildings in the Laguna Morta. The knife would move between the two realms, the cutting device separating and/or unifying the two projects. Architecturally, its image would be rigidified in stone and in wood, so that it would grow as a building on the ground – a bank, surrounded by buildings in the form of serpents and binoculars – and also as a ship, symbol of a daring and unpredictable voyage. In this latter role, it would have a flexibility of site and function that would move it into the realm of performance. From these plans, two real projects emerged – the design of Camp Good Times, for children ill with cancer, in the Santa Monica Mountains of California, in 1985; and *Il Corso del Coltello* itself, a spectacle realized in Venice over the period September 6-8, 1985.

In *Il Corso del Coltello*, the knife became a visual metaphor designating the quality of activeness of both actors and objects. Through costume, it assumed human shape in the form of a souvenir vendor, Dr. Coltello (performed by Oldenburg), flanked by dogs and by a dancer in his

233

image, who made the event light and humorous. As a boat, it conquered the Arsenale canal. Its long oars made it a ritual ship, running along like a young *Bucintoro.* Naturally, its multiple presence on the scene created a magical, hermetic climate; it seemed to condition the events and sets, the actions and internal rhythms. Following its course, it pushed toward an osmosis between the historical and contemporary eras, and toward an integration between European and American culture. Set in Venice, the site of a dramatic encounter between former achievement and contemporary mass tourism, between past and present, between history and kitsch, it placed itself – like all knives – halfway between the two sides of the historical wound; it worked on the local history's contradictions. It gave significance to the dialectic between being and appearing.

In this last function, the knife broke up the continuum formed by the characters of *Il Corso del Coltello.* These characters were a mixture – or, better, a layering, a doubling – of the literary and the everyday, the philosophical and the personal. As conceived by van Bruggen, they were hybrid entities, their aspirations and desires hidden. One went from Dr. Coltello, a souvenir vendor who wanted to be a great painter in the manner of Canaletto, to Frankie P. Toronto (Gehry), a barber who delighted in architecture and would have liked to be the new Palladio; from Georgia Sandbag (van Bruggen), a travel agent who had decided to follow her poetic fantasies, like George Sand, to Basta Carambola (Germano Celant), a pool player who felt like Giordano Bruno; from Primo Sportycuss (Pontus Hulten), an ex-boxer and ex-patron saint of Venice, to Chateaubriand (John Franklin), the frustrated lion fragment. All were dressed as objects, wearing perhaps a corkscrew tie, a column-jacket, wooden trousers, or a crocodile tunic.

These characters joined their discourses on architecture and art, culture and life, with the sounds of the city on the lagoon. They carried on a dialogue with the cooing of the pigeons, the slapping of the waves from the passing boats, the clatter of the restaurants, the footfalls and talk of the hordes of tourists, all the noises of contemporary Venice, which form a kind of Gordian knot of mass culture, entangling and consuming history. Thus the spectacle revealed a certain vertigo, and the actors and the characters they played enunciated their own downfall. They called attention to their own hidden sides – to Hulten's life as a boxer and Celant's as a pool player, to Gehry's wish to make a mark on the history of architecture and van Bruggen's to wander the world writing novels. And here again the knife came in, crossing the stage, showing that identity is neither secure nor one-sided but double. Through the individual participants, it demonstrated carnality, psyche, and history. It slipped into every possible opening, lacerating and pitiless, exposing both the private side of the actor and the public face of the character, which were never separated here. In fact, for Oldenburg, van Bruggen, and Gehry, subject and object are not opposite, but complementary; the one recognizes itself in the other. Frankie Toronto's costume and fish hat were reflections of Gehry's architectural vision, while the souvenir vendor-cum-painter Dr. Coltello was the double of Oldenburg, who makes the commonplace and the kitsch into the materials of art.

This kind of play of cross-references can be infinite, but it was clearly defined in Venice, the city of the cultural hybrid. The characters who moved among the small tables of the curious café in the Campo dell'Arsenale during the three September days of the project's duration were figures in a comedy of the commonplace object. The small square became a meeting place for an eighteen-foot-wide coffee cup and saucer, an "ancient" temple made of Styrofoam, a sphere twelve feet in diameter which, rolling about, seemed to have crushed and collected various pieces of furniture and housewares, a sliced column, odd fragments of soft architecture, a lion statue that sang from Verdi's *Otello,* and, in the starring role, the *Knife Ship,* seventy-eight feet long with its blades opened up, and with a twenty-seven-foot corkscrew. The dominion of these commonplace objects over the various characters reflected American ideas of the relationship between objective reality and human beings, while the textual elements of the work, involving an ironic babble of languages, were European, orchestrated by van Bruggen. Everything existed under the banner of a dissociative strategy that assembled materials in a sort of ordered chaos. Here the commonplace became a mysterious and magical world.

IL CORSO DEL COLTELLO

If, for Gehry, the first subject of architecture is the tie between the fragmented zoomorphic figure and the dwelling, and if, for Oldenburg and van Bruggen, the matrix of art lies in the fall and the explosive, ubiquitous dissemination of the giant whose name is "Everyday," then for all three, creation springs from an initial state of chaos, a catastrophe of meaning. The consequence of this event is a liberation from the power of a single and monolithic vision. These artists seek architecture or objects in which the parts fall, twist, seethe, and whirl, in which perspective is dislocated and multiple. Any visual sense of the whole falls apart in the uncertain relation between support and image. Verticality and horizontality are confounded; there is a progressive loosening up, a rupturing of continuity, of rhythm, of fixity, of art and architecture's sense of absoluteness and totality. Fluctuation, instability, nomadism, and the cut were catalyzed in *Il Corso del Coltello,* for this was a vertigo of images, marked from beginning to end by a feeling of catastrophe, of the swallowing up of hundreds of fragments in an unarticulated mass, of a hinge swinging between the everyday and the imaginary.

The project/performance opened with a fantastic synthesis of history and the present, kitsch and antiquity. At the entrance to the performing space, on the Rio della Tana canal, stood the brightly lit *Espresso Cup Column,* a twenty-four-foot-high soft-sculpture pillar with a huge coffee cup at a dangerous angle on its top. The piece stretched the limits of logic, but signified the two aspects (or, better, the two "blades"), sense and non-sense, of *Il Corso del Coltello.* In fact, the whole spectacular event oscillated around the sense of the double, the interweaving of impossible or unthought-of combinations that here were seen as both possible and thinkable. It constructed an independent order that was disorder, a concrete language that was desire. The *Espresso Cup Column* was the axis that sustained and supported the meaning of the project. As a symbol, it marked the passage between one world and another, and suggested an erotic, sensual relationship – one could see it not

only as column and cup but as mushroom or penis – with the universe of objects and history. It could have been the tree of life, half human and half thing, commemorating the glorious gestures of new beings, but it was also a votive, a triumphal column erected to the ephemeral memory of new heroes and new power. (It inflated and deflated, like objects of consumption.) Like Trajan's Column, in Rome, or the columns of Solomon's Temple, it symbolized a path to other worlds, where unpredictable combinations gave meaning to imbalance and chaos.

Upon entering along the Fondamenta della Madonna, the spectators were divided into groups of twelve. The number symbolizes to me the internal complexity of the universe; it represents the four elements – air, fire, earth, and water – multiplied by the three alchemic principles. This division, then, marked the transformation of the public's energies; the multitude was changed into "the faithful:" (The number twelve was also the number of the disciples of Christ, and the number of the Knights of the Round Table.) Each group of spectators was guided along the Fondamenta della Madonna by waiters in black costumes with large white bow ties, or by busboys wearing large aprons and colored bow ties. Passing over the Ponte dell'Arsenale – called the Ponte del Paradiso (the Bridge of Paradise) in the performance – they came to the Campo dell'Arsenale. (This theme of the initial procession had appeared before in Oldenburg's work, in the Happening *Injun.*) Here, in the ample space of the piazza, the spectators found themselves facing a "café" with tables and chairs, where they sat down. At the center of the café a red serpent was coiled around a flagpole, while some distance back, toward the Calle della Pergola, stood a pseudo-Greek temple, the *Temple Shack*, covered with tar paper. Between the serpent and the temple the space around a small tree had been laid with planks painted green, and under the tree stood a stylized pool table. While the temple and pool table were functional in terms of particular characters who would appear later, the serpent functioned only in terms of the whole. As in ancient legends, it represented the profound, dark, mysterious psychic links between different aspects of human nature, or between our conscious selves and our hidden "doubles." It represented also the metamorphoses that the city of Venice has undergone and continues to undergo, for its multiple scales suggested an infinity of existences interlapping and underlying each other with neither beginning nor end, like the layers of art and history.

Strange characters moved about among these constructions. In addition to the waiters serving the café patrons, one could see Dr. Coltello painting at an easel in the center of the piazza. Before the door to the Arsenale stood a dancer, Sleazy Dora (Brina Gehry), beside some lions and a violinist (Luisa Messinis); leaning on a table, the boxer, Primo Sportycuss, slept, snoring sonorously; next to the pool table stood Basta Carambola, his suit matching the table in its net pockets full of pool balls. Among all these, the magnetic center was Dr. Coltello. His solitude was almost absolute (he was after all, the artist); he was accompanied only by his dogs (Alejo and Sami Gehry, also dressed in knife costume), travelers or messengers between the worlds, symbols of the continuity of the generations. From below, the dogs questioned and communicated with the hero. They were the guardians of tomorrow, of the future.

Yet despite its silent core, the café scene was neither quiet nor static. Rather, it was chaotic, as if the public had caught the actors and technicians before they were ready to begin. The space was full of confused and disorderly sounds, the chairs were out of place, and the characters appeared discomposed and nervous. The lights were too bright, and a number of the slides projected onto a large screen in the piazza were upside down or sideways. This sort of disorder seemed greatly to irritate Basta Carambola; he ran about criticizing the company, yelling at the sound technicians and at the public, trying through shouted words to stave off a professional debacle. This pool player saw a baize table in every surface, pool balls in every thing, and the trajectory of a carom shot in every movement in the space. Knowing the rules, strategies, and combinations of the game, he knew that in order to win, one must place all the elements correctly. Thus Carambola represented reason, discipline, calculation. Accomplice of the artist Dr. Coltello, he used words in an attempt to clarify and organize elusive creativity. In fact, he was a kind of translator, for his words aimed to transform the words of another, the artist, into a new language. So this character was a reflection of the actor who played him, the critic, who tries to give written or spoken order to the secret correspondences of things, to give form to the formless, or, better, to what remains formless in his thoughts. He seeks reason within the conflict of noises and images, hoping to give unity and logic to chaos and disorder – the most obvious elements of The Café, the title of this first part of *Il Corso del Coltello.* The public was introduced into an aural, visual, physical, and gestural indeterminacy; it was not allowed the satisfaction of a cohesive vision, but was presented with an accumulation of uncontrolled fragments, viewable from an infinite number of perspectives.

Once the spectators had been seated, in groups of six, the busboys and busgirls served them – with colored water, which they poured into the hollow surfaces of the tables, forming small lagoons into which they placed floating bits of a plan of the city.

Venice, then, was the first thing served up; these disconnected pools of water were like the nucleus of this city of water, chopped up and shattered by mass tourism, yet still providing the context that united the public, the stage, the objects, and the actors in the performance. The water came in blue, yellow, red, orange, purple, and green, the basic colors of a painter's palette. While this was going on, sometimes accompanied by the music of the violinist, porters dressed in gray were rolling large letters of the alphabet over the bridge. Two O's, a *C*, and an *E* duly arrived in the piazza, to be arranged around Dr. Coltello, who continued serenely to paint "in the style of Guardi" and to talk softly to his knife dogs, oblivious to the chaos that surrounded him. This flowing of large letters onto the stage brought to mind the accumulations of *The Store*: here as then, the space assumed the appearance of a cavity, a receptacle for objects. These rolling letters, transported from a distance, seemed to signify an "elsewhere" from whence Dr. Coltello and his companions had come, and the concept of an "elsewhere" suggested the idea of the

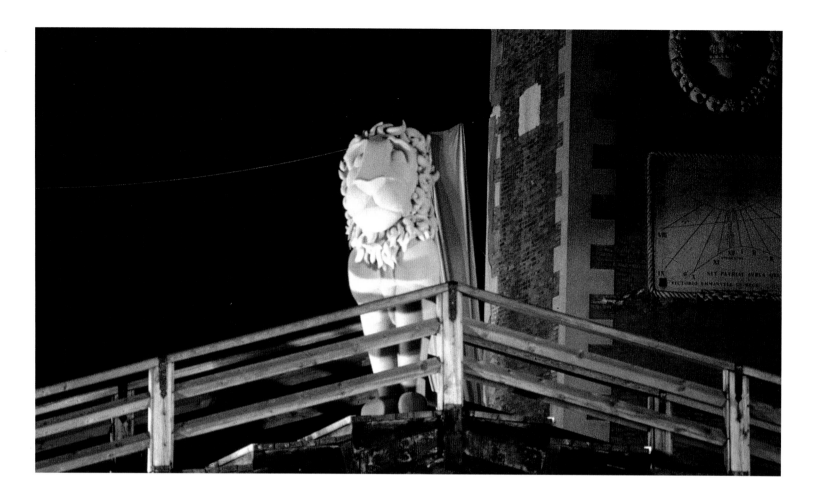

voyage (Dr. Coltello was also called "Murky Apollo," a punning version of "Marco Polo").

Thus the café was transformed into a temporary stopping-off place for the hero. With the arrival of three wood *L*'s and a *T,* the letters' transfer was complete, and they made up the word *coltello.*

Adding to the uncontrolled elements of the performance was a taped score combining voices and noises. This score turned sound into a matrix of splintered and superimposed events, contrasting strongly with the performance of the violinist, who played the kinds of classical pieces often done for tourists by the orchestras in the Piazza San Marco. The tape was violent in impact, and it tended to take over and envelop the space. Oldenburg wrote about his performances in the 1960s: "In my theater the word is not used very much. I don't believe in speeches. The theater is largely visual or tactile, and my use of sound is also concrete. Sound is treated as an object. A naive and literal application of this yields the phonograph record – tangible visual sound,

with a mechanical, material quality. Making references, especially if it is an old record. A record is an event in itself... Other than records the sound in the compositions is the sound of objects, especially of course falling ones. Smashing ones, crushing, stroking, dripping, pouring, scratching, etc. etc. Words are exclamations, grunts, groans, inexplicable human sounds."[7]

And so The Café inaugurated a metaphorical and symbolical flow, a murmuring vortex of "things" that moved about over an uneven terrain. Here chance and chaos were always at work, dictating moves and countermoves, thwarting all efforts at foresight or plan.

In the fall of 1984, when it had been decided actually to realize the performance, van Bruggen, taking George Sand as her guide, set out with a purpose, doing extensive background reading and research on Venice and its history, and branching out into travel journals, especially concerning American writers and artists visiting Italy. Eventually, this reading crystallized in a multitude of images, events, and characters,

which made possible the development of a complex script. *Il Corso del Coltello* recalled happenings in its "total spectacularity," but in other ways it was closer to the commedia dell'arte. Thus it was a bridge between ancient and modern, between European and American. Unlike the happenings of the 1960s, the performance depended on the behavior of specific characters, as conceived by van Bruggen; at the same time, however, it was quite improvisational, relying on the spontaneity of the various actors. As in the sixteenth-century commedia, the dialogue was improvised on the spot. Furthermore, while the entrances and exits of the characters and objects were scripted, precise actions were not learned by heart, but were left to extemporization. Thus everything worked for a controlled chaos, which Oldenburg, van Bruggen, and Gehry used for the transmutation of energy into new forms. They entrusted themselves to the aleatory, allowing for uncontrolled forms to emerge from the material.

The climax of the uncontrolled explosion of The Café arrived when a silver blade

sliced through a wall of the *Temple Shack* and Frankie P. Toronto – the *P* standing for "Palladio" – emerged from the cut. The impetuosity of his appearance was such that the temple fell into ruin. Toronto's arrival coincided with the passage (or cut) from The Café to The Lecture, the second section of *Il Corso del Coltello.* The dramatic destruction of the temple, then, symbolized the architect's act of freeing himself not only from the constrictions of the temple, seen as the tradition of historical iconography, but also from a part of the performance. (The Italian for "temple," *tempio,* is very close to *tempo,* a scene or act of a play.) In this traumatic event lay another beginning. Throwing himself into his lecture, Toronto argued that architecture does not consist in the disinterment of the ruins of the past, as the Postmoderns believe, but rather in the unsettling effect created by buildings that are born from "cutting and slicing – that is the way buildings are made." The temple fell because for the architect, as for Heidegger, novelty consists in "continually knocking the bottom out of historical contexts." For this reason, Toronto continued, "real order is disorder."

This is why history, represented by the *Temple Shack,* was cast not as an irremovable, stable rock in *Il Corso del Coltello,* but rather as a light, aerial structure, easy to take apart and move away. And once it had been moved, space was available for the new Palladio. The character of Frankie Toronto was born from the linguistic disaster that reduces architectural signs to zero (at one point in the performance, his friend and mentor Basta Carambola suggested to him that "the earthquake is the basis of architecture"), bringing us back to a primitive time when dwellings and villages were constructed in the form of tortoises or jaguars. He was obsessed not with Palladio, but also with architecture in the image of trout and serpents, so much so that his costume, which recalled a Palladian basilica, was completed by a hat in the form of a fish, and the slides projected during his lecture depicted fish and snakes inserted like skyscrapers within the cityscapes of Padua and Venice. In his role as orator, Toronto was assisted by Carambola, who corrected his pronunciation and clarified, when possible, his concepts of zoomor-

phic architecture. Both men used words as active and dramatic signs, capable of representing both thoughts and the experience of a dream – of architecture.

The whole stage, meanwhile, was flanked by the slow rise of fragments of soft architecture along the facades of the houses. These fragments recalled infancy and magic, as in Savinio's painting *Oggetti della foresta* (*Objects of the Forest,* 1927). The letters that the porters carried in to form the word *coltello* were also architectural: placed close together, they formed an interior (similar to those of de Chirico's paintings), where Dr. Coltello moved about. That it was an "interior" was confirmed by the fact that the letters were his baggage, but the baggage was also the unconscious, which is why other figures emerged from it. The letter *L* opened up and the Leopard Woman (Berta Gehry) came out, followed by the Knife Dancer (Rossella Fossati) and D'Artagnan (Luca Locatelli). These characters – souvenirs of Dr. Coltello, vendor to Venetian tourists – moved around him and completed the geography of his universe as man, painter, traveler, and seller of kitsch objects. Taken in their corporeality, they revealed his search for both pleasure – identified by the feminine (Leopard Woman), a double of sensuality and rationality – and power, identified by the masculine in the figure of D'Artagnan, both braggart and warrior. Seen as icons and objects, these souvenir characters were fragments beautiful to both the artist's eye, drawn as it is to the commonplace, and the eye of the tourist collecting kitsch souvenirs of a Venetian adventure. The idea of the animated object, or of the thing impregnated with desire, opens the questions of Oldenburg's relationship with Surrealist poetics, but the Surrealists were seduced by still lifes, by fetishes and "exquisite corpses," while Dr. Coltello surrounded himself with fragments and objects that danced and ran, climbed and sweated. To Oldenburg, desire is still alive, and the ruins of the present, whether Venetian or universal, are the sources not only of death, but of pleasure.

During The Lecture the Waiters at the café tables began to recite the "specials of the day," strange dishes using objects from the performance – cream of cork soup, billiard balls with ricotta and sausage, an omelette of limp oars, and so forth. And the Busboys

and Busgirls brought cardboard plates imprinted with images of food. The sustenance being offered to the public in this work, then, was fiction, painting, theater, and particularly what satisfied the eye. The plates were set afloat in the colored-water pools of the tables. Meanwhile, certain elements on stage, hitherto immobile, took on life, as if awakened by the vision of food. In particular, one of the stone lions that stand before the Arsenale miraculously moved, it approached Dr. Coltello, and, between one roar and another, began to sing from *Otello.* This was Chateaubriand, a cross between a statue and a living animal (just as Frankie P. Toronto was a mixture of architecture and fish), a fantastic being reminiscent of the human/animal griffin of medieval statuary. As his name indicated, Chateaubriand held a power born from a crossover between literature and politics. The guardian of the Campo dell'Arsenale, he represented the glory of the lagoon of old, but his terrifying roar was transmuted into a lyrical tenor by the miraculous creative energy that impregnated the performance space. A double-natured divinity, he emerged from Venice's history to be transformed into a many-lifed siren, the lion genius of Italian bel canto.

The characters continued to spread out, with Sleazy Dora dancing floridly as her introverted nature opened up. Her movements recalled alternately Isadora Duncan and Oskar Schlemmer, and she displayed a light, controlled intimacy. In contrast, the boxer, Primo Sportycuss, had awoken, and had become noisy and agitated, even sparring with the immobile serpent. At this point all the elements and characters of *Il Corso del Coltello* seemed to be in place and functioning to perfection, when Georgia Sandbag entered from the north end of the piazza. She was followed by the gigantic *Houseball,* a sort of enormous vividly colored meteorite held together by thick rope, and studded with tables, chairs, doors, and windows it seemed to have picked up as it rolled along. The entrance of Sandbag and this dangerous-looking object, a sort of visual avalanche, drew attention away from the other performers. Frankie P. Toronto, furious at the intrusion, cut off his lecture, and set himself to designing buildings. Basta Carambola concentrated on his pool game, or sat under the tree to chat inti-

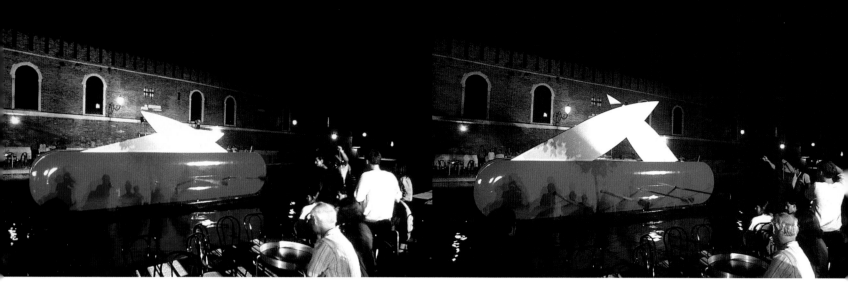

mately with the pigeons. Dr. Coltello took out his merchandise and tried to sell some of it to Primo Sportycuss, while his souvenir characters exercised in silence. The stage belonged to Georgia Sandbag, the true protagonist of The Lecture, and of the opening section of The Bridge, the third part of the piece.

With the *Houseball* in her wake, Sandbag seemed a manifestation of the vortex overtaking concreteness and materiality. Her movements upset and corroded the established rules of passage and the fixed state of the other characters. Anomalous, she refused definition, but was always moving, and always carrying behind her the weight of the condition of "housewife." Emerging from a dark corner of the space, she symbolized the hidden part of the psyche that resists every attempt at control. In her travels Georgia Sandbag never took the same route twice. What mattered to her was the terrible, stressful experience of discovering new and different paths to follow, like a pioneer, in order to learn. Like Dr. Coltello and Frankie P. Toronto, Georgia Sandbag, too, moved in the space of precariousness and the time of transience; she was constantly accompanied by the *Houseball*, a world unto itself of ruined commonplace objects. Sandbag, however, had a certain sureness in her loquaciousness. She used words to describe the actions of the other characters, to put them in a critical position. While they sculpted and built, she constructed discourses. In fact, she gained her disruptive power by lowering her head to read her journals, so that she experienced a rush of blood and saw the world upside down. This view brought her into opposition to human follies and illusions, to the point where she eventually cut Frankie Toronto's mustache to reveal his true self, and, in a slapstick sequence, broke Dr. Coltello's beloved landscape painting over his head to dispel his pretensions. (This action was positive: the landscape was transformed into a book.) Sandbag lived out violent contradictions: she was both traveling companion and gadfly; she moved with agility, yet carried a great weight behind her; she was marked by her travels, but looked to them for vital change; she was the obscure and terrifying, yet precarious, truth. Only Basta Carambola seemed to understand her, elude her, and disturb her, perhaps because he shared her interest in words. In fact, he talked with her about obsessions, making a clatter with his pool balls, and about sexual and literary tensions, resorting to his cue to underline ambiguous verses and phrases. The one aspiring to become Giordano Bruno, the other to be George Sand, these two characters were joined by a common passion for philosophy and art – two "cutting" personalities, intellectual and emotional martyrs.

After the first moments of panic caused by the irruption of the *Houseball*, the other characters resumed their activities. Frankie P. Toronto, followed by a faithful silver fish dragging its severed tail, dedicated himself to his theories and to his lecture, teaching a group of students/washer-men and -women architecture through the use of red and white blocks. Eventually, these would be adapted to build a throne for Toronto. Carambola went on playing pool, seeking with each stroke to make the balls into subject matter for Dr. Coltello's paintings. And Georgia Sandbag, having paced around the café, followed by her cumbersome ball, devoted herself to reading about the poet Byron. Her interest in the subject was echoed by the presence in the café of Lord Styrofoam (John Miller), a minstrel, dressed half in silk and half in a wet suit, whose passion for Byron had made him want to swim in Venice. The lagoon being polluted, he was forced to pretend to swim, sliding along in the air on a luggage trolley. Sharing their literary passion, Georgia Sandbag and Lord Styrofoam embarked on a romantic journey, in a small gondola on the Canale dell'Arsenale, enriched by the presence of the sweet Sleazy Dora.

A state of calm was barely established when another event shook the space. A long softsculpture column sliced into sections and threaded with a rope was pulled by the porters onto the bridge and used in a tug-of-war. After a while one side let go, scattering the parts of the column over performers and public. This ruinous fragmentation forecast the greater catastrophe that would end the performance, and indeed marked the transition to the fourth and last section of *Il Corso del Coltello*, The Ship. By now almost taken over by huge objects such as the *Houseball* and the architectural sculptures, the work was moving ever closer toward breakup. With their uncontrolled energy, forms had filled all voids, so that the space of the piazza overflowed with marvels and monsters. The characters and the objects had begun to communicate through physical contagion, banging and crashing into each other, and the space was

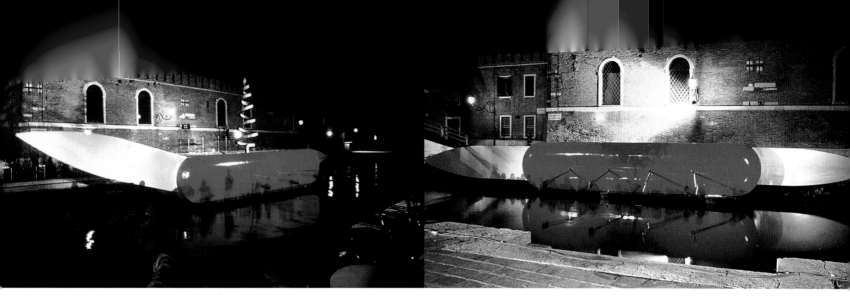

transformed into a magma, a Babel-like sound box. The scene was like a study of Hieronymus Bosch's *Garden of Delights*, with nets and soft pieces of architecture, pool tables and baggage, statues and souvenirs transformed into human beings in the place of the painting's alembics, gnomes, bats, and dragons. Rather than the heresies and alchemies of Bosch, the preference here was for the hybrid and the kitsch. For we were in the Venice of 1985, a city that over the last century has undergone a social and physical dismemberment through tourism. A place of transit for daily droves of visitors drawn to its history and its legends as to candy, it is in a state of decay. Venice today is a dispersed, indescribable landscape, a vertigo of crashes and collisions among hybrid cultures. And *Il Corso del Coltello* was a reflection of this. It followed the same rhythms and chaotic tempos, taking its shape from disorder, from fragments, from ruins, from unlikely juxtapositions. Like Flaubert's *Salammbô* and *Bouvard et Pécuchet*, it was a dramatic essay on the city, which was seen as literally made up of remains of irremediably fragmentary quotations within a unified organic frame.

Consulting his pigeons for omens, Basta Carambola now realized that the presence of the beings on stage, so many of them part human and part object, foretold catastrophe. Other things also hinted to him of the pending fate of the strange Venetian café: for example, the sight of Frankie P. Toronto sitting on the ziggurat-like throne he had built, recalling the prophecy about architecture and the earthquake, and also a violent argument between Georgia Sandbag and Dr. Coltello, culminating when she broke the landscape painting he had been working on over his head. Landscape, then, was to open up and break apart. Following his instincts as an intellectual sibyl, Carambola began to communicate his worries aloud, in the form of short fictional stories. Then, when a giant knife emerged from a building and, at the same moment, the soft architectural elements fell to the ground, fear and distress made him cry out, "At ten o'clock in the evening an enormous fissure will spread from the dead to the live lagoon! A violent earthquake is coming. The tremors can already be felt. The dead will number in the hundreds. It is the catastrophe. The catastrophe. You'd better flee. Get moving! Move! Move!" The reason for the earthquake was unknown, but when Carambola pointed to the canal, it became clear that the direct cause of the rupture to come was the arrival of the enormous *Knife Ship*, equipped with oars, blades, and a corkscrew. As this visionary image cut slowly through the waters of the Canale dell'Arsenale, once Venice's shipbuilding yard, it began to show its fearful power, raising and lowering blades and corkscrew, enthralling in its strength and magic. Its monumental appearance justified all the cataclysms and metamorphoses that had preceded it; it suggested a reality beyond the human, a metaphysical paradise. The *Knife Ship* was a living myth, and all the characters ran to watch it from the Ponte del Paradiso. They shouted and rejoiced at its appearance, while Basta Carambola threw a foam-rubber ring painted gold into the water, sealing the union between the beauty of Venice and the strength of the *Knife Ship*, and underlining the amorous relationship between *Il Corso del Coltello* and the Arsenale. Finally Carambola revealed the secret and fantastic fact that had provoked the catastrophe: "Niagara Falls and the Alps have decided to spend their honeymoon in Venice!"

[1] Maurice Blanchot, *L'Entretien infini* (Paris: Gallimard, 1969), pp. 321-331.

[2] Claes Oldenburg, statement in an interview with Gene Baro, *Art and Artists* (London), December 1966.

[3] Claes Oldenburg, *Store Days* (New York: Something Else Press, 1967), p. 49.

[4] Claes Oldenburg, "A Statement," in Michael Kirby, *Happenings: An Illustrated Anthology* (Dutton: New York 1965), pp. 200-201.

[5] See Enrico Guidoni, "Antropomorfismo e zoomorfismo nell'architettura primitiva," in *L'Architettura, Cronache e Storia* (Rome), no. 222, 1974.

[6] See Germano Celant, *Frank O. Gehry* (New York: Rizzoli International Publications, 1985).

[7] Claes Oldenburg, *Injun and Other Stories* (1960) (New York: Something Else Press, a Great Bear pamphlet, 1966).

Originally published in Germano Celant, *The Course of the Knife: Claes Oldenburg, Coosje van Bruggen, Frank O. Gehry* (Milan: Electa, 1986)

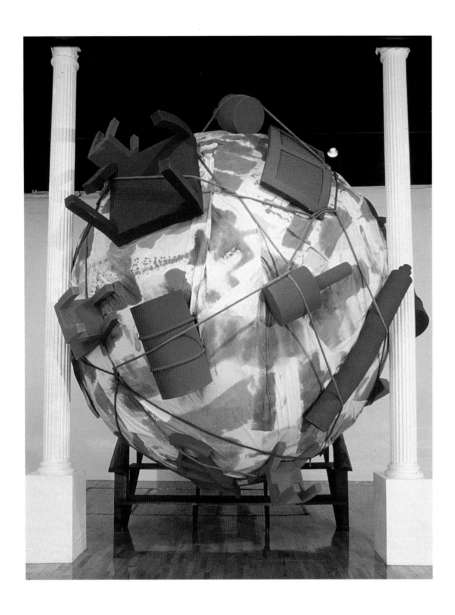

PREVIOUS PAGES:
THE KNIFE SHIP IN FOUR
STAGES OF FOLDING ITS
BLADES AND CORKSCREW
DURING THE PERFORMANCE
OF *IL CORSO DEL
COLTELLO*, VENICE, ITALY,
SEPTEMBER 6-7-8, 1985

THE COURSE OF THE KNIFE,
LEO CASTELLI GALLERY,
NEW YORK, DECEMBER 13,
1986 – JANUARY 24, 1987.
WORK SHOWN IS
HOUSEBALL, 1985

FOLLOWING PAGE:
*ST. THEODORE COSTUME
IN LETTER "T,"* 1985
MODERNA MUSEET,
STOCKHOLM

—— *THE COURSE OF THE KNIFE*, Leo Castelli Gallery, New York, December 13, 1986 – January 24, 1987. Book.
Works exhibited: *Model for Frankie P. Toronto's Hat on Stand*, 1985, cardboard, 14 $^1/_2$ × 9 $^1/_4$ × 8 $^5/_8$ in., on stand 9 × 20 $^1/_2$ × 16 $^1/_4$ in.; *St. Theodore Costume in Letter "T,"* 1985, costume: canvas filled with polyurethane foam, painted with latex, letter "T": wood and canvas labels painted with latex, tunic and breastplate: 48 × 27 × 2 $^1/_2$ in., spear: 81 in. high, shield: 52 $^1/_2$ × 22 $^1/_2$ in., halo: 16 in. diameter, crocodile: 12 × 10 $^1/_2$ × 126 in., letter "T": 85 $^1/_2$ × 55 × 19 $^3/_4$ in.; *Prototype of the Houseball*, 1985, steel, muslin, polyurethane foam, rope, painted with latex, approx. 38 in. diameter; *Soft Book*, 1985, canvas filled with polyurethane foam, painted with latex, 42 × 28 × 20 in.; *Prototype for Dr. Coltello's Baggage*, 1985, balsa wood, canvas, string, painted with latex, letter "C": 8 $^1/_2$ × 7 $^1/_4$ × 2 $^1/_2$ in., letters "O": each 7 $^1/_2$ × 8 $^3/_4$ × 2 $^1/_2$ in., letters "L," "T," "L," "L": each 9 × 5 $^3/_4$ × 2 $^1/_4$ in., letter "E": 6 $^3/_4$ × 7 $^1/_4$ × 2 $^1/_2$ in.; *Basta Carambola Costume: Jacket with Pool Balls*, 1985, jacket: fabric, expanded polystyrene, painted with latex, 34 in. from neck to hem; *Model of Espresso Cup Balloon*, 1985, wood painted with latex, overall dimensions: 41 × 17 × 17 in.; *Umbrella*, 1985, polyurethane foam, canvas, painted with latex, 48 × 28 × 30 in.; *Architectural Fragments, Small Version*, 1985, canvas filled with polyurethane foam, stiffened with glue and painted with latex, overall dimensions: 38 × 124 × 8 $^1/_2$ in.; *Chateaubriand Costume*, 1985, polyurethane foam painted with latex, on wood and metal base, 101 × 30 × 35 in.; letter "E," 1985, polyurethane foam covered with plastic cloth, canvas labels painted with latex, 96 × 76 $^1/_2$ × 23 in.; *Georgia Sandbag's Book with Dangling Punctuation*, 1985, canvas painted with latex, polyurethane foam, vinyl, leather, notepaper, felt pen, T-pins, 13 × 9 $^3/_4$ × 1 $^3/_4$ in., with punctuation extending 15 in. below book; letter "O," 1985, polyurethane foam covered with plastic cloth, 98 × 76 × 24 in.; letter "L" – *Red*, 1985, wood and canvas labels painted with latex, 85 $^1/_2$ × 55 × 19 $^3/_4$ in.; letter "L" – *Blue*, 1985, wood and canvas labels painted with latex, 85 $^1/_2$ × 55 × 19 $^3/_4$ in.; letter "T," 1985, wood and canvas labels painted with latex, 85 $^1/_2$ × 55 × 19 $^3/_4$ in.; *Birds with Stands*, 1985, expanded polystyrene, wood, painted with latex, felt pen, birds: each 18 $^1/_2$ × 14 $^1/_4$ × 1 in., shelf: 19 × 18 $^1/_2$ × 8 $^1/_2$ in.; *Sliced Soft Column*, 1985, canvas and polyurethane foam painted with latex, 6 parts: 2 parts, 70 × 70 × 24 in., 4 parts: 60 × 60 in. diameter; *Temple*

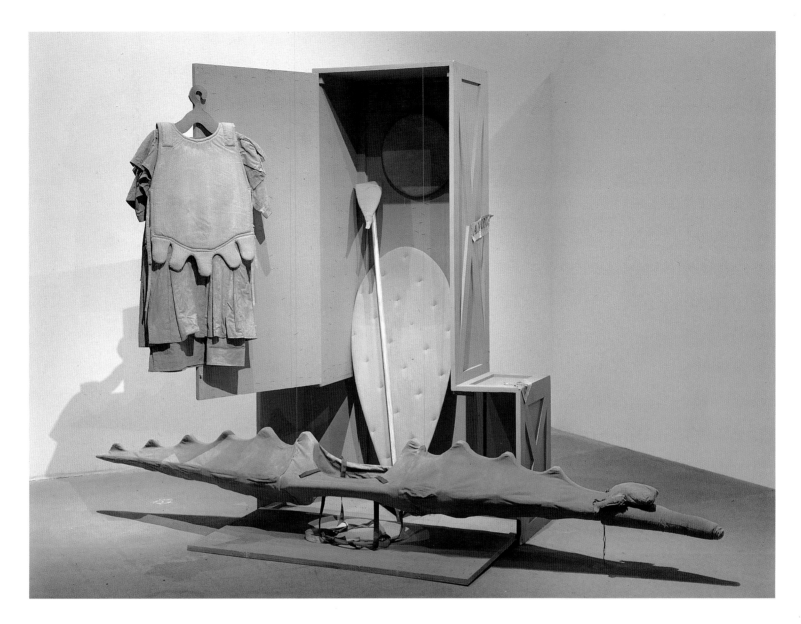

Shack, by Frank O. Gehry, 1985, expanded polystyrene, plastic, spray enamel, 149 × 122 × 110 ¹/₄ in.; *Characters and Props from Il Corso del Coltello, along the Canal di San Marco, Coltello Ship in Background – Version Three,* 1986, charcoal and pastel, 33 ¹/₈ × 43 in.; *Dr. Coltello Costume – Enlarged Version,* 1986, canvas filled with polyurethane foam, painted with latex, 8 ft. 8 in. × 5 ft. × 1 ft. 8 in.; *Frankie P. Toronto Costume – Enlarged Version,* 1986, canvas filled with polyurethane foam, painted with latex, jacket with hat: 6 ft. 7 in. × 7 ft. × 2 ft. 8 in., pants: 6 ft. 3 in. × 5 ft. 5 in. × 1 ft. 1 in.; *Georgia Sandbag Costume – Enlarged Version,* 1986, canvas filled with polyurethane foam, painted with latex, 6 ft. 9 in. overall height, bag: 13 × 39 × 12 in., letter *"O"*: 6 ft. 4 ¹/₂ in. × 8 ft. × 1 ft. 11 in.; *Soft Easel with Stretcher and Paintings,* 1986, muslin stiffened with glue, filled with polyurethane foam, painted with latex, 5 parts, easel: 68 × 30 × 5 in., stretcher: 23 × 17 × 2 in., 3 paintings: each 19 × 24 × 2 in.

——*THE KNIFE SHIP FROM IL CORSO DEL COLTELLO,* The Solomon R. Guggenheim Museum, New York, December 16, 1986 – February 16, 1987. Curated by Germano Celant.

Works exhibited: *Coltello Ship Approaching a Tug-of-War Between the Letters COLTELLO,* 1984, pencil, crayon, watercolor, 12 ³/₈ × 19 ³/₄ in.; *Design for a Theater Library for Venice in the Form of Binoculars and Coltello Ship in Three Stages,* 1984, pencil, colored pencil, chalk, watercolor, 30 × 40 in.; *Proposed Events for Il Corso del Coltello, a Performance in Venice, Italy,* 1984, crayon, pencil, watercolor, 24 × 18 ³/₄ in.; *Plans, Elevations and Details of the Coltello/Ship by J. Robert Jennings,* 1984-1985, pencil on cotton vellum, 30 × 42 in.; *Characters and Props from Il Corso del Coltello, along the Canal di San Marco, Coltello Ship in Background – Version Two,* 1985, charcoal and pastel, 30 × 40 in.; *Coltello Ship, from Above,* 1986, pencil, crayon, watercolor, 30 × 20 ³/₁₆ in.; *Knife Ship II,* 1986, steel, aluminum, wood; painted with polyurethane enamel, motor, closed, without oars: 7 ft. 8 in. × 10 ft. 6 in. × 40 ft. 5 in., extended, with oars: 26 ft. 4 in. × 31 ft. 6 in. × 82 ft. 11 in.; height with large blade raised: 31 ft. 8 in., width with blades extended: 82 ft. 10 in.; *Knife Ship Superimposed on the Solomon R. Guggenheim Museum,* 1986, screenprint, 30 ¹/₂ × 36 ³/₄ in.; *Props and Costumes for Il Corso del Coltello,* 1986, charcoal and pastel, 40 × 30 in.

THE HAUNTED HOUSE,
MUSEUM HAUS ESTERS,
KREFELD, GERMANY, MAY
31 – SEPTEMBER 20, 1987.
WORK SHOWN IS *CALICO
BUNNY*, 1987
PRIVATE COLLECTION,
GERMANY

1987

—— THE HAUNTED HOUSE, Museum Haus Esters, Krefeld, Germany, May 31 – September 20. Curated by Gerhard Storck. Catalogue.

Works exhibited: *Brickbat I and II*, 1987, expanded polystyrene, coated with resin and painted with latex, I: 41 $^1/_2$ × 29 × 20 in., *II*: 41 $^1/_2$ × 29 × 21 $^1/_2$ in.; *Brick Debris*, 1987, expanded polystyrene, cement, painted with latex, 6 assorted sizes; *Broken Bottle with Label Fragment*, 1987, expanded polystyrene, coated with resin and painted with latex, canvas, 48 in. diameter × 70 in. high; *Calico Bunny*, 1987, canvas, balsa wood, expanded polystyrene, coated with resin and painted with latex, 72 × 45 × 12 in.; *Cinder Block and Mortar Fragment*, 1987, expanded polystyrene, coated with resin and painted with latex, steel, 29 $^1/_2$ in. × 36 in. × 32 $^1/_2$ in.; *Cross Section of a Toothbrush with Paste in a Cup on a Sink: Portrait of Coosje's Thinking, Soft and Uprooted Version, with Foundation*, 1987, toothbrush: canvas filled with polyurethane foam, painted with latex, foundation: expanded polystyrene and Thoroseal, painted with latex, toothbrush: 6 $^3/_4$ in. × 1 ft. 9 in. × 5 ft. 11 $^5/_8$ in., foundation: 3 ft. 11 in. × 3 ft. 11 in. × 3 ft.; *Dropped-off Muffler*, 1987, canvas, paper, polyurethane foam, aluminum, expanded polystyrene, coated with resin and painted with latex, 3 ft. × 3 ft. 4 in. × 9 ft.; *Half Tire, with Deflated Tube*, 1987, tire: expanded polystyrene, plaster, coated with resin and painted with latex, tube: canvas, coated with resin and painted with latex, tire: 36 × 16 × 71 in., tube: 38 × 38 × 66 in.; *Lost Heel*, 1987, expanded polystyrene, coated with resin and painted with latex, 49 × 44 × 12 in.; *Rotten Apple Core*, 1987, canvas, polyurethane foam, steel, coated with resin and painted with latex, 65 × 48 × 48 in.; *Stone Debris*, 1987, expanded polystyrene, cement, coated with resin and painted with latex, 6 assorted sizes; *Uprooted Birdhouse*, 1987, expanded polystyrene, coated with resin and painted with latex, 45 × 36 × 84 in.; *Soft Folding Chair – Red*, 1987, canvas and polyurethane foam, painted with latex, 62 × 36 × 32 $^1/_2$ in.

GHOSTING

Coosje van Bruggen

On top of a hill behind which the sun begins to set, a solitary mansion is silhouetted against the scarlet sky. It seems in a ruined state; most of the windows are shattered or boarded up. Apparently the house has been uninhabited for quite some time, and it might even be haunted, for at night, so the story goes, bright lights emanate from its interior. The dream image is suddenly completed by a flash of lightning, which jars the memory, and the scene shifts to a swanky *allée* in a city in Nordrhein-Westfalen, on the edge of the Ruhr district, focusing on a villa surrounded by a well-groomed old garden. A brick house dating from the 1920s, it stands in a specific architectural relationship to the neighboring villa: weren't the two designed for the families of Hermann Lange and Josef Esters, managing directors of the United Silk Weaving Mills in Krefeld? The scrap of memory stimulates a more recent image of the same villas, each with its own scheme of free-flowing, open interior spaces lit by conspicuous bands of windows. But now the Haus Esters seems curiously uninhabited: its rooms, all painted white, are nearly empty. Here and there strange, colorful objects stand on the floor, hang on the walls, or sit on pedestals. In a corner of the entrance hall lies a dilapidated version of a folding chair seen earlier in the house. (Does it have some connection to Barcelona?)

At first the hackneyed image of the decrepit haunted house on the hill seems to evoke no analogies with the carefully tended villas, now turned into museums, so inherently opposed to triviality. But what happens at night? Their shutters are still lowered to keep out burglars. Is this just a left-over custom, a reminder of their original function as a place to live in? "We are all haunted houses," the poet H. D. wrote in her *Tribute to Freud*. We are haunted by our past, lived in by ghosts, stand-ins for those we fear. The associations that arise in our dreams stimulate not only the memory but also the imagination, and it is precisely here that the artist makes his entrance. In *The Haunted House*, through his decision to transform the prominent band of windows of Haus Esters, Claes Oldenburg simultaneously alters its exterior and its interior appearance at the same time as he touches on a deep vulnerability in community life. People are proud to show off their homes through their impeccably clean bay windows, yet they fear burglary. Here, of necessity, functional issues dominated the vision of the architect of Haus Esters, Mies van der Rohe. And here the artist asserts himself through the creation of substitute windows, "ghost" windows that are of no practical use at all. Their "glass" is shattered; as it no longer insulates the inside from the outside world, the imagination and certain anxieties – are all let loose. The equivalence between a window and a painting, both rectangular planes supported by a frame, allows Oldenburg to play on the interaction between Haus Esters' roles as a home and as a museum, and on the interaction between art, architecture, and life. To merge these different areas, some of the "broken windows" have been taken out; they lean against the wall like paintings still to be hung or rejects waiting for a substitute. The visitor to the house might get the impression that the show is not yet mounted or already in the stage of being taken down. The substitute windows consist of triple-ply cardboard sheets cut to fill the existing openings in the walls. They are fastened to heavy-duty stretchers that are invisible from the inside of the house and that from the outside remind one of the backs of scenery flats. These "broken windows" are enlarged from carefully drawn plans made on the windows of a small-scale model that Oldenburg made of the house. Each window has a different composition: its rectangular form is traversed by radiuses and straight lines in combinations that are arrived at intuitively yet firmly geometric. Most of the resulting divisions stay attached to the frame, but the ones in the center are cut out and tilted, dropped in the window well or on the floor. These shards are realized in a scale much larger than normal glass splinters; once they have left the rectangle of the "broken window," they lose their identity. Depending on their position and size, they can become anything from a painting to some bit of debris, from sculpture to obstacle.

In contrast to the rigidity of the patterns that divide the window fragments, the diagonal path of paint, in tones of white, gray, and black, that cover them, move freely across their surfaces. To avoid a naturalistic appearance, their application is based on graphic representations of windows such as those in comic strips. Starting one step away from the real, Oldenburg creates variations not so much on broken windows themselves as on the sign for them. This sign, in its simplicity, lends itself well to a sculptural presentation. In making an object in the form of a flat picture and intensifying its three-dimensionality by using for it an obviously tangible material, cardboard, and by actually breaking up its surface, the artist not only shifts between painting and sculpture but also sets up an ambiguity between reality and imagination. The cardboard, illusionistically painted to appear as shiny as glass, becomes an intermediate material between glass and canvas. It's true that in comparison to the existing window, the stand-in placed in front of it may seem a grimace, a distortion of the real; it may suggest the boarded-up house of the horror movie. However, in their carefully laid-out geometric schemes, and in their application of paint, which stylistically recalls fundamental painting, these windows are no longer merely a film set mimicking reality; they are alienated into art.

When we were talking about these broken windows, seemingly shattered by objects thrown through them, Oldenburg remarked: "The theme of all the things that I've done in the area of installation, starting with *The Tools of the Trade* for Documenta 7 in 1982, has involved the forcible penetration of the museum – in some way the representation of the coming into the museum of the outside, or the intrusion of the objective world into the subjective world and the combination of the two inside the museum. But it's not as aggressive a statement as it appears. It's more the idea that the objects should be halfway outside and halfway inside, a variation on the attempt to bring art and life together. And that's the function that windows might also serve: they are the gate between subjectivity and objectivity – being the way that the brain perceives the outside world, and the way that the outside world enters the brain. In the *Geometric Mouse* the 'eyes' have shutters – the object resembles a camera. The 'eyes' in the *Geometric Mouse Banners*

are *Xed*, like the sign for unconsciousness in comic strips or the diagonal taping done on windows in newly erected skyscrapers. The *Mouse Museum* identifies the head with a house (mouse equals house). Its contents are the memory, and the 'eyes' become plastic cases filled with objects. When the 'eyes' or the windows are broken, the outside enters more quickly, like the house sinking with the dead father in *Huckleberry Finn*."[1] As one approaches Haus Esters, then, what at first sight may appear an act of vandalism toward the architecture on the part of the artist – the throwing of objects through the windows of the main floor – may eventually be seen as a creative act tying together painting and sculpture, juxtaposing two parallel realities: the imaginary one of the artist and the functional one of the architect.

In any case, the aggression signified by the broken windows is offset by the materials used. You can't cut yourself on glass splinters made of cardboard; the sting is taken out, just as it is with Oldenburg's *Ray Gun* from the early 1960s, which "illuminates but doesn't kill," and as it is with the softened *Airflow Automobile* from 1965, which denies the violent potential of crushed metal. Similarly, a brick that seems to have been thrown through the windows is made out of Styrofoam. It is a "wimpy" brick. Lightly floating through space, hitting the window, it would probably bounce back. Thrown in one's face, it wouldn't hurt any more than a cake. The release of violence is transformed into an energizing force, as it is in George Herriman's *Krazy Kat* comic strip when Ignatz the mouse throws his bricks at the Kat, who loves being hit. When the brick bounces off Krazy Kat's head, a little heart spirals off from it as well, symbolizing her gratitude to the mouse for paying her attention. Oldenburg prefers Ignatz, who in his ingenious wickedness is described as "a malignant little tangle of barbed wire," to the well-adjusted, conformist Mickey Mouse. Though Mickey started as a poor mouse in Kansas City, he became a rather bourgeois mouse in Hollywood, whereas Ignatz always stayed an outlaw mouse. And Oldenburg too throws brickbats, aimed at the museum, although, in a mixed reaction of respect and contempt, he also throws bouquets. He has remained consistent with his "I am for" statements from the 1960s, as a small selection of them may show: "I am for an art that is political-erotical-mystical, that does something other than sit on its ass in a museum...I am for an art that embroils itself with the everyday crap and still comes out on top...I am for the art of scratchings in the asphalt, daubing at the walls. I am for the art of bending and kicking metal and breaking glass, and pulling at things to make them fall down."[2]

Arriving at the Wilhelmshofallee, one discovers that as usual the artist has done his damage and then disappeared. "No one knows where he went. He leaves his signs here and there. He is seen in this part of town and the next moment – miraculously – on the other side of town. One senses him rather than sees him – a lounger, a drunkard, a tennis player, a bicycle rider – always violently denying that he did it. Everyone gives a different description of the criminal."[3] Clearly something has happened here; the windows are broken, and an assortment of odd objects is dispersed through the house. Are we supposed to become the players in a game of Clue? ("Mr. Boddy – apparently the victim of foul play – is found in one of the rooms in his mansion. To win you must determine the answers to these three questions: 1. Who done it? 2. Where? and 3. How?") Any group of objects placed in a dramatic setting has the potential to disclose clues to its origins. Furthermore, the condition of the objects – cracked, scratched, bent, and so forth – may evoke memories of events they were part of, and even provide the motives for those events. Was the crime committed in the hall with a muffler, or maybe in the dining room with a bottle? We discover that the case is unsolvable; the criminal has erased all truly revealing traces of evidence. There's no way to track down the specific brand of muffler. All we are left with is a flattened general form, like a dead raccoon lying in the road, run over by car after car. There remains of the bottle only its neck, and a label tied around it is torn so that we can read only the letter *N*. Another dead end: we will never be able to decipher what the label said, or whether the liquid in the bottle was poisoned. Moreover, the body has never been found. The whole case may be just an image in a dream of this writer, who is standing in for the artist in the role of crime reporter. We do know, however, that if it was the artist who left these clues in Haus Esters, he left behind a haunted house, frozen in time, like a Victorian mansion he remembers in Evanston, Illinois, which was preserved precisely as it was at the moment when a bridegroom, coming to take his bride to their wedding, died suddenly on the parlor floor. His car was left in the driveway, and not one piece of furniture or personal belongings was moved for over twenty-five years. What has happened to Haus Esters seems a similarly aimless twist of fate. With the breaking of the windows, and the various other things dropped in, the villa has lost its severe architectural quality. Entropy has set in; it's like spring, when the snow melts, revealing all the debris collected beneath. Yet the mood in the house is autumnal. Remnants of manmade objects, decayed relics of everyday life fallen subject to nature's inevitable corruption, are on permanent display – a Beckettian rubble. They are oversized, as if seen from a child's perspective.

Searching among the debris for durable remains and reminders of a civilization, we find no consistency of time or place. At the sight of *Half Tire, with Deflated Tube*, a white-wall-tire cut in half, with a collapsed inner tube hanging out of it, we are transported to the 1920s or 1930s. A remembrance of things past, a symbol of affluence, the car in the driveway of the Evanston home transferred to Haus Esters? The artist points out, "Back then when you were rich, you bought white-walls, because they conveyed elegance." In another room, however, lies a clear sign of the present, *Rotten Apple Core*, the residue of a natural form altered by man. It hasn't completely disintegrated yet, so it can't have been thrown away too long ago. The crumpled, timeless *Calico Bunny* with its pitch-black, dangling eyes may have been tossed indifferently into a corner, awaiting the fate of being thrown out of the house to undergo painful adventures like a toy in one of Hans Christian Andersen's fairy tales. On the other hand it might just have been saved from the gutter by a sentimental collector. With its overlong ears, a cross between a hare and a rabbit, the bunny's formless, blue-checkered canvas body is contained by a primitive profile derived from a cookie cutter. A relic from the past and thus another ghost, this symbol of the

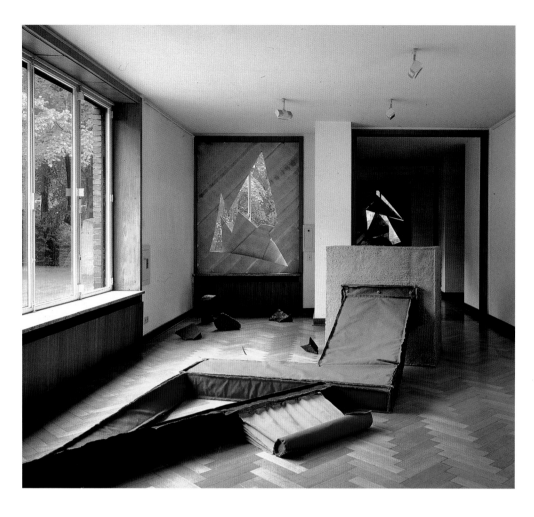

home in the form of a two-dimensional rag doll is an artificial counterpart to the rabbits constantly spotted on the museum grounds. *Broken Bottle with Label Fragment,* in its turn evokes associations from Aladdin's genie through a parable of disobedience in *Struwwelpeter* to a painting in The Metropolitan Museum of Art, New York, by Thomas Cole, *The Titan's Goblet,* 1833, in which the liquid in the goblet is represented as a lake with full-size sailboats. *Uprooted Birdhouse,* with its four sides, roof, and hole, the most elementary type of house, in its vulnerable position also summons a microcosm of childhood memories – the tilted house in *Huckleberry Finn,* Winnie the Pooh's house, the flying house in *The Wizard of Oz.* To Oldenburg, all this is not just a matter of putting suggestive objects together with historical bric-a-brac: "On analysis, some of the things may reflect the museum and/or home where the exhibition takes place, but the overriding effect should be of blind chance, of objects randomly accumulated

in the city." As we move from room to room we find no planned narrative, plot, or progression beyond those correspondences that arise spontaneously. Three of the objects, for instance, consist of a body with a single appendage: *Cinder Block and Mortar Fragment* has its reinforcing rod, *Dropped-off Muffler* its exhaust pipe, and *Uprooted Birdhouse* its post. All three protuberances are rudely disconnected.

Despite the intruding object fragments, each room keeps its sense of intimacy, of someone having been there or lived there. The treatment of these vacant rooms may be compared with Oldenburg's use of a deserted farmhouse on the grounds of the former Dallas Museum of Contemporary Art for the staging of his performance *Injun,* in 1962. While walking through the empty rooms of the farmhouse, the artist was reminded of a scene in the film *The Man from Dakota,* which takes place at the time of the American Civil War. Playing soldiers, Wallace Beery and two others come upon a house in the woods, which

they investigate room by room. Various objects in use – a cooking pot simmering on the stove, for example – indicate human presence, but there is no one in sight. The incident ends with the discovery of the bodies of the recently murdered family in an upstairs room. In the farmhouse in Dallas, Oldenburg found himself identifying with the struggle for meaning and culture that had taken place in a deprived rural environment in the somewhat earlier period of the Depression and the Dustbowl. For *Injun,* the spectators reached the house in the dark, to be led repeatedly through the same rooms. Each room was inhabited by a different performer, attempting in different ways to find some meaning in life. Through bizarre behavior, costumes of secondhand clothes, and the use of battered objects bought in local thrift shops, the performance evoked some of the bitter memories of tenant farmers forced into migration because of crop failures. These memories floated in with the environment and

became an undercurrent of the performance.

Through his imposition of a state of abandonment on Haus Esters, presently kept in such good repair, Oldenburg again points to the inevitable rise and decline of properties, families and cultures. In the fall of 1956, when he had just arrived in New York, he would project his feelings of loneliness by drawing discarded, isolated objects. With the autumn light producing lengthy shadows, he would sit in his room and concentrate on a bottle cap, a bottle of lithographic ink, a razor blade. Chance groupings of objects in relationships that seemed dramatic to him would inspire poems in which the artist tried to enter the inanimate world:

rag asleep in brown melody
furred with old questions
 in a corked world
long trip in a wet thimble
 there can a good rag sleep
a year among the pills
 unafraid of time and arrogant pencils

In a play between calculation and the illusion of spontaneity, the objects in Haus Esters are placed so as to present a similar drama of still life. Things and emotions about things carry a powerful theatrical impact in Oldenburg's house, which he perceives as "haunted" because "art objects are living presences related to spooks." Closest to a spook is the soft version of Cross Section of a Toothbrush with Paste in a Cup on a Sink: Portrait of Coosje's Thinking, his outdoor sculpture that was erected in front of Haus Esters in the autumn of 1983. Its muted colors relate it to the "ghost" versions of household appliances that the artist began in California in 1963, with Light Switches. Oldenburg would first make a model in Styrofoam, then reduce it to a pattern and have it sewn in canvas, as a sketch for the final soft sculpture in vinyl. The canvas "ghost" versions, painted white, have a sheetlike gestalt, and appear "spiritual" in comparison to the colorful vinyl pieces, matching Wallace Stevens' poetic thought: "The houses are haunted by white nightgowns."[4]

Oldenburg's original intention for Haus Esters was to select objects that might have been in use when the villa was still a home, and to complement them with the kind of things found in a sedate museum environment. The museum part, he thought, might be represented by a pedestal with a hoof broken off from an equestrian statue. The things thrown through the windows he associated with the rougher examples of contemporary art. For this group he first considered pairs of objects, one natural and the other shaped by man – a round rock together with a square brick, a branch with a cane, a charred log with a birdhouse. Then, he pondered a mixture of single objects, such as a banana peel, an apple core, a leaf, a bone, a rabbit, a muffler, a chair, a galosh, a bottle, a pencil stub, a match. Eventually the categories coalesced into a group of ambiguous, highly suggestive broken objects, extracted from the junk of the surrounding environment, discarded detritus combining nature and urban nature, and all suitable for transformation and scaling up into sculpture through the chosen techniques of stiffened cloth or Styrofoam. A piece of wall made of cinder block, a construction material with no pretensions, is very different from the brick that Mies van der Rohe so cleverly applied in the construction of Haus Esters. Oldenburg also uses a fragment of brick, but the one in his selection is rendered worthless, being broken. The tree branch has become absorbed into the form of the muffler, which, in dropping off a car, has pulled part of the exhaust pipe with it. Furthermore, the outdoor sculpture Cross Section of a Toothbrush, despite its elite status as an artwork, has undergone the same fate as the other commonplace objects – like the birdhouse, it has been uprooted and thrown, foundation and all, through the window. Inside, however, it has lost its constructivist strength, turned soft. Its twisted parts remind one of a shed snakeskin, caught like a banana peel in the angle of a smashed windowpane. The bottle, set on its head so that its jagged edges face up, becomes an echo of a pedestal; the missing part of its torn label may hold the title of the sculpture.

Finally, the idea of a twisted galosh has been replaced by that of the simplified but suggestive heel of a shoe, worn down on one side, with five nails sticking out of it. More than any of the other objects, Lost Heel, recalls The Street, the installation Oldenburg did in January of 1960 in a small room of the Judson Gallery, New York, in which the city's tough street life was transformed into a metamorphic landscape like a war zone out of Céline. While smaller figures on the walls indicated events at a distance, freestanding figures and objects, their flatness emphasized by black outlines, rose out of a rubble of old shoes, mattress springs, crushed pieces of metal, and so on. To capture their textual flavor, Oldenburg recycled materials he had found on the street – burlap bags, wooden crates, corrugated cardboard. The walls had the double identity of a picture plane and the surface of the street seen from a high vantage point. Painted white, like asphalt reflecting sunlight, they were filled with cut- or torn-out cardboard drawings of street events and figures. In The Haunted House the emphasis is less on the walls, which are left neutral, although their broken windows, which allow the outside to enter, are linked to the object fragments through the ambiguity of their two-dimensional picture planes turning into three-dimensional objects.

Oldenburg recalls a time in the late 1950s in New York when several blocks were demolished on the Lower East Side: "Between the place where I lived on 4th Street and Cooper Union, where I worked, I would pass by all these houses that had been ripped apart, so that you could see inside all the different rooms, and on the street you would find all kinds of relics and remnants of the home." These experiences became the basis for the performance Blackouts (1960), a "theater of unrelated succession" in which the emphasis shifted from the activities of people in relation to things to things themselves. In one event from the performance, for example, Oldenburg, playing the "Ragman," moved in slow motion across the semi-dark stage with no other goal than to grab an illuminated rag on a ladder. The performer was just a tool to begin and end the plot; when he grabbed the rag, the lights went out – a "blackout." Likewise, The Haunted House evolves around the object fragments, the aftermath of human action, frozen in time. They are left behind, yet as the products of human thought they are indirectly connected with people, despite their collapsed state. The Street was derived from a violent, hopeless neighborhood, New York's

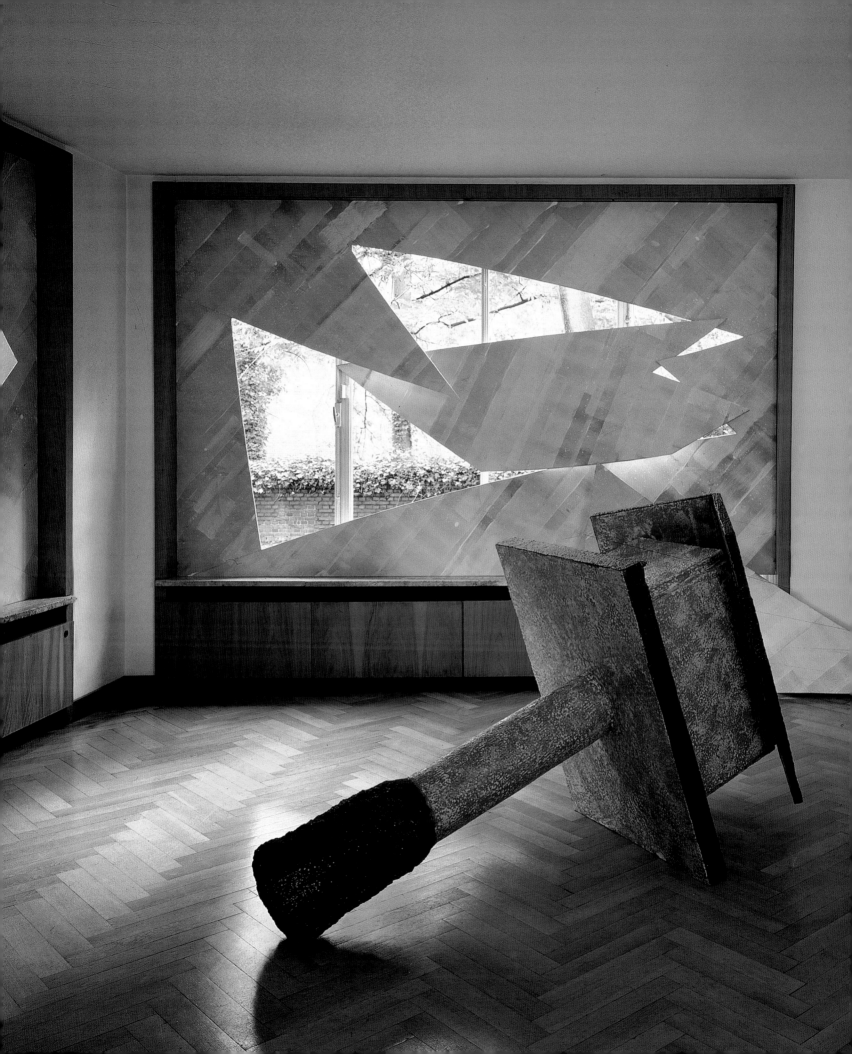

Bowery, where the distinction between squashed tin cans and bums lying around had been erased. *The Haunted House* is based upon the random objects of a vacant suburban lot, objects set in their casual positions by some disinterested force: a playing child, a passing vagrant, a gust of wind. The debris that appears to have been thrown through the windows of Haus Esters, and to have landed in the rooms, lies randomly around, but Oldenburg has unified it through the use of Styrofoam and cloth, materials very adaptable to transformation. He tends to choose subjects that echo his materials: the smooth white plaster in the pieces in *The Store,* for instance, from 1961-1962, represents such food as melting ice cream, while brittle Styrofoam is used for crumbled building materials like the brickbat in *The Haunted House.* In the soft works, cloth is often used as a substitute for metal, as in *Soft Typewriter* (1963), and in *Dropped-off Muffler,* in Haus Esters, frozen into position with resin. In each object fragment Oldenburg takes care not to make the effect entirely sculptural, but to let the paint applied over the forms help to define them, as he did when he used "paint coagulated into the form of an object" in the *Store* pieces.

In the object fragments Oldenburg applies colors individually, one over the other, on the highly textured, scraped, and abraded surface of the Styrofoam, which has been hardened by layers of latex and resin. He compares it to a mountain landscape in which one layer of color fills the valley, a second one covers the slopes, and a third the tops, so that they mix optically and take on a sculptural presence in their interplay between real and illusionary dimensions. Painting is conceived of as a material process. It is tricky to paint over rough surfaces. Oldenburg deals with the task by applying paint with a roller (which he prefers to a brush), by spraying or spattering it onto the surface, and also by soaking a paper towel in it and pressing it onto the surface. The paint can be thrown, dragged, or dabbed, but under no circumstances does the artist want to show his touch, unless he is simulating graffiti or a sign: *Cinder Block and Mortar Fragment,* for example, is a fragment of a red-painted wall with black graffiti on it. "Beautiful" color effects are avoided in favor of harsh

harmonies; in the interest of verisimilitude, some colors are deliberately jarring. The reinforcing rod sticking out of the wall fragment is of a brown color that is disturbing in relation to the cinder block, to keep a "unity of opposites" going.

Through texture and color treatment, position and condition, Oldenburg freely links the otherwise different fragments, spooks, or stand-ins animating the haunted house of his own making. They are disparate as objects yet related in scale as sculptures. He creates a unity of associations, though the less evident and the more enigmatic they are, the better. These object fragments are ghosts, in the sense that they evoke memories, which are different for each visitor. In Haus Esters the artist has left his belongings behind – broken archetypes, detritus. In the aftermath of action, rubble lies everywhere in the rooms of the broken-windowed main floor, like props on a stage after a performance, or like accidentally accumulated rubbish in *The Street.* But despite the wretched state of the debris, a remembrance of its splendid wholeness can still be sensed in the eroded geometry. We think we know whose standins these are, for we can often identify a man by the contents of his pockets, or by a box filled with his possessions.[5] Yet the identification of the stuff with Oldenburg by congenial spirits arriving at the site is partly obscured, for the box containing the shards of these objects is signed by someone else, Mies van der Rohe.

[1] Unless otherwise noted, the quotations of Claes Oldenburg in this article come from discussions between him and the author through March 1987.
[2] Quoted in Claes Oldenburg, *Store Days* (New York and Villefranche-sur-Mer: Something Else Press, 1967), p. 39.
[3] Oldenburg uses "Ray Gun" as an emblem applicable to every aspect of his work. In one disguise or another, "Ray Gun" reappears, personified in this fragment of a prose poem, written in 1960-1961, entitled *Guises of Ray Gun.*
[4] Wallace Stevens, "Disillusionment of Ten O'Clock," in *The Palm at the End of the Mind: Selected Poems and a Play* (New York: Vintage Books, 1972), p. 11.
[5] The idea of a man being no more than the contents of his pockets, or than a box filled with his possessions, was strongly presented in *World's Fair II,* the final performance of Ray Gun Theater done in 1962 in *The Store.* The script reads,

"Lucas [Samaras] and John [Weber] enter carrying Dominic [Capobianco] in a suit stuffed with paper and debris as if dead. They place him on the table, slide him so he is in the middle, and go through his pockets, laying what they find on the tabletop around him. Turn him over etc. When his pockets are empty they push him to the edge of the table and carry him out." The contents of his pockets included flags, jewelry, a flashlight, colored paper, a wristwatch, and silverware.

Originally published in *The Haunted House* (Krefeld, Germany: Museum Haus Esters; and Essen, Germany: Verlag H. G. Margreff, 1987)

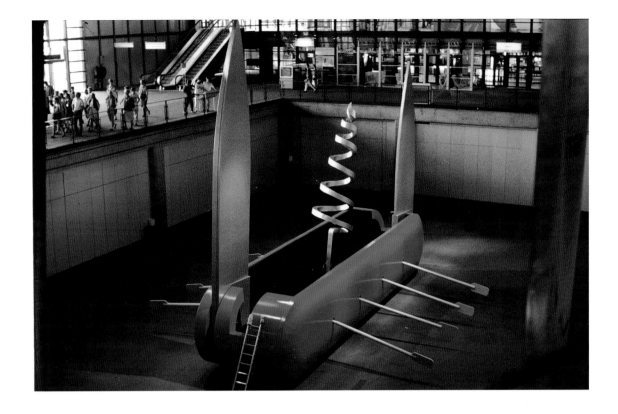

—— *LE COUTEAU NAVIRE: DÉCORS, COSTUMES, DESSINS, IL CORSO DEL COLTELLO DE CLAES OLDENBURG, COOSJE VAN BRUGGEN ET FRANK O. GEHRY,* Musée national d'art moderne, Centre Georges Pompidou, Paris, Forum, July 7 – October 5; Galerie contemporaines, July 7 – August 30. Curated by Germano Celant. Brochure. Works exhibited: *Knife Ship I,* 1985, steel, wood, plastic-coated fabric, motor, closed, without oars: 7 ft. 8 in. × 10 ft. 6 in. × 40 ft. 5 in.; extended, with oars: 26 ft. 4 in. × 31 ft. 6 in. × 82 ft. 11 in.; height with large blade raised: 31 ft. 8 in.; width with blades extended: 82 ft. 10 in.; *Temple Shack* by Frank O. Gehry, 1985, expanded polystyrene, plastic, spray enamel, 149 × 122 × 110 $^1/_4$ in.; *Model of Snake Pole,* by Frank O. Gehry, 1985, foamcore, metal, paper, painted, 10 × 12 × 9 $^1/_2$ in.; *Frankie P. Toronto Costume – Enlarged Version,* 1986, canvas filled with polyurethane foam, painted with latex, jacket with hat: 6 ft. 7 in. × 7 ft. × 2 ft. 8 in., pants: 6 ft. 3 in. × 5 ft. 5 in. × 1 ft. 1 in.; *Model for Frankie P. Toronto's Hat on Stand,* 1985, cardboard, 14 $^1/_2$ × 9 $^1/_4$ × 8 $^5/_8$ in., on stand 9 × 20 $^1/_2$ × 16 $^1/_4$ in.; *Georgia Sandbag Costume – Enlarged Version,* 1986, canvas filled with polyurethane foam, painted with latex, 6 ft. 9 in. overall height, bag: 13 × 39 × 12 in., letter "O": 6 ft. 4 $^1/_2$ in. × 8 ft. × 1 ft. 11 in.; *Dr. Coltello Costume – Enlarged Version,* 1986, canvas filled with polyurethane foam, painted with latex, 8 ft. 8 in. × 5 ft. × 1 ft. 8 in.; *St. Theodore Costume in Letter "T,"* 1985, costume: canvas filled with polyurethane foam, painted with latex, letter "T": wood and canvas labels painted with latex, tunic and breastplate: 48 × 27 × 2 $^1/_2$ in, spear: 81 in. high, shield: 52 $^1/_2$ × 22 $^1/_2$ in., halo: 16 in. diameter, crocodile: 12 × 10 $^1/_2$ × 126 in., letter "T": 85 $^1/_2$ × 55 × 19 $^3/_4$ in.; *Houseball,* 1985, canvas, polyurethane foam, rope, painted with latex, aluminum, approx. 12 ft. diameter; *Knife Dancer,* 1985, ballpoint pen and felt pen, 11 × 8 $^1/_2$ in.; *Prototype of the Houseball,* 1985, steel, muslin,

polyurethane foam, rope, painted with latex, approx. 38 in. diameter; *Soft Book,* 1985, canvas filled with polyurethane foam, painted with latex, 42 × 28 × 20 in.; *Prototype for Dr. Coltello's Baggage,* 1985, balsa wood, canvas, string, painted with latex, letter "C": 8 $^1/_2$ × 7 $^1/_4$ × 2 $^1/_2$ in., letters "O": each 7 $^1/_2$ × 8 $^3/_8$ × 2 $^1/_2$ in., letters "L," "T," "L," "L": each 9 × 5 $^3/_4$ × 2 $^1/_4$ in., letter "E": 6 $^3/_4$ × 7 $^1/_4$ × 2 $^1/_2$ in.; *Labels for Dr. Coltello's Baggage: Cities Visited by Marco Polo Spelled Backward,* 1985, felt pen on canvas, painted with latex, variable dimensions; *Soft Easel with Stretcher and Paintings,* 1986, muslin filled with polyurethane foam, stiffened with glue and painted with latex, easel: 68 × 30 × 5 in., stretcher: 23 × 17 × 2 in., 3 paintings: each 19 × 24 × 2 in.; *Basta Carambola Costume: Jacket with Pool Balls,* 1985, jacket: fabric, expanded polystyrene, painted with latex, 34 in. from neck to hem; *Model of Espresso Cup Balloon,* 1985, wood painted with latex, overall dimensions: 41 × 17 × 17 in.; *Umbrella,* 1985, polyurethane foam, canvas, painted with latex, 48 × 28 × 30 in.; *Architectural Fragments,* 1985, canvas filled with polyurethane foam, painted with latex, 7 elements, yellow stairs: 112 × 34 × 34 $^1/_2$ in., yellow columns with architrave: 112 × 78 $^3/_4$ × 10 $^1/_2$ in., gray stairs: 112 × 34 × 34 $^1/_2$ in., red column: 119 $^1/_4$ × 19 × 19 $^3/_4$, green obelisk: 123 × 31 × 19 in., red arch: 126 × 52 $^3/_4$ × 21 $^1/_4$ in., yellow obelisk: 123 × 31 × 19 in.; *Architectural Fragments, Small Version,* 1985, canvas filled with polyurethane foam, stiffened with glue and painted with latex, overall dimensions 38 × 124 × 8 $^1/_2$ in.; *Café Tables,* 1985, aluminum tables, tinted water, wooden chairs, 6 tables: each 31 × 24 in. diameter, 4 chairs: each 31 × 16 × 24 in.; *Chateaubriand Costume,* 1985, polyurethane foam painted with latex, on wood and metal base, 101 × 30 × 35 in.; letter "E," 1985, polyurethane foam covered with plastic cloth, canvas labels painted with latex, 96 × 76 $^1/_2$ × 23 in.; *Georgia Sandbag's Book with Dangling Punctua-*

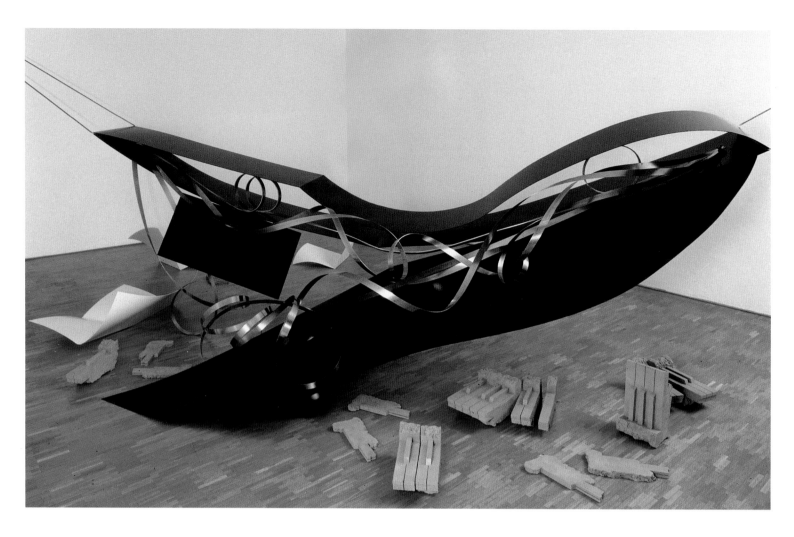

tion, 1985, canvas painted with latex, polyurethane foam, vinyl, leather, notepaper, felt pen, T-pins, 13 × 9 ³/₄ × 1 ³/₄ in., with punctuation extending 15 in. below book; letter *"O,"* 1985, polyurethane foam covered with plastic cloth, 98 × 76 × 24 in.; letter *"L" – Red,* 1985, wood and canvas labels painted with latex, 85 ¹/₂ × 55 × 19 ³/₄ in.; letter *"L" – Blue,* 1985, wood and canvas labels painted with latex, 85 ¹/₂ × 55 × 19 ³/₄ in.; letter *"T,"* 1985, wood and canvas labels painted with latex, 85 ¹/₂ × 55 × 19 ³/₄ in.; *Birds with Stands,* 1985, expanded polystyrene, wood, painted with latex, felt pen, birds: each 18 ¹/₂ × 14 ¹/₄ × 1 in., shelf: 19 × 18 ¹/₂ × 8 ¹/₂ in.; *Knife Slicing Through Wall,* 1986, wood painted with enamel, plasterboard blade: 4 ft. 10 in. × 12 ft. 3 in., 2 wall sections, each 8 ft. × 3 ft. 10 in. × 2 ft. 8 in.; *Espresso Cup Balloon,* 1986, plastic cloth, 6 ft. 3 in. × 15 in diameter.

—— *PIANO/HAMMOCK 1987,* Konrad Fischer Galerie, Düsseldorf, November 24 – December 18.
Work exhibited: *Piano/Hammock,* 1987, steel, painted with polyurethane enamel, stainless steel, cast aluminum, 16 ft. × 6 ft. 5 in. × 5 ft. 3 in.

1988

—— PROPS, COSTUMES AND DESIGNS FOR THE PERFORMANCE IL CORSO DEL COLTELLO BY CLAES OLDENBURG, COOSJE VAN BRUGGEN, FRANK O. GEHRY, Margo Leavin Gallery, Los Angeles, January 9 – February 13.
Works exhibited: *Dr. Coltello,* 1984, ballpoint pen and felt pen, 11 × 8 ¹/₂ in.; *Dr. Coltello in Bar with Knife Dancer,* 1984, felt pen and watercolor, 7 ³/₄ × 11 in.; *Houseball with Two Figures,* 1984, pencil, crayon, watercolor, 9 ³/₈ × 6 ⁵/₈ in.; *Knife Blade Slicing a Housefront,* 1984, felt pen and watercolor, 10 ⁷/₈ × 7 ⁷/₈ in.; *Notebook Page: Prop for Il Corso del Coltello: Ball of Belongings Stuck Between Houses,* 1984, felt pen and watercolor, 10 ¹⁵/₁₆ × 7 ⁷/₈ in.; *Proposed Event for Il Corso del Coltello: Man Hauling Up Soft Column of St. Theodore,* 1984, pencil and watercolor, 10 ⁷/₈ × 7 ⁷/₈ in.; *Prototype for Coltello Guidebook,* 1984, wood, canvas, paper, expanded polystyrene, painted with acrylic and spray enamel, 2 ³/₄ × 6 × 9 ³/₄ in.; *Study for Dr. Coltello,* 1984, pencil and colored pencil on yellow paper, 11 × 8 ¹/₂ in.; *Two Porters Carrying the Coltello,* 1984, felt pen and watercolor, 10 ⁷/₈ × 7 ⁷/₈ in.; *Aragosta Vellata alla Sleazy Dora* and *Lettere di Pollo,* 1985, ballpoint pen and felt pen, 2 sheets, 5 ¹/₈ × 8 ¹/₂ in. and 5 ¹/₈ × 6 ⁷/₈ in.; *Architectural Fragments,* 1985, canvas filled with polyurethane foam, painted with latex, 7 elements, yellow stairs: 112 × 34 × 34 ¹/₂ in., yellow columns

with architrave: 112 × 78 $^3/_4$ × 10 $^1/_2$ in., gray stairs: 112 × 34 × 34 $^1/_2$ in., red column: 119 $^1/_4$ × 19 × 19 $^3/_4$, green obelisk: 123 × 31 × 19 in., red arch: 126 × 52 $^3/_4$ × 21 $^1/_4$ in., yellow obelisk: 123 × 31 × 19 in.; *Architectural Fragments, Small Version,* 1985, canvas filled with polyurethane foam, stiffened with glue and painted with latex, overall dimension: 38 × 124 × 8 $^1/_2$ in.; *Basta Carambola,* 1985, pencil, ballpoint pen, felt pen, collage, 10 $^{15}/_{16}$ × 8 $^3/_8$ in.; *Basta Carambola Costume: Jacket with Pool Balls,* 1985, jacket: fabric, expanded polystyrene, painted with latex, 34 in. from neck to hem; *Café Tables,* 1985, aluminum tables, tinted water, wooden chairs, 6 tables: each 31 × 24 in. diameter, 4 chairs: each 31 × 16 × 24 in.; *Chateaubriand Costume,* 1985, polyurethane foam painted with latex, on wood and metal base, 101 × 30 × 35 in.; *Costume Studies for Knife Dogs,* 1985, pencil and felt pen, 2 sheets: each 11 × 8 $^1/_2$ in.; *Crema di Tappo e di Castagne* and *Calzone con Pattini,* 1985, ballpoint pen and felt pen, 2 sheets: each 5 $^1/_8$ × 8 $^1/_2$ in.; *Espresso Cup – Plans and Elevations,* 1985, pencil, 14 $^1/_2$ × 16 in.; *Frankie with Architectural Fragments,* 1985, pencil and ink, 11 × 8 $^1/_2$ in.; *Georgia Sandbag,* 1985, crayon and watercolor, 18 $^3/_4$ × 14 $^1/_8$ in.; *Georgia Sandbag's Bag,* 1985, polyurethane foam, wood, canvas, painted with latex, 13 × 39 × 12 in.; *Georgia Sandbag's Book with Dangling Punctuation,* 1985, canvas painted with latex, polyurethane foam, vinyl, leather, notepaper, felt pen, T-pins, 13 × 9 $^3/_4$ × 1 $^3/_4$ in., with punctuation extending 15 in. below book; *Houseball Objects, Plans and Elevations,* 1985, pencil, 14 $^7/_{16}$ × 16 $^1/_{16}$ in.; *Houseball,* 1985, canvas, polyurethane foam, rope, painted with latex, aluminum, approx. 12 ft. diameter; *Knife Dancer,* 1985, ballpoint pen and felt pen, 11 × 8 $^1/_2$ in.; letter *"C,"* 1985, polyurethane foam covered with plastic cloth, canvas labels paint-

ed with latex, 96 × 76 $^1/_2$ × 23 in.; letter *"E,"* 1985, polyurethane foam covered with plastic cloth; canvas labels painted with latex, 96 × 76 $^1/_2$ × 23 in.; letter *"L,"* 1985, wood and canvas labels painted with latex, 85 $^1/_2$ × 55 × 19 $^3/_4$ in.; *Model for Frankie P. Toronto's Hat on Stand,* 1985, cardboard, 14 $^1/_2$ × 9 $^1/_4$ × 8 $^5/_8$ in., on stand 9 × 20 $^1/_2$ × 16 $^1/_4$ in.; *Model of Espresso Cup Balloon,* 1985, wood painted with latex, overall dimensions: 41 × 17 × 17 in.; *Notebook Page: Costume for Il Corso del Coltello: Chateaubriand,* 1985, pencil on photocopy, 11 × 8 $^1/_2$ in.; *Notebook Page: Costume for Il Corso del Coltello: D'Artagnan,* 1985, ballpoint pen and felt pen, 8 $^1/_2$ × 5 $^3/_{16}$ in.; *Notebook Page: Costume for Il Corso del Coltello: Longshoreman,* 1985, pencil, ballpoint pen, felt pen, 11 × 8 $^1/_2$ in.; *Notebook Page: Costume for Il Corso del Coltello: Waiter,* 1985, pencil, felt pen, collage, 11 × 8 $^7/_{16}$ in.; *Prototype for Dr. Coltello's Baggage,* 1985, balsa wood, canvas, string, painted with latex, letter *"C"*: 8 $^1/_2$ × 7 $^1/_4$ × 2 $^1/_2$ in., letters *"O"*: each 7 $^1/_2$ × 8 $^3/_8$ × 2 $^1/_2$ in., letters *"L," "T," "L," "L"*: each 9 × 5 $^3/_4$ × 2 $^1/_4$ in., letter *"E"*: 6 $^3/_4$ × 7 $^1/_4$ × 2 $^1/_2$ in.; *Prototype of the Houseball,* 1985, steel, muslin, polyurethane foam, rope, painted with latex, approx. 38 in. diameter; *Rower,* 1985, pencil, ballpoint pen, felt pen, 11 $^1/_8$ × 8 $^1/_4$ in.; *Soft Book,* 1985, canvas filled with polyurethane foam, painted with latex, 42 × 28 × 20 in.; *Soft Pedestal,* 1985, canvas filled with polyurethane foam, painted with latex, 66 × 35 × 35 in.; *St. Theodore Costume in Letter "T,"* 1985, costume: canvas filled with polyurethane foam, painted with latex, letter *"T"*: wood and canvas labels painted with latex, tunic and breastplate: 48 × 27 × 2 $^1/_2$ in., spear: 81 in. high, shield: 52 $^1/_2$ × 22 $^1/_2$ in., halo: 16 in. diameter, crocodile: 12 × 10 $^1/_2$ × 126 in., letter *"T"*: 85 $^1/_2$ × 55 × 19 $^3/_4$ in.; *Verza Ripiena alla Sandbag* and *Coccodrillo di Cioccolato,* 1985,

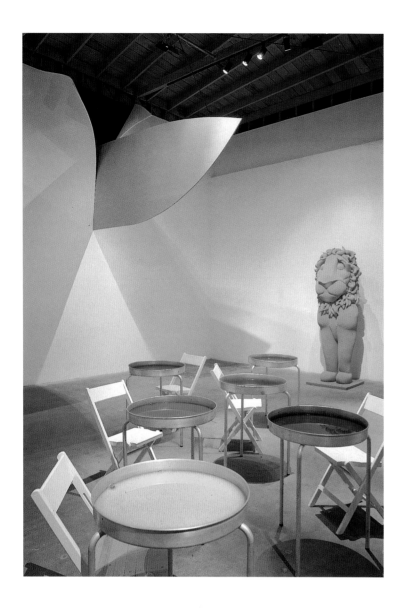

ballpoint pen and felt pen, 2 sheets: each 5 $\frac{1}{8}$ × 8 $\frac{1}{2}$ in.; *Umbrella*, 1985, polyurethane foam, canvas, painted with latex, 48 × 28 × 30 in.; *Characters and Props from Il Corso del Coltello, along the Canal di San Marco, Coltello Ship in Background – Version Three*, 1986, charcoal and pastel, 33 $\frac{1}{8}$ × 43 in.; *Dr. Coltello Costume – Enlarged Version*, 1986, canvas filled with polyurethane foam, painted with latex, 8 ft. 8 in. × 5 ft. × 1 ft. 8 in.; *Espresso Cup Balloon*, 1986, plastic cloth, 6 ft. 3 in. × 15 in. diameter; *Frankie P. Toronto and Exploding Temple Shack with Georgia Sandbag on the Bridge*, 1986, charcoal, pastel, watercolor, 17 $\frac{3}{4}$ × 23 $\frac{3}{4}$ in.; *Frankie P. Toronto Costume – Enlarged Version*, 1986, canvas filled with polyurethane foam, painted with latex, jacket with hat: 6 ft. 7 in. × 7 ft. × 2 ft. 8 in., pants: 6 ft. 3 in. × 5 ft. 5 in. × 1 ft. 1 in.; *Georgia Sandbag*, 1986, felt pen, chalk, collage, watercolor, 11 $\frac{3}{4}$ × 9 in.; *Georgia Sandbag Costume – Enlarged Version*, 1986, canvas filled with polyurethane foam, painted with latex, 6 ft. 9 in. overall height, bag: 13 × 39 × 12 in., letter "*O*": 6 ft. 4 $\frac{1}{2}$ in. × 8 ft. × 1 ft. 11 in.; *Knife Dog Holding Soft Bone*, 1986, charcoal and watercolor, 18 × 13 $\frac{3}{4}$ in.; *Knife Slicing Through Wall*, 1986, wood paint-ed with enamel, plasterboard blade: 4 ft. 10 in. × 12 ft. 3 in., 2 wall sections, each 8 ft. × 3 ft. 10 in. × 2 ft. 8 in.; *Notebook Page: Costume for Il Corso del Coltello: Sleazy Dora, with Inner Tube*, 1986, felt pen and watercolor, 12 × 9 in.; *Notebook Page: Costume for Il Corso del Coltello: Sleazy Dora: Dancing with Paddle*, 1986, felt pen and watercolor, 10 $\frac{7}{8}$ × 8 $\frac{7}{16}$ in.; *Porter Moving Soft C*, 1986, charcoal and watercolor, 40 × 30 in.; *Props and Costumes for Il Corso del Coltello*, 1986, charcoal and pastel, 40 × 30 in.; *Props and Costumes for Il Corso del Coltello, Exhibition Study*, 1986, charcoal and pastel, 40 × 30 $\frac{1}{16}$ in.; *Props and Costumes for Il Corso del Coltello, Exhibition Poster Study*, 1987, charcoal and pastel, 40 × 30 in.

——*A Bottle of Notes and Some Voyages*, Northern Centre for Contemporary Art, Sunderland, England, February 2 – March 26. Curated by Tony Knipe and Terry Friedman. Catalogue. Traveled to The Henry Moore Centre for the Study of Sculpture, Leeds City Art Gallery, Leeds, England, April 27 – June 26; The Serpentine Gallery, London, July 9 – August 29; The Glynn Vivian Art Gallery

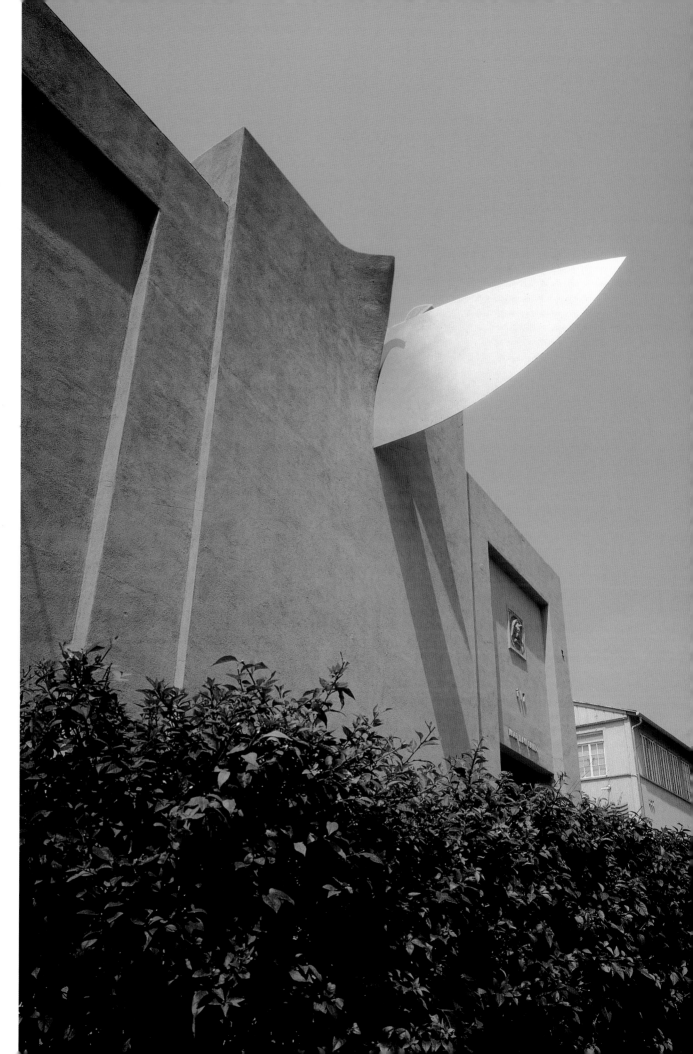

PREVIOUS PAGE:
*Props, Costumes and
Designs for the
Performance Il Corso
del Coltello by Claes
Oldenburg, Coosje van
Bruggen, Frank O.
Gehry, Margo Leavin
Gallery, Los Angeles,
January 9 – February 13,
1988.* WORKS SHOWN ARE
Café Tables, 1985;
***Knife Slicing
Through Wall***, 1986;
***Chateaubriand
Costume***, 1985

***Knife Slicing
Through Wall***, 1989,
PERMANENT
INSTALLATION,
MARGO LEAVIN GALLERY,
LOS ANGELES

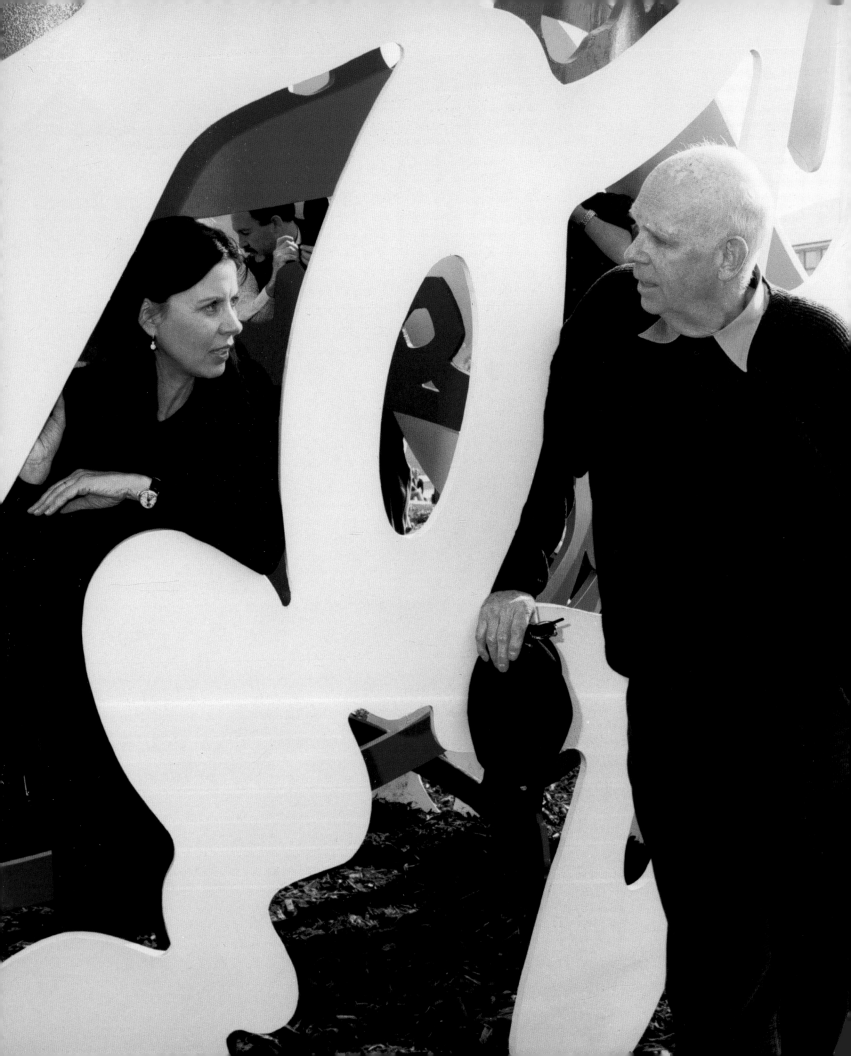

and Museum, Swansea, England, September 17 – November 12; Palais des Beaux-Arts, Brussels, November 27 – December 30, cat. suppl.; Wilhelm-Lehmbruck Museum, Duisburg, Germany, January 22 – March 27, 1989, cat. suppl.; Malmö Konsthall, Malmö, Sweden, April 29 – August 6, 1989, cat. suppl.; IVAM, Centre Julio González, Valencia, Spain, September 15 – November 15, 1989, catalogue; Tampereen Nykytaiteen Museo, Tampere, Finland, January 12 – March 6, 1990.

Works exhibited: *New Media – New Forms in Painting and Sculpture*, 1960, offset lithograph, 22 $^5/_8$ × 17 $^3/_4$ in.; *Ray Gun Poster*, 1961, spray oil wash on torn paper, 24 × 18 in.; *Sketch of a Typewriter*, 1963, pencil and watercolor, 11 × 13 $^3/_4$ in.; *Studies of a Circular Saw, Los Angeles*, 1963, pencil, crayon, ballpoint pen, watercolor, clippings, 11 × 8 $^1/_2$ in.; *Study for a Sculpture in the Form of a Grand Piano*, 1963, cardboard and plaster, painted with enamel, 4 $^5/_8$ × 11 $^1/_2$ × 3 $^1/_2$ in.; *Circular Saw Study*, 1964, cardboard, paper, tape, wire, plaster, T-pins, painted with spray enamel and coated with resin, 11 $^1/_2$ × 12 $^3/_4$ × 11 $^1/_2$ in.; *Study for an Outboard Motor in Action, on a Fragment of Stern, with Notes on Technique and Materials, Paris*, 1964, ballpoint pen, pencil, clippings, 11 × 8 $^1/_2$ in.; *Blue Toilet*, 1965, crayon, watercolor, collage, 29 $^3/_4$ × 21 $^3/_4$ in.; *Study for a Sculpture in the Form of an Outboard Motor*, 1965, clay over toy, coated wire, wood, 8 $^1/_2$ × 6 $^3/_8$ × 3 $^1/_2$ in.; *Study for Silex Juicit*, 1965, cloth, wood, enamel, 24 × 24 × 10 $^5/_8$ in.; *Baked Potato Multiple, Painted Prototype*, 1966, cast resin painted with acrylic, porcelain plate, 8 $^1/_2$ × 4 $^3/_4$ × 5 $^1/_4$ in.; *Bicycle Bell*, 1966, crayon, 9 × 11 $^{13}/_{16}$ in.; *English Light Switch*, 1966, plaster and metal painted with tempera, 5 $^1/_8$ × 6 × 1 $^1/_2$ in.; *Fagends in the Park*, 1966, charcoal, crayon, watercolor, 7 $^1/_8$ × 9 $^1/_8$ in.; *Light Switches for the Outer Archipelago, Stockholm*, 1966, pencil and watercolor, 31 $^1/_2$ × 25 $^3/_{16}$ in.; *Notebook Page: Drill Bit in Place of the Statue of Eros, "Extended," London*, 1966, ballpoint pen, felt pen, pencil, clipping, postcard, 11 × 8 $^1/_2$ in.; *Notebook Page: Drill Bit in Place of the Statue of Eros, London*, 1966, ballpoint pen, pencil, clipping, postcard, 11 × 8 $^1/_2$ in.; *Notebook Page: Proposal for a Building in the Form of an Office Machine, London*, 1966, ballpoint pen, felt pen, pencil, clipping, postcard, collage, 11 × 8 $^1/_2$

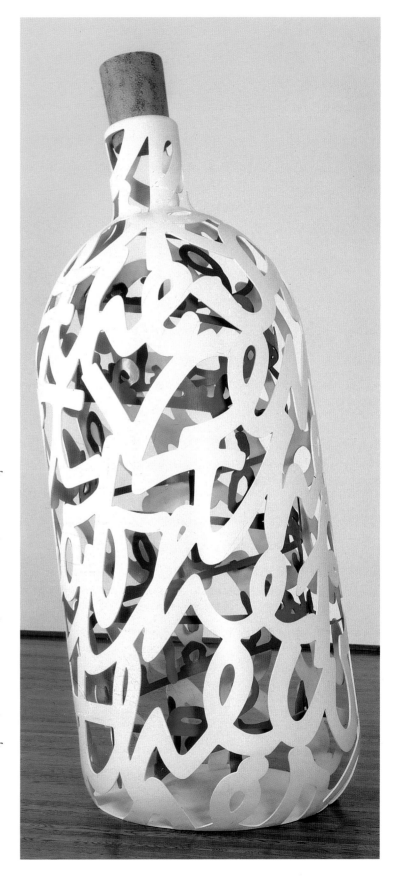

in.; *Notebook Page: Proposal for a Gearstick to Replace Nelson's Column, Trafalgar Square, London*, 1966, postcard, felt pen, crayon, watercolor, pencil, 11 × 8 ¹/₂ in.; *Notebook Page: Rear View Mirror in Place of Nelson's Column, Trafalgar Square, London*, 1966, pencil, clipping, collage, 11 × 8 ¹/₂ in.; *Notebook Page: Sliced Building, Piccadilly Circus, London*, 1966, ballpoint pen, pencil, crayon, watercolor, clipping, postcard, collage, 11 × 8 ¹/₂ in.; *Notebook Page: Square in London in the Form of Objects on a Gentleman's Night Table, London*, 1966, ballpoint pen, felt pen, watercolor, pencil, clipping, 11 × 8 ¹/₂ in.; *Proposed Colossal Monument for Langholmen, Stockholm – Saw*, 1966, pencil, 14 ¹/₂ × 41 ¹/₈ in.; *Proposed Colossal Monument for Stora Höggarn, Stockholm – Stamp*, 1966, crayon and watercolor, 18 × 14 ³/₄ in.; *Saw Handle*, 1966, crayon, pencil, colored pencil, watercolor on cardboard, 40 ¹/₂ × 58 ¹/₂ in.; *Terminus of Proposed New Bridge, Lidingö, Stockholm, in the Form of Swedish Bathtub Fixtures*, 1966, crayon, 11 ¹/₂ × 8 ³/₄ in.; *Winged Screw*, 1966, crayon, 9 × 11 ¹³/₁₆ in.; *Miniature Soft Drum Set*, 1967, canvas, clothesline, wood, cardboard, spray enamel, pencil, variable dimensions: 10 × 19 × 14 in.; *Notebook Page: Study for the Fabrication of the Soft Drum Pedal*, 1967, pencil, felt pen, colored pencil, 11 × 8 ¹/₂ in.; *Proposed Chapel in the Form of a Swedish Extension Plug*, 1967, crayon and watercolor, 30 × 22 in.; *Study for a Soft Sculpture in the Form of a Giant Ketchup Bottle*, 1967, pencil and watercolor, 30 × 22 in.; *Chocolate Earthquake, Los Angeles*, 1968, pencil, ballpoint pen, clipping, 11 × 8 ¹/₂ in.; *Fagend Study*, 1968, plaster and felt, painted with acrylic, 4 ¹/₂ × 10 ¹/₂ × 3 ¹/₄ in.; *Fireplug Souvenir – "Chicago August 1968,"* 1968, cast plaster painted with acrylic, 8 × 8 × 6 in.; *Fragment of an Ionic Column*, 1968, cardboard painted with spray enamel, 9 ¹/₂ × 9 × 6 ¹/₄ in.; *Notebook Page: Colossal Fire Plug for Navy Pier, Chicago, from Above*, 1968, crayon and watercolor, 11 × 8 ¹/₂ in.; *Notebook Page: Flashlight Across the Hollywood Hills*, 1968, ballpoint pen and pencil, 11 × 8 ¹/₂ in.; *Notebook Page: Ionic Column/Fireplug*, 1968, ballpoint pen, 11 × 8 ¹/₂ in.; *Notebook Page: Metamorphic Studies of Cartoon Mice, "OHBOBOOY" Chicago*, 1968, ballpoint pen, 11 × 8 ¹/₂ in.; *Notebook Page: Soft Screw in Waterfall and Screw/Tornado/Searchlights*, 1968, ballpoint pen and watercolor, 11 × 8 ¹/₂ in.; *Notebook Page: Studies of the Mouse/Blimp, Los Angeles*, 1968, pencil, ballpoint pen, colored pencil, collage, 11 × 8 ¹/₂ in.; *Saw Handle, Model*, 1968, expanded polystyrene and cardboard, 43 ¹/₂ × 58 × 5 in.; *Chocolate Earthquake Segment*, 1969, cardboard, canvas, wood, painted with acrylic, 6 ¹/₂ × 15 × 12 in.; *Copy of the Chicago Picasso Maquette*, 1969 (destroyed), cardboard and wood, painted with spray enamel, 39 ¹/₂ × 29 ¹/₂ × 24 ¹/₂ in.; *Geometric Mouse – Original Model*, 1969, cardboard, string, wood, metal, 13 ¹/₂ × 17 ³/₄ × 18 ¹/₄ in.; *Ice Bag #2 – Model*, 1969, wood, cardboard, plastic, spray enamel, 20 × 16 × 4 ¹/₄ in.; *Lipstick (Ascending) on Caterpillar Tracks – Fabrication Model*, 1969, plaster, balsa wood, cardboard, painted with spray enamel, 13 ³/₈ × 11 ³/₄ × 9 ³/₄ in.; *Model for a Mahogany Plug, Scale B*, 1969, plywood and Masonite painted with latex, 59 × 39 × 28 ¹/₂ in.; *Monument for Yale University:*

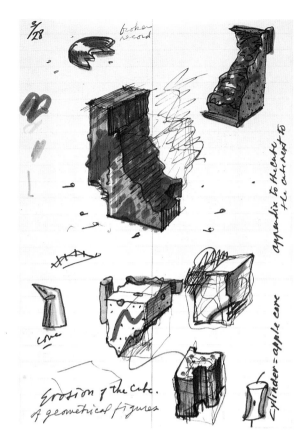

Giant Traveling and Telescoping Lipstick with Changeable Parts in Three Stages of Extension – Presentation Model, 1969, cardboard, canvas stiffened with glue, painted with spray enamel, and shellacked, tractor: 5 $^1/_2$ × 16 $^1/_2$ × 29 $^1/_2$ in., lipstick, stage one: 4 × 8 $^1/_2$ × 10 $^1/_4$ in., lipstick, stage two: 14 $^1/_2$ × 8 $^1/_2$ × 10 $^1/_4$ in., lipstick, stage three: 23 $^1/_2$ × 8 $^1/_2$ × 10 $^1/_4$ in.; *Notebook Page: Design for a Mathematics Building at Yale University*, 1969, pencil and clipping, 11 × 8 $^1/_2$ in.; *Notebook Page: Fagend Butte etc.*, 1969, ballpoint pen and colored pencil, 11 × 8 $^1/_2$ in.; *Notebook Page: Fagend Canyon and Burnt Bread Monument,* 1969, ballpoint pen, colored pencil, pencil, 11 × 8 $^1/_2$ in.; *Notebook Page: Soft Rotating Capitol,* 1969, crayon, 11 × 8 $^1/_2$ in.; *Notebook Page: Studies for the Giant Ice Bag,* 1969, ballpoint pen, pencil, felt pen, 11 × 8 $^1/_2$ in.; *Notebook Page: Toothbrush with Paste,* 1969, pencil, colored pencil, clipping, 11 × 8 $^1/_2$ in.; *Proposal for a Catalog of My Retrospective Exhibition in the Form of a Swiss Cheese Sandwich,* 1969, cardboard painted with spray enamel, 14 $^1/_2$ × 12 $^3/_4$ × 3 $^1/_4$ in.; *Rising and Falling Screw,* 1969, cardboard, wood, pencil, painted with spray enamel and coated with resin, 11 × 28 × 10 $^1/_2$ in.; *Soft Drum Set,* 1969, linen, cord, wood, on cardboard base, 9 $^3/_4$ × 19 × 13 $^3/_4$ in.; *Studies for Lipstick (Ascending), on Caterpillar Tracks*, 1969, ballpoint pen, crayon, pencil, 11 × 8 $^1/_2$ in.; *Studies for Lipstick (Ascending), on Caterpillar Tracks, "TATLIN,"* 1969, ballpoint pen and pencil, 11 × 8 $^1/_2$ in.; *Study for a Soft Screw*, 1969, canvas, wood, wire, nails, painted with latex, 10 $^1/_4$ × 7 $^1/_8$ × 3 $^1/_2$ in.; *Study for Feasible Monument: Lipstick, Yale,* 1969, pencil, colored pencil, spray enamel, 16 $^5/_8$ × 11 $^1/_8$ in.; *Study for Lipstick (Ascending), on Caterpillar Tracks; "a.a. gun emplacement,"* 1969, ballpoint pen, colored pencil, typescript, 11 × 8 $^1/_2$ in.; *Symbolic Self-Portrait with Equals,* 1969, pencil, crayon, spray enamel, watercolor, collage, 11 × 8 $^1/_2$ in.; *Notebook Page: "Towards a Helsinki Monument,"* 1970, ballpoint pen, felt pen, collage, 11 × 8 $^1/_2$ in.; *Notebook Page: Building in the Form of a Rack of Toast,* 1970, ballpoint pen and clipping, 11 × 8 $^1/_2$ in.; *Notebook Page: Costume for a Drainpipe Ballet, Leningrad,* 1970, ballpoint pen, 2 sheets: each approx. 4 $^{11}/_{16}$ × 3 $^7/_8$ in.; *Notebook Page: Licorice Pipe and Tart,* 1970, felt pen, 11 × 8 $^1/_2$ in.; *Notebook Page: Proposed Monument for Helsinki in the Form of Ski Shoes,* 1970, ballpoint pen and felt pen, 11 × 8 $^1/_2$ in.; *Notebook Page: Proposed Monument to the Poet Runeberg in the Form of a "Runebergstarta," Helsinki,* 1970, felt pen, 11 × 8 $^1/_2$ in.; *Notebook Page: Soft Inverted Windmill,* 1970, ballpoint pen, 11 × 8 $^1/_2$ in.; *Notebook Page: Soft, Split Bat/Alphabet,* 1970, ballpoint pen, 11 × 8 $^1/_2$ in.; *Notebook Page: Sphinx Compared to Screw,* 1970, ballpoint pen, felt pen, clipping, 11 × 8 $^1/_2$ in.; *Notebook Page: Three-Way Plug Studies, Dallas,* 1970, ballpoint pen, felt pen, colored pencil, 11 × 8 $^1/_2$ in.; *Three-Way Plug, Scale B, Soft,* 1970, leather, wood, canvas, kapok, 72 × 36 × 11 in.; *Cemetery in the Shape of a Colossal Screw: Skyscraper for São Paulo, Brazil,* 1971, pencil and colored pencil, 14 $^1/_2$ × 11 $^1/_2$ in.; *Bridge Over the Rhine at Düsseldorf in the Shape of a Colossal Saw,* 1971, crayon, pencil, colored pencil, 11 × 14 $^1/_2$ in.; *Notebook Page: Baked Pota-*

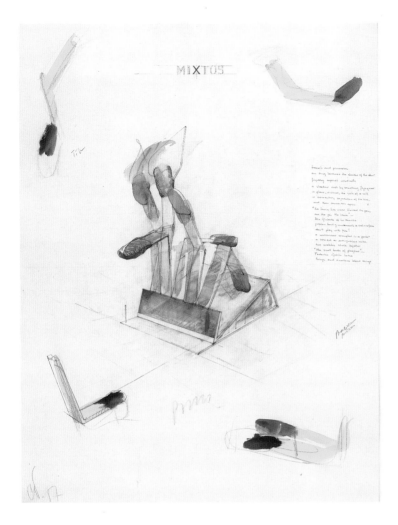

trench and procession
one thing becomes the shadow of the other
fighting against windmills
a shadow cast by something flying over
a plane, a cloud, the sails of a mill
a momentary separation of the sun,
and then connection again.
"the lance has never blunted the pen,
nor the pen the lance" -
Don Quixote of La Mancha
passion boiling underneath a cool surface
don't play with fire!
a matchcover crumpled in a pocket
a torn out or extinguished match
two matches stuck together
"the small buds of phosphor" -
Federico García Lorca
things and emotions about things

(*Stirring Up Spanish Themes*, 1987. Inscription by
Coosje van Bruggen)

to, with Butter, in Place of Alcatraz, 1972, ballpoint pen and col-
ored pencil, 11 × 8 $^1/_2$ in.; *Notebook Page: Beach House in the
Form of Melting Butter*, 1972, ballpoint pen and watercolor, 11 × 8 $^1/_2$
in.; *Sketch of Three-Way Plug (1965)*, 1972, offset lithograph, 32
× 24 $^3/_{16}$ in.; *Three-Way Plug, Position Study*, 1972, plug set in
plaster and wood, painted with latex and spray enamel, 2 $^1/_2$ × 9 $^1/_2$
× 7 $^3/_8$ in.; *Study for a Sculpture in the Form of a Saw, Cutting*,
1973, cardboard painted with spray enamel, 14 $^1/_8$ × 10 × 10 in.;
Inverted Q, 1974, ceramic painted with latex, 5 $^1/_4$ × 5 $^1/_4$ × 4 $^3/_8$ in.;
Notebook Page: Grand Piano Shipwreck, 1974, pencil, 11 × 8 $^1/_2$ in.;
Notebook Page: Knäckebröd Q, 1974, pencil and ballpoint pen, 11
× 8 $^1/_2$ in.; *Study for a Civic Sculpture in the Form of a Mitt and
Ball*, 1974, toy glove and ball, nails, wood, painted with spray
enamel, pencil, 8 $^1/_2$ × 11 $^1/_2$ × 10 in.; *Notebook Page: Bridge for
Duisburg, Derived from an Inverted Elephant Head*, 1975, crayon,
pencil, watercolor, 11 × 8 $^1/_2$ in.; *Notebook Page: Button Studies*,
1975, pencil and ballpoint pen, 11 × 8 $^1/_2$ in.; *Soft Screw* A. C. II,
1975-1976, cast elastomeric polyurethane and lacquered
mahogany base 45 $^3/_4$ × 11 $^5/_8$ × 11 $^5/_8$ in., on base 2 $^1/_4$ × 14 $^5/_8$ in.;
Notebook Page: Sketch of Screwarch for a Rotterdam Site, 1976,
felt pen, ballpoint pen, pencil, envelope, 11 × 8 $^1/_2$ in.; *Inverted Q
– Black 1/2*, 1976-1978, cast resin painted with latex, 72 × 70 × 63 in.;
Screwarch Model A.P. 1/2, 1977-1978, cast bronze with steel base, 17 $^3/_4$

× 31 × 11 in., on base $^1/_4$ × 31 × 11 in.; *Preliminary Study for the
Crusoe Umbrella*, 1978, coated wire, 11 × 8 $^3/_4$ × 9 $^7/_8$ in.; *Study for
the Wayside Drainpipe*, 1978, chalk, wood, cardboard, sand, paint-
ed with spray enamel and coated with resin, 10 $^3/_4$ × 9 $^3/_8$ × 5 $^5/_8$ in.;
Flashlight, 1979, flashlight in plaster, painted with latex, 7 $^1/_2$ × 4 $^1/_2$
× 3 $^7/_8$ in.; *Flashlight, Study for Final Version*, 1979, paper and
wood, painted with casein, 11 $^1/_8$ × 6 $^5/_8$ × 5 $^3/_4$ in.; *Notebook Page:
Bread Slices and Nails*, 1979, pencil, 11 × 8 $^1/_2$ in.; *Notebook Page:
Cocktail Sign Comparisons*, 1979, pencil and ballpoint pen, 11 × 8 $^1/_2$
in.; *Notebook Page: Model of the Screwarch Bridge*, 1979, cray-
on, ballpoint pen, felt pen, watercolor, 11 × 8 $^1/_2$ in.; *Altered Sou-
venir of the Cologne Cathedral*, 1980, aluminum and plaster
painted with enamel, 7 $^1/_2$ × 6 $^1/_2$ × 3 $^1/_2$ in.; *Notebook Page: Cross
Section of Toothbrush in Glass, "Sun Dial,"* 1980, ballpoint pen,
felt pen, pencil, colored pencil, 11 × 8 $^1/_2$ in.; *Notebook Page: Stud-
ies of Tumbling and Rolling Hats in a Field for Salinas, California*,
1980, pencil, 11 × 8 $^1/_2$ in.; *Proposed Sculpture in the Form of a
Desk Pen: "=flame"; Rabbit "cookie cutter,"* 1980, pencil and ball-
point pen, 2 sheets: each 11 × 8 $^1/_2$ in.; *Screwarch Bridge (State II)*,
1980, hard-ground etching, spit-bite, aquatint and sanding, 31 $^1/_4$
× 57 $^3/_4$ in.; *Sign on a Street in Hartford, Connecticut*, 1980, snap-
shot, 11 × 8 $^1/_2$ in.; *Studies for a Sculpture in the Form of a Giant
Sneaker*, 1980, pencil, colored pencil, ballpoint pen, rubber stamp

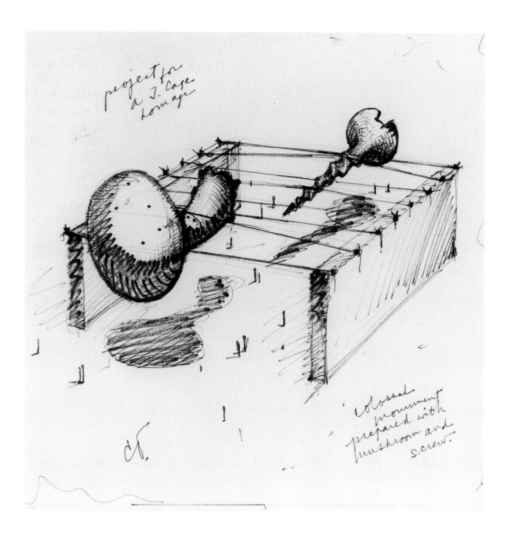

ink, 11 × 8 ¹/₂ in.; *Study for Salinas Hat,* 1980, grinding wheel, plastic cup, sand, coated with glue and painted with spray enamel, 4 ¹/₂ × 7 ¹/₄ × 4 ¹/₂ in.; *Toothbrush in Glass = Percent Sign: "I placed a jar,"* 1980, pencil and ballpoint pen, 11 × 8 ¹/₂ in.; *Screwarch Bridge Model,* 1980-1981, bronze, aluminum, plastic, on steel table, painted with polyurethane enamel, model: 1 ft. 7 ⁷/₈ in. × 8 ft. 3 ⁵/₈ in. × 3 ft. 8 ⁷/₈ in., table: 2 ft. 9 ¹/₁₆ in. × 7 ft. 1 ¹³/₁₆ in. × 2 ft. 7 ¹/₈ in.; *Notebook Page: Sliced Berries and Squashed Butt,* 1981, pencil and colored pencil, 11 × 8 ¹/₂ in.; *Screwarch Bridge (State III),* 1981, hard-ground etching, aquatint, sugar-lift, spit bite, sanding and monoprint, 31 ¹/₄ × 57 ³/₄ in.; *Study for a Sculpture in the Form of a Split Button,* 1981, cardboard painted with spray enamel, 7 ⁷/₈ × 10 ¹/₂ × 10 ³/₄ in.; *Model of Cross Section of a Toothbrush with Paste in a Cup on a Sink: Portrait of Coosje's Thinking,* 1982, aluminum, painted with polyurethane, 105 ³/₈ × 48 ¹/₈ × 15 in.; *Notebook Page: Pencil Points,* 1982, pencil, ballpoint pen, felt pen, 11 × 8 ¹/₂ in.; *Notebook Page: Thumbtack Through Paper, Nails Through Wood,* 1982, felt pen, 11 × 8 ¹/₂ in.; *Souvenir of Documenta 7: Beschmierter Friderico,* 1982, cast plaster painted with enamel, 7 ⁵/₈ × 3 × 3 ¹/₈ in.; *Studies for Sculptures in the Form of a Snapped Match,* 1982, wood, paper, clay, tape, match, nail, painted with latex and spray enamel, 4 ³/₄ × 8 ³/₄ × 3 ¹/₂ in.; *Balancing Tools, Study,* 1983, cardboard, wood (floor seg-

ment), paper, screwdriver, nails, painted with spray enamel, 9 ¹/₄ × 14 ³/₄ × 9 ¹/₄ in.; *Broken Pencil, Writing,* 1983 (destroyed), felt pen, ballpoint pen, crayon, watercolor, 11 ¹⁵/₁₆ × 8 ¹/₂ in.; *Notebook Page: Basketball in Net, on a Cliff Overlooking the Pacific Ocean,* 1983, pencil, colored pencil, ballpoint pen, watercolor, 11 × 8 ¹/₂ in.; *Notebook Page: Sculpture in the Form of Jacks Composed of Tools,* 1983, pencil and watercolor, 11 × 8 ¹/₂ in.; *Notebook Page: Tilting Cocktail in the Vitra Site,* 1983, pencil and felt pen, 11 × 8 ¹/₂ in.; *Proposal for a Monument to the Survival of the University of El Salvador: Blasted Pencil (Which Still Writes), Model,* 1983, painted cardboard, polyurethane foam, wood, metal, 11 × 84 × 24 in.; *Study For a Print of the Blasted Pencil,* 1983, felt pen, pencil, crayon, 11 × 8 ¹/₂ in.; *Tilting Neon Cocktail,* 1983, stainless steel, cast aluminum, acrylic paint, Plexiglas, 18 ³/₈ × 7 × 6 ¹/₄ in.; *Tilting Neon Cocktail Study,* 1983, cardboard, wood, nail, painted with acrylic, felt pen, 16 ¹/₈ × 12 × 9 ³/₈ in.; *Proposal for a Monument to the Survival of the University of El Salvador: Blasted Pencil (Which Still Writes),* 1984, soft-ground, aquatint, and spit bite, 22 × 30 ¹/₈ in.; *Elevations and Plans for the Blasted Pencil, Drawn by J. Robert Jennings,* 1985, pencil, 43 × 27 ¹/₂ in.; *Toppling Ladder with Spilling Paint, Fabrication Model,* 1985, steel painted with polyurethane enamel, 18 ¹/₂ × 12 × 12 in.; *Models for Objects in the Haunted House Haus Esters,* 1986, paper, expanded polystyrene,

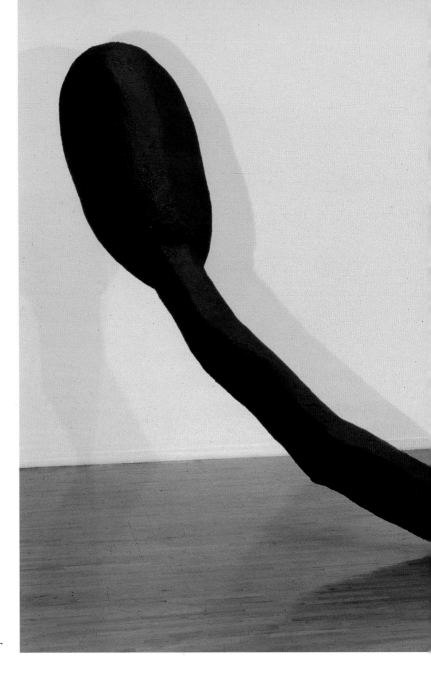

cloth, cardboard, wood, pipe cleaner, sand, foamcore on wood base painted with latex and covered in felt, overall dimensions, in Plexiglas vitrine as exhibited: 5 $^3/_8$ × 21 × 14 $^7/_8$ in.; *Notebook Page: Hammock Study*, 1986, clipping and pencil, 11 × 8 $^1/_2$ in.; *Notebook Page: Knäckebröd/Iron*, 1986, ballpoint pen, pencil, felt pen, napkin, photocopy, collage, 11 × 8 $^1/_2$ in.; *Notebook Page: Melody in Felt*, 1986, felt pen, 11 × 8 $^1/_2$ in.; *Study for a Sculpture in the Form of a Lighted Match in Wind*, 1986, paper, foamcore, wood, painted with spray enamel, 11 $^7/_8$ × 6 $^1/_2$ × 3 $^3/_4$ in.; *Brick Debris*, 1987, expanded polystyrene, cement, painted with latex, 6 assorted sizes; *"Britiship"; "MS in a Bottle,"* 1987, pencil and felt pen, 11 × 8 $^1/_2$ in.; *Calico Bunny*, 1987, canvas, balsa wood, expanded polystyrene, painted with latex, 72 × 45 × 12 in.; *Cover for Bottle of Notes and Some Voyages Version II*, 1987, felt pen and watercolor, 25 $^3/_4$ × 40 $^1/_2$ in.; *Cross Section of a Toothbrush with Paste in a Cup on a Sink: Portrait of Coosje's Thinking, Soft and Uprooted Version, with Foundation*, 1987, toothbrush: canvas filled with polyurethane foam, painted with latex, foundation: expanded polystyrene and Thoroseal, painted with latex, toothbrush: 6 $^3/_4$ in. × 1 ft. 9 in. × 5 ft. 11 $^5/_8$ in., foundation: 3 ft. 11 in. × 3 ft. 11 in. × 3 ft.; *Dropped-off Muffler*, 1987, canvas, paper, polyurethane foam, aluminum, expanded polystyrene, coated with resin and painted with latex, 3 ft. × 3 ft. 4 in. × 9 ft.; *Dropped-off Muffler*, 1987, polyurethane foam, canvas, coated with resin and painted with latex, 19 × 21 × 60 in.; *Extinguished Match*, 1987, steel and polyurethane foam painted with latex, 94 × 270 × 29 in.; *Extinguished Match as Bridge or Arch: "Made in Bklyn!,"* 1987, felt pen and pencil, 5 × 2 $^3/_4$ in.; *Half Tire, with Deflated Tube*, 1987, tire: expanded polystyrene, plaster, coated with resin and painted with latex, tube: canvas, coated with resin and painted with latex, tire: 36 × 16 × 71 in., tube: 38 × 38 × 66 in.; *Lost Heel*, 1987, expanded

polystyrene, coated with resin and painted with latex, 49 × 44 × 12 in.; *Notebook Page: Apple Core Derived from Sphere*, 1987, pencil, 11 × 8 $^1/_2$ in.; *Notebook Page: Cook's Hands, a Gate in Middlesbrough, the Bottle on the Beach*, 1987, felt pen, pencil, clippings, 3 clippings, 11 × 8 $^1/_2$ in.; *Notebook Page: Studies for a Shipwreck Sculpture*, 1987, pencil, colored pencil, felt pen, ballpoint pen, 11 × 8 $^1/_2$ in.; *Notebook Page: Studies for the Haunted House: Bricks, Broken Record, etc.*, 1987, felt pen, 11 × 8 $^1/_2$ in.; *Paper Match Variations*, 1987, pencil, felt pen, ballpoint pen, colored pencil, 11 × 8 $^1/_2$ in.; *Piano/Hammock*, 1987, steel, painted with polyurethane enamel, stainless steel, cast aluminum, 16 ft. × 6 ft. 5 in. × 5 ft. 3 in.; *Rotten Apple Core*, 1987, canvas, polyurethane foam, steel, coated with resin and painted with latex, 65 × 48 × 48 in.; *Sculpture in the Form of a Match Cover – Model*, 1987, cardboard, expanded polystyrene, felt pen, 38 $^1/_2$ × 19 × 38 in.; *Sculpture in the Form of a*

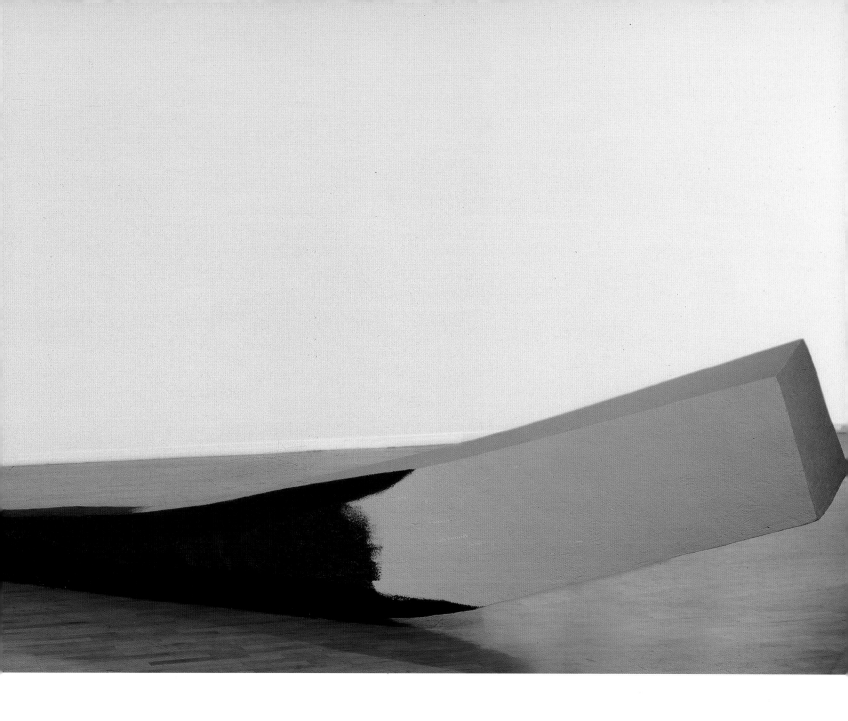

Match Cover with Loose Matches – Fabrication Model, 1987, steel and polyurethane foam, coated with resin and painted with latex, 3 ft. 4 in. × 6 ft. 6 ³/₄ in. × 6 ft. 6 ³/₄ in.; *Stirring Up Spanish Themes,* 1987, pencil, watercolor, felt pen, 30 ¹/₈ × 23 ¹/₄ in.; *Stone Debris,* 1987, expanded polystyrene, cement, painted with latex, 6 assorted sizes; *Studies toward a Sculpture for Barcelona,* 1987, pencil, colored pencil, felt pen, 11 × 8 ¹/₂ in.; *Study for a Sculpture in the Form of a Match Cover,* 1987, wood, paper, clay, painted with latex, 10 ¹/₂ × 8 ¹/₄ × 9 in.; *Study for the Bottle of Notes,* 1987, pencil and colored pencil, 30 × 25 ¹/₂ in.; *Study for the Scripts of the Bottle of Notes,* 1987, pencil, 28 ¹/₄ × 40 in.; *Uprooted Bird-house,* 1987, expanded polystyrene, coated with resin and painted with latex, 45 × 36 × 84 in.; *Proposal for a Colossal Monument, "Prepared Piano" with Mushroom and Screw (for John Cage),* 1987 (signed 1988), ballpoint pen and felt pen, 8 ¹/₄ × 8 ¹/₄ in.

—— THE KNIFE SHIP II, The Temporary Contemporary, Museum of Contemporary Art, Los Angeles, March 22 – June 19.
Work exhibited: *Knife Ship II,* 1986, steel, aluminum, wood, painted with polyurethane enamel, motor, closed, without oars: 7 ft. 8 in. × 10 ft. 6 in. × 40 ft. 5 in., extended, with oars: 26 ft. 4 in. × 31 ft. 6 in. × 82 ft. 11 in.; height with large blade raised: 31 ft. 8 in., width with blades extended: 82 ft. 10 in.

—— COLTELLO RECALLED: REFLECTIONS ON A PERFORMANCE, with Claes Oldenburg, Coosje van Bruggen, Frank O. Gehry and Germano Celant. Japan America Cultural Center, Los Angeles, April 8. Eminences Grises: John Baldessari, Allan Kaprow.

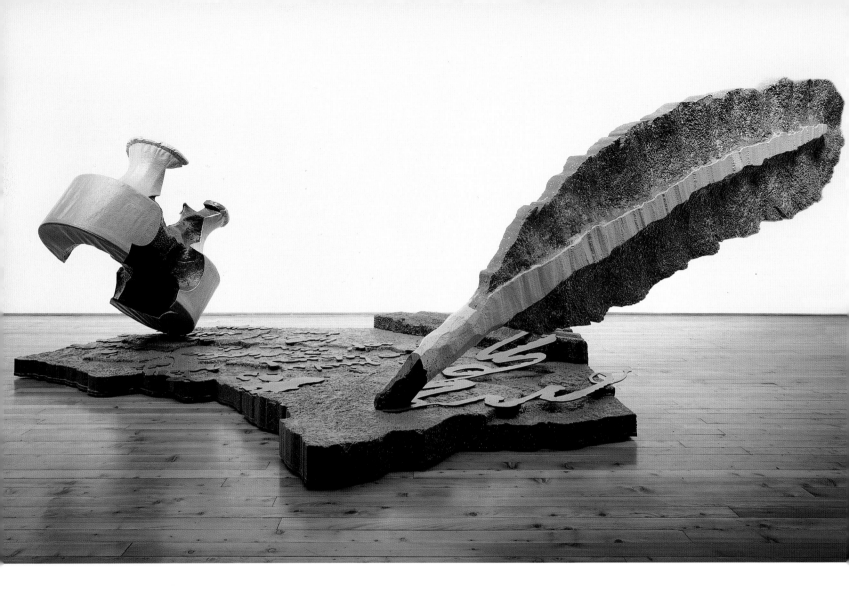

1990

—— THE EUROPEAN DESKTOP, Christian Stein, Milan, May 3 – June 20. Book.

Works exhibited: *Exploding Ink Bottle*, 1989, pencil and watercolor, 9 ³/₈ × 7 ⁷/₁₆ in.; *Ink Bottle and Leaning Quill on Fragment on the Desk Pad*, 1989, pencil and watercolor, 10 ⁹/₁₆ × 8 in.; *Leaning Quill with Solidified Ink on a Fragment of Desk Pad*, 1989 (lost), pencil and watercolor, 9 ³/₈ × 7 ¹/₂ in.; *Notebook Page: Exploding Ink Bottle and Traveling Stamp Blotter*, 1989, pencil and watercolor, 9 ³/₈ × 7 ⁷/₁₆ in.; *Notebook Page: Study for a Sculpture in the Form of a Quill Stuck in Solidified Ink*, 1989, pencil and watercolor, 9 ⁷/₁₆ × 7 ¹/₂ in.; *Quill and Exploding Ink Bottle*, 1989, ballpoint pen and pencil, 11 × 8 ¹/₂ in.; *Quill and Exploding Bottle with Commentary*, 1989, felt pen, pencil, collage, 11 × 8 ¹/₂ in.; *Quill and Ink Bottle on Its Side*, 1989, pencil, 11 × 8 ¹/₂ in.; *Quill Stuck in Ink Bottle, with Blot*, 1989, ink, pencil, colored pencil, clipping, collage, 11 × 8 ¹/₂ in.; *Studies for a Sculpture in the Form of a Collapsing European Postal Scale*, 1989, pencil, 9 ³/₈ × 7 ⁷/₁₆ in.; *Study for the European Desktop – "Desk Lamp,"* 1989, pencil, 10 ⁵/₈ × 8 ¹/₈ in.; *Model for The European Desktop*, 1989-1990, expanded polystyrene,

wood, steel, canvas, coated with resin and painted with latex, 61 × 155 × 82 in., variable dimensions; *Announcement for The European Desktop*, 1990, ink, watercolor, photostat, collage, 8 ¹/₄ × 10 ¹⁵/₁₆ in.; *Desk Pad with Blotters Under Cloud*, 1990, felt pen, pencil, watercolor, 10 ⁵/₈ × 7 ⁵/₈ in.; *European Postal Scale and Envelopes*, 1990, blotted ink, 10 ⁵/₈ × 8 ¹/₄ in.; *European Postal Scale, Elevation*, 1990, pencil and watercolor, 30 × 40 in.; *Fabrication Studies for the Quill and Stamp Blotter*, 1990, pencil, 9 ³/₈ × 7 ¹/₂ in.; *Ink Bottle on Its Side and Rearing Stamp Blotter*, 1990, ink, colored pencil, photostat, collage, 10 ¹³/₁₆ × 8 ¹/₄ in.; *Notebook Page: Color Notes for The European Desktop*, 1990, felt pen and watercolor, 10 ¹⁵/₁₆ × 8 ⁵/₁₆ in.; *Notebook Page: Stamp Blotter from Above, with Blots*, 1990, ink, colored pencil, pencil, collage, 10 ¹³/₁₆ × 8 ¹/₄ in.; *Notebook Page: Studies for a Sculpture in the Form of a Collapsing European Postal Scale*, 1990, pencil, 11 × 8 ¹/₂ in.; *Notebook Page: Studies for a Sculpture in the Form of a European Postal Scale*, 1990, pencil and watercolor, 10 ⁵/₈ × 8 in.; *Notebook Page: Study for The European Desktop – Script over Fragments of the Desk Pad*, 1990, pencil and watercolor, 7 ⁷/₁₆ × 8 ¹/₁₆ in.; *Notebook Page: The European Desktop, Seen from Below*, 1990, pencil and watercolor, 8 ⁵/₈ × 6 ⁵/₁₆ in.; *Pad Corner, Scripts and Blots*, 1990, felt pen, ink, colored pen-

cil, watercolor, photostat, collage, 10 $^{13}/_{16}$ × 8 $^{1}/_{4}$ in.; *Parts of the European Desktop Falling from the Sky – Study for Announcement*, 1990, felt pen and photocopy, 10 $^{13}/_{16}$ × 8 $^{1}/_{4}$ in.; *Quill, Scripts and Blots*, 1990, ink, felt pen, colored pencil, photostat, collage, 10 $^{7}/_{8}$ × 8 $^{1}/_{4}$ in.; *Quill, Writing, with Thrown Ink Bottle*, 1990, pencil and watercolor, 9 $^{3}/_{8}$ × 7 $^{1}/_{2}$ in.; *Scripts and Blots*, 1990, colored pencil, photostat, collage, 10 $^{7}/_{8}$ × 8 $^{1}/_{4}$ in.; *Sculpture in the Form of a Collapsed European Postal Scale*, 1990, expanded polystyrene, aluminum, canvas, coated with resin and painted with latex, 5 ft. 1 in. × 21 ft. × 19 ft. $^{3}/_{8}$ in.; *Sculpture in the Form of a Stamp Blotter, Rearing, on a Fragment of Desk Pad*, 1990, expanded polystyrene, steel, wood, cardboard, coated with resin and painted with latex, 6 ft. 8 $^{11}/_{16}$ in. × 12 ft. 7 $^{1}/_{2}$ in. × 10 ft. 9 $^{15}/_{16}$ in.; *Sculpture in the Form of a Writing Quill and an Exploding Ink Bottle, on a Fragment of a Desk Pad*, 1990, expanded polystyrene, steel, wood, canvas, coated with resin and painted with latex, 7 ft. 8 in. × 22 ft. 11 in. × 11 ft. 9 in.; *Shattered Desk Pad with Stamp Blotters, Under Clouds*, 1990, pencil and watercolor, 10 $^{9}/_{16}$ × 7 $^{7}/_{8}$ in.; *Shattered Desk Pad, with Stamp Blotters*, 1990, expanded polystyrene, wood, cardboard, coated with resin and painted with latex, 1 ft. 1 in. × 6 ft. × 4 ft.; *Stamp Blotter, Elevation*, 1990, pencil and watercolor, 30 × 40 in.; *Stamp Blotter, from Below*, 1990, ink, colored pencil, pencil, collage, 10 $^{7}/_{8}$ × 8 $^{1}/_{4}$ in.; *Stamp Blotter, from Side, with Blots*, 1990, ink, colored pencil, collage, 10 $^{13}/_{16}$ × 8 $^{1}/_{4}$ in.; *Stamp Blotters on Shattered Desk Pad*, 1990, charcoal, pencil, pastel, 38 $^{3}/_{16}$ × 50 $^{1}/_{8}$ in.; *Stamp Blotters, Rearing and Traveling*, 1990, ink, pencil, watercolor, 10 $^{13}/_{16}$ × 8 $^{1}/_{4}$ in.; *Studies for a Sculpture in the Form of a Collapsing European Postal Scale*, 1990, pen and watercolor, 11 × 8 $^{1}/_{2}$ in.; *Studies for a Sculpture in the Form of a European Postal Scale*, 1990, pen and watercolor, 10 $^{13}/_{16}$ × 8 $^{1}/_{4}$ in.; *Studies for a Sculpture in the Form of a Quill*, 1990, pencil, 9 $^{7}/_{16}$ × 7 $^{7}/_{16}$ in.; *Studies for a Sculpture in the Form of an Exploding Ink Bottle*, 1990, pencil, 9 $^{3}/_{8}$ × 7 $^{7}/_{16}$ in.; *Studies for The European Desktop*, 1990, pencil, 7 $^{7}/_{16}$ × 9 $^{3}/_{8}$ in.; *Studies for The European Desktop – Exploding Ink Bottle and Quill "=Tube,"* 1990, pencil, 9 $^{7}/_{16}$ × 7 $^{7}/_{16}$ in.; *Study for Announcement of The European Desktop*, 1990, pencil, felt pen, watercolor, 8 $^{1}/_{16}$ × 10 $^{5}/_{8}$ in.; *Study for Announcement: The European Desktop*, 1990, felt pen and watercolor on photocopy, 11 × 8 $^{1}/_{2}$ in.; *Study for Collapsed European Postal Scale*, 1990, pencil and watercolor, 30 × 40 in.; *Thrown Ink Bottle, with Fly*, 1990, pencil and watercolor, 9 $^{3}/_{8}$ × 7 $^{1}/_{2}$ in.; *Tray with Letter, Collapsed European Postal Scale*, 1990, graphite and watercolor, 40 × 30 in.

To Frédéric

Coosje van Bruggen

Sitting at my desk in solitary
pursuit of fleeting thoughts shards
of your nocturnes sing in my head.
Suddenly the earsplitting siren of
a passing ambulance dissipates
the theme, thin as air, you had
awakened in me, never to be
recaptured.
Once amnesia has set in, I am left
with an unshakable sadness and
rising melancholia. Pens broken and
keyboard untouched, your phantoms,
Pole, now overshadow my lines, and
my cold tears turn into the very
raindrops against your window,
that nightmarish afternoon in Majorca,
that made you see yourself floating
on a lake, foreboding death.

Originally published in *Sketches and Blottings toward The European Desktop* (Milan and Turin: Christian Stein; Florence: Hopeful Monster, 1990)

STUDY FOR ANNOUNCEMENT OF THE EUROPEAN DESKTOP, 1990

THROWN INK BOTTLE, WITH FLY, 1990

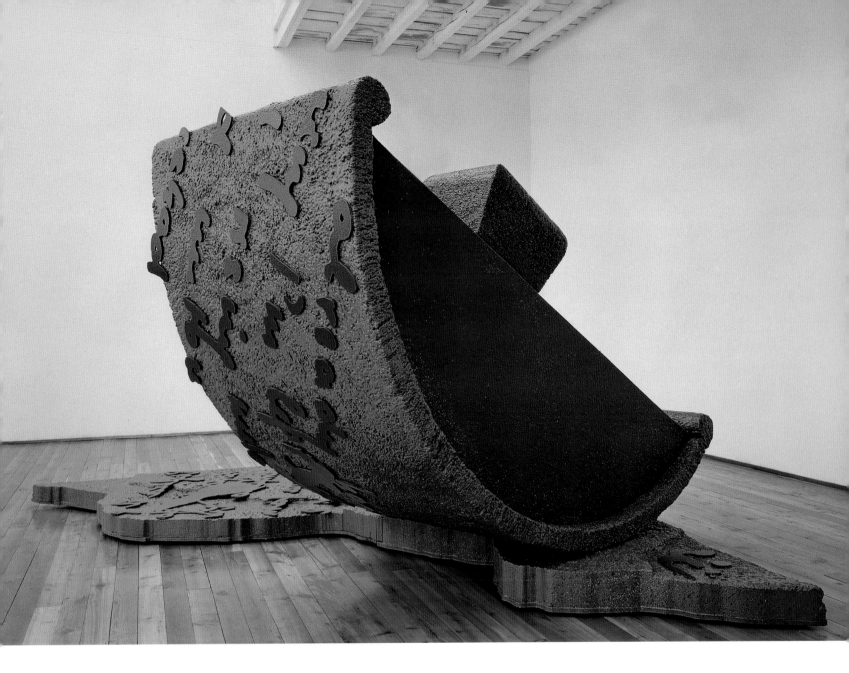

NOTE

Claes Oldenburg

The texts that appear on the blotters of the sculptures in *The European Desktop* were enlarged from two sources provided by Coosje van Bruggen: a poem in the form of a letter by her "to Frédéric" (Chopin) written during the preparation of the sculptures, and a note by Leonardo da Vinci selected by her from the artist's *Notebooks*. In both cases she hand-wrote the selections. As she is ambidextrous, she had no trouble inscribing the note of Leonardo backward (in the way that he wrote). Of course, when the texts become transferred to the blotters it is *her* text that reads in reverse.

Originally published in *Sketches and Blottings toward The European Desktop* (Milan and Turin: Christian Stein; Florence: Hopeful Monster, 1990)

THE EUROPEAN
DESKTOP,
CHRISTIAN STEIN, MILAN,
MAY 3 – JUNE 20, 1990.
WORK SHOWN IS
SCULPTURE IN THE FORM
OF A STAMP BLOTTER,
REARING, ON A
FRAGMENT OF DESK PAD,
1990

FOLLOWING PAGES:
THE EUROPEAN
DESKTOP,
CHRISTIAN STEIN, MILAN,
MAY 3 – JUNE 20, 1990.
WORK SHOWN IS
SCULPTURE IN THE FORM
OF A COLLAPSED
EUROPEAN POSTAL SCALE,
1990

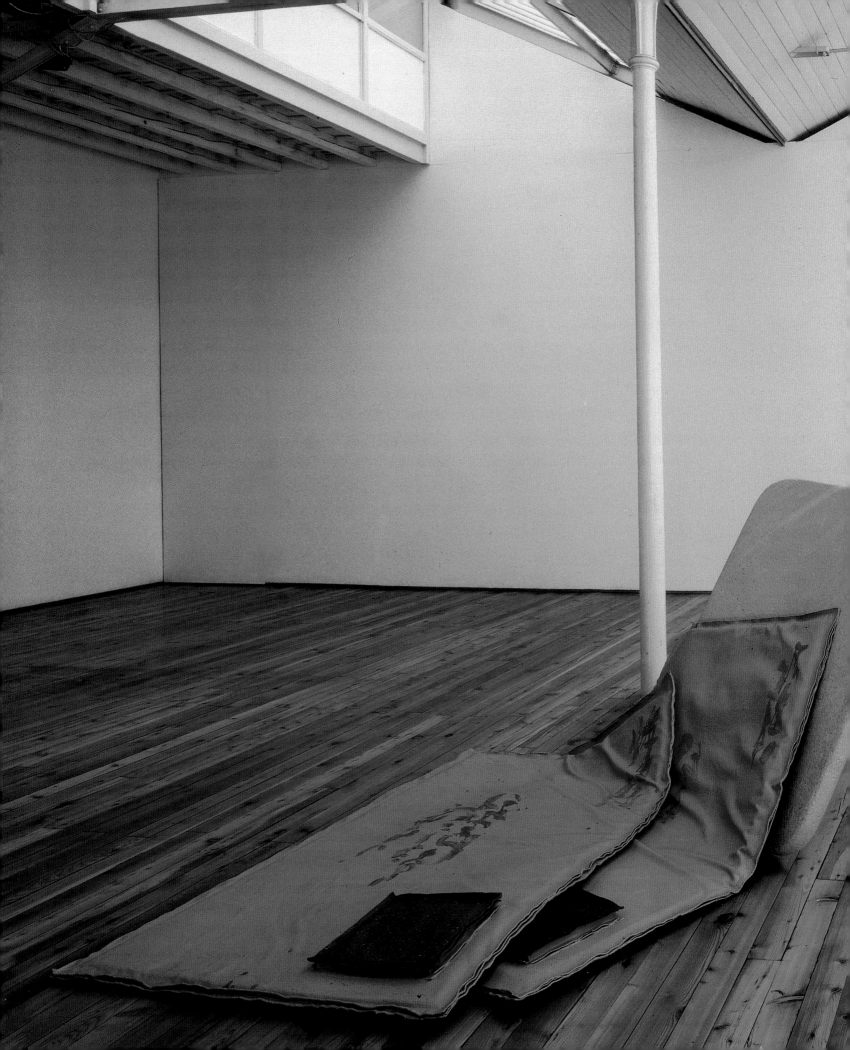

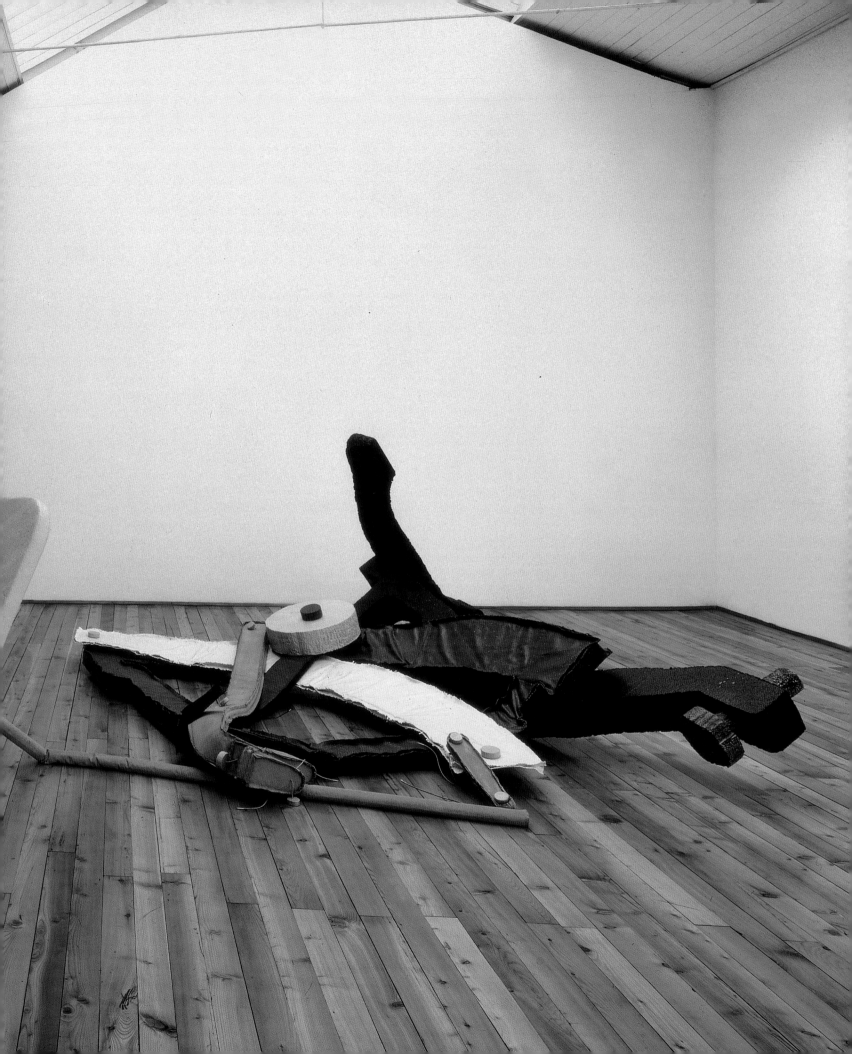

—— CLAES OLDENBURG/COOSJE VAN BRUGGEN, Leo Castelli Gallery, New York, November 27, 1990 – January 12, 1991. Works exhibited: *Biglie con Ricotta e Würstel* and *Spaghetti al Cartoccio Frankie Toronto*, 1985, ballpoint pen, felt pen, watercolor, 2 sheets: each 5 $^1/_8$ × 8 $^1/_2$ in.; *Study for the Bottle of Notes*, 1987, pencil and colored pencil, 30 × 25 $^1/_2$ in.; *Study for the Scripts of the Bottle of Notes*, 1987, pencil, 28 $^1/_4$ × 40 in.; *Alternate Proposal for Number One Poultry Street, London: Prince's Foot in Spaghetti*, 1988, pencil, 13 $^1/_4$ × 9 $^1/_4$ in.; *Bottle of Notes: Version Two (Artforum Cover)*, 1988, crayon and pencil, 25 $^1/_8$ × 20 $^5/_8$ in.; *Apple Core*, 1989, charcoal and pastel, 12 $^7/_8$ × 9 $^1/_8$ in.; *Quill Writing, and Exploding Ink Bottle*, 1989, charcoal, 30 × 40 in.; *From the Entropic Library – Third Study*, 1989, charcoal and chalk, 30 × 40 in.; *Bottle of Notes – Model*, 1989-1990, aluminum and expanded polystyrene, painted with latex, 8 ft. 11 in. × 4 ft. 1 in. × 3 ft. 3 in.; *From the Entropic Library – Model*, 1989-1990, cardboard, rope, expanded polystyrene, wood, aluminum, steel, canvas, coated with resin and painted with latex, 9 ft. 7 in. × 14 ft. 4 in. × 5 ft. 6 in., variable dimensions; *Model for The European Desktop*, 1989-1990, expanded polystyrene, wood, steel, canvas, coated with resin and painted with latex, 61 × 155 × 82 in.; *Study for the Broken Lightbulb*, 1989-1990, pencil, 25 $^7/_8$ × 19 in.; *Broken Bulb, Fallen*, 1990, charcoal, 30 × 40 in.; *Endless Procession of Geometric Mice (Based on an Item From Ripley's "Believe It Or Not")* 1990, pencil, 28 $^5/_8$ × 38 in.; *Flotsam: Broken Cup, Apple Core and Glasses*, 1990, charcoal, 39 $^3/_8$ × 25 $^3/_4$ in.; *Flotsam: Disconnected Socket and Torn Notebook*, 1990, charcoal, 29 $^7/_8$ × 20 in.; *Fragment of a Memo*, 1990, charcoal and watercolor, 6 $^9/_{16}$ × 8 $^9/_{16}$ in.; *Fragment of a Memo with Pencil Writing*, 1990, charcoal and watercolor, 11 $^7/_8$ × 9 in.; *From Coosje's Memos of a Gadfly: "Be What You Is..." with Scrap of Fly Sketch*, 1990, aluminum, expanded polystyrene, coated with resin and painted with latex, 6 parts: 8 × 46 × 8 $^3/_4$ in., 22 × 22 × 25 in., 8 × 18 × 4 in., 8 × 17 × 3 in., 5 × 11 × 3 in., 4 × 12 $^1/_2$ × 5 in., 4 × 12 $^1/_2$ × 5 in.; *From Coosje's Memos of a Gadfly: "Shredded Treaties..." with Scrap of Broken Cup Sketch*, 1990, aluminum, expanded polystyrene, coated with resin and painted with latex, 3 parts: 42 × 31 × 36 in., 30 × 36 × 15 in., 43 × 56 × 19 in.; *From Coosje's Memos of a Gadfly: "Thistles and Roses..." with Scrap of Glasses Sketch*, 1990, aluminum, expanded polystyrene, coated with resin and painted with latex, 3 parts: 48 × 49 × 11 in., 37 $^1/_2$ × 47 × 18 $^1/_2$ in., 34 × 53 × 7 $^1/_4$ in.; *From Coosje's Memos of a Gadfly: "When I'm With You..." with Scrap of Apple Core Sketch*, 1990, aluminum, expanded polystyrene, coated with resin and painted with latex, 3 parts: 41 $^1/_2$ × 42 × 22 in., 42 × 59 × 25 in., 42 × 59 × 25 in.; *From The Entropic Library in a Later Stage #1*, 1990, charcoal, 26 × 40 in.; *From The Entropic Library in a Later Stage #2*, 1990, charcoal and pastel, 29 $^1/_4$ × 39 $^3/_8$ in.; *Pencil Drawing: Ballpoint Writing – Linked, with Fly*, 1990, crayon and watercolor on Mylar, 17 $^1/_2$ × 24 in.; *Study for a Relief Combining Fragments of a Sketch and Writing, with Pencil Stub*, 1990, Masonite, expanded polystyrene, crayon, pencil, cardboard, painted with latex and spray enamel, 58 × 44 × 15 in.; *Study for The European Desktop*, 1990, felt pen, 10 $^9/_{16}$ × 8 in.

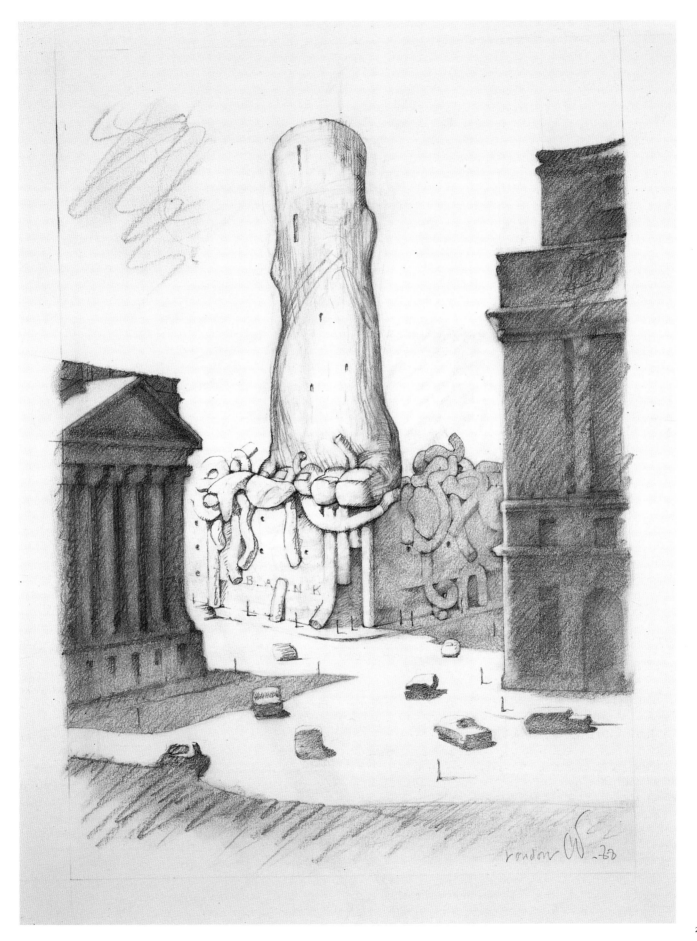

PROPOSAL FOR A MONUMENT TO THE SURVIVAL OF THE UNIVERSITY OF EL SALVADOR: BLASTED PENCIL (WHICH STILL WRITES), 1984

FOLLOWING PAGE:
TORN NOTEBOOK, ONE, 1992
COLLECTION MR. AND MRS. MORTON L. JANKLOW, NEW YORK

TORN NOTEBOOK, TWO, 1992
COLLECTION MARC HAM

1991

—— LARGER THAN LIFE: MONUMENTAL PROPOSALS BY CLAES OLDENBURG AND LARGE-SCALE OUTDOOR SCULPTURE BY CLAES OLDENBURG AND COOSJE VAN BRUGGEN, BP Building, Cleveland, Ohio, November 11, 1991 – January 31, 1992.

Works exhibited: *Scissors as Monument*, 1967, lithograph, 30 × 20 in.; *Notes*, 1968, portfolio of 27 pages, 22 $^{11}/_{16}$ × 15 $^3/_4$ in.; *Model for an Outdoor Sculpture: Buried Three-Way Plug*, 1969, felt pen and ballpoint pen, 8 $^1/_2$ × 11 in.; *Proposed Colossal Monument for Battersea Park, London, Drum Set (1966)*, 1969, offset lithograph, 23 $^7/_8$ × 35 $^1/_4$ in.; *Three-Way Plug*, 1970, felt pen, 4 $^5/_8$ × 6 $^1/_4$ in.; *Geometric Mouse – Scale B*, 1970-1972, aluminum, steel hinges, brass chains, painted with polyurethane enamel, approx.: 36 × 36 × 31 in.; *System of Iconography – Plug, Mouse, Good Humor, Lipstick, Switches (1970)*, 1971, offset lithograph, 28 $^1/_2$ × 20 $^7/_8$ in.; *Geometric Mouse, Scale D "Home-Made,"* 1971, offset lithograph on die-cut cardboard, stainless-steel wire, chains, nickel-plated fasteners, 19 × 16 $^1/_2$ × $^1/_4$ in. (packaged), 13 × 16 × 12 in. (assembled), packaged: 19 $^3/_{16}$ × 16 $^1/_2$ × $^1/_4$ in.; *Sketch of Three-Way Plug (1965)*, 1972, offset lithograph 32 × 24 $^3/_{16}$ in.; *Lipstick (Ascending) on Caterpillar Tracks (1969)*, 1972, lithograph, 30 × 23 $^1/_4$ in.; *Soft Inverted Q – Akron*, 1974, chalk, 14 $^1/_4$ × 20 $^1/_8$ in.; *Picasso Cufflink*, 1974, lithograph, 36 $^1/_8$ × 26 $^7/_8$ in.; *Alphabet/Good Humor* 10/12, 1975, cast resin painted with polyurethane, bronze, wood, 36 × 16 × 7 in.; *Soft Inverted Q – Black, Proof I*, 1975, cast synthetic rubber, 18 × 17 × 10 in.; *Soft Screw* 1/24, 1975-1976, cast elastomeric polyurethane and lacquered mahogany base, 45 $^3/_4$ × 11 $^5/_8$ × 11 $^5/_8$ in. on base 2 $^1/_4$ × 14 $^5/_8$ in.; *Floating Three-Way Plug*, 1976, soft-ground etching and spit bite, 49 $^5/_8$ × 38 $^3/_8$ in.; *Geometric Mouse Pyramid as an Image of the Electoral System, Doubled*, 1976, lithograph, 35 × 26 in.; *Screwarch Model* 1/4, 1977-1978, cast bronze with steel base, 17 $^3/_4$ × 31 × 11 in., on base $^1/_4$ × 31 × 11 in.; *Alternative Proposal for the Allen Memorial Art Museum, Oberlin, Ohio*, 1979, hard-ground and soft-ground etching, aquatint, and spit bite, 34 × 40 $^3/_4$ in.; *Screwarch Bridge (State III)*, 1981, hard-ground etching, aquatint, sugar-lift, spit bite, sanding, and monoprint, 31 $^1/_4$ × 57 $^3/_4$ in.; *Colossal Flashlight in Place of the Hoover Dam*, 1982, offset lithograph, 31 $^1/_4$ × 57 $^3/_4$ in.; *The Spitzhacke, 1982, Superimposed on a Drawing of the Site by Emil Ludwig Grimm, 1822*, 1982, etching, aquatint, and photogravure (from plate by Emil Ludwig Grimm), aquatint, hard-ground, and spit bite, 26 × 20 in.; *Proposal for a Civic Monument in the Form of Two Windows*, 1982, lithograph, 28 × 40 in.; *Proposal for a Monument to the Survival of the University of El Salvador: Blasted Pencil (Which Still Writes)*, 1984, soft-ground, aquatint, and spit bite, 22 $^3/_8$ × 30 $^1/_8$ in.; *Base for the Free Stamp, Standing Version*, 1985-1991, wood, coated with resin and painted with latex, 3 $^1/_2$ × 25 $^3/_4$ × 21 $^3/_4$ in.; *Free Stamp, Second Version, Model*, 1985-1991, wood painted with latex and spray enamel, 14 $^1/_2$ × 22 $^3/_8$ × 20 $^1/_4$ in.; *Monument to the Last Horse, Model*, 1989-1990, steel and concrete painted with latex, 31 × 28 × 22 in.; *Sneaker Lace* 10/12, 1991, cast stainless steel hand-painted with latex, 52 × 24 $^1/_2$ × 42 in.; *Study for Sneaker Lace – Black*, 1991, lithograph, 67 × 41 $^1/_2$ in.; *Study for a Sculpture, Version One*, 1991, cardboard, canvas, steel, coated with resin and painted with latex, on aluminum base, 13 $^1/_2$ × 25 $^1/_4$ × 19 in.

1992

—— CLAES OLDENBURG (WITH COOSJE VAN BRUGGEN), The Pace Gallery, New York, September 18 – October 17. Catalogue.

Works exhibited: *Perfume Bottle*, 1991, crayon and watercolor, 4 $^1/_8$ × 5 $^{13}/_{16}$ in.; *Study for Soft Saxophone*, 1991, charcoal and watercolor, 8 $^1/_2$ × 5 $^1/_2$ in.; *Study for Soft Saxophone*, 1991, charcoal and watercolor, 12 × 9 in.; *Becalmed Leaf Boat*, 1992, pencil and pastel, 40 $^1/_4$ × 30 $^1/_8$ in.; *Blue Saxophone,* 1992, crayon and watercolor, 14 $^3/_4$ × 12 in.; *Capsized Leaf Boat*, 1992, pencil and pastel, 40 × 30 in.; *Clarinet Bridge*, 1992, canvas, wood, clothesline, polyurethane foam, coated with resin and painted with latex, 14 $^1/_2$ × 11 $^1/_4$ × 98 in.; *Fallen Perfume Bottle, on Chair Leg*, 1992, expanded polystyrene, wood, paper, nail, Dacron, canvas, rope, cardboard, coated with resin and painted with latex, 30 × 12 × 13 in.; *Floating Harp*, 1992, pastel, 19 × 25 in.; *Harp, Scale A, Hard*, 1992, muslin, steel, clothesline, Dacron, coated with resin and painted with latex, 51 $^1/_2$ × 27 × 7 $^1/_2$ in.; *Harps in Séance*, 1992, pastel, 14 × 17 in.; *Leaf Boat Study, Storm in the Studio I*, 1992, pencil and pastel, 40 × 30 in.; *Leaf Boat Study, Storm in the Studio II*, 1992, pencil, 30 $^1/_4$ × 40 in.; *Leaf Boat with Floating Cargo*, 1992, leaf boat: canvas, steel, aluminum, cardboard; floating cargo: canvas, polyurethane foam, expanded polystyrene, cardboard, coated with resin and painted with latex, sail: 6 ft. 8 in. × 2 ft. 5 in. × 7 ft. 6 $^3/_4$ in., boat: 5 $^3/_8$ in. × 4 ft. 1 in. × 6 ft. 42 in., apple core: 1 ft. $^3/_4$ in. × 2 ft. 4 $^3/_4$ in. × 5 ft. 5 in., ice cream stick: 4 $^1/_4$ in. × 11 in. × 4 ft 2 in.; *Leaf Boat with Floating Cargo, Study*, 1992, canvas, wood, wire, cardboard, apple core, ice cream stick, peanut shell, potato chip, cork, coated with resin and painted with latex, 11 $^3/_4$ × 11 × 11 $^3/_4$ in.; *Leaf Boat, Study of Freestanding Version*, 1992, wood, cardboard, paper, coated with resin and painted with latex, felt pen, pencil, on wood base, 12 × 12 × 11 $^1/_2$ in., on base $^3/_4$ in.; *Perfume Bottle, Blue*, 1992, muslin, wood, clothesline, Dacron, coated with resin and painted with latex, on aluminum base, 12 $^1/_2$ × 9 $^1/_4$ × 34 $^3/_4$ in., on base: $^1/_2$ × 8 × 30 in.; *Perfume Bottle, Fallen*, 1992, crayon and watercolor, 13 × 15 $^3/_4$ in.; *Perfume Bottle, Fallen*, 1992, crayon, pastel, watercolor, 14 × 11 in.; *Perfume Bottle, Fallen*, 1992, crayon and watercolor, 13 × 15 $^3/_4$ in.; *Perfume Bottle, Fallen*, 1992, charcoal, 25 $^3/_4$ × 37 $^3/_4$ in.; *Perfume Bottle, Fallen, Atomizer Over Edge*, 1992, crayon, pastel, watercolor, 13 $^3/_4$ × 11 in.; *Perfume Bottle, Pink*, 1992, muslin, wood, clothesline, Dacron, coated with resin and painted with latex, on painted aluminum base, 14 $^1/_2$ × 9 $^3/_4$ × 38 $^1/_2$ in., on base $^1/_2$ × 8 × 30 in.; *Perfume Bottle, Yellow*, 1992, muslin, wood, clothesline, Dacron, coated with resin and

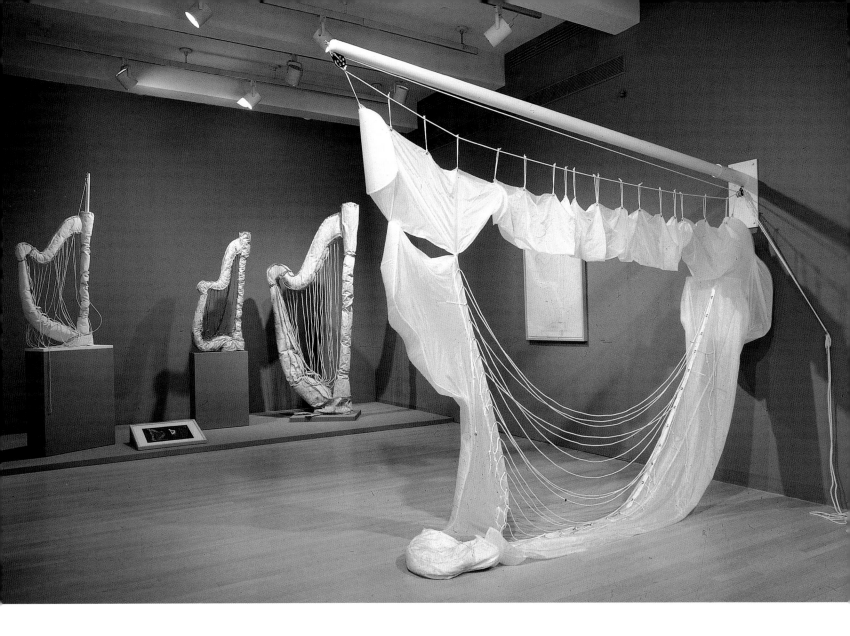

painted with latex, on painted aluminum base, $14 \, {}^5/_8 \times 8 \, {}^1/_8 \times 41 \, {}^1/_4$ in., on base ${}^1/_2 \times 8 \times 30$ in.; *Saxophone Fountain*, 1992, crayon and watercolor, $9 \, {}^7/_{16} \times 12 \, {}^5/_{16}$ in.; *Saxophone Fountain*, 1992, charcoal, crayon, watercolor, 20×26 in.; *Saxophone, Scale A, Hard*, 1992, muslin, wood, clothesline, Dacron, coated with resin and painted with latex, $32 \times 12 \, {}^1/_2 \times 15$ in.; *Soft Clarinet Leaning*, 1992, charcoal, $50 \, {}^1/_8 \times 33 \, {}^1/_4$ in.; *Soft Harp, Plan*, 1992, pencil, $40 \times 30 \, {}^1/_8$ in.; *Soft Harp, Scale A, Harp Sail*, 1992, muslin, Dacron, sash cord, wood, aluminum, painted with latex, on aluminum and wood base, $65 \, {}^1/_2 \times 8 \times 27$ in., on base $1 \times 12 \times 27$ in.; *Soft Harp, Scale B – Ghost Version*, 1992, canvas, steel, aluminum, clothesline, expanded polystyrene, Dacron, painted with latex, 7 ft. 11 in. × 2 ft. 3 in. × 4 ft.; *Soft Harp, Scale C, Harp Sail*, 1992, wood, steel, aluminum, clothesline, feathers, painted with latex, $98 \times 24 \times 123 \, {}^1/_2$ in.; *Soft Saxophone, Scale A, Muslin*, 1992, muslin, hardware cloth, polyurethane foam, wood, Dacron, painted with latex, $25 \times 46 \times 10$ in.; *Soft Saxophone, Scale A, Vinyl*, 1992, vinyl, polyurethane foam, wood, $38 \, {}^1/_2$ in. high, on base ${}^1/_2 \times 24 \times 24$ in.; *Soft Saxophone, Scale B*, 1992, canvas, wood, clothesline, Dacron, coated with resin and painted with latex, $69 \times 35 \times 36$ in.; *Standing Collar with Bow Tie*, 1992, charcoal, pastel, watercolor, $29 \, {}^1/_2 \times 24$ in.; *Standing Collar with Bow Tie*, 1992, steel, canvas, Ethafoam, coated with resin and painted with latex, $34 \, {}^3/_4 \times 9 \, {}^1/_2 \times 40$ in.; *Study for a Sculpture in the Form of a Leaf Boat, Les Tuileries, Paris*, 1992, charcoal and watercolor, 18×24 in.; *Study for a Sculpture of a Torn Notebook*, 1992, charcoal and pastel, 29×23 in.; *Torn Notebook*, 1992, charcoal, pastel, watercolor, 29×23 in.; *Torn Notebook*, 1992, crayon, pastel, watercolor, 14×11 in.; *Torn Notebook Studies A, B, C*, 1992, notebooks coated with resin and painted with latex, mounted on steel bases, study A: $8 \times 5 \, {}^1/_4 \times 4 \, {}^1/_4$ in., study B: $6 \, {}^3/_4 \times 6 \, {}^1/_2 \times 6 \, {}^3/_8$ in., study C: $7 \, {}^1/_8 \times 7 \, {}^1/_2 \times 4 \, {}^3/_4$ in.; *Torn Notebook, One*, 1992, muslin, wire mesh, clothesline, steel, coated with resin and painted with latex, aluminum, $24 \times 25 \times 19$ in.; *Torn Notebook, Two*, 1992, muslin, wire mesh, clothesline, steel, coated with resin and painted with latex, aluminum, $30 \times 24 \, {}^1/_2 \times 24$ in.; *Torn Notebook, Three*, 1992, muslin, wire mesh, clothesline, steel, coated with resin and painted with latex, on aluminum plate, $24 \times 33 \times 36$ in., on plate ${}^1/_2 \times 8 \, {}^1/_4 \times 8 \, {}^1/_4$ in.

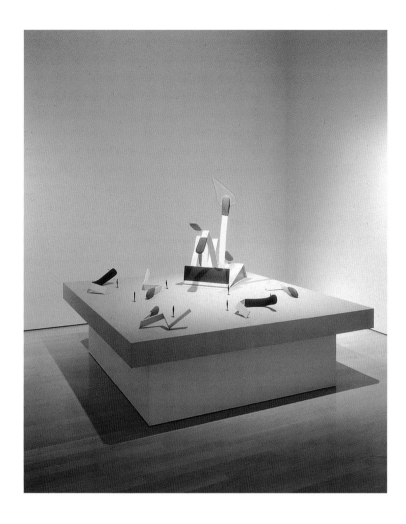

1994

—— SHUTTLECOCKS: THE MAKING OF A SCULPTURE, The Nelson-Atkins Museum of Art, Kansas City, Missouri, July 6 – October 16. Works exhibited: *Notebook Page: Sculpture in the Form of a Knitted Cap, a Sock and Long Underwear*, 1980, ballpoint pen and pencil, 11 × 8 $^1/_2$ in.; *Notebook Page: Notes toward a Sculpture in the Form of a Shuttlecock*, 1992, pencil and ballpoint pen, 11 × 8 $^1/_2$ in.; *Notebook Page: Notes toward a Sculpture in the Form of a Shuttlecock and Other Proposals for The Nelson-Atkins Museum, Kansas City, Missouri*, 1992, pencil and watercolor, 11 × 8 $^1/_2$ in.; *Notebook Page: Studies for a Sculpture in the Form of a Shuttlecock*, 1992, pencil, felt pen, watercolor, 11 × 8 $^1/_2$ in.; *Notebook Page: Study for a Sculpture in the Form of a Feather – "Candle Flame,"* 1992, pencil and watercolor, 11 × 8 $^1/_2$ in.; *Notebook Page: Study for a Sculpture in the Form of a Feather – "Covered Wagon,"* 1992, pencil, 11 × 8 $^1/_2$ in.; *Notebook Page: Study for a Sculpture in the Form of a Feather – "Windmill Blades,"* 1992, pencil, 11 × 8 $^1/_2$ in.; *Notebook Page: Study for a Sculpture in the Form of Feathers – "KC,"* 1992, ballpoint pen and pencil, 11 × 8 $^1/_2$ in.; *Notebook Page: Study for the Fabrication of Shuttlecock Sculpture*, 1992, pencil and felt pen, 11 × 8 $^1/_2$ in.; *Notebook Page: Study of Shuttlecock*, 1992, pencil, 11 × 8 $^1/_2$ in.; *Notebook Page: Study of Shuttlecock Feathers*, 1992, pencil, 11 × 8 $^1/_2$ in.; *Scale Study of the Shuttlecock Sculpture in Relation to The Nelson-Atkins Museum Facade*, 1992, pencil and felt pen, 7 $^1/_2$ × 9 $^3/_4$ in.; *The Idea of a Mouse Descends Over Kansas City*, 1992, pencil, 11 $^9/_{16}$ × 9 in.; *Notebook Page: Basketball/Tornado*, 1993, pencil and watercolor, 11 × 8 $^1/_2$ in.; *Notebook Page: Salt and Pepper Set of Shuttlecocks as Garden Sculptures*, 1993, pencil, 11 × 8 $^1/_2$ in.; *Notebook Page: Shuttlecock Sculpture Adapted to the Interior of the Guggenheim Museum, New York*, 1993, pencil and crayon, 11 × 8 $^1/_2$ in.; *Notebook Page: Studies for a Sculpture in the Form of a Basketball and Net*, 1993, ballpoint pen and felt pen, 11 × 8 $^1/_2$ in.; *Notebook Page: Studies in the Form of a Basketball and Net – "Caught and Set Free,"* 1993, ballpoint pen and felt pen, 11 × 8 $^1/_2$ in.; *Notebook Page: Study for a Basketball Sculpture*, 1993, pencil, 11 × 8 $^1/_2$ in.

1993

—— FOUR ROOMS AND A HOUSEBALL: POP AND THE EVERYDAY OBJECT, Guggenheim Museum SoHo, New York, January 27 – April 25.
Works exhibited: *Tube Supported by Its Contents (Fabrication Model)*, 1983-1985, cast bronze and steel, painted with latex, 37 × 22 × 28 in.; *Proposed Events for Il Corso del Coltello, a Performance in Venice, Italy*, 1984, crayon, pencil, watercolor, 24 × 18 $^3/_4$ in.; *Dr. Coltello's Baggage, from Il Corso del Coltello*, 1985, letters "C," "O," "E," "O": polyurethane foam covered with plastic cloth, canvas painted with latex, 6 ft. 4 $^1/_2$ in. × 8 ft. × 1 ft. 11 in., letters "L," "T," "L," "L": wood and canvas painted with latex, 7 ft. 1 $^1/_2$ in. × 4 ft. 7 in. × 1 ft. 7 $^3/_4$ in.; *Houseball*, 1985, canvas, polyurethane foam, rope, painted with latex, aluminum, approx. 12 ft. diameter; *Georgia Sandbag Costume – Enlarged Version*, 1986, canvas filled with polyurethane foam, painted with latex, 6 ft. 9 in. overall height, bag: 13 × 39 × 12 in, letter "O": 6 ft. 4 $^1/_2$ in. × 8 ft. × 1 ft. 11 in.; *Sculpture in the Form of a Match Cover with Loose Matches – Fabrication Model*, 1987, steel and polyurethane foam, coated with resin and painted with latex, 3 ft. 4 in. × 6 ft. 6 $^3/_4$ in. × 6 ft. 6 $^3/_4$ in.; *Stirring Up Spanish Themes*, 1987, pencil, watercolor, felt pen, 30 $^1/_8$ × 23 $^1/_4$ in.; *Houseball, Naoshima – Presentation Model*, 1992, burlap, rope, expanded polystyrene, coated with resin and painted with latex, 18 $^1/_2$ × 14 $^1/_4$ × 16 in.

FOLLOWING PAGE:
CLAES OLDENBURG
COOSJE VAN BRUGGEN
LARGE-SCALE PROJECTS:
DRAWINGS AND
SCULPTURE, THE PACE
GALLERY, NEW YORK,
DECEMBER 2, 1994 –
JANUARY 7, 1995. WORKS
SHOWN ARE **LEANING**
FORK WITH MEATBALL
AND SPAGHETTI – STUDY,
1993; **LEANING FORK**
WITH MEATBALL AND
SPAGHETTI – TWO VIEWS,
1993; **LEANING FORK**
WITH MEATBALL AND
SPAGHETTI I, 1994; **SOFT**
SHUTTLECOCK, STUDY,
1994, IN FOREGROUND

—— CLAES OLDENBURG COOSJE VAN BRUGGEN LARGE-SCALE PROJECTS: DRAWINGS AND SCULPTURE, The Pace Gallery, New York, December 2, 1994 – January 7, 1995. Book.
Works exhibited: *Study for Feasible Monument: Lipstick, Yale,* 1969, pencil, colored pencil, spray enamel, 16 $^5/_8$ × 11 $^1/_8$ in.; *Study Defining the Outline of the Batcolumn,* 1976, pencil, watercolor, tape, 37 $^7/_8$ × 9 $^3/_8$ in.; *Clothespin – 45 Foot Version, Model,* 1976-1979, Cor-Ten and stainless steel, 60 × 24 × 19 $^5/_8$ in.; *Umbrella, Inscribed "R. Crusoe,"* 1977, crayon and watercolor, 11 × 13 $^3/_4$ in.; *Proposal for a Building in the Form of a Colossal Flashlight, in Place of the Hoover Dam, Nevada – First Study,* 1982, pencil and colored pencil on vellum, 14 $^3/_4$ × 13 $^1/_4$ in.; *Free Stamp with Extended Letters,* 1983, pencil, colored pencil, watercolor, 9 $^7/_{16}$ × 6 $^{11}/_{16}$ in.; *Study for "Caught and Set Free," a Sculpture in the Form of a Basketball in Net, for La Jolla, California – Side View,* 1983, pencil and watercolor, 6 $^3/_4$ × 9 $^1/_2$ in.; *Study for "Caught and Set Free," a Sculpture in the Form of a Basketball in Net, for La Jolla, California – Elevations,* 1983, pencil and watercolor, 6 $^5/_8$ × 9 $^3/_8$ in.; *Silex Juicit Adapted to a Fountain,* 1984, pencil and watercolor, 9 × 11 $^3/_4$ in.; *Study for Bicyclette Ensevelie, Pedal,* 1987, pencil and watercolor over photocopy of charcoal drawing, 5 $^7/_8$ × 7 $^1/_2$ in.; *Alternate Proposal for Number One Poultry Street, London: Prince's Foot in Spaghetti,* 1988, pencil, 13 $^1/_4$ × 9 $^1/_4$ in.; *The Dropped Bowl with Scattered Slices and Peels – In Advance of the Fountain for Metro-Dade Government Center,* 1988, charcoal, pastel, pencil, 40 × 30 in.; *Golf Bag Lookout Sited on the Grounds of the Wentworth Club,* 1990, pencil, 25 $^1/_4$ × 32 $^3/_8$ in.; *The Colossal Soap Seen from the Riverbank, in Moonlight – Coming,* 1991, charcoal, 25 $^3/_4$ × 39 $^1/_4$ in.; *The Colossal Soap Seen from the Riverbank, in Moonlight – Going,* 1991, charcoal, 25 $^3/_4$ × 39 $^1/_4$ in.; *Notebook Page: Shuttlecock Sculpture Studies – "tite rope walker,"* 1992, pencil and watercolor, 11 × 8 $^1/_2$ in.; *Notebook Page: Studies of Sculptures in the Form of Shuttlecocks, for The Nelson-Atkins Museum of Art, Kansas City, Missouri,* 1992, pencil, felt pen, watercolor, 11 × 8 $^1/_2$ in.; *Soft Clarinet Standing,* 1992, charcoal, 50 $^1/_8$ × 38 $^1/_4$ in.; *Study for Sculpture, Version Four,* 1992, cardboard, canvas, steel, coated with resin and painted with latex, on aluminum base, 13 $^1/_2$ × 25 $^1/_4$ × 19 in.; *Inverted Collar and Tie – Third Version,* 1993, canvas, steel, polyurethane

foam, coated with resin and painted with latex, on painted wood base, 60 × 57 × 27 in., on base $^3/_4$ × 38 $^1/_4$ × 38 $^1/_4$ in.; *Leaning Fork with Meatball and Spaghetti – Study,* 1993, pencil and watercolor, 8 $^1/_2$ × 5 $^1/_2$ in.; *Leaning Fork with Meatball and Spaghetti – Two Views,* pencil, pastel, watercolor, 40 × 30 $^1/_4$ in.; *Notebook Page: Shuttlecock Sculpture Studies,* 1993, pencil, colored pencil, watercolor, 11 × 8 $^1/_2$ in.; *Notebook Page: Shuttlecock Sculpture Studies – "Am. Earheart,"* 1993, pencil and colored pencil, 11 × 8 $^1/_2$ in.; *Proposal for a Sculpture in the Form of a Thrown Cup of Coffee and Doughnut – Two Views,* 1993, pencil and crayon, 40 × 30 $^1/_8$ in.; *Garden Sculpture in the Form of a Shuttlecock/Sphinx,* 1994, pencil and colored pencil, 29 × 23 in.; *Golf Bag Typhoon,* 1994, pencil, 33 × 22 in.; *Golf Bag Typhoon – First Study "Ikebana,"* 1994, pencil and crayon, 40 × 30 $^1/_4$ in.; *Leaning Fork with Meatball and Spaghetti,* 1994, cast aluminum painted with polyurethane, 10 ft. 11 $^1/_2$ in. × 4 ft. 3 $^1/_2$ in. × 3 ft. 3 in.; *Leaning Fork with Meatball, Study,* 1994, wood, clothesline, paper, plaster, coated with resin and painted with latex, 24 $^3/_4$ × 13 × 12 $^3/_4$ in.; *Museum à la Mode,* 1994, pencil and colored pencil, 29 × 23 in.; *Proposal for a Sculpture in the Form of a Saw, Sawing,* 1994, pencil, colored pencil, crayon, 40 × 30 in.; *Saw/Tie,* 1994, pencil and crayon, 29 × 23 in.; *Saw/Tie,* 1994, charcoal and pastel, 50 × 38 $^1/_4$ in.; *Saw/Tie,* 1994, canvas, painted with latex, 90 × 60 × 48 in.; *Saw, Ascending – Study,* 1994, wood, paper, wire, expanded polystyrene, coated with resin and painted with latex, 22 $^1/_2$ × 10 × 10 $^1/_4$ in.; *Saw, Sawing – Presentation Model,* 1994, wood, expanded polystyrene, coated with resin and painted with latex, 26 $^1/_2$ × 24 × 24 in.; *Saw, Sawing in Site Tokyo International Exhibition Center, Tokyo, Japan,* 1994, pastel over altered photoprint, 37 $^1/_8$ × 55 in.; *Shuttlecock – Fabrication Model,* 1994, aluminum, cardboard, felt, coated with resin and painted with polyurethane enamel, 27 × 24 $^1/_2$ in. diameter; *Soft Shuttlecock Being Raised,* 1994, pencil and pastel, 27 $^5/_8$ × 39 $^1/_2$ in.; *Soft Shuttlecock, on Ground,* 1994, pencil and pastel, 27 $^1/_2$ × 39 $^1/_4$ in.; *Soft Shuttlecock, Study,* 1994, canvas and wood painted with latex, 13 × 80 in. diameter; *Torn Notebook, for a Site in Lincoln, Nebraska – Study,* 1994, aluminum and steel, painted with latex, 23 × 25 × 21 in., book: 13 × 10 × 8 $^1/_2$ in., sheet one: 10 $^3/_4$ × 10 $^1/_4$ × 9 in., sheet two: 22 $^1/_2$ × 41 × 28 in.; *Torn Notebook, on Ground,* 1994, steel, felt, coated with resin and painted with latex, 33 $^1/_2$ × 70 × 129 in.

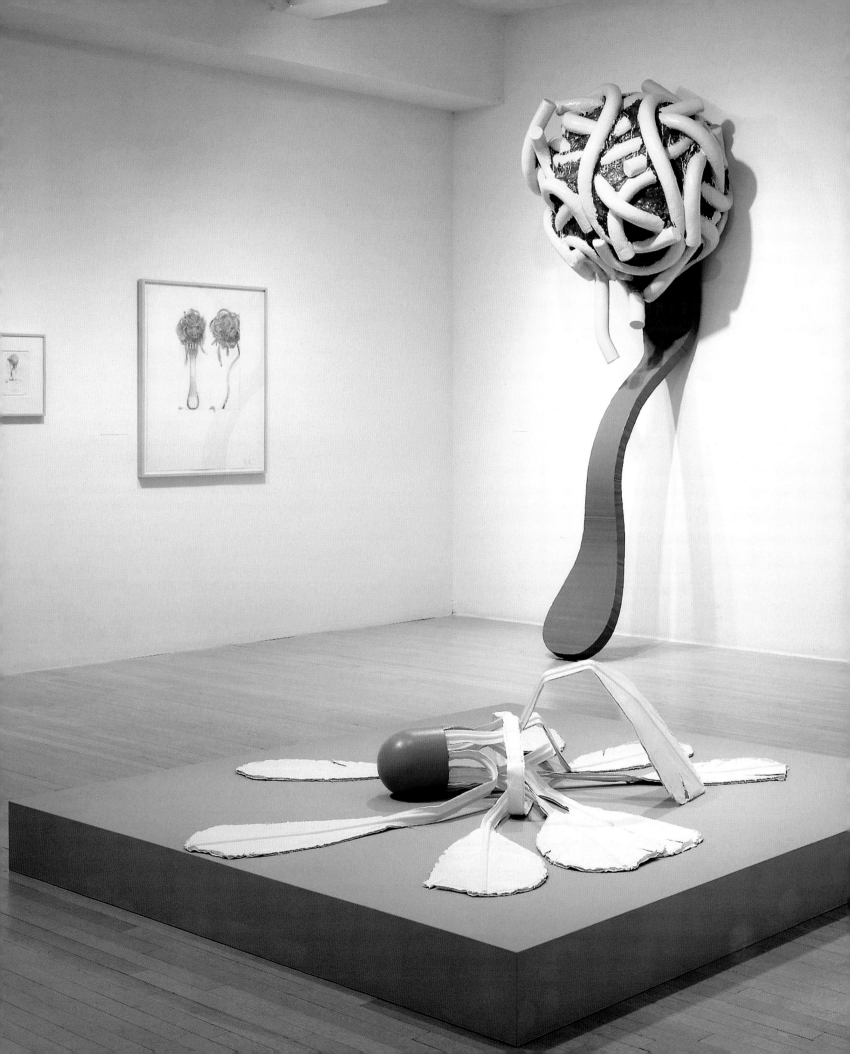

Following page:
*Soft Saxophone, Scale
A, Muslin*, 1992
Courtesy
PaceWildenstein,
New York

1995

—— *Claes Oldenburg: An Anthology*, National Gallery of Art, Washington, D.C., February 12 – May 7. Curated by Germano Celant. Catalogue. Traveled to Museum of Contemporary Art, Los Angeles, July 2 – September 3; Solomon R. Guggenheim Museum, New York, October 7 – January 21, 1996; Kunst- und Ausstellungshalle der Bundesrepublik Deutschland, Bonn, February 15 – May 12, 1996; Hayward Gallery, London, June 6 – August 19, 1996.
Works exhibited: *Milkweed Pods*, 1954-1959, milkweed pods, nail, wire, wood, painted with latex and casein, 8 $^1/_2$ × 4 $^1/_4$ × 3 $^3/_4$ in.; *Self Portrait*, 1958, crayon, 11 $^3/_4$ × 9 in.; *C-e-l-i-n-e Backwards*, 1959, newspaper soaked in wheat paste over wire frame, painted with casein, 30 $^3/_4$ × 39 $^5/_8$ × 3 in.; *Empire ("Papa") Ray Gun*, 1959, newspaper soaked in wheat paste over wire frame, painted with casein, 35 $^7/_8$ × 44 $^7/_8$ × 14 $^5/_8$ in.; *Street Ray Guns*, 1959-1960, 8 objects painted with enamel and casein, mounted in a painted wood box, overall dimensions 16 $^1/_2$ × 13 $^3/_4$ × 4 in.; *Empire Sign – with "M" and "I" Deleted*, 1960, casein and spray paint on cut-and-pasted corrugated cardboard, 54 $^3/_4$ × 23 $^5/_8$ in.; *Letter Tenement*, 1960, oil paint, rags, wood, 24 $^3/_8$ × 7 $^1/_2$ × 4 in.; *Mannikin Torso: Two-Piece Bathing Suit*, 1960, muslin soaked in plaster over wire frame, painted with tempera, 32 $^1/_2$ × 14 $^3/_4$ × 4 $^1/_2$ in.; *Original for Announcement, Reuben Gallery One-Man Show*, 1960, ink, watercolor, newspaper, collage, 13 $^1/_2$ × 10 in. on board 14 $^3/_8$ × 10 $^3/_4$ in.; *Poster Study "New Media, New Forms I," Martha Jackson Gallery*, 1960, newsprint collage, ink, watercolor, 24 × 18 $^1/_2$ in.; *Ray Gun Rifle*, 1960, newspaper soaked in wheat paste, painted with casein, over wire frame, 81 in. long; *Shirt*, 1960, plaster on screening, muslin, wire, painted with tempera, 30 $^{15}/_{16}$ × 24 $^1/_2$ × 4 $^3/_4$ in.; *Rag Doll*, 1960, canvas, stained with enamel and tempera wash, twine, wire, metal, 36 × 8 $^1/_4$ × 11 in.; *U.S.A. Flag*, 1960, muslin soaked in plaster over wire frame, painted with tempera, 24 × 30 × 3 $^1/_2$ in.; *VAN*, 1960, cardboard, oil wash,

wood, 12 $^1/_4$ × 13 in.; *Street Fragment with Car and Girl Walking*, 1960, cardboard, paper, wire, oil wash, 31 × 22 in.; *7-Up*, 1961, muslin soaked in plaster over wire frame, painted with enamel, 55 $^3/_8$ × 39 $^1/_4$ × 5 $^1/_2$ in.; *Auto Tire with Fragment of Price*, 1961, muslin soaked in plaster over wire frame, painted with enamel, 49 × 48 × 7 in.; *Big White Shirt with Blue Tie*, 1961, muslin soaked in plaster over wire frame, painted with enamel, 46 $^7/_8$ × 30 $^{11}/_{16}$ × 13 $^3/_8$ in.; *Blue and Pink Panties*, 1961, muslin soaked in plaster over wire frame, painted with enamel, 62 $^1/_4$ × 34 $^3/_4$ × 6 in.; *Blue Stockings*, 1961, burlap soaked in plaster over wire frame, painted with tempera, 29 $^1/_2$ × 17 $^1/_2$ × 5 $^1/_2$; *Braselette*, 1961, muslin soaked in plaster over wire frame; painted with enamel, 41 × 30 $^1/_4$ × 4 in.; *Bride Mannikin*, 1961, muslin soaked in plaster over wire frame, painted with enamel, 61 × 37 $^1/_2$ × 35 $^1/_2$ in.; *Bunting*, 1961, muslin soaked in plaster over wire frame, painted with enamel, 23 $^1/_2$ × 33 × 5 in.; *Cash Register*, 1961, muslin soaked in plaster over wire frame, painted with enamel, 25 × 21 × 34 in.; *Chocolates in Box (Fragment)*, 1961, muslin soaked in plaster over wire frame, painted with enamel, 44 × 32 × 6 in.; *Funeral Heart*, 1961, muslin soaked in plaster over wire frame, painted with enamel, 56 × 40 × 6 $^1/_2$ in.; *Fur Jacket with White Gloves*, 1961, muslin soaked in plaster over wire frame, painted with enamel, 43 $^{11}/_{16}$ × 38 $^9/_{16}$ × 5 $^7/_8$ in.; *Ice Cream Cone and Heel*, 1961, muslin soaked in plaster over wire frame, painted with enamel, 22 $^1/_2$ × 22 $^1/_2$ × 6 in.; *Ice Cream Sandwich*, 1961, muslin soaked with plaster over wire frame, painted with enamel, 22 × 22 × 7 in.; *Mu-Mu*, 1961, muslin soaked in plaster over wire frame, painted with enamel, 63 $^1/_4$ × 41 $^1/_4$ × 4 in.; *Pepsi-Cola Sign*, 1961, muslin soaked in plaster over wire frame, painted with enamel, 58 $^1/_4$ × 46 $^1/_2$ × 7 $^1/_2$ in.; *Poster for "The Store,"* 1961, letterpress, 28 $^1/_4$ × 22 $^1/_8$ in.; *Red Cap*, 1961, muslin soaked in plaster over wire frame, painted with enamel, on metal stand, cap: 6 $^5/_8$ × 19 × 16 $^3/_8$ in.; *Red Sausages*, 1961, muslin soaked in plaster over wire frame, painted with enamel, 33 × 30 × 5 in.; *Red Tights with Fragment 9*, 1961, muslin soaked in plaster over

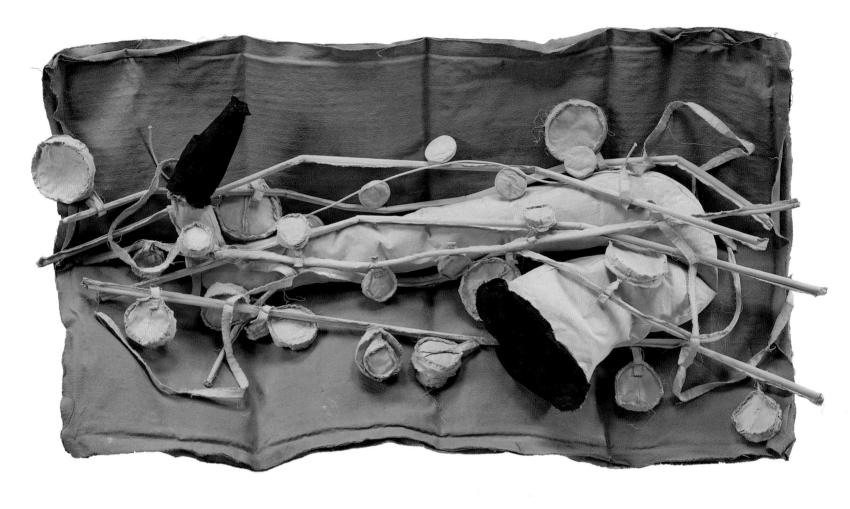

wire frame, painted with enamel, 69 $^5/_8$ × 34 $^1/_4$ × 8 $^3/_4$ in.; *Roast*, 1961, muslin soaked in plaster over wire frame, painted with enamel, rope, 14 × 17 × 16 in.; *Sewing Machine*, 1961, muslin soaked in plaster over wire frame, painted with enamel, 46 $^1/_2$ × 63 $^1/_2$ × 6 in.; *Silver Torso with Brown Underwear*, 1961, enamel on newspaper, irregular dimensions, 22 $^1/_8$ × 15 $^3/_8$ in.; *Small Yellow Pie*, 1961, muslin soaked in plaster over wire frame, painted with enamel, 18 × 16 $^1/_2$ × 7 $^1/_2$ in.; *Studies for Store Objects – Pie, 7-Up, Flag, Oranges, Fifteen Cents*, 1961, crayon, pencil, watercolor, collage, 14 $^7/_8$ × 20 in.; *Success Plant*, 1961, muslin and burlap soaked in plaster over wire frame, painted with enamel, 37 $^3/_8$ in. high; *Black Girdle*, 1961, muslin soaked in plaster over wire frame, painted with enamel, 46 $^1/_2$ × 40 × 4 in.; *Two Girls' Dresses*, 1961, muslin soaked in plaster over wire frame, painted with enamel, 44 $^3/_4$ × 40 × 6 $^1/_2$ in.; *Men's Jacket with Shirt and Tie*, 1961, muslin soaked in plaster over wire frame, painted with enamel, 41 $^3/_4$ × 29 $^1/_2$ × 11 $^3/_4$ in.; *Interior of "The Store" – Sketch for a Poster,* 1961-1962 (not executed), crayon, pencil, ink, watercolor, 24 × 18 $^1/_8$ in.; *Jacket and Shirt Fragment*, 1961-1962, muslin soaked in plaster over wire

frame, painted with enamel, 42 $^1/_8$ × 30 × 6 $^1/_2$ in.; *Pastry Case I*, 1961-1962, burlap and muslin soaked in plaster, painted with enamel, in glass-and-metal case, 20 $^3/_4$ × 30 $^1/_8$ × 14 $^3/_4$ in.; *Battleship: Centerpiece for a Party*, 1962, muslin soaked in plaster over wire frame with nails, painted with enamel, 17 × 35 $^3/_8$ × 18 $^1/_4$ in.; *Blue Pants and Pocket Objects on Chair*, 1962, muslin soaked in plaster over wire frame, painted with enamel, on wood chair, 37 × 17 × 26 $^3/_4$ in.; *Breakfast Table*, 1962, muslin soaked in plaster over wire frame, painted with enamel, 34 $^1/_2$ × 35 $^1/_2$ × 34 $^1/_2$ in.; *Cake Wedge*, 1962, crayon, 25 × 32 $^3/_8$ in.; *Floor Burger*, 1962, canvas filled with foam rubber and cardboard boxes, painted with latex and Liquitex, 4 ft. 4 in. high, 7 ft. diameter; *Floor Cake*, 1962, canvas filled with foam rubber and cardboard boxes, painted with synthetic polymer and latex, 4 ft. 10 in. × 9 ft. 6 $^1/_4$ in. × 4 ft. 10 $^3/_8$ in.; *Floor Cone*, 1962, canvas filled with foam rubber and cardboard boxes, painted with synthetic polymer paint and latex, 4 ft. 5 $^3/_4$ in. × 11 ft. 4 in. × 4 ft. 8 in.; *Freighter & Sailboat*, 1962, muslin filled with shredded foam rubber, painted with spray enamel, freighter: 70 $^{11}/_{16}$ × 19 $^{11}/_{16}$ × 5 $^{15}/_{16}$ in., sailboat: 45 $^1/_{16}$ × 28 $^{15}/_{16}$ × 5 $^5/_{16}$ in.;

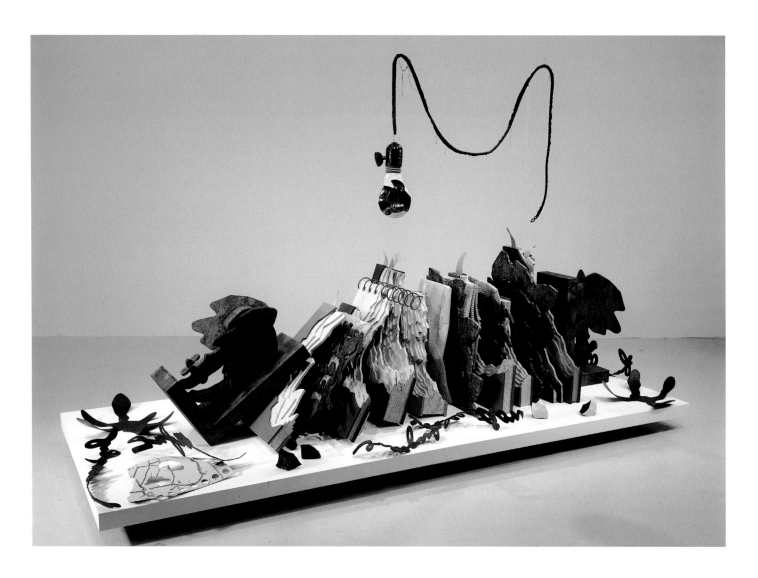

Giant Ice Cream Cone, 1962, muslin soaked in plaster over wire frame, painted with enamel, 13 $^3/_4$ × 37 $^3/_8$ × 13 $^3/_8$ in.; *Glass Case with Pies*, 1962, burlap soaked in plaster, painted with enamel, with pie tins in glass-and-metal case, 18 $^3/_4$ × 12 $^1/_4$ × 10 $^7/_8$ in.; *Lunchroom Pastries*, 1962, canvas stuffed with kapok, painted with enamel, plastic-and-metal pastry stand, 18 in. high; *Pie à la Mode*, 1962, muslin soaked in plaster over wire frame, painted with enamel, 22 × 18 $^1/_2$ × 11 $^3/_4$ in.; *Shirt with Objects on Chair*, 1962, muslin soaked in plaster over wire frame, painted with enamel, on wood chair, 39 $^3/_4$ × 30 × 25 $^1/_4$ in.; *Striding Figure (Final Study for Announcement of a Dance Concert by the Aileen Passloff Dance Company)*, 1962, enamel, 17 $^3/_4$ × 12 $^1/_8$ in.; *Studies for Store Objects – A Sock and Fifteen Cents,* 1962, crayon, watercolor, collage, 24 × 18 $^3/_4$ in.; *Two Cheeseburgers, with Everything (Dual Hamburgers)*, 1962, burlap soaked in plaster, painted with enamel, 7 × 14 $^3/_4$ × 8 $^5/_8$ in.; *Upside Down City*, 1962, muslin, painted with latex and spray enamel, filled with newspaper, wood, clothespins, hangers, overall dimensions: 118 × 60 × 60 in.; *White Gym Shoes*, 1962, muslin soaked in plaster over wire frame, painted with enamel, 24 × 24 × 10 in.; *Baked Potato I*, 1963, burlap soaked in plaster over wire frame, painted with enamel, jersey filled with kapok, 14 × 24 × 14 in.; *Giant BLT (Bacon, Lettuce and Tomato Sandwich)*, 1963, vinyl filled with kapok, wood painted with acrylic, 32 × 39 × 29 in.; *Giant Good Humor*, 1963, vinyl filled with foam rubber, 86 × 37 × 12 in.; *Hamburger with Pickle and Tomato Attached,* 1963, muslin soaked in plaster over wire frame, painted with enamel, 6 in. high, 7 in. diameter; *Soft Fur Good Humors*, 1963, fake fur filled with kapok, and wood painted with enamel, 4 elements: each 2 × 9 $^1/_2$ × 19 in.; *Soft Pay-Telephone*, 1963, vinyl filled with kapok, mounted on painted wood, 46 $^1/_2$ × 19 × 9 in.; *Soft Pay-Telephone – Ghost Version*, 1963, muslin filled with kapok, painted with acrylic, mounted on wood, 49 $^1/_8$ × 22 $^1/_8$ × 11 $^3/_4$ in.; *Soft Typewriter*, 1963, vinyl filled with kapok, Plexiglas, nylon cord, 9 × 26 × 27 $^1/_2$ in.; *Study for a Soft Sculpture in the Form of a Pay Telephone*, 1963, watercolor on newspaper, 42 × 28 in.; *Study for Pillows – Bedroom Ensemble*, 1963, crayon, ink, watercolor, 18 × 24 in.; *Study for the Poster "4 Environments," Sidney Janis Gallery – "The Home,"* 1963, crayon and watercolor, 23 $^1/_2$ × 17 $^1/_2$ in.; *Toy Biplane*, 1963, burlap soaked in plaster over wire frame, on wood base, painted with enamel, biplane: 4 in. high, base: 10 $^1/_2$ in. diameter; *Bedroom Ensemble 3/3*, 1963-1995, wood, Formica, vinyl, aluminum, paper, fake fur, muslin, Dacron, polyurethane foam, lacquer, overall dimensions: 10 ft. × 17 ft. × 21 ft.; *Electric Outlet – Hard Model*, 1964, cardboard, pen, ink, pen-

cil, spray enamel, 48 × 29 × 5 in.; *Giant Toothpaste Tube*, 1964, vinyl, canvas, kapok, wood, metal; painted with enamel, 25 $^1/_2$ × 66 × 17 in.; *Light Switches – Hard Version*, 1964, painted wood and metal, 47 $^3/_4$ × 47 $^3/_4$ × 11 $^3/_4$ in.; *Soft Light Switches 1/2*, 1964, vinyl filled with Dacron and canvas, 47 × 47 × 3 $^5/_8$ in.; *Study for a Sculpture in the Form of a Vacuum Cleaner – From Side*, 1964, chalk, ink, watercolor, 40 × 26 in.; *Viandes (Meats)*, 1964, plaster cast in canvas forms, painted with tempera, with porcelain plates, on marble-top base, 37 × 37 × 16 in.; *Vacuum Cleaner*, 1964-1971, aluminum, vinyl, plastic, rubber, lightbulb, cord, 64 × 29 × 29 in.; *Blue Toilet*, 1965, crayon, watercolor, collage, 29 $^3/_4$ × 21 $^3/_4$ in.; *Colossal Floating Three-Way Plug*, 1965, pencil, 30 × 22 in.; *Notebook Page: Dormeyer Mixer*, 1965, felt pen, ballpoint pen, clippings, collage, 10 $^5/_8$ × 8 in.; *Proposed Colossal Monument for Central Park North, N.Y.C. – Teddy Bear*, 1965, crayon and watercolor, 23 $^7/_8$ × 18 $^7/_8$ in.; *Proposed Colossal Monument for Park Avenue, N.Y.C. – Good Humor Bar*, 1965, crayon and watercolor, 23 $^3/_4$ × 18 in.; *Proposed Monument for the Intersection of Canal Street and Broadway, N.Y.C. – Block of Concrete, Inscribed with the Names of War Heroes*, 1965, crayon and watercolor, 16 × 12 in.; *Soft Airflow – Scale 2*, 1965, canvas filled with kapok, patterned with spray enamel, wood, 42 $^1/_4$ × 25 $^3/_4$ × 13 in.; *Soft Engine Parts #1 (Radiator and Fan), Airflow, Scale 5*, 1965, canvas filled with kapok, patterned with spray enamel, 32 × 24 × 18 in.; *Soft Engine Parts #2 (Filter and Horns), Airflow, Scale 5*, 1965, canvas filled with kapok, patterned with spray enamel, and wood, 41 × 31 × 9 in.; *Soft Juicit*, 1965, vinyl filled with kapok, fake fur, 20 $^1/_2$ × 17 × 16 in.; *The Bathroom Group in a Garden Setting*, 1965, crayon, pencil, watercolor, 26 × 40 in.; *Toilet – Hard Model*, 1965-1966, cardboard, wood, felt pen, painted with enamel and spray enamel, 45 $^1/_4$

× 28 $^3/_8$ × 33 $^7/_{16}$ in.; *Washstand – Hard Model*, 1965-1966, cardboard, wood, felt pen, painted with enamel and spray enamel, 48 $^7/_{16}$ × 36 × 29 $^5/_{16}$ in.; *Mouse Museum*, 1972-1977, 385 objects of various materials, aluminum, wood, Plexiglas, 8 ft. 7 in. × 31 ft. 2 in. × 3 ft. 3 in.; *Ray Gun Wing*, 1965-1977, 258 objects of various materials, photographs, aluminum, wood, Plexiglas, 8 ft. 7 in. × 14 ft. 9 in. × 18 ft. 8 in.; *Bathtub Model – Ghost Version*, 1966, canvas filled with kapok, painted with acrylic, wood: 80 × 30 × 30 in., variable dimensions; *Lipsticks in Piccadilly Circus, London*, 1966, clipping on postcard, 4 $^1/_8$ × 5 $^1/_2$ in. on card 10 × 8 in.; *Model (Ghost) Medicine Cabinet*, 1966, canvas filled with kapok and painted with acrylic, wood on metal rack, 35 $^1/_2$ × 24 × 6 $^1/_2$ in.; *Notebook Page: Drill Bit in Place of the Statue of Eros, "Extended," London*, 1966, ballpoint pen, felt pen, pencil, clipping, postcard, 11 × 8 $^1/_2$ in.; *Shoestring Potatoes Spilling from a Bag*, 1966, canvas filled with kapok, stiffened with glue, and painted with acrylic, 108 × 46 × 42 in., variable dimensions; *Soft Engine for Airflow, Scale 5*, 1966, canvas filled with kapok, patterned with spray enamel, rope, wood, 42 $^1/_4$ × 72 $^3/_4$ × 14 $^1/_8$ in.; *Soft Manhattan, 1 – Postal Zones*, 1966, canvas filled with kapok, patterned with spray enamel, 70 × 26 × 4 in.; *Soft Manhattan, 2 (Tactile Form of the New York Subway Map)*, 1966, canvas filled with kapok, patterned with spray enamel, and wood, 68 × 32 × 7 in.; *Soft Toilet*, 1966, wood, vinyl, kapok, wire, Plexiglas, on metal stand and painted wood base, 57 $^1/_{16}$ × 27 $^5/_8$ × 28 $^1/_{16}$ in.; *Soft Toilet – Ghost Version*, 1966, canvas filled with kapok, painted with acrylic, on metal stand and painted wood base, toilet: 51 × 33 × 28 in., base: 10 × 16 × 16 in.; *Soft Washstand*, 1966, vinyl filled with kapok, on metal stand painted with acrylic, 55 × 36 × 28 in.; *Two Bats, Black and White 1/3*, 1966, canvas filled with shredded polyurethane foam,

FOLLOWING PAGE:
CLARINET BRIDGE, 1992
NATIONAL GALLERY OF
ART, WASHINGTON, D.C.,
GIFT OF PERRY R. AND
NANCY LEE BASS

and wood, approx.: 110 in. long; *Giant Loaf of Raisin Bread, Sliced*, 1966-1967, canvas and canvas stiffened with glue, filled with shredded polyurethane foam, painted with acrylic, on wood base, 46 × 96 × 40 in.; *Giant Soft Fan*, 1966-1967, vinyl filled with polyurethane foam, canvas, wood, metal, plastic, fan: approx. 120 × 58 $^7/_8$ × 61 $^7/_8$ in., cord and plug: 290 in. long; *Giant Soft Ketchup Bottle with Ketchup*, 1966-1967, canvas filled with polyurethane foam, painted with acrylic, 100 × 52 × 40 in.; *Base of Colossal Drainpipe Monument, Toronto, with Waterfall*, 1967, pencil and watercolor, 24 × 22 in.; *Building in the Form of an English Extension Plug*, 1967 pencil, 21 $^3/_8$ × 29 $^3/_8$ in.; *Colossal Fagend in Park Setting*, 1967, pencil and watercolor, 30 × 22 $^1/_8$ in.; *Colossal Fagends in Park Setting, with Man*, 1967, pencil and watercolor, 30 × 22 in.; *Drum Pedal Study – From a Slingerland Drum Catalogue*, 1967, pencil, 30 × 22 in.; *Drum Pedal Study – Schematic Rendering*, 1967, pencil and watercolor, 30 × 22 in.; *Drum Pedal Study – Visualization of Collapsed Version*, 1967, pencil, 30 × 22 in.; *Giant Fagends*, 1967, canvas filled with polyurethane foam, wire, painted with latex in "ashtray" of wood covered with Formica, 4 ft. 4 in. × 8 ft. × 8 ft.; *Giant Pool Balls*, 1967, Plexiglas with metal rack, 16 balls, each 24 in. diameter, overall dimensions: 2 × 10 × 9 ft.; *Giant Soft Drum Set*, 1967, vinyl and canvas, stuffed with shredded foam rubber, painted wood, metal, on wood base covered with Formica, chrome metal railing, 9 instruments (125 parts): 84 × 72 × 48 in.; *Giant Soft Fan – Ghost Version*, 1967, canvas filled with polyurethane foam, wood, metal, and plastic, fan: 120 × 59 × 64 in., cord and plug: 290 in. long; *Late Submission to the Chicago Tribune Architectural Competition of 1922 – Clothespin, Version Two*, 1967, crayon, pencil, watercolor, 22 × 27 in.; *Notebook Page: Stock Exchange Entrance in the Form of a Girdle*, 1967, ballpoint pen, pencil, crayon, rubbing, clipping, 11 ×

8 $^1/_2$ in.; *Proposed Colossal Monument for Park Avenue, New York: Bowling Balls*, 1967, pencil and watercolor, 27 $^7/_8$ × 22 in.; *Proposed Colossal Monument for Thames River: Thames Ball*, 1967, crayon, ink, watercolor, on postcard, 3 $^1/_2$ × 5 $^1/_2$ in.; *Proposed Colossal Monument for Toronto – Drainpipe*, 1967, pencil and watercolor, 40 $^3/_{16}$ × 26 $^3/_{16}$ in.; *Proposed Colossal Monument to Replace the Washington Obelisk, Washington D.C. – Scissors in Motion*, 1967, crayon and watercolor, 30 × 19 $^3/_4$ in.; *Proposed Colossal Monument: Fan in Place of the Statue of Liberty, Bedloes Island*, 1967, pencil, 26 × 40 in.; *Scissors in Action*, 1967, collage, crayon, watercolor, 30 × 19 $^1/_2$ in.; *Small Monument for a London Street – Fallen Hat (For Adlai Stevenson)*, 1967, pencil, colored pencil, watercolor, 23 $^1/_4$ × 32 in.; *Soft Drainpipe – Blue (Cool) Version*, 1967, canvas painted with acrylic, clothesline, metal, adjustable by pulley: 8 ft. 6 in. × 6 ft. × 1 ft. $^7/_8$ in.; *Soft Drainpipe – Red (Hot) Version*, 1967, vinyl filled with expanded polystyrene chips, on painted metal stand, drainpipe: 120 × 60 × 45 in., stand: 96 in. height; *Soft Ladder, Hammer, Saw and Bucket*, 1967, canvas, filled with polyurethane foam, stiffened with glue, and painted with acrylic, 7 ft. 10 in. × 4 ft. 6 in. × 2 ft.; *Study for the Giant Soft Drum Set*, 1967, pencil and spray enamel, 30 × 22 in.; *Design for a Tunnel Entrance in the Form of a Nose*, 1968, crayon and watercolor, 9 $^1/_2$ × 8 in.; *Proposal for a Skyscraper for Michigan Avenue, Chicago, in the Form of Lorado Taft's Sculpture "Death,"* 1968, pencil and ballpoint pen on postcard with collage, 11 $^3/_4$ × 9 $^3/_4$ in.; *Feasible Monument for a City Square: Hats Blowing in the Wind*, 1969, canvas stiffened with glue over wire frame, painted with spray enamel and shellacked on wood base, 10 $^1/_2$ × 28 × 39 in.; *Feasible Monument for Grant Park, Chicago – Memorial to Louis Sullivan*, 1969, cardboard painted with spray enamel and shellacked, 18 × 27 × 24 in.; *Geometric Mouse Banner*,

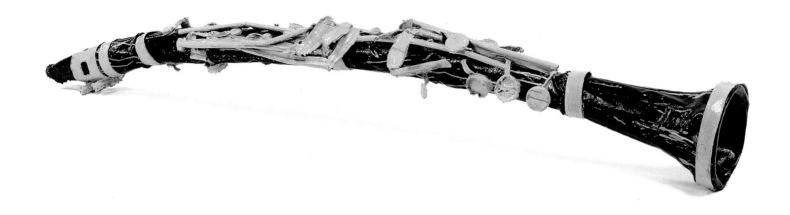

1969, nylon, 15 ft. 5 ¹/₂ in. × 6 ft. 2 in.; *Monument for Yale University: Giant Traveling and Telescoping Lipstick with Changeable Parts in Three Stages of Extension – Presentation Model*, 1969, cardboard, canvas, stiffened with glue, painted with spray enamel and shellacked, tractor: 5 ¹/₂ × 16 ¹/₂ × 29 ¹/₂ in., lipstick, stage one: 4 × 8 ¹/₂ × 10 ¹/₄ in., lipstick, stage two: 14 ¹/₂ × 8 ¹/₂ × 10 ¹/₄ in., lipstick, stage three: 23 ¹/₂ × 8 ¹/₂ × 10 ¹/₄ in.; *Notebook Page: Buildings in the Form of Binoculars, Pelvic Region Characters*, 1969, ballpoint pen and collage, 11 × 8 ¹/₂ in.; *Proposal for a Skyscraper in the Form of a Chicago Fireplug: Inverted Version*, 1969, crayon and watercolor, 17 ¹/₂ × 12 in.; *Proposed Colossal Monument for End of Navy Pier, Chicago: Fireplug (Model)*, 1969, cardboard, wood, plaster, painted with spray enamel and shellacked, 12 × 27 × 23 ¹/₂ in.; *Saw – Hard Version*, 1969, wood, aluminum, polyurethane foam, 144 × 40 × 6 ¹/₂ in.; *Soft Version of the Maquette for a Monument Donated to Chicago by Pablo Picasso*, 1969, canvas and rope, painted with acrylic, 38 × 28 ³/₄ × 21 in.; *Study for Feasible Monument: Lipstick, Yale*, 1969, pencil, spray enamel, 16 ⁵/₈ × 11 ¹/₈ in.; *Symbolic Self-Portrait with Equals*, 1969, pencil, crayon, spray enamel, watercolor, collage, 11 × 8 ¹/₄ in.; *Lipstick (Ascending) on Caterpillar Tracks*, 1969-1974, Cor-Ten steel, aluminum, coated with resin and painted with polyurethane enam-

el, 23 ft. 6 in. × 24 ft. 10 ¹/₂ in. × 10 ft. 11 in.; *Feasible Monument for a Chicago Site: Fragment of the Older City (Old Town Monument)*, 1969-1987, steel, plaster, wire, clothesline, painted with spray enamel, 15 ¹/₈ × 25 ¹/₂ × 21 in.; *Alphabet as Good Humor Bar*, 1970, colored pencil and crayon, 27 ¹⁵/₁₆ × 22 in.; *Giant Three-Way Plug, Scale B 3/3*, 1970, cherry wood, 58 ¹/₂ × 39 × 28 ¹/₂ in.; *System of Iconography: Plug, Mouse, Good Humor Bar, Switches and Lipstick – Version I*, 1970, pencil and crayon, 22 × 15 in.; *Saw – Hard Version II*, 1970-1971, wood, aluminum, polyurethane foam, 14 ft. × 3 ft. 4 in. × 6 ¹/₂ in.; *Geometric Mouse – Scale B*, 1970-1972, aluminum, steel hinges, brass chains, painted with polyurethane enamel: 36 × 36 × 31 in., variable dimensions; *Cemetery in the Shape of a Colossal Screw: Skyscraper for São Paulo, Brazil*, 1971, pencil and colored pencil, 14 ¹/₂ × 11 ¹/₂ in.; *Geometric Mouse, Scale C*, 1971, anodized aluminum: 19 × 20 × 13 in., variable dimensions; *System of Iconography – Plug, Mouse, Good Humor, Lipstick, Switches (1970)*, 1971, offset lithograph, 28 ¹/₂ × 20 ⁷/₈ in.; *Geometric Mouse, Scale D "Home-Made,"* 1971, offset lithograph on die-cut cardboard, stainless-steel wire, chains, nickel-plated fasteners, 19 × 16 ¹/₂ × ¹/₄ in.; *Bridge Over the Rhine at Düsseldorf in the Shape of a Colossal Saw*, 1971, crayon, pencil, colored pencil, 11 × 14 ¹/₂ in.; *Chicago Picasso Adapted to a Colos-*

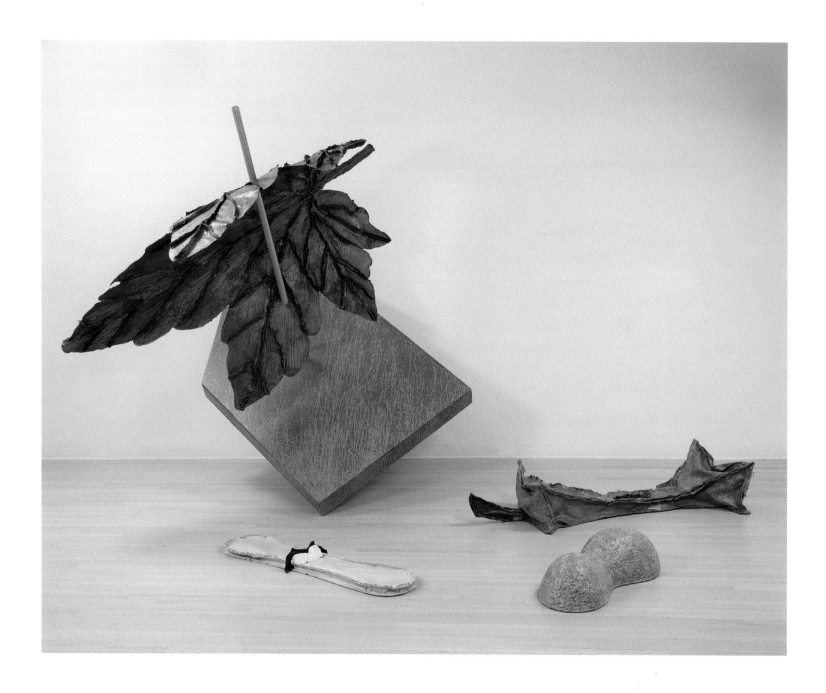

sal Cufflink, 1972, pencil, pastel, crayon, watercolor, 29 × 23 in.; *Project for a Beachhouse in the Form of the Letter Q*, 1972, pencil, colored pencil, pastel, 29 × 23 in.; *Proposal for a Cathedral in the Form of a Colossal Faucet, Lake Union, Seattle*, 1972, pencil, colored pencil, crayon, watercolor, 29 × 22 $^7/_8$ in.; *Soft Drum Set - Ghost Version*, 1972, canvas filled with expanded polystyrene chips, painted with acrylic, metal and painted wood parts, on wood base, 48 × 72 × 84 in.; *Clothespin, 4 Foot Model*, 1972-1973, cardboard painted with spray enamel, 48 $^1/_2$ × 16 $^1/_2$ × 6 $^3/_4$ in.; *Standing Mitt with Ball, Model*, 1973, Cor-Ten steel, lead, wood, 42 × 26 × 16 $^1/_2$ in.; *Three-Way Plug – Scale A, Soft, Brown*, 1975, vinyl filled with polyurethane foam, Masonite, wood, wire mesh, metal, rope, 12 ft. × 6 ft. 5 in. × 4 ft. 11 in.; *Tongue Cloud, over St. Louis (with Arch and Colossal Raisin Bread)*, 1975, pencil, colored pencil, crayon, pastel, chalk, watercolor, 40 × 30 in.; *Study Defining the Outline of the Batcolumn*, 1976, pencil, watercolor, tape, 37 $^7/_8$ × 9 $^3/_8$ in.; *Typewriter Eraser 2/3*, 1976, stainless steel, ferrocement, aluminum, on steel base, 7 ft. 5 in. × 7 ft. 6 in. × 5 ft. 3 in.; *Inverted Q – Black 1/2*, 1976-1978, cast resin painted with polyurethane enamel, 72 × 70 × 63 in.; *Clothespin – 45 Foot Version, Model*, 1976-1979, Cor-Ten and stainless steel, 60 × 24 × 19 $^5/_8$ in.; *Screwarch Model 4/4*, 1977-1978, cast bronze with steel base, 17 $^3/_4$ × 31 × 11 in., on base $^1/_4$ × 31 × 11 in.; *Preliminary Study for the Crusoe Umbrella*, 1978, coated wire, 11 × 8 $^3/_4$ × 9 $^7/_8$ in.; *Fabrication Model for the Crusoe Umbrella*, 1979, aluminum painted with polyurethane enamel, 23 $^3/_8$ × 42 $^1/_8$ × 27 $^3/_4$ in.; *Preliminary Model for the Crusoe Umbrella*, 1979, pine branches, rope, wood, 22 × 33 $^1/_4$ × 23 in.; *Tube Supported by Its Contents*, 1979-1985, cast bronze and steel, painted with polyurethane enamel, 15 ft. × 12 ft. × 9 ft. 6 in.; *Batcolumn, Model*, 1980, steel painted with polyurethane enamel, 9 ft.

7 in. × 1 ft. 8 in. × 1 ft. 8 in.; *Flashlight, Final Model,* 1980, steel painted with polyurethane enamel, on plastic and aluminum base, 37 in. high × 10 $^{1}/_{2}$ in. diameter, on base $^{1}/_{2}$ × 20 $^{1}/_{2}$ × 20 $^{1}/_{2}$ in.; *Study of Cross Section of a Toothbrush with Paste, in a Cup, on a Sink: Portrait of Coosje's Thinking,* 1980, cardboard, wood, clothesline, sand, coated with resin and painted with spray enamel, 19 $^{3}/_{4}$ × 11 $^{1}/_{4}$ × 6 $^{5}/_{8}$ in.; *Screwarch Bridge Model,* 1980-1981, bronze, aluminum, plastic, on steel table, painted with polyurethane enamel, model: 1 ft. 7 $^{7}/_{8}$ in. × 8 ft. 3 $^{5}/_{8}$ in. × 3 ft. 8 $^{7}/_{8}$ in.; table: 2 ft. 9 $^{1}/_{16}$ in. × 7 ft. 1 $^{13}/_{16}$ in. × 2 ft. 7 $^{1}/_{8}$ in.; *The Crusoe Umbrella, Intersected – for an Indoor Space,* 1980-1995, balsa wood coated with resin and painted with latex, 10 ft. 6 in. × 5 in. × 28 ft.; *Cross Section of a Toothbrush with Paste, in a Cup, on a Sink: Portrait of Coosje's Thinking, Model,* 1982, aluminum painted with polyurethane enamel, 11 ft. $^{1}/_{4}$ in. × 4 ft. 6 $^{1}/_{4}$ in. × 1 ft. 3 $^{1}/_{8}$ in.; *Proposal for a Building in the Form of a Colossal Flashlight in Place of the Hoover Dam, Nevada,* 1982, pencil, colored pencil, watercolor, 33 × 23 in.; *Balancing Tools, Study,* 1983, cardboard, wood (floor segment), paper, screwdriver, nails, painted with spray enamel, 9 $^{1}/_{4}$ × 14 $^{3}/_{4}$ × 9 $^{1}/_{4}$ in.; *Design for a Theater Library for Venice in the Form of Binoculars and Coltello Ship in Three Stages,* 1984, pencil, colored pencil, chalk, watercolor, 30 × 40 in.; *Proposed Events for Il Corso del Coltello, a Performance in Venice, Italy,* 1984, crayon, pencil, watercolor, 24 × 18 $^{3}/_{4}$ in.; *Railroad Station in the Form of a Wristwatch, for Florence, Italy (Two Views),* 1984, pencil, colored pencil, watercolor, 30 × 40 in.; *Balancing Tools – Model,* 1985, steel painted with enamel, 46 × 54 × 42 in.; *Dr. Coltello's Baggage, from Il Corso del Coltello,* 1985, letters "*C,*" "*O,*" "*E,*" "*O*": polyurethane foam covered with plastic cloth, canvas painted with latex, letters "*L,*" "*T,*" "*L,*" "*L*": wood and canvas painted with latex, 6 ft. 4 $^{1}/_{2}$ in. × 8 ft. × 1 ft. 11 in., 7 ft. 1 $^{1}/_{2}$ in. × 4 ft. 7 in. × 1 ft. 7 $^{3}/_{4}$ in.; *Houseball,* 1985, canvas, polyurethane foam, rope; painted with latex, aluminum, approx. 12 ft. diameter; *Knife Ship I,* 1985, steel, wood, plastic-coated fabric, motor, closed, without oars: 7 ft. 8 in. × 10 ft. 6 in. × 40 ft. 5 in.; extended, with oars: 26 ft. 4 in. × 31 ft. 6 in. × 82 ft. 11 in.; height with large blade raised: 31 ft. 8 in.; width with blades extended: 82 ft. 10 in.; *Prototype for Dr.*

Coltello's Baggage, 1985, balsa wood, canvas, string, painted with latex, letter "*C*": 8 $^{1}/_{2}$ × 7 $^{1}/_{4}$ × 2 $^{1}/_{2}$ in., letters "*O*": each 7 $^{1}/_{2}$ × 8 $^{3}/_{8}$ × 2 $^{1}/_{2}$ in., letters "*L,*" "*T,*" "*L,*" "*L*": each 9 × 5 $^{3}/_{4}$ × 2 $^{1}/_{4}$ in., letter "*E*": 6 $^{3}/_{4}$ × 7 $^{1}/_{4}$ × 2 $^{1}/_{2}$ in.; *St. Theodore Costume in Letter "T,"* 1985, costume: canvas filled with polyurethane foam, painted with latex; letter "*T*": wood and canvas labels painted with latex, tunic and breastplate: 48 × 27 × 2 $^{1}/_{2}$ in., spear: 81 in. high, shield: 52 $^{1}/_{2}$ × 22 $^{1}/_{2}$ in., halo: 16 in. diameter, crocodile: 12 × 10 $^{1}/_{2}$ × 126 in., letter "*T*": 85 $^{1}/_{2}$ × 55 × 19 $^{3}/_{4}$ in.; *Dr. Coltello Costume – Enlarged Version,* 1986, canvas filled with polyurethane foam, painted with latex, 8 ft. 8 in. × 5 ft. × 1 ft. 8 in.; *Frankie P. Toronto Costume – Enlarged Version,* 1986, canvas filled with polyurethane foam, painted with latex, jacket with hat: 6 ft. 7 in. × 7 ft. × 2 ft. 8 in.; pants: 6 ft. 3 in. × 5 ft. 5 in. × 1 ft. 1 in.; *Georgia Sandbag Costume – Enlarged Version,* 1986, canvas filled with polyurethane foam, painted with latex, 6 ft. 9 in. overall height, bag: 13 × 39 × 12 in., letter "*O*": 6 ft. 4 $^{1}/_{2}$ in. × 8 ft. × 1 ft. 1 in.; *Knife Slicing Through Wall,* 1986, wood painted with enamel, plasterboard blade: 4 ft. 10 in. × 12 ft. 3 in.; 2 wall sections, each 8 ft. × 3 ft. 10 in. × 2 ft. 8 in.; *Props and Costumes for Il Corso del Coltello,* 1986, charcoal and pastel, 40 × 30 in.; *Soft Easel with Stretcher and Paintings,* 1986, muslin stiffened with glue, filled with polyurethane foam, painted with latex, 5 parts, easel: 68 × 30 × 5 in.; stretcher: 23 × 17 × 2 in.; 3 paintings: each 19 × 24 × 2 in.; *Cross Section of a Toothbrush with Paste in a Cup on a Sink: Portrait of Coosje's Thinking, Soft and Uprooted Version, with Foundation,* 1987, toothbrush: canvas filled with polyurethane foam, painted with latex, foundation: expanded polystyrene and Thoroseal, painted with latex, toothbrush: 6 $^{3}/_{4}$ in. × 1 ft. 9 in. × 5 ft. 11 $^{5}/_{8}$ in., foundation: 3 ft. 11 in. × 3 ft. 11 in. × 3 ft.; *Extinguished Match,* 1987, steel and polyurethane foam painted with latex, 94 × 270 × 29 in.; *Sculpture in the Form of a Match Cover with Loose Matches – Fabrication Model,* 1987, steel and polyurethane foam, coated with resin and painted with latex, 3 ft. 4 in. × 6 ft. 6 $^{3}/_{4}$ in. × 6 ft. 6 $^{3}/_{4}$ in.; *Spoonbridge and Cherry, Model,* 1987, painted wood and Plexiglas, 22 $^{1}/_{2}$ × 22 $^{1}/_{2}$ × 49 $^{1}/_{2}$ in.; *Stirring Up Spanish Themes,* 1987, pencil, watercolor, felt pen, 30 $^{1}/_{8}$ × 23 $^{1}/_{4}$ in.; *Study for the Bottle of Notes,* 1987, pencil and colored pencil,

30 × 25 $^1/_2$ in.; *Alternate Proposal for Number One Poultry Street, London: Prince's Foot in Spaghetti*, 1988, pencil, 13 $^1/_4$ × 9 $^1/_4$ in.; *View of Spoonbridge and Cherry, with Sailboat and Skater*, 1988, pencil, pastel, chalk, collage, 33 $^1/_2$ × 20 in.; *From the Entropic Library – Fourth Version*, 1989, pencil, 28 $^1/_2$ × 40 in.; *Quill Writing, and Exploding Ink Bottle*, 1989, charcoal, 30 × 40 in.; *Bottle of Notes – Model*, 1989-1990, aluminum and expanded polystyrene, painted with latex, 8 ft. 11 in. × 4 ft. 1 in. × 3 ft. 3 in.; *From the Entropic Library – Model*, 1989-1990, cardboard, rope, expanded polystyrene, wood, aluminum, steel, canvas, coated with resin and painted with latex, 9 ft. 7 in. × 14 ft. 4 in. × 5 ft. 6 in.; *From Coosje's Memos of a Gadfly: "Shredded Treaties..." with Scrap of Broken Cup Sketch*, 1990, aluminum, expanded polystyrene, coated with resin and painted with latex, 3 parts: 42 × 31 × 36 in.; 30 × 36 × 15 in.; 43 × 56 × 19 in.; *Sculpture in the Form of a Collapsed European Postal Scale*, 1990, expanded polystyrene, aluminum, cloth, coated with resin and painted with latex, 5 ft. 1 in. × 21 ft. × 19 ft. $^3/_8$ in.; *Sculpture in the Form of a Stamp Blotter, Rearing, on a Fragment of Desk Pad*, 1990, expanded polystyrene, steel, wood, cardboard, coated with resin and painted with latex, 6 ft. 8 $^{11}/_{16}$ in. × 12 ft. 7 $^1/_2$ in. × 10 ft. 9 $^{15}/_{16}$ in.; *Sculpture in the Form of a Writing Quill and an Exploding Ink Bottle, on a Fragment of Desk Pad*, 1990, expanded polystyrene, steel, wood, cloth, coated with resin and painted with latex, 7 ft. 8 in. × 22 ft. 11 in. × 11ft. 9 in.; *Shattered Desk Pad, with Stamp Blotters*, 1990, expanded polystyrene, wood, cardboard, coated with resin and painted with latex, 1 ft. 1 in. × 6 ft. × 4 ft.; *Stamp Blotter on a Fragment of Desk Pad (Study for Rolling Blotter)*, 1990, charcoal and watercolor, 38 $^1/_8$ × 50 in.; *Stamp Blotters on Shattered Desk Pad*, 1990, charcoal, pencil, pastel, 38 $^3/_{16}$ × 50 $^1/_8$ in.; *Geometric Apple Core*, 1991, stainless steel, steel, polyurethane foam, coated with resin and painted with latex, 7 ft. 8 in. × 4 ft. 7 in. × 3 ft. 6 in.; *Clarinet Bridge*, 1992, canvas, wood, clothesline, polyurethane foam, coated with resin and painted with latex, 14 $^1/_2$ × 11 $^1/_4$ × 98 in.; *Leaf Boat with Floating Cargo*, 1992, leaf boat: canvas, steel, aluminum, cardboard, floating cargo: canvas, polyurethane foam, expanded polystyrene, cardboard, coated with resin and painted with latex,

sail: 6 ft. 8 in. × 2 ft. 5 in. × 7 ft. 6 $^3/_4$ in., boat: 5 $^3/_8$ in. × 4 ft. 1 in. × 6 ft. 42 in., apple core: 1 ft. $^3/_4$ in. × 2 ft. 4 $^3/_4$ in. × 5 ft. 5 in., ice cream stick: 4 $^1/_4$ in. × 11 in. × 4 ft 2 in., peanut: 8 $^1/_4$ in. × 1 ft. 32 in. × 2 ft. 11 $^3/_4$ in.; *Soft Harp, Plan*, 1992, pencil, 40 × 30 $^1/_8$ in.; *Soft Harp, Scale B – Ghost Version*, 1992, canvas, steel, aluminum, clothesline, expanded polystrene, Dacron, painted with latex, 7 ft. 11 in. × 2 ft. 3 in. × 4 ft.; *Soft Saxophone, Scale A, Muslin*, 1992, muslin, hardware cloth, polyurethane foam, wood, Dacron, painted with latex 25 × 46 × 10 in.; *Soft Saxophone, Scale B*, 1992, canvas, wood, clothesline, Dacron, wire coated with resin and painted with latex, 69 × 35 × 36 in.; *Torn Notebook, Studies A, B, C*, 1992, notebooks coated with resin and painted with latex, mounted on steel bases, study A: 8 × 5 $^1/_4$ × 4 $^1/_4$ in., study B: 6 $^3/_4$ × 6 $^1/_2$ × 6 $^3/_8$ in., study C: 7 $^1/_8$ × 7 $^1/_2$ × 4 $^3/_4$ in.; *Torn Notebook, One*, 1992, muslin, wire mesh, clothesline, steel, aluminum, coated with resin and painted with latex, 24 × 25 × 19 in.; *Torn Notebook, Two*, 1992, muslin, wire mesh, clothesline, steel, aluminum, coated with resin and painted with latex, 30 × 24 $^1/_2$ × 24 in.; *Inverted Collar and Tie – Third Version*, 1993, canvas, coated with resin, steel, polyurethane foam, painted with latex, on painted wood base, 60 × 57 × 27 in., on base $^3/_4$ × 38 $^1/_4$ × 38 $^1/_4$ in.; *Leaning Fork with Meatball and Spaghetti III*, 1994, cast aluminum painted with polyurethane enamel, overall dimensions: 10 ft. 11 $^1/_2$ in. × 4 ft. 3 $^1/_2$ in. × 3 ft. 3 in.; *Shuttlecock – Fabrication Model*, 1994, aluminum, cardboard, felt, coated with resin and painted with polyurethane enamel, 27 × 24 $^1/_2$ in. diameter, on painted aluminum base $^1/_2$ × 18 × 18 in.; *Soft Shuttlecock, Study*, 1994, canvas and wood painted with latex, 13 × 80 in. diameter, variable dimensions; *Soft Shuttlecock*, 1995, canvas, expanded polyurethane and polyethylene foams, steel, aluminum, rope, wood, duct tape, fiberglass-reinforced plastic, painted with latex, nose cone: approx. 6 ft. diameter × 6 ft. long, 9 feathers: approx. 26 ft. long and 6-7 ft. wide each; *Soft Shuttlecocks, Falling, Number Two*, 1995, pencil, charcoal, pastel, 27 $^1/_4$ × 39 $^1/_4$ in.; *Houseball*, 1996, stainless steel, fiber-reinforced plastic, jute netting, polyurethane and polyvinyl chloride foams, painted with polyester gelcoat, 27 ft. 6 in. high × 24 ft. 4 in. diameter.

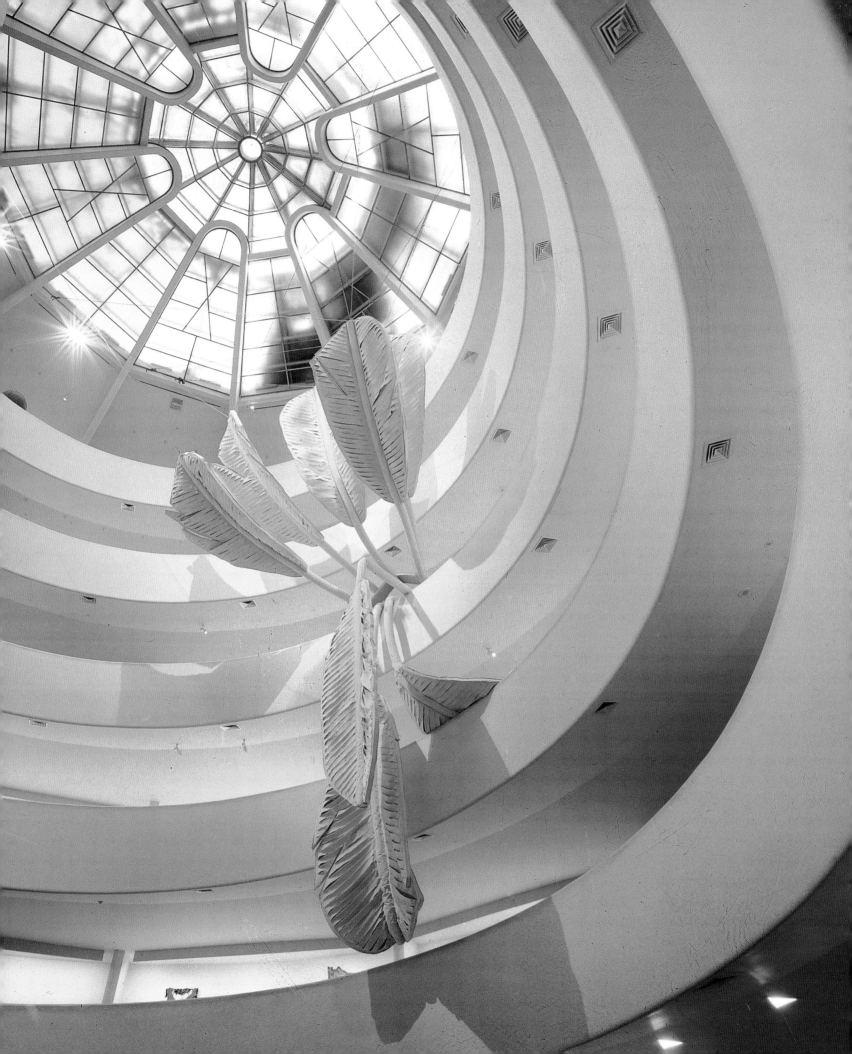

From the Entropic Library

Dieter Koepplin

In thematic terms, still life painting began during the fourteenth and fifteenth centuries, when depictions of holy or otherwise venerable books (as well as such objects as pitchers, washbasins, and liturgical items) were made to look deceptively genuine. These objects were virtually inserted into illusionistically represented niches, with the pictorial surface likewise opening up as a niche. The depicted books belonged to holy men: prophets, Church fathers, priests, pious scholars in their studios. In striving to make their still lifes seem authentic but also compositionally appealing, the painters would attempt to bring a little disorder into the bookshelves. They could claim the fiction that the books, lying around, were the leftovers of a user's spiritual and intellectual labor; they were more or less abandoned, and the real issue was the mental work itself. Examples of such arrangements of books were found chiefly in Netherlandish painting – from the fifteenth-century Master of the Annunciation of Aix, who was trained in Netherlandish art, to seventeenth-century Dutch artists, through to Vincent van Gogh.[1]

From pictures of abandoned books in disorderly piles it was only a small step to the *vanitas* still lifes of the Baroque period featuring tattered – one might say "entropic" – books, accompanied by perhaps a skull, an hourglass, a guttering candle, and similarly meaningful objects. The viewer was meant to understand, and literally see, that even written texts, including the spiritual treasures pressed between two book covers, could not escape decay. "Entropy" does not spare the symbols of literary fame, or the Holy Scriptures, or even writings about transience and futility.[2] A death's head cannot be read. The unread books are dead, futile – though not for the visual artist.

From the Entropic Library, a work created jointly by Claes Oldenburg and Coosje van Bruggen, does not quote art history. But it looks toward Europe and from there toward Africa, mulling over the colonizing past of the West. Not a painting, it is more like a painterly sculpture, a sculptural picture. Given its size, it could almost be called a monument – a monument to a disintegrating, somehow displaced European written culture. But why disintegrated, and how displaced?

This gigantic work is not, like the artists' large-scale projects, situated outside in an urban environment, but rather in a museum, surrounded by paintings and smaller sculptures. The base barely raises the work; the viewer stands practically on the same ground as the sculpture. What the base does is stake off the terrain of the piece, in effect saying, "Come closer, but do not enter; this is where the 'tableau' begins, the work is 'enacted' on this stage." Its restrained theatricality is not insignificant. *From the Entropic Library* postdates their 1985 Venice performance *Il Corso del Coltello,* and, as Oldenburg has noted, a peculiar "theatrical dimension" characterizes the post-*Coltello* work. "Venice has an aftereffect with completely new colors," noted the artist.[3] In this case the colors are cool, broken by white and gray and strongly articulated in connection with the "architecture" of the multipart work and its white base. The delimitation of this four-inch-high rectangular base, which is more a surface than a three-dimensional object, prevents the virtually disintegrating, yet dynamic, sculpture from overflowing.

The "entropic" dynamic of the sculpture allows the viewer to make associations, both concrete and general. Two types of processes constitute the foundation of the internal motion, the richness, and the strange integrity of the work: pushing, pressing, urging, condensing on the one hand, and crumbling, tumbling, toppling, falling, collapsing, dissolving on the other. The work is composed of familiar object forms: books between bookends and a shattered lamp above them. These, by association, suggest other things and processes, and they evidence their own rhythmic interplay beyond the seemingly dominant effect of concreteness.

The principles of composition here are related to some of Oldenburg's earlier works and experiences. In terms of the piece's motifs, this is true especially of the elephant heads that figure in the bookends and the use of handwriting strokes as forms. It also applies generally to the polarity of concentrated absorption and ghostly decay, extending from *The Street* (1960) to *The Haunted House* (1987). In viewing *From the Entropic Library,* one witnesses not only the results but also the development of the sculpture as motion. By 1961, Oldenburg had realized that "my work is always on the way from one point to another."[4] That statement is pertinent both for the interrelatedness of his oeuvre and for the genesis of each individual piece – indeed, it holds true for the various forms and motifs in all his works, each of which is fundamentally in motion and affected by time.

The movement in *From the Entropic Library* ranges from the basic forces of pushing and pressing, toppling and disintegrating to the interweaving of motifs in the bookends (elephant head, outboard motor, L-support), and the coating of the surfaces with gestural, quasi-Abstract Expressionist brushstrokes and ubiquitously sprayed colors. In a recent interview, Oldenburg said: "I like to treat paint as material – to daub it, drop it, let it slide. There was Action Painting, but I also compare it to paint effects found on the streets. This approach is superimposed on a sculptural surface that is also "painterly."[5]

The paint hurled and splashed on the surface adds something light, even sketchy to the sculpture. The Italian word for "splash" is *schizzare,* which leads to the English *sketch,* the French *esquisser,* and the German *skizzieren.* And indeed the treatment of the surface of this huge sculpture, whose execution required a disciplined planning process that included drawings and models, thoroughly underscores the sketchiness of the overall character of the piece (almost in spite of its architectural definiteness).

The sculpture lays claim to function flawlessly and to endure, much as an automobile should function and a building should endure. At times, Oldenburg has appeared to be a constructor, constructing, among other things, a *Soft Pay-Telephone* (1963) and more than one drainpipe (1967). Indeed, he once meticulously designed a huge bridge across the Rhine River near Rotterdam – though in ultimately liberating terms, as a "technological liar,"[6] an artist playing the role of a constructor. Oldenburg has gone so far in role-playing to assume that of one Dr. Coltello (also known as the Kitsch Dragon or Murky Apollo), the unlicensed souvenir peddler in *Il Corso del Coltello.*[7]

Oldenburg's objects and commissioned pieces (such as the monumental public sculptures) *appear* to point in an entirely different direction: toward freedom, toward an art that is free. But that is only partly so. Oldenburg has always systematically sought complicated, ambivalent, multivalent situations in which he could remain in immediate contact with the realities of life. Nevertheless, standing *in medias res,* he needed a way to maintain the possibilities of transformatively shaping that which he wanted to shape anyway, "lying" in a meaningful way, playing seriously, creating a new and convincing artistic reality, and finding a clear and lively form for a fictive reality. Oldenburg likes getting involved in complex situations. These include, especially, the large-scale projects (since 1976 created with van Bruggen), huge commissioned pieces in public spaces to which the artists, as few in our time, have given stimulating, demanding, and universally interesting forms.[8]

Although not commissioned, *From the Entropic Library* was created with a view to a specific project. As part of Jean-Hubert Martin's 1989 Paris exhibition *Magiciens de la Terre,* the sculpture was to occupy a prominent place. This dictated its size and, as will be seen, influenced its content. The show was billed as a "truly international exhibition," bringing together works by one hundred "Third World" and contemporary Western artists who view contemporary "Third World" artworks as art, not merely as anthropological items, yet do not themselves use a "primitive" formal language. The works from both areas were united, according to the organizers of this unusual presentation, by their "magical" effulgence – their aura.[9] Each artist was asked to reply to the question "What is art?" for the exhibition catalogue. The idea of posing this question was suggested by one of the participants, Lawrence Weiner (who provided a terse answer), while many others, particularly Westerners, did not care to respond (surely, a Sigmar Polke, Christian Boltanski, or Daniel Buren could not be expected to do so). Several "Third World" participants emphasized that making art made them happy even if they were not happy otherwise, and that art was simply their life. A Pakistani artist, Rasheed Araeen, penned a memorable statement:

"Art is not magic, and magic is not art. Indeed when art and magic meet, they destroy one another."

For *From the Entropic Library,* the catalogue included a color drawing of the piece by Oldenburg; naturally the sculpture itself could not yet be reproduced on its designated site. Under the rubric "Qu'est-ce que l'art?" were printed thirteen text fragments chosen by van Bruggen from initially unidentified statements and writings by, respectively, Henry David Thoreau, William Carlos Williams, Oldenburg, van Bruggen herself, H. D. quoting Sigmund Freud, Jorge Luis Borges, Samuel Beckett, and Marcel Proust. From these anonymous, almost random fragments, overheard, barely registered, and almost inaudible, a few isolated words were plucked out. Falling, as it were, from the realm of writings and books, three of these words – "futility," "smashingly," and "beautiful" – whose importance and aleatory appearance remain open, are scattered over the base, like objects, almost like autumn leaves or, according to Oldenburg and van Bruggen, like dead insects. The last two words do, indeed, belong together; but on the pictorial plane of the sculpture's base, they too are doomed to be fragments. Other words, sheering out of their contexts – and all of them "written" in Oldenburg's hand – are like reliefs covering three loose "pages" that are inserted into the books of this highly personal reference library.[10] The handwriting peeps out only partially. It is legible in theory, but scarcely in practice: actual words are enclosed in the forms, which seem to move freely as gestures and which, it turns out, are more than pseudo-writing (like that made by children or by Jean Dubuffet in his late work).[11] Nevertheless, the penmanship and the "pages" containing it appear to approach illegibility, a visual-linguistic white noise. One can regard this writing as clues to a secret – clues left by the unknown author who at some point wrote the words within longer texts. However, that author has long since disappeared. (Elias Canetti's aphorism is appropriate here: "No writing is secret enough for a person to truly express himself in it.") Parts of the words are covered by the books. Today, fragmentation characterizes all of one's thinking and perception.

The text fragments and the words taken from them certainly do not provide *the* key to understanding Oldenburg and van Bruggen's sculpture. But one does establish that the written words, this hard evidence of writing, belong to the sculpture, a work that does anything but reject a connection with thinking, speaking, writing, and literature. The sculpture reveals that the world of pictures and the world of words – both of them specifically human worlds – cannot simply overlap, not even in the ideal motif of the *Library,* in which hand-written notes, a closed packet of letters (in the center of the piece), and other bits of paper were slipped in between the books. The bundled letters are silent about their contents. Were they factual, poetic, amorous, or familial? Who knows, who wants to know?

The flat, scattered text-objects do not deny that they are somewhat bizarre; the word "crazy" (from "Crazy Horse Road")[12] is among the word fragments. The handwriting in Oldenburg's "autumn-leaf words" is his own. By contrast, *The European Desktop* (1990) employs, mirrorlike, van Bruggen's handwriting (she is left-handed, like Leonardo da Vinci, whose text mixes with van Bruggen's letter "to Frédéric [Chopin]."[13] The 1993 large-scale project *Bottle of Notes*[14] includes both handwritings: his on the outside, hers on the inside. In discussing the sculpture after its concept and shape were worked out, Oldenburg recalled that his use of penmanship dates back to *The Street*: "When I first came to New York City in late 1956, what struck me most was the agitated writing on the surface of the city: the walls, the streets, every place that could be marked. Graffiti had not yet become self-conscious or stylized; these were anonymous messages of experience and survival. I began to copy them and make monoprints which I put up in the city. After a while I made constructions out of the writing/drawing, using the patterns of newspapers and buildings. In a third stage, I began to see the spatial possibilities of the relation between writing and its ground."[15]

Should one then assume that the handwriting elements in *From the Entropic Library* – which, despite their specific origins are once again "anonymous" – are likewise ultimately "messages of survival," not in a social, but in a more general sense?

The three delicate handwriting "objects" surrounding the books on the surface of the base are loosely connected to a few other scattered oddities. Two multifingered "ink splotches" are colored gray like the handwriting and burst out in all directions. They are vaguely related to the outlines of the fluttering elephant ears that energize the angular bookends. Since the 1960s, Oldenburg has repeatedly depicted explosive formations of liquids that ejaculate suddenly, unavoidably, and uncontrollably. Their shapes, colors, and materialities provide one (in everyday life) with something that is viewed, depending on one's attitude, either as an irksome annoyance, a catastrophe or a violent invasion, or as something comically alive, magical, ghostly, merry. Can these simple splotches – which elude the biological forms of similar phenomena in the work of Jean Arp or Henri Matisse[16] – be regarded as artistic products? For many years, Oldenburg pursued such sculptural action forms in various guises: drawings of coffee pouring out of knocked-over cups, paint hurled against a wall – as in the unrealized large-scale project *Paint Splats (On a Wall by P. J.)* – drops of nail polish, melted chocolate overflowing onto a profiterole, tea oozing from a teabag, ink splashing out of a shattering inkwell (inspired by a legend involving Martin Luther), or just splotches.[17]

In *From the Entropic Library,* near one of the ink splotches, a piece of handwriting spelling out the word "futility" lies on a scrap of notebook paper. The perforated scrap, showing a hasty, undecipherable, figurative red sketch, is disintegrating. Next to it, sculpturally formed bits of a burst lightbulb have landed, with the remnant hanging from the "torn" wire suspended over the books. All this hints at narrative and figuration but is not naturalistic. The motifs are translated into an artistic reality that has its own formal laws, its own internal architecture,[18] its own continuous color quality. However, none of this overwhelms the objects themselves.

The shattered lamp, although "dead," casts a light on the fiction that has been elaborated into a concrete pinpointing of the still life of books. Comparable to the snuffed-out candle in the Dutch *vanitas* still lifes of the seventeenth century, the electric bulb, we may assume, once had the function of allowing the books to be used at night, when they were as yet undevoured: light for the imaginary person who, both writing and reading, used the books, pads, letters, and maps, which were at one time tidily held together by two "tranquil" bookends. But time has marched across them, and its passage has not been merely passive: despite the title of the work, the library has not been only entropic, in terms of decay and growing disorder. Clearly a new and different liveliness has been created by the imagination. (Joseph Beuys felt that every artist, indeed every human being, constantly "proves the reality of the idea and the invalidity of the theory of entropy.")[19] During the period of decay, much has happened, and a great deal is still happening in the pictorial dynamics of the sculpture, which has been seized by new minds. The *nature morte* has gained a life of its own. Does one miss the writer and the reader, without whom the books are dead and have no intellectual reality? In one sense he is in them in an imaginary way and partly he has truly evaporated (he would have to be a giant), leaving the terrain to other forces. Oldenburg has said: "A life cycle can be imposed on an object. An object can be very energetic and active, and then it has a dying phase and a phase of decomposition."[20] Decomposition, however, involves not only loss but also gain: a transformation occurs. A very baroque chalk drawing by Oldenburg from late 1990, *The Entropic Library in a Later Stage, No. 2,* provides an image of the subsequent metamorphosis. The two bookends are keeling over, and the library as a whole looks like a rock formation that has been eroding since time immemorial – a sculptural, objectual, human landscape with the elephant – and that, in its combination of forms, is almost a self-portrait.

The effects that physical forces have on things have always constituted a cherished theme in Oldenburg's sculpture. Indeed, he describes gravity as "my favorite form creator." This force plays a part in decay. Forces and activities – for instance, construction and decomposition – operate in time whereby the latter can be livelier than the former. It is precisely death that breathes new life into the library. Its new lease on life becomes possible only with the departure of the imaginary and unknown book user, when the books are left to their ultimate fate. In 1966, Oldenburg commented on his earlier use of things as subjects: "I am unable to leave out, so I compress and superimpose to get a subject I can handle. The thing as subject is a device for externalizing. Things have presence only when they are alone without visible agents or users."[22]

In *From the Entropic Library* one experiences a twofold solitude of the thing, or a shift in its solitude: initially, the books were possessed by the absent agent, who was succeeded by other forces, those of nature, which were still in the minds of the artists who had previously dispatched the owner of the books. Why do away with these? There were probably two reasons. First, at a glance it appears realistic in terms of present-day culture. Second, only then can one imagine what might happen to the abandoned thing, what metamorphosis under the impact of what forces could compress the thing on a new level: the possibilities for formation out of entropy spring not only from artistic whim. Despite all the conceits, one remains on the terrain of realities. Decay and oblivion are very real and can be terrifying in a real way.

The realistic conceit of abandonment and the ghostly reanimation of things especially marked those works by Oldenburg that directly preceded *From the Entropic Library* and which, incidentally, are all (and this applies to the *Library* as well) thematically grounded in Europe (and Africa, seen from a European vantage point). These include *The European Desktop;*[23] *Piano/Hammock* (1987), with its disintegrating keyboard;[24] and the environmental work *The Haunted House,* which van Bruggen called a "still-life drama" in which "entropy sets in."[25]

Physical forces that become operative in the processes of decay and construction join drives and emotions in the human and animal worlds. The instinct for food, whether human or animal, can create sculptural forms. The books in the library appear to have been neatly nibbled by mice. It is no coincidence that an Oldenburg work of 1966-1971 – *Proposed Colossal Monument in the Form of Bitten Knäckebröd, Stockholm* and its model, *Row of Buildings in the Form of Bitten*

Knäckebröd, Stockholm – which bears some similarity to *From the Entropic Library,* was inspired by food and by biting. Oldenburg, who was born in Stockholm, grew up in the United States, and returned to Stockholm for a 1966 retrospective of his work, commented, "I eat Knäckebröd all the time. They come in stacks and packages. I took a stack and made one of my disappearing food images by biting."[26]

One feels physical human closeness in this instance even more directly than in a library that is tastier to mice than to people (indeed, it would not be far-fetched to recall that one of Oldenburg's guises is that of the geometric mouse). In contrast to *From the Entropic Library,* the dissolution of the Knäckebröd monument seems less like the crumbling of decay and more like an emphatically orderly, gradual decline and sinking of elements, which remain upright to the very end. (In a 1972 drawing they solemnly descend a hill and sink into the sea). The books in the *Library,* on the other hand, are in the process of tipping over, each book pressing upon the next.[27] One of the elephant bookends offers some resistance; the other, with its own strange dynamics, triggers the chain reaction of tipping over and pressing (features intrinsic to books). The realm of the books and bookends as active agents is easily comprehended. As in all works by Oldenburg and by Oldenburg and van Bruggen, the character of the model is neatly preserved. This art is not afraid of calm self-awareness. Obsession and self-distancing are not antithetical.

From the Entropic Library achieved its shape not only by being nibbled, by toppling, by decomposing, and so forth, but also, in terms of its motifs, as the result of a constructive action by the person who has set up the library and installed a reading light above it. In the genesis of the sculpture, an imaginary history assumed by the two artists played an animating role. This novel-like as well as pictorial, object-oriented kind of imagination fostered the preliminary sketches for the project.

The basic fiction, conceived by van Bruggen in the fall of 1988, went as follows: Somewhere in Africa, in a makeshift shelter, an explorer set up his library along with a few notebooks, slips of paper, bundled-up letters, and maps, and installed a lightbulb overhead – still and all, powered by electricity: European light over European books. (Perhaps European banknotes or dollar bills were hidden among the books.) The word "money" appears at the top center of a detailed sketch of early 1989. At some point, the explorer suddenly abandoned his place of activity in Africa and never returned. The books and several items inserted into and between them were left behind. These gradually decomposed; the lightbulb broke. The intensive forces of tropical nature took over, working in their own way on the library. The library was "eaten by time," according to van Bruggen. The now useless library "died" – that is, it gained a different kind of life, shape, madness, meaning, precision, and movement.

From the outset, the fictive library moved within the realm of the pictorial. The drawings help to trace this development. In the context of the exhibition *Magiciens de la Terre,* in which several pieces by African artists were expected to be shown, Oldenburg suggested a subject he had experimented with in earlier work before settling on the idea of the library: the head of an elephant, specifically African because of its big ears. Since *Elephant Mask* (1959), he has enjoyed being accompanied by this animal – as much as by a mouse – more precisely, by the *head* of an elephant, which struck him as suitable even for a bridge project in 1975.[28]

The first sketches that Oldenburg made in the fall of 1988[29] were linked to a 1966 drawing, *Elephant Head Combined with Outboard Motor, Etc., No. 2.*[30] This drawing, which was never turned into a sculpture, involved a fusion so extreme – the combination of an elephant's head with an outboard motor and a drainpipe – as to raise doubts about the importance of the contents.[31] The drainpipe is shaped like an elephant's trunk (at issue were the *forms* of the trunk and the drainpipe, but they retained their identities as objects nonetheless). As an *object,* however, the drainpipe was out of place in Africa, and so it was finally eliminated. Oldenburg and van Bruggen view the 1988 sketches as a first attempt at finding a kind of sculptural emblem for the Paris show, which they interpreted as a "site-specific situation" (like those of the sculptures in public spaces). In one, the elephant was shown with a pistol stuck into its head, and here, linked with the outboard motor, it embodied an endangered Africa. The motor in the trunk could have betokened colonial technology together with environmental exploitation and pollution, that is, the threat posed to Africa by European technology and industrialization. The executed piece could have functioned as a hanging soft sculpture. The trunk, equipped with a ship's propeller, could have piled up on the ground. However, such combinations of motifs are ultimately grounded not in the world of naturalistic objects but in the inventive imagination of forms – an imagination that, to be sure, does not resist comparison with familiar objects; indeed, it plays with them.

In one sketch Oldenburg made in November 1988, which indicated the differences in scale between *Elephant – Outboard Motor* and a viewer standing in front of it, one can see an alternative, a secondary pictorial thought, on the right side of the drawing. Fitting in with the exhibition theme – this time from an American viewpoint – a rigid and extremely stylized elephant/outboard motor is planted in the ground, with the words "Totem Pole" and "Kwakiutls" written next to it. Such a sculpture would have recalled the tremendous Amerindian totem poles of this tribe. Almost simultaneously, during the artists' stay in Paris in the fall of 1988, van Bruggen suggested the theme of the decaying library abandoned by a European explorer in Africa. At first, Oldenburg did not feel that the subject would lend itself to a large sculpture, fearing it would be too static. Nevertheless, he produced a few sketches using the idea. In one version he transferred the *Elephant – Outboard Motor* to the context of a library. He drew the first formation of van Bruggen's idea ("content," as is noted in the upper right-hand margin of the sheet) in a two-part sketch. The right side of the first of the drawings features the books, looking roughly like a cluster of houses; the left side shows the elephant, theoretically supported by the strange propeller and thrusting its tusks and forehead into an L-shaped bookend. In this version the propeller sits not on the elephant's trunk, but rather on its own shaft, facing outward and backward. Oldenburg gave

his own initials to this attractive cross-breed (gray above, incarnadine below – not unerotic), while he wrote "Cos" (Coosje) for the books. The word "souvenir" recalls the unlicensed souvenir vendor, played by Oldenburg, in *Il Corso del Coltello,* and it is also reminiscent of actual bookends with similar motifs that are sold in souvenir shops.

The *Elephant – Outboard Motor* had found its niche in the project – until the final execution of the sculpture. The elephant's presence made sense also because in 1989 Paris was celebrating the bicentennial of the French Revolution. An "elephant's memory" is notorious, while human memory – at least, historical memory – is best preserved in books and files. Thus under the rubric of its recollection, the elephant dovetailed with the books, in excellent cooperation.

The comparability of books and houses likewise remained until the finished piece. Originally, the sculpture was intended for the segment of the exhibition slated for the Centre Georges Pompidou. Van Bruggen felt that the houses around the Pompidou recalled the books in a library, especially when viewed from the upper floors of the complex. Later on, however, the artists decided to move the sculpture to another site hosting the exhibition, La Grande Halle-La Villette, on the outskirts of Paris. The spines of the books in the sculpture formally constitute something like a facade – according to Oldenburg and van Bruggen – a streetfront in a slum in which the exterior is partially maintained, but everything behind it is deteriorating. For Oldenburg, "The problem in drawing was that the books somehow had to be interesting: something had to happen to them. In making the comparison to a street in the slums, we distinguished between the facades and the decaying backs of the houses. The words 'keep this wall' and 'devoured rectangles' are noted in the drawing. The word 'money' is a reminder that some people stick paper money into books."[32]

The contrast between the facadelike spines of the books and the fraying beyond proved to be the best solution. The artists rejected a more painterly variant – more like a still life – for the arrangement of the books between L-shaped supports repre-sented as elephant heads rolled up into balls. This sketch from early 1989 also included the lamp motif suggested by van Bruggen. Oldenburg made it (like everything else) extremely sculptural – a nibbled bulb falling to pieces. The incandescent filament appears as a small analogue to the detached spiral binding from a notebook found in the midst of the books. The lamp, imagined as turned on, subsequently reminded the artists of the memorable lamp in Pablo Picasso's *Guernica* shedding a harsh light on history, as oblivion takes over the *Library.* A similar dimension of experience is also offered within the framework of an exhibition that revealed the historical consequences of colonialism, activated in the bicentennial year of the French Revolution and also valid given the overall malaise that today's consumer society feels toward history.

An especially delirious version, drawn in late November 1988, remained a detour – albeit an attractive one – leading to the idea of the library. Concocted by the two artists during a train trip from Brussels to Paris, it features a single, open book with tattered pages lying on its spine on the ground, "giving up its ghost" in an almost heroic pose – a final waning, a final flaunting in mad excitement. The picture remotely conjures up a book burning (with the corresponding historical memories). This would have been the explorer's well-worn book: the Dutch word *ezelsoor* (dog ear) appears next to it. One could have, as van Bruggen imagined, literally "walked through" and "under" the spine of this catafalque book. She added the title to the drawing, which was subsequently retained: *de la bibliothèque entropique.*

The fluttering book pages lie somewhat further in the dynamic ears of the elephant heads as realized in the sculpture. Somewhat later, Oldenburg created airy, action-istic, but now virtually private, nonmonu-mental notebook constructions in sculptures entitled *Torn Notebooks* (1992): tossed-away (personal) sketchbooks or pocket calendars, their torn-apart halves barely held together by spiral bindings. On the randomly exposed pages, one catches fragments of handwriting and calendar dates.[33]

The curving form of the detached spiral notebook spine claimed a prominent posi-tion in the center of *From the Entropic Library.* Initially, the spiral stood upright – as in two sketches from December 1988 and from 1989. The first was almost a blue-print for a model; the other was a large-format pencil drawing, *From the Entropic Library (Fourth Version),* in which both bookends remain vertical. In the final version, the nibbled notebook was turned ninety degrees, so that the spiral, now useless because of the decayed state of the notebook, loomed and whipped in the air. The spiral lends an effective accent not only through its material (flexible metal) but also as a pure line turning freely in the air. This linear object asserts itself boldly and a bit eerily over the sculptural mass. After earthquakes and bombings such remnants sometimes survive in ghostly form. "Bookmarks" extend out of a few of the books, like antennae stretching upward.

After the decision was reached to hold the group of books together by means of two flanking L-supports, in *Elephant – Outboard Motor,* the artists tried to achieve the desired dynamics and the "entropy" of the library by pushing the bookends very far apart. As a result, some of the books leaned toward one side, the rest toward the other, thereby creating a wedge-shaped opening in the middle; above it hovered the electric lightbulb. The central opening revealed – as Oldenburg noted on a sketch – "lassitude in center = entropy."

Soon afterward, however, van Bruggen suggested tilting one bookend and having all the books lean in the same direction. This produced a stronger pressure and an urgent movement toward the other bookend. In early 1989, Oldenburg, using this approach, made a crayon drawing of a top view of the projected sculpture at a slight angle, enabling one to look into the "interiors" of the disintegrating books. In the process of decay they reveal their insides. This fairly detailed work was the basis for a large drawing (the one in the *Magiciens de la Terre* catalogue) executed with colored cross-hatching and constructive precision. Two flattened bunches of green leaves peep out from between the books: the imaginary explorer was also interested in botany – he pressed leaves between the book pages.

On the basis of this drawing, Oldenburg conducted himself like an architect in executing his sculptural model. The outlines of the books and other elements were each captured individually in precise designs. Next, he began on the sculpture itself, layer by layer. First, he produced a medium-size format of the model, planning it as an intermediary stage, but also as a self-contained work. He then made the final sculpture, which now stands in the Museum of Saint-Etienne, southwest of Lyon. The sculpture is roughly two-thirds higher than a standing person: mighty, yet not oppressive, it is a painterly interior monument that resembles an architectural model.

The three-dimensional "geological" plates of the books, the cluster of invisible letters, the hand-written notes, and the other elements were piled side by side, at increasingly sharper slants, held up by a single elephant-head bookend. The result was a work that was both disparate and integrated, whereby the totality lends an intrinsic value to every element, indeed every detail. Aside from the rough, splashed layer of weathered gaudy paint, the element that contributes most to the integrity is the increasing tilt of the books, that is, the consistently growing pressure; or, to put it in general terms, the progressive dynamic of the compressed sculpture, which is decaying in the imagination – the imaginary metamorphosis.

In terms of the material from which they are formed, the individual elements are fairly elastic. Resisting pressure, yielding a bit, bending slightly, displaying the barely tamed energy of the shove and the counter pressure – these features are characteristics potentially inherent in the resin-coated polystyrene used. Above all, they are in line with the artistic intentions of the work.

The toppling of one bookend, with its consequently upwardly fluttering elephant ears, cannot be regarded as the *cause* of the leaning of the books. The position of this support almost transcends functional rules and naturalistic viewpoints. The rebellious, exuberant, somewhat sinister-looking gray elephant-head bookend, which both lunges and dances (while the other bookend holds its position), is "permitted" to move all the more because it is a thoroughly artificial

figure – though justifiable, as it were, and not exclusively fantastic.

Ultimately, despite its meticulously thought-out iconography, *From the Entropic Library* eludes mere narration, depiction, illustration, and indeed, to some extent, meaning. It is true that much has changed since 1963, when Oldenburg jotted down the following statements, and his collaboration with van Bruggen has strengthened the ideal connections (which go beyond the object, yet are linked to it). Nevertheless, his words are still fundamentally valid: "Although my art gives the (deliberate) impression of being concerned with the outside world, in fact it is simply the personal elaboration of imaginary forms of a limited number, in the guise of occasional appearances...Its use of the elimination of appearances, frankly and directly, is offered as an alternative to saying more effectively that appearances are not what count. It is the forms that count. It is the same to me whether my material image is a cathedral or a girdle...a telephone dial or a stained glass window...the resemblance, while amusing, means nothing. You could say that I have aimed at neutralizing meaning...To eliminate appearances seems to be impossible, and therefore artificial. Simply grasp them and show how little they mean – this is what Cézanne did."[34]

Oldenburg would like to eliminate as far as possible the apparent antitheses between the many interesting details (found or invented and in which he likes to "lose" himself), the many potential meanings, and the general structures of his work. Van Bruggen has tied this to the reality of Platonic ideas or at least to Platonic mathematics and geometry.[35] Ultimately, Oldenburg relies on the strength of form, on the "underlying architecture."[36] Artists – and indeed all people who create in full awareness of their freedom – operate by inventing forms. They operate creatively, like God, so to speak, or like a "magician of the earth."

The inventing is no less "magical" if the artist uses "guise" or "amusing resemblance." He is thereby operating in terms of an initial communication between the human being, the world of things, and the artwork – an *initial* communication, whose semblance is soon made obvious –

that is, unmasked, ultimately frustrating the bewildered viewer.[37] No regained artwork-thing-magic could, as Oldenburg once announced, bring that about: "This elevation of simplicity above bourgeois values, which is also a simplicity of return to truth and first values, will (hopefully) destroy the notion of art and give the object back its power. Then the magic inherent in the universe will be restored and people will live in sympathetic religious exchange with the materials and objects surrounding them. They will not feel so different from these objects, and the animate/inanimate schism [will be] mended. What is now called an art object is a debased understanding of a magic object."[38]

In later years, when Oldenburg began to focus on possible monumental sculptures in the form of everyday objects, he realized his interest had shifted: "The idea of an object as a magic thing no longer obsesses me as it once did...I became far more interested in the architectural form."[39]

This tendency has been strengthened by his collaboration with van Bruggen. At the same time, their work has evinced a denser network of possible revealed meanings and the concomitant ideas – so much denser that the question of "what counts" seems almost meaningless. In this non-reductive, at once serious and cheerful art, which transcends boundaries, many things count. Contradictions count, as does a polar *totality* in a specific form that is experienced as an *event*.

[1] Oldenburg and van Bruggen knew of several such examples without directly referring to them.

[2] See Sabine Schwarz, *Das Bücherstilleben in der Malerei des 17. Jahrhunderts* (Wiesbaden: O. Harrassowitz, 1987); and Barbara John, *Stilleben in Italien. Die Anfänge der Bildgattung im 14. und 15. Jahrhundert* (Frankfurt-am-Main: P. Lang, 1991).

[3] Felix Schmidt, "Neue Welt nach Regeln der Phantasie," *Art* (Hamburg), no. 12 (December, 1991), p. 44.

[4] Barbara Rose, *Claes Oldenburg*, exh. cat. (New York: The Museum of Modern Art, 1970), p. 189.

[5] Quoted (not in regard to *From the Entropic Library)* in an interview with Arne Glimcher, in *Claes Oldenburg*, exh. cat. (New York: The Pace Gallery, 1992), p. 12.

[6] *Claes Oldenburg: Skulpturer och teckningar*, exh. cat. (Stockholm: Moderna Museet, 1966), unpaginated.

[7] Germano Celant, *The Course of the Knife: Claes Oldenburg, Coosje van Bruggen, Frank O. Gehry*, (Milan: Electa, 1986), p. 94. In Bernhard Kerber, *Claes Oldenburg: Schreibmaschine* (Stuttgart: Philipp Reclam, 1971), p. 15, Oldenburg says, "By

dealing with the imaginary, I am once again superfluous in an industrial society. So I act as if I'm playing a part. By imitating the baker or the butcher, I play the worker."

8 See *Claes Oldenburg: Large-Scale Projects, 1977-1980* (New York: Rizzoli International Publications, 1980); and Germano Celant, *A Bottle of Notes and Some Voyages: Claes Oldenburg, Coosje van Bruggen* exh. cat. (Sunderland, England: Northern Centre for Contemporary Art; Leeds, England: The Henry Moore Centre for the Study of Sculpture, Leeds City Art Galleries, 1988).

9 Jean-Hubert Martin, "Preface," in *Magiciens de la Terre* (Paris: Musée national d'art moderne, Centre Georges Pompidou, 1989).

10 The following text fragments, refragmented and semi-concealed, are included in the sculpture: "it is a great art to *saunter*" (Henry David Thoreau); "no ideas but in *things*" (William Carlos Williams); "barges and *tugboats* and freighters going in all directions" (Oldenburg); "the *futility* of *yearning* for perfection" (van Bruggen); "*Crazy* Horse Road" (van Bruggen); "not mere repetition but re-creation" (van Bruggen); "in Rome, even I could afford to wear a *gardenia*" (H[ilda] D[oolittle], quoting Sigmund Freud); "you may have to get it done on your own terms" (van Bruggen); "crossing things out so *smashingly beautiful*" (van Bruggen); "the *danger* is in the neatness of identification" (Samuel Beckett); "OK, I found a *fish-joint*, and if that doesn't do it ..." (Oldenburg); "the *faint trace* of a *smile* or of a *word*" (Jorge Luis Borges); "houses, *avenues*, roads are, *alas* as fugitive as *the years*" (Marcel Proust). Italics indicate words that Oldenburg either isolated completely and placed on the pedestal ("futility," "smashingly," "beautiful") or assigned to the three loose "pages" inserted among the books. On the first "page" one can read (in Oldenburg's handwriting) the following words, which jut out halfway: crazy, gardenia, word, years, faint; on the second "page:" smile, alas, danger, fish-joint, trace; and on the third "page:" saunter, avenues, things, tugboats, yearning.

11 Regarding Dubuffet, see Rose, *Claes Oldenburg*, p. 37; Coosje van Bruggen, *Claes Oldenburg: Nur ein anderer Raum* (Frankfurt-am-Main, Germany: Museum für Moderne Kunst, 1991), pp. 14 ff.

12 When interviewed by Alfons Schilling about his early "proposed colossal monuments," Oldenburg recalled "another guy out there [Korczak Ziolkowski] who wants to make an enormous statue of an Indian, Crazy Horse; he bought a whole mountain [in Custer, South Dakota]. He started a long time ago. I am afraid that this kind of scale would not let me do all the other things I want to do. One of the beautiful things about just drawing these things is that you don't have to build it...It's just difficult to imagine what the effect of it would be. I think we should try one of them anyway, to see." In Alfons Schilling, "Bau: Zeitschrift für Architektur und Stadtebau," *Bau* (Vienna), no. 4, 1966, p. 87b.

13 Claes Oldenburg, Coosje van Bruggen, *Sketches and Blottings toward the European Desktop* (Milan and Turin: Christian Stein; Florence: Hopeful Monster, 1990). In this work Oldenburg likewise used texts chosen or authored by van Bruggen.

14 Celant, *A Bottle of Notes and Some Voyages: Claes Oldenburg, Coosje van Bruggen*, pp. 220 ff.

15 Ibid., p. 224. An early jotting by Oldenburg, quoted in van Bruggen, *Claes Oldenburg: Nur ein anderer Raum* (p. 14), reads, "All is read on the walls of the city."

16 When planning *Paint Splats (On a Wall by P. J.)* for the entrance facade of Marshall Field & Company department store in Houston (1978-1979, a large-scale project that was never executed), van Bruggen and Oldenburg returned to a sketch in a 1965 notebook: *Stains of Nail Polish, "Jamaica Bay," New York*. Oldenburg commented in regard to the wall

project of 1978-1979: "But in any case the shapes, we agreed, had to remain paint specks and not become a composition with biomorphic shapes in the manner of Arp or arabesques in the manner of Matisse or even drips in the manner of Pollock, but real paint traces. The huge blobs could be manufactured out of plastic or painted aluminum" (*Claes Oldenburg: Large-Scale Projects, 1977-1980*, p. 72). Stated Oldenburg in 1966, "So if I see an Arp and I put that Arp into the form of some ketchup, does that reduce the Arp or does it enlarge the ketchup ...?" Bruce Glaser, "Oldenburg, Lichtenstein, Warhol: A Discussion," *Artforum* (Los Angeles), 4, no. 6 (February 1966), p. 23.

17 Specific examples: *Dropped Cup of Coffee – Study for "Image of the Buddha Preaching" by Frank O'Hara* (1967); *Stains of Nail Polish, "Jamaica Bay," New York* (1965).

18 In Glimcher, interview (p. 14), Oldenburg states, "Movement and texture are most important to me, but there is always an underlying architecture."

19 Christos M. Joachimides and Norman Rosenthal, *Zeitgeist* (Berlin: Martin-Gropius-Bau, 1982), p. 82. Beuys had unique ideas about the quality and genesis of heat. "Entropic," vis-à-vis *From the Entropic Library*, probably refers to a kind of disorder and mingling in which all written things become so chaotic in their decay that no one text maintains its own clarity and energy.

20 Glimcher, interview, p. 9.

21 Rose, *Claes Oldenburg*, p. 135.

22 *Claes Oldenburg: Constructions, Models, and Drawings*, exh. cat. (Chicago: Richard Feigen Gallery, 1969), p. 3.

23 Schilling, "Bau: Zeitschrift für Architektur und Stadtebau," p. 87b.

24 Celant, *A Bottle of Notes and Some Voyages: Claes Oldenburg, Coosje van Bruggen*, pp. 211 ff.

25 Ibid., pp. 201 and 196 ("entropy sets in").

26 Barbara Haskell, *Claes Oldenburg: Object into Monument*, exh. cat. (Pasadena, CA.: Pasadena Art Museum; Los Angeles: The Ward Ritchie Press, 1971), p. 31.

27 Van Bruggen later found the following passage in the writings of Leonardo: "One pushes the other. By these square-blocks (which Leonardo drew while tipping and pressing them) are meant the life and the studies of men" (*The Notebooks of Leonardo da Vinci*, vol. 2, *Morals*).

28 In 1975, Oldenburg drew *Bridge for Duisburg, Derived from an Inverted Elephant Head*.

29 See Dieter Koepplin, *Zeichnungen von Beuys, Clemente, Disler, Judd, Nauman, Oldenburg, Penck und Stella aus dem Kupferstichkabinett Basel* (Nuremberg: Kunsthalle Nürnberg, 1990), pp. 11-13.

30 *Claes Oldenburg: Dibujos/Drawings 1959-1989* (Valencia, Spain: IVAM Centre Julio González, 1989), p. 30.

31 Around the same time, Oldenburg produced separate drawings of the outboard motor and the drainpipe.

32 From a conversation with the artist, New York, 1990.

33 Glimcher, interview, pp. 7, 17, 48 ff.

34 Quoted in Rose, *Claes Oldenburg*, p. 192. In London in 1966, Oldenburg noted: "Only when someone looks at nature does it mean something. Because my work is naturally non-meaningful, the meaning found in it will remain doubtful and inconsistent – which is the way it should be. All that I care about is that, like any *startling* piece of nature, it should be capable of stimulating meaning" (Rose, *Claes Oldenburg*, p. 198).

35 *Claes Oldenburg: Dibujos/Drawings 1959-1989*, p. 14.

36 Glimcher, interview, p. 14.

37 In 1966, Oldenburg also commented, "The pieces depend not only on the participation of the spectator but his frustration – which is really a technique of definition: this is not a *real* object" (Rose, *Claes Oldenburg*, p. 194).

38 Claes Oldenburg, *Store Days: Documents from The Store*

(1961) and Ray Gun Theater (1962) (New York: Something Else Press, 1967), p. 60.

39 *Claes Oldenburg: Proposals for Monuments and Buildings, 1965-1969* (Chicago: Big Table, 1969), p. 33.

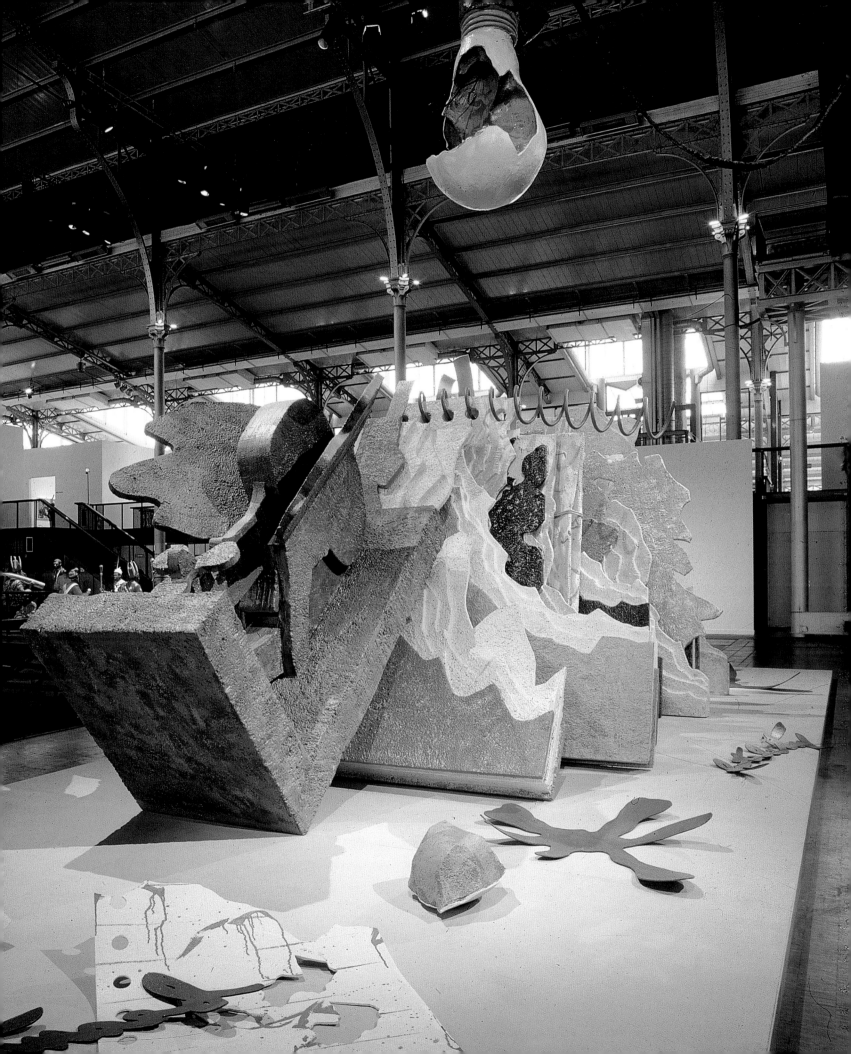

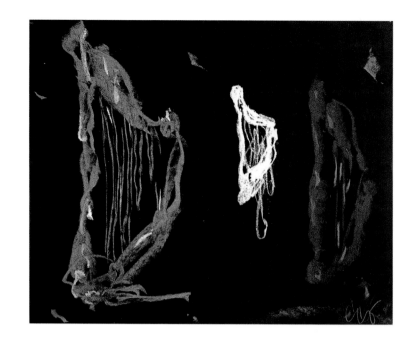

1996

—— CLAES OLDENBURG: DRAWINGS, SCULPTURES, AND STUDIES FOR LARGE-SCALE PROJECTS IN COLLABORATION WITH COOSJE VAN BRUGGEN, Wildenstein Tokyo, Ltd., Tokyo, March 5 – April 5.
Works exhibited: *Split Bat Containing Soft Alphabet*, 1977, pencil and watercolor, 29 × 23 $^1/_8$ in.; *Notebook Page: Soft Saxophone*, 1989, felt pen, crayon, watercolor, 11 × 8 $^9/_{16}$ in.; *Fragment of a Memo*, 1990, charcoal and watercolor, 6 $^9/_{16}$ × 8 $^9/_{16}$ in.; *Fragment of Memo with Pencil Writing*, 1990, charcoal and watercolor, 11 $^7/_8$ × 9 in.; *Golf Bag Lookout Sited on the Grounds of the Wentworth Club*, 1990, pencil, 25 $^1/_4$ × 32 $^3/_8$ in.; *Notebook Page: Study for a Sculpture in the Form of a Perfume Bottle – Blue*, 1991, felt pen, pencil, watercolor, 3 $^5/_8$ × 6 in.; *Notebook Page: Study for a Sculpture in the Form of a Perfume Bottle – Green*, 1991 (lost), felt pen, pencil, watercolor, 11 × 8 $^1/_2$ in.; *Notebook Page: Study for a Sculpture in the Form of a Perfume Bottle – Yellow*, 1991, felt pen, pencil, watercolor, 3 $^5/_8$ × 6 in.; *Study for Soft Saxophone*, 1991, charcoal and watercolor, 8 $^1/_2$ × 5 $^1/_2$ in.; *Leaf Boat Study, Storm in the Studio I*, 1992, pencil and pastel, 40 × 30 in.; *Leaf Boat with Floating Cargo, Study*, 1992, canvas, wood, wire, cardboard, apple core, ice cream stick, peanut shell, potato chip, cork; coated with resin and painted with latex, 11 $^3/_4$ × 11 × 11 $^3/_4$ in.; *Perfume Bottle, Fallen*, 1992, crayon and watercolor, 13 × 15 $^3/_4$ in.; *Saxophone Fountain*, 1992, crayon and watercolor, 12 × 16 in.; *Saxophone Fountain*, 1992, crayon and watercolor, 9 $^7/_{16}$ × 12 $^5/_{16}$ in.; *Soft Saxophone, Scale A, Vinyl*, 1992, vinyl, polyurethane foam, wood, 38 $^1/_2$ in. high, attached to $^1/_2$ × 24 × 24 in. base; *Torn Notebook*, 1992, charcoal, pastel, watercolor, 29 × 23 in.; *Golf Bag Typhoon – First Study "Ikebana,"* 1994, pencil and crayon, 40 × 30 $^1/_4$ in.; *Museum à la Mode*, 1994, pencil and colored pencil, 29 × 23 in.; *Saw, Ascending – Study*, 1994, wood, paper, wire, expanded polystyrene, coated with resin and painted with latex, 22 $^1/_2$ × 10 × 10 $^1/_4$ in.; *Saw, Sawing –*

Presentation Model, 1994, wood, expanded polystyrene, coated with resin and painted with latex, 26 $^1/_2$ × 24 × 24 in.; *Collided Cones*, 1996, pencil and colored pencil, 29 × 23 in.

—— CLAES OLDENBURG: DRAWINGS AND STUDIES IN COLLABORATION WITH COOSJE VAN BRUGGEN, Galerie Biedermann, Munich, March 7 – April 30.
Works exhibited: *Man and Woman Walking on Street – Woman in Front*, 1960, crayon, 13 $^{15}/_{16}$ × 16 $^{11}/_{16}$ in.; *Walking Woman, with Talk Balloon and Orpheum Sign*, 1960, ink, 9 $^7/_8$ × 13 $^9/_{16}$ in.; *Street Chick – "Housewares,"* 1961, ink, newspaper, collage, 13 $^1/_2$ × 10 in.; *Study for the Double-Nose/Purse/Punching Bag/Ashtray: "Icebag,"* 1969, ballpoint pen and crayon, 11 × 8 $^1/_2$ in.; *Free Stamp with Extended Letters*, 1983, pencil, colored pencil, watercolor, 9 $^7/_{16}$ × 6 $^{11}/_{16}$ in.; *Study for "Caught and Set Free," a Sculpture in the Form of a Basketball in Net, for La Jolla, California – Elevations*, 1983, pencil and watercolor, 6 $^5/_8$ × 9 $^3/_8$ in.; *Railroad Station in the Form of a Wristwatch, for Florence, Italy*, 1984, pencil and watercolor, 8 $^5/_{16}$ × 12 $^5/_8$ in.; *Study for a Poster of the Stake Hitch*, 1984, charcoal and watercolor, 36 × 22 $^1/_2$ in.; *Study for Bicyclette Ensevelie, Pedal*, 1987, crayon and watercolor over photocopy of charcoal drawing, 5 $^7/_8$ × 7 $^1/_2$ in.; *Notebook Page: Study for a Sculpture in the Form of Soft Saxophone*, 1989 (destroyed), felt pen and pencil, 11 × 8 $^1/_2$ in.; *The Colossal Soap Seen from the Riverbank, in Moonlight – Going*, 1991, charcoal, 25 $^3/_4$ × 39 $^3/_4$ in.; *Becalmed Leaf Boat*, 1992, pencil and pastel, 40 $^1/_4$ × 30 $^1/_8$ in.; *Floating Harp*, 1992, pastel, 19 × 25 in.; *Harps in Séance*, 1992, pastel, 14 × 17 in.; *Leaf Boat, Capsized*, 1992, pencil and watercolor, 2 sheets: each 8 $^1/_2$ × 5 $^3/_8$ in.; *Notebook Page: Knocked Over Perfume Bottles*, 1992, pencil and watercolor, 3 $^5/_8$ × 6 in.; *Perfume Bottle, Fallen*, 1992, crayon, pastel, watercolor, 14 × 11 in.; *Perfume Bottle, Fallen*, 1992, crayon and watercolor, 13 × 15 $^3/_4$ in.; *Perfume Bottle, Fallen, Atomizer Over Edge*, 1992, crayon, pastel, watercolor, 13 $^3/_4$ × 11 in.

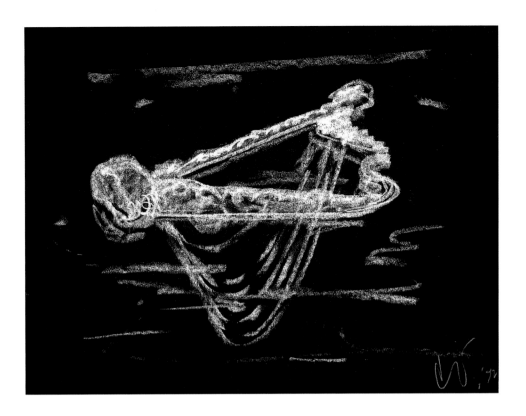

—— Torn Notebook: The Project, Claes Oldenburg and Coosje van Bruggen, Sheldon Memorial Art Gallery, University of Nebraska, Lincoln, September 6 – December 1.

Works exhibited: *Notebook Page: Aluminum Water-cut Sample*, water-cut aluminum, 14 × 22 × 18 in.; *Miniature Soft Drum Set*, 1970, screenprint on canvas, clothesline, wood painted with spray enamel, wood covered with screenprinted paper: 9 $^3/_4$ × 19 × 13 $^3/_4$ in., variable dimensions; *Geometric Mouse, Scale D "Home-Made,"* 1971, offset lithograph on die-cut cardboard, stainless-steel wire, chains, nickel-plated fasteners, 19 × 16 $^1/_2$ × $^1/_4$ in.; *Soft Drum Set*, 1972, lithograph; *Store Window: Bow, Hats, Heart, Shirt, 29¢*, 1973, lithograph, 22 $^7/_8$ × 26 $^3/_4$ in.; *Spoon Pier*, 1975, soft-ground etching, sugar-lift, and aquatint; *Study for Standing Mitt*, 1976, offset lithograph, 38 × 24 $^1/_4$ in.; *Voting Button in Landscape*, 1984, screenprint, 30 × 23 in.; *Study for the Bottle of Notes*, 1987, pencil and colored pencil, 30 × 25 $^1/_2$ in.; *Study for the Scripts of the Bottle of Notes*, 1987, pencil, 28 $^1/_4$ × 40 in.; *Flotsam: Disconnected Socket and Torn Notebook*, 1990, charcoal, 29 $^7/_8$ × 20 in.; *Fragment of a Memo*, 1990, charcoal and watercolor, 6 $^1/_2$ × 8 $^1/_2$ in.; *Fragment of Memo with Cup*, 1990, charcoal and watercolor, 6 $^9/_{16}$ × 8 $^9/_{16}$ in.; *Fragment of Memo with Pencil Writing*, 1990, charcoal and watercolor, 11 $^7/_8$ × 9 in.; *From Coosje's Memos of a Gadfly: "Shredded Treaties..." with Scrap of Broken Cup Sketch*, 1990, aluminum, expanded polystyrene, coated with resin and painted with latex, 3 parts: 42 × 31 × 36 in.; 30 × 36 × 15 in.; 43 × 56 × 19 in.; *Notebook Page: Studies for a Sculpture in the Form of a Torn Notebook*, 1991, pencil and ballpoint pen, 11 × 8 $^1/_2$ in.; *Notebook Page: Studies for a Large Sculpture in the Form of a Triple-Decker Sandwich*, 1992, pencil and watercolor, 11 × 8 $^1/_2$ in.; *Notebook Page: Studies for a Large Sculpture in the Form of Corn, Before and After Popping*, 1992, pencil, 11 × 8 $^1/_2$ in.; *Notebook Page: Studies for a Sculpture in the Form of a*

Torn Notebook, 1992, pencil, colored pencil, watercolor, 11 × 8 $^1/_2$ in.; *Notebook Page: Studies for Torn Notebook – Torn Notebook Compared to Sailboat and Shuttlecock*, 1992, pencil and ballpoint pen, 2 $^1/_2$ × 5 $^1/_2$ in.; *Notebook Page: Torn Notebook*, 1992, felt pen, pencil, watercolor, 11 × 8 $^1/_2$ in.; *Torn Notebook*, 1992, charcoal, pastel, watercolor, 29 × 23 in.; *Torn Notebook*, 1992, charcoal and pastel, 29 × 23 in.; *Notebook Page: "NB (Notebook) Is Split By Platte,"* 1993, pencil, 5 $^3/_8$ × 8 $^1/_2$ in.; *Notebook Page: "Nebraska Notebook Concept,"* 1993, typescript and pencil, 11 × 8 $^1/_2$ in.; *Notebook Page: Arch on Campus and Wesleyan University, Lincoln, Nebraska*, 1993, ballpoint pen and clipping, 11 × 8 $^1/_2$ in.; *Notebook Page: Comments on the Torn Notebook – Adding Roughness*, 1993, pencil, 11 × 8 $^1/_2$ in.; *Notebook Page: Covered Wagon Compared to Cup*, 1993, ballpoint pen and postcard, 11 × 8 $^1/_2$ in.; *Notebook Page: Details in Surroundings, Lincoln, Nebraska*, 1993, pencil and clippings, 11 × 8 $^1/_2$ in.; *Notebook Page: Map of Nebraska Compared to Torn Notebook*, 1993, pencil and clipping, 11 × 8 $^1/_2$ in.; *Notebook Page: Preliminary Notes on a Project for Lincoln, Nebraska – "cup and do-nut,"* 1993, pencil, 8 $^1/_2$ × 6 in.; *Notebook Page: Preliminary Notes on a Project for Lincoln, Nebraska – "flowers" "worms,"* 1993, pencil, 8 $^1/_2$ × 6 in.; *Notebook Page: Preliminary Notes on a Project for Lincoln, Nebraska – "sports – movement. arc,"* 1993, pencil, 8 $^1/_2$ × 6 in.; *Notebook Page: Preliminary Notes on a Project for Lincoln, Nebraska: "Wallet – Am. Earheart,"* 1993, pencil, 8 $^1/_2$ × 6 in.; *Notebook Page: Preliminary Notes on a Project for Lincoln, Nebraska: "Workers Mon,"* 1993, pencil, 11 × 8 $^1/_2$ in.; *Notebook Page: Proposals for a Large Sculpture in the Form of a Sliced Roller Skate, for Lincoln, Nebraska*, 1993, pencil, 11 × 8 $^1/_2$ in.; *Notebook Page: Silhouette of Flying Bird Compared to Torn Notebook*, 1993, pencil, 11 × 8 $^1/_2$ in.; *Notebook Page: Snapshot of Eagle Sculpture on Parking Garage, Lincoln, Nebraska*, 1993, color photograph, 6 × 4 in.; *Notebook Page:*

FRAGMENT OF MEMO
WITH PENCIL WRITING,
1990

FOLLOWING PAGE:
FRAGMENT OF MEMO
WITH CUP, 1990

Studies for a Large Sculpture – Cup and Doughnut with Perfume Bottle, 1993, pencil and colored pencil, 11 × 8 ¹/₂ in.; *Notebook Page: Studies for a Large Sculpture - Cup, Spoon and Doughnut*, 1993, pencil and colored pencil, 11 × 8 ¹/₂ in.; *Notebook Page: Studies for a Large Sculpture – Cup, Spoon and Two Doughnuts*, 1993, pencil and colored pencil, 11 × 8 ¹/₂ in.; *Notebook Page: Studies for a Large Sculpture – Roller Skate, Cup and Doughnut*, 1993, ballpoint pen, crayon, pencil, colored pencil, watercolor, 11 × 8 ¹/₂ in.; *Notebook Page: Studies for a Large Sculpture Using Popcorn*, 1993, pencil, colored pencil, watercolor, 11 × 8 ¹/₂ in.; *Notebook Page: Study for a Large Sculpture in the Form of a Torn Notebook with Loose Pages, for Park in Lincoln, Nebraska*, 1993, pencil and felt pen, 11 × 8 ¹/₂ in.; *Notebook Page: Study for a Sculpture in the Form of a Torn Notebook with Loose Pages*, 1993, pencil, 11 × 8 ¹/₂ in.; *Originals for Script on Pages of Torn Notebook – Claes': "donut," "cap," "popcorn,"* 1993, felt pen and pencil, 8 ¹/₂ × 5 ¹/₄ in.; *Originals for Script on Pages of Torn Notebook – Claes': "potato chips," "l-bow,"* 1993, felt pen and pencil, 8 ¹/₂ × 5 ¹/₄ in.; *Originals for Script on Pages of Torn Notebook – Claes': "roller skate cup,"* 1993, felt pen and pencil, 8 ¹/₂ × 5 ¹/₄ in.; *Originals for Script on Pages of Torn Notebook – Claes': "roller skate," "football,"* 1993, felt pen and pencil, 8 ¹/₂ × 5 ¹/₄ in.; *Originals for Script on Pages of Torn Notebook – Coosje's: "desert ocean of grasses,"* 1993, felt pen, 11 × 8 ¹/₂ in.; *Originals for Script on Pages of Torn Notebook – Coosje's: "in wayward winds sway,"* 1993, felt pen, 11 × 8 ¹/₂ in.; *Originals for Script on Pages of Torn Notebook – Coosje's:*

"peregrine falcons atop flagpoles," 1993, felt pen, 11 × 8 ¹/₂ in.; *Originals for Script on Pages of Torn Notebook – Coosje's: "Ulysses Volunteer Fire Company,"* 1993, felt pen, 11 × 8 ¹/₂ in.; *Originals for Script on Pages of Torn Notebook – Coosje's: "you know when you blow out the match/I'll kiss you,"* 1993, felt pen, 11 × 8 ¹/₂ in.; *Proposal for a Large Sculpture in the Form of a Roller Skate for Lincoln, Nebraska*, 1993, pencil, 8 ¹/₂ × 10 ¹/₂ in.; *Proposal for a Large Sculpture in the Form of Popping Popcorn, for Lincoln, Nebraska*, 1993, pencil and colored pencil, 8 ¹/₂ × 10 ¹/₂ in.; *Proposal for a Sculpture in the Form of a Thrown Cup of Coffee and Doughnut – Two Views*, 1993, pencil and crayon, 40 × 30 ¹/₈ in.; (recto) *Notebook Page: Studies for a Large Sculpture – Cup and Doughnut, Barbed Wire, Etc.*, (verso) *Study for a Large Sculpture in the Form of a Spilling Bowl of Cereal and Milk – Notations by Coosje*, 1993, ballpoint pen, crayon, pencil, colored pencil, watercolor, 11 × 8 ¹/₂ in.; (recto) *Study for a Large Sculpture in the Form of a Cup/Cap*, (verso) *Notebook Page: Studies for a Large Sculpture – Falling Potato Chips, Cups and Doughnut, Etc.*, 1993, ballpoint pen and colored pencil, 11 × 8 ¹/₂ in.; *Studies for a Notebook Edition of Images Related to Lincoln Nebraska – Covered Wagon, "L Bow," Etc.*, 1993, pencil and felt pen, 8 ¹/₂ × 5 ¹/₄ in.; *Studies for a Notebook Edition of Images Related to Lincoln Nebraska – Cup*, 1993, pencil and felt pen, 8 ¹/₂ × 5 ¹/₄ in.; *Studies for a Notebook Edition of Images Related to Lincoln Nebraska – Donut*, 1993, pencil and felt pen, 8 ¹/₂ × 5 ¹/₄ in.; *Studies for a Notebook Edition of Images Related to Lincoln Nebraska –*

Steer Head, Flag, Sower, 1993, pencil and felt pen, 8 $^1/_2$ × 5 $^1/_4$ in.; Studies for a Notebook Edition of Images Related to Lincoln, Nebraska – Barbed Wire, 1993, pencil and felt pen, 8 $^1/_2$ × 5 $^1/_4$ in.; Studies for a Notebook Edition of Images Related to Lincoln, Nebraska – Football, Steer Head, Etc., 1993, pencil and felt pen, 8 $^1/_2$ × 5 $^1/_4$ in.; Studies for a Notebook Edition of Images Related to Lincoln, Nebraska – Roller Skate, 1993, pencil and felt pen, 8 $^1/_2$ × 5 $^1/_4$ in.; Torn Notebook as an Arch, for Park in Lincoln, Nebraska, 1993, pencil, 8 $^7/_{16}$ × 10 $^3/_8$ in.; Instructions for Cutting Handwriting out of Aluminum, "Roller Skate," 1994, blueprint with pencil, 24 $^1/_8$ × 18 $^1/_8$ in.; Layout of Handwriting on Page – "Barbed Wire," 1994, pencil and colored pencil, 30 × 21 $^1/_4$ in.; Layout of Handwriting on Page – "Barbed Wire," 1994, pencil on tracing paper, 30 × 21 in.; Layout of Handwriting on Page – "Buffalo Peas," 1994, pencil on tracing paper, 30 × 21 in.; Layout of Handwriting on Page – "Crop Trials," 1994, pencil and colored pencil on tracing paper, 30 × 21 in.; Layout of Handwriting on Page – "Crop Trials," 1994, photocopies and pencil, 30 $^1/_4$ × 40 in.; Layout of Handwriting on Page – "Desert Ocean," 1994, pencil on tracing paper, 27 $^1/_2$ × 18 $^5/_8$ in.; Layout of Handwriting on Page – "Donut," 1994, pencil and colored pencil on tracing paper, 30 × 21 in.; Layout of Handwriting on Page – "Poppies," 1994, photocopies and pencil, 30 $^1/_4$ × 40 in.; Layout of Handwriting on Page – "Roller Skate," 1994, pencil and colored pencil on tracing paper, 30 × 21 in.; Layout of Handwriting on Page – "Roller Skate," 1994, pencil on tracing paper, 30 × 21 in.; Layout of Handwriting on Page – "Roller Skate," 1994, photocopies and pencil, 30 $^1/_4$ × 40 in.; Originals for Script on Pages of Torn Notebook – Claes': "barbed wire," "L-bow," 1994, felt pen and colored pencil, 8 $^1/_2$ × 5 $^1/_4$ in.; Originals for Script on Pages of Torn Notebook – Claes': "goose," "arch," "hoop," 1994, felt pen and colored pencil, 8 $^1/_2$ × 5 $^1/_4$ in.; Originals for Script on Pages of Torn Notebook – Claes': "roller skate," 1994, felt pen and colored pencil, 8 $^1/_2$ × 5 $^1/_4$ in.; Texts by Coosje van Bruggen in Her Handwriting – "desert ocean of grasses," 1994, photocopy with colored pencil and translucent tape, 17 $^1/_2$ × 15 in.; Texts by Coosje van Bruggen in Her Handwriting – "desert ocean of grasses," 1994, photocopy with colored pencil and translucent tape, 30 $^1/_2$ × 23 in.; Torn Notebook, for a Site in Lincoln, Nebraska – Study, 1994, aluminum and steel, painted with latex, 23 × 25 × 21 in., book: 13 × 10 × 8 $^1/_2$ in., sheet one: 10 $^3/_4$ × 10 $^1/_4$ × 9 in., sheet two: 22 $^1/_2$ × 41 × 28 in.; Torn Notebook, on Ground, 1994, steel, felt, coated with resin and painted with latex, 33 $^1/_2$ × 70 × 129 in.; Torn Notebook, 1995, pencil on vellum, 24 × 36 in.; Torn Notebook, 1995, pencil on vellum, 24 × 36 in.; Torn Notebook, 1995, pencil on vellum, 24 × 36 in.; Torn Notebook Study #1, 1996, steel and canvas, coated with resin and painted with latex, 9 $^5/_8$ × 12 × 12 in.; Torn Notebook, Study #2, 1996, steel and canvas, coated with resin and painted with latex, 10 $^1/_4$ × 12 × 12 in.; Torn Notebook – Fabrication Model, ca. 1993, steel, aluminum, Mylar, ink, tape, painted with polyurethane enamel, notebook: 18 × 17 $^5/_8$ × 16 in., page: 9 $^5/_8$ × 8 $^1/_2$ × 7 in.; CO.Cos (Signature for Layout), ca. 1994, pencil and felt pen on tracing paper, 4 $^1/_2$ × 9 in.; Untitled (Third Page of the Torn Notebook Wrapped Around a Pole), ca. 1994, steel painted, 24 $^1/_4$ × 7 × 7 in.

1999

—— CLAES OLDENBURG COOSJE VAN BRUGGEN, Museo Correr, Venice, May 22 – October 3. Curated by Germano Celant. Catalogue. Works exhibited: *Notebook Page: Studies for Site Now Occupied by the Pan Am Building*, 1957, ballpoint pen, 11 × 8 ¹/₂ in.; *Notebook Page: First Sketch for a Good Humor Bar to Replace the Pan Am Building on Park Avenue, New York*, 1962, ballpoint pen, 11 × 8 ¹/₂ in.; *Fountain in the Form of Wet Blue Jeans*, 1964, ballpoint pen and clipping, 11 × 8 ¹/₂ in.; *Study for an Outboard Motor in Action, on a Fragment of Stern, with Notes on Technique and Materials, Paris*, 1964, ballpoint pen, pencil, clippings, 11 × 8 ¹/₂ in.; *Proposed Colossal Monument for Times Square, New York: Banana, Lying Position*, 1965, crayon and watercolor, 23 × 29 in.; *Study for a Sculpture in the Form of an Outboard Motor*, 1965, clay over toy, coated wire, wood, 8 ¹/₂ × 6 ³/₈ × 3 ¹/₂ in.; *Knees as Columns, Cathedral Facade, Etc.*, 1966, crayon, pencil, watercolor, 15 × 22 in.; *Notebook Page: Candle Skyscrapers, Malmö, Sweden*, 1966, ballpoint pen, 11 × 8 ¹/₂ in.; *Notebook Page: Drill Bit in Place of the Statue of Eros, "Extended," London*, 1966, ballpoint pen, felt pen, pencil, clipping, postcard, 11 × 8 ¹/₂ in.; *Notebook Page: Drill Bit in Place of the Statue of Eros, London*, 1966, ballpoint pen, pencil, clipping, postcard, 11 × 8 ¹/₂ in.; *Notebook Page: Proposal for a Building in the Form of an Office Machine, London*, 1966, ballpoint pen, felt pen, pencil, clipping, postcard, collage, 11 × 8 ¹/₂ in.; *Notebook Page: Proposal for a Gearstick to Replace Nelson's Column, Trafalgar Square, Lon*-don, 1966, postcard, felt pen, crayon, watercolor, pencil, 11 × 8 ¹/₂ in.; *Notebook Page: Rear View Mirror in Place of Nelson's Column, Trafalgar Square, London*, 1966, pencil, clipping, collage, 11 × 8 ¹/₂ in.; *Notebook Page: Sliced Building, Piccadilly Circus, London*, 1966, ballpoint pen, pencil, crayon, watercolor, clipping, postcard, collage, 11 × 8 ¹/₂ in.; *Notebook Page: Square in London in the Form of Objects on a Gentleman's Night Table, London*, 1966, ballpoint pen, felt pen, watercolor, pencil, clipping, 11 × 8 ¹/₂ in.; *Notebook Page: Stock Exchange Entrance in the Form of a Girdle*, 1967, ballpoint pen, pencil, crayon, rubbing, clipping, 11 × 8 ¹/₂ in.; *Notebook Page: Colossal Noses in Landscape*, 1968, ballpoint pen, pencil, colored pencil, felt pen, 11 × 8 ¹/₂ in.; *Notebook Page: Flashlight Across the Hollywood Hills*, 1968, ballpoint pen and pencil, 11 × 8 ¹/₂ in.; *Notebook Page: Soft Screw in Waterfall and Screw/Tornado/Searchlights*, 1968, ballpoint pen and watercolor, 11 × 8 ¹/₂ in.; *Notebook Page: Two Office Buildings, Drawing for "Notes," Gemini GEL, Page X*, 1968, ballpoint pen and clipping, 11 × 8 ¹/₂ in.; *Monument for Yale University: Giant Traveling and Telescoping Lipstick with Changeable Parts in Three Stages of Extension – Presentation Model*, 1969, cardboard, canvas, stiffened with glue, painted with spray enamel and shellacked, tractor: 5 ¹/₂ × 16 ¹/₂ × 29 ¹/₂ in., lipstick, stage one: 4 × 8 ¹/₂ × 10 ¹/₄ in.; lipstick, stage two: 14 ¹/₂ × 8 ¹/₂ × 10 ¹/₄ in., lipstick, stage three: 23 ¹/₂ × 8 ¹/₂ × 10 ¹/₄ in.; *Notebook Page: Building in the Form of Binoculars, Pelvic Region Characters*, 1969, ballpoint pen and newspaper clippings, 11 × 8 ¹/₂ in.; *Notebook Page: Design for a Mathematics Building at Yale Univer*-

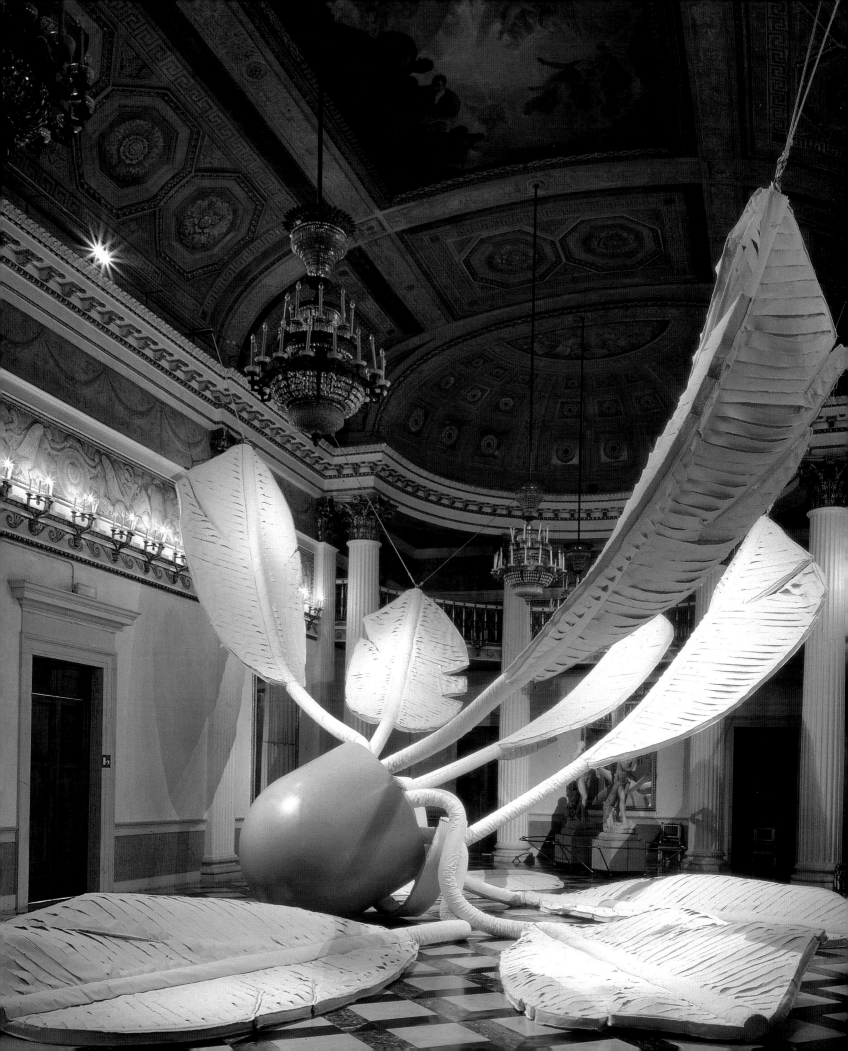

sity, 1969, pencil and clipping, 11 × 8 1/$_2$ in.; *Notebook Page: Soft Rotating Capitol,* 1969, crayon, 11 × 8 1/$_2$ in.; *Notebook Page: Stocking on Knee, with Thumbs, and Man's Shirt – as Fountains,* 1969, ballpoint pen and clippings, 11 × 8 1/$_2$ in.; *Notebook Page: Studies for the Giant Ice Bag,* 1969, ballpoint pen, pencil, felt pen, 11 × 8 1/$_2$ in.; *Rising and Falling Screw,* 1969, cardboard, wood, pencil, painted with spray enamel and coated with resin, 11 × 28 × 10 1/$_2$ in.; *Study for a Soft Screw,* 1969, canvas, wood, wire, nails; painted with latex, 10 1/$_4$ × 7 1/$_8$ × 3 1/$_2$ in.; *Aerial View of Eraser in 57th Street Site with Sphinx and Colossal Wristwatch,* 1970, pencil, colored pencil, watercolor, 11 1/$_2$ × 14 1/$_2$ in.; *Notebook Page: Building in the Form of a Rack of Toast,* 1970, ballpoint pen and clipping, 11 × 8 1/$_2$ in.; *Notebook Page: Sphinx Compared to Screw,* 1970, ballpoint pen, felt pen, clipping, 11 × 8 1/$_2$ in.; *Study for Typewriter Eraser,* 1970, expanded polystyrene, cardboard, wood, rope, painted with tempera and spray enamel, and drawn on with pencil, 21 1/$_2$ × 12 × 14 in.; *Typewriter Eraser,* 1970, vinyl, canvas, cardboard, painted with spray enamel, 21 1/$_2$ × 12 3/$_4$ × 9 in. on base: 13/$_{16}$ × 21 3/$_{16}$ × 19 1/$_8$ in.; *Alcatraz Island Reconstructed as a Landscape in the Form of an Upturned Foot – (Planned Monument to the American Indian) – View of the Entrance,* 1971, pencil and colored pencil, 11 3/$_8$ × 14 11/$_{16}$ in.; *Arch to Span the Suez Canal – Ears of the Sphinx,* 1971, pencil and colored pencil, 14 7/$_{16}$ × 11 in.; *Cemetery in the Shape of a Colossal Screw: Skyscraper for São Paulo, Brazil,* 1971, pencil and colored pencil, 14 1/$_2$ × 11 1/$_2$ in.; *Colossal Sculpture in the Form of a Bear on the Flag of California – Shown in the Final Stages of Excavation,* 1971, pencil and colored pencil, 15 1/$_{16}$ × 12 1/$_4$ in.; *Memorial to the 1941 Attack on Pearl Harbor, Hawaii – Water Park with "Foliage" in the Form of Explosions,* 1971, pencil and colored pencil, 11 9/$_{16}$ × 14 1/$_2$ in.; *Notebook Page: Summer House for Blueberry Pie Point, Lake Sunapee, New Hampshire,* 1971, crayon, ballpoint pen, colored pencil, 11 × 8 1/$_2$ in.; *Tower in the Form of a Colossal Thumb, "Czar's Thumb," on the Moscow Road,* 1971, pencil and colored pencil, 14 9/$_{16}$ × 11 9/$_{16}$ in.; *Bridge Over the Rhine at*

Düsseldorf in the Shape of a Colossal Saw, 1971, crayon, pencil, 11 × 14 1/$_2$ in.; *Model of Mouse Museum – First Version, for Documenta 5,* 1972, cardboard, wood, spray enamel, pencil, chalk, rubber stamp on Masonite base, 4 5/$_8$ × 19 7/$_8$ × 20 7/$_8$ in. on base 3/$_8$ in. high; *Proposal for a Colossal Structure in the Form of a Clothespin – Compared to Brancusi's "Kiss,"* 1972, screenprint, 29 7/$_8$ × 21 1/$_2$ in.; *Study for a Sculpture in the Form of a Saw, Cutting,* 1973, cardboard painted with spray enamel, 14 1/$_8$ × 10 × 10 in.; *Fagend – Trial Proof,* 1975, cast aluminum painted with enamel, 9 3/$_4$ × 18 1/$_2$ × 7 1/$_2$ in.; *Notebook Page: Studies for the Batcolumn,* 1975, ballpoint pen and pencil, 11 × 8 1/$_2$ in.; *Fagend Study,* 1976, cast aluminum painted with enamel, 10 × 18 1/$_2$ × 9 1/$_4$ in.; *Study Defining the Outline of the Batcolumn,* 1976, pencil, watercolor, tape, 37 7/$_8$ × 9 3/$_8$ in.; *Clothespin – 45 Foot Version, Model,* 1976-1979, Cor-Ten and stainless steel, 60 × 24 × 19 5/$_8$ in.; *Model of the Mouse Museum,* 1977, cardboard and wood, painted with tempera and spray enamel, pencil, 6 7/$_{16}$ × 18 7/$_8$ × 18 7/$_8$ in.; *Model of the Ray Gun Wing,* 1977, cardboard and wood painted with tempera, spray enamel, pencil, 6 1/$_8$ × 12 7/$_8$ × 18 7/$_8$ in.; *Umbrella, Inscribed "R. Crusoe,"* 1977, crayon and watercolor, 11 × 13 3/$_4$ in.; *Preliminary Study for the Crusoe Umbrella,* 1978, coated wire, 11 × 8 3/$_4$ × 9 7/$_8$ in.; *Alternative Proposal for the Allen Memorial Art Museum, Oberlin, Ohio,* 1979, hard-ground and soft-ground etching, aquatint, and spit bite, 34 × 40 3/$_4$ in.; *Fabrication Model for the Crusoe Umbrella,* 1979, aluminum painted with polyurethane enamel, 23 3/$_8$ × 42 1/$_8$ × 27 3/$_4$ in.; *Flashlight,* 1979, flashlight in plaster, painted with latex, 7 1/$_2$ × 4 1/$_2$ × 3 7/$_8$ in.; *Flashlight, Study for Final Version,* 1979, paper and wood, painted with casein, 11 1/$_8$ × 6 1/$_8$ × 5 3/$_4$ in.; *Notebook Page: Model of Screwarch Bridge,* 1979, crayon, ballpoint pen, felt pen, watercolor, 11 × 8 1/$_2$ in.; *Preliminary Model for the Crusoe Umbrella,* 1979, pine branches, rope, wood, 22 × 33 1/$_4$ × 23 in.; *Flashlight, Final Model 1/4,* 1980, steel painted with polyurethane enamel on plastic and aluminum base, 37 in. high × 10 1/$_2$ in. diameter, on base 1/$_2$ × 20 1/$_2$ × 20 1/$_2$ in.; *Model of Cross Section of a Toothbrush, with*

PREVIOUS PAGE:
*HOUSEBALL WITH
FALLEN TOY BEAR*, 1997
PRIVATE COLLECTION,
NEW YORK

*PROPOSAL FOR A
SCULPTURE IN THE FORM
OF A FAUCET AND
SHOWER HOSE, FOR
STOCKHOLM HARBOR*,
1997
THE MUSEUM OF
MODERN ART, NEW YORK
THE JUDITH ROTHSCHILD
FOUNDATION
CONTEMPORARY
DRAWINGS COLLECTION,
2005

Paste in a Cup, 1980, wood and cardboard on wood base, painted with enamel, 58 $^3/_4$ × 22 $^1/_4$ × 4 in. on base $^3/_4$ in. high × 18 $^3/_8$ in. diameter; *Study of Cross Section of a Toothbrush with Paste, in a Cup, on a Sink: Portrait of Coosje's Thinking*, 1980, cardboard, wood, clothesline, sand, coated with resin and painted with spray enamel, 19 $^3/_4$ × 11 $^1/_4$ × 6 $^5/_8$ in.; *Notebook Page: Cross Section of Toothbrush in Glass, "Sun Dial,"* 1980, ballpoint pen, felt pen, pencil, colored pencil, 11 × 8 $^1/_2$ in.; *Notebook Page: Half Button*, 1980, pencil and Polaroid photograph, 11 × 8 $^1/_2$ in.; *Study for Salinas Hat*, 1980, grinding wheel, plastic cup, sand, coated with glue and painted with spray enamel, 4 $^1/_2$ × 7 $^1/_4$ × 4 $^1/_2$ in.; *Salinas Hat – Fabrication Model*, 1981, aluminum and steel painted with latex on steel base, 26 $^3/_4$ × 27 × 23 in. on base $^1/_4$ × 19 $^7/_8$ × 10 in.; *Screwarch Bridge (State III)*, 1981, hard-ground etching, aquatint, sugar-lift, spit bite, monoprint, 31 $^1/_4$ × 57 $^3/_4$ in.; *Split Button, Model*, 1981, wood painted with latex, 4 $^5/_8$ high × 17 $^3/_4$ in. diameter on base $^7/_8$ × 19 $^{15}/_{16}$ × 19 $^{15}/_{16}$ in.; *Study for a Sculpture in the Form of a Split Button*, 1981, cardboard painted with spray enamel, 7 $^7/_8$ × 10 $^1/_2$ × 10 $^3/_4$ in.; *Colossal Flashlight in Place of the Hoover Dam*, 1982, offset lithograph, 31 $^1/_4$ × 57 $^3/_4$ in.; *Proposal for a Bridge over a City Street in the Form of a Spoon with Cherry*, 1982, spoon, wood, cardboard, nails painted with spray enamel and colored pencil, 7 $^9/_{16}$ × 2 $^3/_4$ × 7 in.; *Spitzhacke, Model*, 1982, aluminum on aluminum base painted with polyurethane enamel, 47 $^1/_4$ × 51 × 24 in. on base 1 $^1/_2$ × 18 × 18 in.; *Balancing Tools, Study*, 1983, cardboard, wood (floor segment), paper, screwdriver, nails, painted with spray enamel, 9 $^1/_4$ × 14 $^3/_4$ × 9 $^1/_4$ in.; *Balancing Tools, Position Study*, 1983, pencil, crayon, tape, collage, 22 × 19 $^3/_8$ in.; *Notebook Page: Sculpture in the Form of Jacks Composed of Tools*, 1983, pencil and watercolor, 11 × 8 $^1/_2$ in.; *Notebook Page: Three Studies for Caught and Set Free, a Sculpture in the Form of a Basketball in Net, for La Jolla, California*, 1983, pencil and watercolor, 9 $^3/_8$ × 6 $^{11}/_{16}$ in.; *Study for Balancing Tools*, 1983, wood and metal, painted with spray enamel, 27 × 40 × 15 $^1/_2$ in.; *Tilting Neon Cocktail*, 1983, stain-

less steel, cast aluminum, painted with acrylic, Plexiglas, 18 $^3/_8$ × 7 × 6 $^1/_4$ in.; *Tilting Neon Cocktail, Study*, 1983, cardboard, wood nail, painted with acrylic, felt pen, 16 $^1/_8$ × 12 × 9 $^3/_8$ in.; *Design for a Theater Library for Venice in the Form of Binoculars and Coltello Ship in Three Stages*, 1984, pencil, colored pencil, chalk, watercolor, 30 × 40 in.; *Free Stamp*, 1984, watercolor, pencil, tape on photoprint, 31 $^1/_2$ × 23 $^1/_2$ in.; *Project for Venice, Italy: A Fire Station by Frank O. Gehry in the Form of a Snake and an Office Building in the Form of a Grand Piano Lid*, 1984, pencil, crayon, watercolor, 29 $^{15}/_{16}$ × 24 in.; *Proposed Events for Il Corso del Coltello, a Performance in Venice, Italy*, 1984, pencil, crayon, watercolor, 24 × 18 $^3/_4$ in.; *Railroad Station in the Form of a Wristwatch, for Florence, Italy*, 1984, pencil and watercolor, 8 $^5/_{16}$ × 12 $^5/_8$ in.; *Studies for a Railroad Station in the Form of a Wristwatch, for Florence, Italy*, 1984, paper, cardboard, wood, pencil, painted with watercolor and spray enamel, 6 × 6 $^3/_4$ × 22 $^5/_8$ in.; *Architectural Fragments*, 1985, canvas and polyurethane foam, painted with latex, 7 elements, yellow stairs: 112 × 34 × 34 $^1/_2$ in., yellow columns with architrave: 112 × 78 $^3/_4$ × 10 $^1/_2$ in., gray stairs: 112 × 34 × 34 $^1/_2$ in., red column: 119 $^1/_4$ × 19 × 19 $^3/_4$, green obelisk: 123 × 31 × 19 in., red arch: 126 × 52 $^3/_4$ × 21 $^1/_4$ in., yellow obelisk: 123 × 31 × 19 in.; *Proposal for Sculpture in the Form of Nails Projecting into a Room*, 1985, charcoal, chalk, pastel, 30 × 22 $^1/_8$ in.; *Prototype of the Houseball*, 1985, steel, muslin, polyurethane foam, rope, painted with latex, approx. 38 in. diameter; *Toppling Ladder with Spilling Paint, Fabrication Model*, 1985, steel painted with polyurethane enamel, 18 $^1/_2$ × 12 × 12 in.; *Toppling Ladder, Study*, 1985, aluminum painted with enamel on aluminum base, 6 $^7/_8$ × 5 $^1/_4$ × 3 $^5/_8$ in. on base $^1/_8$ × 3 $^1/_2$ × 3 $^1/_2$ in.; *Free Stamp, Second Version, Model*, 1985-1991, wood painted with latex and spray enamel, 14 $^1/_2$ × 22 $^3/_8$ × 20 $^1/_4$ in.; *Study for a Sculpture in the Form of a Lighted Match in Wind*, 1986, paper, foamcore, wood, painted with spray enamel, 11 $^7/_8$ × 6 $^1/_2$ × 3 $^3/_4$ in.; *Bottle of Notes and Some Voyages*, 1987, watercolor and felt pen, 26 × 40 $^1/_2$ in.; *Free Stamp, Thrown Position, Model*, 1987 (destroyed), cast

epoxy painted with latex, 3 $^1/_4$ × 6 × 5 in.; *Monument to the Last Horse – Study*, 1987, horseshoe and wood, painted with latex, 7 $^3/_8$ × 6 $^1/_{16}$ × 6 in.; *Notebook Page: "MONOLITHIC MATCHES," with Woman and Baby Carriage*, 1987, pencil and colored pencil, 11 × 8 $^1/_2$ in.; *Notebook Page: Cook's Hands, a Gate in Middlesbrough, the Bottle on the Beach*, 1987, felt pen, pencil, clippings, 11 × 8 $^1/_2$ in.; *Sculpture in the Form of a Match Cover – Fabrication Model*, 1987, cardboard, expanded polystyrene, felt pen, 38 $^1/_2$ × 19 × 38 in.; *Stirring Up Spanish Themes*, 1987, pencil, watercolor, felt pen, 30 $^1/_8$ × 23 $^1/_4$ in.; *Study for "last horse mon. Marfa,"* 1987, ballpoint pen, felt pen, watercolor, 4 $^7/_8$ × 3 $^3/_8$ in.; *Study for Rotten Apple Core*, 1987, canvas coated with resin and painted with latex, 24 × 12 × 12 in.; *Study for the Bottle of Notes*, 1987, pencil and colored pencil, 30 × 25 $^1/_2$ in.; *Study for the Scripts of the Bottle of Notes*, 1987, pencil, 28 $^1/_4$ × 40 in.; *Notebook Page: Study for an Equestrian Monument*, 1989, pencil, felt pen, colored pencil, watercolor, 11 × 8 $^1/_2$ in.; *Bottle of Notes – Model*, 1989-1990, aluminum and expanded polystyrene, painted with latex, 8 ft. 11 in. × 4 ft. 1 in. × 3 ft. 3 in.; *Monument to the Last Horse, Prototype for Edition*, 1990, steel, cement, wood on steel base, painted with latex, 31 $^1/_4$ × 28 $^1/_2$ × 19 $^1/_4$ in. on base $^1/_4$ × 18 × 18 in.; *Geometric Apple Core, Study*, 1991, canvas and wood, painted with latex, 9 $^1/_2$ × 12 × 8 in.; *Notebook Page: Inverted Collar and Tie with the Top of the Woolworth Building*, 1991, pencil and watercolor, 11 × 8 $^1/_2$ in.; *Inverted Tie Study*, 1992, tie, coated with resin, steel, 13 × 11 $^1/_8$ × 8 $^1/_4$ in.; *Notebook Page: Cap and Tie Atop West End Str. I, Frankfurt-am-Main, Germany*, 1992, pencil, colored pencil, watercolor, 11 × 8 $^1/_2$ in.; *Model for Inverted Collar and Tie*, 1992, canvas and wood painted with latex and spray enamel, 19 $^1/_2$ × 16 $^1/_2$ × 13 in.; *Houseball, Naoshima – Presentation Model*, 1992,

burlap, rope, expanded polystyrene, coated with resin and painted with latex, 18 $^1/_2$ × 14 $^1/_4$ × 16 in.; *Inverted Collar and Tie*, 1993, canvas, coated with resin, steel, painted with latex, wood painted with polyurethane enamel, 92 × 38 × 52 in.; *Inverted Collar and Tie, Second Version, Presentation Model*, 1993, canvas, wood, on wood base, coated with resin and painted with latex, 35 $^7/_{16}$ × 11 $^{13}/_{16}$ × 27 $^{15}/_{16}$ in. on base 5 $^7/_8$ × 13 $^9/_{16}$ × 13 $^9/_{16}$ in., 40 $^1/_8$ in. high overall; *Notebook Page: Shuttlecock Sculpture Studies*, 1993, pencil, colored pencil, watercolor, 11 × 8 $^1/_2$ in.; *Notebook Page: Shuttlecock Sculpture Studies – "Am. Earheart,"* 1993, pencil and colored pencil, 11 × 8 $^1/_2$ in.; *Shuttlecock*, 1994, pastel, 28 $^7/_8$ × 23 in.; *Torn Notebook, Model*, 1994, steel painted with latex, 10 $^1/_4$ × 12 × 12 in.; *Position Study for Soft Shuttlecock in Guggenheim Museum, New York, in Rotunda*, 1995, pencil, 29 × 23 in.; *Position Study for the Soft Shuttlecock in Guggenheim Museum, New York, Cross Section*, 1995, pencil, 23 × 29 in.; *Proposal for a Pedestrian Bridge in the Form of Two Hammers*, 1995, pencil and colored pencil, 30 × 40 in.; *Saw, Sawing, Model*, 1995, wood and polyurethane foam, coated with resin and painted with latex, 54 × 48 × 48 in.; *Soft Shuttlecock*, 1995, canvas, expanded polyurethane and polyethylene foams, steel, aluminum, rope, wood, duct tape, fiberglass-reinforced plastic, painted with latex, nose cone: approx. 6 ft. diameter × 6 ft. long; 9 feathers, each approx. 26 ft. long and 6-7 ft. wide; *Soft Shuttlecock in Guggenheim Museum, New York*, 1995, charcoal and pastel, 29 × 23 in.; *Study for a Multiple: Apple Core*, 1995, expanded polystyrene, wood, canvas, painted with latex, 10 $^3/_4$ × 6 $^1/_2$ × 9 in.; *Study for a Multiple: Metamorphic Apple Core*, 1995, expanded polystyrene, cardboard, wood, painted with latex, 13 $^1/_2$ × 10 $^3/_4$ × 2 $^3/_4$ in.; *Golf Typhoon* 1/5, 1996, bronze, acrylic polyurethane on aluminum base,

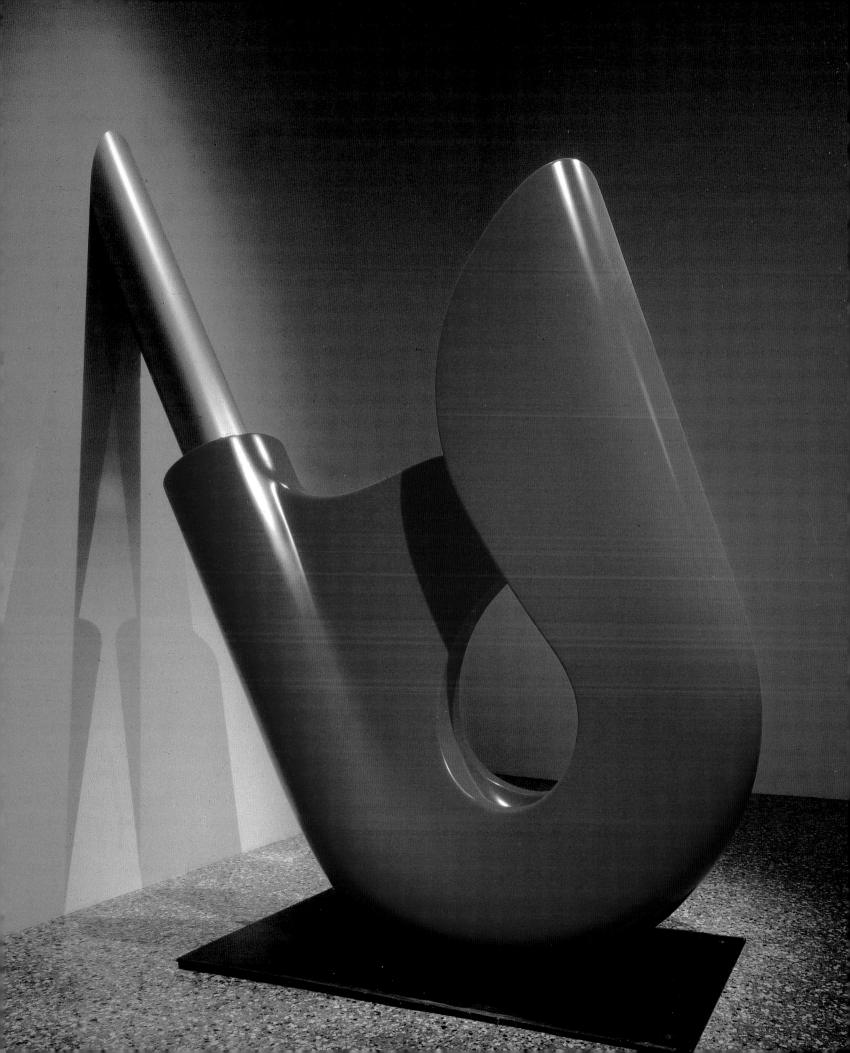

61 $^3/_4$ × 16 $^3/_4$ × 16 $^1/_2$ in.; *Shuttlecock/Sphinx*, 1996, pencil and pastel, 38 × 50 in.; *Architect's Handkerchief*, 1997, screenprint and papier collé, 31 $^1/_4$ × 23 $^1/_2$ in.; *Feasible Monument in the Form of Two Banana Peels, for Stockholm Harbor*, 1997, pencil and pastel, 30 $^3/_{16}$ × 40 in.; *Houseball with Fallen Toy Bear*, 1997, charcoal and pastel, 37 $^3/_4$ × 49 $^3/_4$ in.; *Proposal for a Sculpture in the Form of a Faucet and Shower Hose, for Stockholm Harbor*, 1997, pencil and pastel, 30 × 40 in.; *Study for a Sculpture in the Form of a Perfume Bottle and Atomizer*, 1997, expanded polystyrene and wire painted with latex, 8 $^1/_4$ × 8 × 5 in.; *Valentine Perfume, Study*, 1997, expanded polystyrene, wood, wire, painted with latex, 14 × 10 × 7 in.; *Elevation of Shuttlecock/Blueberry Pies, on Stairs*, 1997, pencil and colored pencil, 30 × 40 in.; *Study for a Sculpture in the Form of a Pan and Broom with Sweepings*, 1997, pencil and pastel, 30 × 40 in.; *Sphinx Fragments on a Playing Field*, 1997, pencil and pastel, 30 × 40 in.; *Blueberry Pie Island*, 1998, pencil and pastel, 30 × 38 $^3/_4$ in.; *Blueberry Pie, Flying, Scale B* 1/3, 1998, cast aluminum and steel painted with latex, 33 × 25 $^1/_2$ × 18 in, on base $^3/_4$ × 14 × 14 in.; *Blueberry Pie, Flying, Scale C* I-VI, 1/3, 1998, cast aluminum painted with acrylic polyurethane, 6 sculptures, each approx. 15 $^1/_2$ × 4 × 4 in.; *Caught and Set Free Sited in Stockholm, Sweden*, 1998, pencil, pastel colored pencil, 30 × 40 in.; *Dream Pin*, 1998, pencil, colored pencil, pastel, 40 × 30 $^3/_{16}$ in.; *Floating Peel, Model*, 1998, felt, expanded polystyrene, coated with resin and painted with latex, cardboard, T-pins, 25 × 16 $^1/_8$ × 16 in.; *Flung Peel, First Position, Model*, 1998, paper and expanded polystyrene painted with latex, wood, on cardboard base, with pencil, 5 × 7 $^{15}/_{16}$ × 7 in. on base 1 $^3/_8$ × 10 $^7/_8$ × 10 $^1/_2$ in.; *Proposal for a Sculpture in the Form of a Dropped Cone, for Neumarkt Galerie,*

Cologne, 1998, pencil, colored pencil, pastel, 25 $^3/_4$ × 18 $^7/_{16}$ in.; *Proposed Sculpture for the Harbor of Stockholm, Sweden, "Caught and Set Free," Model*, 1998, steel, aluminum, wood, plaster, sand, painted with acrylic polyurethane and latex, 23 × 39 $^3/_4$ × 30 in.; *Study for the Lion's Tail, Museo Correr*, 1998, colored pencil and pencil, 13 × 12 $^1/_2$ in.; *Typewriter Eraser, Model for Scale X*, 1998, aluminum and medium-density fiberboard, painted with acrylic polyurethane, 38 $^3/_4$ × 24 × 31 in.; *Pyramid of Pears and Peaches, Final Version*, 1998, charcoal and pastel, 38 × 50 in.; *Study for a Sculpture in the Form of a Broom and Pan with Sweepings*, 1998, pencil and colored pencil, 30 × 40 in.; *Big Sweep, Model*, 1999, aluminum painted with polyurethane enamel, 59 $^1/_2$ × 45 $^5/_8$ × 27 $^3/_4$ in.; *Canapé Gazebo*, A.P., 1999, cast aluminum painted with latex, 55 $^1/_2$ × 24 $^3/_4$ × 13 in.; *Corridor Pin, Blue* 3/3, 1999, stainless steel and aluminum painted with polyurethane enamel, 21 ft. 3 in. × 21 ft. 2 in. × 1 ft. 4 in.; *Dream Pin, Clasp*, 1999, steel and fiber-reinforced plastic painted with polyurethane enamel, on steel plate, 9 ft. $^{11}/_{16}$ in. × 7 ft. 11 in. × 1 ft. $^5/_{16}$ in.; *Flying Pins, Presentation Model*, 1999, wood, cardboard, expanded polystyrene, polyurethane foam, coated with resin and painted with latex, 10 $^1/_2$ × 47 × 23 $^1/_2$ in.; *Lion's Tail*, 1999, stainless steel, aluminum, wood, fiber-reinforced plastic, expanded polystyrene, painted with polyurethane enamel, nylon, 18 ft. 6 in. × 15 ft. × 4 ft.; *Proposal for a Sculpture in the Form of a Needle, Thread, and Knot, for Piazzale Cadorna, Milan*, 1999, pencil and colored pencil, 30 × 40 in.; *Shuttlecock/Blueberry Pies*, I and II, 1999, cast aluminum painted with acrylic polyurethane: each 48 × 24 × 24 in.; *Valentine Perfume* 1/2, 1999, cast aluminum painted with acrylic polyurethane, 46 $^1/_2$ × 25 × 20 in.

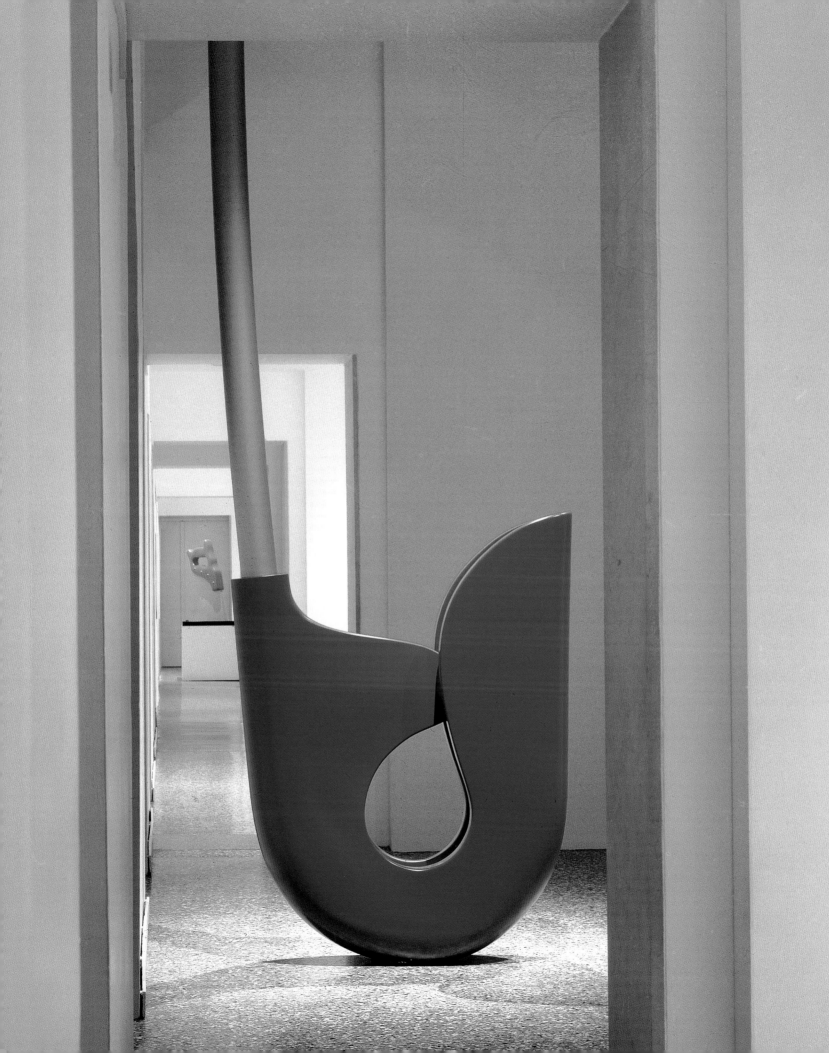

2000

—— CLAES OLDENBURG AND COOSJE VAN BRUGGEN, Carpenter Center for the Visual Arts, Harvard University, Cambridge, February 28 – March 30.
Works exhibited: *Proposal for a Sculpture in the Form of a Faucet and Shower Hose, for Stockholm Harbor,* 1997, pencil and pastel, 30 × 40 in.; *Canapé Gazebo 1/4,* 1999, cast aluminum painted with latex, 55 $^1/_2$ × 24 $^3/_4$ × 13 in.; *Proposal for a Sculpture in the Form of a Needle, Thread, and Knot, for Piazzale Cadorna, Milan,* 1999, pencil and colored pencil, 30 × 40 in.; *Valentine Perfume 1/2,* 1999, cast aluminum painted with acrylic polyurethane, 46 $^1/_2$ × 25 × 20 in.

—— CLAES OLDENBURG AND COOSJE VAN BRUGGEN: FLYING PINS: A NEW STATUE FOR EINDHOVEN, Van Abbemuseum, Eindhoven, the Netherlands, May 27 – September 3.

Works exhibited: *Sketchbook Page: Flying Pins in the Intersection of the John F. Kennedylaan, Fellenoord, and Prof. Dr. Dorgelolaan, Eindhoven,* 1998, pencil, colored pencil, watercolor, 5 $^1/_2$ × 8 $^1/_4$ in.; *Sketchbook Page: Flying Pins, Game of Life,* 1998, pencil and watercolor, 5 $^1/_2$ × 8 $^1/_4$ in.; *Sketchbook Page: Flying Pins, Pears and Peaches Pile Up,* 1998, pencil, 5 $^1/_2$ × 8 $^1/_4$ in.; *Sketchbook Page: Study of the Flying Pins,* 1998, pencil and watercolor, 5 $^1/_2$ × 8 $^1/_4$ in.; *Sketchbook Study of the Flying Pins, Corner Site,* 1998, pencil, 5 $^1/_2$ × 8 $^1/_4$ in.; *Flying Pins, Paper Studies for Fabrication Model,* 1999, paper cardboard, foamcore, T-pins, pencil, 7 pins, 4 $^7/_8$ × 3 $^5/_8$ × 2 $^3/_8$ in., 3 $^7/_8$ × 2 $^7/_8$ × 2 $^1/_4$ in., 7 $^1/_8$ × 5 $^1/_2$ × 5 $^5/_8$ in., 6 $^1/_8$ × 2 $^7/_8$ × 3 $^1/_8$ in., 7 $^7/_8$ × 6 $^3/_4$ × 5 $^7/_8$ in., 5 $^7/_8$ × 3 $^3/_4$ × 3 $^1/_2$ in., 5 $^1/_8$ × 3 $^3/_4$ × 4 $^1/_8$ in., ball, 3 in. high × 5 $^3/_4$ in. diameter; *Flying Pins, Presentation Model,* 1999, wood, cardboard, expanded polystyrene, polyurethane foam, coated with resin and painted with latex, 12 × 23 $^1/_2$ × 47 in.; *Flying Pins, Fabrication Model,* 2000, polyurethane foam on wood base painted with latex, 9 $^1/_2$ × 36 × 21 in.

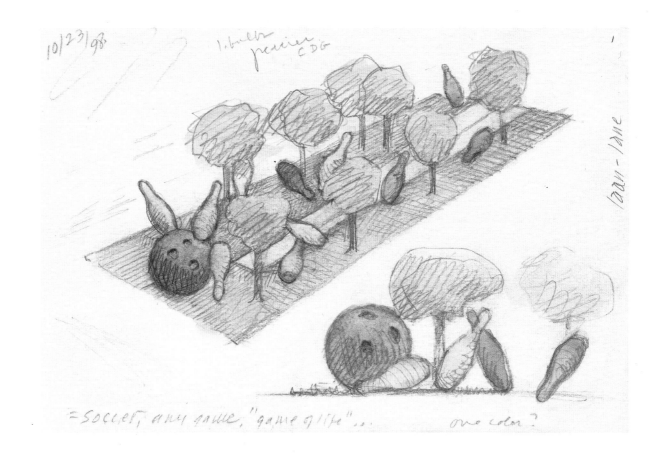

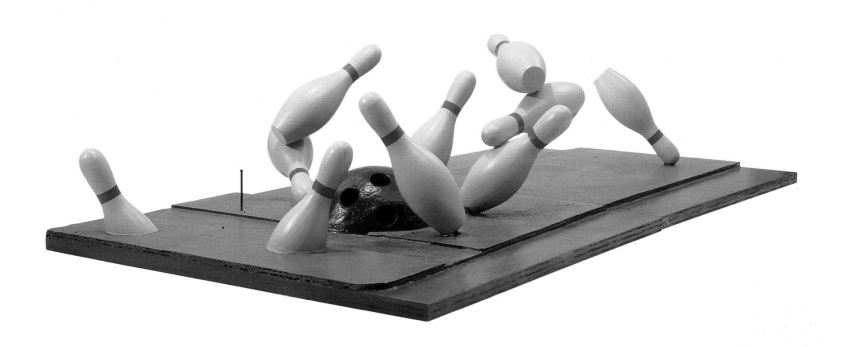

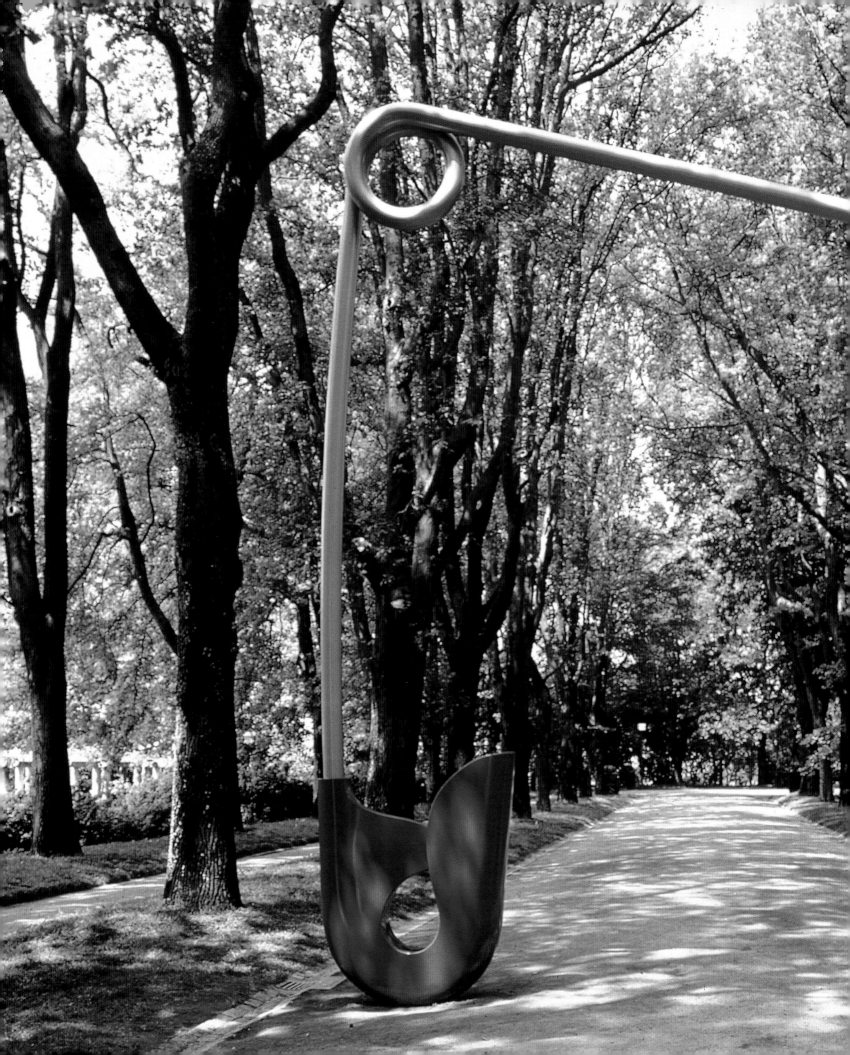

Pelo Passeio dos Liquidâmbares: Escultura no Parque/Down Liquidambar Lane: Sculpture in the Park, Museu de Arte Contemporânea de Serralves, Porto, May 18 – October 14, 2001. Work shown is **Corridor Pin, Blue** 3/3, 1999, The Sydney and Walda Besthoff Sculpture Garden, New Orleans Museum of Art, New Orleans, Museum Purchase, Sydney and Walda Besthoff Foundation

2001

—— *Pelo Passeio dos Liquidâmbares: Escultura no Parque/Down Liquidambar Lane: Sculpture in the Park*, Museu de Arte Contemporânea de Serralves, Porto, May 18 – October 14. Curated by Vicente Todoli. Catalogue.

Works exhibited: *Alcatraz Island Reconstructed as a Landscape in the Form of an Upturned Foot – (Planned Monument to the American Indian) – View of the Entrance*, 1971, pencil and colored pencil, $11\,^3/_8 \times 14\,^{11}/_{16}$ in.; *Arch to Span the Suez Canal – Ears of the Sphinx*, 1971, pencil and colored pencil, $14\,^7/_{16} \times 11$ in.; *Cemetery in the Shape of a Colossal Screw: Skyscraper for São Paulo, Brazil*, 1971, pencil and colored pencil, $14\,^1/_2 \times 11\,^1/_2$ in.; *Colossal Sculpture in the Form of a Bear on the Flag of California – Shown in the Final Stages of Excavation*, 1971, pencil and colored pencil, $15\,^1/_{16} \times 12\,^1/_4$ in.; *Memorial to the 1941 Attack on Pearl Harbor, Hawaii – Water Park with "Foliage" in the Form of Explosions*, 1971, pencil and colored pencil, $11\,^9/_{16} \times 14\,^1/_2$ in.; *Tower in the Form of a Colossal Thumb, "Czar's Thumb," on the Moscow Road*, 1971, pencil and colored pencil, $14\,^9/_{16} \times 11\,^9/_{16}$ in.; *Bridge Over the Rhine at Düsseldorf in the Shape of a Colossal Saw*, 1971, crayon, pencil, watercolor, $11 \times 14\,^1/_2$ in.; *Preliminary Study for the Crusoe Umbrella*, 1978, coated wire, $11 \times 8\,^3/_4 \times 9\,^7/_8$ in.; *Fabrication Model for the Crusoe Umbrella*, 1979, aluminum painted with polyurethane enamel, $23\,^3/_8 \times 42\,^1/_8 \times 27\,^3/_4$ in.; *Preliminary Model for the Crusoe Umbrella*, 1979, pine branches, rope, wood, $22 \times 33\,^1/_4 \times 23$ in.; *Crusoe Umbrella*, 1979, aquatint and sugar-lift, etching, $20\,^1/_4 \times 24$ in.; *Postcard of the Spoon in Ile St. Louis with Needles*, 1979, soft-ground and hard-ground etching, sugar-lift and spit bite, $26\,^1/_4 \times 21$ in.; *Screwarch Bridge (State III)*, 1981, hard-ground etching, aquatint, sugar-lift, spit bite, monoprint, $31\,^1/_4 \times 57\,^3/_4$ in.; *Notebook Page: Spoon as a Bridge, for Vail, Colorado*, 1982, pencil, $11 \times 8\,^1/_2$ in.; *Study for Rotten Apple Core*, 1987, canvas coated with resin and painted with latex, $24 \times 12 \times 12$ in.; *Study for the Bottle of Notes*, 1987, pencil and colored pencil, $30 \times 25\,^1/_2$ in.; *Notebook Page: "NAIVE, Alps,"* 1988, pencil, colored pencil, ballpoint pen, $11 \times 8\,^1/_2$ in.; *Notebook Page: Colossal Sign for the Alps: EVIAN, Reversed*, 1988, pencil and watercolor, $11 \times 8\,^1/_2$ in.; *Notebook Page:*

SKETCHBOOK PAGE:
BLUEBERRY PIE
TRANSFORMATIONS FOR
J. V. – CHAIR, À LA MODE,
1996

SKETCHBOOK PAGE:
BLUEBERRY PIE
TRANSFORMATIONS FOR
J. V. – ON END, À LA MODE,
1996

FOLLOWING PAGE:
SKETCHBOOK PAGE:
SCULPTURE FOR THE PARK
(WITH J. V.) – LEANING
CLARINET, 1996

NOTEBOOK PAGE:
SLINGSHOT VALENTINE, 1992

Civic Sculpture in the Form of a Canapé of Pretzels and Cheese, 1989, pencil, ballpoint pen, felt pen, watercolor, 11 × 8 $\frac{1}{2}$ in.; *Notebook Page: Golf Club Related to Landscape,* 1989, pencil, ballpoint pen, watercolor, 11 × 8 $\frac{1}{2}$ in.; *Notebook Page: Studies for a Print Commemorating the French Revolution,* 1989, ballpoint pen, felt pen, pencil, watercolor, 11 × 8 $\frac{1}{2}$ in.; *Notebook Page: Studies of Broom Shapes,* 1989, pencil, felt pen, watercolor, 11 × 8 $\frac{1}{2}$ in.; *Notebook Page: Study for the Golf Bag Lookout with Swan,* 1989, pencil, felt pen, ballpoint pen, 11 × 8 $\frac{1}{2}$ in.; *Thoughts about the French Revolution while Eating a Shrimp Salad,* 1989, soft-ground etching and aquatint, 30 × 22 $\frac{3}{8}$ in.; *Apple Core – Autumn,* 1990, lithograph, 41 × 31 $\frac{1}{4}$ in.; *Apple Core – Spring,* 1990, lithograph, 40 × 30 in.; *Notebook Page: Street Sculpture in the Form of a Broom, "sweepings,"* 1990, pencil, felt pen, crayon, watercolor, 11 × 8 $\frac{1}{2}$ in.; *Notebook Page: Street Sculpture in the Form of a Scoop, "rainy nite,"* 1990, pencil, felt pen, watercolor, 11 × 8 $\frac{1}{2}$ in.; *Sculpture in the Form of a Stamp Blotter, Rearing, on a Fragment of Desk Pad,* 1990, expanded polystyrene, steel, wood, cardboard, coated with resin and painted with latex, 6 ft. 8 $\frac{11}{16}$ in. × 12 ft. 7 $\frac{1}{2}$ in. × 10 ft. 9 $\frac{15}{16}$ in.; *Shattered Desk Pad, with Stamp Blotters,* 1990, expanded polystyrene, wood, cardboard, coated with resin and painted with latex, 1 ft. 1 in. × 6 ft. × 4 ft.; *Stamp Blotter on a Fragment of Desk Pad (Study for Rolling Blotter),* 1990, charcoal and watercolor, 38 $\frac{1}{8}$ × 50 in.; *Stamp Blotters on Shattered Desk Pad,* 1990, charcoal, pencil, pastel, 38 $\frac{3}{16}$ × 50 $\frac{1}{8}$ in.; *Apple Core – Summer,* 1990, lithograph, 41 × 31 $\frac{1}{4}$ in.; *Apple Core – Winter,* 1990, lithograph, 40 × 30 in.; *Geometric Apple Core, Study,* 1991, canvas and wood, painted with latex, 9 $\frac{1}{2}$ × 12 × 8 in.; *Notebook Page: Apple*

on Fork, "= C.U.," 1991, pencil and watercolor, 11 × 8 $\frac{1}{2}$ in.; *Notebook Page: Garden Sculpture in the Form of a Madeleine Dipped in Tea,* 1991, pencil and watercolor, 11 × 8 $\frac{1}{2}$ in.; *Notebook Page: Perfume Bottle – "breath," "heart," "lungs," Barcelona,* 1991, pencil and watercolor, 11 × 8 $\frac{1}{2}$ in.; *Notebook Page: Perfume Bottle, Blue, from Rear,* 1991, pencil and watercolor, 11 × 8 $\frac{1}{2}$ in.; *Study for a Sculpture in the Form of a Perfume Bottle,* 1991, pencil, felt pen, watercolor, 4 × 6 in.; *Apple Core,* 1991, lithograph, 31 × 22 $\frac{3}{4}$ in.; *Capsized Leaf Boat,* 1992, pencil and pastel, 40 × 30 in.; *Leaf Boat Study, Storm in the Studio I,* 1992, pencil and pastel, 40 × 30 in.; *Leaf Boat Study, Storm in the Studio II,* 1992, pencil, 30 $\frac{1}{4}$ × 40 in.; *Leaf Boat with Floating Cargo,* 1992, leaf boat: canvas, steel, aluminum, cardboard, floating cargo: canvas, polyurethane foam, expanded polystyrene, cardboard, coated with resin and painted with latex, sail: 6 ft. 8 in. × 2 ft. 5 in. × 7 ft. 6 $\frac{3}{4}$ in., boat: 5 $\frac{3}{8}$ in. × 4 ft. 1 in. × 6 ft. 4 2 in., apple core: 1 ft. $\frac{3}{4}$ in. × 2 ft. 4 $\frac{3}{4}$ in. × 5 ft. 5 in., ice cream stick: 4 $\frac{1}{4}$ in. × 11 in. × 4 ft. 2 in., peanut: 8 $\frac{1}{4}$ in. × 1 ft. 32 in. × 2 ft. 11 $\frac{3}{4}$ in., potato chip: 5 $\frac{3}{4}$ × 2 ft. 11 in. diameter; *Leaf Boat with Floating Cargo, Model,* 1992, canvas, wood, wire, cardboard, apple core, ice cream stick, peanut shell, potato chip, cork, coated with resin and painted with latex, 11 $\frac{3}{4}$ × 11 × 11 $\frac{3}{4}$ in.; *Leaf Boat, Capsized,* 1992, pencil and watercolor, 2 sheets: each 8 $\frac{1}{2}$ × 5 $\frac{3}{8}$ in.; *Notebook Page: Column Dressed as a Bottle of Perfume, Place Vendôme, Paris,* 1992, pencil and watercolor, 11 × 8 $\frac{1}{2}$ in.; *Notebook Page: Design for a Perfume Bottle, "M-Prix,"* 1992, pencil, colored pencil, watercolor, 11 × 8 $\frac{1}{2}$ in.; *Notebook Page: Dried Apple Core,* 1992, pencil, crayon, watercolor, 11 × 8 $\frac{1}{2}$ in.; *Notebook Page: Perfume Bottle as Landscape and Architecture,* 1992, pencil

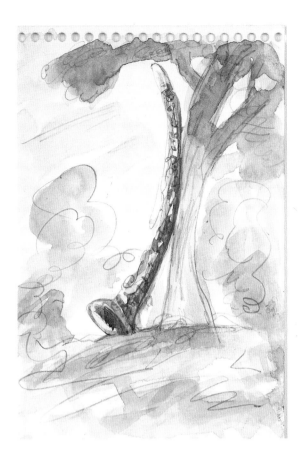

and watercolor, 11 × 8 $^1/_2$ in.; *Notebook Page: Perfume Bottle with Yellow Spray, Falling*, 1992, pencil and watercolor, 11 × 8 $^1/_2$ in.; *Notebook Page: Poppies, July 22*, 1992, pencil and watercolor, 11 × 8 $^1/_2$ in.; *Notebook Page: Reflections on a Scoop Shape*, 1992, felt pen and wash, 11 × 8 $^1/_2$ in.; *Notebook Page: Slingshot Valentine*, 1992, colored pencil, ballpoint pen, watercolor, 11 × 8 $^1/_2$ in.; *Notebook Page: Three Designs for a Perfume Bottle, "Monoprix,"* 1992, pencil and watercolor, 11 × 8 $^1/_2$ in.; *Perfume Bottle, Blue*, 1992, muslin, wood, clothesline, Dacron, coated with resin and painted with latex, on aluminum base, 12 $^1/_2$ × 9 $^1/_4$ × 34 $^3/_4$ in., on base: $^1/_2$ × 8 × 30 in.; *Proposed Monument for Mill Rock, East River, New York: Slice of Strawberry Cheesecake*, 1992, soft-ground etching and aquatint, 25 × 29 $^1/_2$ in.; *Notebook Page: Perfume Bottle on a Pillow*, 1993, pencil and watercolor, 11 × 8 $^1/_2$ in.; *Golf Bag Typhoon – First Study "Ikebana,"* 1994, pencil and crayon, 40 × 30 $^1/_4$ in.; *Notebook Page: Saw Typhoon*, 1994, crayon, pencil, watercolor, 11 × 8 $^1/_2$ in.; *Notebook Page: Soft Shuttlecock Studies*, 1994, pencil and watercolor, 11 × 8 $^1/_2$ in.; *Notebook Page: Soft Shuttlecock, in Flight*, 1994, pencil and watercolor, 11 × 8 $^1/_2$ in.; *Notebook Page: Soft Shuttlecocks, Lying*, 1994, pencil and colored pencil, 11 × 8 $^9/_{16}$ in.; *Soft Shuttlecock, Study*, 1994, canvas and wood painted with latex, 13 × 80 in. diameter, variable dimensions; *Golf Typhoon, First Study*, 1995, cardboard, felt, sand, polyurethane foam, wood, coated with resin and painted with latex, 19 $^3/_4$ × 6 × 6 in.; *Proposal for a Pedestrian Bridge in the Form of Two Hammers*, 1995, pencil and colored pencil, 30 × 40 in.; *Study for a Multiple: Apple Core*, 1995, expanded polystyrene, wood, canvas, painted with latex, 10 $^3/_4$ × 6 $^1/_2$ × 9 in.; *Study for a Multiple: Apple Core Slice*, 1995, expanded polystyrene, wood, paper, metal, clothesline, painted with latex, 23 $^1/_2$ × 19 × 7 $^1/_8$ in.; *Study for a Multiple: Metamorphic Apple Core*, 1995, expanded polystyrene, cardboard, wood, painted with latex, 13 $^1/_2$ × 10 $^3/_4$ × 2 $^3/_4$ in.; *Blueberry Pie à la Mode, Flying, Scale A 2/2*, 1996, cast aluminum painted with polyurethane enamel, 29 × 20 × 50 in; *Notebook Page: Apple Core Carved in a Tree*, 1996, pencil and watercolor, 10 $^7/_8$ × 8 $^3/_8$ in.; *Notebook Page: Apple Gazebo*, 1996, pencil and watercolor, 10 $^7/_8$ × 8 $^1/_2$ in.; *Notebook Page: Bridge in the Form of Two Hammers, "Bilbao,"* 1996, pencil, felt pen, watercolor, 10 $^{15}/_{16}$ × 8 $^1/_2$ in.; *Notebook Page: Gazebos in the Form of a Blueberry Pie à la Mode and a Poppy*, 1996, pencil, colored pencil, watercolor, 11 × 8 $^1/_2$ in.; *Notebook Page: Giant Asparagus in Landscape*, 1996, pencil and watercolor, 11 × 8 $^1/_2$ in.; *Notebook Page: Sandwich Cabaña*, 1996, pencil and watercolor, 11 × 8 $^1/_2$ in.; *Sketchbook Page: Blueberry Pie Transformations for J. V. – Blueberry Pie Island*, 1996, pencil and watercolor, 3 $^{15}/_{16}$ × 5 $^7/_8$ in.; *Sketchbook Page: Blueberry Pie Transformations for J. V. – Castaway à la Mode*, 1996, pencil and watercolor, 3 $^{15}/_{16}$ × 5 $^7/_8$ in.; *Sketchbook Page: Blueberry Pie Transformations for J. V. – Cliff House, à la Mode*, 1996, pencil and watercolor, 5 $^7/_8$ × 3 $^{15}/_{16}$ in.; *Sketchbook Page: Blueberry Pie Transformations for J. V. – Dropped, à la Mode*, 1996, pencil and watercolor, 3 $^{15}/_{16}$ × 5 $^7/_8$ in.; *Sketchbook Page: Blueberry Pie Transformations for J. V. – On End, à la Mode*, 1996, pencil and watercolor, 5 $^7/_8$ × 3 $^{15}/_{16}$ in.; *Sketchbook Page: Blueberry Pie Transformations for J. V. – Sliding, à la Mode*, 1996, pencil and watercolor, 5 $^7/_8$ × 3 $^{15}/_{16}$ in.; *Sketchbook Page: Blueberry Pie Transformations for J. V. – Chair, à la Mode*, 1996, pencil and watercolor, 5 $^7/_8$ × 3 $^{15}/_{16}$ in.; *Sketchbook*

Page: Blueberry Pie Transformations for J. V. – Folded, à la Mode, 1996, pencil and watercolor, 3 $^{15}/_{16}$ × 5 $^{7}/_{8}$ in.; Sketchbook Page: Blueberry Pie Transformations for J. V. – Terrace House, à la Mode, 1996, pencil and watercolor, 3 $^{15}/_{16}$ × 5 $^{7}/_{8}$ in.; Sketchbook Page: Blueberry Pie Transformations for J. V. – Tumbling, à la Mode, 1996, pencil and watercolor, 5 $^{7}/_{8}$ × 3 $^{15}/_{16}$ in.; Sketchbook Page: Figure Seated in the Woods (Wood Nymph), 1996, pencil, 5 $^{7}/_{8}$ × 3 $^{15}/_{16}$ in.; Sketchbook Page: Golf Bag Folly, 1996, pencil and watercolor, 5 $^{7}/_{8}$ × 3 $^{15}/_{16}$ in.; Sketchbook Page: Golf Bag Folly, in Brick, 1996, pencil, colored pencil, watercolor, 5 $^{7}/_{8}$ × 3 $^{15}/_{16}$ in.; Sketchbook Page: Old Man, 1996, pencil and watercolor, 5 $^{7}/_{8}$ × 3 $^{15}/_{16}$ in.; Sketchbook Page: Sculpture for the Park (with J. V.) – Body Section in the Tree, 1996, pencil and watercolor, 5 $^{7}/_{8}$ × 3 $^{15}/_{16}$ in.; Sketchbook Page: Sculpture for the Park (with J. V.) – Cheese in the Woods, 1996, pencil and watercolor, 5 $^{7}/_{8}$ × 3 $^{15}/_{16}$ in.; Sketchbook Page: Sculpture for the Park (with J. V.) – Leaning Clarinet, 1996, pencil and watercolor, 5 $^{7}/_{8}$ × 3 $^{15}/_{16}$ in.; Sketchbook Page: Sculpture for the Park (with J. V.) – Madeleine, 1996, pencil and watercolor, 5 $^{7}/_{8}$ × 3 $^{15}/_{16}$ in.; Sketchbook Page: Sculpture for the Park (with J. V.) – Paintbrush Trees, 1996, pencil and watercolor, 5 $^{7}/_{8}$ × 3 $^{15}/_{16}$ in.; Sketchbook Page: Sculpture for the Park (with J. V.) – Poppy Gazebo, 1996, pencil and watercolor, 3 $^{15}/_{16}$ × 5 $^{7}/_{8}$ in.; Sketchbook Page: Sculpture for the Park (with J. V.) – Torso in Tree, 1996, pencil and watercolor, 5 $^{7}/_{8}$ × 3 $^{15}/_{16}$ in.; Notebook Page: Opposing Hammers, 1996, pencil and watercolor, 8 $^{1}/_{2}$ × 4 $^{15}/_{16}$ in.; Architect's Handkerchief, 1996, screenprint, 31 $^{1}/_{4}$ × 23 $^{1}/_{2}$ in.; Feasible Monument in the Form of Two Banana Peels, for Stockholm Harbor, 1997, pencil and pastel, 30 $^{3}/_{16}$ × 40 in.; Proposal for a Sculpture in the Form of a Faucet and Shower Hose, for Stockholm Harbor, 1997, pencil and pastel, 30 × 40 in.; Proposed Sculpture in the Form of Asparagus, for the Fireplace of Pavilion Four, 1997, pencil, colored pencil, pastel, 40 $^{1}/_{8}$ × 30 $^{1}/_{4}$ in.; Sketchbook Page: Study of Vegetable Ark, with Rudder of Carrot and Beet Slice, 1997, pencil and watercolor, 5 $^{1}/_{4}$ × 8 $^{1}/_{4}$ in.; Sketchbook Page: Vegetable Ark, for Jerusalem, 1997, pencil and watercolor, 5 $^{5}/_{16}$ × 8 $^{1}/_{4}$ in.; Study for Valentine Perfume, 1997, pencil, colored pencil, chalk, watercolor, 23 × 18 in.; Study for a Sculpture in the Form of a Perfume Bottle and Atomizer, 1997, expanded polystyrene and wire painted with latex, 8 $^{1}/_{4}$ × 8 × 5 in.; Valentine Perfume, 1997, stainless steel, cast aluminum, aluminum pipe, painted with acrylic polyurethane, 21 ft. × 4 ft. 9 in. × 9 ft. 4 in.; Valentine Perfume, Model, 1997, expanded polystyrene, wood, wire, painted with latex 14 × 10 × 7 in.; Elevation of Shuttlecock/Blueberry Pies, on Stairs, 1997, pencil and colored pencil, 30 × 40 in.; Proposal for a Sculpture in the Form of a Pan and Broom, 1997, pencil and pastel, 30 × 40 in.; Sphinx Fragments on a Playing Field, 1997, pencil and pastel, 30 × 40 in.; Vegetable Ark, 1997, pencil and pastel, 30 $^{3}/_{16}$ × 40 in.; Blueberry Pie, Flying, Scale B 1/3, 1998, cast aluminum and steel painted with latex, 33 × 25 $^{1}/_{2}$ × 18 in., on base $^{3}/_{4}$ × 14 × 14 in.; Blueberry Pie, Flying, Scale C I-IV 2/3, 1998, cast aluminum painted with acrylic polyurethane, 6 sculptures, each approx. 15 $^{1}/_{2}$ × 4 × 4 in.; Caught and Set Free Sited in Stockholm, Sweden, 1998, pencil, pastel, colored pencil, 30 × 40 in.; Proposed Sculpture for the Harbor of Stockholm, Sweden, Caught and Set Free, Model, 1998, steel, aluminum, wood, plaster, sand, painted with acrylic polyurethane and latex, 23 × 39 $^{3}/_{4}$ × 30 in.; Sketchbook Page: Apple Aflame, in Boat (after J. V. and E. D.), 1998, pencil and watercolor, 5 $^{5}/_{16}$ × 8 $^{1}/_{4}$ in.; Sketchbook Page: Flying Pins in the Intersection of the John F. Kennedylaan, Fellenoord, and Prof. Dr. Dorgelolaan, Eindhoven, 1998, pencil, colored pencil, watercolor, 5 $^{1}/_{2}$ × 8 $^{1}/_{4}$ in.; Sketchbook Page: Flying Pins, Game of Life, 1998, pencil and watercolor, 5 $^{1}/_{2}$ × 8 $^{1}/_{4}$ in.; Sketchbook Page: Flying Pins, Pears and Peaches Pile Up, 1998, pencil, 5 $^{1}/_{2}$ × 8 $^{1}/_{4}$ in.; Sketchbook Page: Study of the Flying Pins, 1998, pencil and watercolor, 5 $^{1}/_{2}$ × 8 $^{1}/_{4}$ in.; Sketchbook Study of the Flying Pins, Corner Site, 1998, pencil, 5 $^{1}/_{2}$ × 8 $^{1}/_{4}$ in.; Gazebo in the Form of a Dropped Flower, with Figure for Scale, 1998, canvas, tape, string, wire, wood, metal, polystyrene foam, coated with resin and painted with latex, 12 $^{1}/_{4}$ × 29 $^{1}/_{4}$ × 21 in.; Study for Vegetable Ark, 1998, polystyrene foam, burlap, wood, painted with latex, 15 × 18 × 16 in.; Pyramid of Pears and Peaches, Final Version, 1998, charcoal and pastel, 38 × 50 in.; Study for a Sculpture in the Form of a Broom and Pan with Sweepings, 1998, pencil and colored pencil, 30 × 40 in.; Architect's Handkerchief 1/3, 1999, fiber-reinforced plastic painted with polyester gelcoat and polyurethane clear coat, 12 ft. 5 in. × 12 ft. 3 in. × 7 ft. 5 in.; Canapé Gazebo 1/4, 1999, cast aluminum painted with latex, 55 $^{1}/_{2}$ × 24 $^{3}/_{4}$ × 13 in.; Corridor Pin, Blue 3/3, 1999, stainless steel and aluminum painted with polyurethane enamel, 21 ft 3 in. × 21 ft. 2 in. × 1 ft. 4 in.; Corridor Pin, Red 2/3, 1999, stainless steel and aluminum painted with polyurethane enamel, 21 ft. 3 in. × 21 ft. 2 in. × 1 ft. 4 in.; Dream Pin, Clasp, 1999, steel and fiber-reinforced plastic painted with polyurethane enamel, on steel plate, 9 ft. $^{11}/_{16}$ in. × 7 ft. 11 in. × 1 ft. $^{5}/_{16}$ in.; Flying Pins, Presentation Model, 1999, wood, cardboard, expanded polystyrene, polyurethane foam, coated with resin and painted with latex, 10 $^{1}/_{2}$ × 47 × 23 $^{1}/_{2}$ in.; Golf Bag Ruin, 1999, pencil and pastel, 35 × 49 $^{1}/_{4}$ in.; Shuttlecock/Blueberry Pies, I and II, 1999, cast aluminum painted with acrylic polyurethane, 48 × 24 × 24 in. each; Shuttlecock/Sphinx in Autumn, 1999, pencil, pastel, charcoal, 38 $^{1}/_{8}$ × 50 in.; Study for Plantoir – Back View, 1999, pencil, 40 $^{1}/_{8}$ × 30 in.; Study for Plantoir – Front View, 1999, pencil, charcoal, pas-

Pelo Passeio dos
Liquidâmbares:
Escultura no
Parque/Down
Liquidambar Lane:
Sculpture in the Park,
Museu de Arte
Contemporânea de
Serralves, Porto, May 18 –
October 14, 2001. Work
shown is *Plantoir* 2/3,
2001
Fundaçao Serralves,
Porto

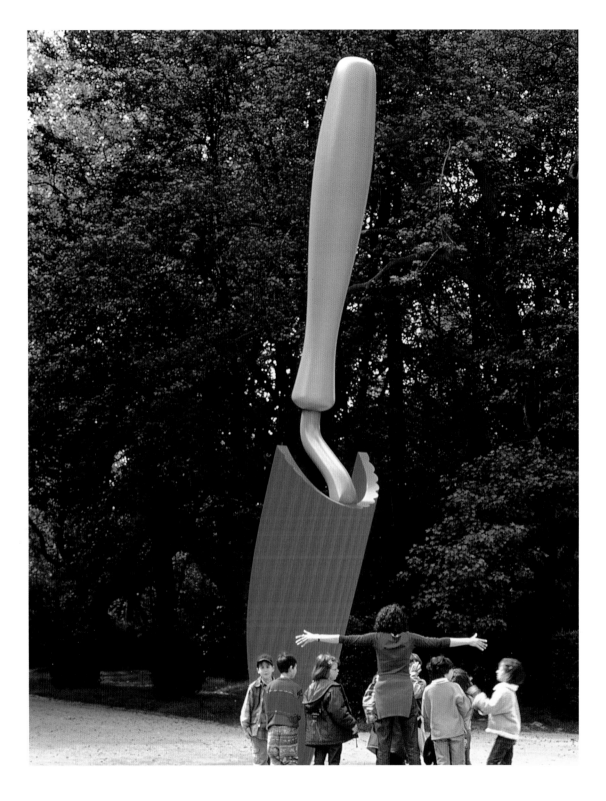

tel, 30 $^1/_4$ × 22 $^1/_4$ in.; *Study for Plantoir, Jardin des Tuileries, Paris*, 1999, pencil, colored pencil, watercolor, 12 × 9 $^3/_4$ in.; *Valentine Perfume* 1/2, 1999, cast aluminum painted with acrilyc polyurethane, 46 $^1/_2$ × 25 × 20 in.; *Maquette for Plantoir 2/2*, 2000, aluminum and cast epoxy painted with polyurethane enamel, 25 $^3/_4$ × 12 × 12 in.; *Plantoir – Elevations*, 2000, pencil and colored pencil, 40 × 30 in.; *Proposal for a Monument to Honoré de Balzac in the Form of a Pyramid of Pears and Peaches, Place Jean Jaurès,* *Tours, France*, 2000, pencil, colored pencil, pastel, charcoal, postcard, 30 $^1/_{16}$ × 40 in.; *Leaf Boat, Sited in the Tuileries, Paris*, 2001, charcoal and pastel, 26 $^1/_{16}$ × 49 $^9/_{16}$ in.; *Plantoir* 2/3, 2001, stainless steel, aluminum, fiber-reinforced plastic; painted with polyurethane enamel, 23 ft. 11 in. × 4 ft. 5 in. × 4 ft. 9 in.; *Scattered Pyramid of Pears and Peaches – Balzac/Pétanque, Model*, 2001, polyurethane foam, hardware cloth, canvas, coated with resin and painted with latex, variable height on area 53 $^1/_2$ × 89 in.

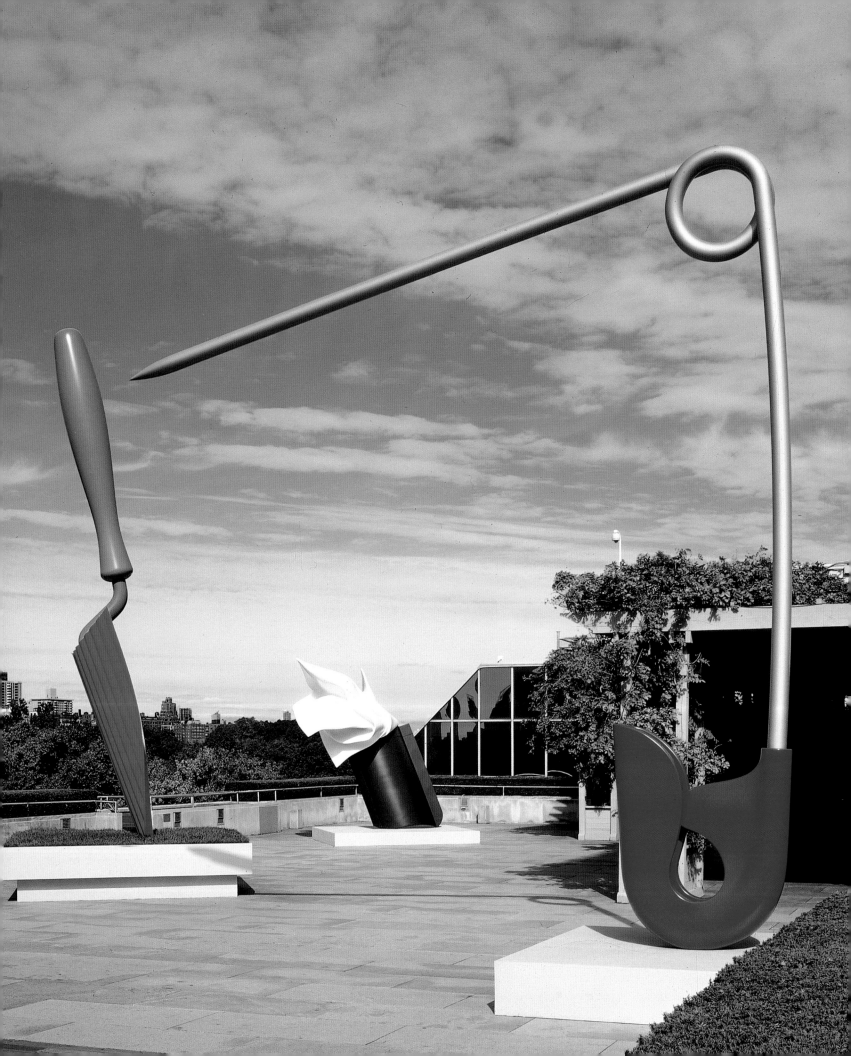

PREVIOUS PAGE:
OLDENBURG AND VAN BRUGGEN ON THE ROOF, THE IRIS AND B. GERALD CANTOR ROOF GARDEN, THE METROPOLITAN MUSEUM OF ART, NEW YORK, MAY 1 – NOVEMBER 3, 2002. WORKS SHOWN ARE *PLANTOIR* 3/3, 2001, COLLECTION MEREDITH CORPORATION, DES MOINES IOWA; *ARCHITECT'S HANDKERCHIEF* 1/3, 1999, COLLECTION SHINSEGAE CO. LTD., SHINSEGAE SCULPTURE GARDEN, SEOUL, SOUTH KOREA; *CORRIDOR PIN, BLUE* 3/3, 1999, THE SYDNEY AND WALDA BESTHOFF SCULPTURE GARDEN, NEW ORLEANS MUSEUM OF ART, NEW ORLEANS, MUSEUM PURCHASE, SYDNEY AND WALDA BESTHOFF FOUNDATION

PROPOSAL FOR A LIGHTHOUSE IN THE FORM OF A BANANA PEEL, FOR THE COAST OF NEW ZEALAND, 2001 COLLECTION MARIA AND CONRAD JANIS, LOS ANGELES

2002

—— OLDENBURG AND VAN BRUGGEN ON THE ROOF, The Metropolitan Museum of Art, New York, May 1 – November 3. Pamphlet. Works exhibited: *Architect's Handkerchief* 1/3, 1999, steel and fiber-reinforced plastic painted with polyester gelcoat and polyurethane clear coat, 12 ft. 5 in. × 12 ft. 3 in. × 7 ft. 5 in.; *Corridor Pin, Blue* 3/3, 1999, stainless steel and aluminum painted with polyurethane enamel, 21 ft. 3 in. × 21 ft. 2 in. × 1 ft. 4 in.; *Shuttlecock/Blueberry Pies,* I and II, 1999, cast aluminum painted with acrylic polyurethane, 48 × 24 × 24 in. each; *Plantoir* 3/3, 2001, stainless steel, aluminum, fiber-reinforced plastic, painted with polyurethane enamel, 23 ft. 11 in. × 4 ft. 5 in. × 4 ft. 9 in.

—— CLAES OLDENBURG AND COOSJE VAN BRUGGEN: RECENT WORK, PaceWildenstein, New York, May 2 – June 28. Catalogue. Works exhibited: *Feasible Monument in the Form of Two Banana Peels, for Stockholm Harbor,* 1997, pencil and pastel, 30 $^3/_{16}$ × 40 in.; *Floating Peel, Model,* 1998, felt, expanded polystyrene, coated with resin and painted with latex, cardboard, T-pins, 25 × 16 $^1/_8$ × 16 in.; *Pyramid of Pears and Peaches, Final Version,* 1998, charcoal and pastel, 38 × 50 in.; *Proposal for a Monument to Honoré de Balzac in the Form of a Pyramid of Pears and Peaches, Place Jean Jaurès, Tours, France,* 2000, charcoal, pencil, colored pencil, pastel, postcard, 30 × 39 $^3/_4$ in.; *Resonances, after J. V.,* 2000, canvas, polyurethane foam, cardboard, coated with resin and painted with latex, wood, paper, hardware, "envelope" and "tiles": crayon, pencil, watercolor, overall dimensions: 58 $^7/_{16}$ × 55 $^3/_{16}$ × 16 $^1/_8$ in.; *Book Cover: Composition of Peaches and Pears,* 2001, pastel, charcoal, pencil, tape, collage, 37 $^3/_8$ × 48 $^1/_4$ in.; *Proposal for a Lighthouse in the Form of a Banana Peel, for the Coast of New Zealand,* 2001, charcoal and pastel, 28 $^{13}/_{16}$ × 22 $^1/_2$ in.; *Soft Viola Island,* 2001, charcoal and pastel, 34 × 46 $^1/_2$ in.; *Balzac/Pétanque,* 2002, fiber-reinforced plastic and cast epoxy painted with polyester gelcoat, stainless steel, 8 $^1/_2$ × 25 × 37 ft.; *Floating Peel* 1/3, 2002, fiber-reinforced plastic painted with polyester gelcoat, 13 ft. 9 in. × 8 ft. 6 in. × 19 in.; *Flung Peels,* 2002, aluminum painted with acrylic polyurethane, 37 × 23 $^3/_4$ × 45 in.; *Soft Viola* 1/2, 2002, canvas, wood, polyurethane foam, coated with resin and painted with latex, clothesline, hardware, 8 ft. 8 in. × 5 ft. × 1 ft. 10 in.

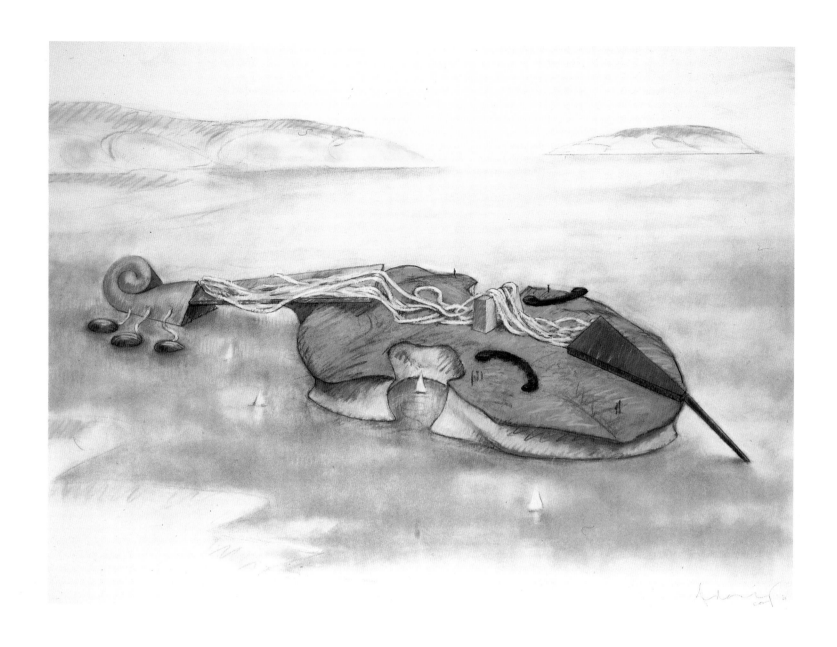

Soft Viola Island, 2001
Whitney Museum of
American Art, New York,
Gift of Robert J. Hurst
and The American
Contemporary Art
Foundation

IF MUSIC BE THE FOOD OF LOVE, PLAY ON... NEW SCULPTURE BY CLAES OLDENBURG AND COOSJE VAN BRUGGEN

Richard Morphet

INTRODUCTION

The first and last works in this exhibition transport us in imagination to the seventeenth and the nineteenth centuries, even as they also convey freshness and urgency of experience in the twenty-first, in which they were made. Moving from one to the other of these sculptures, the viewer progresses not only through time but also from private to public, from indoors to out, and from the intimate to the monumental.

The exhibition's central theme is the pull exerted by the senses. By subjecting motifs to processes of deconstruction, concentration, and fabrication, and by choices of texture and color, the artists not only evoke all five senses strongly but also heighten our awareness of them. The works' focus on deceptively familiar objects also prompts reflection on desire and its pursuit. The artists interrelate the elements of each work so as to identify a key moment of change, a moment of liberation from the constraints of the known or the preordained. By adjusting the scale of some objects and by introducing elements of disruption, they open their motifs to greater complexity of reference and meaning. They uncover the link between object, emotion, and memory.

Oldenburg and van Bruggen are American citizens who divide their time between the United States and France. The works in this exhibition were made in both countries and draw upon the culture of each, as well as reflecting aspects of the cultures of the artists' countries of origin (respectively, Sweden and the Netherlands). Their art, created jointly for a quarter of a century, is also a fusion of their individual personalities. More often than not, a work comes into existence when an idea conceived by van Bruggen as an image is recorded by Oldenburg in a notebook sketch. From this starting point, concept and image develop in tandem, through stages propelled by a dialogue to which the artists contribute equally. Each introduces surprises into the transaction, and as the work evolves it becomes impossible to define them simply as conceiver (van Bruggen) and maker (Oldenburg), for their roles interchange unpredictably. The two artists' inputs become so integrated that in many finished works it is almost as if, whatever a sculpture may depict, an important part of the subject is their partnership.

CONSUMMATION AND MEMORY

Coosje van Bruggen, who was trained as an art historian at the University of Groningen, has long had a special interest in seventeenth-century Dutch painting. Of particular interest to her is the work of Johannes Vermeer, whose peopled interiors communicate a sense that more is going on than we are shown. For van Bruggen these interiors are alive with an intensity of relationships, not only between forms in three-dimensional space but also between the figures whose observed activities seem at first so matter-of-fact, as well as between them and the unseen figures whose imminent involvement is implied. Matters are further complicated by the immediacy with which Vermeer invests each inanimate object. The presence of objects is so compelling as to give them as active a role as that of humans, for whom they can sometimes be read as surrogates. Finally, the viewer not only is made unusually aware of perspective but is almost mesmerized by its effects. Thus for all its supreme harmony and balance, an interior by Vermeer contains elements that variously disrupt those very qualities. At the heart of Vermeer's importance for Oldenburg and van Bruggen is his use of still life to open vistas of a life that is anything but still.

Crucial in *Resonances, after J. V.* (2000), as the title might imply, is the role of stringed instruments, one of the recurrent motifs of Vermeer's art. The sculpture was inspired by two Vermeers in particular, *A Young Woman Standing at a Virginal*, and *A Young Woman Seated at a Virginal*, both in the National Gallery, London.[1] Van Bruggen sees these pictures as "stills" that freeze moments in a continuous narrative, the subject of which is love. In each painting the woman is alone, but the vital part played by men in other Vermeers, including scenes of music-making,[2] is far from being the only pointer to their importance in the story these paired pictures tell.

For van Bruggen, the woman standing is anticipating the arrival of her lover, whom an empty chair awaits. In this painting, the largest of several pictures within a picture is an image of Cupid, whose bow actually touches the woman's head, pictorially. In contrast to the relatively austere and measured design of this Vermeer, the picture of the seated woman is more complex and crowded. Metaphorically, the woman's lover has now arrived. Whereas it is unclear whether the standing woman is actually playing the keys that she fingers, her seated counterpart is "playing" in more senses than one. As if to confirm the theme of lovemaking, the largest of the paintings depicted here shows a scene with a procuress. *Resonances, after J. V.* was prompted by van Bruggen's regret that no third Vermeer exists to reveal what happens next. That, therefore, is what she and Oldenburg show us in their intricate tableau.

Attention has already been drawn to the importance in Vermeer's paintings of roles, of enclosed spaces, and of figures entering into them. To these factors may be added the crucial element of lighting. It is thus apt that Oldenburg and van Bruggen should present the third moment in this narrative in the form of a small stage. Following a genre in the Dutch art of Vermeer's day, they have created a peep show, which may be compared to an example by Vermeer's contemporary Samuel van Hoogstraten, *A Peepshow with Views of the Interior of a Dutch House*. This likewise gives prominence to chairs and to a patterned floor. Its outer surface depicts Cupid. However, van Hoogstraten's peep show and that by Oldenburg and van Bruggen show different stages of Cupid's activity, which helps explain the contrast between the orderly character of van Hoogstraten's interiors (and the first of Vermeer's) and the disarray that prevails in *Resonances, after J. V.* In this difference strings play a vital role. In Vermeer's painting of a young woman standing, Cupid's strung bow is at the ready. By the time of the second picture the artists visualize his arrow as having been shot. Thus when in the third "still"

(their own) Cupid's bow reappears, it has been hung up on the wall, its work done. The arrow that hangs beside it is bent, from the force of its impact on the lovers. The extent of that force can be judged by examining the stringed instrument that dominates the shallow space and even protrudes from it into our own, as if hanging over the edge of a bed. No longer leaning at the ready (as in the Vermeer painting of the woman seated), the viola da gamba now sags limply, as indeed does Cupid's arrow, which has become soft. The gamba's formerly taut strings trail slackly along its extended and deconstructed form.

The analogy between the form of any instrument of the violin family and a woman's body has long been celebrated in art. It is inevitably of interest to Oldenburg and van Bruggen, whose objects repeatedly refer to the shape of the human body, regarded as a key "given" of our existence. Though not there literally, a human presence can, paradoxically, be intensified when represented by objects. Moreover, to Oldenburg and van Bruggen the object is a receptacle for the projection of feelings. Here, therefore, the woman/gamba lies in a state of satiation. The lovemaking is over and we witness the confusion in which its ardor has left the room. The curious chair that intrudes into the scene extends the ambiguities of presence/absence and of metaphor that van Bruggen finds in Vermeer's paintings. Complementing the gamba's curves and pointing toward the reclining instrument, its sharply assertive form makes it a male presence by proxy. Its design repeats that of a famous Dutch object of the modern era, Rietveld's Zigzag Chair of 1934.

In introducing this anachronistic motif into a seventeenth-century scene, Oldenburg and van Bruggen reinforce their work's theme of disruption. They also augment the pervasive quality of instability. A supposedly firm object is collapsing; the black voids in its casing prove on inspection to be solids; and the tableau rests on a floor composed of angular lozenges, of which the black-and-white contrasts are visually unsettling. The sense of disorientation is compounded because Cupid's arrow, both types of bow, the chair, the envelope, and the floor patterning all point in different directions.

The atmosphere is one of mysterious concealment and revelation, in which the heavy curtain (another stagelike feature) plays a major role.

An earlier work that fed into the conception of *Resonances, after J. V.* was Oldenburg's famous *Bedroom Ensemble*, the first version of which was made in 1963. That work is likewise stagelike, includes furniture and pictures on the wall, and confuses perception by tricks of perspective. It, too, juxtaposes soft with hard forms, though without according central importance, like so many of Oldenburg's works of that decade, to changing the very meaning of a customarily hard object by making it soft. In the new peep show, where this does happen, the collapsed viola da gamba has "given in," its helpless state resembling not only the end of life but also the "small death" with which orgasm is traditionally equated. The force of the emotion embodied in this object, as in the piece as a whole, is an indicator of a key contrast between the *Bedroom Ensemble* and the much later interior. A frozen quality pervades the *Bedroom Ensemble*, which not only recalls an actual motel room but also comments on the stiff stylization of the interiors presented in furniture advertisements by conforming to (and, in the absurdity of three dimensions, exposing) the rigidity of their formalized perspective illusion.

Ellen Johnson has written that "in the *Bedroom Ensemble* the dwelling of Eros becomes a chamber of death."[3] Though Eros is (in contrast) at work in *Resonances, after J. V.*, a kind of death occurs here, too, as we have seen. But it is a death in the midst of life, a life that resonates with emotion and across time. It also spills out to the viewer, thus again contrasting with the *Bedroom Ensemble*, about which Johnson added that "chaining it off from its surroundings is unnecessary; its remoteness is intrinsic." There is a link between the feeling of fuller engagement in *Resonances, after J. V.* and the artists' more mature perspective. Their work is now more layered, even more "baroque," than the emergent art of the 1960s. It not only reflects a longer experience, but constitutes an assertion of the permanent value of a richer, more complex art, not least at a time when fash-

ion decrees the preeminence of the young. The smaller objects that rest on the viola da gamba in *Resonances, after J. V.* invite alternative readings, or questions. Displaced in the frenzy of love, an earring lies where it has fallen on the hastily set-aside instrument. This detail suggests that the woman has departed; but why, and in what mood? The riddle is compounded by the adjacent envelope. The eye-catching diamond of its red interior (the color of love) holds the whole complex composition together, while emphasizing that the envelope is empty. In several of Vermeer's paintings the writing or receiving of letters is significant. *The Love Letter* links such an incident to the playing of a stringed instrument. Like Vermeer, Oldenburg and van Bruggen leave us to guess the contents of the message the letter contains. Thus not only love but also mystery lies at the heart of their tableau.

The envelope conveys that not everything is public. Vermeer's depicted characters are not the only people whose private relationships are celebrated, for while reinforcing our awareness of the love they perceive as animating Vermeer's figures, Oldenburg and van Bruggen also attest to their own for each other – and *its* privacy. Like Vermeer's paintings, *Resonances, after J. V.* includes pictures within the "picture." Thirty-three of these are images in the manner of Delft tiles, painted by Oldenburg to an iconography provided by van Bruggen. Their meanings are personal and, though some are discussed below, not all are disclosed.

The other picture within this "picture" is the framed drawing that hangs on the rear wall, behind the curtain, and can be viewed only obliquely. As in Vermeer's picture of a woman standing, it includes a representation of Cupid's bow (and, here, his arrow). It is a visualization of a large-scale sculpture soon to be sited alongside San Francisco Bay. Unlike the "real" weapon that hangs beside it, the bow in this image is fully taut, on the point of release. Yet, mysteriously, it also gives a sense that the arrow has hit home, for both bow and arrow are partially embedded in the earth (and thus, in a further ambiguity, also read like the image of a ship plowing through waves).

Cupid's bow and the viola da gamba are

both stringed contrivances. The new tableau may be soundless, but it resounds with recent melodies, as well as with memories of the love that Cupid's arrow has set in motion. Part of its subject is vibrations across time. Some of these reach us from Vermeer's world, which seems at once near and impossibly far, and some are from the artists' own memories.[4] But *Resonances, after J. V.* – conceived by a woman and executed by a man – testifies, too, to the equality of Oldenburg and van Bruggen's professional partnership in terms of the roles of each individual and each gender.

A French Domain

The viola da gamba in *Resonances, after J. V.* is one of a family of transformed musical instruments by Oldenburg and van Bruggen that has been growing for a decade. A particular link between the artists and the music rooms their peep show recalls is their own creation of such a room at the home they established in Europe in 1992, in which they spend some months of each year. Much farther south than Oldenburg's native Sweden and van Bruggen's Netherlands, it lies in the Loire Valley, the favored region in which, significantly, the weather is generally held to change from northern to southern. The house, the Château de la Borde at Beaumont-sur-Dême, has strong American associations, for an earlier owner, Gustave de Beaumont, accompanied his friend Alexis de Tocqueville (1805-1859), after whom the street outside the gates is named, on the journey to the United States that resulted in the latter's renowned *Democracy in America*.

The music room at Beaumont-sur-Dême, formerly the salon, is an unusual example of the genre. Unplayable musical instruments, enlarged to the scale of human figures, hang on the wall or (in the case of a pair of clarinets elegantly arcing toward each other, their horns nearly touching) rest on the fire surround. One is another viola da gamba, its supposedly taut body yielding, owing to the softness of its materials. In his drawing studio, two floors above this room, Oldenburg recently visualized another gamba as an island, large enough for its hollows to become sheltering bays and its bridge a kind of Stone-

henge. But at Beaumont-sur-Dême transformation is everywhere. From the music room the eye is led to the park, which flows from the house in three directions and which contains not only natural growth but, in Oldenburg and van Bruggen's imagination, object-inhabitants that, like humans, take up positions among the trees.

The artists' decision to live in the French countryside was born of their instinct to re-engage, in at least three different ways. They wished to extend the engagement with European culture that each had long pursued, despite having relinquished their original nationalities. They wished also to be able to operate more thoughtfully and at a slower pace than their working life on the East and West Coasts of America permits. Third, they sought to deepen the awareness of nature and of the elements implicit in their extensive practice of conceiving and installing large-scale site-specific sculptures around the world.[5] House, outbuildings, and park at Beaumont-sur-Dême are quintessentially French, the ensemble being complemented by the curved roof and spire on the bell tower of the village church, visible just beyond the gates. However, as Oldenburg has observed, their estate is not so much in France as in Coosjeania. It was van Bruggen who took the lead in establishing this European base, and whose imagination and energy are steadily enriching both its arboricultural and its poetic scope.

Large numbers of trees were lost in the hurricane that hit the park at Beaumont-sur-Dême on December 26, 1999. This made possible not only replacement but reconstruction of planting projects on a grand scale. Blocks and drifts of contrasting color at ground level, and more especially above it, create views of great variety and animation. Trees and plants were sought from widely separated sources, so that the dialogue between large and small forms interweaves with that between different species and nationalities.

The longer they live at Beaumont-sur-Dême, the more the park heightens Oldenburg and van Bruggen's awareness of time (a preoccupation at the heart of their sculpture after Vermeer). As a living record of acts performed over the generations, the

park *tells* the time in both decades and centuries, as well as in seasons. It also testifies to the endurance of the natural world in spite of wars and natural disasters. In this extensive landscape, to observe a particular effect of light, climate, or weather is frequently to recall a long-dead writer's account of precisely such an experience, often in the same month. This sense of a continuum has highlighted for van Bruggen the capacity of art to deal with time. The park's pervading peacefulness and the unforced rhythm of time there have the effect of slowing down their pressure and of permitting reflection, without which nourishing art cannot be created. Moreover, in a landscape that is both extensive and concentrated, the senses are heightened. As a consequence, the art of van Bruggen and Oldenburg is increasingly concerned with restorative delectation and with longer perspectives. In New York they are in the twenty-first century; in Beaumont-sur-Dême they feel just as much in the nineteenth.

Like art, however, the park is man-made. To cultivate it is to recognize how often what we perceive as natural is anything but nature in the raw. Life at Beaumont-sur-Dême also enhances the artists' awareness that their art springs from an interaction between the urban and the rural. Indeed, in the middle of a reverie amid Beaumont's glades, one can be startled by the scream of fighter jets. And it is not there but at a factory in American Canyon, California, that the artists oversee the physical realization of the outdoor sculptures they have conceived and visualized in France. The final choice of color for any work is entrusted, as is the artists' custom, to van Bruggen. It is the outcome of long deliberation aimed at heightening identity, radiance, and sensuous vitality. A living, organic quality is sought. Color is crucial in transforming the often strongly linear character of the drawings for a sculpture into a vivid three-dimensionality. At the same time, it has the effect of directing attention to the surface of the sculpture, to its durable yet painterly skin. A focus on surface has been a constant in Oldenburg's sculpture: from the distressed surfaces of works for *The Street* (1960) through the dribbled paint of those for *The Store* (1961) to the canvas

of the soft sculptures, the gleam of those in vinyl, and a whole variety of textures in subsequent decades.

The finished outdoor sculptures for the château have a largeness of scale that relates both to the park at Beaumont-sur-Dême and to the artists' awareness of the generous dimensions of plants in California. But the means by which forms are enlarged is often digital technology, and the artists maintain a deliberate balance between a sense of the natural world and frank exposure of the works' industrial fabrication. Oldenburg and van Bruggen find forms in nature – in its widest sense – to which they apply their own aesthetic. They identify attributes that, while strengthening the originating form, also link it unexpectedly to other aspects of life. The sculptures they have placed outdoors at Beaumont-sur-Dême bring allusions to the indoor and the manufactured into play with the park's long vistas and open skies. They thus continue, in transmuted form, the long-established convention of follies and statues in the landscaped garden. Combining a light touch with positioning that enables the effect of each image to carry to its fullest across the setting, these incongruous objects enrich a world of sights, sound, and movement in the park that was already complex, in actuality as well as in imagination.

Oldenburg and van Bruggen see the château's surroundings as a sequence of contrasting zones. The ample terrace and the view that fans out from it are akin to an opera stage. The entrance facade faces a wood that could be from *A Midsummer Night's Dream*. The opposite view from the house, down toward the river, is the site of Happenings, as animals both wild and domesticated arrive and pass from view. The adjacent village is like the set for a realist drama. The gates to the château might swing open, like curtains in a theater, to disclose a stage on which the life of the village would unfold. The whole domain resounds with a continuous concert, of owls, cockerels, winds, church bells, and the sounds of cultivation. It is a conversation of the senses, in which the brightly colored new sculptures play a prominent part.

A PARK IN PORTUGAL

For the summer of 2001 these outdoor sculptures were transplanted to a very different parkland setting when, as part of the city's role as a European City of Culture for the year, the Museu Serralves in Porto, Portugal, presented a major exhibition on Oldenburg and van Bruggen, displayed both outdoors and in.[6]

Near the museum building is a clearing of almost unbroken green. There, surrounded by small, medium, and huge conifers, a twenty-one-foot-high sculpture of one heart balanced on another, from which a tall, smokelike puff of cloud flutters toward the sky, provided a brilliant accent of contrasting red and white. Much enlarged, it represents the bottle, bulb, and spray of an imaginary perfume bottle, conceived by Oldenburg as a Valentine's Day gift to van Bruggen. On one level the image, with its freely curling tube through which the perfume passes en route to atomization, is almost abstract. Yet this exuberant dance of shapes culminates in a joyous emission that is not only an extraordinary motif for a public sculpture, but also, like the first and last works in the present exhibition, a striking symbol of the artists' love.

Some key areas of the park at Serralves are severely formal. At one end of a long rectangular lawn another white configuration, the *Architect's Handkerchief* (1999), burst from a containing form, this time like a flower. The most difficult of all these outdoor sculptures to "read," it typified them in being an unexpected incursion of concentrated vitality into a setting of great calm; yet it was perfectly in keeping with the park's theme of the opening and closing of natural forms. Halfway along a nearby formal avenue of slender, mature trees one encountered, startlingly, *Corridor Pin, Blue* (1999), a giant safety pin balancing on its clasp. Unexpectedly, it was open. Thus high above one's head the unsheathed, near-horizontal pin pointed imperiously across the landscape with seeming, albeit enigmatic, urgency. The trees here are liquidambar, thus giving the exhibition its title and forming a further link both with the park at Beaumont-sur-Dême (where van Bruggen has planted an allée of this species) and with California, where these large-scale works were made

(and where the artists are familiar with a lane of liquidambar trees).

The avenue leads to the most emphatically formal of all the Serralves spaces, the Central Garden, with its Art Deco scheme of lawns, topiary, and pink paths divided by ranks of brilliant red flowers, rigidly positioned. Improbably sited on the piers at the top of the stairs leading down from the terrace were twin slices of blueberry pie, resting on scoops of ice cream. The poise with which these overflowing slices were balanced, upright, was explained by their titles, *Shuttlecock/Blueberry Pies*, I and II. The view from the terrace culminated in a glimpse of the elbow and prong of a second giant safety pin, *Corridor Pin, Red* (1999). The sculpture's placement on a small circular vantage point for viewing the landscape beyond accentuated the pins' character as frames that reveal vistas through their near-rectilinear apertures. At ground level, the confinement of the site encouraged visitors to examine the lowest section of the work close-up and thus to appreciate the almost erotic conjunction of the two sides of the pin's clasp. From here one looked downward onto a mysterious lake. On its far bank, a slice of blueberry pie had opened, becoming a bird in flight.

Penetrating the earth decisively was the exhibition's keynote sculpture, *Plantoir* (2001). This work is an emblem of the creativity at Beaumont-sur-Dême, as well as of the continuous activity that enables the park at Serralves to retain its ordered design. An implement of this type is also symbolic of the artists' relationship. Their collaboration began with the installation of *Trowel I* (1971-1976), first in one park in the Netherlands and then in another, the work's permanent home, the Rijksmuseum Kröller-Müller, Otterlo, where the monochrome blue form rises more than thirty-eight feet above the ground. *Plantoir* shows, in a sense, two stages in a process simultaneously, for while it penetrates the soil in order to plant it, its form is that of an already unfolding flower.[7] There is a connection between this organic metaphor and the intense red of the *Plantoir*'s scoop, a color chosen by van Bruggen for its emotional resonance and signaling a deeper register of feeling than in the cooler *Trowel I*.

Floating Peel

Plantoir focuses on a decisive physical action that initiates disruption so as to make future pleasure possible. *Resonances, after J. V.* (which is also linked to *Plantoir* through the motif of a trowel on one of the "Delft tiles") and *Balzac/Pétanque*, the culminating sculpture in the present exhibition, both do the same. So, too, does the tallest work in the exhibition, *Floating Peel* (2002). Though made after the Serralves exhibition, the *Peel* extends the engagement with air and space implicit in all the sculptures made for outdoor settings.

An important theme of Oldenburg's work has always been the pull of gravity and its effects. He is fascinated also by its antithesis, but the concern with flight and with taking off that is so evident in his and van Bruggen's joint work comes more especially from her imagination. This concern is particularly overt in *Floating Peel*, which draws strongly on van Bruggen's experiences in childhood. Casually flung away, a banana skin flies through the air, its configuration combining exuberance with grace. Caught at a moment of infinitely precarious balance between its parts, it presents the most extreme state of poise possible without the structure collapsing. Techniques of aircraft manufacture were employed to achieve this balance. This is curiously appropriate as the concept was first developed by the artists for Schipol Airport in Amsterdam. Though that project was not realized, the associations with aircraft propeller and windmill vane present in the original idea remain in the finished sculpture. The horizontal sections of peel flex gently, yet the work as a whole conveys the sensation of accelerating through space, while opening up for the viewer the shifting planes of a construction that combines overall simplicity with considerable complexity in detail.

Floating Peel embodies van Bruggen's memory of the elegant arcs she described when skating on Dutch canals. But vital here is the sense of speed with which van Bruggen has imbued the sculpture. The image incorporates her recollection of the dynamic motion of speed skating around the curve of a rink. Paradoxically, it also captures her delight, as a young ballet dancer, at balancing on the toe, elevated for only a moment, yet a moment of extraordinary freedom and exhilaration. The banana skin is caught at a split second in its trajectory. In everyday life we experience occasional flashes of insight elusive in nature, difficult to attain and impossible to retain, except in imagination. Underlying the concern with instants of time that links many of Oldenburg and van Bruggen's sculptures is the wish to make concrete the magic of such moments that look both forward and back. *Resonances, after J. V.* does this. It is like a snapshot taken as love runs its course in a music room in seventeenth-century Delft, yet equally it celebrates Vermeer's ability to make objects speak of the human condition in any era. *Floating Peel*, too, compresses powerful memories. In this exhibition it leads toward a final work – *Balzac/Pétanque* (2002) – that does the same as it looks back to nineteenth-century France.

The Loire Valley

Beaumont-sur-Dême is in the northern part of Touraine, through which the Loire River flows. Fruit, the principal motif of *Balzac/Pétanque*, plays a major role in both the economy and the gastronomy of the region. Long an important subject in art, food has been prominent in Oldenburg's work in particular for over forty years. In 1964 the food his sculpture represented was specifically French. For an exhibition at the Galerie Ileana Sonnabend in Paris he created a group of sculptures of food made of plaster of Paris. The refined, painterly image of a work such as *Viandes* (*Meat*) strongly recalls the art of Chardin, while other sculptures in the group highlight the invitation to indulgence that is the essence of elegantly presented French *pâtisseries*.

There is a natural affinity between the delight in appearance, taste, smell, and touch implicit in all these works (as in Oldenburg and van Bruggen's art in general) and the long tradition of the celebration of these qualities in the literature of the Loire region. A leading example is the work of François Rabelais (c. 1483-1553), of whom Terence Cave has observed that "the exuberant linguistic inventiveness of his writing...creates a self-contained imaginative world in which...real events and problems...are transformed and tran-

scended,"[8] and that his "emphasis on eating, drinking, and other bodily activities should be seen, not as some kind of outdated schoolboy humour, but as a vigorous and far-reaching attempt to portray human nature as a whole."[9] The work of Oldenburg and van Bruggen is consistent with these aims, as is the Rabelaisian directness of their pleasure, in *Balzac/Pétanque*, in fruit cultivated in their region.[10] Love and nature are also important themes in the work of the great poet Pierre de Ronsard (1524-1585), who lived in the Loire Valley.

Respectively to the south and north of Beaumont-sur-Dême are key locations in the life and work of George Sand (1804-1876), at Nohant, and of Marcel Proust (1871-1922), at Illiers/Combray. It was an item of food, a madeleine, that for Proust had the power to bring back the past, beginning with the intense memories it evoked of this region. A sense of the potency of this small baked delicacy underlies the sketch in which it is discovered, enlarged, leaning against a tree in the park at Beaumont-sur-Dême. But of all the region's great writers it is Honoré de Balzac (1799-1850) to whom, in *Balzac/Pétanque*, the artists pay homage – the Balzac who imitated Rabelais,[11] only to be himself both imitated and defended by Proust, the "vast plan" of whose *À la recherche du temps perdu* was influenced by that of Balzac's *La Comédie humaine*;[12] the Balzac, too, who followed Ronsard in immortalizing the landscape and produce of Touraine and who was a friend of George Sand.

Balzac

Though van Bruggen is an art historian, her key field of study was French literature; the literary stereotypes that play a part in the artists' work emanate from her. Van Bruggen's student research into the work of nineteenth-century French poets, including Baudelaire and Verlaine, gave rise to a keen response to their period as a whole, and this interest expanded naturally to include the novels of the somewhat older Balzac. One outcome is the largest work in this exhibition, which began as an idea for an image that van Bruggen conceived and offered to Oldenburg to develop visually.

In his writing, Balzac sought instinctively to take account of everything he encountered or knew of, and not only to embrace the whole world but to reveal the interconnectedness of all its parts. As Graham Robb has observed: "His metaphorical mind was incapable of perceiving a fact in isolation; pulling at the smallest impression invariably brought up the whole root system."[13] These qualities, which are echoed in Oldenburg and van Bruggen's own art, would almost certainly have led to the influence from Balzac's essentially generous vision of life, a likelihood ensured by the artists' establishment of a home in the Loire region. As Robb also writes: "The lasting significance of Balzac's experience of Paris lies in his return to what he came to consider as his true mother – the Loire Valley. Leaving the grime of Paris for Touraine in early spring was a revelation. These days imprinted themselves in Balzac's mind so deeply that they recur in his novels throughout his life."[14]

Oldenburg and van Bruggen visualize their works first in the form of drawings. They conceived *Balzac/Pétanque* not only as a striking indoor sculpture, but also as a proposal for a monument to the writer, to be sited in a square in Tours, the city of his birth. The vividness Balzac's evocation of the fecundity of nature in the region of which Tours is the heart gives the monument's imagery a special aptness in this location. Though unlike Rodin's superb visualization of Balzac, which offers a naturalistic image of its subject, *Balzac/Pétanque* is consistent with all of Oldenburg and van Bruggen's monuments to individuals in representing its subject by means of attributes. In the case of Balzac, the chosen attribute is peaches and pears. Also crucial is the attendant knife, for Oldenburg and van Bruggen focus on an act central to Balzac's enjoyment of life, the *consumption* of fruit. Of special inspiration in the conception of this sculpture was an eyewitness account of such an episode: "...his lips quivered, his eyes shone with happiness, his hands twitched with pleasurable anticipation at sight of a pyramid of beautiful pears or peaches...He was magnificent in his flamboyant, Pantagruelian way; he had removed his cravat and his short collar was open; with a fruit knife in his hand he laughed, drank, and carved into the juicy flesh of a large pear..."[15]

Prolific though he was, Balzac's publishers found it extraordinarily difficult to extract manuscripts from him. Robb relates how on one occasion Edmond Werdet "hurried all the way to Nemours to collect a long-overdue manuscript, only to be told that Balzac had spent the weekend pruning fruit trees."[16] Moreover: "Pear was the dominant smell in his Passy retreat according to Nerval, and at one point his pear reserves reached 1,500."[17] As Robb observes in the same passage: "In any account of Balzac's life his stomach would be one of the heroes...Feasting for Balzac was partly a spectator sport, until it came to the fruit course," when he would home in on what he himself described, in *Les Paysans*, as "those twisted, desiccated fruits with black patches that gourmets know from experience and under whose skins Nature enjoys placing exquisite tastes and odours."

The use of pears to evoke an individual recalls irresistibly the devastating lithographs in which Daumier employs the fruit to represent the French king Louis-Philippe. *Gargantua* (1831), in which the king's already pear-shaped head sits atop a naturalistic body, has been described as "a scatological caricature of Rabelaisian inspiration."[18] In *Masks of 1831*,[19] fourteen precisely delineated faces of politicians surround the image of a single pear that, though uncaptioned, would have been recognized by contemporaries as representing the king, even though his facial features are barely visible. By the time of *Heave-ho!...Heave-ho! Heave-ho!* (1832), the king, "now completely transformed into a pear, is 'executed' by hanging by the bell-ringers of the people, who make him chime out like a giant bell."[20] Édouard Papet identifies an impulse to portray universal types as common to Daumier and Balzac, who were born only nine years apart.[21]

Daumier's work as a whole was seen by Baudelaire as a complement to Balzac's *La Comédie humaine*,[22] and Ségolène Le Men has described Daumier as Balzac's best illustrator.[23] In admiring Daumier's ability to condense an idea or person in a visual metaphor, Balzac was identifying a gift possessed not only by himself but also by Oldenburg and van Bruggen, who conceive his monument as a celebration of the abundance of nature.

Balzac/Pétanque presents the classically stable structure of a pyramid, yet visualizes it as destabilized by the novelist's actions. Curiously, when Balzac was ten his father had been "the first person to think of erecting a pyramid in front of the Louvre."[24] In an image that again associates stability with its opposite, Balzac described his father as "the Pyramid of Egypt, immovable, even as the planet falls apart around him."[25] For the artists, the appeal of the pyramid lies partly in the interest in primary objects that runs throughout their work (and which they shared with their friend Donald Judd). Most of their versions of everyday motifs are constructed by combining a number of such forms to give maximum concentration to the image. Oldenburg's *Bedroom Ensemble* is a gathering of such forms, destabilized by deliberate oddities of perspective.

Providing a parallel to the juxtaposition of a pyramid of rounded forms with a knife is Oldenburg's *Proposed Colossal Monument for Stockholm: Knife in Pyramid of Butter Balls* (1966). Familiar from the artists' individual memories of the gastronomic cultures of both Sweden and the Netherlands, the motif of butter balls contributed to the thinking that led to *Balzac/Pétanque*. In each work, the factor that gives life to so classic a form as the pyramid is the inclusion of elements that imply movement and change; a sense of finality is thus undermined. This fundamental principle of the art of Oldenburg and van Bruggen is specially appropriate in the case of a monument to Balzac. As Robb states: "Critics adhering to classical principles would pass negative judgment on Balzac's work...[for] his novels lack the smug sufficiency of the perfectly finished product...they retain and radiate the willpower...that produced them."[26] Van Bruggen has remarked recently that Balzac "never got rid of the impurities in his style despite endless rewritings of his texts. I am sympathetic to such a pure-impure mixture, for it relates to our dynamics of transforming stereotypes."[27] Among the sources of their works' open-

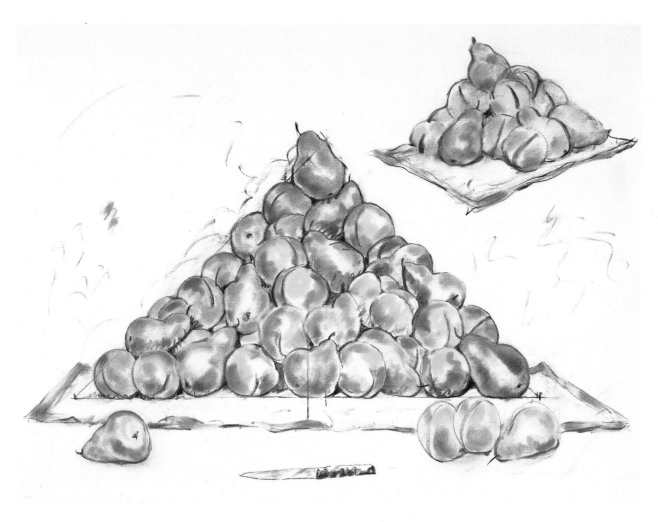

ness and unpredictability is the way each of the artists' thoughts intrudes on the other's while the concept of sculpture evolves and is brought to realization.

FRUITFUL VISIONS

Among the best-known images of pyramids of fruit in art are those of the eighteenth-century French painter Chardin. Part of the power of these still lifes, which are much admired by Oldenburg and van Bruggen for the way in which everyday motifs are pared down to essentials, lies in their gravity and, indeed, their very stillness. Yet for the artists such pictures gain added interest from the potential for change, movement, and even collapse implicit in their conception. Set in pantry, kitchen, or dining room, they all point to imminent transformation by human action. Even were that not so, the stability

of the arrangements we are shown is threatened not only by decay but by the closeness of objects to the edges of shelves or tables or by the keen interest of dogs and cats in the meat, game, and fish on display. For Oldenburg and van Bruggen the pyramid in still life is of interest as being a given, a tradition within the genre, but it is all the more compelling for them in Chardin because he exposes that stereotype to the threat of disarray.

One of the most spectacular of Chardin's pictures of a pyramid of fruit is *The Buffet* (1728). Prominent in the composition, as in *Balzac/Pétanque*, are peaches, pears, a white tablecloth, and a knife. Chardin juxtaposed a pyramid of fruit with a knife in several pictures, and though other painters did the same, his knives seem more purposeful, less incidental. This sense of the actuality of use is emphasized

by the way in which, as in *The Buffet*, Chardin's knives protrude over the edges of the surfaces on which they lie. In *The White Tablecloth* (c. 1732; The Art Institute of Chicago), the protruding knife lies on a white tablecloth that bears a blue line and a fallen drinking glass. This and *The Buffet* are among Chardin's largest works.

Chardin's pictures give a sense of immediacy to the fruit and knives disposed on surfaces and to the pleasure of food. A century later these qualities are seen in French painting with renewed vividness, in the numerous Impressionist still lifes, in which the setting is the open air. In *Balzac/Pétanque* it is impossible to escape the image of Balzac at table, yet the work's imagined setting is at least as much alfresco. Fruits and knife rest on and around a white napkin or tablecloth, the central elements of the composition being loosely

framed by the fabric's narrow blue borders. Along with the appeal of ripe fruit, such an arrangement evokes the pleasure of human company in an ambience of warmth and light.

In an important early precedent, Manet's *Le Déjeuner sur l'herbe* (1863), fruit spills onto discarded garments, but three years later in Monet's picture of the same title in the Musée d'Orsay, pears and peaches are among the fruits that lie, adjacent to a knife, on a large white tablecloth. All three of the great *Bathers* paintings from the end of Cézanne's career must represent picnics, for in two of them fruit is prominent in the foreground (in at least one case on a tablecloth or napkin), while in the third the central figures are laying a cloth on the ground.[28] In the astonishing issue of these pictures, Picasso's *Les Demoiselles d'Avignon* (1907, The Museum of Modern Art, New York), fruit lies on a similar white fabric, between viewer and women.

The present exhibition begins and ends with works in which a scene that was originally controlled is presented in a state of disorder. We are shown the aftermath of an event not witnessed, but whose nature is implicit in what we see. However, whereas the turbulence in *Resonances, after J. V.* has taken place under the visible aegis of love's personification, in *Balzac/Pétanque* an affective interpretation hinges on suggestions in the imagery's form and context.

Manet's *Le Déjeuner sur l'herbe*, with its nude woman seated between men, and Picasso's *Demoiselles*, set in a brothel, associate foregrounded fruit with relations between the sexes. Nothing so definite can be said about Cézanne's late *Bathers*, yet it certainly can be said about two of his own (so-titled) versions of the theme of *Le Déjeuner sur l'herbe*[29] (especially the later in date), both of which center on white tablecloths supporting fruit. Also set outdoors (though not on the grass), the same artist's *L'Orgie (Le Festin)* of c. 1870,[30] likewise centers on fruit on a white tablecloth. It is therefore interesting that in Cézanne's *Still Life with Cupid* (1894-1895), pears and peaches are piled at the feet of this symbolic figure, as if in tribute to the powers of the god of love.

In the absence of any figure, the effect of *Balzac/Pétanque* is to make us examine more closely the fruits that, disposed on and around the "stage" of the tablecloth, are the actors in this work. Their ripe forms and seductive colors emphasize the fecundity of nature, but also put us in mind of Picasso's use of fruit forms to represent his mistress, Marie-Thérèse Walter.[31] There is an affinity between this erotic anthropomorphism and Oldenburg's observation that "one can speak of the sexuality of an object."[32] This preoccupation of Oldenburg's can be traced back at least as far as *The Store*, his extraordinary creation on New York's Lower East Side in 1961.

Balzac/Pétanque takes us at once farther back and farther forward in time. Conceived in and for the Loire Valley, it evokes the range of the appetites experienced in the region in the nineteenth century by the pear-loving novelist of whom Robb writes: "His walks in the countryside [correspond] in nearly all of Balzac's brilliant Touraine landscapes to a sexual awakening."[33] But it also celebrates the artists' own response, in nearby Beaumont-sur-Dême, to the sensuous fullness of nature and also, in the distinctly gendered forms of the two chosen fruits, to each other.

SPORT IN FRANCE

Like Balzac, Oldenburg and van Bruggen work in both city and country, and it has already been observed how their art reflects both contexts. Robert L. Herbert has demonstrated how the country picnics painted by the Impressionists, today so redolent of unspoiled nature, were in reality an aspect of life in the city.[34] In *Balzac/Pétanque*, Oldenburg and van Bruggen reinforce this duality by associating luscious country fruits with the unpredictability and collisions of a pastime pursued throughout France – but in cities, towns, and villages rather than in the landscape.

It was natural to connect Balzac's appetite for fruit to the picnics enjoyed in the mid-nineteenth century, in which fruit played so central a role. Moreover, it was not only Balzac's appetite that implied the disintegration of the pyramid of peaches and pears. For in picnics on the grass, pyramids of fruit are impractical and in Impressionist picnics fruits roll across uneven surfaces. This image suggested to Oldenburg and van Bruggen the disorderly scattering of balls in the national recreation of *pétanque* (also called *boules*).

In introducing this theme into their still life, Oldenburg and van Bruggen typically revitalize a familiar motif by exposing it to an unexpected disruptive force. In *pétanque*, balls of three sizes are thrown along a course of sand or grit (hence the sandy setting of *Balzac/Pétanque* in the present exhibition). The first ball thrown, which is of wood, is the smallest and forms the target, while the others are metal, the largest number being small but heavy *boules* in polished steel. Seeking to ensure that one of their own *boules* ends up closest to the target, players often use one *boule* forcefully to displace others that have already come to rest. Impact and change are at the heart of the game. The notion of the ruin of Balzac's pyramid by hostile lobs recalls the demolition job attempted on his reputation by many critics in his lifetime, but the references in *Balzac/Pétanque* are wider in scope. As van Bruggen has explained: "The association with...*la pétanque*...jolts the imagination. The appearance of having been struck gives trajectories to the pears and peaches. The focus on the moment of impact and scattering creates the dynamic of the piece and its metamorphic qualities."[35]

The target in *pétanque* does not resemble a pyramid. But pool, curiously, another game of skill involving the propulsion of balls over a surface, begins when one ball is aimed at others that have been arranged to form a triangle. For Braque, one of the great poets of fruits, napkin, and knife, the table in the closely related game of billiards was another important motif. Oldenburg himself had earlier explored the potential of balls arranged in a triangle and then dispersed across a surface. There is an analogy between his *Giant Pool Balls* and *Balzac/Pétanque*, in that the spheres in the earlier work can be displayed either with fifteen in a neat triangle, with a sixteenth resting loose beside it, or dispersed across the floor but with their triangular rack leaning against the wall, thus reasserting their formal starting point in the appearance of a pyramid. These alternative modes of displaying the work can, however, never be seen together, whereas

Balzac/Pétanque presents a bold architectural structure simultaneously with the scattering of its parts through violent impact.

In *Balzac/Pétanque* the artists have increased the scale of the peaches and pears from that observed by Balzac to one where individual fruits are waist high. The image constitutes an environment or small piazza, in which the disintegration of the pyramid is experienced more startlingly than in either a meal or a game of skill. In each of two recent works realized on an environmental scale, Oldenburg and van Bruggen again anticipate *Balzac/Pétanque* by combining such disorientating new perspectives with brilliant color and with the effects of violent movement. The first of these, *Dropped Bowl with Scattered Slices and Peels* (1990), installed in the Metro-Dade Open Space Park in Miami, has colors similar to *Balzac/Pétanque* and also has a motif of fruit. One hundred five feet in its longest dimension, it includes eight bowl fragments, four peels, and five orange sections. The other, *Flying Pins* (2000), installed on Kennedylaan in Eindhoven in the Netherlands, connects closely with *Balzac/Pétanque* in its presentation of the violent impact of a ball in a game played on a long track. As well as the thrown ball (complete with finger holes) used in ten-pin bowling, the sculpture shows all ten skittles immediately after the moment of impact, three of them still in mid-air and easy to walk under.

Like these related works and all other sculptures created by the artists since they began working together, *Balzac/Pétanque* is the product of a collaboration between Oldenburg and van Bruggen that contradicts the idea of separate roles. In such a narrow view, van Bruggen would be the source of ideas and Oldenburg the creator of their visible appearance. The work did indeed begin in this way, but once Oldenburg's initial drawing had given the image a vivid reality on paper, its form developed through a joint dialogue. At the fabrication stage, van Bruggen played an equal part with Oldenburg in the process of digital enlargement and in decisions on structural materials. Realizing the image in three dimensions involved different considerations from the drawn visualiza-tion. As the sculpture took form, van Bruggen defined the composition of the decomposing pyramid and its scattered pieces and determined the exact position of each fruit.

Crucial to a sculpture's effect are decisions on color, which articulates the forms and determines how the work will be read, both in its environmental setting and in its emotional import. For *Balzac/Pétanque*, van Bruggen formulated a technique of nearly transparent layers of resin washes, brushstrokes applied by Oldenburg, and sprayed paint, in order to achieve a likeness to watercolor, even as open-air durability was maintained. Visually strong from afar, the surface of each fruit becomes almost immaterial close up. Such delicacy of effect is not normally associated with factory process. It is as though this sculpture, inspired in part by the outdoor images of Impressionist painting, is an image not only of fruit, napkin, and knife, but also of one of the innumerable *plein-air* watercolors that Impressionism inspired. Like the interior after Vermeer, it is a play on conventions. If the artists realize their hope of siting it in Tours, their *image* of still life in landscape will come full circle, finally becoming a still life in actual landscape.

DISSOLUTION AND CONTINUITY

Just as the enduring form of the pyramid is destroyed in *Balzac/Pétanque* by implied human action, so in the work's fiction the fruits of which it was composed are destined themselves to be degraded, even if uneaten, by the processes of nature. Indicators of a particular season, they make us aware of the cycle of the year. The sculpture's theme, the dissolution of what started out as a strongly defined form, exhibits a preoccupation that runs throughout Oldenburg and van Bruggen's work, namely, with changes of state that signify both extinction and renewal. Thus like many of their works, *Balzac/Pétanque* is a metaphor not only for an annual cycle, but for the cycle of life itself.

Consistent with this concern, *Balzac/ Pétanque* also highlights the simultaneous assertion (again made by most of Oldenburg and van Bruggen's work) of hard and soft, stable and unstable. The fruits here have a hard material finality, industrially fashioned, yet we think of them as both yielding and transient. Their image of spilling abundance recalls the same motif in the strongly structured still lifes of Cézanne, in which, as here, observed reality was adjusted so as not only to affirm solidity but also to charge the composition with a stimulating vitality. These qualities in *Balzac/Pétanque* would be writ still larger were the sculpture to be installed in front of the Hôtel de Ville at Tours. To the concept of a pyramid would be added the durability of a public monument; yet, bizarrely, the image set in front of a dignified civic architecture would be that of a structure in collapse. This would, however, be an appropriate way of commemorating Balzac. For while he showed how fragile is life and how fleeting are the pleasures of the senses, he showed, too, that the instinct to enjoy such pleasures is permanent and inextinguishable.

A FLIGHT OF FANCY

In a sculpture that offers so lively an interplay between the fixed and the unstable, we should finally consider the lowest-lying element. Like the numerous *fruits/boules*, the cloth in *Balzac/Pétanque*, spread out on a notional table or grass, also has a dual identity. Supporting a manifest pileup of solid objects, one feels that it at least must be securely grounded. Yet van Bruggen, entranced in childhood by *The Thousand and One Nights* (commonly known as *The Arabian Nights*), determined at an early point that the cloth should also have the character of a flying carpet, able magically to transport its passengers to other times and places.[36] This, perhaps, is why the cloth has shifting locations – on the table at which Balzac eats his pyramid of fruit; on the grass at Impressionist picnics in the half century after Balzac's death; and as a substitute for the gritty terrain on which *pétanque* – invented only in 1910 – is still played throughout France. The introduction of magic is consistent with Oldenburg and van Bruggen's inspiration from the park at Beaumont-sur-Dême. As we have seen, time collapses there, and the artists see the park as inhabited by the mysterious objects embodied both in their sculptures and in Oldenburg's sketches. In some of the latter, moreover, trees are actually

turning into other things – giant paint-brushes, inverted torsos, or wood nymphs. In the quarter century since Oldenburg and van Bruggen's partnership began, the theme of flight has recurred increasingly in their art. A classic example is the several versions of the improbable *Blueberry Pie, Flying*, of the late 1990s. Another is the giant *Shuttlecocks* of 1994, installed on the lawn of The Nelson-Atkins Museum of Art in Kansas City. The two motifs come together in the twin *Shuttlecock/Blueberry Pies* of 1999, which perch on either side of the steps at Beaumont-sur-Dême that lead from terrace to park. This image anticipates *Balzac/Pétanque* in combining flight, landing, fruit, spheres, and the idea of something being sliced into. But it also connects with the quality of enigma that is another ingredient of the new sculpture. For the form of the shuttlecock is inseparable, for van Bruggen, from that of the carved stone sphinxes on a war memorial in Kansas City, which have veiled their faces with their wings. Oldenburg has drawn a number of *Shuttlecock/Sphinxes* that relate both to these and to the sculptures of sphinxes in the gardens of the château of Chenonceau in the Loire Valley. The artists regard each of these drawn sphinxes as representing a different season. These enigmatic creatures embody or respond to the forces of nature. In the no less enigmatic *Balzac/Pétanque*, it is the addition of movement – itself a natural force – that unlooses the effects. As in all of the artists' works, shape and form are articulated cleanly, yet movement introduces a creative confusion, opening up the work in terms of both meaning and feeling.

There is a connection between the artists' recurrent interest in flight or floating and all the works in this exhibition. *Balzac/Pétanque* may be the only one to represent continuing flight, but from the slackening that follows the firing of Cupid's arrow in *Resonances, after J. V.* through the relaxed state of the large individual musical instruments to the liberation of the banana implied in *Floating Peel*, a common factor is delight in the sensation of release.[37] This quality is present in *Balzac/Pétanque* in the dissolution of the formal structure of the pyramid, as well as in the work's capacity to become airborne. *Floating Peel*, too, is in a kind of

flight, for the sculpture visualizes the peel on its way to ground, after the banana eater has flung it away. The gentle swaying of its thirteen-foot-high structure acts, in this exhibition, as a prelude to the flying carpet in the final room.

The capacity of a magic carpet to collapse distance and time (in a manner comparable to a dissolve in film) relates to the principle at work in *Resonances, after J. V.*, by which the artists were able to pass without interruption from the seventeenth to the twenty-first century. Intense emotion experienced in both eras coalesces, so that the unifying factor is feeling. In each work in the exhibition, the play of emotion is synonymous with the breaking open of something previously enclosed, intact, or controlled – the conventions of polite society in seventeenth-century Delft, the "defenses" of the woman whose heart is struck by Cupid's arrow, the integrity of each musical instrument, the form of the banana, the decorum of the fashionable picnic, the perfection of the pyramid of fruit, and the sense of hierarchy in human society that the pyramid symbolizes. In each case it is the human touch that has wrought the change, initiating a rite of passage. The invariable outcome is a state of imperfection. Oldenburg and van Bruggen acknowledge this in their work as the condition of life today. Far from being escapist, their art reflects contemporary experience; however, in dismantling familiar things they do not violate their motif but rather liberate it, creating a new thing that is open to response and interpretation as it takes its place in the world.

Each of the works in this exhibition is like a window on time. The window is opened by the jolt of surprise that associates imagery strongly recalling the past with the experience of here and now. In *Resonances, after J. V.*, Rietveld's modernist chair is a key agent of this effect. In *Balzac/Pétanque*, thought is led forward in steps of time, from Balzac's feast to the later context of the Impressionist picnic and then, startlingly, to the twentieth-century sport of *pétanque*. The resulting sense of collision coincides with one in which a vista opens up. Players of *pétanque* throw a metal ball into the air. This movement through space leads naturally to the image

of the flying carpet, with its freedom to link different times and places. As these analogies imply, a central message of *Balzac/Pétanque* – as of *Resonances, after J. V.* – is that the impact of the insights embodied in a powerful work of art is not confined to the era in which it is made. The effect lasts indefinitely, but it needs a sense of contemporary reality to make it vital in the art of a later generation. Just as strange as what went long before, this reality can help us perceive, through art, that the seeming strangeness of the past once represented normality. *Floating Peel* and the first and last works in this installation are linked by the image of fruit. Peaches and pears are the motif of the design on the curtain in *Resonances, after J. V.* and also one of the motifs on the tiles in that sculpture. The recurrence of this subject is a token of the growing degree to which Oldenburg and van Bruggen draw inspiration for their work directly from the natural world. This influence nourishes them in concert with that of the culture of the past, which is also of increasing importance to their art. We have seen how in each sculpture the artists accord a crucial role to disruption. It is therefore paradoxical that the qualities that are intensifying in their work – the natural and the traditional – denote strongly the value of continuity and of reflection. The clarity and concentration of each of Oldenburg and van Bruggen's images gives their sculptures a striking immediate impact, but this leads, for the viewer, to a slower and steadier unfolding of the work's rich metaphorical content. It leads, as well, to a delighted savoring of the world of feeling and sensation.

[1] *Resonances, after J. V.* was first shown in the National Gallery's exhibition *Encounters: New Art from Old*, June-September 2000, and is the subject of the present author's essay, in the catalogue that accompanied the exhibition, pp. 250-261.

[2] For example, *A Lady at the Virginal with a Gentleman (The Music Lesson)*, in The Royal Collection, London.

[3] Ellen H. Johnson, *Claes Oldenburg* (Harmondsworth, UK: Penguin Books [New Art 4], 1971), p. 27.

[4] All the works in the present exhibition can be related to the opening words of Shakespeare's *Twelfth Night*: "If music be the food of love, play on." Every work by Oldenburg and van Bruggen involves the selection of a stereotype that is given new life by unexpected recontextualization. While the stereotypes are most frequently everyday objects,

Shakespeare's words remind us that stereotypes can also be literary.

5 See Claes Oldenburg, Coosje van Bruggen, *Large-Scale Projects* (London: Thames & Hudson, 1995).

6 *Pelo Passeio dos Liquidâmbares: Escultura no Parque/Down Liquidambar Lane: Sculpture in the Park*, May-October 2001 (extended to November). A related book, published in 2002, includes an essay by Richard Cork, "Into the Woods," and "Down Liquidambar Lane: A Conversation Between Coosje van Bruggen, Claes Oldenburg, and Alexandre Melo."

7 The artists' work as a whole relates to that of the pioneer German photographer of architectonic plant forms, Karl Blossfeldt (1865-1932).

8 Terence Cave, in Peter France, ed., *The New Oxford Companion to Literature in French* (London: Clarendon Press; New York: Oxford University Press, 1995), p. 665.

9 Ibid., p. 596.

10 Cf. the following passage in Rabelais (François Rabelais, *Gargantua and Pantagruel*, transl. J. M. Cohen [Harmondsworth, UK: Penguin Books, 1955], p. 565:

"When the meal was quite finished, Greatclod gave us a large quantity of fine, fat pears, saying as he did so: 'Take these, my friends. They are singularly good pears, and you won't find them as good elsewhere. Not every land grows everything... Set some seedlings from them if you like, in your own country.'

'What do you call them?' asked Pantagruel. 'They seem excellent to me, and they have a fine flavour...'

'We just call them pears,' answered Greatclod. 'We're simple folk, as it pleased God to make us.' 'We call figs figs, plums plums, and pears pears.'

'Indeed,' said Pantagruel. 'When I get back home – and pray God it be soon – I'll plant and graft some of them in my garden in Touraine on the banks of the Loire...'"

11 David Bellos, in Peter France, ed., *The New Oxford Companion to Literature in French*, p. 62.

12 George D. Painter, *Marcel Proust: A Biography* (London: Chatto & Windus, 1965), vol. 2, pp. 99-100, 102, 136.

13 Graham Robb, *Balzac* (1994) (London and Basingstoke, U.K.: Papermac, 1995), pp. 170-171.

14 Ibid., p. 30.

15 Léon Gozlan, quoted in Stefan Zweig, *Balzac,* transl. William and Dorothy Rose, Book 2, *Balzac at Work* (New York: Viking Press, 1946), pp. 113-14.

16 Robb, *Balzac*, p. 274.

17 Ibid., p. 347.

18 Ségolène Le Men, in *Daumier,* exh. cat. (Ottawa: National Gallery of Canada), 1999, pp. 76-77 (where *Gargantua* is reproduced as no. 5).

19 Ibid., no. 7, p. 79.

20 Ibid., no. 8, p. 81.

21 Ibid., p. 89.

22 Cited by Henri Loyrette, ibid., p. 18.

23 Ibid., p. 40.

24 Robb, *Balzac*, p. 33.

25 Ibid., p. 78.

26 Ibid., p. 42.

27 "Down Liquidambar Lane: A Conversation Between Coosje van Bruggen, Claes Oldenburg, and Alexandre Melo," in *Pelo Passeio dos Liquidâmbares: Escultura no Parque/Down Liquidambar Lane: Sculpture in the Park* (Porto: Fundaçao Serralves, 2002), p. 69.

28 It has often been remarked how the structure of these paintings is based on the triangle. Cézanne's concern with a stability dependent (as in the pyramid) on a widening base is exemplified by his preoccupation with the motif of Mont Sainte Victoire.

29 *Le Déjeuner sur l'herbe* of c. 1870, and *Le Déjeuner sur l'herbe* of 1877-1882, both private collection, reproduced in Mary Louise Krumrine, *Paul Cézanne: The Bathers* (1989) (London: Thames & Hudson, 1990), ills. 39 and 43.

30 Private collection, ibid., ill. 23.

31 Cf. William Rubin, "Reflections on Picasso and Portraiture," in *Picasso and Portraiture*, exh. cat. (New York: The Museum of Modern Art, 1996), pp. 67-69, and Robert Rosenblum, "Picasso's Blond Muse: The Reign of Marie-Thérèse Walter," ibid., p. 360. (Rosenblum's essay, p. 362, contains a reproduction of a 1917 postcard associating fruits, including peaches and a banana, with male and female body parts.)

32 Richard Kostelanetz, "Interview with Claes Oldenburg," in *The Theater of Mixed Means* (New York: Dial Press, 1968), p. 157.

33 Robb, *Balzac*, p. 30.

34 See Robert L. Herbert, *Impressionism: Art, Leisure and Parisian Society* (New Haven and London: Yale University Press, 1988), pp. 170-177.

35 "Down Liquidambar Lane: A Conversation Between Coosje van Bruggen, Claes Oldenburg, and Alexandre Melo," p. 73.

36 One reason for introducing this motif was van Bruggen's awareness of the frequency with which Balzac refers to *The Arabian Nights* in *La Comédie humaine*. On the incidence of flying carpets in *The Arabian Nights* and in twentieth-century film, see Robert Irwin, "Flying Carpets," in *Hali*, no. 109 (March-April, 2000), p. 192.

37 This is the explicit subject of Oldenburg and van Bruggen's proposal for a sculpture in Stockholm, *Caught and Set Free* (1998), which shows a basketball at the moment of escape from the net.

Originally published in *Claes Oldenburg Coosje van Bruggen* (New York: PaceWildenstein, 2002)

—— Unwound and Entwined: Recent Projects by Claes Oldenburg and Coosje van Bruggen, Frederik Meijer Gardens, Grand Rapids, Michigan, May 16 – August 17.

Works exhibited: *Study for Rotten Apple Core,* 1987, canvas coated with resin and painted with latex, 24 × 12 × 12 in.; *Notebook Page: Studies of Broom Shapes,* 1989, pencil, felt pen, watercolor, 11 × 8 $^1\!/_2$ in.; *Apple Core – Autumn,* 1990, lithograph, 41 × 31 $^1\!/_4$ in.; *Apple Core – Spring,* 1990, lithograph, 40 × 30 in.; *Notebook Page: Street Sculpture in the Form of a Broom, "sweepings,"* 1990, pencil, felt pen, crayon, watercolor, 11 × 8 $^1\!/_2$ in.; *Notebook Page: Street Sculpture in the Form of a Scoop, "rainy nite,"* 1990, pencil, felt pen, watercolor, 11 × 8 $^1\!/_2$ in.; *Apple Core – Summer,* 1990, lithograph, 41 × 31 $^1\!/_4$ in.; *Apple Core – Winter,* 1990, lithograph, 40 × 30 in.; *Geometric Apple Core, Study,* 1991, canvas and wood, painted with latex, 9 $^1\!/_2$ × 12 × 8 in.; *Notebook Page: Perfume Bottle – "breath," "heart," "lungs," Barcelona,* 1991, pencil and watercolor, 11 × 8 $^1\!/_2$ in.; *Notebook Page: Perfume Bottle, Blue, from Rear,* 1991, pencil and watercolor, 11 × 8 $^1\!/_2$ in.; *Notebook Page: Perfume Bottle, Yellow, from Rear,* 1991, pencil and watercolor, 8 $^1\!/_2$ × 5 $^3\!/_8$ in.; *Apple Core,* 1991, lithograph, 31 × 22 $^3\!/_4$ in.; *Notebook Page: Column Dressed as a Bottle of Perfume, Place Vendôme, Paris,* 1991, pencil and watercolor, 11 × 8 $^1\!/_2$ in.; *Notebook Page: Dried Apple Core,* 1992, pencil, crayon, watercolor, 11 × 8 $^1\!/_2$ in.; *Notebook Page: Perfume Bottle as Landscape and Architecture,* 1992, pencil and watercolor, 11 × 8 $^1\!/_2$ in.; *Notebook Page: Perfume Bottle with Yellow Spray, Falling,* 1992, pencil and watercolor, 11 × 8 $^1\!/_2$ in.; *Notebook Page: Reflections on a Scoop Shape,* 1992, felt pen and watercolor, 11 × 8 $^1\!/_2$ in.; *Notebook Page: Three Designs for a Perfume Bottle, "Monoprix,"* 1992, pencil and watercolor, 11 × 8 $^1\!/_2$ in.; *Perfume Bottle, Blue,* 1992, muslin, wood, clothesline, Dacron, coated with resin, on aluminum base, painted with latex, 12 $^1\!/_2$ × 9 $^1\!/_4$ × 34 $^3\!/_4$ in. on base $^1\!/_2$ × 8 × 30 in.; *Notebook Page: Perfume Bottle on a Pillow,* 1993, pencil and watercolor, 11 × 8 $^1\!/_2$ in.; *Golf Typhoon, First Study,* 1995, cardboard, felt, sand, polyurethane foam, wood, coated with resin and painted with latex, 19 $^3\!/_4$ × 6 × 6 in.; *Study for a Multiple: Apple Core,* 1995, expanded polystyrene, wood, canvas, painted with latex, 10 $^3\!/_4$ × 6 $^1\!/_2$ × 9 in.; *Study for a Multiple: Apple Core Slice,* 1995, expanded polystyrene, wood, paper, metal, clothesline, painted with latex, 23 $^1\!/_2$ × 19 × 7 $^1\!/_8$ in.; *Study for a Multiple: Metamorphic Apple Core,* 1995, expanded polystyrene, cardboard, wood, painted with latex, 13 $^1\!/_2$ × 10 $^3\!/_4$ × 2 $^3\!/_4$ in.; *Notebook Page: Apple Core Carved in a Tree,* 1996, pencil and watercolor, 10 $^7\!/_8$ × 8 $^3\!/_8$ in.; *Notebook Page: Apple Gazebo,* 1996, pencil and watercolor, 10 $^7\!/_8$ × 8 $^1\!/_2$ in.; *Proposal for a Sculpture in the Form of a Faucet and Shower Hose, for Stockholm Harbor,* 1997, pencil and pastel, 30 × 40 in.; *Study for Valentine Perfume,* 1997, pencil, colored pencil, chalk, watercolor, 23 × 18 in.; *Study for a Sculpture in the Form of a Perfume Bottle and Atomizer,* 1997, expanded polystyrene and wire painted with latex, 8 $^1\!/_4$ × 8 × 5 in.; *Elevation of Shuttlecock/Blueberry Pies, on Stairs,* 1997, pencil and colored pencil, 30 × 40 in.; *Proposal for a Sculpture in the Form of a Pan and Broom,* 1997, pencil and pastel, 30 × 40 in.; *Sphinx Fragments on a Playing Field,* 1997, pencil and pastel, 30 × 40 in.; *Blueberry Pie, Flying, Scale B* 1/3, 1998, cast aluminum and steel painted with latex, 33 × 25 $^1\!/_2$ × 18 in. on base $^3\!/_4$ × 14 × 14 in.; *Blueberry Pie, Flying, Scale C* I-VI 2/3, 1998, cast aluminum painted with acrylic polyurethane, 6 sculptures, each approx. 15 $^1\!/_2$ × 4 × 4 in.; *Sketchbook Page: Apple Aflame, in Boat (after J. V. and E. D.),* 1998, pencil and watercolor, 5 $^5\!/_{16}$ × 8 $^1\!/_4$ in.; *Typewriter Eraser, Model for Scale X,* 1998, aluminum and cast resin, painted with polyurethane enamel, 38 in. high on base $^3\!/_4$ × 24 × 31 in.; *Study for a Sculpture in the Form of a Broom and Pan with Sweepings,* 1998, pencil and colored pencil, 30 × 40 in.; *Dream Pin, Clasp,* 1999, steel and fiber-reinforced plastic painted with polyurethane enamel, on steel plate, 9 ft. $^{11}\!/_{16}$ in. × 7 ft. 11 in. × 1 ft. $^5\!/_{16}$ in.; *Golf Bag Ruin,* 1999, pencil and pastel, 35 × 49 $^1\!/_4$ in.; *Study for Plantoir – Back View,* 1999, pencil, 40 $^1\!/_8$ × 30 in.; *Study for Plantoir – Front View,* 1999, pencil, charcoal, pastel, 30 $^1\!/_4$ × 22 $^1\!/_4$ in.; *Study for Plantoir, Jardin des Tuileries, Paris,* 1999, pencil, colored pencil, watercolor, 12 × 9 $^3\!/_4$ in.; *Valentine Perfume* 1/2, 1999, cast aluminum painted with acrylic polyurethane, 46 $^1\!/_2$ × 25 × 20 in.; *Maquette for Plantoir* 2/2, 2000, aluminum and cast epoxy, painted with polyurethane enamel, 25 $^3\!/_4$ × 12 × 12 in.; *Plantoir* A.P., 2001, stainless steel, aluminum, fiber-reinforced plastic, painted with polyurethane enamel, 23 ft. 11 in. × 4 ft. 5 in. × 4 ft. 9 in.; *Scattered Pyramid of Pears and Peaches – Balzac/Pétanque, Model,* 2001, polyurethane foam, hardware cloth, canvas, coated with resin and painted with latex, variable height on area 53 $^1\!/_2$ × 89 in.; *Standing Soft Clarinet – Gray,* 2001, canvas coated with resin and painted with latex, 55 $^1\!/_8$ × 9 × 9 $^1\!/_2$ in.; *Soft Viola* 2/2, 2002, canvas, wood, polyurethane foam, coated with resin and painted with latex, clothesline, hardware, 8 ft. 8 in. × 5 ft. × 1 ft. 10 in.

—— Claes Oldenburg Drawings in the Whitney Museum of American Art (Claes Oldenburg Drawings, 1959-1977; Claes Oldenburg with Coosje van Bruggen: Drawings, 1992-1998), Whitney Museum of American Art, New York, June 6 – September 15. Curated by Janie C. Lee. Catalogue.

SOFT SHUTTLECOCKS,
FALLING, NUMBER TWO,
1995
WHITNEY MUSEUM OF
AMERICAN ART, NEW
YORK, PURCHASE, WITH
FUNDS FROM THE LAUDER
FOUNDATION, EVELYN
AND LEONARD LAUDER
FUND

Works exhibited: *Pat Reading in Bed, Lenox*, 1959, crayon, 14 × 16 $^1/_2$ in.; *Bicycle on Ground*, 1959, crayon, 12 × 17 $^5/_8$ in.; *Man and Woman Walking on Street – Woman in Front*, 1960, crayon, 13 $^{15}/_{16}$ × 11 $^{11}/_{16}$ in.; *Nude Figure with American Flag – "A B C HOORAY,"* 1960, ink and watercolor, 11 × 8 $^1/_2$ in.; *Street Scene – Man, Woman, TA*, 1960, pencil, 13 $^7/_8$ × 16 $^5/_8$ in.; *Study for the Poster, "New Media – New Forms," Martha Jackson Gallery*, 1960, pencil, crayon, ink, watercolor, collage, 13 $^1/_2$ × 9 $^{15}/_{16}$ in.; *Suggested Design for a Brochure Announcing "Ray Gun" Show at the Judson Gallery*, 1960, crayon, pencil, pastel, typescript, 8 $^9/_{16}$ × 10 $^{13}/_{16}$ in.; *Sex Act*, 1961, crayon and watercolor, 8 $^1/_2$ × 10 $^3/_4$ in.; *Silver Torso with Brown Underwear*, 1961, enamel on newspaper, 22 $^1/_8$ × 15 $^3/_8$ in.; *Store Window – Man's Shirt, Mannekin Torso, 39 – On Fragment*, 1961, crayon and watercolor, irregular dimensions: 18 × 21 in.; *Store Window – Yellow Shirt, Red Bow Tie*, 1961, crayon and watercolor, 11 $^{13}/_{16}$ × 17 $^1/_2$ in.; *Newspaper Stocking Against Newspaper Ads – "CHROMEQUEEN,"* 1962, ink, watercolor, collage on newspaper, 15 × 10 $^3/_4$ in.; *Sketch for a Soft Sculpture in the Form of a Cake Wedge – Woman for Scale*, 1962, crayon and watercolor, 11 × 13 $^{11}/_{16}$ in.; *Biplane*, 1963, ink, 8 $^1/_2$ × 10 $^7/_8$ in.; *Dressing Table*, 1963, crayon and watercolor, 13 $^3/_4$ × 11 in.; *Icebox*, 1963, crayon, pencil, watercolor, 13 $^3/_4$ × 11 $^1/_{16}$ in.; *Material and Scissors*, 1963, ballpoint pen and watercolor, 10 $^{15}/_{16}$ × 8 $^1/_2$ in.; *Study for Announcement for One-Man Show at Dawn Gallery – Mickey Mouse with Red Heart*, 1963, crayon and watercolor, 17 × 14 in.; *Study for the Poster "4 Environments," Sidney Janis Gallery – "THE HOME,"* 1963, crayon and watercolor, 23 $^1/_2$ × 17 $^1/_2$ in.; *Study for Zebra Chair – Bedroom Ensemble*, 1963, chalk, colored pencil, spray enamel, watercolor, tape, 26 × 40 in.; *A Toilet*, 1964, pencil, colored pencil, watercolor, 17 $^3/_4$ × 23 $^3/_8$ in.; *Plan for a Sculpture in the Form of Wall Switches*, 1964, pencil, ballpoint pen, crayon, wash, collage, 29 × 23 $^5/_8$ in.; *Study for a Sculpture in the Form of a Vacuum Cleaner*, 1964, pencil, crayon, ballpoint pen, watercolor, 23 $^{11}/_{16}$ × 18 $^3/_{16}$ in.; *Baked Potato, Thrown in Corner, Under Light Bulb*, 1965, crayon and watercolor, 18 × 12 in.; *Ketchup, Thick and Thin – from a N.Y.C. Billboard*, 1965, crayon and watercolor, 17 $^1/_2$ × 12 in.; *Proposed Colossal Monument for Central Park North, N.Y.C. – Teddy Bear*, 1965, crayon and watercolor, 23 $^7/_8$ × 18 $^7/_8$ in.; *Proposed Colossal Monument for Lower East Side – Ironing Board*, 1965, crayon and watercolor, 11 $^{15}/_{16}$ × 17 $^{11}/_{16}$ in.; *Proposed Colossal Monument for Park Avenue, N.Y.C. – Good Humor Bar*, 1965, pen and watercolor, 12 $^1/_8$ × 17 $^3/_4$ in.; *Sketch for a Soft Toilet*, 1965, crayon, pencil, watercolor, 11 $^{11}/_{16}$ × 9 in.; *Sketch of the Airflow, from a Snapshot (Front End)*, 1965, crayon, pencil, watercolor, 30 × 22 in.; *Study of a Silex Juicit*, 1965, pencil, colored pencil, crayon, watercolor, 30 $^1/_{16}$ × 22 $^1/_8$ in.; *Study of Fan Blades*, 1965, pencil, crayon, spray enamel, 41 $^3/_4$ × 39 $^1/_2$ in.; *Proposed Colossal Monument for Ellis Island – Shrimp*, 1965, crayon and watercolor, 11 $^{15}/_{16}$ × 15 $^{15}/_{16}$ in.; *The Airflow – Top and Bottom, Front, Back and Sides, to be Folded into a Box (Study for Cover of Art News)*, 1965, (mounted and re-signed 1972), ballpoint pen, watercolor, collage, 17 $^1/_4$ × 17 $^7/_8$ in.; *Study for a Soft Sculpture in the Form of an Airflow Instrument Panel, Wheel, Gearshift, Etc.*, 1965 (signed 1967), crayon and watercolor, 29 $^7/_8$ × 22 in.; *Banana*, 1966, crayon and watercolor, 7 $^{13}/_{16}$ × 5 in.; *"Capric" – Adapted to a Monument for a Park*, 1966, crayon and watercolor,

22 $^1/_4$ × 30 in.; *Proposal for Monument in a London Park in the Form of an Electric Shaver, with Cord*, 1966, crayon and watercolor, 22 $^1/_{16}$ × 14 $^{15}/_{16}$ in.; *Proposed Colossal Monument for Toronto – Drainpipe, View from Lake*, 1966, crayon and watercolor, 17 $^{13}/_{16}$ × 23 $^5/_8$ in.; *Soft Drainpipe*, 1966, crayon and watercolor, 18 $^1/_8$ × 14 $^{15}/_{16}$ in.; *Various Positions of a Giant Lipstick to Replace the Fountain of Eros, Piccadilly Circus, London*, 1966, crayon and watercolor, 18 × 24 in.; *Base of a Colossal Drainpipe Monument, Toronto, with Waterfall*, 1967, pencil and watercolor, 24 × 22 in.; *Drainpipe – Dream State*, 1967, pencil and crayon, 29 $^{15}/_{16}$ × 22 $^1/_4$ in.; *Looking up Two Girls at Expo '67, Looking at a Giant Baseball Bat, in Fuller Sphere*, 1967, pencil and colored pencil, 30 × 22 $^1/_{16}$ in.; *Notebook Page: Colossal Boots at the End of Navy Pier, Chicago*, 1967, ballpoint pen, felt pen, clipping, 10 $^3/_4$ × 8 $^1/_4$ in.; *Nude with Electric Plug*, 1967, pencil, colored pencil, watercolor, 39 $^7/_8$ × 26 $^1/_{16}$ in.; *Proposal for a Skyscraper in the Form of a Basketball Backstop with Ball in Net*, 1967, crayon, pencil, watercolor, 9 $^3/_4$ × 9 in.; *Proposed Colossal Monument for End of Navy Pier, Chicago: Bed – Table Lamp*, 1967, crayon and watercolor, 13 $^5/_8$ × 11 in.; *Proposed Colossal Underground Monument – Drainpipe*, 1967, crayon, pencil, colored pencil, watercolor, spray enamel, collage, 30 $^1/_4$ × 21 $^{15}/_{16}$ in.; *Small Monument for a London Street – Fallen Hat (for Adlai Stevenson)*, 1967, pencil, colored pencil, watercolor, 23 $^1/_4$ × 32 in.; *Small Monument for a London Street – Fallen Hat (for Adlai Stevenson)*, 1967, pencil, crayon, watercolor, 15 $^1/_2$ × 22 in.; *Study for a Memorial to Clarence Darrow in the Lagoon of Jackson Park, Chicago: Rising Typewriter – Showing Stages*, 1967, crayon and watercolor, 13 $^{15}/_{16}$ × 16 $^3/_4$ in.; *Study for a Soft Sculpture in the Form of a Giant Lipstick*, 1967, crayon, pencil, watercolor, 29 $^7/_8$ × 22 $^1/_4$ in.; *Design for a Police Building Using the Word "POLICE,"* 1968, pencil, 22 × 30 in.; *Giant Fireplug Sited in the Civic Center, Chicago*, 1968, crayon, ballpoint pen, watercolor, 10 $^{15}/_{16}$ × 8 $^7/_{16}$ in.; *Museum Design Based on a Cigarette Package*, 1968, pencil, 21 $^{15}/_{16}$ × 30 in.; *Proposal for a Skyscraper in the Form of a Chicago Fireplug*, 1968, crayon and watercolor, 13 $^1/_2$ × 10 $^3/_4$ in.; *Proposal for a Tomb in the Form of a Giant Punching Bag – with Obelisk*, 1968, crayon, 11 × 13 $^3/_4$ in.; *Proposed Colossal Monument for the End of Navy Pier, Chicago: Fireplug – Two Views*, 1968, pencil, 30 × 22 in.; *Smoke Studies During the Burning of Chicago*, 1968, pencil, ballpoint pen, spray enamel, collage, 8 $^1/_2$ × 11 in.; *Study of a Chicago Fireplug, Upside Down*, 1968, pencil and colored pencil, 19 $^3/_4$ × 21 $^3/_4$ in.; *Study of a Nose*, 1968, crayon, 29 $^7/_8$ × 22 in.; *Two Fagends Together, I*, 1968, pencil, 30 × 22 in.; *Two Fagends Together II*, 1968, crayon and watercolor, 13 $^{11}/_{16}$ × 10 $^{15}/_{16}$ in.; *The Letters "L" and "O" in Landscape*, 1968, crayon, colored pencil, pencil, watercolor, 9 $^3/_{16}$ × 13 $^{11}/_{16}$ in.; *Giant Ice Bag Cross Section, View II, New Haven*, 1969, pencil, ink, felt pen, colored pencil, spray enamel, watercolor, 22 $^1/_2$ × 28 $^1/_2$ in.; *Soft Fireplug*, 1969, crayon and watercolor, 13 $^5/_8$ × 11 in.; *Study for Feasible Monument: Lipstick, Yale*, 1969, pencil, colored pencil, spray enamel, 16 $^5/_8$ × 11 $^1/_8$ in.; *Study of a Soft Fireplug, Inverted*, 1969, pencil, 26 $^3/_4$ × 22 in.; *Typewriter Erasers – Position Studies*, 1970,

colored pencil and watercolor, 14 $^3/_8$ × 11 $^3/_8$ in.; *Proposal for a Cathedral in the Form of a Colossal Faucet, Lake Union, Seattle,* 1972, pencil, colored pencil, crayon, watercolor, 29 × 22 $^7/_8$ in.; *Typewriter Eraser,* 1977, crayon and watercolor, 16 $^1/_2$ × 11 in.; *Clarinet Bridge,* 1992, charcoal, 37 $^3/_4$ × 50 in.; *Notebook Page: Clarinet Adapted to the Form of a Bridge,* 1992, felt pen and clipping, 8 $^1/_2$ × 11 in.; *Notebook Page: Study for a House on the Shore of a Lake in the Form of a Blueberry Pie à la Mode,* 1992, pencil and watercolor, 11 × 8 $^1/_2$ in.; *Perfume Bottle, Fallen,* 1992, charcoal, 25 $^3/_4$ × 39 $^3/_8$ in.; *Perfume Bottle, Fallen,* 1992, charcoal, 25 $^3/_4$ × 37 $^3/_4$ in.; *Notebook Page: Shuttlecock Sculpture Studies,* 1993, pencil, colored pencil, watercolor, 11 × 8 $^1/_2$ in.; *Notebook Page: Shuttlecock Sculpture Studies – "Am. Earheart,"* 1993, pencil and colored pencil, 11 × 8 $^1/_2$ in.; *Notebook Page: Saw-Tie,* 1994, pencil and watercolor, 11 × 8 $^1/_2$ in.; *Notebook Page: Soft Shuttlecock, One Feather Elevated,* 1994, pencil and colored pencil, 11 × 8 $^1/_2$ in.; *Notebook Page: Soft Shuttlecock, Spread on a Field,* 1994, pen-

cil and colored pencil, 11 × 8 $^1/_2$ in.; *Notebook Page: Study for a Colossal Sculpture of a Woman's Legs, Running,* 1994, felt pen, pencil, watercolor, 11 × 8 $^1/_2$ in.; *Notebook Page: Study for a Colossal Sculpture of a Woman's Legs, Walking, for Michigan Avenue, Chicago,* 1994, ballpoint pen and clipping, 11 × 8 $^1/_2$ in.; *Notebook Page: Variations on a Sculpture in the Form of a Saw,* 1994, pencil, 11 × 8 $^1/_2$ in.; *Proposal for a Sculpture in the Form of a Saw, Sawing,* 1994, pencil, colored pencil, crayon, 40 × 30 in.; *Soft Shuttlecock, Raised,* 1994, pencil and pastel, 39 $^3/_{16}$ × 27 $^1/_2$ in.; *Soft Shuttlecocks Falling, Number Two,* 1995, pencil, pastel, charcoal, 27 $^1/_4$ × 39 $^1/_4$ in.; *Blueberry Pie à la Mode, Sliding Down a Hill,* 1996, charcoal and pastel, 39 $^1/_2$ × 30 $^1/_8$ in.; *Notebook Page: Island in the Form of a Blueberry Pie à la Mode,* 1996, pencil and watercolor, 11 × 8 $^1/_2$ in.; *Blueberry Pie Island,* 1998, pencil and pastel, 30 × 38 $^3/_4$ in.; *Dream Pin,* 1998, pencil, colored pencil, pastel, 40 × 30 $^3/_{16}$ in.

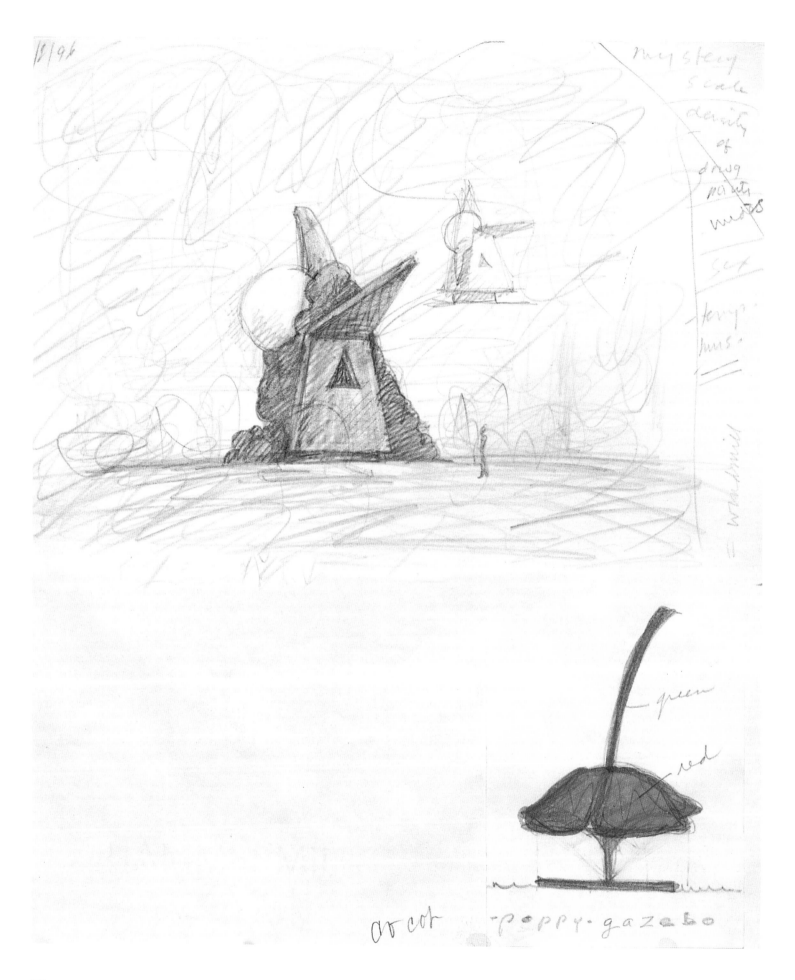

Previous page:

Notebook Page:
Gazebos in the Form
of a Blueberry Pie à la
Mode and a Poppy, 1996

Notebook Page:
Château Marmont as
Caviar/Avocado
Mousse, Los Angeles,
1991

2003

—— Claes Oldenburg and Coosje van Bruggen, Notebook Pages: A Dialogue, The Chinati Foundation, Marfa, Texas, October 11, 2003 – May 30, 2004.

Works exhibited: *Notebook Page: Sculpture in the Form of a Sneaker Lace*, 1978, pencil, colored pencil, felt pen, clipping, 11 × 8 ¹/₂ in.; *Notebook Page: Model of the Screwarch Bridge*, 1979, crayon, ballpoint pen, felt pen, watercolor, 11 × 8 ¹/₂ in.; *Notebook Page: Cross Section of Toothbrush in Glass, "Sun Dial,"* 1980, ballpoint pen, felt pen, pencil, colored pencil, 11 × 8 ¹/₂ in.; *Notebook Page: Half Button*, 1980, pencil and Polaroid photograph, 11 × 8 ¹/₂ in.; *Studies for Hat in Three Stages of Landing*, 1980, pencil, 11 × 8 ¹/₂ in.; *Variations on a Cowboy Hat, "=saddle,"* 1980, pencil and clippings, 11 × 8 ¹/₂ in.; *Spitzhacke along the Fulda River*, 1981, pencil, felt pen, crayon, 11 × 8 ¹/₂ in.; *Coosje's Idea to Place the Stake and Rope Inside the Dallas Museum of Art*, 1982, pencil, crayon, felt pen, 11 × 8 ¹/₂ in.; *Notebook Page: Spoon as a Bridge, for Vail, Colorado*, 1982, pencil, 11 × 8 ¹/₂ in.; *Studies for Sculpture in the Form of a Stake with Rope*, 1982, pencil, 11 × 8 ¹/₂ in.; *Notebook Page: Basketball in Net, on a Cliff Overlooking the Pacific Ocean*, 1983, pencil, colored pencil, ballpoint pen, watercolor, 11 × 8 ¹/₂ in.; *Notebook Page: First Sketch for a Sculpture in the Form of a Swiss Army Knife, with Other Subjects, Skate, Balloon, etc., Freiburg-im-Breisgau, Germany*, 1983, ballpoint pen and pencil, 11 × 8 ¹/₂ in.; *Notebook Page: Large Sculpture in the Form of a Swiss Army Knife – for Brüglinger Park, Basel, Switzerland*, 1983, crayon, felt pen, colored pencil, watercolor, 11 × 8 ¹/₂ in.; *Notebook Page: Residence in the Shape of a Sliced Banana, with Garage*, 1983, ballpoint pen and watercolor, 11 × 8 ¹/₂ in.; *Notebook Page: Sculpture in the Form of Jacks Composed of Tools*, 1983, pencil and watercolor, 11 × 8 ¹/₂ in.; *Notebook Page: Swiss Army Knife on a Site in the City of Basel, with Paperclips, Thumbtacks – "tram (green and shiny) = knife (red and shiny),"* 1983, ballpoint pen, felt pen, pencil, 11 × 8 ¹/₂ in.; *Notebook Page: Swiss Army Knife: Different Situations in Merian Park and the City of Basel*, 1983, ballpoint pen, pencil, colored pencil, watercolor, 11 × 8 ¹/₂ in.; *Stake Hitch: Studies for the Stake*, 1983, pencil, crayon, felt pen, watercolor, 11 × 8 ¹/₂ in.; *Studies for a Sculpture Using Thumbtacks and Paper Clips*, 1983, pencil, ballpoint pen, felt pen, 11 × 8 ¹/₂ in.; *Notebook Page: Events for Il Corso del Coltello*, 1984, pencil, 11 × 8 ¹/₂ in.; *Notebook Page: Prop for Il Corso del Coltello: Ball of Belongings Stuck Between Houses*, 1984, felt pen and watercolor, 10 ¹⁵/₁₆ × 7 ⁷/₈ in.; *Notebook Page: Prop for Il Corso del Coltello: Whittled Column*, 1984, felt pen, 10 ¹⁵/₁₆ × 7 ¹⁵/₁₆ in.; *Fountain in the Form of a Dropped Plate of Orange Slices*, 1985, pencil and felt pen, 11 × 8 in.; *Notebook Page: Costume for Il Corso del Coltello: Chateaubriand*, 1985, pencil on photocopy, 11 × 8 ¹/₂ in.; *Notebook Page: Costume for Il Corso del Coltello: D'Artagnan*, 1985, ballpoint pen and felt pen, 11 × 8 ¹/₂ in.; *Notebook Page: Costume for Il Corso del Coltello: Frankie P. Toronto*, 1985, pencil, photocopy, collage, 11 × 8 ¹/₂ in.; *Notebook Page: Costume for Il Corso del Coltello: Georgia Sandbag with Mule's Head*, 1985, ballpoint pen and felt pen, 11 × 8 ¹/₈ in.; *Notebook Page: Costume for Il Corso del Coltello: Longshoreman*, 1985, pencil, ballpoint pen, felt pen, 11 × 8 ¹/₂ in.; *Notebook Page: Costume for Il Corso del Coltello: Robe of Primo Sportycuss*, 1985, ballpoint pen, pencil, felt pen, 11 × 8 ¹/₂ in.; *Notebook Page: Costume for Il Corso del Coltello: Waiter*, 1985, pencil, felt pen,

collage, 11 × 8 $^7/_{16}$ in.; *Notebook Page: Costume Studies for Il Corso del Coltello: Leading Characters*, 1985, ballpoint pen, pencil, colored pencil, felt pen, 8 $^1/_2$ × 11 in.; *Notebook Page: Costume Studies for Il Corso del Coltello: Students and Washers*, 1985, ballpoint pen, felt pen, pencil, 8 $^1/_2$ × 11 in.; *Notebook Page: Dr. Coltello Costume: Hats and Other Souvenirs on Cape*, 1985, ballpoint pen, 11 × 8 $^1/_2$ in.; *Notebook Page: Menu for Il Corso del Coltello: Asparagi Carambola*, 1985, ballpoint pen and felt pen, 11 × 8 $^1/_8$ in.; *Notebook Page: Menu for Il Corso del Coltello: Farfalle de Busboys*, 1985, ballpoint pen and felt pen, 8 $^1/_8$ × 11 in.; *Notebook Page: Menu for Il Corso del Coltello: Filetto alla Donna Leopardo*, 1985, ballpoint pen and felt pen, 8 $^1/_2$ × 11 in.; *Notebook Page: Menu for Il Corso del Coltello: Obelisco Vegetariano*, 1985, ballpoint pen and felt pen, 8 $^1/_8$ × 11 in.; *Notebook Page: Prop for Il Corso del Coltello – Blades Cutting Out of Box*, 1985, felt pen and watercolor, 7 $^7/_8$ × 10 $^{15}/_{16}$ in.; *Orange Peel*, 1985, felt pen, 11 × 8 $^1/_2$ in.; *Notebook Page: Costume for Il Corso del Coltello: Sleazy Dora, with Inner Tube*, 1986, felt pen and watercolor, 12 × 9 in.; *Notebook Page: Costume for Il Corso del Coltello: Sleazy Dora: Dancing with Paddle*, 1986, felt pen and watercolor, 10 $^7/_8$ × 8 $^7/_{16}$ in.; *Notebook Page: Knäckebröd/Iron*, 1986, ballpoint pen, pencil, felt pen, napkin, photocopy, collage, 11 × 8 $^1/_8$ in.; *Notebook Page: Sculptures in the Form of Nails Projecting into a Room*, 1986, pencil and colored pencil, 11 × 8 $^1/_2$ in.; *Notebook Page: Apple Stalks and Lips*, 1987, clippings, 11 × 8 $^1/_2$ in.; *Notebook Page: Hut in the Woods in the Form of Rip van Winkle's Rifle*, 1987, pencil, felt pen, crayon 11 × 8 $^1/_2$ in.; *Notebook Page: Sculpture in the Form of a Lying Match with Flame*, 1987, felt pen, 11 × 8 $^1/_2$ in.; *Notebook Page: Studies for a Sculpture on an Office Building Terrace, Boston, Massachusetts*, 1987, pencil and watercolor, 11 × 8 $^1/_2$ in.; *Notebook Page: Studies for the Haunted House: Boot, Eaten Apple Core, Old Shoe, etc.*, 1987, felt pen, pencil, colored

pencil, 11 × 8 $^1/_2$ in.; *Notebook Page: Whittled Column*, 1987, ballpoint pen and felt pen, 11 × 8 $^1/_2$ in.; *Studies for Sculptures: Woman's Shoe, Shuttlecock*, 1987, pencil and felt pen, 11 × 8 $^1/_2$ in.; *Notebook Page: "NAIVE, Alps,"* 1988, pencil, colored pencil, ballpoint pen, 11 × 8 $^1/_2$ in.; *Notebook Page: Bottle of Ink and Quill, in Side, with Blot – "Leonardo,"* 1988, pencil, colored pencil, watercolor, collages, staples, 11 × 8 $^1/_2$ in.; *Notebook Page: Colossal Sculpture in the Form of a Woman's Shoe*, 1988, felt pen, pencil, watercolor, 11 × 8 $^1/_2$ in.; *Notebook Page: Colossal Sign for the Alps: EVIAN, Reversed*, 1988, pencil and watercolor, 11 × 8 $^1/_2$ in.; *Notebook Page: Sculpture Combining an Elephant Head, Outboard Motor, and Pistol*, 1988, felt pen, pencil, pastel, watercolor, 11 × 8 $^1/_2$ in.; *Notebook Page: Skyscraper for Cleveland, Ohio: Upended Bag with Spilling Contents – Version One*, 1988, ballpoint pen, 11 × 8 $^1/_2$ in.; *Notebook Page: Skyscraper for Cleveland, Ohio: Upended Bag with Spilling Contents – Version Two*, 1988, ballpoint pen, 11 × 8 $^1/_2$ in.; *Study for a Poster: Dropped Bowl with Scattered Slices and Peels*, 1988, ballpoint pen, colored pencil, felt pen, 11 × 8 $^1/_2$ in.; *Notebook Page: Apple Core Stages*, 1989, pencil and watercolor, 11 × 8 $^1/_2$ in.; *Notebook Page: Civic Sculpture in the Form of a Canapé of Pretzels and Cheese*, 1989, pencil, ballpoint pen, watercolor, 11 × 8 $^1/_2$ in.; *Notebook Page: Exploding Ink Bottle and Traveling Stamp Blotter*, 1989, pencil and watercolor, 9 $^3/_8$ × 7 $^7/_{16}$ in.; *Notebook Page: Golf Club Related to Landscape*, 1989, pencil, ballpoint pen, watercolor, 11 × 8 $^1/_2$ in.; *Notebook Page: Shattering Ink Bottle*, 1989, felt pen, pencil, watercolor, 11 × 8 $^1/_2$ in.; *Notebook Page: Studies of Broom Shapes*, 1989, pencil, felt pen, watercolor, 11 × 8 $^1/_2$ in.; *Notebook Page: Study for a Sculpture in the Form of a Quill Stuck in Solidified Ink*, 1989, pencil and watercolor, 9 $^7/_{16}$ × 7 $^1/_2$ in.; *Notebook Page: Study for an Equestrian Monument*, 1989, pencil, felt pen, colored pencil, watercolor, 11 × 8 $^1/_2$ in.; *Notebook Page: Study for Drawing of*

Quill and Shattering Ink Bottle, with Comments, 1989, felt pen and pencil, 11 × 8 ¹/₂ in.; *Notebook Page: Color Notes for The European Desktop*, 1990, felt pen and watercolor, 10 ¹⁵/₁₆ × 8 ⁵/₁₆ in.; *Notebook Page: Objects of The European Desktop, Falling on a Desktop Landscape (after Quote by Leonardo da Vinci)*, 1990, pencil and watercolor, 9 ³/₈ × 7 ⁷/₁₆ in.; *Notebook Page: Parts of The European Desktop Falling from the Sky – Original for Announcement*, 1990, pencil, watercolor, photocopy, 8 ¹/₄ × 10 ⁷/₈ in.; *Notebook Page: Stamp Blotter from Above, with Blots*, 1990, ink, colored pencil, pencil, collage, 10 ¹³/₁₆ × 8 ¹/₄ in.; *Notebook Page: Street Sculpture in the Form of a Scoop, "rainy nite,"* 1990, pencil, felt pen, watercolor, 11 × 8 ¹/₂ in.; *Notebook Page: Studies for a Sculpture in the Form of a Collapsing European Postal Scale*, 1990, pencil, 11 × 8 ¹/₂ in.; *Notebook Page: Studies for a Sculpture in the Form of a European Postal Scale*, 1990, pencil and watercolor, 10 ⁵/₈ × 8 in.; *Notebook Page: Studies for Sculptures: Envelope with Letter, Piano Keys, and Shoelaces*, 1990, pencil, felt pen, watercolor, 11 × 8 ¹/₂ in.; *Notebook Page: Study for The European Desktop – Script over Fragments of the Desk Pad*, 1990, pencil and watercolor, 10 ⁷/₁₆ × 8 ¹/₁₆ in.; *Notebook Page: The European Desktop, Seen from Below*, 1990, pen and watercolor, 8 ⁷/₈ × 6 ⁹/₁₆ in.; *Notebook Page: Apple on Fork, "= C.U.,"* 1991, pencil and watercolor, 11 × 8 ¹/₂ in.; *Notebook Page: Assorted Perfume Bottles*, 1991, pencil and watercolor, 11 × 8 ¹/₂ in.; *Notebook Page: Colossal Monument in the Form of a Man's Tie, to Encircle the Musée d'Art Moderne, Luxembourg*, 1991, pencil and watercolor, 11 × 8 ¹/₂ in.; *Notebook Page: Garden Sculpture in the Form of a Madeleine Dipped in Tea*, 1991, pencil and watercolor, 11 × 8 ¹/₂ in.; *Notebook Page: Inverted Collar and Tie with the Top of the Woolworth Building*, 1991, pencil and watercolor, 11 × 8 ¹/₂ in.; *Notebook Page: Perfume Bottle, Blue, from Rear*, 1991, pencil and watercolor, 11 × 8 ¹/₂ in.; *Notebook Page: Perfume Bottle, Yellow, from Rear*, 1991, pencil and watercolor, 11 × 8 ¹/₂ in.; *Notebook Page: Various Shapes of Perfume Bottles*, 1991, pencil, felt pen, watercolor, 11 × 8 ¹/₂ in.; *Tie Fountain, Two Positions*, 1991, pencil, 11 × 8 ¹/₂ in.; *Flying Matches I*, 1991, pencil and watercolor, 7 ⁵/₈ × 5 in.; *Flying Matches II*, 1991, pencil and watercolor, 7 ⁵/₈ × 5 in.; *Flying Matches III*, 1991, pencil and watercolor, 7 ⁹/₁₆ × 5 in.; *Flying Matches IV*, 1991, pencil and watercolor, 7 ⁵/₈ × 5 in.; *Notebook Page: Broom Ties*, 1992, pencil and watercolor, 11 × 8 ¹/₂ in.; *Notebook Page: Cap and Tie Atop West End Str. I, Frankfurt am Main, Germany*, 1992, pencil, colored pencil, watercolor, 11 × 8 ¹/₂ in.; *Notebook Page: Design for a Perfume Bottle, "M-Prix,"* 1992, pencil, colored pencil, watercolor, 11 × 8 ¹/₂ in.; *Notebook Page: Dried Apple Core*, 1992, pencil, crayon, watercolor, 11 × 8 ¹/₂ in.; *Notebook Page: Fountain in the Form of a Soft Saxophone – Cross Section*, 1992, pencil and watercolor, 11 × 8 ¹/₂ in.; *Notebook Page: Perfume Bottle as Landscape and Architecture*, 1992, pencil and watercolor, 11 × 8 ¹/₂ in.; *Notebook Page: Perfume Bottle on Chair Leg*, 1992, pencil and watercolor, 11 × 8 ¹/₂ in.; *Notebook Page: Perfume Bottle with Yellow Spray, Falling*, 1992, pencil and watercolor, 11 × 8 ¹/₂ in.; *Notebook Page: Perfume Bottle, Off Shelf*, 1992, pencil and watercolor, 11 × 8 ¹/₂ in.; *Notebook Page: Reflections on a Scoop Shape*, 1992, felt pen and watercolor, 11 × 8 ¹/₂ in.; *Notebook Page: Perfume Bottle on a Pillow*, 1993, pencil and watercolor, 11 × 8 ¹/₂ in.; *Notebook Page: Quartered Apple Core*, 1993, pencil, colored pencil, pastel, 11 × 8 ¹/₂ in.; *Notebook Page: Sculpture in the Form of a Fork with Meatball and Spaghetti*, 1993, pencil, colored pencil, watercolor, 11 × 8 ¹/₂ in.; *Notebook Page: Saw-Tie*, 1994, pencil and colored pencil, 11 × 8 ¹/₂ in.; *Notebook Page: Saw Typhoon*, 1994, crayon, pencil, watercolor, 11 × 8 ¹/₂ in.; *Notebook Page: Sculpture in the Form of a Freestanding Pocket, with Handkerchief*, 1994, pencil, 11 × 8 ¹/₂ in.; *Notebook Page: Shuttlecock Sphinx – First Study*, 1994, pencil and watercolor, 11 ×

SKETCHBOOK PAGE:
APPLE AFLAME, IN BOAT
(AFTER J. V. AND E. D.),
1998

after Delacroix

8 ¹/₂ in.; *Notebook Page: Soft Shuttlecock – Position Studies*, 1994, pencil and colored pencil, 11 × 8 ¹/₂ in.; *Notebook Page: Soft Shuttlecock – Studies for an Outdoor Site*, 1994, pencil and watercolor, 11 × 8 ¹/₂ in.; *Notebook Page: Soft Shuttlecock in the Rotunda of the Guggenheim Museum, New York*, 1994, pencil, colored pencil, watercolor, 11 × 8 ¹/₂ in.; *Notebook Page: Soft Shuttlecock Studies*, 1994, pencil and watercolor, 11 ¹/₁₆ × 8 ¹/₂ in.; *Notebook Page: Soft Shuttlecocks, Lying*, 1994, pencil and colored pencil, 11 × 8 ⁹/₁₆ in.; *Notebook Page: Proposal for the Rotunda of the Guggenheim Museum, New York: Fallen Teddy Bear, on Pillow*, 1995, pencil and colored pencil, 11 × 8 ¹/₂ in.; *Notebook Page: Tower of Balancing Ice Cream Cones*, 1995, pencil and watercolor, 11 × 8 ¹/₂ in.; *Notebook Page: Wedding Anniversary Greetings*, 1995, felt pen and watercolor, 11 × 8 ¹/₂ in.; *Notebook Page: Apple Core Carved in a Tree*, 1996, pencil and watercolor, 10 ⁷/₈ × 8 ³/₈ in.; *Notebook Page: Apple Gazebo*, 1996, pencil and watercolor, 10 ⁷/₈ × 8 ¹/₂ in.; *Notebook Page: Bridge in the Form of Two Hammers, "Bilbao,"* 1996, pencil, felt pen, watercolor, 10 ¹⁵/₁₆ × 8 ¹/₂ in.; *Notebook Page: Dropped Blueberry Pie à la Mode*, 1996, pencil and watercolor, 11 × 8 ¹/₂ in.; *Notebook Page: Flying Pizzas*, 1996, pencil and colored pencil, 11 × 8 ¹/₂ in.; *Notebook Page: Folly in the Form of a Golf Bag Ruin*, 1996, ballpoint pen and colored pencil, 11 × 8 ¹/₂ in.; *Notebook Page: Gazebos in the Form of a Blueberry Pie à la Mode and a Poppy*, 1996, pencil, colored pencil, watercolor, 11 × 8 ¹/₂ in.; *Notebook Page: Giant Asparagus in Landscape*, 1996, pencil and watercolor, 11 × 8 ¹/₂ in.; *Notebook Page: Houseball with Fallen Teddy Bear*, 1996, pencil, colored pencil, watercolor, 11 × 8 ¹/₂ in.; *Notebook Page: Items for Reference: Goethe's Wheel of Color, Hanging Skirt with Blots, Pizza Close-Up*, 1996, clippings, 11 × 8 ¹/₂ in.; *Notebook Page: Sandwich Cabaña*, 1996, pencil and watercolor, 11 × 8 ¹/₂ in.; *Notebook Page: Sculpture in the Form of a Beached Anchor, for Miami, Florida*, 1996, pencil, colored pencil, watercolor, 11 × 8 ¹/₂ in.; *Notebook*

Page: Sculpture in the Form of Stacked Ice Cream Sodas, 1996, pencil, ballpoint pen, colored pencil, watercolor, 11 × 8 ¹/₂ in.; *Notebook Page: Studies for Sculpture: Bacon, Lettuce, and Tomato Sandwich Rising, Blonde Wig*, 1996, pencil and watercolor, 11 × 8 ¹/₂ in.; *Notebook Page: Studies for Sculptures of Flying Blueberry Pies à la Mode*, 1996, pencil and watercolor, 11 × 8 ¹/₂ in.; *Notebook Page: Studies for Sculptures: Blueberry Pies à la Mode and Spilling Spoon*, 1996, pencil and watercolor, 11 × 8 ¹/₂ in.; *Notebook Page: Studies for Sculpture: Spilling Spoon and Pocket Handkerchief – On Wall*, 1996, 11 × 8 ¹/₂ in.; *Notebook Page: Study for a Print Commissioned by the Freud Foundation: Colossal Cigar, Cigar on Couch*, 1996, pencil and colored pencil, 11 × 8 ¹/₂ in.; *Notebook Page: Study for a Print Commissioned by the Freud Foundation: Icons in a Smoke-filled Room*, 1996, crayon and pencil, 11 × 8 ¹/₂ in.; *Notebook Page: Turner Galleon Compared to Rack of Toast*, 1996, clippings, 11 × 8 ¹/₂ in.; *Notebook Page: Opposing Hammers*, 1996, pencil and watercolor, 11 × 8 ¹/₂ in.; *Notebook Page: French Sausage Dispenser*, 1997, pencil and watercolor, 11 × 8 ¹/₂ in.; *Notebook Page: Sculpture in the Form of a Perfume Bottle*, 1997, pencil and watercolor, 11 × 8 ¹/₂ in.; *Notebook Page: Ice Cream Cone Display, Cologne, Germany*, 1998, snapshot collage, 11 × 8 ¹/₂ in.; *Sketchbook Page: Flying Pins in the Intersection of the John F. Kennedylaan, Fellenoord, and Prof. Dr. Dorgelolaan, Eindhoven*, 1998, pencil, colored pencil, watercolor, 5 ¹/₂ × 8 ¹/₄ in.; *Sketchbook Page: Flying Pins, Game of Life*, 1998, pencil and watercolor, 5 ¹/₂ × 8 ¹/₄ in.; *Sketchbook Page: Flying Pins, Pears and Peaches Pile Up*, 1998, pencil, 5 ¹/₂ × 8 ¹/₄ in.; *Notebook Page: Bacon Flag*, 2000, crayon and watercolor, 11 × 8 ¹/₂ in.; *Notebook Page: Apple Compared to Pétanque Ball*, 2001, clipping, 11 × 8 ¹/₂ in.; *Notebook Page: Colossal Monument in the Form of a C-clamp, for the Hudson River, New York City*, 2001, photocopy and watercolor, 11 × 8 ¹/₂ in.

—— CLAES OLDENBURG AND COOSJE VAN BRUGGEN: OBJECTS AND DRAWINGS, Grant Selwyn Fine Art, New York, October 17 – November 16.

Works exhibited: *Landscape with Lighthouse (Provincetown)*, 1960, scrap wood, 12 $^1/_2$ × 17 $^1/_2$ in.; *Store Ray Guns*, 1962, plaster painted with enamel, in wooden box with hinged doors, 26 $^3/_8$ × 22 $^1/_4$ × 4 $^5/_8$ in.; *Boxers in Box*, 1962, sailcloth, foam rubber and wood painted with enamel, 3 elements: each 16 × 18 × 1 in., box: 9 × 18 $^3/_4$ × 19 $^3/_4$ in.; *Proposed Colossal Monument for the Battery, N.Y.C. – Vacuum Cleaner, East River View*, 1965, crayon and watercolor, 12 × 17 $^3/_4$ in.; *Fan – Hard Model*, 1965-1966, cardboard, spray enamel, crayon, straight pins, 42 × 28 $^1/_2$ × 18 in.; *Fixture for a London Taxi: Interior Lamp in the Form of an Ear*, 1966, crayon, pencil, watercolor, 15 × 22 $^1/_{16}$ in.; *Lampette Monument on Building, for London, England*, 1966, crayon and watercolor, 14 $^7/_8$ × 22 $^1/_{16}$ in.; *Drainpipe Study*, 1967, crayon and watercolor, 30 × 22 $^1/_8$ in.; *Proposed Colossal Monument to Replace the Buckingham Fountain, Grant Park, Chicago: Breaking Plate of Scrambled Eggs, View from Above*, 1967, crayon, pencil, watercolor, 22 × 30 in.; *Position Sketch, Fireplug Ad for Artforum*, 1969, crayon, pencil, colored pencil, watercolor, collage, 12 $^1/_8$ × 11 $^{15}/_{16}$ in.; *7-Up Pie, Pink Characters, Green Background*, 1972, crayon and chalk, 22 $^7/_8$ × 28 $^7/_8$ in.; *Proposal for a Feasible Monument in the Form of a Cap, on End, Akron*, 1973, crayon and chalk, 18 × 24 in.; *Standing Mitt with Ball in Greenwich Site – Back View*, 1973, crayon, chalk, watercolor, 14 × 20 in.; *Study for Bottle of Notes*, 1988, charcoal and pastel, 40 × 30 in.; *From the Entropic Library in a Later Stage #2*, 1990, charcoal and pastel, 29 $^1/_4$ × 39 $^3/_8$ in.; *Study for a Sculpture of a Torn Notebook*, 1992, charcoal and pastel, 29 × 23 in.; *Study for Valentine Perfume*, 1997, pencil, colored pencil, chalk, watercolor, 23 × 18 in.; *Tarte over Boule*, 1997, pencil and watercolor, 10 $^1/_2$ × 15 $^9/_{16}$ in.; *Tarte over Boule, Two Positions*, 1997, pencil and watercolor, 10 $^5/_8$ × 16 $^1/_8$ in.; *Blueberry Pie, Flying, Scale C* I-VI, 2/3, 1998, cast aluminum painted with acrylic polyurethane, 6 sculptures, each approx., 15 $^1/_2$ × 4 × 4 in.; *Elevation of the Cupid's Span, First Study, with Figure for Scale*, 1999, pencil and colored pencil, 17 $^7/_{16}$ × 30 $^1/_{16}$ in.; *Study for Plantoir – Back View*, 1999, pencil, 40 $^1/_8$ × 30 in.; *Study for Plantoir – Front View*, 1999, pencil, charcoal, pastel, 30 $^1/_4$ × 22 $^1/_4$ in.; *Study for Plantoir, Jardin des Tuileries, Paris*, 1999, pencil, colored pencil, watercolor, 12 × 9 $^3/_4$ in.; *Valentine Perfume* 1/2, 1999, cast aluminum painted with acrylic polyurethane, 46 $^1/_2$ × 25 × 20 in.; *Cupid's Span, Sited in Rincon Park, San Francisco*, 2000, pencil, colored pencil, pastel, 30 $^1/_2$ × 21 $^3/_4$ in.; *Leaf Boat, Sited in the Tuileries, Paris*, 2001, charcoal and pastel, 26 $^1/_{16}$ × 49 $^9/_{16}$ in.

FOLLOWING PAGE:
NOTEBOOK PAGE:
BANANA SPLIT, NEW
YORK, 1987
PRIVATE COLLECTION,
NEW YORK

NOTEBOOK PAGE: BLUE
FISH, NEW YORK, 1987
COURTESY PAULA COOPER
GALLERY, NEW YORK

NOTEBOOK PAGE:
MOZZARELLA DI BUFALA,
NEW YORK, 1987
COURTESY PAULA COOPER
GALLERY, NEW YORK

NOTEBOOK PAGE:
PARISPARAGUS, PARIS,
1989
COURTESY PAULA COOPER
GALLERY, NEW YORK

2004

—— IMAGES À LA CARTE, Paula Cooper Gallery, New York, April 24 – June 30. Book.

Works exhibited: *Banana Split, New York*, 1987, pencil and watercolor, 11 × 8 ¹/₂ in.; *Blue Fish, New York*, 1987, pencil and watercolor, 11 × 8 ¹/₂ in.; *Mozzarella di Bufala, New York*, 1987, pencil and watercolor, 11 × 8 ¹/₂ in.; *Profiteroles Imaginaires, New York*, 1987, pencil and watercolor, 11 × 8 ¹/₂ in.; *Shrimp Cocktail, Hamden, Connecticut*, 1987, pencil and watercolor, 11 × 8 ¹/₂ in.; *Taco Gasoline, Marfa, Texas*, 1987, felt pen, 11 × 8 ¹/₂ in.; *Tartuffo, Hamden, Connecticut*, 1987, pencil, felt pen, watercolor, 11 × 8 ¹/₂ in.; *Watermelon with Flies, Marfa, Texas*, 1987, felt pen, 11 × 8 ¹/₂ in.; *Apple Core, New York*, 1988, pencil and watercolor, 11 × 8 ¹/₂ in.; *Benno's Dessert, Amsterdam*, 1988, pencil, felt pen, watercolor, 11 × 8 ¹/₂ in.; *Chicken Liver Hors d'Œuvre, Minneapolis*, 1988, pencil, felt pen, watercolor, 11 × 8 ¹/₂ in.; *Cornbread and Cake Slice with Cherries, Minneapolis*, 1988, pencil, felt pen, watercolor, 11 × 8 ¹/₂ in.; *Hazelnut Ice Cream with Blueberries, Chester, Connecticut*, 1988, pencil, felt pen, watercolor, 11 × 8 ¹/₂ in.; *Hazelnut Tart, Minneapolis*, 1988, pencil, felt pen, watercolor, 11 × 8 ¹/₂ in.; *Kumamoto Oysters, Los Angeles*, 1988, pencil and watercolor, 11 × 8 ¹/₂ in.; *Orange Peel in the Name of My Love, New York*, 1988, pencil and felt pen, 11 × 8 ¹/₂ in.; *Pineapple Romanoff, Swansea, England*, 1988, pencil, felt pen, watercolor, 11 × 8 ¹/₂ in.; *Profiteroles – Coming and Going, New York*, 1988, pencil and watercolor, 11 × 8 ¹/₂ in.; *Sea Food Wrap, Minneapolis*, 1988, pencil and watercolor, 11 × 8 ¹/₂ in.; *Strawberry Cheesecake, Leeds, England*, 1988, ballpoint pen and watercolor, 11 × 8 ¹/₂ in.; *Study for Poster of Dropped Bowl, with Scattered Slices and Peels*, 1988, charcoal and pastel, 40 × 28 in.; *Chocolate Velour, Vinyl on the Side, New York*, 1989, pencil, ballpoint pen, watercolor, 11 × 8 ¹/₂ in.; *Colombi Appetizer, Freiburg-im-Breisgau*, 1989, pencil and watercolor, 11 × 8 ¹/₂ in.; *Duck with Olives – Before and After, New York*, 1989, pencil and water color, 11 × 8 ¹/₂ in.; *Écrevisse, Paris*, 1989, pencil and watercolor, 11 × 8 ¹/₂ in.; *"Feeling nicely decomposed," New York*, 1989, felt pen, pencil, watercolor, 11 × 8 ¹/₂ in.; *Flounder in Broth, New York*, 1989, pencil, watercolor, typescript, 11 × 8 ¹/₂ in.; *Green Tea Ice Cream, New York*, 1989, pencil and watercolor, 11 × 8 ¹/₂ in.; *Île Flottante, Paris*, 1989, pencil and watercolor, 11 × 8 ¹/₂ in.; *Maartje's Tempura, New York*, 1989, pencil and watercolor, 11 × 8 ¹/₂ in.; *Millefeuille with Strawberries, Malmö*, 1989, pencil, ballpoint pen, watercolor, 11 × 8 ¹/₂ in.; *Parisparagus, Paris*, 1989, pencil, colored pencil, watercolor, 11 × 8 ¹/₂ in.; *Paulus' Noodle Script, New York*, 1989, pencil and watercolor, 11 × 8 ¹/₂ in.; *Squeezed Lemon, New York*, 1989, pencil and watercolor, 11 × 8 ¹/₂ in.; *Lakkasorbetilla Täytetty Kotijäätelö, Tampere – Finland*, 1990, pencil, ballpoint pen, watercolor, 11 × 8 ¹/₂ in.; *Langoustine, Paris*, 1990, pencil and watercolor, 11 × 8 ¹/₂ in.; *Terrine, Utrecht*, 1990, pencil, felt pen, watercolor, 11 × 8 ¹/₂ in.; *Château Marmont as Caviar/Avocado Mousse, Los Angeles*, 1991, ballpoint pen, pencil, watercolor on sheet of hotel memo paper, 11 × 8 ¹/₂ in.; *Profiteroles Pyrénées, Barcelona*, 1991, pencil and watercolor, 11 × 8 ¹/₂ in.; *Pyrénées, Barcelona*, 1991, pencil and watercolor, 11 × 8 ¹/₂ in.; *Shrimp Cocktail, New Haven, Connecticut*, 1991, pencil, felt pen, watercolor, 11 × 8 ¹/₂ in.; *Slice of Pear Tart, New York*, 1991, pencil and watercolor, 11 × 8 ¹/₂ in.; *Lemon Slice on Ice, Paris*, 1992, pencil, felt pen, watercolor, 11 × 8 ¹/₂ in.; *Mil Hojas, Barcelona*, 1992, ballpoint pen, felt pen, watercolor, 11 × 8 ¹/₂ in.; *Blueberry Pie à la Mode, Sliding Down a Hill*, 1996, charcoal and pastel, 39 ⁵/₈ × 30 ³/₁₆ in.; *Blueberry Pie à la Mode, Tipped Up, and Spilling*, 1996, crayon and watercolor, 16 ¹/₈ × 10 ⁹/₁₆ in.; *House in the Form of a Blueberry Pie à la Mode – First Study*, 1996, pencil and watercolor, 9 ⁵/₈ × 7 in.; *Sketchbook Page: Blueberry Pie Transformations for J. V. – Blueberry Pie Island*, 1996, pencil and watercolor, 5 ⁷/₈ × 3 ¹⁵/₁₆ in.; *Sketchbook Page: Blueberry Pie Transformations for J. V. – Castaway, à la Mode*, 1996, pencil and watercolor, 5 ⁷/₈ × 3 ¹⁵/₁₆ in.; *Sketchbook Page: Blueberry Pie Transformations for J. V. – Cliff House, à la Mode*, 1996, pencil and watercolor, 5 ⁷/₈ × 3 ¹⁵/₁₆ in.; *Sketchbook Page: Blueberry Pie Transformations for J. V. – Dropped, à la Mode*, 1996, pencil and watercolor, 5 ⁷/₈ × 3 ¹⁵/₁₆ in.; *Sketchbook Page: Blueberry Pie Transformations for J. V. – On*

End, à la Mode, 1996, pencil and watercolor, 5 $^7/_8$ × 3 $^{15}/_{16}$ in.; *Sketchbook Page: Blueberry Pie Transformations for J. V. – Sliding, à la Mode,* 1996, pencil and watercolor, 5 $^7/_8$ × 3 $^{15}/_{16}$ in.; *Sketchbook Page: Blueberry Pie Transformations for J. V. – Chair, à la Mode,* 1996, pencil and watercolor, 5 $^7/_8$ × 3 $^{15}/_{16}$ in.; *Sketchbook Page: Blueberry Pie Transformations for J. V. – Folded, à la Mode,* 1996, pencil and watercolor, 3 $^{15}/_{16}$ × 5 $^7/_8$ in.; *Sketchbook Page: Blueberry Pie Transformations for J. V. – Terrace House,* 1996, pencil and watercolor, 3 $^{15}/_{16}$ × 5 $^7/_8$ in.; *Sketchbook Page: Blueberry Pie Transformations for J. V. – Tumbling, à la Mode,* 1996, pencil and watercolor, 5 $^7/_8$ × 3 $^{15}/_{16}$ in.; *Sketchbook Page: Sculpture for the Park (with J. V.) – Cheese in the Woods,* 1996, pencil and watercolor, 5 $^7/_8$ × 3 $^{15}/_{16}$ in.; *Sketchbook Page: Sculpture for the Park (with J. V.) – Madeleine,* 1996, pencil and watercolor, 5 $^7/_8$ × 3 $^{15}/_{16}$ in.; *Soft Sculpture in the Form of a Blueberry Pie, à la Mode, Raised,* 1996, crayon, pencil, watercolor, 7 × 9 $^{11}/_{16}$ in.; *Sketchbook Page: Tarte sur Boule, Studies (Peach),* 1997, pencil and watercolor, 6 $^1/_{16}$ × 4 $^1/_8$ in.; *Sketchbook Page: Tarte sur Boule, Studies (Pistachio),* 1997, pencil and watercolor, 6 $^1/_{16}$ × 4 $^1/_8$ in.; *Sketchbook Page: Tarte sur Boule, Study (Cassis),* 1997, pencil and watercolor, 6 $^1/_{16}$ × 4 $^1/_8$ in.; *Tarte Slice, on Boule,* 1997, pencil and pastel, 39 $^1/_4$ × 28 $^5/_8$ in.; *Elevation of Shuttlecock/Blueberry Pies, on Stairs,* 1997, pencil and colored pencil, 30 × 40 in.; *Proposal for a Sculpture in the Form of a Dropped Cone, for Neumarkt Galerie, Cologne,* 1998, pencil, pastel, colored pencil, 25 $^3/_4$ × 18 $^7/_{16}$ in.; *Proposal for a Sculpture in the Form of a Dropped Cone, for Neumarkt Galerie, Cologne,* 1998, pencil and colored pencil, 11 $^{13}/_{16}$ × 9 $^5/_{16}$ in.; *Canapé Gazebo 1/4,* 1999, cast aluminum painted with latex, 55 $^1/_2$ × 24 $^3/_4$ × 13 in.; *Shuttlecock/Blueberry Pies,* I and II, 1999, cast aluminum painted with acrylic polyurethane, 48 × 24 × 24 in. each; *Sketchbook Page: Peach in Landscape,* 1999, pencil and watercolor, 4 $^1/_8$ × 6 $^1/_{16}$ in.; *Sketchbook Page: Sliced Carrot,* 1999, pencil and watercolor, 4 $^1/_8$ × 6 $^1/_{16}$ in.; *Sketchbook Page: Sliced Pear and Broken Cup,* 1999, pencil and watercolor, 6 $^1/_{16}$ × 4 $^1/_8$ in.; *Sketchbook Page: Sliced Vegetables with Peel,* 1999, pencil and watercolor, 4 $^1/_8$ × 6 $^1/_{16}$ in.; *Crabcake, Amsterdam,* 2001, pencil and watercolor, 5 × 2 $^3/_4$ in.; *Sketchbook Page: Apple Core Gazebo,* 2001, pencil and watercolor, 4 $^1/_8$ × 6 $^1/_{16}$ in.; *Almond Pear Dessert, New York,* 2003, ballpoint pen and watercolor, 11 × 8 $^1/_2$ in.; *Boules with Eventails – Sculptures for a Stair,* 2003, pencil, colored pencil, pastel, 32 $^1/_4$ × 30 in.; *Cheese with Fig, Los Angeles,* 2003, pencil, ballpoint pen, crayon, watercolor, 11 × 8 $^1/_2$ in.; *Filet Mignon, Chicago,* 2003, pencil, ballpoint pen, crayon, watercolor, 11 × 8 $^1/_2$ in.; *Pecan and Chocolate Torte, Los Angeles,* 2003, ballpoint pen, crayon, watercolor, 11 × 8 $^1/_2$ in.; *Rack of Lamb with Stuffed Tomatoes, Los Angeles,* 2003, ballpoint pen, crayon, watercolor, 11 × 8 $^1/_2$ in.; *Tartelette Quetsche, Beaumont-sur-Dême – France,* 2003, pencil and watercolor, 11 × 8 $^1/_2$ in.

(All drawings mounted on 11 × 8 $^1/_2$ in. sheets are Notebook Pages.)

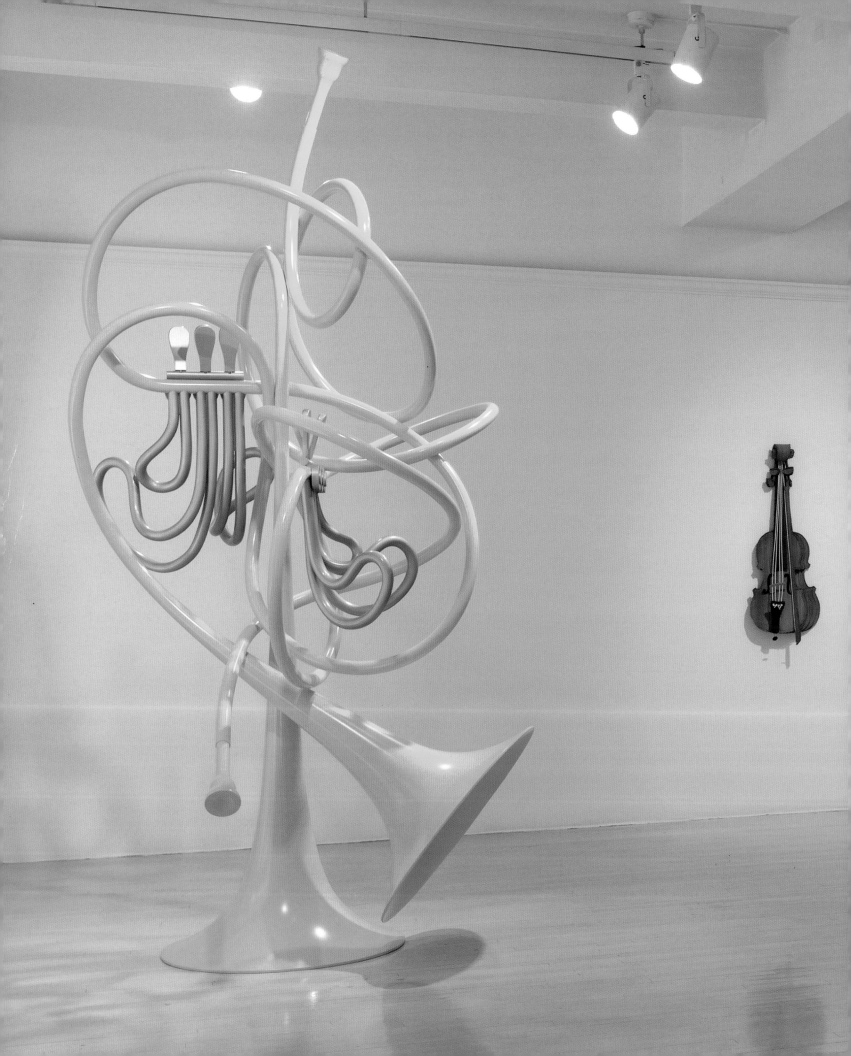

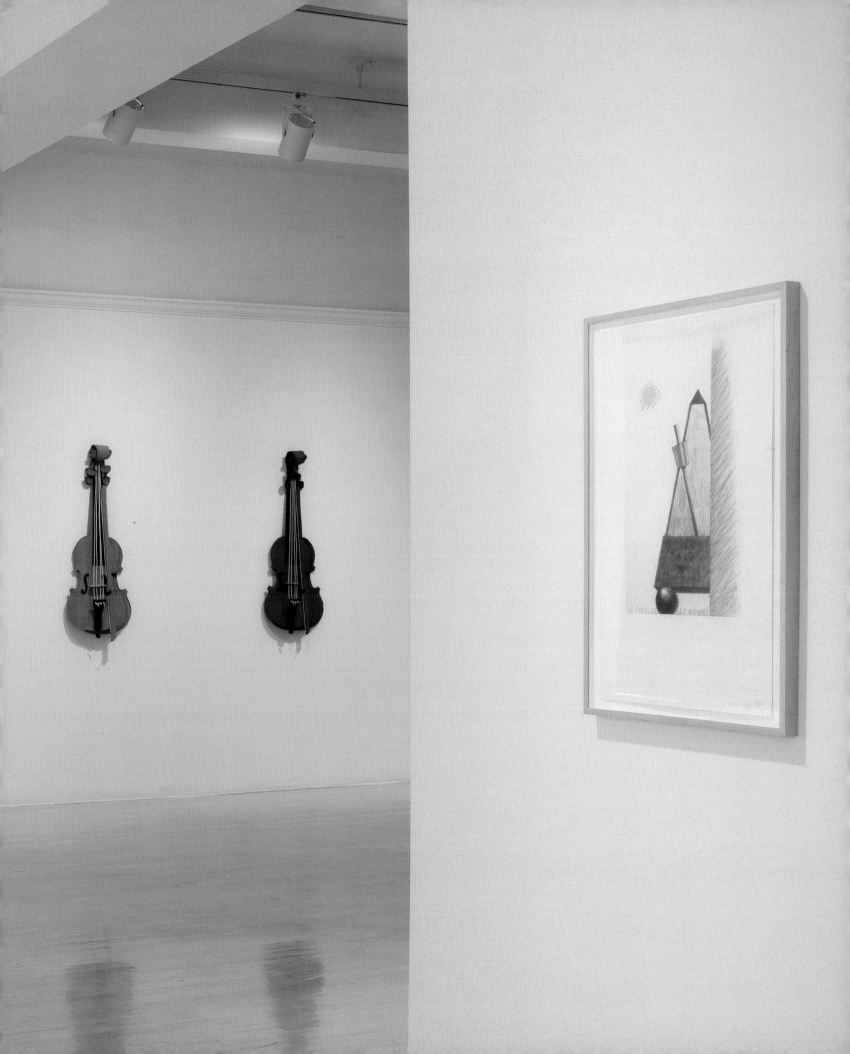

2005

—— CLAES OLDENBURG COOSJE VAN BRUGGEN: THE MUSIC ROOM, PaceWildenstein, New York, April 22 – June 18. Catalogue. Works exhibited: *Resonances, after J. V.*, 2000, canvas, polyurethane foam, cardboard, coated with resin and painted with latex, wood, paper, hardware, "envelope" and "tiles": crayon, pencil, watercolor, overall dimensions: 58 $^7/_{16}$ × 55 $^3/_{16}$ × 16 $^1/_8$ in.; *French Horn, Unwound, Hanging*, 2001, charcoal and pastel, 50 × 38 $^3/_{16}$ in.; *French Horn, Unwound, Horn Against Ground*, 2001, charcoal and pastel, 37 × 48 in.; *Standing Soft Clarinet – Gray*, 2001, canvas coated with resin and painted with latex, 55 $^1/_8$ × 9 × 9 $^1/_2$ in.; *Two French Horns, Unwound, Entwined, on Ground*, 2001, charcoal and pastel, 38 $^3/_{16}$ × 50 in.; *Soft Viola* 2/2, 2002, canvas, wood, polyurethane foam, coated with resin and painted with latex, clothesline, hardware, 8 ft. 8 in. × 5 ft. × 1 ft. 10 in.; *Sliced Stradivarius – Rose*, 2003, canvas, wood, cord, hardware painted with latex, 45 × 18 × 5 $^1/_2$ in.; *Soft French Horn, Unwound*, 2003, canvas and wood, painted with latex, plastic tubing, 80 $^1/_2$ × 30 × 25 $^1/_4$ in.; *Metronome Stock Exchange at 4 PM*, 2004, pencil and pastel, 30 $^3/_8$ × 19 $^3/_8$ in.; *Silent Metronome, 16 inch., Version One,* 2004, canvas, wood, metal, cord, painted with acrylic and latex, 16 $^1/_2$ × 11 × 11 in.; *Silent Metronome, 18 inch.*, 2004, canvas, wood, cord, hardware, painted with acrylic and latex, 19 × 11 × 13 in.; *Sliced Stradivarius – Crimson*, 2004, canvas, felt, wood, cord, hardware, painted with latex, 45 × 18 × 5 $^1/_2$ in.; *Sliced Stradivarius – Gold*, 2004, canvas, felt, wood, cord, hardware, painted with latex, 45 × 18 × 5 $^1/_2$ in.; *Tied Trumpet* 1/3, 2004, aluminum, canvas, felt, polyurethane foam, rope, cord, coated with resin and painted with latex, plastic tubing, 50 $^1/_2$ × 23 $^1/_2$ × 15 in.; *Tied Trumpet* 2/3, 2004, aluminum, canvas, felt, polyurethane foam, rope, cord, coated with resin and painted with latex, plastic tubing, 50 $^1/_2$ × 23 $^1/_2$ × 15 in.; *Study for Beached Lutes – Version One*, 2005, muslin, wood, metal, polyurethane foam, cord, coated with resin and painted with latex, 14 $^1/_2$ × 20 × 13 $^1/_2$ in.; *Collar and Bow 1:16*, 2005, aluminum painted with polyurethane enamel, 51 $^1/_2$ × 45 $^1/_4$ × 39 $^1/_2$ in.; *Falling Notes*, 2005, canvas coated with resin, cord, string, painted with latex, 65 $^1/_2$ × 30 × 12 in.; *French Horns, Unwound and Entwined* 1/3, 2005, stainless steel and aluminum painted with polyurethane enamel, 11 ft. 4 in. × 4 ft. 8 in. × 5 ft. 6 in.; *Lute – Version One*, 2005, canvas, wood, metal, polyurethane foam, cord, coated with resin and painted with latex, weighted with sandbag, 31 × 18 × 29 in.

—— IMAGES À LA CARTE, Konrad Fischer Galerie, Düsseldorf, Germany, September 3 – October 22.

Works exhibited: *Shrimp Cocktail, Hamden, Connecticut*, 1987, pencil and watercolor, 11 × 8 $^1/_2$ in.; *Tartuffo, Hamden, Connecticut*, 1987, pencil, felt pen, watercolor, 11 × 8 $^1/_2$ in.; *Watermelon with Flies, Marfa, Texas*, 1987, felt pen, 11 × 8 $^1/_2$ in.; *Chicken Liver Hors d'Œuvre, Minneapolis*, 1988, pencil, felt pen, watercolor, 11 × 8 $^1/_2$ in.; *Hazelnut Tart, Minneapolis*, 1988, pencil, felt pen, watercolor, 11 × 8 $^1/_2$ in.; *Kumamoto Oysters, Los Angeles*, 1988, pencil and watercolor, 11 × 8 $^1/_2$ in.; *Sea Food Wrap, Minneapolis*, 1988, pencil and watercolor, 11 × 8 $^1/_2$ in.; *Study for Poster of Dropped Bowl, with Scattered Slices and Peels*, 1988, charcoal and pastel, 40 × 28 in.; *Chocolate Velour, Vinyl on the Side, New York*, 1989, pencil, ballpoint pen, watercolor, 11 × 8 $^1/_2$ in.; *Colombi Appetizer, Freiburg-im-Breisgau*, 1989, pencil and watercolor, 11 × 8 $^1/_2$ in.; *Écrevisse, Paris*, 1989, pencil and watercolor, 11 × 8 $^1/_2$ in.; *Flounder in Broth, New York*, 1989, pencil, watercolor, typescript, 11 × 8 $^1/_2$ in.; *Lakkasorbetilla Täytetty Kotijäätelö, Tampere – Finland*, 1990, pencil, ballpoint pen, watercolor, 11 × 8 $^1/_2$ in.; *Langoustine, Paris*, 1990, pencil and watercolor, 11 × 8 $^1/_2$ in.; *Pyrénées, Barcelona*, 1991, pencil and watercolor, 11 × 8 $^1/_2$ in.; *Apple Core in the Wind*, 1992, crayon and watercolor, 12 $^1/_3$ × 9 $^1/_2$ in.; *Lemon Slice on Ice, Paris*, 1992, pencil, felt pen, watercolor, 11 × 8 $^1/_2$ in.; *Mil Hojas, Barcelona*, 1992, ballpoint pen, felt pen, watercolor, 11 × 8 $^1/_2$ in.; *Blueberry Pie à la Mode, Sliding Down a Hill*, 1996, charcoal and pastel, 39 $^5/_8$ × 30 $^3/_{16}$ in.; *Canapé Gazebo*, 1996, pencil and colored pencil, 40 × 30 in.; *Sketchbook Page: Blueberry Pie Transformations for J. V. – Chair, à la Mode*, 1996, pencil and watercolor, 5 $^7/_8$ × 3 $^{15}/_{16}$ in.; *Sketchbook Page: Blueberry Pie Transformations for J. V. - Terrace House*, 1996, pencil and water-color, 3 $^{15}/_{16}$ × 5 $^7/_8$ in.; *Study for a Sculpture in the Form of Two Ice Cream Cones, Tips Touching*, 1996, felt pen and watercolor, 9 $^5/_8$ × 7 in.; *Sketchbook Page: Tarte sur Boule, Studies (Peach)*, 1997, pencil and watercolor, 6 $^1/_{16}$ × 4 $^1/_8$ in.; *Sketchbook Page: Tarte sur Boule, Studies (Pistachio)*, 1997, pencil and watercolor, 6 $^1/_{16}$ × 4 $^1/_8$ in.; *Sketchbook Page: Tarte sur Boule, Study (Cassis)*, 1997, pencil and watercolor, 6 $^1/_{16}$ × 4 $^1/_8$ in.; *Tarte Slice, on Boule*, 1997, pencil and pastel, 39 $^1/_4$ × 28 $^5/_8$ in.; *Blueberry Pie, Flying, Scale B*, 1998, cast aluminum painted with acrylic polyurethane, 33 × 25 $^1/_2$ × 18 in.; *Proposal for a Sculpture in the Form of a Dropped Cone, for Neumarkt Galerie, Cologne*, 1998, pencil and colored pencil, 11 $^{13}/_{16}$ × 9 $^5/_{16}$ in.; *Canapé Gazebo 1/4*, 1999, cast aluminum painted with latex, 55 $^1/_2$ × 24 $^3/_4$ × 13 in.; *Shuttlecock/Blueberry Pies*, I and II, 1999, cast aluminum painted with acrylic polyurethane, 48 × 24 × 24 in. each; *Sketchbook Page: Sliced Vegetables with Peel*, 1999, pencil and watercolor, 4 $^1/_8$ × 6 $^1/_{16}$ in.; *Crabcake, Amsterdam*, 2001, pencil and watercolor, 11 × 8 $^1/_2$ in.; *Sketchbook Page: Apple Core Gazebo*, 2001, pencil and watercolor, 4 $^1/_8$ × 6 $^1/_{16}$ in.; *Almond Pear Dessert, New York*, 2003, ballpoint pen and watercolor, 11 × 8 $^1/_2$ in.; *Boules with Eventails - Sculptures for a Stair*, 2003, pencil, colored pencil, pastel, 32 $^1/_4$ × 30 in.; *Cheese with Fig, Los Angeles*, 2003, pencil, ballpoint pen, crayon, watercolor, 11 × 8 $^1/_2$ in.; *Filet Mignon, Chicago*, 2003, pencil, ballpoint pen, crayon, watercolor, 11 × 8 $^1/_2$ in.; *Rack of Lamb with Stuffed Tomatoes, Los Angeles*, 2003, ballpoint pen, crayon, watercolor, 11 × 8 $^1/_2$ in.; *Tartelette Quetsche, Beaumont-sur-Dême – France*, 2003, pencil and watercolor, 11 × 8 $^1/_2$ in.

(All drawings mounted on 11 × 8 $^1/_2$ in. sheets are Notebook Pages.)

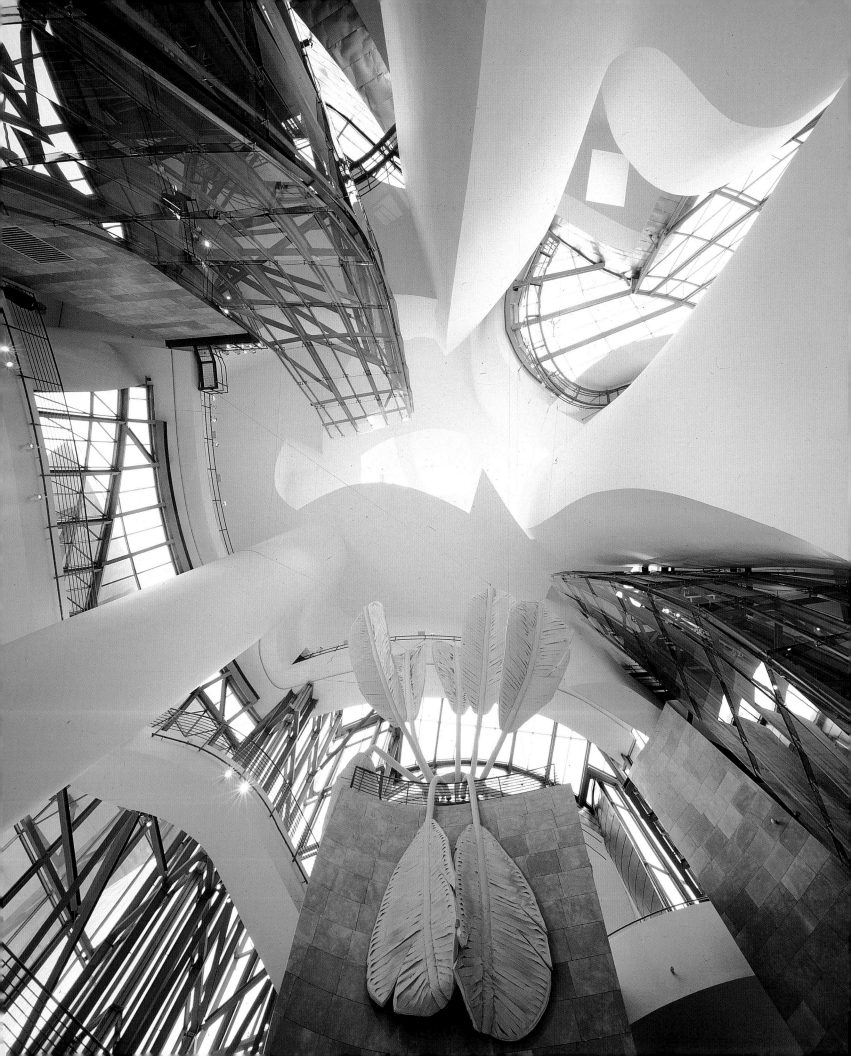

SELECTED GROUP EXHIBITIONS

1989

—— *Magiciens de la Terre*, Musée national d'art moderne Centre Georges Pompidou, Paris; La Grande Halle, La Villette, Paris, May 18 – August 14. Curated by Jean-Hubert Martin. Catalogue.
Work exhibited: *From the Entropic Library,* 1989, cloth, wood, aluminum, expanded polystyrene, coated with resin and painted with latex, 11 ft. 9 $^3/_4$ in. × 22 ft. 6 $^1/_{16}$ in. × 8 ft. 4 in., variable dimensions.

1996

—— *Masterworks of Modern Sculpture: The Nasher Collection,* Fine Arts Museums of San Francisco, California, October 16, 1996 – January 18, 1997. Curated by Robert Flynn Johnson. Traveled to the Solomon R. Guggenheim Museum, New York, February 7 – June 1, 1997 as *A Century of Sculpture: The Nasher Collection.* Curated by Carmen Giménez and Steven A. Nash. Catalogue.
Work exhibited: *Typewriter Eraser* 2/3, 1976, ferrocement, aluminum, painted with acrylic polyurethane, stainless steel, on steel base, 7 ft. 5 in. × 7 ft. 6 in. × 5 ft. 3 in.

1997

—— *Futuro, Presente, Passato (Future, Present, Past),* 47th International Art Exhibition, The Venice Biennale, Venice, Italy June 15 – November 9. Curated by Germano Celant. Catalogue.
Work exhibited: *Valentine Perfume,* 1997, stainless steel, cast aluminum, aluminum pipe, painted with acrylic polyurethane, 21 ft. × 4 ft. 9 in. × 9 ft. 4 in.

—— *The Guggenheim Museums and the Art of This Century,* Guggenheim Museum, Bilbao, Spain, October 19, 1997 – June 1, 1998. Work exhibited: *Soft Shuttlecock,* 1995, canvas, expanded polyurethane and polyethylene foams, steel, aluminum, rope, wood, duct tape, fiberglass-reinforced plastic, painted with latex, nose cone: approx. 6 ft. diameter × 6 ft. long, 9 feathers: approx. 26 ft. long and 6-7 ft. wide each.

2000

—— *Encounters: New Art from Old,* National Gallery, London, June 14 – September 17. Curated by Richard Morphet. Catalogue.
Work exhibited: *Resonances, after J. V.,* 2000, canvas, polyurethane foam, cardboard, coated with resin and painted with latex, wood, paper, clothesline, string, hardware, "envelope" and "tiles": crayon, pencil, watercolor, overall dimensions: 58 $^7/_{16}$ × 55 $^3/_{16}$ × 16 $^1/_8$ in.

2001

—— *The Global Guggenheim: Selections from the Extended Collection,* Solomon R. Guggenheim Museum, New York, February 9 – April 22.
Work exhibited: *Soft Shuttlecock,* 1995, canvas, expanded polyurethane and polyethylene foams, steel, aluminum, rope, wood, duct tape, fiberglass-reinforced plastic, painted with latex, nose cone: approx. 6 ft. diameter × 6 ft. long, 9 feathers: approx. 26 ft. long and 6-7 ft. wide each.

2002

———— *An American Legacy – A Gift to New York*, Whitney Museum of American Art, New York, October 24, 2002 – January 26, 2003. Curated by Marla Prather. Catalogue.
Works exhibited: *Soft Viola Island 1/2*, 2001, charcoal and pastel, 34 × 46 $^3/_2$ in.; *Soft Viola 1/2*, 2002, canvas, wood, polyurethane foam, coated with resin and painted with latex, clothesline, hardware, 8 ft. 8 in. × 5 ft. × 1 ft. 10 in.

2004

———— *Arti & Architettura 1900-2000 (Arts & Architecture 1900-2000)*, Palazzo Ducale, Genoa, Italy, October 2, 2004 – February 13, 2005. Curated by Germano Celant. Catalogue.
Works exhibited: *Alcatraz Island Reconstructed as a Landscape in the Form of an Upturned Foot - (Planned Monument to the American Indian) - View of the Entrance*, 1971, pencil and colored pencil, 11 $^3/_8$ × 14 $^{11}/_{16}$ in.; *Cemetery in the Shape of a Colossal Screw: Skyscraper for São Paulo, Brazil*, 1971, pencil and colored pencil, 14 $^1/_2$ × 11 $^1/_2$ in.; *Tower in the Form of a Colossal Thumb, "Czar's Thumb," on the Moscow Road*, 1971, pencil and colored pencil, 14 $^9/_{16}$ × 11 $^9/_{16}$ in.; *Bridge Over the Rhine at Düsseldorf in the Shape of a Colossal Saw*, 1971, crayon, pencil, watercolor, 11 × 14 $^1/_2$ in.; *Model of the Mouse Museum*, 1977, cardboard and wood painted with tempera and spray enamel, pencil, 6 $^7/_{16}$ × 18 $^7/_8$ × 18 $^7/_8$ in.; *Model of the Ray Gun Wing*, 1977, cardboard and wood painted with tempera and spray enamel, pencil, 6 $^1/_8$ × 12 $^7/_8$ × 18 $^7/_8$ in.; *Alternative Proposal for the Allen Memorial Art Museum, Oberlin, Ohio*, 1979, hard-ground and soft-ground etching, aquatint, spit bite, 34 × 40 $^3/_4$ in.; *Screwarch Bridge (State III)*, 1981, hard-ground etching, aquatint, sugar-lift, spit bite, monoprint, 31 $^1/_4$ × 57 $^3/_4$ in.; *Design for a Theater Library for Venice in the Form of Binoculars and Coltello Ship in Three Stages*, 1984, pencil, colored pencil, chalk, watercolor, 30 × 40 in.; *Railroad Station in the Form of a Wristwatch, for Florence, Italy*, 1984, pencil and watercolor, 8 $^5/_{16}$ × 12 $^5/_8$ in.; *Railroad Station in the Form of a Wristwatch, for Florence, Italy*, 1984, pencil and watercolor, 30 × 40 in.; *Studies for a Railroad Station in the Form of a Wristwatch, for Florence, Italy*, 1984, paper, cardboard, wood, pencil, painted with watercolor and spray enamel, 6 × 6 $^3/_4$ × 22 $^5/_8$ in.; *Model for the Chiat/Day Building, Los Angeles, Binocular with Lightbulb*, 1984, wood painted with latex, hardware, 31 $^3/_4$ × 15 $^1/_2$ × 16 $^3/_4$ in.; *Architect's Handkerchief 2/3*, 1999, steel and fiber-reinforced plastic painted with polyester gelcoat and polyurethane clear coat, 12 ft. 5 in. × 12 ft. 3 in. × 7 ft. 5 in.

———— *Contemporary Art: Floor to Ceiling, Wall to Wall*, The Wadsworth Atheneum Museum of Art, Hartford, Connecticut, October 31, 2004 – April 24, 2005.
Work exhibited: *Leaning Fork with Meatball and Spaghetti*, 1994, cast aluminum painted with polyurethane, overall dimensions: 10 ft. 11 $^1/_2$ in. × 4 ft. 3 $^1/_2$ in. × 3 ft. 3 in.

WORKS IN THE EXHIBITION

Unless otherwise indicated, all works Collection Claes Oldenburg and Coosje van Bruggen, New York.

All works by Claes Oldenburg and Coosje van Bruggen, except those indicated with an asterisk (*), which are by Claes Oldenburg.

STUDIES

* *Lighthouse Flag, Provincetown*, 1960
Found wood and nails
9 $^3/_4$ × 3 $^1/_2$ × 8 $^3/_4$ in.

* *Pile of Toast*, 1961
Plaster painted with enamel, porcelain plate
2 $^1/_8$ in. high × 9 $^3/_8$ in. diameter

* *Circular Saw Study*, 1964
Cardboard, paper, tape, wire, plaster, T-pins; painted with spray enamel and coated with resin
11 $^1/_2$ × 12 $^3/_4$ × 11 $^1/_2$ in.

* *Study for a Sculpture in the Form of an Outboard Motor*, 1965
Clay over toy, coated wire, wood
8 $^1/_2$ × 6 $^3/_8$ × 3 $^1/_2$ in.

* *Baked Potato Multiple, Painted Prototype*, 1966
Cast resin painted with acrylic, porcelain plate
8 $^1/_2$ × 4 $^3/_4$ × 5 $^1/_4$ in.

* *Fagend Study*, 1968
Plaster and felt; painted with acrylic
4 $^1/_2$ × 10 $^1/_2$ × 3 $^1/_4$ in.

* *Fireplug Souvenir – "Chicago August 1968,"* 1968
Cast plaster painted with acrylic
8 × 8 × 6 in.

* *Chocolate Earthquake Segment*, 1969
Cardboard, canvas, wood; painted with acrylic
6 $^1/_2$ × 15 × 12 in.

* *Lipstick Monument Souvenir*, 1969
Plaster and cardboard; painted with spray enamel
7 × 4 $^1/_8$ × 5 $^1/_8$ in.

* *Rising and Falling Screw*, 1969
Cardboard, wood, pencil; painted with spray enamel and coated with resin
11 × 28 × 10 $^1/_2$ in.

* *Study for a Soft Screw*, 1969
Canvas, wood, wire, nails; painted with latex
10 $^1/_4$ × 7 $^1/_8$ × 3 $^1/_2$ in.
reproduced, p. 84

* *Three-Way Plug, Position Study*, 1972
Plug set in plaster, and wood; painted with latex and spray enamel
2 $^1/_2$ × 9 $^1/_2$ × 7 $^3/_8$ in.

* *Study for a Sculpture in the Form of a Saw, Cutting*, 1973
Cardboard painted with spray enamel
14 $^1/_8$ × 10 × 10 in.
reproduced, p. 84

* *Inverted Q*, 1974
Ceramic painted with latex
5 $^1/_4$ × 5 $^1/_4$ × 4 $^3/_8$ in.

* *Soft Inverted Q in Stage of Deflation*, 1974
Pigmented ceramic
3 $^1/_2$ × 6 $^1/_2$ × 4 $^1/_2$ in.

* *Study for a Civic Sculpture in the Form of a Mitt and Ball*, 1974
Toy glove and ball, nails, wood; painted with spray enamel, pencil
8 $^1/_2$ × 11 $^1/_2$ × 10 in.

* *Fagend Study*, 1976
Cast aluminum painted with enamel
10 × 18 $^1/_2$ × 9 $^1/_4$ in.

* *Emerald Pill*, 1977
Aluminum coated with porcelain paint, stainless steel
2 $^1/_2$ × 6 $^1/_4$ × 6 $^1/_4$ in.

Preliminary Study for the Crusoe Umbrella, 1978
Coated wire
11 × 8 $^3/_4$ × 9 $^7/_8$ in.

Study for the Wayside Drainpipe, 1978
Chalk, wood, cardboard, sand; painted with spray enamel and coated with resin
10 $^3/_4$ × 9 $^3/_8$ × 5 $^5/_8$ in.

Flashlight, 1979
Flashlight in plaster; painted with latex
7 $^1/_2$ × 4 $^1/_2$ × 3 $^7/_8$ in.

Flashlight, Study for Final Version, 1979
Paper and wood; painted with casein
11 $^1/_8$ × 6 $^1/_8$ × 5 $^3/_4$ in.

Altered Souvenir of the Cologne Cathedral, 1980
Aluminum and plaster; painted with enamel
$7\,^1/_2 \times 6\,^1/_2 \times 3\,^1/_2$ in.

*Study of Cross Section of a Toothbrush with Paste, in a Cup,
on a Sink: Portrait of Coosje's Thinking*, 1980
Cardboard, wood, clothesline, sand; coated with resin and
painted with spray enamel
$19\,^3/_4 \times 11\,^1/_4 \times 6\,^5/_8$ in.

Study for Salinas Hat, 1980
Grinding wheel, plastic cup, sand; coated with glue and painted
with spray enamel
$4\,^1/_2 \times 7\,^1/_4 \times 4\,^1/_2$ in.

Study for a Sculpture in the Form of a Split Button, 1981
Cardboard painted with spray enamel
$7\,^7/_8 \times 10\,^1/_2 \times 10\,^3/_4$ in.

*Proposal for a Bridge Over a City Street in the Form of a Spoon
with Cherry*, 1982
Spoon, wood, cardboard, nails; painted with spray enamel,
colored pencil
$7\,^9/_{16} \times 2\,^3/_4 \times 7$ in.

Studies for Sculptures in the Form of a Snapped Match, 1982
Wood, paper, clay, tape, match, nail; painted with latex and
spray enamel
$4\,^3/_4 \times 8\,^3/_4 \times 3\,^1/_2$ in.
reproduced, p. 86

Balancing Tools, Study, 1983
Cardboard, wood (floor segment), paper, screwdriver, nails;
painted with spray enamel
$9\,^1/_4 \times 14\,^3/_4 \times 9\,^1/_4$ in.
reproduced, p. 85

Study for a Balloon in the Form of a Teddy Bear, 1983
Toy bear and wood; coated with resin and painted with latex,
pencil
$4\,^3/_8 \times 3 \times 1\,^{15}/_{16}$ in.

Study for a Sculpture in the Form of a Mallet, 1983
Clay, wood, cardboard, sand; painted with spray enamel
$7 \times 2\,^3/_4 \times 2$ in.

Tilting Neon Cocktail Study, 1983
Cardboard, wood, nail; painted with acrylic, felt pen
$16\,^1/_8 \times 12 \times 9\,^3/_8$ in.
reproduced, p. 86

Prototype for Coltello Guidebook, 1984
Wood, canvas, paper, expanded polystyrene; painted with acrylic
and spray enamel
$2\,^3/_4 \times 6 \times 9\,^3/_4$ in.
reproduced, p. 87

*Studies for a Railroad Station in the Form of a Wristwatch,
for Florence, Italy*, 1984
Paper, cardboard, wood, pencil; painted with watercolor and
spray enamel
$6 \times 6\,^3/_4 \times 22\,^5/_8$ in.

Georgia Sandbag's Bag, 1985
Polyurethane foam, wood, canvas; painted with latex
$13 \times 39 \times 12$ in.
reproduced, p. 220

Georgia Sandbag's Book with Dangling Punctuation,
1985
Canvas painted with latex, polyurethane foam, vinyl, leather,
notepaper, felt pen, T-pins
$13 \times 9\,^3/_4 \times 1\,^3/_4$ in., with punctuation extending 15 in. below
book

Study for a Sculpture in the Form of a Lighted Match in Wind,
1986
Paper, foamcore, wood; painted with spray
enamel
$11\,^7/_8 \times 6\,^1/_2 \times 3\,^3/_4$ in.

Bottle of Notes, First Study, 1987
Plastic water bottle, tape, cork, felt pen
$8\,^7/_8$ in. high $\times 3\,^1/_2$ in. diameter

Monument to the Last Horse – Study, 1987
Horseshoe and wood; painted with latex
$7\,^3/_8 \times 6\,^1/_{16} \times 6$ in.

Profiterole, 1989
Cast aluminum painted with latex, brass
$5\,^3/_4 \times 6\,^1/_2 \times 6\,^1/_2$ in.

Geometric Apple Core, Study, 1991
Canvas and wood; painted with latex
$9\,^1/_2 \times 12 \times 8$ in.
reproduced, p. 206

Inverted Tie Study, 1992
Tie coated with resin, steel
$13 \times 11\,^1/_8 \times 8\,^1/_4$ in.

Leaf Boat with Floating Cargo, Study, 1992
Canvas, wood, wire, cardboard, apple core, ice cream stick,
peanut shell, potato chip, cork; coated with resin and painted
with latex
$11\,^3/_4 \times 11 \times 11\,^3/_4$ in.
reproduced, p. 89

Collar and Bow Tie – First Study, 1994
Cardboard, canvas, wire, staples; painted with latex and spray
enamel
$14\,^1/_2 \times 11\,^1/_2 \times 7$ in.

Studio Valentine, 1994
Burlap coated with resin, wire, wood; painted with latex and spray enamel
$9 \times 4\,^{1}/_{2} \times 4$ in.
reproduced, p. 88

Torn Notebook, Study, 1994
Steel painted with latex
$10\,^{1}/_{4} \times 12 \times 12$ in.

Golf Typhoon, First Study, 1995
Cardboard, felt, sand, polyurethane foam, wood; coated with resin and painted with latex
$19\,^{3}/_{4} \times 6 \times 6$ in.
reproduced, p. 208

Study for a Multiple: Apple Core, 1995
Expanded polystyrene, wood, canvas; painted with latex
$10\,^{3}/_{4} \times 6\,^{1}/_{2} \times 9$ in.
reproduced, p. 206

Study for a Multiple: Metamorphic Apple Core, 1995
Expanded polystyrene, cardboard, wood; painted with latex
$13\,^{1}/_{2} \times 10\,^{3}/_{4} \times 2\,^{3}/_{4}$ in.
reproduced, p. 208

Calico Bunny, 1997
Screenprint on canvas, Dacron, wood painted with latex, hardware
$13 \times 10 \times 6$ in.

Caught and Set Free, Study, First Position, 1997
Toy basketball hoop, cardboard, expanded polystyrene, T-pins, pushpin, nails, wire, tape, glue, pencil
$9\,^{1}/_{4} \times 10\,^{3}/_{4} \times 5$ in.

Study for a Sculpture in the Form of a Perfume Bottle and Atomizer, 1997
Expanded polystyrene and wire; painted with latex
$8\,^{1}/_{4} \times 8 \times 5$ in.

Valentine Perfume, Study, 1997
Expanded polystyrene, wood, wire; painted with latex
$14 \times 10 \times 7$ in.

Blueberry Pie, Flying, Scale C I-VI, 1/3, 1998
Cast aluminum painted with acrylic polyurethane
Three of six sculptures, each approximately
$15\,^{1}/_{2} \times 4 \times 4$ in.

Study for a Gazebo in the Form of a Dropped Flower, 1998
Canvas and rope coated with resin, foamcore, cardboard, nail; painted with latex
$6\,^{9}/_{16} \times 10 \times 7$ in.

Study of Soft Shuttlecock, 1999
Wood, canvas, cardboard, rope, hardware; painted with latex
Nine feathers, each approximately $15\,^{1}/_{2} \times 6\,^{1}/_{2} \times ^{1}/_{2}$ in.;
nose cone, $3\,^{1}/_{2} \times 3\,^{1}/_{4}$ in.

Cupid's Span – Presentation Study, 2000
Polyurethane foam, wood, paper, aluminum, steel, sand, cord; painted with latex
$15 \times 26\,^{1}/_{16} \times 7\,^{1}/_{2}$ in.

Maartje and Rustom Wedding Tart, 2000
Cast plaster painted with latex and spray varnish
Five casts, each $3\,^{1}/_{4} \times 2 \times 1\,^{3}/_{4}$ in.

Maquette for Plantoir 1/2, 2000
Aluminum coated with resin and painted with acrylic polyurethane
$25\,^{3}/_{4} \times 12 \times 12$ in.
Courtesy PaceWildenstein, New York

Chardin's Shuttlecock, 2001
Polyurethane foam, paper, cord, wood; painted with latex
$6\,^{3}/_{8} \times 5\,^{7}/_{8} \times 5\,^{1}/_{2}$ in.
reproduced, p. 87

French Horns, Unwound and Entwined, Study, 2001
Polyurethane foam, wire, wood; coated with resin and painted with spray enamel
$10\,^{1}/_{4} \times 5\,^{1}/_{4} \times 3\,^{1}/_{2}$ in.

French Horn, Unwound, on Ground, Study, 2001
Polyurethane foam, wire; coated with resin and painted with spray enamel
$3 \times 16 \times 5\,^{1}/_{4}$ in.

Study for Sculpture of Madeleine Dipped in Tea, 2001
Plaster, metal, coated wire, fragment of porcelain cup, metal spoon, wood; painted with latex and spray enamel
$13\,^{3}/_{8} \times 6 \times 4\,^{5}/_{16}$ in.
reproduced, p. 88

Valentine, Based on French Horns, Unwound, Entwined, for Coosje, 2002
Wood, polyurethane foam, wire; coated with resin, painted with latex and spray enamel
$12\,^{1}/_{2} \times 4\,^{1}/_{4} \times 4\,^{3}/_{8}$ in.

Study for Beached Lutes – Version Three, 2005
Muslin, wood, metal, polyurethane foam, cord; coated with resin and painted with latex
$16\,^{1}/_{2} \times 22 \times 13\,^{1}/_{4}$ in.

MODELS

Model for the Chiat/Day Building, Los Angeles, Binocular with Lightbulb, 1984

Wood painted with latex, hardware
31 $^3/_4$ × 15 $^1/_2$ × 16 $^3/_4$ in.
reproduced, p. 90

Toppling Ladder with Spilling Paint, Fabrication Model, 1985
Steel painted with polyurethane enamel
18 $^1/_2$ × 12 × 12 in.
reproduced, p. 108

Sculpture in the Form of a Match Cover – Model, 1987
Cardboard, expanded polystyrene, felt pen
38 $^1/_2$ × 19 × 38 in.
reproduced, p. 92

Model for The European Desktop, 1989-1990
Expanded polystyrene, wood, steel, canvas; coated with resin and
painted with latex
61 × 155 × 82 in., variable dimensions
Courtesy PaceWildenstein, New York
reproduced, p. 67

Free Stamp, Second Version, Model, 1985-1991
Wood painted with latex and spray enamel
14 $^1/_2$ × 22 $^3/_8$ × 20 $^1/_4$ in.
reproduced, p. 91

Houseball, Naoshima – Presentation Model, 1992
Burlap, rope, expanded polystyrene; coated with resin and
painted with latex
18 $^1/_2$ × 14 $^1/_4$ × 16 in.

Model for Inverted Collar and Tie, 1992
Canvas and wood; painted with latex and spray enamel
19 $^1/_2$ × 16 $^1/_2$ × 13 in.

Inverted Collar and Tie, 1993
Canvas coated with resin, steel; painted with latex, wood painted
with polyurethane enamel
92 × 38 × 52 in.

*Gazebo in the Form of a Dropped Flower, with Figure for Scale,
Model,* 1998
Canvas, tape, string, wire, wood, metal, polystyrene foam; coated
with resin and painted with latex
12 $^1/_4$ × 29 $^1/_4$ × 21 in.
reproduced, pp. 96-97

*Proposed Sculpture for the Harbor of Stockholm, Sweden,
Caught and Set Free, Model,* 1998
Steel, aluminum, wood, plaster, sand; painted with acrylic
polyurethane and latex
23 × 39 $^3/_4$ × 30 in.
reproduced, p. 94

Flying Pins, Presentation Model, 1999
Wood, cardboard, expanded polystyrene, polyurethane

foam; coated with resin and painted with latex
12 × 23 $^1/_2$ × 47 in.
reproduced, p. 307

Valentine Perfume 1/2, 1999
Cast aluminum painted with acrylic polyurethane
46 $^1/_2$ × 25 × 20 in.
reproduced, p. 93

Model for Dropped Cone, 2000
Clay, wood, paper; painted with latex
28 × 21 $^1/_2$ × 24 in.
reproduced, p. 99

Question Mark at Play, Final Model, 2000
Felt, cardboard, wood, wire; coated with resin and painted with
latex
24 $^3/_4$ × 26 × 12 in.
reproduced, p. 98

*Scattered Pyramid of Pears and Peaches – Balzac/Pétanque,
Model,* 2001
Polyurethane foam, hardware cloth, canvas; coated with resin and
painted with latex
Variable height on area 53 $^1/_2$ × 89 in.
reproduced, p. 95

Cupid's Span – Fabrication Model, 2002
Cast polyester and epoxy resins and steel; painted with polyester
gelcoat
56 × 120 × 31 in.
Courtesy PaceWildenstein, New York

Model for Tied Trumpet, 2003
Cardboard, canvas, paper, wood, wire, plastic tubing; painted
with spray enamel
57 $^3/_4$ in. high × 13 in. diameter

Collar and Bow 1:16, 2005
Aluminum painted with polyurethane enamel
51 $^1/_2$ × 45 $^1/_4$ × 39 $^1/_2$ in.
Courtesy PaceWildenstein, New York
reproduced, p. 101

SOLITUDE FOR TWO: NOTEBOOK AND SKETCHBOOK
PAGES

Notebook Page: Equitable Building as a Pencil Sharpener, 1983
Pencil, colored pencil, watercolor, clipping
11 × 8 $^1/_2$ in.
reproduced, p. 20

Notebook Page: Study for Blasted Pencil (Which Still Writes), 1983
Pencil, colored pencil, felt pen, watercolor
10 $^1/_4$ × 7 $^9/_{16}$ in. on sheet 11 × 8 $^1/_2$ in.

Notebook Page: First Thoughts about a Fountain for Miami,
1984
Pencil, ballpoint pen, felt pen, clippings, collage
11 × 8 $^1/_2$ in.

*Notebook Page: Costumes for Dr. Coltello, Georgia Sandbag,
and Frankie P. Toronto – Study for a Poster,* 1986
Felt pen
11 × 8 $^1/_2$ in.

*Notebook Page: Events from Il Corso del Coltello: Porters Carrying
Sliced Columns and Houseball Over Ponte del Paradiso,* 1986
Felt pen and watercolor
5 $^3/_{16}$ × 8 $^1/_2$ in. on sheet 11 × 8 $^1/_2$ in.

*Notebook Page: Props for Il Corso del Coltello in Front of the
Arsenale, after Canaletto – Study for the Cover of Il Corso del
Coltello,* 1986
Ballpoint pen, felt pen, colored pencil
5 $^1/_8$ × 8 $^1/_2$ in. on sheet 11 × 8 $^1/_2$ in.

Notebook Page: "Britiship"; "MS in a Bottle," 1987
Pencil and felt pen
Two sheets, 5 × 2 $^3/_4$ in. and 2 $^3/_4$ × 5 in., on sheet 11 × 8 $^1/_2$ in.

*Notebook Page: Cook's Hands, a Gate in Middlesbrough, the
Bottle on the Beach,* 1987
Felt pen, pencil, clippings
Three clippings, 2 $^1/_8$ × 2 $^{13}/_{16}$ in., 2 $^3/_4$ × 4 in., 3 $^3/_4$ × 2 $^1/_2$ in., on
sheet 11 × 8 $^1/_2$ in.

*Notebook Page: Extinguished Match as Bridge or Arch: "Made
in Bklyn!,"* 1987
Felt pen and pencil
5 × 2 $^3/_4$ in. on sheet 11 × 8 $^1/_2$ in.

Notebook Page: Flamenco Dancer's Shoes in Action, 1987
Pencil, colored pencil, ballpoint pen, felt pen
5 × 2 $^3/_4$ in. on sheet 11 × 8 $^1/_2$ in.
reproduced, p. 26

*Notebook Page: "MONOLITHIC MATCHES," with Woman and
Baby Carriage,* 1987
Pencil and colored pencil
5 × 2 $^3/_4$ in. on sheet 11 × 8 $^1/_2$ in.
reproduced, p. 19

Notebook Page: Paper Match Variations, 1987
Pencil, felt pen, ballpoint pen, colored pencil
11 × 8 $^1/_2$ in.

Notebook Page: Studies toward a Sculpture for Barcelona,
1987
Pencil, colored pencil, felt pen
Two sheets, each 2 $^3/_4$ × 5 in., on sheet 11 × 8 $^1/_2$ in.
reproduced, p. 27

Notebook Page: Apple Core, New York, 1988
Pencil and watercolor
5 × 2 $^3/_4$ in. on sheet 11 × 8 $^1/_2$ in.

*Notebook Page: Architectural Features, for a Project with Frank
O. Gehry in Cleveland, Ohio,* 1988
Ballpoint pen and watercolor
Three sheets, each 5 × 2 $^3/_4$ in., on sheet 11 × 8 $^1/_2$ in.

Notebook Page: Colossal Sign for the Alps: EVIAN, Reversed, 1988
Pencil and watercolor
Two sheets, each 2 $^3/_4$ × 5 in., on sheet 11 × 8 $^1/_2$ in.
reproduced, p. 33

Notebook Page: Pineapple Romanoff, Swansea, England, 1988
Pencil, felt pen, watercolor
3 × 5 in. on sheet 11 × 8 $^1/_2$ in.

Notebook Page: Strawberry Cheesecake, Leeds, England, 1988
Ballpoint pen and watercolor
5 × 3 in. on sheet 11 × 8 $^1/_2$ in.

Notebook Page: "Feeling nicely decomposed," New York,
1989
Felt pen, pencil, watercolor
Three sheets, each 5 × 2 $^3/_4$ in., on sheet 11 × 8 $^1/_2$ in.

*Notebook Page: Proposal for a Fountain in Duisburg, Germany
Based on the Confluence of the Rühr and Rhine Rivers,* 1989
Ballpoint pen, felt pen, watercolor
Two sheets, each 5 × 2 $^3/_4$ in., on sheet 11 × 8 $^1/_2$ in.

*Notebook Page: Proposal for a Sculpture in the Form of a
Rearing Clothes Hanger,* 1989
Pencil and watercolor
5 × 2 $^3/_4$ in. on sheet 11 × 8 $^1/_2$ in.

*Notebook Page: Studies for a Print Commemorating the French
Revolution,* 1989
Ballpoint pen, felt pen, pencil, watercolor
Three sheets, each 5 × 2 $^3/_4$ in., and one sheet 2 $^{15}/_{16}$ × 2 $^3/_4$ in., on
sheet 11 × 8 $^1/_2$ in.
reproduced, p. 25

Notebook Page: "Tack = Mushroom," 1989
Pencil and felt pen
Two sheets, each 5 × 2 $^3/_4$ in., on sheet 11 × 8 $^1/_2$ in.

Notebook Page: Two Sculptures in the Form of Orange Peels,
1989
Pencil and watercolor
5 × 2 $^3/_4$ in. on sheet 11 × 8 $^1/_2$ in.

Notebook Page: Terrine, Utrecht, 1990
Pencil, felt pen, watercolor
2 $^3/_4$ × 5 in. on sheet 11 × 8 $^1/_2$ in.

Notebook Page: Château Marmont as Caviar/Avocado Mousse, Los Angeles, 1991
Ballpoint pen, pencil, watercolor on sheet of hotel memo paper
5 $^{15}/_{16}$ × 4 in. on sheet 11 × 8 $^1/_2$ in.
reproduced, p. 333

Notebook Page: Pedestrian Bridge in the Form of an Extinguished Match, Île St. Germain, Paris, 1991
Pencil, felt pen, watercolor
9 $^1/_2$ × 5 $^7/_8$ in. on sheet 11 × 8 $^1/_2$ in.

Notebook Page: Perfume Bottle – "breath," "heart," "lungs," Barcelona, 1991
Pencil and watercolor
4 $^3/_4$ × 6 $^5/_{16}$ in. on sheet 11 × 8 $^1/_2$ in.

Notebook Page: Study for Harp Sail, 1991
Felt pen, pencil, watercolor
5 $^7/_8$ × 4 $^3/_4$ in. on sheet 11 × 8 $^1/_2$ in.

Notebook Page: Perfume Bottle as Balloon, 1991-1992
Pencil and watercolor
8 $^7/_{16}$ × 5 $^3/_8$ in. on sheet 11 × 8 $^1/_2$ in.

Notebook Page: Column Dressed as a Bottle of Perfume, Place Vendôme, Paris, 1992
Pencil and watercolor
8 $^7/_{16}$ × 5 $^3/_8$ in. on sheet 11 × 8 $^1/_2$ in.
reproduced, p. 28

Notebook Page: Shuttlecock Sculpture Studies – "tite rope walker," 1992
Pencil and watercolor
Two sheets, each 5 × 2 $^3/_4$ in., on sheet 11 × 8 $^1/_2$ in.

Notebook Page: Slingshot Valentine, 1992
Colored pencil, ballpoint pen, watercolor
4 $^1/_2$ × 3 $^9/_{16}$ in. on sheet 11 × 8 $^1/_2$ in.

Notebook Page: Study for an Etching: Sharpened Pencil Stub with Broken-off Tip of the Woolworth Building, 1992
Pencil, crayon, watercolor
8 $^1/_2$ × 5 $^7/_{16}$ in. on sheet 11 × 8 $^1/_2$ in.

Notebook Page: Three Designs for a Perfume Bottle, "Monoprix," 1992
Pencil and watercolor
5 $^3/_8$ × 8 $^7/_{16}$ in. on sheet 11 × 8 $^1/_2$ in.

Notebook Page: Sculpture in the Form of a Colossal Hammock, with Hat; "hammock = bacon," 1993
Pencil, colored pencil, watercolor
Two sheets, 2 $^3/_4$ × 5 in. and 5 × 2 $^3/_4$ in., on sheet 11 × 8 $^1/_2$ in.

Notebook Page: Giant Soft Shuttlecock in the Rotunda of the Guggenheim Museum, 1994
Pencil and colored pencil
8 $^7/_{16}$ × 10 $^1/_8$ in. on sheet 11 × 8 $^1/_2$ in.

Notebook Page: Proposal for a Colossal Monument in the Form of C-clamp, for the Hudson River, New York City, 1994
Pencil and crayon
8 $^1/_2$ × 5 $^1/_2$ in. on sheet 11 × 8 $^1/_2$ in.

Notebook Page: Pushcart Monument, 1994
Pencil
Two sheets, each 2 $^3/_4$ × 5 in., on sheet 11 × 8 $^1/_2$ in.

Notebook Page: Sculpture in the Form of a Shuttlecock, for the Rotunda of the Guggenheim Museum, New York, 1994
Pencil, ballpoint pen, colored pencil
8 $^7/_{16}$ × 5 $^7/_{16}$ in. on sheet 11 × 8 $^1/_2$ in.

Notebook Page: Proposal for the Rotunda of the Guggenheim Museum, New York: Fallen Teddy Bear, on Pillow, 1995
Pencil and colored pencil
6 × 8 $^1/_2$ in. on sheet 11 × 8 $^1/_2$ in.

Notebook Page: Collided Ice Cream Cones, 1996
Pencil and watercolor
Two sheets, each 2 $^3/_4$ × 5 in., on sheet 11 × 8 $^1/_2$ in.

Notebook Page: Peel Flung on a Terrace of the Hayward Gallery, London, 1996
Pencil and watercolor
Two sheets, each 2 $^3/_4$ × 5 in., on sheet 11 × 8 $^1/_2$ in.

Sketchbook Page: Blueberry Pie Transformations for J. V. – Blueberry Pie Island, 1996
Pencil and watercolor
5 $^7/_8$ × 3 $^{15}/_{16}$ in.

Sketchbook Page: Blueberry Pie Transformations for J. V. – Dropped, à la Mode, 1996
Pencil and watercolor
5 $^7/_8$ × 3 $^{15}/_{16}$ in.

Sketchbook Page: Blueberry Pie Transformations for J. V. – Sliding, à la Mode, 1996
Pencil and watercolor
5 $^7/_8$ × 3 $^{15}/_{16}$ in.

Sketchbook Page: Blueberry Pie Transformations for J. V. – Tumbling, à la Mode, 1996
Pencil and watercolor
5 $^7/_8$ × 3 $^{15}/_{16}$ in.

Sketchbook Page: Sculpture for the Park (with J. V.) – Cheese in the Woods, 1996
Pencil and watercolor
5 $^7/_8$ × 3 $^{15}/_{16}$ in.

Sketchbook Page: Collided Cones, for Place Jean Jaurès, Tours, France, 1997
Pencil, colored pencil, watercolor
8 $^1/_4$ × 5 $^1/_4$ in.

Sketchbook Page: Colossal Inner Tube in Stockholm Harbor, 1997
Pencil and watercolor
11 × 8 $^1/_2$ in.

Sketchbook Page: "Cos: 'Pyramid of Peaches and Pears' (Balzac)," 1997
Pencil and watercolor
5 $^1/_4$ × 8 $^1/_4$ in.

Sketchbook Page: Pomme de Douche, Château de la Borde, France, 1997
Pencil, colored pencil, watercolor
4 × 5 in.

Sketchbook Page: Pomme de Douche, Château de la Borde, France, 1997
Pencil, crayon, watercolor
4 × 5 in.

Sketchbook Page: Prehistoric Wagon, 1997
Pencil and watercolor
4 $^1/_8$ × 5 $^3/_4$ in.

Sketchbook Page: Sphinx Fragments, on a Playing Field, 1997
Pencil and watercolor
5 $^1/_4$ × 8 $^1/_4$ in.

Sketchbook Page: Study for Caught and Set Free in Stockholm Harbor, 1997
Pencil and watercolor
5 $^1/_4$ × 8 $^1/_4$ in.

Sketchbook Page: Triple Decker Sandwich with Olive, 1997
Pencil and watercolor
5 $^1/_4$ × 8 $^1/_4$ in.

Sketchbook Page: Vegetable Ark, for Jerusalem, 1997
Pencil and watercolor
5 $^5/_{16}$ × 8 $^1/_4$ in.

Notebook Page: Studies for a Sculpture in the Form of a Flaming Question Mark, Presseamt, Berlin, 1998
Pencil and watercolor
Two sheets, each 4 $^7/_{16}$ × 3 $^7/_{16}$ in., on sheet 11 × 8 $^1/_2$ in.

Sketchbook Page: Apple Aflame, in Boat (after J. V. and E. D.), 1998
Pencil and watercolor
5 $^5/_{16}$ × 8 $^1/_4$ in.
reproduced, p. 336

Sketchbook Page: Sculpture in the Form of a Knot for Piazzale Cadorna, Milan, Italy, 1998
Crayon, pencil, watercolor
7 $^{13}/_{16}$ × 5 $^5/_{16}$ in.

Sketchbook Page: Sculpture in the Form of a Needle and Thread for Piazzale Cadorna, Milan, Italy, 1998
Pencil and watercolor
7 $^5/_8$ × 5 $^5/_{16}$ in.
reproduced, p. 162

Sketchbook Page: Study for the Flying Pins, 1998
Pencil and watercolor
5 $^1/_2$ × 8 $^1/_4$ in.
reproduced, p. 168

Sketchbook Page: Study for the Lion's Tail, Venice, over a Balcony, 1998
Pencil and colored pencil
8 $^1/_4$ × 5 $^5/_{16}$ in.

Sketchbook Page: Shuttlecock/Sphinx in Autumn, 1999
Pencil and colored pencil
4 $^1/_8$ × 6 $^1/_8$ in.

Sketchbook Page: Shuttlecock/Sphinx in Winter, 1999
Pencil and colored pencil
4 $^1/_8$ × 6 $^1/_8$ in.

Sketchbook Page: Study for Pyramid of Peaches and Pears Sited in Place Jean Jaurès, Tours, France, 1999
Pencil and watercolor
5 $^5/_{16}$ × 8 $^1/_4$ in.

Notebook Page: Music Pages with Falling Notes, 2000
Crayon and watercolor
Irregular 8 $^{11}/_{16}$ × 6 $^1/_{16}$ in. on sheet 11 × 8 $^1/_2$ in.

Notebook Page: Proposal for a Lighthouse in the Form of a Banana Peel, for the Coast of New Zealand, with Shuttlecock Balloon, 2000
Pencil and watercolor
8 $^1/_2$ × 5 $^3/_{16}$ in. on sheet 11 × 8 $^1/_2$

Notebook Page: Soft Viola Island, 2000
Pencil and watercolor
4 $^1/_8$ × 5 $^3/_4$ in. on sheet 11 × 8 $^1/_2$ in.

Sketchbook Page: Wedding Cake with Cupid's Bows, Invitation to the Marriage of Maartje and Rustom, 2000
Pencil and watercolor
8 × 5 $^1/_4$ in.

Sketchbook Page: Leaf Boat Sited in the Tuileries, Paris, 2001
Pencil and watercolor
3 $^{15}/_{16}$ × 6 $^{1}/_{16}$ in.

*Sketchbook Page: Leaf Boat Sited in the Tuileries, Paris –
Overhead View*, 2001
Pencil and watercolor
3 $^{15}/_{16}$ × 6 $^{1}/_{16}$ in.

*Sketchbook Page: Lighthouse in the Form of a Banana Peel,
"Peel Phare,"* 2001
Pencil, colored pencil, watercolor
8 $^{1}/_{8}$ × 5 $^{3}/_{8}$ in.

Sketchbook Page: Study for French Horn, Unwound, 2001
Pencil and watercolor
5 $^{1}/_{4}$ × 8 $^{1}/_{4}$ in.

Sketchbook Page: Study for Clarinet Leaning in the Wind, 2004
Charcoal and pastel
7 $^{3}/_{4}$ × 5 $^{1}/_{2}$ in.

DRAWINGS

*Design for a Theater Library for Venice in the Form of
Binoculars and Coltello Ship in Three Stages*, 1984
Pencil, colored pencil, chalk, watercolor
30 × 40 in.
details reproduced, p. 90 and p. 102

Free Stamp, 1984
Pencil, watercolor, tape; on photoprint
31 $^{1}/_{2}$ × 23 $^{1}/_{2}$ in.
reproduced, p. 91

*Proposed Events for Il Corso del Coltello, a Performance in
Venice, Italy*, 1984
Crayon, pencil, watercolor
24 × 18 $^{3}/_{4}$ in.
The UBS Art Collection
reproduced, p. 39

*Characters and Props from Il Corso del Coltello, along the Canal
di San Marco, Coltello Ship in Background – Version Three*, 1986
Charcoal and pastel
33 $^{1}/_{8}$ × 43 in.
Collection Julie and Edward J. Minskoff, New York
reproduced, pp. 36-37

*Frankie P. Toronto and Exploding Temple Shack with Georgia
Sandbag on the Bridge*, 1986
Charcoal, pastel, watercolor
17 $^{3}/_{4}$ × 23 $^{3}/_{4}$ in.
Collection Frank and Berta Gehry, Santa Monica, California
reproduced, p. 38

Props and Costumes for Il Corso del Coltello, 1986
Charcoal and pastel
40 × 30 in.
Collection Robert and Jane Meyerhoff, Phoenix,
Maryland
Courtesy PaceWildenstein, New York
reproduced, p. 41

Props and Costumes for Il Corso del Coltello, Exhibition Study,
1986
Pastel and charcoal
40 × 30 $^{1}/_{16}$ in.
Courtesy Paula Cooper Gallery, New York
reproduced, p. 40

*Study for Poster of Dropped Bowl, with Scattered Slices and
Peels*, 1988
Charcoal and pastel
40 × 28 in.
Courtesy Konrad Fischer Galerie, Düsseldorf

*Study for Poster of Dropped Bowl, with Scattered Slices and
Peels*, 1988
Charcoal and pastel
39 $^{7}/_{8}$ × 30 in.

*The Dropped Bowl with Scattered Slices and Peels – In Advance
of the Fountain for the Metro-Dade Government Center*
(drawing for offset edition), 1988
Charcoal, pencil, pastel
40 × 30 in.

From the Entropic Library – Second Study, 1989
Charcoal and pastel
25 $^{3}/_{8}$ × 36 in.

From the Entropic Library – Third Study, 1989
Charcoal and chalk
30 × 40 in.
reproduced, p. 62

Quill on a Fragment of Desk Pad, 1990
Charcoal and watercolor
38 $^{3}/_{16}$ × 50 in.
reproduced, p. 68

*Stamp Blotter on a Fragment of Desk Pad (Study for Rolling
Blotter)*, 1990
Charcoal and watercolor
38 $^{1}/_{8}$ × 50 in.
reproduced, p. 69

Stamp Blotters on Shattered Desk Pad, 1990
Charcoal, pencil, pastel
38 $^{3}/_{16}$ × 50 $^{1}/_{8}$ in.
reproduced, p. 68

Study for Collapsed European Postal Scale, 1990
Pencil and watercolor
30 × 40 in.
reproduced, p. 69

Proposal for a Sculpture in the Form of a Pan and Broom, 1997
Pencil and pastel
30 × 40 in.

Proposal for a Sculpture in the Form of a Dropped Cone, for Neumarkt Galerie, Cologne, 1998
Pencil, colored pencil, pastel
25 $^3/_4$ × 18 $^7/_{16}$ in.
reproduced, p. 174

Study for a Sculpture in the Form of a Broom and Pan with Sweepings, 1998
Pencil and colored pencil
30 × 40 in.

Proposal for a Monument to Honoré de Balzac in the Form of a Pyramid of Pears and Peaches, Place Jean Jaurès, Tours, France, 2000
Charcoal, pencil, colored pencil, pastel, postcard
30 $^1/_{16}$ × 40 in.
Courtesy PaceWildenstein, New York

French Horn, Unwound, on Ground, 2001
Charcoal and pastel
38 $^3/_{16}$ × 49 $^5/_8$ in.

Two French Horns, Unwound, Entwined, on Ground, 2001
Charcoal and pastel
38 $^3/_{16}$ × 50 in.

Cupid's Span, 2003
Crayon, colored pencil, pastel
26 $^1/_4$ × 37 $^{11}/_{16}$ in.

Clarinet Leaning in the Wind, 2004
Charcoal, chalk, watercolor
38 $^1/_4$ × 28 in.
Courtesy PaceWildenstein, New York

Spring, a Large-Scale Project by Coosje van Bruggen, 2005
Pencil and colored pencil
29 × 22 $^3/_4$ in.

Sculptures

Architectural Fragments, 1985
Canvas filled with polyurethane foam; painted with latex
Seven elements: yellow stairs, 112 × 34 × 34 $^1/_2$ in.; yellow columns with architrave, 112 × 78 $^3/_4$ × 10 $^1/_2$ in.; gray stairs, 112 × 34 × 34 $^1/_2$ in.; red column, 119 $^1/_4$ × 19 × 19 $^3/_4$ in.;

green obelisk, 123 × 31 × 19 in.; red arch, 126 × 52 $^3/_4$ × 21 $^1/_4$ in.; yellow obelisk, 123 × 31 × 19 in.
Castello di Rivoli Museum of Contemporary Art, Rivoli-Turin
reproduced, pp. 56-57

Houseball, 1985
Canvas, polyurethane foam, rope; painted with latex, aluminum
Approximately 12 ft. diameter
Courtesy PaceWildenstein, New York
reproduced, p. 55

Dr. Coltello Costume – Enlarged Version, 1986
Canvas filled with polyurethane foam; painted with latex
8 ft. 8 in. × 5 ft. × 1 ft. 8 in.
Courtesy PaceWildenstein, New York
reproduced, p. 52

Frankie P. Toronto Costume – Enlarged Version, 1986
Canvas filled with polyurethane foam; painted with latex
Pants: 6 ft. 3 in. × 5 ft. 5 in. × 1 ft. 1 in.;
jacket with hat: 6 ft. 7 in. × 7 ft. × 2 ft. 8 in.
Courtesy PaceWildenstein, New York
reproduced, p. 54

Georgia Sandbag Costume – Enlarged Version, 1986
Canvas filled with polyurethane foam; painted with latex
6 ft. 9 in. overall height; bag: 13 × 39 × 12 in.;
letter "O": 6 ft. 4 $^1/_2$ in. × 8 ft. × 1 ft. 11 in.
Courtesy PaceWildenstein, New York
reproduced, p. 53

Project for the Walls of a Dining Room: Broken Plate of Scrambled Eggs, with Fabrication Model of the Dropped Bowl Fountain, 1987
Wood, aluminum, steel, galvanized metal, cast resin, expanded polystyrene; painted with latex and spray enamel
9 ft. 10 $^1/_8$ in. × 15 ft. 3 $^1/_{16}$ in. × 18 ft. 2 in.
Castello di Rivoli Museum of Contemporary Art, Rivoli-Turin
reproduced, pp. 58-59, 60-61

From the Entropic Library, 1989
Cloth, wood, aluminum, expanded polystyrene; coated with resin and painted with latex
11 ft. 9 $^3/_4$ in. × 22 ft. 6 $^1/_{16}$ in. × 8 ft. 4 in., variable dimensions
Musée d'Art Moderne, Saint-Etienne, France
reproduced, pp. 63-65

Resonances, after J. V., 2000
Canvas, polyurethane foam, cardboard; coated with resin and painted with latex, wood, paper, clothesline, string; painted with latex, hardware, "envelope" and "tiles": crayon, pencil, watercolor
Overall dimensions: 58 $^7/_{16}$ × 55 $^3/_{16}$ × 16 $^1/_8$ in.
Courtesy PaceWildenstein, New York
reproduced, p. 71

Soft Clarinets, Paired, 2000
Canvas painted with latex
53 × 44 × 10 in.

Soft Viola, 2000
Canvas, wood, polyurethane foam, cord; coated with resin and
painted with latex, hardware painted with latex
78 $^3/_4$ × 35 $^3/_8$ × 15 $^3/_4$ in., variable dimensions

Soft French Horn, Unwound, 2002
Canvas and wood; painted with latex, plastic tubing
80 $^1/_2$ × 30 × 25 $^1/_4$ in., variable dimensions

Falling Notes, 2003
Canvas coated with resin, cord, string; painted with latex and
spray enamel
37 $^7/_{16}$ × 21 $^1/_4$ × 11 $^{13}/_{16}$ in., variable dimensions
Courtesy PaceWildenstein, New York
reproduced, p. 72

French Horn, Sliced and Unwound, 2003
Expanded polystyrene, cardboard, plaster, wood, hardware;
painted with latex and spray enamel
33 $^1/_2$ × 31 $^9/_{16}$ × 9 $^7/_8$ in.
reproduced, p. 76

Soft French Horn, Unwound, 2003
Canvas and wood; painted with latex, plastic tubing
80 $^1/_2$ × 30 × 25 $^1/_4$ in., variable dimensions
Courtesy PaceWildenstein, New York
reproduced, p. 74

Sliced Stradivarius – Rose, 2003
Canvas, felt, wood, cord, hardware; painted with latex
45 × 18 × 7 in., variable dimensions
reproduced, p. 79

Sliced Stradivarius – Crimson, 2004
Canvas, felt, wood, cord, hardware; painted with latex
45 × 18 × 7 in., variable dimensions
Collection Mr. and Mrs. Christopher M. Harland, New York
reproduced, p. 79

Tied Trumpet 2/3, 2004
Aluminum, canvas, felt, polyurethane foam, rope, cord;
coated with resin and painted with latex, plastic tubing
50 $^1/_2$ × 23 $^1/_2$ × 15 in.
Courtesy PaceWildenstein, New York
reproduced, p. 77

Silent Metronome, 16 inch, Version Four, 2005
Canvas, wood, hardware, cord; painted with acrylic and latex
16 × 8 $^1/_2$ × 10 in.

Leaning Clarinet 1/3, 2006
Aluminum painted with acrylic polyurethane

11 ft. 9 in. × 5 ft. 2 in. × 2 ft. 8 in.
Private collection, Paris
Courtesy PaceWildenstein, New York
reproduced, p. 73

Dropped Flower, 2006
Polyurethane foam, fiber-reinforced plastic, felt, burlap, rope,
aluminum, copper, expanded polystyrene; painted with acrylic
9 ft. 8 in. × 16 ft. 4 in. × 24 ft. 2 in.
Castello di Rivoli Museum of Contemporary Art, Rivoli-Turin
Permanent loan
Fondazione CRT Project for Modern and Contemporary Art
reproduced, cover

SELECTED BIBLIOGRAPHY
1985-2005

BOOKS BY THE ARTISTS

1990

Sketches and Blottings toward The European Desktop. Milan and Turin: Christian Stein; and Florence: Hopeful Monster. In English and Italian.
Includes "To Frédéric" by Coosje van Bruggen and "Acknowledgments" by Claes Oldenburg.

1994

Claes Oldenburg Coosje van Bruggen: Large-Scale Projects. New York: The Monacelli Press; and London: Thames & Hudson (1995). In English.
Photography by Attilio Maranzano.
Includes "The Lipstick: A Colossal Keepsake Product" by Susan P. Casteras, "Message in a Bottle" by Richard Cork, "Monument to the Last Horse: Animo et Fide" by Donald Judd, "The Lipstick at Yale: A Memoir" by Vincent Scully, "Sculpture on the Borderline" by Gerhard Storck, "Leaps into the Unknown: Large-Scale Projects in Collaboration with Frank O. Gehry" by Coosje van Bruggen, and case histories by Claes Oldenburg and Coosje van Bruggen.

2004

Images à la Carte. New York: Paula Cooper Gallery. In English.
Includes "Vignette" by J.V. and afterword by Claes Oldenburg.

BOOKS ABOUT THE ARTISTS

1986

Celant, Germano. *The Course of the Knife: Claes Oldenburg, Coosje van Bruggen, Frank O. Gehry*. Milan: Electa. In English.
Includes "The Indiscreet Knife" by Germano Celant, "First Thoughts" by Claes Oldenburg, "Studies" by Frank O. Gehry, "Final Stage Directions and Dialogue" by Claes Oldenburg and Coosje van Bruggen, and "Waiting for Dr. Coltello," "Coosje's Journals," and "Characters" by Coosje van Bruggen.

1994

Inverted Collar and Tie: Claes Oldenburg, Coosje van Bruggen. Ostfildern, Germany: Buchhandelsausgabe DG BANK and Cantz Verlag. In German and English.
Photography by Gerd Kittel.
Includes introduction by Luminita Sabau, "Claes Oldenburg and Coosje van Bruggen: A Conversation" by Erwin Leiser, and transcript of a panel discussion with Coosje van Bruggen and Claes Oldenburg about the unveiling of the sculpture *Inverted Collar and Tie*, held on June 21, 1994.

1997

Bottle of Notes: Claes Oldenburg, Coosje van Bruggen. Middlesbrough, England: Middlesbrough Borough Council. In English.
Includes introduction by Tony Duggan and Les Hooper, "Message in a Bottle" by Richard Cork, "Making the Monument" by Tony Duggan and Les Hooper, and "Notes towards a Large-Scale Project for Middlesbrough" by Claes Oldenburg and Coosje van Bruggen.

2002

Pelo Passeio dos Liquidâmbares: Escultura no Parque/Down Liquidambar Lane: Sculpture in the Park. Porto, Portugal: Fundação Serralves. In Portuguese and English.
Includes introduction by Vicente Todoli, "Into the Woods" by Richard Cork, and "Down Liquidambar Lane: A Conversation between Coosje van Bruggen, Claes Oldenburg, and Alexandre Melo."

EXHIBITION CATALOGUES

1986

El Cuchillo Barco: Il Corso del Coltello, Claes Oldenburg, Coosje van Bruggen, Frank O. Gehry. Milan: Electa. In Spanish.
Includes "Un cuchillo indiscreto" by Germano Celant and "Esperando al Dr. Coltello" and "Personajes" by Coosje van Bruggen.

1987

The Haunted House. Krefeld, Germany: Museum Haus Esters; and Essen, Germany: Verlag H. Gerd Margreff. In German and English.
Includes introduction by Gerhard Storck and "Ghosting" by Coosje van Bruggen.

1988

Celant, Germano. *A Bottle of Notes and Some Voyages: Claes Oldenburg, Coosje van Bruggen*. Sunderland, England: Northern Centre for Contemporary Art; and Leeds, England: The Henry Moore Centre for the Study of Sculpture, Leeds City Art Galleries. Distributed internationally by Rizzoli International Publications, New York. In English and edition in Spanish.
Includes "In and Out of the Bottle" by Germano Celant, "Sculpture on the Borderline" by Gerhard Storck; "Cross Section of a Toothbrush" and "Aboard the Broome Street" by Claes Oldenburg; "Some Observations on Oldenburg's Alternative Proposal for an Addition to the Allen Memorial Art Museum, Oberlin, Ohio," "Repression and Resistance at the University of

El Salvador, 1968-83," and "Ghosting" by Coosje van Bruggen; and case histories by Claes Oldenburg and Coosje van Bruggen: "Log of the Three-Way Plug," "In the Wake of the Screwarch," "Douse the Glim," "Stranded Piano," and "Notes towards a Large-Scale Project for Middlesbrough."

1989
Claes Oldenburg: Dibujos/Drawings 1959-1989 from the Collection of Claes Oldenburg and Coosje van Bruggen. Valencia, Spain: IVAM, Centre Julio González. In Spanish and English.
Includes "The Realistic Imagination and Imaginary Reality of Claes Oldenburg" by Coosje van Bruggen and "Appendix: Notes on Some Illustrations" by Claes Oldenburg.

1992
Claes Oldenburg. New York: The Pace Gallery. In English.
Includes interview with Claes Oldenburg by Arne Glimcher.

1995
Claes Oldenburg: An Anthology. New York: Solomon R. Guggenheim Museum. In English and edition in German.
Includes "Claes Oldenburg and the Feeling of Things" and "The Sculptor Versus the Architect" by Germano Celant, "From the Entropic Library" by Dieter Koepplin, "Unbridled Monuments" by Mark Rosenthal, and a biographical overview by Marla Prather.

1999
Celant, Germano, editor. *Claes Oldenburg Coosje van Bruggen.* Milan: Skira. In Italian and edition in English.
Includes "Claes Oldenburg and Coosje van Bruggen: Urban Marvels" and "Coosje van Bruggen, Claes Oldenburg, Germano Celant: A Conversation" by Germano Celant, and case histories by Claes Oldenburg and Coosje van Bruggen.

2002
Claes Oldenburg Coosje van Bruggen. New York: PaceWildenstein. In English.
Includes "If Music Be the Food of Love, Play On…New Sculpture by Claes Oldenburg and Coosje van Bruggen" by Richard Morphet.

Lee, Janie C. *Claes Oldenburg: Drawings, 1959-1977; Claes Oldenburg with Coosje van Bruggen: Drawings, 1992-1998 in the Whitney Museum of American Art.* New York: Whitney Museum of American Art. Distributed by Harry N. Abrams, Inc., New York. In English.
Includes introduction and interview with Claes Oldenburg by Janie C. Lee.

Oldenburg and van Bruggen on the Roof. New York: The Metropolitan Museum of Art. Pamphlet. In English.

2005
Claes Oldenburg Coosje van Bruggen: The Music Room. New York: PaceWildenstein. In English.
Photography by Todd Eberle.
Includes "The Instrumentation of Emotion" by Richard Morphet.

Group Exhibition Catalogues

1988
World Cities and the Future of the Metropolis: Beyond the City, The Metropolis. 17th Triennale of Milan. Milan: Electa.
Includes "Squares, Streets, Gardens: The Urban Scenography Facing the Metropolitan Development" by Bazon Brock and "MIArt" by Germano Celant.

1989
Martin, Jean-Hubert, editor. *Magiciens de la Terre.* Paris: Musée national d'art moderne, Centre Georges Pompidou.
Includes "From the Entropic Library" by Coosje van Bruggen.

Modern Masters '89. Helsinki, Finland: Helsinki Art Hall.

1996
A Century of Sculpture: The Nasher Collection. New York: Solomon R. Guggenheim Museum.

1997
Celant, Germano, editor. *Past, Present, Future.* 47th International Art Exhibition, The Venice Biennale. Milan: Electa.

Contemporary Sculpture. Projects in Münster 1997. Stuttgart, Germany: Verlag Gerd Hatje.
Includes "The Architect's Handkerchief" by Claes Oldenburg and Coosje van Bruggen.

2000
Morphet, Richard. *Encounters: New Art from Old.* London: National Gallery Company Ltd.

2002
Prather, Marla, and Dana A. Miller. *An American Legacy, A Gift to New York.* New York: Whitney Museum of American Art.

2004
Celant, Germano, editor. *Architecture & Arts 1900/2004: A Century of Creative Projects in Building, Design, Cinema, Painting, Photography, Sculpture.* Milan: Skira.
Includes "Model as Artwork" by Germano Celant and "Leaps into the Unknown: Large-Scale Projects in Collaboration with Frank O. Gehry" by Coosje van Bruggen.

2005
Pollock to Pop: America's Brush with Dalí. St. Petersburg, FL: Salvador Dalí Museum.

GENERAL REFERENCE BOOKS
INCLUDING WORK BY THE ARTISTS

1985
Borges, Jorge Luis. *Atlas.* New York: E.P. Dutton.

1987
Stratton, Susan, editor. *The Barcelona Plazas: Preview of an Urban Experience. Notes on the Proceedings of a Symposium Held in Conjunction with an Exhibition at the Spanish Institute.* New York: Queen Sofía Spanish Institute.

1990
Walker Art Center: Painting and Sculpture from the Collection. Minneapolis, MN: Walker Art Center; and New York: Rizzoli International Publications.

1991
Nuridsany, Michel. *La Commande Publique.* Paris: Réunion des Musées Nationaux.

1992
La Vall d'Hebron. Barcelona, Spain: Tipografía Emporium S. A.

Bach, Penny Balkin. *Public Art in Philadelphia.* Philadelphia: Temple University Press.

Jencks, Charles, editor. *The Post-Modern Reader.* London: Academy Editions; and New York: St. Martin's Press.

Senie, Harriet F. *Contemporary Public Sculpture: Tradition, Transformation, and Controversy.* New York and Oxford: Oxford University Press.

1994
Gebhard, David, and Robert Winter. *Los Angeles: An Architectural Guide.* Salt Lake City, UT: Gibbs-Smith.

1995
Tokyo International Exhibition Center (Tokyo Big Sight) Art Work.

1996
La Villette. Paris: Guides Gallimard.

1997
Lippard, Lucy R. *The Lure of the Local: Senses of Place in a Multicentered Society.* New York: The New Press.

2000
Art and Architecture. Marfa, Texas: The Chinati Foundation. Includes introduction by William F. Stern, "Recent Work" by Frank O. Gehry, and "Why Run Into Buildings When You Can Walk Between Them?" by Claes Oldenburg and Coosje van Bruggen.

Root-Bernstein, Robert, and Michèle Root-Bernstein. *Sparks of Genius: The Thirteen Thinking Tools of Creative People.* Boston: Houghton Mifflin Company.

2001
Gift to the Nation. Washington, D.C.: Friends of Art and Preservation in Embassies.

Lambert, Jenneke, and Peter Thoben. *Beeldenboek Eindhoven.* Eindhoven, the Netherlands: Museum Kempenland.

Spector, Nancy, editor. *Guggenheim Museum Collection: A to Z,* 2d rev. ed. New York: Solomon R. Guggenheim Museum. Includes "Collaboration" by Coosje van Bruggen, "Claes Oldenburg" by Nancy Spector, and "Oldenburg/Coosje van Bruggen" by Joan Young.

2002
Antenucci Becherer, Joseph. *Gardens of Art: The Sculpture Park at the Frederik Meijer Gardens.* Grand Rapids, MI: Frederik Meijer Gardens.

Sarnoff, Irving, and Suzanne Sarnoff. *Intimate Creativity: Partners in Love and Art.* Madison, WI: The University of Wisconsin Press.

2003
Cork, Richard. *Annus Mirabilis? Art in the Year 2000.* New Haven and London: Yale University Press.

___. *Breaking Down the Barriers: Art in the 1990s.* New Haven and London: Yale University Press.

___. *New Spirit, New Sculpture, New Money: Art in the 1980s.* New Haven and London: Yale University Press.

Gianelli, Ida, and Marcella Beccaria, editors. *Castello di Rivoli Museum of Contemporary Art: The Castle – The Collection.* Turin: Umberto Allemandi.

2004
Eco, Umberto. *History of Beauty.* New York: Rizzoli International Publications.

2005
Janovy, Karen O., editor. *Sculpture from the Sheldon Memorial Art Gallery.* Lincoln, NE: University of Nebraska Press.

SELECTED PUBLICATIONS
AND WRITINGS BY COOSJE VAN BRUGGEN

1983
"Richard Artschwager." *Artforum* (New York) 22, no. 1 (September 1983), pp. 44-51.

"Repression and Resistance at the University of El Salvador, 1968-83." *Real Life Magazine*, nos. 11-12 (Winter 1983-1984), pp. 15-18.

1984
"Waiting for Dr. Coltello: A Project by Coosje van Bruggen, Frank O. Gehry, and Claes Oldenburg." *Artforum* (New York) 23, no. 1 (September 1984), pp. 88-91.

1985
"Gerhard Richter: Painting as a Moral Act." *Artforum* (New York) 23, no. 9 (May 1985), pp. 82-91.

"'Les Infos du Paradis': Il Corso del Coltello." *Parkett* (Zurich), no. 7 (October 1985), pp. 98-109.

1986
"Leaps into the Unknown." In *The Architecture of Frank Gehry*. Minneapolis, MN: Walker Art Center; and New York: Rizzoli International Publications, pp. 122-141.

"The True Artist Is an Amazing Luminous Fountain." In *Bruce Nauman: Drawings/Zeichnungen, 1965-1986*. Basel: Museum für Gegenwartskunst, pp. 10-27.

1988
Bruce Nauman. New York: Rizzoli International Publications.

1990
John Baldessari. New York: Rizzoli International Publications.

"Today Crossed Out." In *Hanne Darboven, Urzeit/Uhrzeit*. Artist's book, ed. 250. New York: Rizzoli International Publications, pp. 241-246.

1991
Claes Oldenburg: Nur ein anderer Raum (Just another room). Frankfurt-am-Main, Germany: Museum für Moderne Kunst.

"Die Schöne und die Bestie" (Beauty and the beast). In *Emanuel Hoffman-Stiftung*. Basel: Wiese Verlag, pp. 194-197.

1999
Frank O. Gehry, Guggenheim Museum in Bilbao. New York: Solomon R. Guggenheim Museum.

2002
"Sounddance." In Robert C. Morgan, editor. *Bruce Nauman*. Baltimore, MD and London: Johns Hopkins University Press, pp. 43-68.

2005
"Buiten de Perken, 'Ik Zie Dat Wel'" (Beyond the pale: "I can see that well"). On the occasion of the "Manifestations" *Op Losse Schroeven* and *Sonsbeek 71*, in *Wim Beeren – om de kunst*. Rotterdam: Nai Uitegevers, pp. 182-186.

ARTICLES ABOUT THE ARTISTS

Apgar, Garry. "Public Art and the Remaking of Barcelona." *Art in America* (New York) 79, no. 2 (February 1991), pp. 108-121, 159.

Apple Jr., R.W. "Where Winter's a Wonder and Smiles Are Sincere. You Betcha." *New York Times*, January 28, 2000, sec. E, pp. 33, 42.

Arditi, Fiamma. "Razionalmente differenti inconsciamente simili." *Ars* (Milan) 3, no. 11 (November 1999), pp. 109-112.

Artforum (New York) 26, no. 7 (March 1988), cover photograph.

Artnews (New York) 104, no. 7 (Summer 2005), cover photograph.

Baker, Kenneth. "Take a Bow." *San Francisco Chronicle: Datebook*, December 23, 2002, sec. D, pp. 1, 8.

Bashkoff, Tracy. "Collection in Focus: Uncommon Objects, Claes Oldenburg and Coosje van Bruggen." *Guggenheim Magazine* (New York) 10, no. 2 (Spring 1997), pp. 8-11.

Blanc, Giulio V. "Bombs and Oranges: Discovering Miami's Explosive Art Scene." *NY Arts Magazine* (New York) 65, no. 3 (November 1990), pp. 75-79.

Byong-chol, Kang. "Shell Design Unveiled for Cheonggye Stream." *International Herald Tribune* (Asia), December 22, 2005, p. 2.

Celant, Germano. "San Marco sul Niagara." *Domus* (Milan), no. 665 (October 1985), pp. 74-75.

Cembalest, Robin. "Post-Franco Flourish." *Stroll* (New York), nos. 4-5 (October 1987), cover photograph, pp. 18-27.

Ceriani, Giulia. "Percezioni metropolitane. Quel segno urbano, così riottoso." *Il Sole 24 Ore* (Milan), February 6, 2000, p. 36.

Chinati Foundation Newsletter. The Chinati Foundation, Marfa, Texas. Vol. 9, 2004. Special issue dedicated to the artists.

"Claes Oldenburg and Coosje van Bruggen – Torn Notebook." *Sculpture* (Washington, D.C.) 15, no. 8 (October 1996), p. 14.

Clothier, Peter. "L.A. Outward Bound." Aʀᴛnews (New York) 88, no. 12 (December 1989), pp. 127-131.

"Commissions: Claes Oldenburg and Coosje van Bruggen, Dropped Bowl with Scattered Slices and Peels." *Sculpture* (Washington, D.C.) 10, no. 4 (July-August 1990), p. 52.

Cork, Richard. "Message in a Bottle." *Modern Painters* (London) 8, no. 1 (Spring 1995), pp. 76-81.

___. "New, Improved Traditional Values." *Times* (London), June 14, 2000, pp. 20-21.

___. "Positive Message in a Bottle." *Times* (London), September 22, 1993.

Domino, Christophe. "Objet du discours et discours de l'objet." *Artstudio* (Paris), no. 19 (Winter 1990), pp. 40-55.

Faria, Óscar. "Coosje van Bruggen Claes Oldenburg: Metaforas do Quotidiano." *Público* (Lisbon), May 19, 2001, pp.18-21.

Filler, Martin. "The Bird Man." *New York Review of Books* 52, no. 20 (December 15, 2005), pp. 32-33.

"Frank O. Gehry & Associates: Chiat/Day Main Street, Venice, California, U.S.A." *GA Document* (Tokyo), no. 32 (March 1991), cover illustration, pp. 8-21.

"Frank Gehry in Collaboration with Claes Oldenburg & Coosje van Bruggen: Chiat/Day Building, Venice, California." *Architectural Design* (London) 62, nos. 7-8 (July-August 1991), pp. 57-62.

Freedman, Adele. "The Next Wave." *Progressive Architecture* (Cleveland, OH) 67, no. 10 (October 1986), pp. 97-101.

Friedman, Lise. "Sculpting Pair: The Oldenburgs." *Vis à Vis* (New York) 2, no. 7 (July 1988), pp. 60-61.

Friedman, Martin. "Growing the Garden." *Design Quarterly* (Minneapolis, MN), no. 141 (1988), cover photograph, pp. 4-42.

"A Gallery of the Century's Brightest Talents." *Architectural Digest* (New York) 56, no. 4 (April 1999), p. 108.

Gamarekian, Barbara. "Miró and Murrow, D.C.'s Latest Attractions." *New York Times*, February 13, 2000, pp. 21, 27.

Gambrell, Jamey. "Art Against Intervention." *Art in America* (New York) 72, no. 5 (May 1984), pp. 9-15.

Garcia-Marques, Francesca. "Frank O. Gehry & Associates/Claes Oldenburg & Coosje van Bruggen: Office Building, Venice/California." *Domus* (Milan), no. 735 (February 1992), pp. 29-39.

___. "Oldenburg/van Bruggen: Il Coltello Affetta-Muro." *Domus* (Milan), no. 716 (May 1990), pp. 14-15.

Gastel, Minnie. "Aprile: emozioni in piazza." *Donna* (Milan), April 2000, p. 109.

Gayford, Martin. "Spot the Difference." *The Independent Magazine* (London), June 10, 2000, pp. 10-13.

Graham-Dixon, Andrew. "Making Spaghetti for the Prince." *The Independent* (London), July 7, 1988, p. 16.

Graham-Dixon, Andrew (text), and Bruce Weber (photography). "Bottle of Pop." *Vogue* (London) 154, no. 8 (August 1990), pp. 128-137.

Gross, Jaime. "Just Back from Los Angeles: Claes Oldenburg and Coosje van Bruggen." *Travel and Leisure*, December 2005, p. 222.

Grundmann, Heidi. "Ein Löwe ist ein Löwe…Venezia/Vienna." *Artefactum* (Antwerp) 2, no. 12 (February-March 1986), pp. 50-51.

Hoffmans, Christiane. "Magier des Alltags." *Nordrhein-Westfalen* (Cologne), March 25, 2001, p. 115.

Huberty, Erica-Lynn. "Venice: Claes Oldenburg and Coosje van Bruggen." *Sculpture* (Washington, D.C.) 18, no. 9 (November 1999), pp. 76-77.

Katz, Vincent. "Book Review: Claes Oldenburg: An Anthology and Large-Scale Projects." *Print Collector's Newsletter* (New York) 26, no. 5 (November-December 1995), pp. 193-195.

Kirk, Deborah. "The Tail End." *Interview* (New York), June 1999, pp. 82-83.

Kohen, Helen L. "Art Review: Dropped Bowl Makes a Splashy Debut, Playful Sculpture Captures Essence of the Big Orange." *Miami Herald*, March 25, 1990, sec. 1, p. 1.

Koury, Renee. "Will Huge S. F. Sculpture Be Fun or Folly?" *San Jose Mercury News* (San Jose, CA), July 14, 2002.

Kowallek, Rochus. "Hier steht der Schlips." *Art – das Kunstmagazin* (Hamburg, Germany), no. 8 (August 1994), cover photograph, pp. 4, 44-49.

Kutner, Janet. "Dallas to Dismantle its Signature Sculpture." *Dallas Morning News*, August 6, 2002, sec. A, pp. 1, 10.

Leffingwell, Edward. "All Sorts of Valuable Objects." *Art in America* (New York) 90, no. 10 (October 2002), pp. 142-147.

Leiser, Erwin. "Claes Oldenburg & Coosje van Bruggen." *Frankfurter Allgemeine Magazin* (Frankfurt-am-Main, Germany), September 10, 1993, cover photograph, pp. 10-18.

Levy, Paul. "This Art Is Inspired, in More Ways Than One." *Wall Street Journal* (New York), June 19, 2000, sec. A, pp. 42, 44.

Lindsay, Karen. "Sculptors Turn to FRP as an Alternative to Metals." *Composites Design & Application,* May-June 1997.

Litt, Steven. "'Free Stamp' Makes Its Mark." *Plain Dealer* (Cleveland, OH), November 14, 1991, sec. E, pp. 9, 16.

MacAdam, Barbara A. "Theaters of Irony." *ARTnews* (New York) 94, no. 10 (December 1995), p. 96.

"A Magnet for Visitors, in a Pinch." *New York Times*, April 11, 2002, p. 1, photograph.

Masoero, Ada. "Le cose in grande." *Vernissage – Il Giornale dell'Arte* (Turin) 18, no. 186, March 2000, p. 22.

Meisler, Stanley. "Sculpture Blossoms in a New Garden on the Mall." *Smithsonian* (Washington, D.C.) 30, no. 5 (August 1999), pp. 63-67.

Melo, Alexandre. "Vida Artística: Beaumont-sur-Dême." *Arte Ibérica* (Lisbon), March 2001, p. 82.

Molinari, Luca. "Piazzale Cadorna." *Abitare* (Milan), no. 394, April 2000, pp. 158-165.

"Monument to the Last Horse." *Interview* (New York) 22, no. 1 (January 1992), p. 6.

Muchnic, Suzanne. "Oldenburg 'Ladder' Has a Leg to Stand on in L.A." *Los Angeles Times*, September 24, 1986, pp. 1, 6.

___. "Art; Tying Up a Sizable Loose End." *Los Angeles Times*, June 20, 2004, sec. E, p. 38.

Murphy, Jim. "A Venice Collaboration." *Progressive Architecture* (Cleveland, OH) 73, no. 3 (March 1992), pp. 66-73.

Nasim, Antonella. "Claes Oldenburg e Coosje van Bruggen in una mostra a Venezia." *Koine* (Milan) 7, no. 21 (August 1999), pp. 46-49.

"An Outsize Exhibition Cuts a Wide Swath at the Guggenheim." *People Weekly* (New York), January 26, 1987, pp. 102-103.

Panicelli, Ida. "Casa d'artista/An Artist's House." *Ulisse 2000* (Rome) 10, no. 76 (July 1990), pp. 149-159.

Peppiatt, Michael (text), and Marina Faust (photography). "The Art of Inspiration: Claes Oldenburg and Coosje van Bruggen Engage the Unexpected in the Loire Valley." *Architectural Digest* (New York) 62, no. 4 (April 2005), pp. 184-189.

Quarzo Cerina, Maria Pia. "Der Lauf des Messers." *Du: Die Zeitschrift für Kunst und Kultur* (Zurich), no. 12 (December 1985), pp. 126-131.

Rose, Barbara. "Larger than Life: Claes Oldenburg and Coosje van Bruggen Think—and Build–Big." *The Journal of Art* (New York) 4, no. 5 (May 1991), pp. 33, 40-43.

Rubino, Monica. "Panettoni e cammelli per l'Ago di Cadorna." *La Repubblica* (Rome), February 3, 2000, p. 2.

Sabulis, Tom. "Sculpture Takes Pop at Painting...Roll Out the Fruit." *The Atlanta Journal-Constitution*, September 17, 2005, sec. A, pp. 1, 5.

Schels, Evelyn. "Atelierbesuch Bei den Oldenburgs: Scherz-Artikel." *Elle* (Munich), February 1992, pp. 226-230.

Schwartzman, Allan. "Art vs. Architecture." *Architecture* (New York) 86, no. 12 (December 1997), pp. 56-59.

___. "Fruit of the Boom." *House & Garden* (New York), November 1990, pp. 202-203.

"Sculptural Diplomacy." *Sculpture* (Washington, D.C.) 20, no. 7 (September 2001), pp. 48-51.

Solomon, Deborah. "Partners in Art." *Elle* (New York) 3, no. 12 (August 1988), pp. 138, 140.

Soutif, Daniel. "Claes Oldenburg de l'autoportrait à l'objet." *Artstudio* (Paris), no. 19 (Winter 1990), pp. 40-55.

Spaninks, Angelique. "Vliegende kegels boven de berm." *Eindhovens Dagblad* (Eindhoven, the Netherlands), May 31, 2000, Kunst Agenda, p. 1.

Steele, James. "Main Street Metaphors." *Architectural Review* (New York) 190, no. 1 (May 1992), pp. 71-75.

___. "The Myth of LA and the Reinvention of the City." *Architectural Design* (London) 62, nos. 7-8 (July-August 1992), pp. 66-67.

Sterling, Carol. "Where a Soul's at Ease: Gardens, Museums, and the Urban Fabric." *Sculpture* (Washington, D.C.) 18, no. 8 (October 1999), pp. 34-43.

Strano, Carmelo. "L'alba di Milano/Dawn of Milan." *L'ARCA* (Milan), no. 147, (April 2000), cover photograph, pp. 4-5.

Tanguy, Sarah. "The National Gallery of Art, Sculpture Garden." *Sculpture* (Washington, D.C.) 18, no. 8 (October 1999), pp. 24-29.

Teicher, Hendel (text), and Balthasar Burkhard (photography). "Il Corso del Coltello." *Faces, journal d'architectures* (Geneva), no. 2 (Spring 1986), pp. 33-37.

Valentin, Éric. "Oldenburg et Boccioni: échos fin de siècle de l'avant-gardisme." *Ligeia, dossiers sur l'art* (Paris), nos. 21-24, (October 1997 – June 1998), pp. 27-38.

Väth-Hinz, Henriette. "Kunst, Die Jeden Rahmen Sprengt." *Pan: Zeitschrift für Kunst und Kultur* (Offenburg, Germany), no. 7, July 1989, pp. 4, 46-52.

Vogel, Carol. "Inside Art: Peaches and Pears." *New York Times*, November 15, 2002, sec. E, p. 33.

Wallach, Amei. "The Evolution of a Team." *Newsday* (New York), December 2, 1990, pp. 23-24.

Weber, Bruce. "Pitted Against the Sky." *New York Times Magazine*, April 17, 1988, p. 106.

Weschler, Lawrence. "Art Under the Influence." *New York Times Magazine*, May 28, 2000, pp. 38-42.

Wexler, Alice Ruth. "Venice, Sliced: Il Corso del Coltello." *High Performance* (Los Angeles) 8, no. 4 (1985), pp. 65-66.

Woodward, Richard B. "Pop and Circumstance: Oldenburg and van Bruggen." *ARTnews* (New York) 89, no. 2 (February 1990), cover photograph, pp. 118-123.

"Working with Monumental Sculpture: Claes Oldenburg and Coosje van Bruggen." *Scholastic Art* (New York), March 2002.

Zinnes, Harriet. "Oldenburg and van Bruggen." *NY Arts Magazine* (New York) 7, no. 6 (June 2002), p. 30.

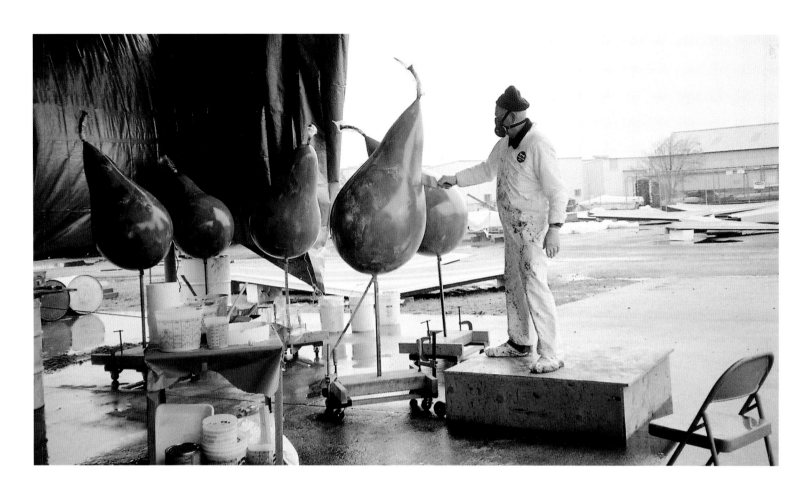

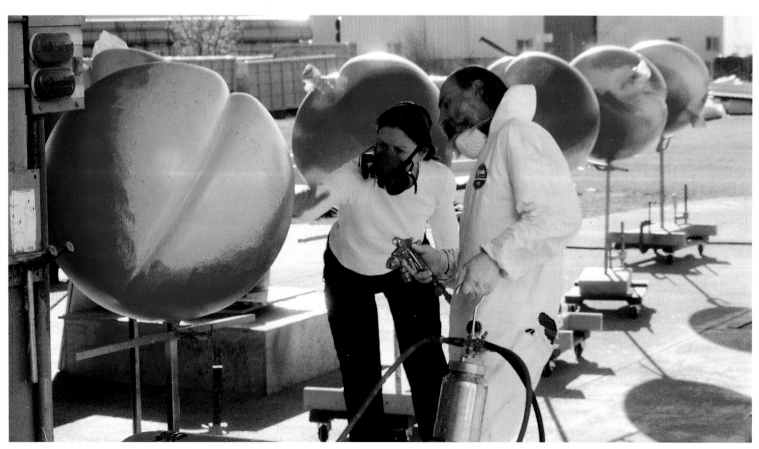

CLAES OLDENBURG COOSJE VAN BRUGGEN

The artistic team of Coosje van Bruggen and Claes Oldenburg has to date executed more than forty large-scale projects, which have been sited in various urban surroundings in Europe, Asia, and the United States. These include *Batcolumn* (1977), Harold Washington Social Security Center, Chicago; *Flashlight* (1981), University of Nevada, Las Vegas; *Stake Hitch* (1984), Dallas Museum of Art, Dallas, Texas; *Spoonbridge and Cherry* (1988), Minneapolis Sculpture Garden, Walker Art Center, Minneapolis, Minnesota; *Bicyclette Ensevelie (Buried Bicycle*, 1990), Parc de la Villette, Paris; *Binoculars, Chiat/Day Building* (1991), Venice, California; *Free Stamp* (1991), Willard Park, Cleveland, Ohio; *Mistos (Match Cover*, 1992), Vall d'Hebron, Barcelona; *Inverted Collar and Tie* (1994), Mainzer Landstrasse, Frankfurt-am-Main, Germany; *Saw, Sawing* (1996), Tokyo International Exhibition Center, Big Sight, Tokyo; *Ago, Filo e Nodo (Needle, Thread, and Knot*, 2000), Piazzale Cadorna, Milan; *Flying Pins* (2000), Eindhoven, the Netherlands; *Dropped Cone* (2001), Neumarkt Galerie, Cologne, Germany; and *Cupid's Span* (2002), Rincon Park, San Francisco. Van Bruggen and Oldenburg's most recent works are *Big Sweep*, for the Denver Art Museum, Denver, Colorado; *Spring*, for Cheonggyecheon Stream, Seoul, South Korea; and *Collar and Bow*, under construction, for the Disney Concert Hall in Los Angeles.

Recent awards of the team include Distinction in Sculpture, Sculpture Center, New York (1994); Nathaniel S. Saltonstall Award, ICA, Boston (1996); Partners in Education Award, Solomon R. Guggenheim Museum, New York (2002); and Medal Award, School of the Museum of Fine Arts, Boston (2004).

Claes Oldenburg and Coosje van Bruggen have together received honorary degrees from California College of the Arts, San Francisco, California, in 1996; University of Teesside, Middlesbrough, England, in 1999; Nova Scotia College of Art and Design, Halifax, Nova Scotia, in 2005; and the College for Creative Studies in Detroit, Michigan, in 2005.

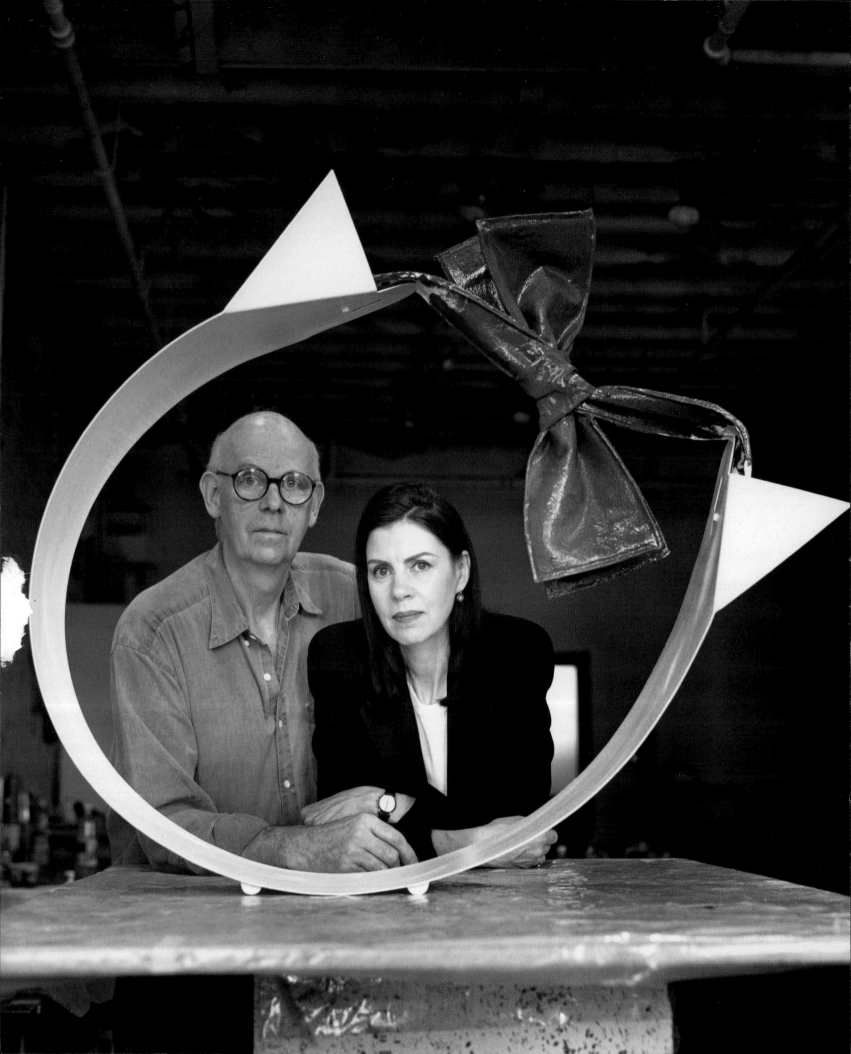

CLAES OLDENBURG was born in Stockholm, Sweden, in 1929. After living in New York City, Rye, New York, and Oslo, Norway, he moved to Chicago in 1936. Oldenburg attended Yale University from 1946 to 1950 and became an American citizen in 1953. Following work as an apprentice reporter at the Chicago City News Bureau and studies at The Art Institute of Chicago, he settled permanently in New York City in September 1956.

Using as his subject matter the common and commercial objects in his urban surroundings, especially the city's Lower East Side, Oldenburg established himself at the beginning of the 1960s with a series of installations and performances, among them *The Street* (1960), *The Store* (1961), and *Ray Gun Theater* (1962), which contributed significantly to the emergence of American Pop art. During a stay in Los Angeles in 1963, he focused on subjects inspired by what he called *The Home*, including the installation *Bedroom Ensemble* (1963). He went on to create performances in Los Angeles (*Autobodys*, 1963), Chicago (*Gayety*, 1963), Washington, D.C. (*Stars*, 1963), New York (*Washes* and *Moveyhouse*, 1965), and Stockholm (*Massage*, 1966). In 1964, after showing sculptures based on European edibles in Paris, he returned to New York and, continuing to use ordinary, everyday objects as his means of expression, developed "soft" sculptures and fantastic proposals for buildings and civic monuments.

At the end of the decade, Oldenburg took up fabrication on a large scale with *Lipstick (Ascending) on Caterpillar Tracks* (1969), which became a controversial focus for student protest when it was installed on the campus of Yale University, followed by other works such as *Geometric Mouse* (1969), *Giant Ice Bag* (1970), *Giant Three-Way Plug* (1970), *Standing Mitt with Ball* (1973), and *Alphabet/Good Humor* (1975). His first sculpture to be realized in urban scale, the 45-foot-high *Clothespin*, was installed in downtown Philadelphia in 1976. Soon thereafter, he began working with Coosje van Bruggen; they were married in 1977.

COOSJE VAN BRUGGEN was born in Groningen, the Netherlands, in 1942. After receiving a master's degree in art history from the Rijksuniversiteit in Groningen, she served as a member of the curatorial staff of the Stedelijk Museum in Amsterdam from 1967 to 1971, a breakthrough period for Conceptual and Earth Art and Arte Povera. She was co-editor of the catalogue for *Sonsbeek 71*, an exhibition of contemporary sculpture held in Park Sonsbeek, Arnhem, and at other sites throughout the Netherlands. From 1971 to 1976 she taught fine arts and art history at the Academy of Fine Arts in Enschede, the Netherlands.

Van Bruggen has worked in partnership with Claes Oldenburg since 1976, when they rebuilt and relocated *Trowel I*, originally shown at *Sonsbeek 71*, to the sculpture garden of the Kröller-Müller Museum in Otterlo, the Netherlands. In 1978 van Bruggen moved to New York (becoming an American citizen in 1993) where she continued to work with Oldenburg to establish direct contact with a wider audience by creating site-specific large-scale urban works. Their collaboration eventually extended to smaller-scale park and garden sculptures as well as to indoor installations.

Over the next ten years, Coosje van Bruggen also served as an international independent curator and critic and lectured widely: she was a member of the selection committee for *Documenta 7* in Kassel, Germany (1982); a contributor to *Artforum* (1983-1988); and Senior Critic in the Department of Sculpture at Yale University School of Art in New Haven (1996-1997). In addition to her extensive writings on Oldenburg's early work and on the collaborative projects, she created the characters for the performance *Il Corso del Coltello* (Venice, 1985). Van Bruggen is the author of essays on Richard Artschwager and Gerhard Richter and books on John Baldessari, Hanne Darboven, Bruce Nauman, and, most recently, Frank O. Gehry's Guggenheim Museum Bilbao.